*A Biographical Dictionary of Women Artists*
*in Europe and America Since 1850*

# A Biographical Dictionary of Women Artists in Europe and America Since 1850

**Penny Dunford**

University of Pennsylvania Press

Philadelphia

First published in the United States 1989 by the
University of Pennsylvania Press, Philadelphia

First published in Great Britain 1989 by
Harvester-Wheatsheaf

Library of Congress Cataloging-in-Publication Data

Dunford, Penny.
   Biographical dictionary of women artists in Europe and
America since 1850/by Penny Dunford.
      p.      cm.
   ISBN 0–8122–8230–2
   1. Women artists — Europe — Biography.  2. Art,
Modern — 19th century — Europe.  3. Art, Modern —
20th century — Europe.  4. Women artists — United
States — Biography.  5. Art, Modern — 19th century —
United States.  6. Art, Modern — 20th century — United
States.
   I. Title.
   N6757.D86    1990
   709.2′2 —dc20
   [B]                     89–16663
                             CIP

ISBN 0–8122–8230–2

Printed in Great Britain

For John

# Contents

# List of Plates

The colour plate section is *located between pages 168 and 169*.

While every effort has been made to trace the holders of the copyright to the works illustrated in this book, it has not proved possible to locate all of them. The author and publishers would be pleased to hear from any copyright holders whom they have been unable to contact.

# Preface

## NAMES

The entry has been placed under the name most frequently used by the artist during her professional life. Where an artist practised under more than one surname, cross-references are given. These other surnames appear in the main entry as alternatives. If an artist married, but did not practise under her married name, no alternative is given although the name of the husband(s) may be mentioned in the text.

## DATES

Where there is disagreement in the sources on dates of birth, the possibilities are separated by a stroke, as in 1904/7. However, where a date of birth occurred at some time between two dates, the two are separated by a hyphen, as in 1834–40. A question mark for the date of death indicates that the artist is known or presumed to be dead, but the date of death is not known. Where the date of birth is followed simply by a hyphen, the artist is still alive according to the information available to the author. In some cases this has not been possible to verify, although every effort has been made at accuracy.

## EXHIBITIONS

Full details of the venues at which an artist exhibited or of the precise nature of the awards received are not within the remit of this dictionary, although the information may often be found in the sources of reference. Details of various international exhibitions have been given because this information is not so readily available and adds a useful dimension to assessing an artist's reputation among her contemporaries. The exhibitions noted specifically include, in Europe, the series of *Expositions Universelles* held in Paris in 1855, 1867, 1878, 1889 and 1990, and the Venice *Biennali*, which began at the turn of the century, continued through the Fascist period, and still take place today. In America, the 1876 Philadelphia Centennial, the 1893 Chicago World's Columbian Exposition, together with some of the subsequent expositions, notably the St Louis of 1904 and the Panama-Pacific of 1915, have been mentioned in individual entries. More recently world's fairs have played a similar role.

In Paris the single Salon, which had existed since the eighteenth century, acquired rivals at the turn of the century in much the same way as the conservatism of the Royal Academy in London led to the formation in 1886 of the New English Art Club, itself regarded as conservative 20 years later. However, the other salons varied in their degree of radicalism, with the Salon des Artistes Français demonstrating the most academic art while the Salon des Tuiléries and the Salon d'Automne included a broader range of styles.

Under the original Salon rules, the term *hors concours* applied to all artists who obtained at least two medals which together added up to the value of a second-class award. For this purpose medals won at the *Expositions Universelles* were of the same value as those from the regular Salon. The rules were adjusted in 1900, after which all artists obtaining a second-class medal, or higher, were classed as *hors concours* and had the right to enter two oil paintings, together with two drawings or pastels and two pieces of decorative art each year without submitting them to the jury. Each year one *bourse de voyage* was also awarded and from the mid-1890s when it was won for the first time by a woman, female artists received it with reasonable frequency at least up to the later 1920s.

It should be remembered that solo shows remained exceptional until this century in both Europe and America and began to proliferate only after World War I, although memorial exhibitions were sometimes organised for well-known artists.

## SOURCES AND REFERENCES

The sources and references that occur at the end of each entry can be of three kinds:

1. *Publications*, which lists works published by the artist herself.
2. *Examples*, which lists a selection of places where examples of the artist's work can be seen.
3. *Literature*, which lists any books, catalogues and articles which deal with the life and work of the artist concerned.

It should be noted that the sources given in an entry do not necessarily reflect all the author's sources, but only the more accessible and informative. Sources that concern only one artist are given with the entry for that person and are not repeated in the bibliography, whereas those that provide material for more than one woman appear again in the bibliography. Frequently occurring sources have been abbreviated and may be traced initially through the list of abbreviations and then in the bibliography. Where a published source contains an extensive bibliography on the artist, the abbreviation (bibl.) follows the reference to that source in the entry.

It should be noted that in each case *Dictionary of women artists: an international dictionary of women artists born before 1900* (C. Petteys), *Dictionnaire des peintures, sculpteurs, dessinateurs et engravers* (E. Bénézit) and *Allgemeines Lexikon der Bildenden Künstler* (V. Thieme and F. Becker (known as Thieme-Becker)) were consulted and within the time limits of each publication many of the women mentioned in this dictionary were included by them. For reasons of space these references have not been given for each individual.

For brevity the volume and part numbers of journals have been combined. Where, for example, v6/2, 34–7 follows a journal title, this indicates volume 6, part 2, pages 34–7.

## LOCATIONS

The list of locations (given at the end of each entry under *Examples*) of an artist's work given in the entry is not intended as exhaustive. Such lists would be too lengthy. Rather it is intended as a guide to those wishing to pursue work by individuals or to see the products of women's art practice in a particular place. In many areas, information was extremely sparse. Paintings and sculpture by nineteenth-century artists often exist predominantly in private collections, so little reaches the market in an identifiable form. Conversely, with contemporary artists some forms of

practice, notably (but not exclusively) performance art, cannot be recorded in the traditional way. The entries under this section therefore vary considerably but only locations to which the public have access have been cited.

Where a place-name only appears, the reference is usually to the municipal gallery; major national or other institutions are named in full.

## ABBREVIATIONS

Abbreviations in the text fall into three categories. There are those for words or terms in frequent use, such as G for Gallery. Others, such as BA, may be easily understood in the context of an individual's education. The third category consists of bibliographical sources which occur frequently in the references for individual entries and have been introduced for reasons of space. In the majority of cases the abbreviation is the author's name and this may be readily traced in the main bibliography. The list of abbreviations contains all other abbreviations in the categories itemised in this paragraph, except for the states of the USA which are used in their abbreviated form when they occur in *Publications, Examples, Literature* and the bibliography.

# Abbreviations

| | |
|---|---|
| *AJ* | *Art Journal*, published London 1849– (the more recent American publication is given as *Art J*) |
| alt. | alternatively known as . . . |
| BA | Bachelor of Arts |
| Bachmann | See Bibliography under Bachmann, D. |
| BFA | Bachelor of Fine Art USA |
| Clayton | See bibliography under Clayton, E. |
| Clement | See bibliography under Clement, C. |
| Cooper | See bibliography under Cooper, E. |
| *Das Verborgene Museum* | See bibliography under *Das Verborgene Museum* |
| Deepwell | See bibliography under Deepwell, K. |
| *DNB* | *Dictionary of National Biography* and supplements |
| *DWB* | See bibliography under Uglow, J. |
| Edouard-Joseph | See bibliography under Edouard-Joseph, R. |
| *FAJ* | *Feminist Art Journal* |
| *Fair Muse* | See bibliography under *The genius of the fair muse* |
| G | Gallery/galleries or equivalent in language of appropriate country |
| *Graphic muse* | See bibliography under Field, R. & Fine, R. |
| Harris | See bibliography under Harris, A. & Nochlin, L. |
| Heller | See bibliography under Heller, N. |
| ICA | Institute of Contemporary Art |
| Inst. | Institute or equivalent in language of appropriate country |
| *J* | Journal |
| Krichbaum | See bibliography under Krichbaum, J. & Zondergeld, R. |
| *Mag.* | Magazine |
| Mallalieu | See bibliography under Mallalieu, H. |

| | |
|---|---|
| MFA | Master of Fine Art USA |
| MOMA | Museum of Modern Art – with name of city following |
| Munro | See bibliography under Munro, E. |
| Nat. | National, or equivalent in language of appropriate country |
| NAD | National Academy of Design, New York |
| NMAA | National Museum of American Art, Washington DC |
| NMWA | National Museum of Women in the Arts, Washington DC |
| NMWA catalogue | See bibliography under McWilliams, M. & Wood, M. |
| *Notable American Women* | See bibliography under Edwards, J., James, J.W. & Boyer, P. |
| *Notable American Women* v4. | See bibliography under Sickermann, B. & Green, C. |
| Nottingham, 1982 | See bibliography under *Women's art show 1550–1970* |
| NY | New York State |
| NYFAI | New York Feminist Art Institute |
| NYSWA | New York Society of Women Artists |
| PAFA | Pennsylvania Academy of Fine Arts, Philadelphia |
| Petersen | See bibliography under Petersen, K. & Wilson, J. |
| Proske, 1968 | See bibliography under Proske, B. |
| q.v. | See entry under this name |
| RA | Royal Academy, London |
| Roth | See bibliography under Roth, M. |
| Rubinstein | See bibliography under Rubinstein, C. |
| Schurr | See bibliography under Schurr, G. |
| Sellars | See bibliography under Sellars, J. |
| SMPK | Staatliche Museen Preussicher Kulturbesitz |
| SWA | Society of Women Artists. Used primarily but not exclusively to denote the society founded in London in 1857 and still in existence. At various times the name was Society of Female Artists and Society of Lady Artists, but the same abbreviation has been retained throughout. |
| Tufts 1987 | See bibliography under Tufts, E. |
| UFPS | Union des Femmes Peintres et Sculpteurs, founded Paris, 1881 |
| Vergine | See bibliography under Vergine, L. |
| *WAJ* | *Women's Art Journal* |

| | |
|---|---|
| Watson-Jones | See bibliography under Watson-Jones, V. |
| WIAC | Women's International Art Club |
| Withers, 1979 | See bibliography under Withers, J. |
| WASL | Women Artists' Slide Library |
| Wood, 1978 | See bibliography under Wood, C. |
| W.S. Sparrow | See bibliography under Sparrow, W.S. |
| Yeldham | See bibliography under Yeldham, C. |

# Acknowledgements

Many people and institutions have contributed in a variety of ways towards this book:

I would like to thank Sunderland Polytechnic for its assistance, both in terms of sabbatical leave and for contributing towards travel expenses. I am also grateful to the British Federation of University Women for the award of a Bursary enabling me to carry out research in London.

Thanks are due to Sally Sedgwick for the enthusiasm with which she assisted me in the gathering and filing of material for the twentieth-century artists and for sharing the excitement of our discoveries.

Research facilities were willingly opened to me by Krystyna Wasserman, the librarian of the National Museum of Women in the Arts, Washington DC; by Paula Pressley formerly of the AIR Gallery, and the National Society of Women Artists, both in New York; by the International Sculpture Center, Washington DC; and by Pauline Barrie and Nicole Veillard of the Women Artists' Slide Library in London. My use of Sunderland Polytechnic's library services was extensive and particular thanks are due to Rose Pearson and Chris Ord.

Thanks are due to Karen King and Pat Rowley for assistance with the task of translation.

Many scholars, curators, artists and gallery owners were generous with time and resources and I would like to thank all whom I consulted for their assistance. In particular I am grateful to the following: Institute of History and Art, Albany NY; Stichting Vrouwen in de Beeldende Kunst, Amsterdam; Peachtree Gallery, Atlanta; Nancy Azara; Musées Royaux des Beaux-Arts de Belgique; Nationalgalerie, Berlin; Neue Gesellschaft für Bildende Kunst, Berlin; Public Sculpture Index, the Polytechnic, Birmingham; Kunsthalle, Bremen; Brookgreen Gardens, S. Carolina; Bev Bytheway; Bradford City Art Gallery; Brandywine Museum, Chadd's Ford; Cheltenham Ladies' College; Anne Chernow; Inga Christensen; Royal Museum of Fine Arts, Copenhagen; Fine Art Society, Edinburgh and London; Musée du Petit Palais, Geneva; Greenville County Museum of Art; Kunsthalle, Hamburg; Gwen Hardie; Alison Harper; Ann Sutherland Harris; Ateneumin Taidemuseo, Helsinki; Margaret Hunter; Heckscher Museum, Huntington, NY; Rita Keegan; Angela Flowers Gallery, London; Crane Kalman Gallery, London; Leinster Fine Art, London; London Transport Museum; The Royal Collection, London; Theatre Museum, Victoria and Albert Museum, London; Raffaela Lucchesi; Irene Macneil; Arika Madeyska; Civiche Raccolte d'Arte, Milan; Alexander Moffat; Museum of Fine Arts, Montgomery, Alabama; Bayerische Staatsgemäldesammlungen, Munich; Rachel Adler Gallery, New York; Child's Gallery, New York; Knoedler's, New York; Twining Gallery, New York; Dr Nicholas Penny; Sarah Polden; Jean Whitney Payson Gallery, Westbrook College, Portland, Maine; Anne Rivière; Rochdale Art Gallery; Soprintendenza alla Galleria d'Arte Moderna, Rome; Maxwell Galleries, San Francisco; Graves Art Gallery, Sheffield; Southampton City Art Gallery; Michael og Anna Anchers Hus, Skagen; Skagens Museum; Sylvia Sleigh; Nationalmuseum, Stockholm; Antonietta Toni; Museo Civico, Treviso; Marjorie Tuttle; Lea Vergine; Moira Vincentelli; Pirjo Walton; Muzeum Narodowe, Warsaw; Corcoran Gallery, Washington DC; National Museum of American Art, Washington DC; Alison Watt; Anne Wichstrøm; Josephine Withers; Amy Wolf; Worthing Art Gallery.

I would like to thank the many artists and galleries who were so generous with their assistance over photographs. In particular I would like to thank Ghida Khairallah, of Whitford and Hughes, London; Robin Salmon of Brookgreen Gardens, S. Carolina; Berta Walker of Graham Modern, New York; Sharon Essor of the Lisson Gallery, London; Alice Jackson of the Odette Gilbert Gallery, London; Agnieszka Morawinska of the Muzeum Narodowe, Warsaw; M. Roosen of David Messum, London; Timo Keinänen of the Ateneumin Taidemuseo, Helsinki; the Leinster Gallery, London; the Carlo Lamagna, New York; the Dean and Chapter of Salisbury Cathedral; Galérie Isy Brachot, Paris and Brussels; the Lisson Gallery, London; Dr Nicholas Penny of the Ashmolean Museum, Oxford; Marjorie Tuttle of UMass Arts Council, University of Massachusetts at Amherst; Gillian Raffles of the Mercury Gallery, London; Gerry Denning of the Bowmoore Gallery, London; Alice Aycock; Nancy Azara; Pauline Barrie; Ann Chernow; Prunella Clough; Diska; Dorothy Gillespie; Mary Grigoriadis; Gwen Hardie; Margaret Hunter; Rita Keegan; Mary Kelly; Caroline Lee; Mary Lloyd Jones; Mary Miss; Gina Pane; Elaine Reichek; Sylvia Sleigh and Athena Tacha. I would also like to thank the owners of the works in private collections and the copyright holders who gave their permission for reproduction.

Above all, I would like to thank John, Alastair and Ashley for their help, advice, support and patience during this project.

# Introduction

This dictionary is intended as a reference book for those seeking information about the many women artists working in Europe and the United States after 1850. That there is a need for such a work is evident from the growing number of women's studies courses at all levels, many of which cross the boundaries of traditional disciplines. It will be of use both to the general reader, who may encounter the name of an artist and wish to find out more about her, and also to artists and art students who want to know how women in the past succeeded in overcoming the variety of obstacles the profession and society put before them.

The chief problem for women artists in the nineteenth century was access to an adequate standard of training, particularly in life-drawing. Middle-class families were usually happy for their daughters to acquire some skill in drawing and watercolour since this was regarded as an accomplishment which made a girl more eligible for marriage. Many parents opposed any idea of proceeding beyond that level, believing, as Edith Courtauld Arendrup's father did, that it was not appropriate for women to study seriously, particularly from the model. The question of access to the life class bedevilled art training for women in all countries.[1] Without knowledge of anatomy and instruction in life-drawing no artist could produce competent figurative works, especially those on historical and literary themes, which represented the most prestigious – and the most financially rewarding – category in the hierarchy of art. As a result many women artists were restricted to those subjects where the lack of training in figure drawing would be less apparent. This did not prevent them from becoming extremely successful; the sisters Anna and Martha Mutrie, and mother and daughter Mary and Maria Harrison exhibited still-life paintings extensively over a period of many years and provided themselves with an income. However, because of the perceived necessity for life-drawing as part of an artist's training, private classes such as those organized in London by Eliza Bridell-Fox were important in providing women with the opportunity to work from the model and to prepare for further study elsewhere. For admission to the Royal Academy Schools in London certain prescribed figure studies had to be submitted, and the practice was similar in other countries.

Women who came from artistic families had less of a problem and many received instruction from a relative. A few private schools in England and France began to offer life classes to women earlier in the century, although some required persuasion. When Elizabeth Gardner arrived from America in 1864, she was astounded to find that no Paris art school would accept her. Undeterred she cropped her hair and dressed as a man in order to attend the government-run École de Dessin until she later succeeded in being accepted at the Académie Julian.[2] By the mid-1870s the popularity of this establishment with women artists of many nationalities resulted in its expansion into further premises. A women's class was established, depriving the women of the opportunity of working alongside their male colleagues and benefiting from the same teaching. Women such as May Alcott realized that they were paying higher fees and receiving less rigorous instruction owing to the tendency among the visiting Academicians to assume that the women were not intending to be professional artists. Nevertheless, as we can see by the numbers of women in the dictionary who attended the Julian at some time during their career,

the instruction and the opportunities there were better than in many other places. The École des Beaux-Arts admitted women only at the end of the century, whereas the Academy in Rome remained a male preserve even longer. In America, a life class for women opened at the Pennsylvania Academy in 1868, but it was not until nine years later that women were permitted to draw from the male nude.[3] At the Royal Academy in London the male model to which women were eventually allowed access in 1893 was covered with so many layers of material that the victory seemed somewhat pyrrhic.

In view of this situation it is initially surprising to find that large numbers of women were practising as artists in the nineteenth century. One of the early writers on women artists, Ellen Clayton, observed that

> As has been the general rule with artists, who seldom belong to the ranks of the landed gentry, or even rise from the ranks of the merchant princes, it was a matter of necessity for a woman artist to adopt the profession as a means of acquiring an income.[4]

From the available evidence, many women in the nineteenth century did indeed rely on their art for an income. Henrietta Rae, for example, was brought up with the knowledge that she, like her siblings, would have to earn her own living as her father's income was insufficient to support them as adults. In some cases, like that of Louise Jopling, the need to maintain an income dictated much of her subject matter. Nearly all Victorian artists, male and female, undertook portraits for precisely that reason. Besides, the fact that still lifes found a ready market also influenced women artists who relied for their livelihood on selling their work. Within the dictionary will be found many women whose life contradicts the traditional notion of the middle-class woman. There are those who combined a career with marriage and children, as well as those who chose not to marry and those for whom marriage and art proved incompatible. The tangible evidence of success in the nineteenth century – prizes, regular acceptance at the main exhibitions and the engraving of works for publication – bears witness to the abundant talent and determination these women possessed. The fact that they have been almost entirely lost from the history of art is due partly to inadequate documentation and partly to the change in taste which caused so much nineteenth-century art to be ignored in favour of modernism and the avant-garde.

It seems a paradox that the most difficult period in which to find information on women artists is the twentieth century, before the rise of the women's movement. Because the major exhibition venues of the nineteenth century lost their dominant position to an increasingly dealer-orientated market, records are fewer and more scattered. Twentieth-century art practice has been increasingly fragmented, with artists sometimes working in isolation or in small groups and exhibiting in a variety of official and unofficial locations. The problem has been exacerbated by the concentration of art historians on those artists working in modernist styles to the virtual exclusion of all others, male and female. This dictionary includes artists working in a wide range of styles covering the whole of the modernist-academic spectrum.

With the advent of the women's art movement around 1970, the situation changed. Feminist scholars researched into women artists of the past and also supported contemporary women. Artists like Lee Krasner and Louise Nevelson, who had experienced a sense of isolation in a male-orientated system, welcomed the appreciation and support from younger women who were discovering them. At the same time many younger and as yet unestablished women artists set up alternative galleries, support networks and marketing strategies to help each other. Because of the under-financing of alternative spaces, there was often insufficient funding for catalogues and the show was less likely to be reviewed by critics. The lack of substantial reviews and

catalogues means that the knowledge of the existence of that art will be lost to future re-searchers. Unfortunately there are also catalogues which fail to provide sufficient information on the artist, and such publications do no service to those whose works were exhibited.

The terms *woman artist* and *feminist artist* should not be confused. In this book all women who practise art are women artists. The term feminist artist varies in its definition within the women's movement itself. In this dictionary it has been used to refer to a limited number of female artists from the period after 1970, when a growing number sought to explore in their art aspects of the position of women within society. The writings of some British scholars could give the impression that the only truly feminist art is scripto-visual work, believing this to be the most successful means of questioning traditional aesthetic values.[5] This view has in turn been challenged by those who believe that this is an unnecessarily restrictive view which fails to allow for a variety of form and media for the purpose of making feminist interventions in the establish-ment or of operating outside it.[6] Those who subscribe to the second view believe that the case for scripto-visual work has caused many young women artists to feel that the medium of painting is incompatible with feminist ideas. They argue that women artists should feel able to use any medium and, providing they understand the stereotypical imagery which has become part of that tradition, they can use that medium for questioning ideas and forms of representation. This dictionary contains examples of artists whose philosophical positions lie at all points between radical feminists and those who believe that being female has no effect on the art they produce.

The aim of this dictionary has been to represent women artists of all persuasions in order to establish the varied and continuous contribution that women have always made to art. Too often in the past women artists, when they are mentioned at all, are presented as prodigies and exceptions in a male domain rather than as part of a thriving tradition. As more research is carried out, evidence for this tradition is growing all the time. The two most notable recent publications in this respect are Chris Petteys' *Dictionary of women artists* (1984) and Charlotte Rubinstein's *American women artists from early Indian times to the present day* (1984). The present dictionary will help to re-establish this tradition for today's readers. In doing this I have not merely recorded a bare professional outline for each artist, but rather showed how women adapted the cir-cumstances of their lives and society to their activity as artists. Details concerning their personal lives are therefore included, as far as these are available, for these have a crucial impact on the form of women's art practice. The support or antagonism of parents, partners or friends, and the ability to obtain assistance with domestic work or finance for study are vital to an under-standing of the way in which women have been able to function as artists. In some cases, inevitably, details of personal circumstances could not be found or were incomplete, but despite this some artists warranted inclusion and it is hoped that such entries will enable others to search for further information. Other artists proved tantalisingly elusive and even information on their professional lives was sparse.

Despite this there have been far more women artists in the period since 1850 that can be encompassed in this one dictionary. The wealth of this tradition lies behind the geographical limitations, regrettable though it is, to exclude the practice of women artists outside Europe and America. Within the limitations of available information, I have tried to maintain a balance between media, nationality, modernism and academic art, and to represent women active throughout the period from 1850. Some artists whose career began before this date are included, for the year 1850 has not been used as a rigid boundary. In order to maintain this balanced representation of women artists, the criteria for inclusion have been flexible. I sought evidence of a professional attitude to art, whether or not the artist was professional in the narrow sense of earning their living from it. The scale of this activity, particularly in the nineteenth century, was

heartening. I have also included women who, in addition to being artists, improved the educational or exhibiting facilities available to female artists. To this end membership of societies of women artists has been indicated. Details of prizes and awards as well as membership of the established male-dominated national professional organizations, election to which signified the artist's merit in the eyes of her peers, have also been included, for they reveal the degree of acceptance of an artist in relation to her contemporaries and demonstrate how women artists were integrated into the art world of their society.

To a considerable extent the choice was dictated by the information available, but the final selection involved some difficult decisions, a number of interesting artists having to be omitted in the interests of balance. Further examples of English and American artists could have been included but would have increased the existing preponderance of those countries beyond what were felt to be reasonable limits. Conversely I encountered the names of many artists from continental Europe about whom adequate biographical information could not be located. Information about Spanish artists was extremely sparse, and the excellent catalogue of the women artists represented in the Berlin museums – *Das Verborgene Museum*[7] – unfortunately arrived too late to be incorporated adequately into the dictionary. Because of the impossibility of an exhaustive dictionary, photographers and film/video makers have been excluded. Although there are examples of video artists, they have been principally involved in other media, usually performance art. The number of textile artists is also limited, partly because of the problem of obtaining information. As a result there is a bias towards traditional Fine Art media. While the majority of artists in the dictionary are painters or sculptors, a much wider range of media is represented for the modern period. It has not been my intention to take a restrictive view and to ignore the recent debates on the definitions of Fine and Decorative Art. Nevertheless painters such as Anna Ancher or Ray Howard-Jones are still almost completely unknown outside their own countries. Through the efforts of scholars, some women artists, such as the Surrealists, are becoming more familar, but there is still a long way to go before art students are offered as many female exemplars as male and the general public becomes able to name readily more than three women artists. It is hoped that this dictionary will go some way towards this, and that it will encourage others to carry out further research on women artists.

The choice of artists for inclusion will doubtless be criticized and for a variety of reasons. Any individual writing such a book would have a different choice of artists and the responsibility for the selection is mine. If readers can supply further information about any women detailed here or other artists not included, I should be pleased to hear from them.

## NOTES

1. See A.S. Harris & L. Nochlin, *Women artists 1550–1950*, County Museum of Art, Los Angeles, 1976, pp.50–8; C. Yeldham, *Women artists in nineteenth-century France and England*, 2 vols, New York & London, 1984; C. Rubinstein, *American women artists from early Indian times to the present day*, Boston, 1982.
2. Rubinstein, op. cit. p.92
3. Harris & Nochlin, op. cit. p.52.
4. E.C. Clayton, *English female artists*, London, 1876, v2, p.44.
5. R. Parker & G. Pollock, *Framing feminism: art and the women's movement 1970–85*, London, 1987.
6. K. Deepwell, 'In defence of the indefensible: feminism, painting and post-modernism', *FAN*, (*Feminist Art News*) v2/4, 1987, pp. 9–12; A. Partington, 'Conditions of a feminist art practice', *ibid.*, pp.13–15, 30.
7. Berlin, Akademie der Künste, *Das Verborgene Museum: Dokumentation der Kunst von Frauen in Berliner öffentlichen Sammlungen*, Neue Gesellschaft der Bildende Kunst, 1987.

# ABAKANOWICZ, Magdalena (1930–)

*Polish sculptor of abstract works in hessian, rope, and wood*

Abakanowicz began her studies around 1950 at the Academy of Fine Art at Sopot, proceeding to the Academy in Warsaw, where she remained until 1955. In 1957 she married an engineer. Although she was initially active in both painting and sculpture, it was from 1960 that her concern focused on textiles as a form of expression. From reliefs she soon moved on to producing large three-dimensional forms using rope, completely unlike anything in the European textile tradition and breaking down the traditional boundaries between fine art media. She works in series, with the earliest called *Abakany*, from her name, with succeeding ones including various themes concerning alterations: images of human structure (1974–5), figures turning their backs, and heads (1975–7). These cycles are made from fibre and sacking, with open and closed forms. More recently she has included elements of rough-hewn wood, either with ropes or alone. She has travelled and exhibited extensively, has had more than 40 solo shows and won many international awards since 1965, the year in which she also began teaching at the School of Art in Poznan, where she is now a professor.

*Examples:* Stedelijk Mus., Amsterdam; Nat. G, Berlin; Canberra; Lodz; MOMA, New York; Centre Nat. d'Art Moderne, Paris; Stockholm; Warsaw.

*Literature: Das Verborgene Museum*; Heller; M. Jacob & J. Reichardt, *MA*, Mus. of Contemporary Art, Chicago & New York, 1982 (full bibl.); *Künstlerinnen International 1877–1977*, Schloss Charlottenburg, Berlin, 1977; Biennale catalogue, Venice, 1980.

# ABBEMA, Louise (1858–1927)

*French painter of portraits, genre and allegory*

Born at Etampes, Seine-et-Oise, she was inspired to become an artist by the example of Rosa Bonheur (*q.v.*) and studied in Paris with Chaplin, Henner and Carolus-Duran in the tradition of Salon painting. At the age of 18 she achieved great acclaim with her portrait of Sarah Bernhardt (*q.v.*), with whom she had a long-lasting and passionate relationship. A flamboyant personality, she frequently dressed as a captain of dragoons, with a bicorned hat, and apparently relished the attention this attracted. She executed the wall and ceiling paintings for the Sarah Bernhardt Theatre, as well as other large buildings, in addition to her output of easel paintings. She exhibited at the Salon from 1874 until 1926, and at the international expositions at Chicago in 1893 and Paris in 1900. Abbema stands as an example of a highly successful academic painter. She also illustrated *La Mer* by Maizeroy, and contributed articles and illustrations to various art and fashion journals. Among her many awards was that of the Chevalier de la Légion d'honneur in 1906.

*Example:* Pau, Pyrénées Atlantiques.

*Literature:* Cooper; M. Elliott; G. Greer, *The obstacle race*, London, 1979; Krichbaum; J. Martin, *Nos peintres et sculpteurs*, Paris, 1897; Petersen; C. Skinner, *Madame Sarah*, London, 1967; W.S. Sparrow; Weimann.

# ACCARDI, Carla (1924–)

*Italian painter of abstract works*

Born in Trapani, Sicily, Accardi began to frequent the academies at Palermo and Florence only after graduating in classics in her native city. By 1947, when she settled in Rome, however, she was already sufficiently established to be in group shows both in Rome and Prague. She was one of the signatories of the *Forma* manifesto and contributed to the abstract orientation of the group. The following year a work of hers was selected for the Venice Biennale. Her marriage to artist Antonio Sanfilippo also took place in 1948, and a daughter was born in 1951. She held her first solo show in Rome in 1950, and since then she has participated in many group and solo shows internationally. Artists with whom she has exhibited include Tapies, Manzoni, Fontana and Twombly. She was always an abstract artist, but her use of line to create the structure of the composition was replaced by greater emphasis on planes and colour. In the early 1960s, she began experimenting with painting on plastic shapes such as cones, and in the 1970s created some environmental work such as *Three tents*. Her recent work consists of small non-geometric, brightly coloured shapes placed on a primed or unprimed canvas. She was a member of a women artists' co-operative founded in Rome in 1976 and participated in the 1988 Venice Biennale.

*Literature:* Biennale catalogue, Venice, 1988; *Italian painting of today*, New Vision Art Centre,

London, 1961; Krichbaum; *Recent Italian painting and sculpture*, Jewish Mus., New York, 1968; Vergine.

## ACHESON, Anne Crawford (1882–1962)

*Irish sculptor of figures, portraits and architectural works in wood, stone, concrete and metal*

Born in Portadown, Northern Ireland, Acheson trained at Victoria College, Belfast, and at the Royal College of Art, London, under Lanteri, until 1910. She exhibited from that year at the RA, SWA, and in Belfast, Glasgow and Liverpool as well as in Paris. In 1919 she was awarded a CBE for her work with the Surgical Requisites Association in London during World War I. She subsequently divided her time between London and Glenlavy, Co. Antrim, and in 1938 she received the Feodora Gleichen (*q.v.*) Memorial Award. Much of her early work was in wood, but she later extended her range to include a variety of other materials. Her achievements were recognised in her election as member of the Royal Society of British Sculptors and the SWA.

*Literature: Irish women artists*; Mackay; Waters; *Who's Who*.

## ACHILLE-FOULD, Georges (1868–1951)

*French painter of historical subjects, genre and portraits*

Her mother, Wilhelmine Joséphine Fould, was an actress, sculptor and art critic who, before her second marriage to Prince Stirbey of Romania, wrote under the name Gustav Haller. Born in Asnières, Seine, she, like her sister Consuelo (b. 1865), studied under Cabanel, Vollon and Comerre in Paris. She is described as having begun her exhibiting career in 1884 at the Salon 'while still in short skirts'. She exhibited at the Salon until 1914, receiving several medals, at the UFPS and the Indépendants between 1928 and 1937. From 1897 she was declared *hors concours* and won a bronze medal at Paris in 1900 for *The Gold Mine*. She preferred using real characters rather than professional models for her works, but disliked realism. A period of portraiture in the 1890s was most notable for that of *Rosa Bonheur* (*q.v.*) painted (1893) in the latter's studio as she paused during the painting of a large picture of lions. Achille-Fould was elected member of the Société des Artistes Français.

*Literature:* Clement; Edouard-Joseph; Prince B. Karageorgevitch, 'Mlle AC', *Mag. of Art*, 1903, 341–5; W.S. Sparrow.

## ADSHEAD, Mary (1904–)

*English mural painter, illustrator and designer*

The daughter of a professor of architecture, Adshead studied at the Slade between 1922 and 1925 after attendance at a Parisian lycée. She had first exhibited in 1920 and remained an active exhibitor at the RA while building up a reputation as a mural painter. In 1929 she married the artist Stephen Bone, who had also studied at the Slade, and over the years they collaborated in producing several children's books. Adshead was commissioned to carry out seven posters for London Transport, in addition to the decoration of the Bank underground station. Although in the early 1950s she designed three postage stamps (10s, 5s, 8d), her mural schemes remained her major preoccupation. These included the restaurant at the Werner Museum, Luton Hoo, the Jungle Restaurant in Selfridges department store, and the Highways Club, Shadwell, on which she collaborated with Rex Whistler, as well as several churches. She was a member of the AIA, and during World War II she assisted refugees. She was also a committee member in WIAC, and a member of both the London Group, NEAC (from 1930) and the Society of Mural Painters, of which she was secretary for some time in the 1960s. In 1964, a period when she was involved in several church commissions, she used a method of working straight on to the wall in oil, wax medium, encaustic and casein.

*Publications: Travelling with a sketchbook*, London, 1966; (with S. Bone) *The little boy and his house*, London, 1936; *The silly snail*, London, 1942; *The little boys and their boats*, London, 1953.

*Examples:* St Alban's church, Hemel Hempstead; St Francis' church, Luton; St Peter's church, Plymouth; St Mary's church, Plymstock; St Christopher's church, Withington.

*Literature:* M. Day, *Modern art in church: a gazetteer*, London, 1982; Deepwell; Waters; *Who's Who in Art*.

## AGAR, Eileen (1899–)

*English Surrealist artist working with paint, collage and mixed media*

Although born in Buenos Aires, Agar came to London with her wealthy English parents at the age of six. At an early stage, she determined to be an artist, despite the opposition of her parents, and set out to avoid the dilettante art teaching often afforded to young women. After a few months of study at the Byam Shaw School of Art, she moved on to Underwood's School at Hammersmith, where fellow students included Henry Moore and Gertrude Hermes (*q.v.*) and where considerable emphasis was placed on life drawing. Having cut herself off from her family, she attended the Slade under Henry Tonks from 1925 to 1926, was married briefly and spent the years 1928–30 in Paris working with Foltyn, the Czech Cubist painter. It was there that she both learnt about structure in abstract compositions and also became interested in Surrealism. From explorative self-portraits, she moved onto the depiction of natural forms, frequently marine life, abstracted and juxtaposed in unexpected ways. When Paul Nash, a good friend who shared her interest in found objects in the natural world, persuaded Herbert Read and Roland Penrose to visit her studio in 1936, they recognised her as another Surrealist and drew her into their circle. She exhibited with the London Group in 1933 and also had her first solo show that year, so that by the time she participated in the Surrealists' International Exhibition in London in 1936, she was already independently established as an artist. While contributing to further British and international Surrealist exhibitions in the late 1930s, she was the only female signatory to their manifesto in support of 'Peace, Democracy and Cultural Development'. When war broke out in 1939, she met other British Surrealist artists, including women such as Rimmington (*q.v.*), Pailthorpe (*q.v.*) and Colquhoun (*q.v.*), to discuss the formation of the International Federation of Independent Revolutionary Art. The war disrupted her work and she resumed painting only in 1946 after visits to Tenerife revived her relish for it. Since then her appetite for work has continued unabated. Her paintings, collages and three-dimensional objects include a wide range of natural elements. The rocks at Ploumanach in Brittany, which she photographed in 1936 and which inspired a painting by Paul Nash, formed the basis for a series of hallucinatory paintings of her own in 1985. The interest of her second husband, Joseph Bard (a Hungarian who died in 1975), in classical cultures and his collection of seals and engraved gems, also broadened her field of reference, particularly with regard to landscape. Making use of found objects and pre-existing material for collage, she combined elements with a sense of curiosity and with touches of humour in a way which transforms them and disregards the logic of the rational. Of the women Surrealist artists, she is the one who has had most direct involvement with the movement as such and arguably the one who has maintained the longest and most active exhibiting career.

*Publications: A look at my life*, London, 1988; 'A movement of the spirit', *The artist's and illustrator's mag.*, no.25, Oct. 1988, 14–17.

*Examples:* Nat. G of Scotland, Edinburgh; Leeds; Tate G and V & A, London; Manchester; Southampton.

*Literature:* W. Chadwick, *Women artists and the Surrealist movement*, London, 1985; *EA: a retrospective*, Birch & Conran G, London, 1987; Deepwell; G. Hedley, *Let her paint*, City Art G, Southampton, 1988; Krichbaum; Nottingham 1982; *Salute to British Surrealism*, Minories G, Colchester, Essex, 1985; *The Surrealist spirit in Britain*, Whitford & Hughes G, London, 1988; Vergine.

## AINSLEY, Sam (1950–)

*English fabric artist producing abstract and semi-figurative works*

Born in North Shields, Tyne and Wear, Ainsley has spent most of her working life in Scotland. Trained at Leeds, Newcastle-upon-Tyne Polytechnic and in the tapestry department of Edinburgh College of Art, she has now carried out a number of large public commissions for banners, tapestries and wall-hangings. After she had paid a seminal visit to Japan in 1976, her work took on an austere appearance with limited colours and an emphasis on materials. Because she explores the space between painting, sculpture and textiles, her work can be allied to the off-stretcher works of artists such as Stephanie Bergman and to the concerns of Eva Hesse (*q.v.*) and Agnes Martin (*q.v.*). Colour returned to her work between 1979 and 1980, after she visited New York in 1978 and realised she could not permanently maintain her ascetic approach. The early 1980s saw a series of colourful fabric constructions, which resulted in

a commission for banners to be hung at the opening of the new premises of the Scottish National Gallery of Modern Art in Edinburgh. Other commissions followed from this. *The Banner for Greenham* was also crucial in engaging her with political and feminist concerns and thus bringing figuration into her work as a means for exploring Ainsley's own role as a woman artist. She sought to create positive and accessible images, her references covering a wide range of female predecessors and contemporaries in art and literature. Recent work continues this figurative iconography, with twice life-size constructions around the many connotations of the colour red. She has exhibited regularly in group shows since 1978 and had her first solo show in 1986.

*Examples:* Royal Edinburgh Hospital; Scottish Nat. G of Modern Art and Royal Scottish Mus., Edinburgh; Leeds.

*Literature:* S. Brown. *SA: why I choose red*, Third Eye Centre, Glasgow, 1987.

## AIRY, Anna (1882–1964)

*English painter and etcher*

Airy's artistic talents manifested themselves early, and she became a student at the Slade at the age of 17, remaining there for four years until 1903. Under Fred Brown, Tonks and Steer she won the Melville Nettleship prize there in three consecutive years. In the early years of the century she sought her subjects from criminal haunts along the Thames. She witnessed cockfights and boxing without gloves. On one occasion she was present in an underground gambling den when a murder was committed and escaped the police cordon only through the quick thinking of a card-sharper friend. She became an Associate of the Royal Society of Painters and Etchers in 1908 (full member in 1914), a member of the Royal Society of Oil Painters in 1909 and a member of the Royal Society of Painters in Watercolour in 1918. During 1918–19 the Imperial War Museum commissioned her to paint scenes of munitions factories staffed by both women and men. After her marriage to Geoffrey Pocock, she lived near Ipswich. Her works reveal a stress on geometrical structure, with a certain division into planes. She continued exhibiting internationally and also took on the post of part-time inspector to the Board of Education.

*Publications: The art of pastel*, London, 1930; *Making a start in art*, London, 1951.

*Examples:* Blackpool; Doncaster; Harrogate; Huddersfield; Ipswich; WAG, Liverpool; British Mus., Imperial War Mus. and V & A, London; Rochdale; Toronto; Vancouver.

*Literature:* J. Coleman, 'AA, 1882–1964', *WASL J*, Apr.–May 1988, 6–7; Deepwell; Sellars.

## AKHVLEDIANI, Elena Dmitrievna (1901–?)

*Soviet painter, printmaker and designer for the theatre*

Born in Telav, Georgia, she studied at the Academy of Tbilisi, capital of Georgia, in 1922, but then lived in France and Italy until 1927. She is best known for her town scenes, but she has also illustrated books of Georgian writers and a translation of Longfellow's poems. Her career as art director in the theatre has been a distinguished one, with over 60 plays to her name, in addition to films, operas and ballet, including the Kirov Ballet Company. She has won several awards, and holds the title People's Artist of the Georgian Soviet Socialist Republic.

*Literature:* W. Mandel, *Soviet women*, New York, 1975.

## ALALOU-JONQUIERES, Tatiana. (alt. ALALOU; JONQUIERES) (1902–?)

*Soviet sculptor whose early work was figurative whereas her later work moved towards abstraction*

Born in Bialystock, she studied at the Moscow Academy and then from 1918 to 1920 with Archipenko. In 1920 she decided to pursue her studies in Paris where she worked under Bourdelle, later becoming his assistant. Her early sculpture, predominantly in stone, consisted of a traditional repertoire of naturalistic portrait busts, including those of her artistic contemporaries. These she exhibited in the Salons from the early 1920s. As she turned to clay and bronze, her work evolved along increasingly abstract lines. In 1937 she was one of the small number of invited, as opposed to juried, participants in the *Femmes artistes d'Europe* exhibition in Paris, and she also received a commission for a monumental work for the Paris

World's Fair the same year. She also took part in the Salons de la Jeune Sculpture. At one stage an accident affected her eyesight and prevented her working for several years.

*Literature:* Edouard-Joseph; Krichbaum; Mackay.

### ALBERS, Anni (1899–)

*German-born Bauhaus weaver who in America took up printmaking*

Born in Berlin, she became a student at the Bauhaus in 1922. Unable to enter the glass workshop, which had its full quota of students, she reluctantly chose weaving. By the time she married painter Josef Albers, who taught at the Bauhaus, she was becoming known for her abstract geometrical pictorial weaving. She remained at the Bauhaus until 1930, but three years later, when Hitler closed the school, the Alberses emigrated to America, where they subsequently acquired citizenship. They were invited to teach at Black Mountain College, North Carolina, and there Anni Albers set up a weaving workshop which introduced revolutionary ideas about weaving to both fine art and industrial design. Evidence of her success in dissolving the barriers that then existed between craft and art was provided in 1949 when MOMA in New York unprecedentedly gave her a solo show. In the meantime, she continued to design for industry, carry out commissions and write on weaving. But it was the appointment of her husband to the directorship of Yale School of Fine Arts in 1950 which ultimately led to her discovery of printmaking. When Josef Albers accepted an invitation to work for a period at the Tamarind Lithography Workshop in California, Anni Albers decided to try printmaking herself, and later she was invited to return there as artist-in-residence. She used a variety of printmaking techniques and experimented with ways of transferring the variety of thread texture to the print. In other works she uses repetition of small geometrical elements, but in an unrepetitive way, for they are not mathematically calculated. Her prints have been more widely exhibited and brought her greater recognition than her textiles, but it is the concern with thread that underlies all her work.

*Publications: On designing*, New Haven, 1959; *On weaving*, Middletown, 1965; entry on handweaving in *Encyclopaedia Britannica*; *Pre-Columbian Mexican miniatures*, New York, 1970.

*Examples:* Baltimore; Bauhaus-Archive, Berlin; Art Institute, Chicago; V & A, London; Brooklyn Mus., Jewish Mus. and MOMA, New York, Neue Sammlung Mus., Munich; Nürnberg; Zurich.

*Literature: AA*, Brooklyn Mus., New York, 1977 (bibl.); *AA: pictorial weavings*, MIT, Cambridge, Mass., 1959; I. Anscombe, *A woman's touch: women in design from 1860 to the present day*, London, 1984; *Das Verborgene Museum*; Rubinstein; N. Weber, 'AA and the printerly image', *Art in America,* summer 1975, 89.

### ALCOTT, May. née Abba May. (alt. NIERIKER) (1840–79)

*American painter of still life, flowers and portraits*

The youngest of the four Alcott sisters, she was immortalised as Amy the artist in the novel *Little women* by her sister Louisa. Both from this source and from the diaries of her three sisters, a detailed account of her life can be constructed. She was born in Concord, Massachusetts where her father Amos Bronson Alcott (educator, author and mystic) moved to in 1840. Although rather spoilt, she had an affectionate and cheerful disposition which encouraged others to make sacrifices on her behalf. She enjoyed an intellectually rich but financially poor childhood, her family tolerating her artistic efforts in a variety of media with good humour. At the age of 16 she paid the first of several long visits to Boston, where she studied drawing. She shared lodgings with her sister Louisa, who had been sent to Boston to write in tranquillity because her earnings were so desperately needed. On one visit May attended the School of Design and studied under William Hunt, and in 1862 with Dr Rimmer. Her training was nevertheless patchy, but by 1868 she was able to take pupils to supplement her income. Through the generosity of a friend, May and Louisa undertook an extended European tour in 1870, meeting Margaret Foley (*q.v.*) and other women sculptors in Rome. On the second of her visits to London, May met John Ruskin while she was copying works by Turner in the National Gallery. As a result, May's paintings were given to students at the South Kensington Schools to study. Like many artists, she produced pretty panels, which sold easily, in order to finance her more serious work. In 1875 she was instrumental in founding an art centre in Concord, Mass. In her enthusiasm

to make art freely available, she taught classes there and presented her books to the library. After further visits to England she arrived in Paris in 1876, joining the all-female class at Krug's Academy for some months. Her first work was accepted for the Salon in 1877. Later that year she returned to England, where she could more easily sell her work, and exhibited at several venues, including the SWA. In 1878 she met and married Ernest Nieriker, a young Swiss businessman with a modest income, and they settled at Meudon, near Paris. The happiness conveyed by her letters resulted in the completion of many works and her second Salon piece was accepted in 1879. Just as she was entering on a more established phase of her artistic career, she died in December, six weeks after the birth of a daughter.

*Publications: Studying art abroad and how to do it cheaply*, Boston, 1879.

*Literature:* Clement; C. Ticknor, *MA: A memoir*, Boston, 1927.

## ALEXANDER, Francesca. née Esther Frances ALEXANDER (1837–1917)

*American artist living Italy who produced drawings and illustrations of Tuscan peasants and landscapes*

Born in Boston, she spent most of her life in Tuscany with her expatriate parents. Her father was a self-taught portrait painter, while her over-protective mother dominated her daugher's life to such an extent that when her mother finally died aged 101, Francesca took to her bed and died the following year. Her incursion into art began purely as a means of raising money for philanthropic causes. Through her pen and ink drawings she became fascinated by her subjects, the life and land of the Tuscan rural labourers. Her illustrated books were extremely popular. John Ruskin encountered her, and greatly admired her detailed observation of nature, feeling that her works also contained elements of the spirituality he sought in art. He promoted her work in his lectures at Oxford.

*Publications: Roadside songs of Tuscany*, 1885.

*Literature:* G. Constance, *FA: a hidden servant*, Cambridge, Mass., 1927; P. Nunn, 'Ruskin's patronage of women artists', *WAJ*, v2/1, 8–13; Rubinstein; M. Spielman, 'FA', *Mag. of Art*, July 1895.

## ALLEN, Marion. née BOYD (1862–1941)

*American painter of portraits, figures and landscapes*

Born in Boston, Allen only took up painting at the age of 40, having given up her early life to the care of her invalid mother. Through her talent for drawing she was encouraged to enrol at the Boston Museum School of Art, where she completed prize-winning works under Benson and Tarbell. During the course of her training she married, graduating in 1910. Portraits were the hallmark of the earlier part of her career, and she soon became successful, with solo shows from 1910. She exhibited in the Panama-Pacific Exposition in 1915 and began to accumulate prizes with regularity. One was awarded for her unusual portrait of Anna Huntington (*q.v.*), the sculptor, working on a model of her Joan of Arc (1919), a picture that shows characteristic strong modelling of the figure and rich pigment. From the early 1920s she began to paint landscapes, for which she undertook many arduous and difficult journeys throughout North America. Accounts show her to have been a resourceful and courageous woman. Her landscape paintings, usually vertical in format, were realistic and richly painted. Her portraits of Arizona Indians each had an individual frame carved by native craftsmen. When not travelling she lived in Boston.

*Literature: Fair Muse*; Tufts, 1987.

## ALLI, Aïno Sophia. née NEUMANN (1879–?)

*Finnish painter of portraits and miniatures, many on ivory and copper*

Born in Uleaborg, she trained in the School of Art at Wiborg, followed by periods at the University of Helsingfors and the Julian and Colarossi academies in Paris. Finally she attended the atelier of H. Morisset in Paris. She exhibited from 1909 in Wiborg, Helsingfors, London (from 1927) and at the Salon d'Automne in Paris, where she became a jury member. At the Salon Strindberg in 1923, she had a solo show consisting of 90 works, of which 30 were miniatures. In 1929 she received a commission for a portrait of the daughter of the Finnish president. She is best known for oil portraits such as this, together with pastels and miniatures

on ivory and copper; but she also painted still lifes and figure subjects.

*Literature:* Edouard-Joseph.

## ALLINGHAM, Helen. née PATERSON (1848–1926)

*English watercolour and graphic artist depicting rural life and landscapes*

The eldest of six children of a doctor, she was born in Burton-on-Trent but lived in Altrincham, Cheshire until her father's death in 1862. The family then moved to Birmingham, and Paterson began attending the School of Design, where she remained for four of the next five years. In January 1867 she went to live in London in the care of her maternal aunt, Laura Herford (*q.v.*), who in 1861 was the first woman admitted to the Royal Academy Schools. Paterson followed in her aunt's footsteps to the Royal Academy Schools after three months at the Female School of Art, Queen's Square. After visiting Italy for two months in 1868, she began to earn money for her tuition fees by illustrating magazines and children's books, and while still a student became one of the regular staff on the *Graphic* magazine. Later she carried out wood engravings for *Once a Week, Cornhill Magazine* and others. She excelled at watercolour, in which she was influenced by Fred Walker and M. Birket Foster, and exhibited almost entirely at the Old Watercolour Society (221 works) of which she became an Associate in 1875 and a full member in 1890. In 1874 she married the poet William Allingham and despite having several children continued to work prolifically. She exhibited at Chicago (1893 bronze medal), Paris (1878 and 1900), and Brussels (1901 silver medal), as well having seven exhibitions with the Fine Art Society between 1886 and 1913. Through her husband she mixed in literary circles where she encountered John Ruskin, who admired her work. She specialised in scenes of idyllic rural England, with children and pretty cottages. She also executed several portraits of the writer Thomas Carlyle, who was a family friend, in his later years.

*Examples:* Belfast; British Mus. and V & A, London; Maidstone; Manchester; Southampton.

*Literature:* Clayton; Clement; H. Furniss, *Some Victorian women: good, bad and indifferent*, London, 1923; G. Hedley, *Let her paint*, City Art G, South-ampton, 1988; H.B. Huish, *Happy England as painted by HA*, London, 1903, repr. 1985; C. Neve, 'Mrs A's cottage gardens', *Country Life*, v155, 632–3; P. Nunn, *Victorian women artists*, London, 1987; J. Ruskin, *Academy Notes*, 1875 and *Art of England*, 1884; W.S. Sparrow; Wood, 1978.

## ALMA-TADEMA, Anna (1865–1943)

*English painter of portraits, genre, landscapes, interiors and flowers*

The daughter of Sir Lawrence Alma-Tadema by his first wife, Marie, she was always rather over-shadowed in her long career by the success of her father and stepmother, Laura (*q.v.*). She exhibited extensively from the age of 20, her work being shown at the RA and elsewhere in London, at Paris in 1889, where she showed three water-colours of interiors, and at Vienna in 1894.

*Literature:* W.S. Sparrow.

## ALMA-TADEMA, Laura Theresa. née EPPS (1852–1909)

*English painter of portraits, domestic scenes, Dutch genre, flowers and landscapes*

The youngest of three artist daughters of a London doctor, Laura was given music lessons instead of instruction in painting like her sisters, Emily and Nellie (*q.v.* under Gosse). Laura's first serious training began in 1870 with Lawrence Alma-Tadema, whose second wife she became in 1871. Having noted the talent of her sisters he was sure that she would be able to paint and, under his tuition, she made rapid progress. After their marriage, they toured France, Holland and Belgium, a pattern which continued during succeeding years. This confirmed her artistic ambitions and she went on to produce many studies of children, often in seventeenth-century Dutch costume, genre subjects, pastel portraits and small landscapes usually of Italy. An opponent of women's suffrage, she portrayed women in traditional roles. Her prolific output was only temporarily slowed when in 1874 an explosion at her home in Regent's Park nearly destroyed the house; but even then she succeeded in completing one work for the RA in 1875. She exhibited her first picture at the Paris Salon in 1872

to considerable acclaim. This was followed by works at the RA from 1873 and at other London galleries. She enjoyed a distinguished international exhibiting record, including not only the Paris Salon and the expositions there in 1878, 1889 and 1900, winning silver medals at the first and last of these, but also regularly at Berlin and at the Chicago Exposition in 1893. Her husband, who became RA in 1879, was knighted in 1899 and is believed to have said that his greatest ambition was to have inscribed on his tombstone, 'Here lies the husband of Mrs Alma-Tadema'.

*Examples:* Adelaide Art G, New South Wales; The Hague; Manchester.

*Literature:* Bachmann; D. Cherry, *Painting women: Victorian women artists*, Art G, Rochdale, 1987; Clayton; Clement; Edouard-Joseph; M. Elliott; G. Greer, *The obstacle race*, London, 1979; Krichbaum; A. Meynell, 'LA-T, *AJ*, 1883, 345–7; P. Nunn, *Victorian women artists*, London, 1987; W.S. Sparrow; Wiemann; Wood, 1978.

## ANCHER, Anna Kirstine. née BRöNDUM (1859–1935)

*Danish painter of interiors and figures in a small fishing community*

Much of Ancher's life was spent in her native town of Skagen, a fishing community at the most northerly point of Denmark, where her parents ran an hotel. Her initial instruction took place in Copenhagen with Vilhelm Kyhn from 1875 to 1878. She began exhibiting in 1879, but in the 1880s her colour began to develop under the influence of Christian Krogh, and from 1888 to 1889 she worked in Paris with Puvis de Chavannes. It was the Impressionism she encountered there which had a lasting effect on her work, and when she returned to Skagen she evolved an independent style in which the technique varied between thick brush strokes and thin, light touches; her colours are rich and harmonious. She married the painter Michael Ancher in 1880 and, with his active support, continued to paint. When she was busy, food would be brought in from her parents' hotel, and as her husband was successful she had the freedom to paint as she wanted. She exhibited both in Denmark and abroad – at Berlin and St Petersburg in 1900, winning medals at Paris in 1889 and 1900. Her works depict the daily events of family life in the cottages of the fisherfolk of Skagen rather than working life. She was one of a group of Danish artists who worked in the village,

but they chose other aspects to paint. Her house is now a museum.

*Examples:* Copenhagen; Skagen.

*Literature:* Clement; *Dreams of a summer night*, Hayward G, London, 1985; Edouard-Joseph; Krichbaum; K. Madsen, *Skagens Malere*, Copenhagen, 1929.

## ANDERSON, Laurie (1947–)

*American performance artist, musical performer and composer*

One of seven children, she was strongly influenced by music and story-telling in her childhood. After completing her MFA in sculpture in 1972 at Columbia University, New York, she began at once to work in performance. An accomplished player, she featured the violin (combined with narrative) in most of her work. The content resulted from the manipulation of autobiographical material, transformed through memory and often concerned with the theme of time. Some of her early performances took place on the street. Parallel with these, from 1974 onward she returned to sculpture, but this has never been a major part of her work. Increasingly from the late 1970s she placed the narrative into songs and her work became more self-referential than simply autobiographical. Her recorded songs often deal with pop music but her work, whatever form it takes, can always be enjoyed on several levels.

*Literature:* R. Goldberg, 'Public performance: private memory', *Studio International*, July–Aug. 1976, 19–23; L. Lippard, *Get the message*, New York, 1984; Roth; P. Stewart, 'LA: with a song in my art', *Art in America*, Mar.–Apr. 1979, 110–13.

## ANDERSON, Sophie. née GENGEMBRE (1823–*c*.98)

*French-born painter of portraits and genre, who worked mainly in England.*

Soon after she was born in Paris, her father, a French architect and her English mother moved to a remote area of France. As a child she spent much of her time drawing, but was unaware of other kinds of art until, when 16, she saw the work of some travelling painters who would complete a portrait in a couple of hours. For the next few years she copied their method until she

was invited by friends to Paris, where she started training with Steuben. However, he returned permanently to Russia almost as soon as she arrived, so Gengembre was left to learn as best she could from the other female students in the studio for the rest of the year before returning home. At 25 she fled to America with her family to escape the 1848 revolution. There, despite being virtually self-taught, she became a successful portrait painter in Cincinnati and Pittsburgh, undertaking this work in order to earn a living. While in America she married Walter Anderson, an English artist, and they settled in England in 1854, living in London, Cumbria and Bramley, Surrey. She quickly established herself as an artist and exhibited at the RA from 1855 to 1896, as well as at other London galleries and at Liverpool. In 1871 her health necessitated a move to Capri, from which she and her husband returned about 1894 to live in Falmouth. Sophie Anderson is one of the many women artists known and judged only by one work. *No walk today* depicts a small girl looking wistfully through the window, but Anderson produced many works, including some for chromolithographs in America, and in 1852 she contributed five illustrations to Henry Howe's *Historical Collections of the Great West*. Twice forced to establish a reputation in countries where she had no contacts, she nevertheless maintained a successful career, making the most of the opportunities which came her way.

*Example:* WAG, Liverpool.

*Literature:* Bachmann; Clayton; Harris; Heller; P. Nunn, *Victorian women artists*, London, 1987; Sellars; W.S. Sparrow; Wood, 1978.

## ANNOT. (pseud. of Anna Ottilie KRIGAR-MENZEL, alt. JACOBI) (1894–1981)

*German figurative painter who worked for pacifism for many years*

Belonging to a Berlin doctor's family, she studied in 1915 with Lovis Corinth. It was at this stage that

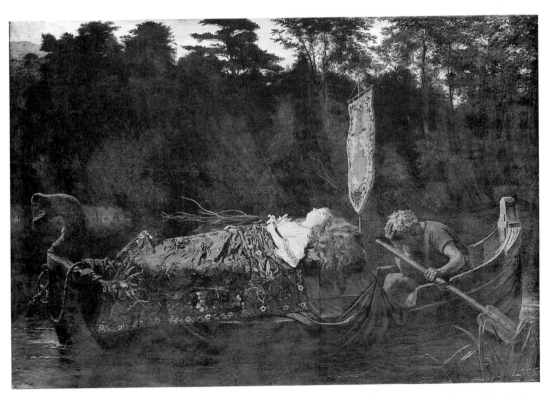

**Sophie Anderson** *Elaine*, 1870, oil on canvas, 158.4 × 240.7 cm, Walker Art Gallery, Liverpool. (photo: John Mills (Photography) Ltd)

she first encountered pacifism, with which she began her personal involvement, in Oslo in 1917, with the production of leaflets. She maintained her activity for this cause during the early 1920s, after her return to Berlin, and was a founder member of several organisations. In 1921 she married the painter Rudolph Jacobi and had two children. From 1923 to 1926 she and her family lived in Positano, near Naples, after which she studied in the Paris atelier of André Lhote. Returning to Berlin, she began exhibiting and also set up the Annot Art School, attended by several later well-known women artists. When this was closed by the Nazis in 1933, she emigrated to America, where until 1950 she spent her spare time working with a Quaker organisation sending food parcels to Europe. From 1956 she lived in Puerto Rico and it was not until 1967 that she returned to Germany, spending the rest of her life in Munich. In her eighties she was still concerned with political matters, and in 1976 painted two Irish women peace campaigners, Betty Williams and Mairead Corrigan. Although figurative, her paintings are not highly finished and precise but allusive and suggestive.

*Publications:* 'Die Frau als Malerin', in A. Schmidt-Weil (ed.), *Die Kultur der Frau*, Berlin, 1931.

*Examples:* Berlinische G, Berlin; Nat. G, Washington, DC.

*Literature: Das Verborgene Museum*; Krichbaum; *Künstlerinnen International 1877–1977*, Schloss Charlottenburg, Berlin, 1977.

## ANSINGH, Lizzy. née Maria Elizabeth Georgina ANSINGH (1875–1959)

*Dutch painter of portraits and still lifes*

Lizzy (or Lizzi) Ansingh came from an artistic family in Utrecht; her aunt, to whom she was very close, was Thérèse Schwartze (*q.v.*), and this undoubtedly influenced her choice of career, leading her to undertake training at the Amsterdam Academy from 1893 to 1897. There she met some of the other women artists who later became known as the *Amsterdamse Joffers* – the young ladies of Amsterdam – (*q.v.* under Ritsema). After painting portraits and still lifes in the early part of her career, in 1936 she began the doll paintings for which she became famous. She also undertook lithographs and book illustration.

*Literature:* Krichbaum; A. Venema, *Die Amsterdamse Joffers*, Baarn, 1977.

## ANTIN, Eleanor. née FINEMAN (1935–)

*American peformance artist*

Although Fineman was born in New York City, her parents were Polish. Far from certain as to what she would do as a career, she majored in writing from City College. Before completing the course she left, having found a temporary job as an actress. This suited her predisposition to adopt other names and personalities, which has been called an identity crisis. After dance training, which ended prematurely because of her health, and modelling for artists, including Isobel Bishop (*q.v.*), she married David Antin and began to visit art exhibitions. In the early 1960s she wrote poetry, but also began to paint and make collages. Her first solo show was held at Long Island University. In 1968, when her son was a year old, the family moved to California, where her husband had taken up a new appointment. She herself obtained a teaching post at the University of California and began to develop her work within the context of the west coast and its women's movement. After *Adventures of 100 boots* documented in photographs 100 wellington boots in different locations to form a narrative sequence, another series documented a weight loss. Her performance work dates mainly from the 1970s, when she evolved a series of characters for herself: the King of Solana Beach, the Ballerina, the Nurse and the Black Movie Star. The exploration of these *alter egos* takes place not only through performance, but also through writing, drawing, video, painting and photography. Using the role differently on each occasion, she applies it to a range of social, personal and artistic issues. What is presented as autobiography is 'an imaginative reconstruction of the self in a new temporal context, a transformation of identity through and into art'.

*Publications:* 'Reading Ruscha', *Art in America*, Nov.–Dec. 1973; 'On self-transformation', *Flash Art*, Mar.–Apr. 1974; 'An autobiography of the artist as autobiographer', *Journal of the Los Angeles Inst. of Contemporary Art*, Oct. 1974; 'Before the Revolution', *High Performance*, winter 1980.

*Literature:* J. Crary, 'EA', *Arts Mag.*, Mar. 1976, 8; K. Levin, 'EA', *Arts Mag.*, Mar. 1977, 19; L. Lippard, *Get the message*, New York, 1984; Munro;

Nemser, *Art Talk*, New York, 1975; Petersen; Roth; Rubinstein.

## ARENDRUP, Edith. née COURTAULD (1846–?)

*English painter of landscapes (especially Egyptian) and religious subjects*

Daughter of the youngest partner in the textile firm of Courtauld, Edith never needed to earn a living from painting. However, from the age of six she was determined to be an artist and began by copying prints of horses by Rosa Bonheur (*q.v.*). By 13 she was attempting ambitious oil paintings of subjects such as bullocks in a Scottish landscape. When her father showed this work to Edwin Landseer, the leading animal painter, he said, 'Don't let her have any [teaching]; what the masters teach she knows already.' Landseer himself had received the traditional long training and no boy of equivalent talent would have been left virtually to teach himself. Courtauld struggled on alone, and at 15 sold a painting of hers from the RA exhibition Eventually in 1866 she sought advice from J.R. Herbert, an Academician, as to her future studies and, much against her father's wishes, he taught her how to draw the figure. Despite his disapproval of art as anything more than a pastime for his daughter, her father had two studios built for her, one in their garden at Braintree, Essex, and the other in the garden of her uncle, the painter George Hering, in St John's Wood. This area of London was inhabited by many artists, many of whom Courtauld now met. By 1870 she had become a Roman Catholic, rented a house and studio with a woman friend and begun work on *Memories of the First Palm Sunday*, which was well received at the RA. In the autumn of 1872 she went to Egypt where she met and, in 1873, married a Dane, Col. Arendrup. He was killed in action two years later in Abyssinia, and she returned to work in England, producing a series of religious works which she exhibited at the RA and elsewhere, while most of her Egyptian landscapes were shown at the Dudley Gallery.

*Example:* Melbourne, Australia.

*Literature:* Clayton; Krichbaum; Yeldham; Wood, 1978.

## ARGYLL, Duchess of. See LOUISE, Princess.

## ARMINGTON, Caroline Helena. née WILKINSON (1875–1939)

*Canadian-born painter and engraver, especially of European city scenes, who worked in Paris*

Although born in Brampton, Ontario, Armington spent most of her career in Paris after first going there to study at the Académie Julian. She first exhibited at the Salon in 1908 and from then her work appeared regularly at exhibitions in France, Belgium and Chicago, and at Liverpool from 1910 to 1912. She had several solo shows in the mid-1920s in Washington, DC and New York, as well as exhibiting jointly with her husband, Frank. She was elected an Associate of the École Nationale des Beaux-Arts, member of the Chicago Society of Etchers and the Société de la Gravure Originale en Noir. Although she was producing aquatints from early in her career, her engravings date only from after 1925. She usually chose views where the emphasis was on architectural features rather than on people.

*Examples:* British Mus. and V & A, London; New York Public Library; Nat. G, Ottawa; Petit Palais and Mus. d'Art Moderne, Paris; Congressional Library, Washington, DC.

*Literature: Art News*, 14 Nov. 1925, 4, and 12 Feb. 1927, 9; Edouard-Joseph.

## ARMOUR, Mary Nicol Neill. née STEEL (1902–)

*Scottish painter of flowers and landscapes*

The daughter of a steelworker, she was born in Blantyre, Lanarkshire. A scholarship to Hamilton Academy at the age of 11 brought Steel into contact with the art teacher Penelope Beaton, who was to be a formative influence, not only giving her pupil a sound training but also inspiring her towards a professional career. In 1920 she enrolled at the Glasgow School of Art, where she studied under Maurice Greiffenhagen and David Wilson. On leaving in 1925 she taught in schools but had to give this up when she married the painter William Armour in 1927. With a circle of their friends and her husband to provide support and criticism, she was able to exhibit regularly and received increasing acclaim. In 1941 she executed a mural commission in the naval canteen at Rosyth. Elected an Associate of the Royal Scottish Academy in the same year, she began to move away from

tonal values and muted colours during that decade, but it was in the 1950s that a radical change took place in her work. In 1951 a teaching post at the Glasgow School of Art brought her into contact with younger artists who were experimenting with colour, as were the artists she knew in Edinburgh, such as Anne Redpath (*q.v.*). Her colours became brighter and more freely handled, her palette lighter. Her landscapes were reinvigorated by a move from Milngavie to Kilbarchan, on the hills above the Clyde. The broader brushstrokes and feeling of spontaneity conceal the carefully considered composition. Retiring from teaching in 1962, she enjoyed a prolific decade as a leading Scottish painter and won many awards and elections, although her full membership of the RSA had taken place in 1958.

*Examples:* Glasgow; Greenock; Paisley; Victoria, New South Wales.

*Literature:* R. Billcliffe, *MA: a retrospective exhibition.* Fine Art Society, Edinburgh, 1986; *Centenary exhibition of the Society of Lady Artists*, Society of Women Artists, Glasgow, 1982; *Who's Who in Art.*

**Mary Armour** *Nellie Moser*, 1987, oil on canvas, 74.8 × 50 cm, private collection. (photo: Fine Art Society Ltd.)

## ARNESEN, Borghild (1872–1950)

*Norwegian figurative painter, often on machine-made metal forms*

Born in Sarpsborg, she studied at the Royal Norwegian School of Art and Craft in Oslo with Asta Nörregaard (*q.v.*) and at a private school, where she was taught by Harriet Backer (*q.v.*). In 1895, she travelled to Paris, attending various academies, and to Italy. Three years later she became a pupil of Armand Point, a close follower of Paladin and the Rosicrucians, from whom she learnt engraving and enamel work. She was influenced by him to use designs from nature for decoration. She exhibited in Oslo from 1890, in several Paris salons until at least 1928, and had a large solo exhibition in a private gallery there in 1904.

*Example:* Thielska G, Stockholm.

*Literature:* Edouard-Joseph; Krichbaum.

## ARNIM, Bettina von (1940–)

*German painter of fantastic images, including robots and machinery, who lives in France*

Born in Zernikow (Mark Brandenburg), she attended the Hochschule für Bildende Künste from 1960 to 1965. She spent some time in 1962–3 in Paris, where she learnt engraving, and on her return to Berlin she began to exhibit. The year 1967–8 was spent teaching, and in 1975 she settled in the south of France. During the 1970s her imagery included machine-like figures, sometimes seen from a low viewpoint that gave them a sense of monumentality and menace. Painted in a tightly controlled way, with no background to distract the spectator, these figures possess a Surreal quality.

*Example:* Berlinische G, Berlin.

*Literature:* *Das Verborgene Museum*; Krichbaum.

## ARP, S. See TAÜBER, Sophie

## ATHES-PERRELET, Louise (*c.* 1865–?)

*Swiss sculptor, textile designer and engraver*

While still a student in Geneva from 1888 to 1891, she won a succession of prizes in drawing, paint-

ing and sculpture. She was, unusually, able to study painting with two women artists, Mme Carteret and Mme Gillet, while her sculpture studies were taken with Bovy. She subsequently executed statues, busts and medallion portraits, and by 1902 was involved in designing costumes for the theatre of Geneva. These she would decorate with hand-painting. She also conducted tapestry-weaving workshops in New York. She was a member of the Union des Femmes Peintres et Sculpteurs and the Cercle Artistique.

*Literature:* Clement; A. Prather-Moses, *International dictionary of women workers in the decorative arts*, New York, 1981.

## ATWOOD, Clare (1866–1962)

*English painter of interiors, still life, portraits and flowers*

The daughter of an architect in Richmond, Surrey, she studied at the Westminister and Slade schools of art. She became a prolific artist who exhibited extensively in London, Glasgow and Liverpool from 1893. In her early paintings she showed a predilection for depicting workers and factory scenes. She was elected a member of the Women's International Art Club and, in 1912, of NEAC, although she had exhibited with them from the beginning of her career, showing a total of 108 paintings at NEAC alone. During World War I, she received several official commissions through the war artists' scheme.

*Example:* Imperial War Mus., London.

*Literature:* Waters; *Who's Who in Art.*

## AYCOCK, Alice Frances (1946–)

*American sculptor of fantastic architecture and machines*

Born in Harrisburg, Pennsylvania, Aycock was influenced in childhood by her father's construction business. He had studied architecture and engineering and had built the family house. She graduated from Douglass College, New Jersey, with a BA and from Hunter College, New York, in 1971 with an MFA for which she had studied with Robert Morris. Her approach to art as a means of pursuing knowledge over a range of subjects, coincided with that of Morris; and although she admired the intellectual rigour of minimalism, even her early works show her interests as broader

than purely formal concerns. Her wooden constructions of the mid-seventies were architectural but all contained elements of irrationality and disorientation for the spectator. From 1977 to 1979 these structures became more elaborate, but all were made by Aycock herself. She then enlarged her range of materials to include glass, metals and scientific equipment of various kinds. With these she designed and made intricate pseudo-machines such as *How to catch and manufacture ghosts* (1970), in which she questions the ability of science to provide all the answers in the face of invisible forces in the universe. Underlying all her work is a breadth of reading and knowledge which enables her to link ideas from several disciplines and cultures. Her blade machines of the 1980s derive from a desire to connect modern technology with medieval, and from the notion that violence with a blade is involved in both the growing of crops and the preparation of food. Several of these works included moving blades, at the same time sinister and riveting. These images also coincided with a personal crisis: her marriage to and separation from the artist Dennis Oppenheim in 1982. Aycock has used texts and drawings as increasingly important elements of her work. This was due in part to the theoretical basis of her sculptures and also to the reduced funding available for large-scale installations. Aycock has exhibited widely in Europe and America, with solo shows in most years since 1971. She has one son, born in 1986, and is currently an assistant professor at Hunter College, New York City.

*Examples:* MOMA, New York; NMWA, Washington, DC.

*Literature:* Heller; M. Poirier, 'The ghost in the machine', *ARTnews*, Oct. 1986, 78–85; H. Risatti, 'The sculpture of AA and some observations on her work', *WAJ*, v6/1, spring-summer 1985, 28–38; C. Robins, *The pluralist era*, New York, 1984; Rubinstein; *Sitings*, Mus. of Contemporary Art, La Jolla, 1986; Watson-Jones.

## AYRES, Gillian (1930–)

*English painter of highly coloured abstract gestural works*

A Londoner by birth, Ayres decided at the age of 14 to become an artist. She studied from 1946 to 1950 at Camberwell School of Art, and was selected for the first-ever Young Contemporaries exhibition in her final year. In 1951 she shared a job at the AIA Gallery with the painter Henry

Mundy. Through this she met many artists and writers, and began to exhibit with the London Group. She began to visit Wales, where she has lived permanently since 1981. Athough she had her first solo show in 1956, it was not until the following year that the opportunity came for working on a large scale. An architect asked her to carry out, in six weeks, paintings on 25-metre-long panels in a school dining-room. She began teaching, which has always been an important part of her work, at Bath Academy of Art in 1958, when her first son, James Mundy, was one year old. (Her second son was born in 1966.) Other members of staff included Howard Hodgkin and Robyn Denny. In 1966 she moved to St Martin's College of Art, London, and in 1978 became head of painting at Winchester School of Art, where she remained until 1981. Throughout this period she was receiving many invitations to exhibit internationally with other abstract painters who were evolving from the influences of Abstract Expressionism, as well as having a series of solo shows. Her strong colours were based on admiration for the work of Titian, Rubens and Matisse. Her earlier works included stained canvas, then heavy impasto with dark colours, followed in turn by a period of bright acrylic paintings. In 1976 she returned to oils and moved away from American influences to large-scale paintings where there is no central focus, but where the eye moves constantly over the surface of vibrant broken marks of colour. Since she moved to the northwest coast of Wales, suggestions of landscape and sea have emerged within the painterly elements. Despite her extensive exhibiting record, she remains a comparatively unfamiliar figure in the sphere of abstract painting in Britain.

*Examples:* WAG, Liverpool; Manchester; Rochdale; Sheffield.

*Literature: Current affairs*, MOMA, Oxford, 1987 (bibl.); T. Hilton, *GA*, Serpentine G, London, 1983; P. Rippon, *GA*, Kettle's Yard, Cambridge, 1978; Sellars.

## AZARA, Nancy (1940–)

*American sculptor of abstract carved and painted wooden pieces and producer of artists' books; also co-founder and a director of the New York Feminist Art Institute (NYFAI)*

Azara initially attended the Polakov studio of stage design in New York from 1960 to 1962, and only in 1964 did she enrol at the Art Students' League to study painting for three years. This was followed by a period in Italy, during which she began her exhibiting career. Through Azara's involvement with the women's movement and a desire to translate religious experience into visual art, she has over a period of some years worked on a series of sculptures from assembled pieces of wood, varying in scale up to over two metres, although most of her more recent work is smaller. She utilises the varying textures and applies brightly coloured paint and gold leaf to create a feeling of richness. She has also produced many artists' books, including visual diaries. Since 1977 she has been deeply involved with the founding and administration of NYFAI, and has taught many courses and workshops both there and in other institutions. Parallel with these many activities she has maintained a consistent exhibiting record.

*Literature:* E. La Rose, 'NA', *Arts Mag.*, Sept. 1984, 18; *Transformations*, Coliseum, New York, 1981; *Who's Who in American Art*.

## BACH-LIMAND, Aino Gustavovna. (alt. BACH) (1901–after 1976)

*Soviet printmaker and book illustrator*

Born in Cape Koeru, Estonia, she studied at the Pallas Art School in Tartu from 1924 to 1935. She is best known for her aquatints and drypoints, although she also uses other printmaking techniques. Her subjects include portraits and scenes from everyday life; she has also illustrated the works of many Estonian writers. She has won several awards, including the 1947 Estonia prize.

*Literature:* B. Bern, *Aino Bach*, Moscow, 1959; W. Mandel, *Soviet women*, New York, 1975.

## BACKER, Harriet (1845–1932)

*Norwegian painter of interiors of both domestic settings and churches, figures subjects, portraits and still lifes, the main concern of which is the play of light, whether natural or artificial*

As one of her country's leading painters and a teacher of art, Backer provided a role model for many of her compatriots. She was fortunate to be

born into a wealthy and cultured family where music and art were encouraged, and a younger sister, Agathe Backer Grondahl, became a famous composer and pianist. Her father was a shipowner and they lived in the busy shipping centre of Holmestrand until 1857, when they moved to Oslo (then Christiania). Her artistic studies were extensive and extended, beginning when she was six and continuing until she was 43. One of the Norwegian art schools she attended was that at Bergslien (1872–4), and she also spent time travelling, including six-month stays in Berlin (1866), Florence (1871), Weimar (1871–2) and Cologne (1873). An important period began in 1874 when she started four years' study with her compatriot Eiliff Petersen, who with Kitty Kielland (*q.v.*), whom she also met in Munich, remained her lifelong friend. At this stage her dark-toned paintings were based on realism, with figure subjects predominating. In 1878 Backer was one of the first Norwegian artists to leave Munich for Paris, where she studied briefly with Bastien-Lepage, but felt she gained more from Bonnat. Her contact with French Naturalism contributed towards her greater use of colour as a major component, and in this a visit to Brittany with Kielland (who lived with Backer in Paris from 1881 to 1888) in 1881 or 1882 was decisive. From this time the study of light becomes her real subject, for she wrote of trying to achieve 'the *plein-air* in the interior'. She employed colour, composition and content to create scenes which convey an atmosphere of tranquillity. Having won an award with her first exhibit at the Salon in 1880, she continued exhibiting and won a medal at the Paris Exposition of 1889. Having returned to Norway, she ran a popular art school in Oslo from 1888 to 1912. Parallel with her interiors, often with a woman reading or sewing, she developed a series of church interiors which continued until 1913. In these, light streams in through doors and windows, often contrasting the timelessness of religious observance with a glimpse of the everyday world seen through a doorway. Backer continued to travel abroad until 1920 and to paint until her death.

*Examples:* Nat. G, Oslo; Stavanger; Stockholm; Trondheim.

*Literature: Dreams of a summer night*, Hayward G, London, 1985; G. Greer, *The obstacle race*, London, 1979; E. Kielland, *HB*, Oslo, 1958; Krichbaum; M. Lange, *HB 1845–1932: Kitty L. Kielland 1843– 1914*, Stifelsen modums Blaafarveværk, Åmot, 1983; M. Vishny, 'HB: a Northern light', *Arts Mag.*, v59, May 1983, 78–80; A. Wichstrom, *Kvinnor ved staffeliet*, Oslo, 1983.

## BACKHOUSE, Margaret. née HOLDEN (1818–after 1885)

*English painter of figure subjects, especially Swiss and Italian*

The daughter of a vicar, Holden was born in Summer Hill, near Birmingham, but spent her early childhood at Brighton, before the family moved to Calais. Yearning for better instruction than her governess could give her, she persuaded her father to allow her to study in Paris. He was eager to give his children every advantage in education, and it was arranged that she should study with Troivaux and Grenier but it is not clear how long this lasted. With family support she was able to study at Sass' in London a year or two later. There she persuaded Mr Sass to allow her to undertake the more severe studies then reserved for male students and followed this course for nearly a year. Marriage did not halt her activities, for she continued to study with William Mulready and Goodall. She travelled abroad extensively in Italy and Switzerland, sketching both figures and settings. She liked to draw working women whom she felt were majestic and noble, but they are not presented in a socially conscious manner. She was a prolific artist, exhibiting from 1846 to 1885 at many London galleries, including the RA and the SWA. Many of her paintings were issued by Rowney's as chromolithographs. Her daughter Mary was also a painter, who attended the South Kensington and RA Schools.

*Literature:* Clayton; Wood, 1978.

## BACON, Peggy. née Margaret Francis BACON (1895–)

*American visual satirist in prints and illustrations*

The daughter of two professional painters, Peggy Bacon was born in Ridgefield, Connecticut and was introduced to art at an early age. Her parents did not, however, encourage professional aspirations because they knew how poor many artists were; indeed her father committed suicide in 1913 because of his lack of recognition. It was Lucia Fuller (*q.v.*), the miniaturist, who had provided Bacon with that impetus, and despite the shock of her father's death, Bacon continued her studies at the New York School of Applied Arts for Women. From 1915 to 1920 she studied at the Art Students'

League with Miller, Bellows and Sloan. She admired the urban scenes of the Ash Can painters, as well as the social comment of Daumier. While there she taught herself printmaking, as there was no teacher, and had soon found her *métier*: drypoint caricatures. In 1920 she married fellow student Alexander Brook, and after a visit to England that year, they spent the next two decades in or near the art colony of Woodstock (New York), which was then a centre of advanced political and artistic ideas. She soon abandoned painting altogether, feeling inadequate beside her husband. Despite two children, born in 1920 and 1922, she pursued her satirical prints in the form of lithographs, etchings and illustration. She had written and illustrated a book published in 1915 and went on to produce illustrations for over 80 more books. The award of a Guggenheim Fellowship in 1934 enabled her to produce a volume of caricatures. Over this period she had several shows and with her family spent the winters in New York, where Brook worked for the Whitney Studio Club. By the late thirties she abandoned her caricatures, despite many commissions, because too many people were hurt by them. From 1938 she began to visit Ogunquit, Maine, in the summers and drew genre scenes and landscapes. Divorced in 1940, she taught in colleges, continued her illustrations, and wrote a prize-winning mystery novel. In 1975 she was the first living woman artist to be given a retrospective at the National Museum of American Art, and in 1980 she received the gold medal of the Academy Institute of Arts and Letters for eminence in the graphic arts, for which Jasper Johns and Robert Rauschenberg were the other contenders. In the 1950s she began to paint once more and continued into her mid-eighties, when she developed a technique of using lines over washes of colour to depict life in a small New England town with the occasional element of fantasy.

*Publication: Off with their heads*, New York, 1934.

*Example:* Ogunquit, Me.

*Literature:* Rubinstein; R. Tarbell, *PB: personalities and places*, NMAA, Washington, DC, 1975; *Women pioneers in Maine art 1900–45*, J.W. Payson G, Portland, Me., 1985.

## BADIALI, Carla (1907–)

*Italian abstract painter*

Born in Novedrate, Como, she lived in St Etienne in France, where her family had settled, until the age of 13. Her father, who was an amateur painter, taught her to use oil paints. Her schooling completed in Italy, she became a student at the National Institute for Silk in Como and there trained as a fabric designer. Apart from artistic training, this involved the translation of a design on to minutely squared paper for the silkweavers, which resulted in an abstraction of even a realistic design. Parallel with this she studied music for ten years. Following a period with one of the large silk firms, she opened a design studio in Milan and until 1963 she designed and made fabrics for the *haute couture* fashion market. In Milan she became acquainted with a number of abstract artists, and from 1933 she began to paint planar compositions, some geometrical, others with less regular shapes. In 1937 she joined the second-generation Futurist movement and exhibited with the Valori Primordiali Futuristi di Sant'Elia Group on several occasions, including the Venice Biennale of 1942. From her marriage in 1943 to an architect dates a series of more spontaneous works in oil and ink, which reflect a sudden spurt of optimism in the midst of war. While pregnant, she was arrested in 1944 and imprisoned for her work in the Resistance. After the war, she had a consistent career, exhibiting in major galleries in Italy and abroad, although she herself has shunned publicity.

*Literature: Künstlerinnen International, 1877–1977*, Schloss Charlottenburg, Berlin, 1977; Vergine.

## BAILLY, Alice (1872–1938)

*Swiss painter of figures in a synthesis of Cubism, Futurism and Fauvism*

Born in Geneva, she studied at the École des Beaux-Arts from where she received a scholarship to study in Munich. She spoke fluent German and declined to attend the necessary classes, preferring to work on her own. This was typical of her independent character. After the withdrawal of the scholarship, she had to return to Geneva where, pressured by her mother, she made an abortive attempt at teaching in a school. A visit to Naples reinforced her convictions about the artistic provincialism of Geneva, and in 1904 she went to Paris, where she remained until the outbreak of war in 1914. At this period avant-garde artists were migrating to Paris, and she became friendly with many, including Dufy, and, in the Cubist circle, Gleizes, Picabia, Laurencin (*q.v.*) and Lewitska. She exhibited in the Salon d'Automne

every year from 1906 and in that of 1908 her paintings were shown in the same room as those of the Fauves, indicating her highly keyed palette, which was a consistent feature of her work. At the same time she produced many wood engravings. She also exhibited in the Salon des Tuileries and the Salon des Indépendants. By 1910, she had taken up the Cubist ideas of Picasso and Braque and was evolving her own version, retaining bright colours, but her conclusion was quite different from that of Sonia Delaunay (*q.v.*). Selected in 1912 to represent her country in an international touring exhibition, she was simultaneously absorbing the results of her encounter with Futurism. Fascinated by the study of movement, her studies at this point resembled those of Balla and Duchamp, while using themes from city life. Forced by the war to return to Switzerland, she began exploring the use of collage combined with painting. Isolated from contemporary developments, she extended her collage to the production of wool pictures, where the wool replaced brushstrokes. According to Vergine, she produced at least 27 of these. She spent much of 1921 in Paris, but returned to Switzerland for the rest of her life. Continuing to paint and exhibit, she finally obtained belated recognition in her native city with an exhibition in 1928. Her last project was the execution of eight large murals for the theatre at Lausanne. During this period she also campaigned for greater awareness and support of modern art in her country and to this end established a foundation to provide scholarships for young Swiss artists.

*Example:* Geneva; theatre, Lausanne; Lucerne; NMWA, Washington, DC.

*Literature:* J. Butler, 'AB: Cubo-Futurist pioneer', *Oxford Art J.*, v3, Apr. 1980, 52–5; Edouard-Joseph; NMWA catalogue; Schurr, v6; Vergine.

## BARNEY, Alice Pike (1857–1931)

*American painter of women, children, portraits and landscapes in oil and pastel; also a patron and supporter of artists*

Born in Cincinnati, she was the youngest of four daughters of an extremely wealthy businessman who was also an active patron of the arts. They moved to New York in 1867 and after her father's death in 1872, Alice Pike accompanied her mother and sisters on a visit to Europe. While in London she met and fell in love with the explorer Henry Stanley. After a visit by Stanley to New York in 1874, they became unofficially engaged to be married two years later, for he was about to embark on an expedition and he named both his boat and the Lady Alice Rapids in Zaire (formerly Congo) after her. However, in 1875 Alice Pike suddenly married Albert Barney, who was very conventional and reserved but whose suit had the support of Mrs Pike. Interestingly, in 1890 Stanley married another woman artist, Dorothy Tennant (*q.v.*). Alice Barney had two daughters, Natalie and Laura, whom in 1884 she took to the studio of Elizabeth Nourse (*q.v.*) to pose. In this way Barney discovered a source of self-expression which was to be increasingly important to her. After teaching Barney for some time, during which Barney paid for Nourse to make a crucial visit to Paris, Nourse suggested that Barney too should pursue her studies in Paris so, while her daughters were at school in Fontainebleau from 1886 to 1889, Barney studied with the academic painters, Carolus-Duran and Henner, and then with Whistler who was the strongest influence on her. She exhibited at the Salon in 1889 as well as in America, to which she returned that year. Although her husband did not approve of his wife's artistic activities, she organised her life in a way which ensured she could continue to paint, and they spent increasing periods of time apart. The largest part of her output dates from the 1890s. Many paintings were of women, whether portraits, nude studies or models in the guise of mythological figures. Elements of Symbolism are present in both style and content and several works depict legendary *femmes fatales* common in late nineteenth-century French art. Her portraiture benefitted from the teaching of Carolus-Duran, and this is the only area of her art in which she depicted men. While in Paris, she began to use pastels, and found they suited her preference for working rapidly. Widowed in 1902, she subsequently divided her time between Washington and New York, with occasional trips to Europe.

*Examples:* Works by Barney from the Barney Loan Collection can be found in universities, museums and government offices; permanent locations include University of Virginia Mus. of Fine Art, Charlottesville; Dayton, Ohio; Opera House, Paris; Folger Shakespeare Library and the Studio House, Washington, DC.

*Literature: Fair Muse;* D. Hall, *Catalogue of the APB memorial lending collection,* Washington, DC, 1965; D. McClelland, *Where shadows live: APB and her friends,* 1978, Smithsonian Institution, Washington, DC, 1978; Rubinstein.

## BARNS-GRAHAM, Wilhemina (1912–)

*Scottish painter of semi-abstract landscapes*

Born in Scotland, she arrived in Cornwall in 1940, where she was associated with the modernist landscape painters working in and around St Ives. She exhibited with them and had had her first solo show by 1947. With Mary Jewels (*q.v.*) she was a founder member of the Penwith Society of Arts in the town in 1949. In the same year she married artist David Lewis. Although financial problems were acute, she sought through her painting the discovery of a personal freedom. This involved abandoning visual reality in favour of abstract compositions, which were originally based on studies of glaciers in the Swiss Alps, a subject which fascinated her until the 1960s. Her painting continued to be based on landscape, notably Porthmeor, Cornwall. Intrigued by the contrasting elements of solidity and transparency, she transposed on to the canvas roughly geometrical planes and forms moulded like sculpture. By 1956/7 she was teaching at Leeds School of Art and exhibiting in London. Divorced in 1963 she settled in St Andrews, Scotland in 1973, from where she continued to visit St Ives. Since the 1960s the references to landscape have become indirect so that the paintings appear abstract.

*Examples:* Tate G and V & A, London.

*Literature:* A. Bowness, *WB-G*, Scottish G, Edinburgh, 1956; *Cornwall, 1945–55*, New Art Centre, London, 1977; W. Jackson, *WBG – paintings and drawings*, Crawford Centre, St Andrews; Nottingham, 1982; *St Ives, 1939–64*, Tate G, London, 1985.

## BARRIE, Pauline (1954–)

*English painter and sculptor, particularly in enamel; co-founder and co-ordinator of the Women Artists' Slide Library (WASL)*

Born in Cumbria, she had three brothers and resented the way in which she was expected, like her mother, to minister to their requirements. During two years at Lancaster College of Art (1970–2) she was exposed to a wide variety of technical processes, including stained glass. Arriving in London in 1972 to attend Kingston Polytechnic, she made contact with the emergent women's art movement and was a member of some of the earliest groups. Through the women's movement she was able to understand her position

as due to socialisation and to come to terms with this. Graduating with a first-class degree, she soon began to receive prizes and commissions, having exhibited since 1973. By 1977 she was one of several women aware of the lack of resources on women's art and began to collect slides of work by women. Two years later this collection opened to the public, initially for a few hours a week, and over the years Barrie became increasingly involved with the project, fund raising, finding premises, lecturing and organising the archive. WASL made increasing demands on her time, but she has continued to exhibit her enamels during the 1980s and is a member of the British Society of Enamellers. Gradually the organisation has been built up with the help of both paid workers and volunteers, so that it is now the chief British resource for the works of contemporary and historical women artists, even though it has to rely on sponsorship, donations and grants. Barrie has written and lectured on many aspects of women in the arts and campaigns for equality of representation of women in all spheres of art.

*Literature: Contemporary British enamels*, Shipley Art G, Gateshead, 1985; G. Elinor *et al.*, *Women and craft*, London, 1987.

## BARTHOLOMEW, Anne Charlotte. née FAYERMANN. (alt. TURNBULL) (1800–62)

*English painter of genre, allegory, flowers and fruit; also a writer of plays and poems*

Born in Lodden, Norfolk, she trained as an artist, but where is not known. Before her first marriage in 1827 to the composer, Walter Turnbull, Fayermann painted, and from 1826 exhibited, allegorical works and scenes of Swiss and French peasants, which suggest she travelled abroad at some stage. As Mrs Turnbull she exhibited predominantly miniature portraits between 1829 and 1844. She may have been constrained by domestic and financial circumstances to produce something that found a ready market. The fact that she continued to exhibit under the name Turnbull for a few years after remarrying – to Valentine Bartholomew – in 1840 might indicate that she was building up a clientele, which could have been confused by the change of name. By 1844 she was using the name Bartholomew in all exhibitions. Her husband was a prolific flower and fruit painter and became Flower Painter in Ordinary to Queen Victoria and the Duchess of Kent. It was under his influence

that Anne Bartholomew began to paint similar subjects, but her chief employment was still the painting of miniatures for brooches and other jewellery. She was an early member of the SWA, founded in 1857, although she exhibited nothing after this date. She published two plays: a farce in 1825 called *It's only my aunt*, which was first performed in 1849 and a domestic drama in two acts, called *The ring*, in 1845.

*Example:* British Mus., London.

*Literature:* AJ, Oct. 1862; *Athenaeum*, Aug. 1862; Clayton; *DNB*; Mallalieu; P. Nunn, *Victorian women artists*, London, 1987; Wood, 1978.

## BARTLETT, Jennifer (1941–)

*American painter who produces paintings in multiple sections, often in a grid format and with references to landscape*

The oldest of four children, Bartlett was always fascinated by the sea in her native Long Beach, California. Her mother had been a fashion illustrator and her father was an engineering contractor. Some lessons from a woman artist at the age of 13 confirmed her decision as to her future career, and she was a successful if rather rebellious student at Mills College, after which she completed her MFA at the Yale School of Art and Architecture where she married a medical student. After Yale she was disillisioned with her large abstract paintings derived from Abstract Expressionism. The new direction in her work occurred in 1969, the year when she was also divorced. She began to construct serial works consisting of grid formations of canvas, and, later, steel plates, on which she would paint or silk-screen coloured areas. After using colours arbitrarily, she moved in the early 1970s to the introduction of landscape elements into the panels. The key work from this period was *Rhapsody*, in which she attached to the gallery wall 998 steel plates each 30cm square, on each of which was silk-screened a grid. Onto this total of 2,304 squares she painted parts of motifs – a house, a tree, a mountain, the sea – in a limited range of colours modulated by brushstrokes. The resulting effect was of movement, rippling across the squares, partly realistic and partly abstract. This large-scale work brought her several commissions for building interiors in which she maintains the sea or garden imagery. Even her relatively small works reveal her basic dislike of the single image and consist of several parts rather than one. Her work is now exhibited in America and abroad.

*Examples:* Federal Building, Atlanta, Ga.; MOMA and Whitney Mus., New York.

*Literature:* M. Goldwater, R. Smith & C. Tomkins, *JB*, New York, 1985; Heller; Munro; C. Robins, *The pluralist era*, New York, 1984; Rubinstein.

## BARTON, Glenys (1944–)

*English sculptor of ceramic figures and heads*

Born in Stoke-on-Trent, Barton trained at the Royal College of Art from 1968 to 1971, winning a travelling scholarship and another prize while there. While sustaining herself through part-time teaching, she began to exhibit in 1973. From 1976 to 1977 she was artist-in-residence at the Wedgwood factory, which gave her the opportunity for technical experimentation with clay. Her work has always been based on the figure, but with a tendency towards the universal rather than the individual, always in stark setting. From the early 1980s she has gradually come to concentrate more on the head, which she depersonalises by removing the hair, enabling a concentration on the simplified features. Many of the heads are portraits, but Barton was interested in the shape of the skull and on the glazed effects which she could achieve on the smooth surfaces. In her pursuit of a timeless quality she avoids the exact details of an individual's face. A move to Essex with her son some years ago caused a change in her working methods, owing to the fact that there was initially no studio or kiln. She began to make free-standing relief profiles, which she has maintained parallel with the complete heads. Some of her projects, such as a *Madonna*, reflect her concern with the environment brought about through the discovery that her village was intended as a site for the disposal of nuclear waste. Through the use of a variety of glazes, Barton creates very different effects in her work.

*Examples:* Birmingham; Royal Scottish Mus., Edinburgh; Leeds; Leicester; Manchester; Reading; Boymans Inst., Rotterdam; Southampton; Stockholm.

*Literature:* M. Beaumont; 'GB', *Arts Review*, 24 Oct. 1986, 576; E. Cooper, 'GB–sculptures and reliefs', *Ceramic Review*, v85, 1984, 10–11; *Women's images of men*, ICA, London, 1980.

## BARTON, Rose Maynard (1856–1929)

*Irish painter of landscape and city scenes in oil and, more frequently, in watercolour, in which she produced atmospheric effects*

The daughter of a solicitor in Rochestown, Co. Tipperary, she was brought up in Dublin high society, although her background was Anglo-Irish. She travelled to Brussels in 1874 with her mother and sister, and there took lessons in drawing and painting. She then studied in London with Paul Naftel and in the early 1880s went to Paris, where she worked under the salon artist Henri Gervex. She exhibited widely and over a long period from her debut in Dublin in 1878. She divided her time between London and Dublin, but much of the 1880s was devoted to establishing herself in London. She exhibited at the RA, the SWA, and was elected to associate and then full membership of the Royal Society of Painters in Watercolour in 1893 and 1911 respectively. After 1893 most of her paintings were exhibited there. Her watercolours were influenced by Turner and Whistler, but she retained a sense of spontaneity. Barton specialised in the depiction of different but specific weather conditions. Her subjects were basically simple, but rendered with a freely handled Impressionist style, with a fairly bright palette. Another aspect of her work began in 1898 when she illustrated a book on Dublin, and six years later she published a similar book on London, although this time she wrote the text as well as providing over 50 illustrations. Less familiar are her rustic genre works, close to the *plein-air* painting of her contemporaries and to those of her lifelong friend, Mildred Butler (*q.v.*).

*Publication: Familar London*, London, 1904.

*Examples:* Belfast; Crawford; Nat. G and Hugh Lane Municipal G, Dublin.

*Literature: AJ*, 1887, 157; *Irish women artists*; Mallalieu; W.S. Sparrow.

## BASHKIRTSEFF, Marie (1858–84)

*Russian-born painter of figure subjects and portraits, who lived in Paris*

Born in Poltava, in southern Russia, she was brought up with her brother and cousin by her mother and aunt, after her parents had separated. They travelled to France, living in Nice before settling in Paris in 1877. Although her education was desultory, she became fluent in four languages and could read both Greek and Latin. She was also a talented singer and musician and initially intended to pursue music. Through her travels, however, she had seen many works of art and by the autumn of 1877 she was enrolled at the Académie Julian under Robert-Fleury. Much to her tutors' surprise, she showed single-minded determination and set herself the highest of standards. These years are recorded in her diaries, including her reactions to fellow students such as Breslau (*q.v.*) and Beaury-Saurel (*q.v.*). She attended assiduously and took additional private lessons in anatomy. Her Salon début came in 1879 with a painting of her cousin Dina reading, which showed the vigour of her drawing and her ability to capture individual characteristics. A visit to Spain in 1881 was the catalyst for the development of her colour. Independently she arrived at the *plein-air* naturalism of Jules Bastien-Lepage, but her principal subject-matter was the everyday life of the city and its people, particularly the poorer ones. She also carried out many portraits. Tuberculosis curtailed her career, so that her full potential was never realised. One of her paintings was hung in the Women's Building at the 1893 Chicago Exposition. Although her diaries caused a sensation when published, recent scholarship has revealed the extent of the editing of the 84 exercise books by her family in order to excise her radical ideas (she was an active supporter of the suffrage movement), her frankness about sexuality and her anger at the restrictions placed on women.

*Literature:* Bachmann; MB *Le Journal de MB*, A. Theuriet (ed.), 2 vols, Paris, 1887; various English translations from 1890, most recently London, 1985, introduced by R. Parker & G Pollock; M. Blind, *A study of MB*, in A. Theuriet, *Jules Bastien-Lepage and his art: a memoir*, London, 1892, pp.149–90; M.L. Breakell, 'MB: the reminiscence of a fellow student', *Nineteenth century and after*, 1904, v. LXII, 110–25; A. Cahuet, *Moussia, ou la vie et la mort de MB*, Paris, 1926; Clement; C. Cosnier, *MB: un portrait sans retouches*, Paris, 1985; D. Creston, *Fountains of youth: the life of MB*, London, 1936; T. Garb, '"Unpicking the seams of her disguise": self representation in the case of MB', *Block*, no.13, winter 1987–8, 79–86; J. Gilder (ed.), *The last confessions of MB and her correspondence with Guy de Maupassant*, New York, 1901; G. Greer, *The obstacle race*, London, 1979; Harris; D.L. Moore, *Marie and the Duke of H: the day-dream love affair of MB*, London, 1966; R. Parker, 'Portrait of the artist as a young woman: MB', *Spare Rib*, no.30, Apr. 1975, 32–5; W.S. Sparrow; Weimann.

## BAUCK, Jeanna Maria Charlotta (1846–1925)

*Swedish-born painter of landscapes and portraits who worked in Germany*

The pattern of Bauck's life reflects her dual nationality, for she lived in her native Stockholm with her Swedish mother and German father until she was 23. She then travelled through Germany, receiving instruction in art in Dresden, Düsseldorf and Munich before continuing to Paris. She settled in Munich, where she opened a school of art for women, and by the end of the century she was teaching in the Women's Art School in Berlin, where she provided the role model of a serious female artist for Paula Modersohn-Becker (*q.v.*). From these centres she travelled to both mountain and coastal towns for subject matter, including Venice and Switzerland. Her restful landscapes were much in demand by the English, and her portraits reveal the use of rich tonalities. One of her paintings depicts her close friend, the Danish painter Berthe Wegmann, engaged in painting a portrait.

*Example:* Nationalmuseum, Stockholm.

*Literature:* Clement; L. Hagen, 'Lady artists in Germany', *International Studio*, v4, 1898, 91–9; *Kvinnor som malat*, Nationalmuseum, Stockholm, 1975; *Lexikon der Frau*; W.S. Sparrow.

## BAUERMEISTER, Mary Hilde Ruth (1934–)

*German-born assemblage artist best known for her boxes with lenses*

Belonging to an academic, scientifically orientated family in Frankfurt, it was intended that Bauermeister should be a mathematician. She, however, could not easily accommodate any kind of institutional life, even that of art schools. Essentially untrained, therefore, she began to paint in 1954. By 1957, her studio in Cologne was the centre for avant-garde musical events and happenings in which the participants included Karlheinz Stockhausen, John Cage and Merce Cunningham. Following the precepts of Stockhausen, she began to apply musical theories to visual art, at the same time aware of the use of ready-made objects by people such as Jean Tinguely. Finding her work was not appreciated in her own country, she held her first solo show in Amsterdam in 1961 and with the proceeds of this she emigrated to America,

becoming in due course a naturalised citizen. She believed that Europe was not the place for artistic innovation. Her first assemblages consisted of pebbles and sand arranged on boards in variations on a grid formation, but she soon moved on to boxes. Her lifelong delight in combining materials and objects in unexpected ways found an outlet in these assemblages. The play on illusion and reality came to the fore with the introduction of lenses into the surface of the boxes, thus creating different effects with the objects, writing and drawing within the box. In the 1960s she married Stockhausen, had five children, and in 1972 returned to live near Cologne. By that time she was producing larger sculpture constructed from artists' easels.

*Examples:* Guggenheim Mus., and Whitney Mus., New York; Hirschhorn Mus., Washington, DC.

*Literature:* Archives of American Art, Washington, DC; Petersen; Rubinstein.

## BAUER-STUMPF, Jo. née STUMPF (1873–1964)

*Dutch painter of portraits and still lifes*

She studied at the State Academy in Amsterdam under Allerbé. In 1902 she married Marius Bauer, another painter, and together they undertook several extensive study tours including Indonesia and Egypt. She was a member of the women artists' group, the *Amsterdamse Joffers* – the young ladies of Amsterdam (*q.v.*under Ritsema).

*Literature:* Krichbaum; A. Venema, *Die Amsterdamse Joffers*, Baarn, 1977

## BAUMANN, E. See JERICHAU, Elizabeth

## BEATRICE MARY VICTORIA FEODORE, (Princess) (1857–1944)

*English amateur painter of landscapes*

The fifth daughter and youngest child of Queen Victoria, she became her mother's closest companion as her older sisters married. Like them she was taught art by A. Corbauld and has been described as the best and most serious artist in the family, although Princess Louise (*q.v.*) might also lay claim to that description. Certainly great care was taken over her education and her marked artistic

talents were fostered in every possible way. She was also a gifted pianist. She was made an honorary member of the Royal Institute of Painters in Watercolour in 1885. In the same year she married, and from then until 1917 was known as Princess Henry of Battenburg, although her husband was killed on a military expedition in 1896. One of her paintings was exhibited at the Chicago Exposition in 1893 and while in Egypt, 1903–4, she painted many of her best landscapes.

*Literature: DNB*; M. Elliott; Mallalieu; M.E. Sara, *The life and times of HRH Princess Beatrice*, London, 1945; Weimann.

## BEAURY-SAUREL, Amelie. (alt. JULIAN) (1848–1924)

*French painter of portraits, many in pastel, genre and literary scenes*

Although she was born in Barcelona, her parents were French, and she was one of the four most illustrious female pupils of the Académie Julian in the 1870s, where she studied under Jules Lefebvre, Robert-Fleury and J-P. Laurens; here she was a contemporary of Marie Bashkirtseff (*q.v.*) in whose *Journal* she features as 'the Spanish girl'. She exhibited at the Salon from 1882 until her death, as well as winning prizes at, for example, the Exposition Universelle of 1889. She also had illustrations published in several journals, including *Illustration* and *Art*. She married Rodolphe Julian, founder of the eponymous academy, and ran at first two and then all the women's studios. After his death in 1907, she assumed the management of the whole school while retaining her directorship of the female ateliers. She was awarded the Croix de la Légion d'honneur.

*Example:* Amiens.

*Literature:* Clement; Edouard-Joseph; J. Martin, *Nos peintres et sculpteurs*, Paris, 1897; Yeldman.

## BEAUX, Cecilia (1855–1942)

Soon after Cecilia Beaux' birth, her mother died and her father returned to his native France, leaving his daughter to be brought up in a largely female environment in Philadelphia. She was well educated and her artistic talent was fostered in-

itially by her maiden aunt, and later by Catharine Drinker (*q.v.*), her uncle's cousin. Beaux was thus provided with the role model of a professional woman artist and it was Drinker who introduced the 15-year-old to the potential of light. Two years later she studied under Drinker's own teacher, the Dutch artist Van der Whelen. Because her uncle disapproved of her life-drawing, she was not allowed to attend the Pennsylvania Academy, but despite this she was influenced by the realism of Thomas Eakins. It was only in a private women's class, where William Sartain came to advise students twice a week, that she worked from the model and it was he who taught her to capture the forms in a few brushstrokes and to enjoy the richness of the pigment. During the 1880s Beaux carried out a certain amount of teaching but was forced to paint portraits on china plates in order to maintain herself. Her first major portrait, of her sister and nephew (1883), won a prize in 1885 and was accepted for the Paris Salon. Beaux herself went to Paris in 1888 and, living frugally, studied at the Académie Julian. Her most formative experience was the summer period spent in Concarneau, as well as firsthand sight of works by Manet, the Impressionists and Sargent. After her return to Philadelphia, she built up a reputation as a portraitist. She was elected an Associate of the NAD in 1894 and a full member in 1903. Consistently exhibiting at the Salon she was also elected a member of the Société Nationale des Beaux-Arts, a rare honour for a woman then. Numerous other prizes and awards indicated the opinion of her contemporaries that she was the leading American woman painter. As a result she became the first full-time woman instructor at the Pennsylvania Academy, a position she held from 1895 to 1916. In 1900 she moved to New York, where she mixed with writers, critics and collectors, and established a summer home in Gloucester, Mass. A hip fracture in 1924 reduced her mobility but she continued to paint and wrote her autobiography. Although her paintings are in the academic tradition, there is an almost unsurpassed vitality in the rapidity of the brushstroke and an exploration of the effects of light on fabrics, most notably in a series of predominantly white paintings spread throughout her career.

*Publications: Background with figures*, 1930

*Examples:* Brooklyn; Uffizi, Florence; Art Inst., Chicago; Brooks Memorial G, Memphis; Metropolitan Mus. and Whitney Mus., New York; Pennsylvania Academy, Philadelphia; Corcoran G, Washington, DC.

*Literature:* Bachmann; Clement; Fine 1978; F. Goodyear & E. Bailey, *CB: portrait of an artist*, Pennsylvania Academy, Philadelphia, 1974; G. Greer, *The obstacle race*, London, 1979; Harris; Heller; *Notable American Women*; Petersen; Rubinstein; Tufts, 1987.

## BEERNAERTS, Euphrosine (1831–1901)

*Belgian painter of landscapes in oil*

Born in Ostend, she was trained in Brussels in the ateliers of at least three artists before beginning her extensive exhibiting career in 1854. She travelled, particularly in France, Germany and Italy, to obtain material for her landscapes, which she exhibited in the main Salons in Belgium, in Paris, Vienna and Australia. Her painting *Autumn Evening* was in the Women's Building at Chicago in 1893 and she had also been represented at the Philadelphia Centennial in 1876. She received a number of awards including that of Chevalière de l'Ordre de Léopold in 1881.

*Examples:* Antwerp; Bruges; Brussels; Ghent; Namur; Ostend.

*Literature:* Clement; M. Elliott; Krichbaum; W.S. Sparrow; Weimann.

## BEGAS, Luise. née PARMENTIER. (alt. BEGAS-PARMENTIER) (1850–?)

*Austrian painter of landscapes, architectural monuments and interiors; also an engraver*

Like her older sister, Marie, who also became an artist, she was educated in her native Vienna, with Schindler in painting and Unger in etching. In 1877 she married Adelbert Begas, a painter who was mainly a copyist of famous paintings, and established her studio in Berlin. She travelled in Italy, the source of most of her architectural scenes and landscapes. Her painting of the *Burial ground at Scutari* attracted much attention for the unusual subject, and two scenes of Constantinople, one of the places she visited after the death of her husband in 1888, were shown at Berlin in 1890. From 1886 she exhibited with the Women Artists' Association in Berlin, and one of her Venetian scenes was included in the Chicago Exposition of 1893.

*Example:* Kupferstichkabinett, SMPK, Berlin.

*Literature:* Clement; *Das Verborgene Museum*; M. Elliott; Weimann.

## BELASHOVA, Ekaterina Fedorovna (1906–)

*Soviet sculptor and president of the Union of Artists of the USSR*

One of the most highly honoured artists in her country, she was born in St Petersburg and studied at the Vkhutein Art Institute there from 1926 to 1932. In 1942 she began ten years' teaching at the Moscow Institute of Applied and Decorative Arts and then became a professor at the Moscow Higher School of the Arts Industry, a post she held until 1965. At the same time she had, since 1957, been the executive secretary of the Artists' Union, which represented all professional artists in the country. In 1971 the membership of over 13,000 included 2,500 women. Her presidency of this association, which began in 1968, thus represented a singular acknowledgement of her skills. One of her best-known works, *The Unbroken*, symbolises Soviet women in Nazi-occupied territory in World War II. She has also completed monuments to Pushkin, Chopin and others, in addition to figurative pieces. Awarded the Order of Lenin and the Order of the Red Banner of Labour, she also won the title People's Artist of the USSR in 1963 and was nominated a Corresponding Member of the Soviet Academy of Arts in 1964.

*Examples:* Tretyakov Mus., Moscow; Chopin Mus., Warsaw.

*Literature:* O. Beskin, *EFB* , Moscow, 1958; B. Fedorov (ed.), *EFB*, [album of her works], Moscow, 1966; W. Mandel, *Soviet women*, New York, 1975.

## BELL, Enid (1904–)

*English sculptor who worked in America, producing figures in wood, marble and terracotta, and wooden reliefs*

Bell was born in London, and initially trained at the St John's Wood School of Art. This was followed by some time as a pupil of Sir William Reid Dick, before attending the Glasgow School of Art. She is also recorded as having attended the

Art Students' League in New York, and by 1929 had a solo show in that city. She must therefore have gone to America between 1926 and 1928. For most of the time from then until 1968, she was involved in teaching, initially at Cornelia Chapin's (q.v.) school in New York (1929–31), but from 1944 until her retirement she worked at the Newark School of Fine and Industrial Art. During the 1930s she organised and supervised various government-sponsored projects in New Jersey, in addition to executing reliefs and sculpture under the Federal Art Project. Her subjects for these panels included events from the settlement of America in the eighteenth century and panels representing the arts and sciences; her scene of three scientists working shows two women as the most prominent figures. During this period, she began to win many awards, including a gold medal from the Paris International Exposition in 1937. Sometime before 1934 she married the painter Missak Palanchian, with whom she had several joint exhibitions. She did not let the arrival of her son diminish her output and she remained a consistent exhibitor, with many one-person shows and gallery affiliations. She was elected a member of the National Sculpture Society, who awarded her a special prize in 1949 for her reliefs.

*Publications:* 'The sculpture of Eugenie Shonnard', *American Artist*, v30, June 1966, 62–7, 86–9.

*Examples:* Public library, Englewood, NJ; Deaf Smith Historical Mus. and Post Office, Hereford, Tex.; Centre for Youth Education (formerly Robert Treat School) and Beth Israel Hospital, Newark NJ.

*Literature:* Archives of American Art, Washington, DC; *Who's Who in American Art*.

# BELL, Vanessa. née STEPHEN (1879–1961)

*English painter of figures, still lifes, interiors and landscapes in a modernist style influenced by early twentieth-century French art*

The oldest of four children of the writer Leslie Stephen and Julia Duckworth, she was born and brought up in London. Her sister was Virginia Woolf. She received her first instruction from Sir Arthur Cope (c. 1899–1900) and then studied under Sargent and at the RA Schools between 1901 and 1904. Her study was not continuous because, after the sudden death of her mother (in 1895), Vanessa (the oldest daughter) was forced to as-

sume responsibility for running the house and ministering to her father and siblings emotionally. After her father's death, she moved the family into a house in Bloomsbury, which became a meeting place for the writers and intellectuals who became known as the Bloomsbury Group. In 1905 she founded the Friday Club as an artistic discussion group, and through this met artist and critic Clive Bell, whom she married in 1907. Two sons were born in 1908 and 1910, but she soon ceased to live with Bell. However, with the usual practice of employing nursemaids, she was able to continue a pattern of European travel over the years. For a time she and Roger Fry, the critic, were passionately devoted to each other and always retained considerable respect for each other. Fry influenced her approach to art through his admiration for and theoretical ideas about modernist French art, while between 1913 and 1919 Bell contributed to Fry's Omega Workshop, designing fabrics, painting screens and furniture. This side of her activity continued when in 1916 she and artist Duncan Grant moved to Charleston, Sussex, where they progressively decorated the house and designed the furnishings. She also designed covers for books published by the Woolfs' Hogarth Press, notably for her sister's novels. Her paintings became primarily concerned with formal values, reducing details and creating depth without the use of traditional devices such as chiaroscuro. For a time, around 1915, she painted abstract works, although most of her work was representational. Her subjects were those most easily available to her, particularly from 1916 when Charleston was relatively isolated by road and rail. A daughter, Angelica, was born in 1918. Bell needed all her diplomatic skills and self-denial in her relationship with Grant, who was homosexual. Gradually her work received increasing recognition and she exhibited frequently in London, often with the London Group, of which she was a member. She regularly visited France, and for some years maintained a house on the Mediterranean coast. Her design work brought her several notable commissions, including a dinner service for Sir Kenneth Clarke, on which she painted portraits of famous women, murals for the church in Berwick, Sussex, and for the Normandy house of Ethel Sands and Nan Hudson (q.v.), designs for composer Ethel Smyth's *Fête Galante* and commissions for the liner *Queen Mary*. Several deaths marred the pre-war years: those of Lytton Strachey and Dora Carrington in 1932, Fry's in 1934, that of her son in the Spanish civil war in 1937 and the suicide of Virginia Woolf in 1941. Increasingly Bell remained in the country and continued to work until almost the end of her life.

*Examples:* Bristol; St Michael and All Angels' church, Berwick, E. Sussex; Birkenhead; Bolton; Leicester; Courtauld Inst. G and Tate G, London; Manchester; Rochdale; Sheffield; Southampton.

*Literature:* Bachmann; C. Bell, *Old friends*, London, 1956; *DWB*; G. Elinor, 'VB and Dora Carrington: Bloomsbury painters', *WAJ*, v5/1, spring-summer 1984, 28–34; Harris; G. Hedley, *Let her paint*, City Art G, Southampton, 1988; R. Pickvance, *VB: a memorial exhibition of paintings*, Arts Council G, London, 1964; F. Spalding, *VB*, London, 1983 and San Diego, 1985.

## BELLINGHAM-SMITH, Elinor (1906–88)

*English painter of London scenes and later Suffolk landscapes, in which she combined atmospheric effects of the weather with a perceptive observation of the world around her*

Bellingham-Smith was a Londoner by birth. Her father was an obstetrician at Guy's Hospital whose spare time was devoted to his considerable art collection, while her uncle was the painter Hugh Bellingham-Smith. Before deciding to pursue painting, she studied music and dancing to a professional level. Entering the Slade School of Art in 1928, she was one of the last generation of art students to be taught by Henry Tonks. Although not noted for regarding his female students with favour, Tonks admired her independence and professional attitude. Soon after completing her training in 1931, she married a fellow student, the painter Roderigo Moynihan. In the same year, she began to exhibit with the London Group, and was given a succession of solo shows by the Leicester Gallery, extending into the late 1960s. During the 1930s her illustrations and fashion drawings provided the couple with an income, since Moynihan's 'Objective Abstractions' were financially unsuccessful. After World War II she exhibited more frequently; a commission from the Arts Council in 1951 for the Festival of Britain won a prize at the exhibition *Sixty paintings for '51*. On her separation from Moynihan in 1957 she moved to Boxted in Suffolk. Here her former Thames-side scenes were transmuted into those of the Suffolk countryside, the subject of her artistic explorations for the rest of her life. At one stage her point of departure lay in cloud formations and vapour trails in the sky, and the final result was abstract. At other times she painted local children in the countryside; but in her landscapes, notably those of the Fens, there is an uncompromising austerity achieved through great subtlety of tone.

Although a traditionalist, she was no conservative, creating an interplay between 'the vibrant calligraphic strokes on the surface of the canvas and the life of the landscape which the canvas opens to reveal'. She continued to paint until her final illness.

*Example:* Aberdeen; Tate G, London.

*Literature:* EB-S, Leicester G, London, 1967; R, Shone, 'EB-S', *The Independent*, 9 Nov. 1988 (obit.); Waters.

## BENDALL, Mildred (1891–1977)

*Anglo-French painter of highly coloured interiors, still lifes, flowers and harbour scenes*

The third and youngest child of a successful English merchant and his French wife living in Bordeaux, she never needed to paint for money. Her serious approach to art was tolerated by her family, and she spent four years in the atelier of a local artist, Félix Carme. After the war she exhibited in Bordeaux and at the Salon des Artistes Français. A crucial development in her art occurred in 1927–8 when she attended the Académie de la Grande Chaumière in Paris and became friendly with Matisse and Marquet. Their attitude to colour was in harmony with her own, and for a while she worked closely with Matisse. She was also influenced by André Lhote and Dufy, but the precision of her forms and the strict organisation of the composition reveal a debt to Cubism. Returning to Bordeaux, she became an active member of Société des Artistes Indépendants, remaining a leading figure in modernist art circles there. Through this she maintained contact with the Parisian artists she had met, and in 1937 she participated in a group exhibition which included Van Dongen and Dufy. It was in 1954 that she first visited La Rochelle, which proved to be the inspiration for most of her harbour scenes. Since the death of her parents in the late thirties, Bendall had lived with her brother and sister in the house that had formerly been the summer home of the family at Montségur. In 1966 her brother and sister died within months of each other, and a fire in 1970 destroyed a number of her paintings. The last of a series of solo shows was held in 1969. The application of glowing colours with great technical facility is combined in her works with much very personal subject matter. The objects of the still lifes were her own possessions in her house, while the flowers had been picked from her garden. Although remaining a figurative painter, some of her later harbour scenes border on the abstract.

*Examples:* Bordeaux; Centre Nat. d'Art Moderne, Paris.

*Literature: MB,* Whitford & Hughes G, London, 1987.

## BENEDETTA. (pseud. of Benedetta CAPPA or CAPA, alt. MARINETTI) (1897–1977)

*Italian Futurist painter, theatre designer and writer*

Born in Rome, she was the second of five children and wrote poetry from an early age. While acting as a children's nanny, she studied with the Futurist painter Giacomo Balla. It was at his studio that she met, in 1917 or 1918, Filippo Marinetti, the founder and organiser of Futurism, whom she married in 1923. Having absorbed the tenets of the first phase of Futurism, in 1919–20 she began to make tactile tables, which influenced Marinetti to write a manifesto on *Tactilismo* (1921). By 1924 she was exploring the notion of speed, through lines of force penetrating objects, by the use of geometrical shapes in paintings. Her first novel was published that year and at the same time Benedetta wrote a number of articles in which aspects of Futurism were discussed. This she continued to do over many years. When the second phase of Futurism was launched, Benedetta was a signatory of several manifestos, including that on aerial painting in 1929. The aim of this was to project not only the changes of perspective seen by the pilot, but also other associated phenomena. Her paintings on this theme are figurative with geometrical elements to show movement and light. She exhibited in Milan, Rome and at the Venice Biennali of 1930 and 1934, in addition to France and Germany. She was commissioned to paint five panels on different forms of modern communication for Palermo post office. From this period also came a number of landscapes, given a mystical and almost surreal interpretation. At the same time she began to produce the stage designs for several of Marinetti's plays, and further novels were published in 1931 and 1935. Typical of the Futurists, she adopted a right-wing approach to the political situation in the 1930s. After World War II, she devoted herself to the international exhibition of Futurist works.

*Publications:* 'Le futurisme', *Cahiers d'Art,* 1950.

*Literature:* B. Katz, 'The women of Futurism', *WAJ,* v7/2, fall 1986-winter 1987, 3–13; *Künstlerinnen International 1877–1977,* Schloss Charlotten-burg, Belin, 1977; B.G. Sanzin, *Benedetta aeropoetessa e pittore futuristo,* Rome, 1939; Vergine.

## BENGELSDORF, Rosalind (1916–79)

*American abstract painter and co-founder of the American Abstract Artists Association*

Born in New York City, she studied at the Art Students' League with several realist artists, including Anne Goldthwaite (*q.v.*), from 1930 to 1934. During a year at the Annot School of Art in Germany, run by the woman artist Annot (*q.v.*), she learnt to cover the whole canvas with forms without concern for their representational value. After this she was able to return to Hans Hofmann's school in New York in 1935 and benefit from his teaching. In the climate of the Federal Art Project abstract work was not well received and rarely commissioned, but from 1935 to 1940 Bengelsdorf was employed in the mural division. Under its auspices she carried out a mural for a nurse's home on Welfare Island in which she moved away from total objectivity towards an approach combining biomorphic imagery and hard-edged forms, in which objects are abstracted and used in a conceptual way. In 1936 Bengelsdorf, with other abstract artists, including Alice Mason (*q.v.*) and Gertrude Greene (*q.v.*), formed an association called American Abstract Artists, which provided a forum and exhibiting space for non-figurative work in a rather hostile environment. In 1940, she married painter George Browne and had a son. She gave up her art, not wishing to compete with her husband, and began a second career as a writer and critic.

*Publications:* 'The new realism', *American Abstract Artists' Year book,* New York, 1938; 'The American Abstract Artists and the WPA Federal Art Project', in F. O'Connor, *The New Deal Projects: an anthology of memoirs,* Washington, DC, 1972.

*Literature:* K. Marling & H. Harrison, *7 American women: the Depression decade,* Vassar College Art G, Poughkeepsie, 1976; Rubinstein.

## BENGLIS, Lynda (1941–)

*American abstract sculptor using imagery of soft materials, often knotted or poured*

Born at Lake Charles, Louisiana, she graduated from Newcomb College, New Orleans in 1964 and

then attended the School of the Brooklyn Museum in New York. In New Orleans she met and admired Ida Kohlmeyer (q.v.), who provided a role model for her. She has always been fascinated by creating the illusion of one material through another. Moving her early latex relief works from the wall on to the floor involved transitional corner pieces and used the motif of wings to defy and mock gravity. In the early seventies, she was also making encrusted wax pieces and working in video. She achieved international attention in 1973 when she published a photograph of herself nude, with a greased body, sunglasses and giant dildo in *Artforum*. This was part of her reaction to constant debates at the time about female sensibility. In the late seventies and early eighties she has continued to deal with the question of materials, producing, for example, a series of knotted forms, often with exuberant coloured pleats and folds. Her painterly approach to sculpture led her to experiment with materials, colour and form, which has encouraged other sculptors to broaden their horizons. She has exhibited widely in group and solo shows since 1969.

*Examples:* Baltimore; Abright-Knox G, Buffalo, NY; Detroit; Houston; New Orleans; MOMA, New York; Philadelphia; Seattle.

*Literature: Early work: LB, Joan Brown, Luiz Jimenez, Gary Stephan, and Lawrence Weiner*, The New Museum, New York, 1982; Heller; R. Pincus-Witten, 'LB: the frozen gesture', *Artforum*, v13/3, Nov. 1974, 54–9; C. Robins, *The pluralist era*, New York, 1984; Rubinstein; Watson-Jones.

## BENOIS, Nadia. née Nadezhda Leontievna BENOIS (1896–1975)

*Russian-born painter of landscape and flowers, who also designed ballet and theatre sets*

Benois was the daughter of the court architect and professor of architecture at the St Petersburg Academy and came from a family in which involvement with the arts was traditional. She studied first with an uncle and then Shoukhaer at a private academy in St Petersburg. She married Jonah Ustinov in 1920 and came to settle in England. Her son was born soon after her arrival, but despite this and the somewhat irascible personality of her husband, she endeavoured to retain her artistic practice and her independence. She exhibited in a number of London galleries, as well as at NEAC, in Paris, Pittsburgh and Canada.

She travelled to Ireland, Wales, Scotland and France for landscape material, as well as within England. Her style developed into a 'sternly unaffected impressionism', richer than that of her early oils and evincing signs of a strong personality. Through painting what she saw her works were imbued with a sense of what she felt. From 1932 she became involved in designing sets and costumes for several ballet companies, including the Ballet Rambert. This activity continued during and after the war, not only for ballets but also for plays. This in turn provided her with material for her painting, and she worked closely with the French avant-garde theatre company the Compagnie Quinze. She was the mother of actor and playwright Peter Ustinov, for whose play *House of regrets* she carried out the designs.

*Publications: Klop*, London, 1974.

*Examples:* Tate G, London; Manchester.

*Literature:* Deepwell; *NB*, Leicester G, London, 1943; P. Ustinov, *Dear me*, London, 1977; Waters; *Who's Who in Art*.

## BENT, Margaret (1903–)

*Norwegian sculptor*

Born in Oslo, she studied at the Stockholm Academy and Revold's so-called illegal art school before proceeding to Paris, where she enrolled at the Académie de la Grande Chaumière. Most of her documented work dates from after 1940, when she began exhibiting actively and entering competitions. She designed several war memorials and carried out a bronze relief portrait for the military headquarters. At one time she was vice-chair of an association to help young artists to become better known.

*Literature: Illustrert Norsk Kunstnerleksikon*, Oslo, 1956.

## BENTIVOGLIO, Mirella. née BERTARELLI (1922–)

*Italian sculptor, performance artist, poet and critic*

Born in Klagenfurt, Austria, she was brought up in Milan although she attended German-speaking schools in Switzerland and Milan, while her university education took place in England.

Bentivoglio believes this multi-lingual education played a large part in her subsequent fascination for language. Another factor were the books which surrounded her from childhood; her father was a scientist with broad interests, but she was aware of the frustration felt by her mother, who was unable to find an outlet for her creative talents within her domestic role. After publishing her first volume of poems in 1943 she began to write art criticism, and in 1963 published a monograph on Ben Shahn. In the meantime she married a law professor in 1949 and had three daughters (in 1950, 1952 and 1960). In 1966 she began to move into a visual expression of her poetry and exhibited in shows of concrete poetry. The theme of books runs through her work parallel with that of the egg. Her sculpture began by exploring the letter O and in the early 1980s she produced further pieces based on E. She prefers to make large-scale sculptures in an urban setting. In 1976 she installed an egg two-and-a-half metres high just outside the walls of the small town of Gubbio in central Italy, a site where in former days adulterous women were stoned to death. However, her use of the egg and book forms carry meaning on many levels and her feminism emerges through the nature of her subject matter and its symbolism. Over the years the references in her sculptures have become universal rather than specific. Bentivoglio has organised exhibitions, including one of 80 women artists concerned with the connection between language and image for the Venice Biennale of 1978. Since 1976 she has carried out performances which explore further the themes present in her sculpture and poetry, finding that these helped her through her grief at the sudden death of her husband in 1980. She has exhibited extensively and remains an active organiser in the Italian art world.

*Publications:* See below in *Literature.*

*Literature:* F. Pohl, 'Language/image/object: the work of MB', *WAJ*, 6/1, spring-summer 1985, 17–22; A. Quintavalle, *MB: Hyper Ovum*, Torre del Lebbroso, Aosta, 1987, (full list of publications and bibl.); J. Rosenberg, 'Visual poetry; feminist sculpture for an Italian town', *Women Artists' News*, summer 1980, 8.

## BERGMAN, Anna-Eva (1909–87)

*Norwegian abstract painter and engraver*

Born in Stockholm, she studied at the Academy there from 1926 to 1928 and in Vienna under Professor Steinhof in 1929. After this she travelled widely in Europe for much of the 1930s, and lived in Paris from 1952. She exhibited widely and was given solo shows from 1931 in several countries.

*Literature: Illustrert Norsk Kunstnerleksikon*, Oslo, 1956.

## BERLY, Madeleine. (pseud. of Madeleine Charlotte de VLAMINCK) (1896–1953)

*French painter of highly coloured gouaches of portraits of women, still lifes and flowers*

The daughter of the Fauvist painter, Maurice Vlaminck, Berly used her mother's name. Born in Nanterre, she was barely 18 when she was given her first solo show by Paul Guillaume. Taught presumably by her father, she demonstrated a distinctive understanding of Fauvism that was quite different from his. Her still lifes are altogether more solid, and there are indications of Japanese influence in the arrangement of her flower compositions. Her shoulder-length pictures of individual, if unnamed, women show a strongly developed sense of colour. She painted in oil but preferred gouache.

*Example:* Petit Palais, Geneva.

*Literature:* Schurr, v3.

## BERNHARDT, Sarah. (pseud. of Henriette Rosine BERNARD) (1844–1923)

*French sculptor and painter, better known as an actress*

When she was already established in her acting career, the Parisian Bernhardt, who always sought new challenges, took up art around 1870. She herself states that she first studied sculpture, under Mathieu Meunier, who had been impressed by her perceptive criticism of his work. However, other sources vary as to whether she took up painting before or after sculpture, but in either case she was taught painting by Alfred Stevens. She had felt the need of greater intellectual stimulation than her acting afforded and, particularly from 1873, she devoted almost all her available time to sculpture, producing a series of portrait busts, one of which was sent to the Salon in 1875. In the 1876 Salon her group, *After the Tempest*, depicted a woman, three of whose five sailor sons had been drowned, lamenting the similar fate of her grandson. It received an honourable mention and much critical

acclaim. The dealer Gambart bought it for 10,000 fr., and a smaller version was sold from the solo exhibition of six sculptures and ten paintings which Bernhardt organized at a private gallery in London in 1878 or 1879. In her autobiography Bernhardt is quite open about the financial motive for the exhibition, the opening of which 1,200 people attended. Her best-known painting was *Young girl and Death*. Altogether she produced about 40 sculptures, most of which were portraits, and an unknown number of paintings. In addition to the Salon she exhibited at Chicago in 1893 and was made an Officier de l'Académie. She achieved this output in addition to her acting career by virtue of working very long hours, often sculpting through the night after a performance at the theatre, for she needed little sleep. In her studio she would don white drill trousers and a sculptor's shirt, a fact which, combined with her nocturnal habits, gave rise to rumours concerning her conduct. She continued to practise both painting and sculpture until almost the end of her life, and in 1916 completed a painting of one of her grand-daughters. Her son, born in 1864, was the natural son of Prince Henri de Ligne of Belgium, but relied on his mother for most of his income, even after his marriage. Bernhardt shared a long and passionate relationship with the painter Louise Abbema (*q.v.*). Sarah Bernhardt was a strong character both physically and mentally, cared little for social convention and relished new experiences and absorbing occupations.

*Publications: Memoirs: my double life*, London, 1907, repub. 1968.

*Literature: SB: 1844–1923*, Ferrers G, London, 1973; Clement; *DWB*; Krichbaum; M. Elliott; J. Martin, *Nos peintres et sculpteurs*, Paris, 1897; J. Richardson, *SB and her world*, New York, 1977; S. Rueff, *I knew SB*, London, 1951; Weimann.

## BERNSTEIN, Theresa (1886–)

*American painter and printmaker of scenes of everyday city life*

Born in Philadelphia, she studied at the School of Design there and, from 1912, at the Art Students' League, New York, with W.M. Chase and Robert Henri. While in New York she encountered work by the Ash Can artists, and knew John Sloan, Edward Hopper and Stuart Davis. A visit to Europe excited her admiration for the Expressionist artists, Kandinsky, Marc and Munch. Her subject matter grew from that of the Ash Can

school, and she depicted the busy streets of New York or Gloucester, Massachusetts, where, with her husband William Meyerowitz, she was an active member of the artistic community for over 50 years. Her interest lay chiefly in the observation of middle-class and working people within the urban setting, reflecting the interest she has in social reform. She used a dark palette with strong, expressive brushwork. She was one of the original members of the New York SWA and remained active the longest. She has exhibited widely in America, with solo shows since 1920, and was the recipient of many awards. Bernstein also taught – Louise Nevelson (*q.v.*) was one of her pupils – wrote poetry and was the author of several books.

*Literature: Fair Muse*; A. Wolf, *New York Society of Women Artists, 1925*, ACA G, New York, 1987.

## BERTAUX, Hélène. née PILATE (1825–1909)

*French sculptor of religious, allegorical and mythological works, who worked tirelessly to promote the position of women in the arts*

Born in Paris, she studied with her father, Pierre, and with Dumont before beginning her prolific exhibiting career in 1849, receiving medals four times, including a gold at the Exposition Universelle in 1889 for a mythological group. Her works include a bronze memorial fountain for Amiens (1864), decorations for the front of the Tuileries (1865) and statues of St Philip and St Matthew for St Laurent, also in Paris (1868). Her output ranged over reliefs, statues and groups in terracotta and marble, as well as bronze. She carried out some portraits. Like other artists she began to take pupils and taught her husband Léon. In 1873, however, she opened a 'cours de modelage et de sculpture' in Paris, in which she aimed to give women the opportunity both of art education and of earning a living. After three months at least nine of her pupils had had works accepted at the Salon. This scheme expanded in 1879, when she had a house built in which she could set up a school of sculpture for women. From this time onwards she demonstrated a commitment to helping women artists. In 1881 she founded and was the first president of the Union des Femmes Peintres et Sculpteurs (UFPS), through which exhibiting opportunities for women artists were provided. Many famous women artists sent their works there as well as to the traditional mixed venues, but there was constant criticism of amateurishness. Bertaux remained president until 1894, during which time she had campaigned for

the admission of women to the Ecole des Beaux-Arts. She was herself an unsuccessful candidate for membership of the Académie in 1892 and exhibited in the Women's Building at Chicago in 1893.

*Examples:* Memorial fountain, Amiens; Grenoble; Nantes; facade, Tuileries, Paris; portal statues, church of St Laurent, Paris; Notre-Dame, Vincennes.

*Literature:* M. Elliott; T. Garb, 'L'art féminin: the formation of a critical category in late nineteeth century France', *Art History*, v12/1, March 1989, 39–65; E. Lepage, *Une conquête feministe: Mme. Lén Bertaux*, Paris, 1911; *Lexikon der Frau*; Weimann; Yeldham.

## BIENFAIT, Aline (1941–)

*Belgian-born painter and sculptor who works in France and Mexico*

Born in Courcelles, she first exhibited at the age of 15, before she had received any training. After instruction from a local artist she spent the years 1957–64 at the art academies in Binch, Charleroi and Brussels. At this point her paintings were powerful and expressive, the human figures appearing monumental. On her first visit to Mexico in 1968, Bienfait became the assistant of the muralist Siqueiros on the strength of the prizes she had won for mural painting. There she designed and directed the execution of a huge painted sculpture. Working with Siqueiros again, in 1970, she also encountered other artists who encouraged her to simplify her palette and increase the sculptural strength of her forms. This led to a series of nudes, first in painting and then in sculpture. In Europe she exhibited regularly in France and Belgium, and in 1975 settled at Cirey-sur-Blaise. There she produced sculptures in marble, stone and bronze whose organic, even sensual, forms are adapted to the play of light.

## BILINSKA-BOHDANOWICZ, Anna. née BILINSKA (1857–1893)

*Polish painter of portraits, still lifes, land- and seascapes in oil, watercolour and pastel*

Bilinska was born in Zlotopole, Ukraine. Between 1869 and 1871, when her family was living in exile

**Anna Bilinska** *Self-portrait*, (unfinished) 1892, oil on canvas, 163 × 113.5 cm, Muzeum Narodowe, Warsaw.

in Siberia, she had her first drawing lessons with Andriolli. Later training with Gerson in Warsaw revealed her prodigious talent. After visiting Vienna, Munich and Italy, she studied at the Académie Julian in Paris in 1882, continuing her studies with Merson in 1883, and from 1885 to 1887 in various ateliers in the city. At this time she painted the portraits of many distinguished Poles, including Paderewski. During the summer she would travel to different regions of France, and was particularly fond of Brittany, where she produced silvery seascapes which have sometimes been connected with works of Monet. Her portraits are deceptively straightforward and contain a strong sense of personality. Although perhaps best known for these, she produced a wide range of subjects, including historical genre. She exhibited in Paris from 1885, in London (1888–92), Munich, Warsaw and Berlin, where she won a gold medal at the International Exposition of 1891, following a similar award at Paris in 1889. In 1892 she married a Polish doctor, and they returned to

their native country, where she intended to start an art school for women in Warsaw. But this was never realised, because she died of heart disease in the same year.

*Example:* Nat. Mus., Warsaw.

*Literature:* J.C. Jenson, *Polnische Malerei von 1830 bis 1914,* Cologne, 1978; Krichbaum; Petersen.

## BISHOP, Isabel (1902–)

*American painter of figures*

A lonely childhood in Cincinnati, Ohio, was to affect her well into adulthood. The youngest of five children by 13 years, she was prevented from playing with other children by the social outlook of her schoolmaster father. Her mother was a feminist and active supporter of the suffrage movement. By the age of 12, Bishop was drawing the nude in Saturday morning art classes and after leaving school at 15 she attended a private art school in Detroit. Through the generosity of a cousin, she was able to enrol at the New York School of Design for Women in 1918. After two years of commercial art she transferred to the Art Students' League, where she chose to study with Kenneth Miller, who taught traditional representational methods. Her arrival coincided with the first mixed life class. She retained contact with the league after her three years there, and by 1928 she was working in 14th Street, where she had been joined by a group of realist painters. Sometimes known as the Fourteenth Street School, they lived and worked near Union Square, which became the focus for realist painting in the 1920s and 1930s. She took her subject matter from the variety of people in that area: shop assistants, tramps, workers and office staff. Her technique is strongly influenced by Rubens, with transparent washes on the white ground, on top of which are added the drawing and paint glazes, with the result that the underpainting and white ground glow through in places. The works seem to shimmer with a vibrancy which derives from the paint itself. Throughout her career she has aimed to represent movement, both physical and social. In 1934 she married Harold Wolff, a neurologist, and moved to a suburb of New York. She retained her Union Square studio, commuting each day for office hours, as well as bringing up a son. In 1937 she became the only full-time woman member of staff at the Art Students' League. Her later works are more concerned with light, though retaining the figurative basis of her previous paintings. Her

contribution to American art has been recognised in many awards and distinctions. She has exhibited widely and had a retrospective at the Whitney Museum in New York. She believes that the theme of the walking figures, whose paths never cross, and the lonely crowds represent aspects of contemporary life.

*Examples:* Indianapolis; Corcoran G and Phillips Collection, Washington, DC.

*Literature:* L. Alloway, 'IB: the grand manner and the working girl', *Art in America,* Sept.–Oct. 1975, 61–5; Bachmann; Fine; Harris; Munro; Petersen; Rubinstein.

## BISSCHOP-ROBERTSON, Suze. née ROBERTSON (1857–1922)

*Dutch painter of figure subjects, landscapes and portraits*

The youngest of nine children, she was born in The Hague, where her father was a merchant. After her mother died in 1857, she was brought up by an aunt and later sent to a private boarding school. From 1874/5 until 1877 she attended the Academy at The Hague, where female pupils had been accepted since 1872. At the end of the course, she obtained a teaching post at a girls' school in Rotterdam, at the same time attending evening classes at the local academy and from 1880 receiving lessons on Sundays from the rustic genre painter, Petrus van de Welden. When she changed her job to teach in a school in Amsterdam in 1882, she continued to further her own studies by attending classes at the Academy there. The following year she reached the point where she gave up her relatively well-paid job in order to devote herself to painting. Returning to The Hague, she encountered many artists, including Jozef Israels, and spent the summers near Laren, a region favoured by many painters. It is from this time that the theme of women and girls doing housework first appears in her work. As a member of the Pulchri Painting Association, she requested that the reading room be opened to women for two hours a week, a request which was granted in 1890. Two years later she married the painter, Richard Bisschop, and her only child, Sara, was born in 1894. Bisschop-Robertson paid the rent on the family's home by giving drawing lessons to the landlord, a method which she continued to use to secure the financial situation for some time after the family moved from Brabant to The Hague.

From 1898 she took part regularly in exhibitions both within Holland and abroad, and won a number of prestigious awards. Later that decade her sales are recorded as over four times her annual salary as a teacher. From 1903 her daughter is recorded in a series of foster homes and Bisschop-Robertson occupied a studio in The Hague, possibly having separated from her husband. Using thick paint, freely handled, she evoked the life of ordinary people.

*Literature:* A. Hammacher, *SR*, Amsterdam, 1943; Krichbaum; *Kunst door vrouwen*, Stedelijk Mus. De Lakenhal, Leiden, 1987; *SR*, Stedelijk Mus., Amsterdam, 1956; *Tentoonstellung van schilderijn van SB-R*, Kunsthandel J. Biesing, s'Gravenhage, 1909; *Vrouwen op de Bres: drie kunstnaressen rond 1900*, Gemeentemuseum, The Hague, 1980; A. Wagner & H. Henkels, *SR*, Amsterdam, 1985.

## BISWAS, Sutapa (1962–)

*Indian-born painter of figurative art interpreting Asian experiences with humour and satire*

Born in Bolpur, Biswas graduated from Leeds University in 1985. Since then she has taught part-time and lectured widely. Her imagery is based on her cultural heritage, the experience of her family and the issues of race and gender. She depicts women as strong figures, often taking positive action against their oppression. She also introduces figures and motifs from Hindu culture. Her use of pastel, with its traditional links with women's art, is a deliberate ploy, for she uses it on a scale and intensity of colour not normally associated with the medium. She has exhibited in group shows since 1985 and had her first solo show in 1987. In her aim to make art by women of colour more visible, she has exhibited in establishment and alternative galleries.

*Literature: The issue of painting*, Art G, Rochdale, 1986; S. Nairne, *State of the Art*, London, 1986; H. Robinson, *Visibly female: feminism and art today*, London, 1987; *The thin black line*, ICA, London, 1985.

## BLACKADDER, Elizabeth (1931–)

*Scottish painter of landscape, still lifes and interiors in oil and watercolour*

Blackadder was born in Falkirk, Stirlingshire, her father being an engineer and her mother a teacher.

She graduated from Edinburgh School of Art, where she studied under William Gillies, in 1954. The award of two travel scholarships then enabled her to visit Yugoslavia and Greece, and to spend nine months in Italy, where the Byzantine mosaics and architecture made a lasting impression on her. She subsequently travelled to Spain in 1958 and from 1960 began to visit the continent regularly by car. Married in 1956 to John Houston, a near contemporary at Edinburgh, she taught part-time and from 1959 to 1961 was the librarian in the Fine Art Department at the university, then resuming her teaching there. It is from this point that her career as a painter developed, and her first solo show in 1959 brought commissions, notably for lithographs. Her oil paintings of the 1960s show a broad, expressionist handling, together with a density of pigment, creating a kaleidoscope of brilliant colours over the canvas. By the end of the decade she was more concerned with buildings or incidents within the landscape, and parallel with this developed in her watercolours the still lifes or domestic landscapes that were to preoccupy her into the 1980s. She placed objects on tables or within a room and depicted them as though looking at them from above. The result was an exploration of form and pattern in an ambiguous space, creating in the early 1970s almost abstract works. Landscape assumed a secondary importance and watercolour became her chief medium of experimentation. She has always been a prolific artist, and although still life has been her most consistent subject, this can embrace flowers, both as a still life and as studies in themselves, figures, including self-portraits, nudes, animal studies and interiors. Official recognition came with a series of elections: Associate of the Royal Scottish Academy in 1963, Associate of the RA in 1971 and full Academician of the RSA (1972) and the RA in 1976.

*Examples:* Aberdeen; Carlisle; Eastbourne; City Art Centre, Royal Edinburgh Hospital, and Nat. G of Modern Art, Edinburgh; Glasgow; Hove; Tate G, London; Paisley; Sheffield.

*Literature:* J. Bumpus, *EB*, London, 1988; *EB*, Scottish Arts Council, Edinburgh, 1981; Parry-Crooke.

## BLACKBURN, Jemima. née WEDDERBURN (1823–1909)

*Scottish painter of animals and particularly birds*

Wedderburn's father, who died before she was born, was Solicitor-General in Scotland. A delicate

child, she drew to amuse herself, copying first from Bewick and then studying anatomy by dissecting animals and birds, composing her pictures from this and from memory. She was therefore entirely self-taught. Later she came to need figures, still life and landscape as accompaniments to the animals, and studied these by similarly working from the underlying structure. During a visit to London in 1840, she drew at the zoo and met Landseer and William Mulready, who gave her advice on perspective. She exhibited at the RA from 1849 and also at the RSA, but most of her output consisted of illustrations in books, which have been called the best of their kind since Audubon, for she went to great lengths to see the birds in their natural settings. Her first book was published in 1847 and others appeared regularly over the following decades. She married Hugh Blackburn in 1849. He was then a Fellow of Trinity College, Cambridge, but by 1875 had become professor of mathematics at Glasgow. Jemima Blackburn did not need to work, and Clayton says that although strictly speaking she is an amateur, her conscientious study and consistent output make this a misnomer. In addition to paintings, she executed stained glass and etchings.

*Publications: Illustrations of scripture by an animal painter (c. 1855); Scenes from animal life and character (1858); Birds drawn from nature (1862); A few words about drawing for beginners (1893); Birds from Moidart (1895); Caw. caw; The Pipits; British birds*, etc. Illustrated many books by other authors.

*Example:* British Mus.

*Literature:* Clayton; R. Fairley (ed.), *Jemima: the paintings and memoirs of a Victorian lady*, London, 1988; Mallalieu; P. Nunn, *Victorian women artists*, London, 1987; Sarah Tytler, *Modern painters*, London, 1873.

## BLACKER, Kate (1955–)

*English-born sculptor using corrugated iron, who lives in France*

Born in Hampshire, she studied at Camberwell School of Art (1975–8) and the Royal College of Art (1978–81). Since leaving she has participated in many shows, both group and solo, in Britain and other European countries. Since the late 1970s she has used corrugated iron sheets as her basic material, and she now lives in Lyons, where it is made. Attracted to it both because of its connotations with the urban world and because of the implications of movement arising from the undu-

lations, she has pursued two main themes. One is that of landscape, whereby she cuts the metal, welds it into position and paints it in appropriate colours. Particular subjects include *Everest, Magic Mountain* and *Colorado*. The other series consists of figures, predominantly women. The series of Greek women emerge with difficulty from the architecture in the manner of caryatids, while others are relatively free of encumbrance. The corrugated metal is bent, cut and painted, but there is no intention of disguise. Blacker was one of three selectors for *The sculpture show* in 1983. Collaborative work has also featured in her career, notably that with the dancer Gaby Agis in 1984, when Blacker designed sets of corrugated iron and costumes to imitate the same material.

*Example:* WAG, Liverpool.

*Literature: KB: once removed*, Musée, Valence, 1985; M. Newman, 'New sculpture in Britain', *Art in America*, Sept. 1982, 104–14, 177, 179; *The sculpture show*, Hayward G, London, 1983; Sellars.

## BLACKSTONE, Harriet (1864–1939)

*American painter of portraits and figures*

Blackstone was born in New Hartford, Connecticut. Her farming parents gave her a traditional girl's education, so that her first job was teaching drawing and drama to children. In 1883 the family moved to Chicago, and five years later to Galesburg, Illinois. Teaching at a progressive girls' school brought her into contact with radical ideas about women, which led to her decision to take up art. From 1903 to 1905 she studied at the Pratt Institute in Brooklyn, New York and began to exhibit in 1906. Soon after this she spent almost two years in Europe with a friend and her daughter. She settled in Paris and enrolled at the Académie Julian, but also spent time in the Louvre, becoming fascinated by da Vinci's work. As a result of showing in the 1907 Salon, Blackstone received many portrait commissions on her return to Glencoe, Illinois, where she then lived with her mother. Through the generosity of patrons she was able to revisit Europe in 1912, attending one of William Chase's summer schools in Bruges for part of the time. This was crucial for the evolution of her painting: her brushstrokes became bolder and her colours brighter. During World War I she was sent by the government to New Mexico and her encounter with the culture of the native Indians increased her dissatisfaction with portraiture as her only subject. Although now 57, she searched for a new means of expression and made the break

with her mother to live in New York. While portraits brought in her income, she experimented with more expressionistic interpretations of her figures and ways of capturing the essence of a personality. One of her most successful works was a portrait of the concert pianist, Stell Andersen. The pianist and her friend, the writer Esther Morgan, came to know Blackstone well. About the time of her first solo show in 1928, Blackstone met a young graduate, Mary Landis, and the two became constant companions. In her seventies she continued to paint as far as her health permitted.

*Example:* Boston, Mass.

*Literature: A mystical vision: the art of HB. 1864–1939,* Bennington Mus., Bennington, Vt., 1984.

## BLAINE, Nell (1922–)

*American painter of colourful, loosely handled landscapes and still life*

Blaine was born in Richmond, Virginia, where her father had a lumber business. The visual world burst upon her suddenly when she was given glasses to correct her short-sightedness. She first studied art at her local university, where in her second year she was taught by a woman artist who had studied with Hans Hofmann. Inspired by this different type of instruction, Blaine, upon graduating in 1942, took her portfolio to Hofmann and asked for a scholarship. Having seen her work, he awarded her this for two years. Soon afterwards she moved into abstraction and had her first solo show in 1945. In 1948 her five-year marriage to a musician was annulled and she began to travel to Europe. A period in Paris made her brushwork looser and her palette lighter, before a return to figurative work and an interest in the effects of natural light. In the 1950s she designed sets, costumes and posters for her partner, the pioneer dancer Midi Garth. She also had to undertake various mundane tasks to finance her painting. On a visit to Greece in 1959 she contracted polio, since when she has been confined to a wheelchair. Nevertheless she has continued to paint prolifically, with the support of her partner since the late 1960s, the painter Carolyn Harris. She has received many awards and has exhibited widely.

*Publications:* 'Credo', *Iconograph*, Sept. 1946; 'A lack of wholeness' and 'The act of painting', *Women and art*, summer, 1972.

*Examples:* Asheville, NC; Fitchburg, Mass.; Newark, NJ; MOMA, New York; NMWA, Washington, DC.

*Literature:* L. Campbell, 'NB' *Art News*, Apr., 1960; Munro; Rubinstein; M. Sawin, 'NB' *WAJ* v3/1, spring-summer 1982, 35–9.

## BLAKE, Naomi (1924–)

*Czech-born abstract sculptor working in England*

One of nine children born into an Orthodox Jewish business family, she had the traumatic experience of having her parents and four siblings die in Nazi concentration camps, while she herself is a survivor of Auschwitz. She came to England via Israel, which she revisited after the war. There she met her husband, a German refugee who had escaped to Britain in 1939. It was only after her marriage that she began to practise art, and became a student at Hornsey College of Art (now part of Middlesex Polytechnic) for seven years at the same time as bringing up her children. Initially her studio was half the kitchen table. Then she produced representational figures in wood, marble, stone and clay, but more recently she has used only styrofoam, from which bronze casts are made of her now predominantly abstract works. These are often oval in shape, sometimes enclosing a figure. She has undertaken many large-scale commissions and was elected a member of the Royal Society of British Sculptors in 1979.

*Examples:* Cathedral, Bristol; Fitzroy Square, Waterlow Park, and St Botolph's church, London; cathedral, Norwich.

## BLANCHARD, Maria. (alt. GUTIERREZ-BLANCHARD) (1881–1932)

*Spanish painter of figures and still lifes in a Cubist style*

Born in Santander, she was an invalid from birth after her French-Polish mother suffered an accident during pregnancy. Her father was Spanish. As a child, therefore, she was isolated, and drawing provided her with a means of escaping the physical limitations of her world. At the age of 18, she went to Madrid, but her teacher, Salas el Sotomayor, was an exuberant painter not ideally suited to a student concerned with expressing her interior world. On her first visit to Paris in 1908, she

studied with the Fauvist Van Dongen and with Hermen Aglada, but because of her disability and the fact she was a woman, she was again isolated and devoted herself to her work. Back in Madrid in 1914, she met Marie Laurencin (*q.v.*) and Jacques Lipchitz, who were both involved with Cubism. After the war she returned to Paris with them, and in this way encountered other Cubists, including Gris and Metzinger as well as Picasso. Through Cubism, Blanchard's work became more sculptural, but unlike many of the other painters, she concentrated on adapting the style to the human figure, particularly that of women and girls. She began to receive critical attention in 1920, and friends organized two large exhibitions for her in Brussels in 1923 and 1927.

*Example:* Hanover.

*Literature:* Bachmann; W. George, *MB*, Brussels, 1927; Krichbaum; F. Mathey, *Six femmes peintres*, Paris, 1951; Petersen; Schurr, vl.

## BLAND, Beatrice. née Emily Beatrice BLAND (1864/9–1951)

*English painter of flowers and landscapes*

A native of Lincolnshire, she studied first at Lincoln School of Art and then at the Slade. She exhibited extensively with NEAC (108 works), at the RA and SWA, as well as at private galleries such as the Leicester, where she joined the gallery artists in 1925. In 1937 she was one of the English artists represented in the exhibition *Les Femmes artistes d'Europe*. Two of her works were bought for the nation. Earlier in her career she depicted flowers and still lifes but later painted landscapes as well, travelling to Italy for some of her material.

*Examples:* WAG, Liverpool; Worthing.

*Literature:* BB Leicester G, London, 1934; Sellars.

## BLOMJOUS, A.T. See VANDENBERG, Diana

## BLOW, Sandra (1925–)

*English abstract painter and collagist*

Blow has always lived in London. Four years at St Martin's School of Art (1942–6) were followed by a

year in Rome, where she heard from an American about the teaching of Hans Hofmann in New York, which contributed much to the development of abstract art in America. Nevertheless she was more influenced at the time by the rough textured patchwork pieces of the Italian Alberto Burri, and for the next 16 years she explored texture through surfaces encrusted in sand, sacking and plaster, while reducing colour to a few earth tones. Bright hues came to the fore in her post-1966 works and the thick textures gave way to canvas strips attached to the surface, which she used unprimed and stained with tea and washes of colour. A more geometric phase came in the early 1970s after her involvement in an architectural project, and metal bands replaced the canvas strips. These in turn have given way to wood or canvas elements, which are combined with more complex textures on the surface. This gives her work the quality of shallow relief. More recently she has experimented with PVC, on which she paints and collages and then boxes in perspex. Her place among Britain's post-war abstract painters is inadequately acknowledged by historians, and yet she has exhibited internationally from 1950, frequently in shows representing contemporary British art. Blow has received a number of awards, including Associate of the RA in 1971 and full membership in 1978.

*Examples:* Albright-Knox G, Buffalo, NY; Fitzwilliam Mus., Cambridge; Carlisle; Leeds; Leicester; WAG, Liverpool; Tate G and V & A, London; MOMA, New York; Sheffield.

*Literature:* Hayward Annual '78, Hayward G, London, 1978; Parry-Crook; Sellars; *St Ives, 1939–64*, Tate G, London, 1985.

## BLUMENFIELD, Helaine (c.1940–)

*American sculptor of abstract organic pieces in terracotta and marble*

After obtaining a Ph.D. in philosophy from Columbia University, New York, in 1964, Blumenfield studied with Ossip Zadkine in Paris, where she was trained in every sculptural technique. Her first solo show consisting of bronzes was held in Vienna in 1966, and since then she has exhibited in Europe and America, with a New York retrospective in 1976. Her larger-scale earlier work involved much refining of the original figurative form, which she used even then as a vehicle for symbolic meaning. She became interested in the

Helaine Blumenfield *Dreams*, 1988, Macedonian marble, 56 × 48.2 × 38 cm, collection of the artist. (photo: Benvenuto Saba)

space between two or three forms, which she saw in terms of male-female relationships. Although her work became abstract, strictly speaking, the organic forms were intended to symbolize human figures. In 1986 she created a vast seven-part structure, which can be separated and assembled in various ways, for the setting of a preview of a ballet. The sculpture, made on castors for ease of movement, remained as an installation in the plaza at the Lincoln Center, New York, for some months after the performance. This derived from her experimentation, firstly, with complex sculptural units which, far from having a fixed viewpoint, could be turned in any direction or even inverted, and, secondly, with several smaller-scale pieces which could be locked or placed together in an infinite variety of ways. According to how they are placed, different moods and ideas are communicated. Blumenfield now lives and works in a community of sculptors in Tuscany, where she works mainly in marble.

*Literature:* HB, Herbert Art G, Coventry, 1986; *Four American sculptors working in Britain*, Sainsbury Centre, University of East Anglia, Norwich, 1981; E. Lucie-Smith, *The sculpture of HB*, London, 1982.

## BLUNDEN, Anna E. (alt. MARTINO) (1829–1915)

*English painter of landscapes and figures*

A Londoner by birth, Blunden was brought up in Exeter, Devon with her two younger sisters. Her father was a bookbinder, while her mother was a gifted but untrained amateur watercolourist. While both parents were pleased at Blunden's artistic talent, they considered art too uncertain for a career and sent her to be trained as a governess, a fact which indicates that she was expected to earn her own living. Blunden abandoned her post as governess after one year and, having avidly read John Ruskin's *Modern Painters*, she successfully persuaded her parents to allow her to study art. She attended Leigh's Academy, Newman Street, London on the days set aside for female pupils, where she was able to draw from the live model and study anatomy. On the other days she drew in the British Museum and the National Gallery. She began exhibiting in 1854, when her painting of a seamstress at the Society of British Artists was engraved and reproduced in the *Illustrated London News*. After her return to Devon in 1855 she corresponded with Ruskin until 1862. She became rather over dependent on his advice, and it has been suggested that she was in love with him in 1857–8. Her early works were predominantly figurative and many contained a social theme with a female subject. Her parents wanted her to carry out more portraits, presumably for economic reasons, but Ruskin's advice was to avoid emotive subjects and lessen the emphasis on figures. She followed this suggestion, for *The returning penitent* of 1860 was her last work of this type of subject. The feature of her work which was commented on throughout her career was her sense of colour. After living with her sister until 1867, Blunden went to Europe, travelling in Switerland and Germany, painting landscapes, then setting up a studio in Rome, where she remained until her marriage in December 1872 to Francis Martino. After her marriage she settled in Birmingham and by 1876 had three children. Nevertheless she continued exhibiting in Birmingham and elsewhere until her death.

*Example:* Greenock AG.

*Literature: AJ*, May 1870; Clayton; D. Cherry, *Painting women: Victorian women artists*, Art G, Rochdale, 1987; Mallalieu; P. Nunn, 'Ruskin's patronage of women artists', *WAJ*, v2/1, fall 1981-winter 1982, 8–13; P. Nunn, *Victorian women artists*, London, 1987; Ruskin, *Academy Notes*, 1858,

1859; V. Surtees, *Sublime and instructive: letters from John Ruskin*, London, 1972; J. Treuherz, *Hard Times: social realism in Victorian art*, City Art G, Manchester, 1987; C. Wood, *Victorian panorama*, London, 1976; Wood, 1978.

## BODICHON, Barbara. née LEIGH SMITH (1827–91)

*English painter of landscapes, many of Algeria, and coastal scenes in watercolour*

Best known as a pioneer of education and campaigner for women's rights, Bodichon was also a painter who was well regarded by contemporary critics and artists alike. The eldest and illegitimate child of Benjamin Leigh Smith, the MP for Norwich and a 17-year-old milliner, whom he did not marry, she was brought up in her father's household where humanitarian causes and artistic practice were both valued. Her grandfather bought works by artists of the Norwich school and on one occasion took her to see Turner at work in his studio. All three Leigh Smith daughters received lessons from William Hunt the elder. Barbara was the most talented and went on to have further instruction from a number of artists, including a brother of John Varley. The Ladies College in Bedford Square had been founded in 1849 by Elizabeth Reid and drawing classes were supervised by Francis Cary. Barbara attended these classes in the early days of the college, before studying with Belloc, a pupil of Géricault. She was at some point also advised by David Cox and De Wint. Despite these many influences she evolved her own style from three main traditions: the Barbizon School, with its belief in the open air, British watercolour tradition and her own reactions to the scene. Although she knew the Pre-Raphaelite artists, she earned John Ruskin's disapproval for her grey, damp, overcast scenes. From 1864, Corot took her into his studio for several periods and she shared an enthusiasm for coastal scenery near Hastings with Daubigny who was both friend and instructor. Her paintings are usually quite small, at times heightened with oils, gouache or charcoal, but a few works are much larger. She exhibited more than 250 works in London galleries from 1850, particularly at the SWA and the Dudley, and others in Liverpool, Paris and elsewhere. She also held private exhibitions at her London house. She used much of the money from her paintings towards Girton College, Cambridge, which she co-founded with Emily Davies. She made time in between her many other activities for her painting, and the search for subjects enabled her to retreat to one of her country homes and to travel abroad. In the course of these travels she met and in 1857 married the French doctor, Eugène Bodichon. Her sketches of their honeymoon trip to America were subsequently exhibited and they spent their winters together in Algeria. Each summer she would return alone to pursue her various activities, a rare freedom in a nineteenth-century marriage but without that freedom she might never have married. She had no children. Over half Bodichon's paintings are landscapes of Algeria, the others being divided between Sussex, Cornwall and Brittany. Her paintings show few figures, but reveal her own love of the effects of light and weather on land and sea. For 25 years she was a close friend of George Eliot, who modelled her character Romola on Bodichon.

*Publications: An American diary 1857–8*, J.W. Reed Jr. (ed.), London, 1972.

*Examples:* Girton College, Cambridge; Hastings, Sussex.

*Literature:* Many of the more recent studies of Bodichon mention her art only briefly, if at all. Her art is dealt with at greater length in the following: H. Burton, *BB 1827–1891*, London, 1949; D. Cherry, *Painting women: Victorian women artists*, Art G, Rochdale, 1987; Clayton; J. Crabbe, 'An artist divided', *Apollo*, May 1981, 311–14; *DNB*; Fine; J. Matthews, 'BB: integrity in diversity', essay in *Feminist theorists*, D. Spender (ed.) London, 1983; P. Nunn, *Victorian women artists*, London, 1987; D. Spender, *Women of ideas*, London, 1982, 404–20; *The Times*, 15 June 1891 (obit.).

## BOHDANOWICZ, A. See BILINSKA-BOHDANOWICZ, Anna

## BONE, Phyllis Mary (1896–1927)

*Scottish sculptor of animals*

Born in Hornby, Lancashire, to a doctor's family, she began her studies at Edinburgh College of Art. From the beginning of her career she specialised in animals, either singly or in groups, so she worked under Navallier in Paris for some time. During World War I she served as a motor driver in the Women's Legion. Her art training completed, she set up her studio in Edinburgh and began her

extensive exhibiting career. In 1939 she became an Associate of the Royal Scottish Academy, and was elected to full membership in 1944. She wrote articles on animal sculpture and in her spare time enjoyed golf and salmon-fishing. The last years of her life were spent in Kirkcudbright.

*Examples:* Aberdeen; Scottish Nat. War Mus., Edinburgh; Glasgow; Inchcape Mon, Glenapp; St. Winifred's church, Welbeck.

*Literature: Lexikon der Frau; Who's Who in Art.*

## BONHEUR, Juliette. (alt. PEYROL or PEYROL-BONHEUR) (1830–91)

*French painter of animals*

The younger sister of Rosa Bonheur (*q.v.*), she too was trained by her father, Raymond. She exhibited at the Salon from 1852 to 1889, winning several awards, and in London. It would therefore appear that she was not hindered by her marriage in 1852 to Hippolyte Peyrol, a lithograph publisher. She also taught at the École Gratuite de Dessin from 1849, the year when Rosa became director in succession to their father, who died only a year after his appointment. The school was intended to train girls from poorer homes to earn a living, but an English student Joanna Samworth attended for some months and commented on the high standard of work expected at the school. Although Juliette Bonheur chiefly painted animals, she also produced still lifes and a few figure subjects.

*Literature:* C. Clement and L. Hutton, *Artists of the nineteenth century*, 1879; *Dict. de Biographie Française*; A. Hirsch, *Die Bildenden Künstlerinnen der Neuzeit*, 1905. See also under Rosa B.

## BONHEUR, Rosa. née Marie Rosalie BONHEUR (1822–99)

*French animal painter and sculptor; one of the best-known women artists of her time*

Bonheur was born in Bordeaux, her mother having trained with and then married her father. The family moved to Paris in 1829, and the four children, two boys and two girls, all became artists. Their mother died young and their father espoused the radical philosophies of the St Simonian group; through this the children encountered many intel-

lectuals of the day. As Rosa Bonheur did not take kindly to discipline, her formal education was sporadic and an attempt to apprentice her to a seamstress was disastrous. When her father accepted that she wanted to be an artist, he instructed her and sent her to copy in the Louvre. After attempting more traditional subject matter, she found that animals were to be her preoccupation. She set about dissection and studied her subjects in the zoo, the veterinary school and abattoirs. In order to carry this out she wore men's clothes, for which permission from the police was needed. This attire suited her unconventional character, for she wore her hair short and smoked cigarettes. She first exhibited at the Salon in 1841, and began to win awards there in 1845. *The horse fair* of 1853 brought her great fame, and henceforward she was exempt from submitting her works to the jury, but she was not allowed to receive the award of the Cross of the Légion d'honneur, which was her due, because she was a woman. On the death of her father in 1849, she replaced him as head of the government School of Design for Women for ten years, after which she bought an estate at By, near Fontainebleau. She lived there for the rest of her life, first with Nathalie Micas, two years her junior, whom Rosa had met at the age of 14, and Micas' mother. Micas relieved Bonheur of all domestic cares and their relationship lasted until Micas died in 1889. Some years later, Bonheur fell in love with painter Anna Klumpke (*q.v.*) and demanded that she give up her career to live with her. By then Bonheur was accepted as one of the most exceptional painters in France, and had received the award of Chevalier de la Légion d'honneur (1895) from the Empress Eugénie. Her vigorous paintings, based on sound technique and anatomical knowledge, were part of the tradition of animal painting and she avoided the anthropomorphic implications of the work of Landseer, with whom she was often compared.

*Publications:* 'Fragments of my autobiography', *Mag. of Art*, v36, 1902, 531–6.

*Examples:* Kupferstichkabinett, SMPK, Berlin; Metropolitan Mus., New York; Mus. du Louvre, Paris.

*Literature:* Bachmann; Clement; Cooper; *Das Verborgene Museum*; *Dict. de Biographie Française*: DWB; E. Ellett, *Women artists in all ages and countries*, 1859; Fine, 1978; Harris; A. Klumpke, *RB: sa vie, son oeuvre*, Paris, 1908; Petersen; T. Stanton, *Reminiscences of RB*, London, 1910; E. Tufts, *Our hidden heritage: five centuries of women artists*, New York, 1974; W.S. Sparrow.

## BONTECOU, Lee (1931–)

*American sculptor and assemblagist*

Bontecou was born in Providence, Rhode Island, but brought up in Westchester County, New York. Her parents supported her decision to take up art and from 1952 to 1955 she attended the Art Students' League, New York. There she studied painting before trying sculpture with William Zorach. A year at Skowhegan School of Painting and Sculpture was followed by two years in Italy, through a Fulbright scholarship. Her first solo show in New York in 1959 consisted of semi-abstract birds and animals, in addition to some figures. These were made of cast bronze sections welded together. In the same year she began to collect discarded items, including canvas conveyor belts from the laundry over which she was living. This proved to be the initial solution to her search for a light material that would enable her to place her sculpture on the wall rather than the floor. She constructed welded frames to surround the canvas, and the frames were then welded to each other to create a patchwork relief. Using many different types of discarded canvas, she left them in their original earthy colours, sometimes just adding sooty shading. The focal point of many was a gaping hole, which could be in black velvet, painted white or given a menacing saw-like edge. Some of her anger at political events was manifest in the more aggressive pieces. These works made her extremely successful: she was the only woman represented by the Leo Castelli Gallery in New York; she won the first prize from the National Institute of Arts and Letters in 1966 and in 1964 she received the commission for a wall relief in the State Theater at the Lincoln Center, New York. She was one of the few women accepted in mainstream art, and was greatly admired by Eva Hesse (*q.v.*). She married and, in 1967, had a daughter. Abandoning harsh materials in favour of vacuum-moulded plastic, Bontecou produced structures up to three metres high, in which were incorporated natural forms such as fish and flowers. In the early and mid-seventies, with a daughter and her widowed father to care for, she concentrated on her drawing and, through this, on the search for a new direction.

*Examples:* Akron; Stedelijk Mus., Amsterdam; Basle; Albright-Knox G, Buffalo, NY; Cleveland, Ohio; Dallas; Houston; Walker Art Center, Minneapolis; Guggenheim Mus. and Whitney Mus., New York; Hirschhorn Mus. and NMWA, Washington, DC.

*Literature:* D. Judd, 'LB', *Arts Mag.*, v39/7, Apr. 1965, 16–21; Heller; Munro; NMWA catalogue; Petersen; Rubinstein; Watson-Jones.

## BOREEL, Wendela. (pseud. of Edith WANDELA) (1895–after 1974)

*English painter and engraver of figures and architectural subjects*

Boreel was born in Pau, Pyrénées Atlantiques. Her mother was American and her father a Dutch diplomat. As he was later posted to England, she trained from 1911 at the Slade, then at the Westminster School of Art, where she attended Walter Sickert's evening classes. He singled her out and, telling her she was too talented to be there, obtained a studio for her and visited her there each day. She felt his influence to be somewhat overbearing. Her first solo show was held in 1922 and in the following year came the first of many elections to both French and English artistic bodies including associate membership of the Royal Society of Engravers (1923) and the Société Nationale des Beaux-Arts (1935). In 1924 she married L.G. Wylde and had one son, but her husband died in 1935. She was a prolific artist and exhibited extensively in England and France. One of her commissions was for Queen Mary's Doll's House at Windsor. In 1935 she was elected member of the Société Nationale des Beaux-Arts, an unusual honour for a foreign artist. During World War II she went to America, afterwards returning to settle in France.

*Examples:* V & A, London; Metropolitan Mus., New York.

*Literature:* W. Baron, *The Sickert women and the Sickert girls*, Parkin G, London, 1974; Deepwell; G. Greer, *The obstacle race*, London, 1979; Waters; *Who's Who in Art*.

## BORTOLAN, Rosa (1818–92)

*Italian painter of religious scenes and portraits*

Bortolan was born in Treviso, Veneto, to a rich family. Her father was general secretary to the town council. She studied at the Accademia in Venice and from the late 1840s the originality of her paintings began to arouse critical comment. She received many commissions for altarpieces in

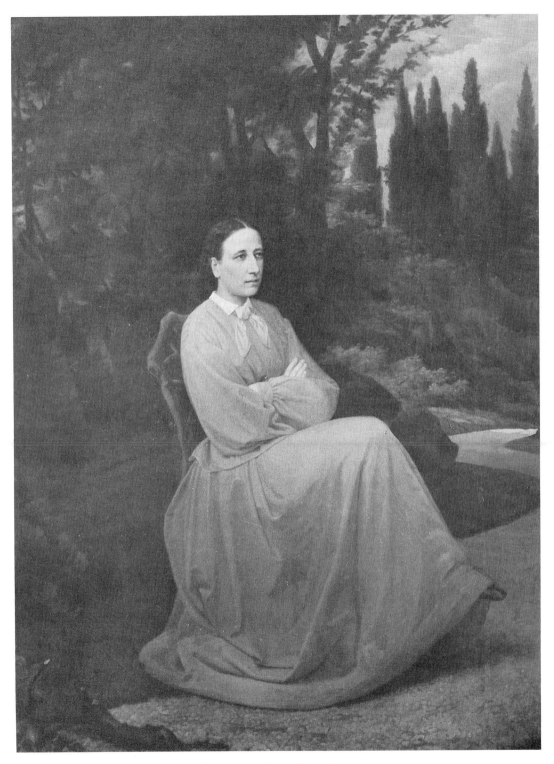

**Rosa Bortolan**  *Portrait of Luigia Codelmo*, oil on canvas, Museo Civico, Treviso.

the Veneto area and for portraits. She renounced her bourgeois background and chose to adopt a bohemian lifestyle in Venice, establishing a studio behind the church of S. Simeone with her friend and fellow painter Luigia Codelmo.

*Examples:* Church of S. Maria Maggiore, Carpenedo, Veneto; Treviso; church in Valdobbiadene, Veneto.

*Literature:* Clement; A. Comanducci, *Dizionario illustrato*, 3rd ed., Milan, 1966; *Lexikon der Frau*.

## BOSSI, Erma. (alt. Erminia or Barrera BOSSI) (1882/5–1952)

*Italian expressionist painter of figures, still lifes and landscapes, who belonged to Der Blane Reiter (the Blue Rider group)*

The biographical details vary according to the sources consulted, as does Bossi's first name. She was born in Pola and studied at the Bavarian Academy at Munich. It was while there that she met the artists who later formed the Blue Rider group of Expressionist painters and became particularly friendly with Kandinsky and Gabriel Münter (*q.v.*). An interior from this period shows her stylistically close to Münter and also influenced by Japanese art. In the years immediately before and after World War I she was in Paris, but she spent most of the inter-war years in Milan, where she exhibited. At both the Venice Biennale of 1930 and the fortieth anniversary exhibition of the Biennale in 1935, she was represented by still lifes and her name given as Erma Bossi, although her works were signed as Barrera Bossi.

*Examples:* Kunsthalle, Bremen; Lenbachhaus, Munich.

*Literature:* A. Comanducci, *Dizionario illustrato*, 3rd ed., Milan, 1966; Vergine.

## BOURGEOIS, Louise (1911–)

*French-born sculptor of abstract organic forms in wood, stone and plaster, who works in America*

The daughter of a feminist and socialist, Bourgeois was the third of four children born to the owners of a tapestry business in Aubusson. From childhood she assisted her mother with old tapestries sent for restoration and at 15 she made working drawings for her parents. Schooling in Paris was followed by a period at the Sorbonne, where she derived comfort at her mother's death from her mathematical studies. She was 25 when she began to study at the École des Beaux-Arts, the Académie de la Grande Chaumière, with Ozenfant and with Léger. In 1938 she met and married art historian Robert Goldwater and returned to New York with him. Subsequently she had three sons. She began attending the Art Students' League and to exhibit Surrealist drawings and engravings. Many of the Surrealist artists were then in New York and she was particularly friendly with Duchamp. Her works from this period reflect her sense of being isolated from her culture and her family, and grow out of feelings buried in the subconscious. Returning to sculpture in the mid-1940s, she created for her first solo show in 1949 an atmosphere of loneliness from tall (2m) wooden forms placed alone or in small groups suggestive of figures. She has said that all her work, whether abstract or figurative is concerned with the relationships of men and women, and her work reflects the female experience of life. By the 1960s she was creating a series of 'lairs' with latex and papier mâché over a wire-mesh base to form caves or hiding places. Inside these were visceral formations, highly unusual in a period of rigid minimalism. This series culminated in the *Destruction of the father* of 1975, a fantasy environment that came directly out of her father's *ménage à trois* with her mother and an Englishwoman employed as the children's tutor. Within her work are series which often overlap, and she frequently moves from one material to another. She is not primarily concerned with aesthetics, but with the transformation of her own strong feeling about an issue, often connected with the position of women. Her *Cumul* series, based on the sight of clusters of round huts seen when flying over the Sahara desert, have been claimed by feminists as an essentially female image. Although Bourgeois states that these are merely symbols of life, there are within her work many forms which are in a subtle way reminiscent of the sexual organs of both men and women, with folds, crevices, and domes. The *Cumul* series incorporates many variations in both imagery, interpretation and material. Although for a long period her work was largely unrecognised and ignored, like that of many women artists, she continued working and has exhibited consistently over four decades. Since the late 1970s honours have finally been accorded to her, with at least four honorary doctorates, and a retrospective exhibition at MOMA, New York in 1982.

*Examples:* Detroit; Storm King Art Center, Mountainville, NY; Metropolitan Mus., Whitney Mus. and MOMA, New York; Centre Nat. de l'Art Moderne and Mus. de la Ville, Paris; Portland, Me.

*Literature:* Heller; *Künstlerinnen International 1877 –1977*, Schloss Charlottenburg, Berlin, 1977; Mackay; Munro; Petersen; C. Robins, *The pluralist era*, New York, 1984; Rubinstein; R. Storr, 'LB: gender and possession', *Art in America*, v71/4, 1983, 128– 37; Watson-Jones; D. Wye, *LB*, MOMA, New York, 1982 (bibl.).

## BOUGUEREAU, E. See GARDNER, Elizabeth

## BOURILLON-TOURNAY, Jeanne (1867/70–1932)

*French portrait painter*

She trained in her native Paris under Humbert, Saintpierre and Henri Delacroix. She exhibited from at least the mid-1890s and won a succession of awards at the Salon (gold medal, 1914) and the Union des Femmes Peintres et Sculpteurs, carrying off the Palmes Académiques by winning the two chief prizes of the UFPS – in 1895. She was a member both of that body and the Société des Artistes Français and continued to exhibit until her death.

*Literature:* Clement; Edouard-Joseph; Schurr, v4.

## BOWKETT, Jane Maria (1837–91)

*English painter of domestic genre and seaside scenes*

The eldest of the large family of a surgeon in Poplar, London, Bowkett exhibited her first painting in 1860. Although we do not know where the interest or the training came from, not only Jane Bowkett, but also three of her sisters and a cousin became artists. In 1860 Bowkett met Charles Stuart, a painter popular for somewhat grandiose landscapes of the Highlands. Early in 1862 they were married, when Bowkett was already pregnant, and by the time their daughter was born in June they were living with Stuart's parents in Stepney. They remained there for five years, during which time

Bowkett's work gained in maturity. Between 1865 and 1869 she gave birth to five more children, including twins, but in a series of personal tragedies three children died, followed soon afterwards by her parents. Not surprisingly her output diminished temporarily in the early 1870s. In 1874 they moved to the artistically fashionable area of Chelsea, but by the late 1870s they were living in West Hampstead, where the house had a large studio, which both Stuart and Bowkett could use and where they entertained many well-known artistic and theatrical figures. Bowkett maintained her output of scenes of figures, especially children, in the home, in the countryside, and at the seaside. Unusually for the time, she always used her maiden name to sign her pictures, which she exhibited not only in many London galleries but also in the provinces and Scotland. She died during the influenza epidemic of 1890–1 and was buried in Kensal Green cemetery.

*Literature:* D. Cherry, *Painting women: Victorian women artists*, Art G, Rochdale, 1987; J.F. Foley, 'The world of JMB', *The Lady*, 18/25 Dec. 1986; P. Nunn, *Victorian women artists*, London, 1987; Wood, *Victorian panorama*, London, 1876; Wood, 1978.

## BOYCE, Joanna Mary. (alt. WELLS) (1831–61)

*English painter of figure subjects, including genre, historical and literary themes*

Boyce was the third of five children, her father being a London merchant who later became a pawnbroker. Her oldest brother was George Boyce, the Pre-Raphaelite landscape painter. Joanna Boyce was gifted in both music and art, but by her late teens had determined upon art. She went sketching with her brother, whose tuition and contacts were useful to her at this time. In 1849 she began her studies at Cary's School of Art and proceeded to Leigh's in 1852. Her surviving sketchbooks reveal her as a serious and diligent student, with a strong sense of herself as a woman artist. Six weeks in Paris in 1852 with her supportive father helped her education. Her first painting was accepted at the RA in 1855 and commented on favourably by John Ruskin. A second visit to Paris was made in 1855 with her mother and brother, but Joanna remained there to study alone after the others returned. She attended the life class in Couture's atelier, a fact which she did not com-

municate to her mother. Her paintings of this period demonstrate her accord with Pre-Raphaelite values in the sense of diligently seeking after visual truth, of authentic if somewhat uncommon colouring and the depiction of a certain physical type of woman from one or two models only. Her work was always rather more bold and vigorous than that of the Pre-Raphaelites and, had she lived, this divergence would probably have become more distinct. In May 1857 she embarked on a visit to Rome and in December married the ever-persistent Henry Wells. The Italian tour continued and her subsequent work benefited from it in terms of colour and composition. Several paintings resulting from the visit were exhibited and acclaimed by critics. Her death in childbirth was described as 'a real loss to the English school'.

*Example:* Tate G, London.

*Literature:* D. Cherry, *Painting women: Victorian women artists*, Art G, Rochdale, 1987; P. Nunn, *Victorian women artists*, London, 1987; *JMW*, Tate G, London, 1935.

## BOYCE, Sonia (1962–)

*English figurative painter*

Born in Islington, London, she was one of five children of West Indian immigrants. She drew much as a child, and was conscious of the strong figure of her mother, to whom she was close. At school she was encouraged to pursue art by a teacher whom she still consults. After studying for a year at East Ham College of Art and Technology in 1979–80, she completed a degree in fine art at Stourbridge College, near Birmingham, in 1983. This was the first time she had lived outside London, in a predominantly white area, and she was conscious of having to struggle to assert her identity, because of being female and black. This process became clearer after attending the first national conference of black artists in 1982. Having worked in isolation, she became aware of many other black artists in the same predicament. It was there that she met Lubaina Himid (*q.v.*), who encouraged her and chose Boyce for what was to be her first exhibition in 1983. Since then Boyce has painted, exhibited and lectured, but has also helped with community projects and had periods of unemployment. Many of her large paintings deal with relationships within the family, which in turn reflect the basis of power in society. A child's curiosity about the adult world forces the spectator

to readjust to another viewpoint. Surrounding her figures are patterns she adapts from collections of material and wallpapers.

*Literature: SB*, AIR G, London, 1986; *SB*, Art G, Rochdale, 1987; *Along the lines of resistance: an exhibition of contemporary feminist art*, Cooper G., Barnsley, 1988; S. Nairne, *State of the art*, London, 1987; *The thin black line*, ICA, London, 1985.

## BOYD AND EVANS. (pseud. of Fionnuala BOYD) (1944–)

*English artist working in a partnership to produce paintings based on photographs of street scenes or events from the news*

Boyd was born in St Albans, Hertfordshire, and studied at Leeds University. Since 1968 she has worked with Leslie Evans, her husband, whom she met during a foundation studies year at her local school of art. Initially they used photographs they had taken themselves of events in the street, which, isolated from a context, take on the appearance of stills from a film. Early on they discovered that with a spray gun and stencils they could successfully eliminate the problem of individual styles within the one work, a factor that may have helped when they had to integrate their work with the raising of children. Although the technique is reminiscent of Super-realist painting, Boyd and Evans always draw attention to the process of painting, with devices such as tilting the canvas or blurring the image. More recently they have changed to using brushed acrylic paint rather than the spray gun. In their early works they juxtaposed images and settings to produce pictures that were both disconcerting and amusing. They then introduced subjects in which a narrative was implied but not resolved, and since the early 1980s they have used not only photographs they have taken, but also others from newspapers and television. Ambiguity of meaning is a hallmark of their paintings. Increasingly they have drawn attention to the ways in which photographs are changed to create particular effects and are not a snapshot of reality to be taken at face value. The essential ingredient in their work is a commitment to narrative, but with the inclusion of some kind of psychological drama, enhanced by an awareness of the peculiarity of ordinary events.

*Examples:* Belfast; Leeds; Manchester; MOMA, New York; Sheffield; Wigan.

*Literature:* M. Amaya, 'Big brother lives next door: B & E in Milton Keynes', *Studio International*, v196, no. 1004, Apr. 1984, 39; *B & E: drawings*, Angela Flowers G, London, 1982; M. Gooding, 'B & E', *Art Monthly*, July–Aug. 1986, 13–15; P. Overy, 'Triangular relationships with a new slant', *The Times*, 1 Mar. 1977.

## BOZNANSKA, Olga (1865–1940)

*Polish painter of* intimiste *studies of people and still lifes*

Boznanska was the eldest of two daughters born to a bourgeois Cracow family. Her father knew many artists and her mother, who was French and a drawing instructor, began to teach her elder daughter at the age of ten. From 1883 she studied under the portrait painter, Powchwalski, and at the only art school for women in the city. After three years she left for Munich, where her father had artistic friends, but her three years of study there gave her little except a strong technical base. Having opened her own studio in Munich in 1889, she began exhibiting, and gathered round her a cosmopolitan group of young artists. Mainly known for her muted colour, she often painted on coarsely primed cardboard and left her surfaces unvarnished. Her subjects were never anecdotal but a study in colour and atmosphere. For this reason she has been compared to Whistler, with whom she shared an admiration for Spanish and Japanese art. In many of her paintings of individual half-length figures she captured a poignant melancholy prevalent in the 1890s. The backgrounds are neutral, while the whole scene is pervaded by a particular atmosphere that separates the space of the sitter from that of the spectator. Many of her paintings are portraits of friends, who were often artists and writers and, while in all the individuality of the person is stressed, there is a perceptibly greater personal involvement with the sitter in works from around 1900. A series of self-portraits avoids any sense of narcissism; those from the period 1906–7 are intellectually objective while the medium is handled with greater freedom. Having visited Paris at intervals from 1878, Boznanska moved there permanently in 1898, although she continued to maintain a studio in Cracow. She won gold medals in Munich (1893), Vienna (1894) and London (1901) and exhibited extensively in many European countries. She refused the post of professor of painting at the Academy of Fine Arts in Cracow and also a teaching position in the Warsaw Academy in order to devote herself fully to her painting. She was elected member of the Société Nationale de Beaux-Arts in 1904, was made a Chevalier de la Légion d'honneur in 1910 and was awarded the Order of Polonia Restituta by the Polish government in 1938.

*Examples:* Boston, Mass.; Cracow; Kielce; Mus. d'Orsay, Paris; Warsaw.

*Literature:* H. Blum, *OB*, Warsaw, 1974 (bibl.); Clement; Edouard-Joseph; Krichbaum; *Lexikon der Frau*.

## BRACKEN, J. See WENDT, Julia

## BRACQUEMOND, Marie, née QUIVERON (1841–1916)

*French Impressionist painter of contemporary figure scenes*

Born in Morlaix, she studied with Ingres and was judged by one writer to be one of his most intelligent pupils. In 1869 she married a leading engraver, Felix Bracquemond, through whom she made many useful contacts in the art world. He also taught her etching, but she only produced nine works in this medium in her career. In the late 1870s, inspired by Monet and Renoir, she became fascinated by *plein-air* painting; she used more intense, often unmodulated colours and applied them in a looser way, not attempting to hide the brushmarks. Like the other Impressionists she was also concerned with representing contemporary life. Having had work accepted at the Salon in 1874–5, she changed to exhibiting her work with that of the Impressionists in 1879, 1880 and 1886. Her work was also shown in London in 1881 and was chosen for the Chicago Exposition in 1893. Her paintings of the 1880s reflect the circumscribed everyday life of a middle-class woman and depict her family and friends in house and garden. Her husband strongly opposed the tenets of Impressionism, a factor which must have militated against her furthering potentially supportive artistic contacts. Her sister Louise and later her son Pierre encouraged her to continue painting, but her output diminished sharply from 1890, after which time she lived a secluded life at Sèvres producing only a few small works. Tamar Garb attributes this to a desire for domestic harmony, for her husband not only disagreed with her philosophy, but was jealous of her talent and unable to accept her criticism of his work. In an unpublished account

of his mother's life, Pierre documents the conflict encountered by his mother in her roles of wife and artist, and it was he who organised the retrospective exhibition of 156 of her works at the Galérie Bernheim-Jeune in 1919.

*Examples:* Cambrai; Petit Palais, Geneva; Cabinet de Dessins, Louvre and Petit Palais, Paris.

*Literature:* J-P. Bouillon & E. Kane, 'MB', *WAJ*, v5/2, 21–7; M. Elliott; T. Garb, *Women of Impressionism*, Oxford, 1986; Weimann.

## BRANDT, Marianne (1893–after 1980)

*German painter and designer, principally of metal products, who taught at the Bauhaus*

Born in Trier, Brandt began to study art at the Weimar Academy of Fine Art when she was 18. After her marriage in 1919, she lived in Norway, then in France. On returning to Germany, she resumed her studies and attended the Bauhaus from 1923 to 1928. She elected to be in the metal workshop which was then led by Laszlo Moholy-Nagy, and so began her work in modern industrial design. Adopting an approach based on the function for which the object was required, the simple, plain lines of her designs were revolutionary at the time, but were soon in industrial production. Her lamp designs in particular were highly regarded. On the departure of Moholy-Nagy, Brandt took over the direction of the metal workshop until it was amalgamated with others. She then worked in the office of the director, Walter Gropius, and organised the Dammerstock centre. She soon left, and in 1929 she became the designer for a company producing metal goods at Gotha. During the Nazi period she lived at Chemnitz, illustrating books and other items, but from 1949 to 1954 she taught at the academies of applied art and design in Dresden and Berlin. After her retirement she returned to Chemnitz.

*Example:* Bauhaus-Archiv., Berlin.

*Literature:* M. Keller, 'Women of the Bauhaus', *Heresies*, winter 1978, 54–6; Krichbaum; Vergine.

## BREITLING, Gisela A. (1939–)

*German figurative painter*

Born in Berlin, she spent her childhood in Lindau, and her initial training took place there from 1958

to 1960. This was followed by two years at the textile school in Krefeld, some months in Italy on a travel scholarship and six further years at the Berlin School of Art with Stabenau. Since 1966 she has exhibited many times in group and solo shows. Her figurative paintings, often depicting women, for she is a committed feminist, contain some element of mystery or ambiguity the spectator is required to consider. In 1988 she was a member of the group which organized an exhibition of women's art from the Berlin museums.

*Publications: Die Spuren des Schiffs in den Wellen,* Berlin, 1980; (co-author), *Das verborgene Museum: Dokumentation der Kunst von Frauen in Berliner öffentlichen Sammlungen*, Berlin, 1988.

*Examples:* Kupferstichkabinett, Berlin; Kupferstichkabinett, Frankfurt; Hamburg; Karlsruhe; V & A, London; Albertina, Vienna.

*Literature:* Krichbaum; *Künstlerinnen International, 1877–1977*, Schloss Charlottenburg, Berlin, 1977.

## BRESLAU, Louise Catherine. (alt. Louisa) (1856–1927)

*German painter of portraits, children and genre*

Breslau was born in Munich, two years before the family moved to Zurich in 1858, where her father, a doctor, died when she was seven, thus necessitating the adoption of a career. After instruction from Pfyffer, she continued her training in Paris at the Académie Julian from 1875 to 1881. There she met Marie Bashkirtseff (q.v.), from whose diary she emerges as highly talented in drawing and the most successful artist of the women's class. She first exhibited in the Salon in 1879 and was a member of the Société National des Beaux-Arts from 1881. In that year she visited Brittany, subsequently travelling to many European countries, of which Holland was her favourite. Her early portraits were noted for their lack of flattery, but they and her genre scenes, mostly of middle-class mothers and children in interiors, became known for their psychologically acute portrayal of character, to which end she used colour to surround objects; the figures were relatively large within the horizontal canvas. Later she turned to pastels of children, often with animals and flowers, reverting to oils after 1893 but retaining the lighter palette brought about by the use of pastel. Her contemporaries referred to her as an *intimiste*. She won gold medals at the Paris Expositions Universelles of 1889 and 1900, and in 1901, by which time she

was a successful and famous artist, she was awarded the Chevalier de la Légion d'honneur. In the same year she had her first solo show in Zurich, enjoying five more in Paris before her death. A major retrospective was held in 1928. Never marrying, she set up home at Neuilly with Madeleine Zillhardt, whom she had met at Julian's.

*Examples:* Carpentras; Mus. Arland, Lausanne; Mus. d'Orsay, Paris.

*Literature:* A. Alexandre, *LB*, Paris, 1928; Bachmann; M. Bashkirtseff, *Journal*, various editions, e.g. M. Blind (trans.), with a new intro. by R. Parker & G. Pollock, London, 1985; Clement; G. Greer, *The obstacle race*, London, 1979; Krichbaum; Petersen; Yeldham; M. Zillhardt, *LCB et ses amis*, Paris, 1937.

## BRETT, Rosa. (occasional pseud. Rosarius BRETT) (1829–82)

*English painter of landscapes, topographical works and small mammals in their habitat, in a Pre-Raphaelite style*

The only girl among five children of a soldier, she was born while he and his wife were posted to Dublin. After some years they moved to north Kent, which provided the setting for Rosa Brett's landscapes. Information on her early life is sparse, but she seems to have studied under her brother John and sold her first drawing in 1850. Despite poor health throughout her life, and domestic pressures as the only daughter, she worked hard when time allowed. Her career also suffered because of the expectation that John Brett should be promoted as an artist. During the 1850s they collaborated on a number of works, a fact overlooked by contemporary critics. She accepted from early on that landscapes should be painted in the open air, whatever the discomfort. She exhibited at the RA spasmodically between 1858 and 1881. Her copious sketchbooks show a detailed Pre-Raphaelite approach to nature, including many studies of skies, particularly in the late 1860s. There are also records of portraits by her hand. Before 1867 she exhibited under the name Rosarius Brett, but the assumed name could not compensate for the restrictions placed on her by her family position and external expectations that John Brett as a man was the more significant artist.

*Literature:* P. Nunn, 'RB', *Burlington Mag.*, v126, Oct. 1984, 630–4; P. Nunn, *Victorian women artists*, London, 1987; Wood, 1978.

## BREWSTER, A. See RICHARDS, Anna

## BRICKDALE, Eleanor. née Mary Eleanor FORTESCUE BRICKDALE. (alt. FORTESCUE-BRICKDALE) (1872–1945)

*English painter of historical, literary, imaginative subjects and genre in oil and watercolour and a prolific illustrator of books*

One of five children of a barrister, she was born near in Upper Norwood, Surrey and educated privately. Although he remained an amateur, her oldest brother at one time attended the Ruskin School of Drawing in Oxford, and at the age of 17 Eleanor decided to become a professional artist. After initial instruction at the Crystal Palace School of Art, she proceeded to the RA Schools, where she was a student from 1897 to 1900. In December 1897 she won a £40 prize for the design of a lunette in the RA dining room, and began exhibiting at the RA in 1896. During these years most of her work was in black and white and she regularly sold book-plates and illustrations. The death of her father in 1894 may have necessitated this income. However, by 1899 her first oil paintings were accepted – and sold – at the RA and she received a commission to produce paintings over a two-year period for a London gallery. This culminated in the first of a number of solo shows at a time when they were not a common event. Only two years after leaving the RA, she was elected both the first woman member of the Royal Institute of Painters in Oils and an Associate of the Royal Watercolour Society, becoming a full member in 1919. She illustrated numerous works of prose and poetry for adults and children, with both black and white illustrations and watercolours. Her paintings show a concern for precise rendering and jewel-like colours that continue the Pre-Raphaelite tradition. For a time she taught at the Byam Shaw School of Art. Frequent visits to Italy and the south of France took her away from her London base, as did sojourns with friends in many parts of England. During World War I she designed posters for government departments, and the end of the war increased the demand for her stained glass windows. Over 20, dating mainly from the later part of her career, were executed. She was able to maintain this activity until 1940, even after the onset of blindness in the mid-1920s.

*Publications:* article in *Women's employment*, 15 Jan. 1932, 27; for publications illustrated, see below in *Literature*.

*Examples:* Birmingham; cathedral and old church, Clifton, Bristol; church of St. James the Great, Flockton, Yorkshire; Leeds; WAG, Liverpool; St George's church, Aubrey Walk, London W8; Lady Lever Art G, Port Sunlight, Merseyside; the Minster, York.

*Literature:* Mallalieu; Sellars; W.S. Sparrow; W.S. Sparrow, 'EFB', *Studio*, v23, 1901, 31–44; *Studio*, v13, 1898, 103–8; G. Taylor, *Centenary exhibition of EFB 1872–1945*, Ashmolean Mus., Oxford, 1972 (lists many of published illustrations etc.); *Who was who*, 1941–50; Wood, 1978.

## BRIDELL-FOX, Eliza Florance, née FOX. (*c.* 1825–after 1895)

*English painter of Arab scenes, and children in literary, historical and genre contexts, who contributed to the improvement of women's art education*

As one of three children of W.J. Fox, MP for Oldham, who was the first man to introduce a bill for national education, she benefited in her schooling from the high value her father placed on learning. When she was ten, her parents separated, her father living subsequently with the composer Eliza Flower. Fox grew up in their circle of writers and intellectuals, among whom were noted supporters of feminism, a fact that may partly explain her early sympathy for the cause of women. Unfortunately her father initially believed that no special training was required for artists, so she persisted with an anatomy book and copying in the British Museum until the age of 19, when she attended Sass' art school in London for three years. Conscious of the inadequacies of art education for women, she established a class in her father's library in 1849 in order that she and other like-minded women could draw from the nude model. Among the early participants was Laura Herford (*q.v.*), the first woman to be admitted to the RA Schools. Initially run on a co-operative basis, subsequent classes were taught by Fox until her marriage. On a visit to Rome in 1858–9 she met and married the artist Frederick Bridell. They spent long periods in Italy but after his death in 1863, she made a prolonged visit to Algeria, where she began the scenes of Arabian life which were to be her best-known works. She married her cousin, George Fox, in 1871, henceforth exhibiting under the name Bridell-Fox. She retained her involvement in women's issues in various ways, including exhibiting at the SWA from its inception in 1857 and teaching life-drawing classes there in 1866–7. She exhibited at the RA and several other London

galleries from 1846 until 1887, and in Paris in 1866, so she clearly allowed neither of her marriages to impede her work.

*Example:* Southampton.

*Literature:* Clayton; P. Nunn, *Victorian women artists*, London, 1987; Yeldham.

## BRIDGES, Fidelia (1834–1923)

*American painter mainly of flowers, but also birds and landscapes, in watercolour*

Born in Salem, Massachusetts, she was the youngest daughter and third of four surviving children of a merchant captain and his wife, who both died in 1849. Fidelia's older sister Eliza, who was a schoolteacher, then had to support the other children. In 1854, they all moved to Brooklyn, New York, where family friends lived but Eliza, after starting her own school, died in 1856. Fidelia, who had become a governess, determined to study art and in 1860 became a pupil in Philadelphia of William Richards, a follower of the Pre-Raphaelites. Within two years she set up her own studio in the city, but retained a warm friendship with Richards and his family, which included his artist daughter Anna (*q.v.*), one of a series of such relationships which provided her with companionship without commitments. Richards helped her to gain patrons and to exhibit. By 1865, when she returned to Brooklyn, her paintings were botanically accurate, precise renderings of nature. She spent the year 1867–8 in Rome, when she lodged with Anne Whitney (*q.v.*) and Boston painter Adeline Manning. Turning increasingly to watercolour, she concentrated on depicting close-up studies of parts of plants in bright colours. These works brought her considerable success, including election as Associate of the NAD in 1873 and the opportunity to exhibit in the Philadelphia Centennial Exposition of 1876. During the 1870s she spent summers in Stratford, Connecticut, painting the plants and birds of the countryside and enjoying the close friendship of artist Oliver Lay and his family each year. At the same time she began to produce illustrations, both for books, especially about birds, and for greetings cards. After a year's stay in England with her brother in 1879–80, during which time she exhibited at the RA, she returned there regularly for the rest of her life. In 1892 she moved away from the Brooklyn family where she had been based and lived in Canaan, a small Connecticut village, until her death. One of her patrons was Mark Twain. In her later work

the backgrounds became simplified and the asymmetrical compositions carried hints of oriental influence.

*Example:* Smithsonian Inst., Washington, DC.

*Literature:* Clement; *Notable American Women*; Petersen; Rubinstein; Tufts, 1987; Withers, 1979.

# BRIDGWATER, Emmy (1902–)

*English Surrealist painter*

Bridgwater studied at the School of Art in her native Birmingham before going on to further training in Oxford and London. It was in the late 1930s, when living at Stratford-upon-Avon, that she turned to Surrealism, under the influence of Robert Melville in Birmingham. She became a member of the British Surrealist group in 1940 and exhibited with them on a number of occasions, including the 1947 International Surrealist exhibition in Paris. Like Colquhoun (*q.v.*), she believed that through automatism she could attempt to represent the constant transmutations of the natural world. In her works she used a variety of materials to create texture. There is no focal point, for she fragmented any logical resting places for the eye and transformed objects into convoluted spirals and mazes. She contributed automatic poems and drawings to several Surrealist periodicals.

*Literature: British women Surrealists*, Blond Fine Art, London, 1985; W. Chadwick, *Women artists and the Surrealist movement*, London, 1985; *Salute to British Surrealism 1930–50*, Minories G, Colchester, 1985.

# BROOKS, Romaine. née Beatrice Romaine GODDARD (1874–1970)

*American painter of androgynous figures and portraits*

Born in Rome to American parents, Goddard had a disturbed childhood in the company of her neurotic mother and mentally unstable older brother. Not until she was 21 did she gain the freedom to study art, and she was the only female student at the Scuola Nazionale in Rome. Her courage in drawing from the live model resulted in unwelcome advances from fellow students, and this, combined with her childhood experiences and at least one unhappy love affair, led her in 1899 to join the homosexual community on the island of Capri. This period enabled her to paint

seriously and to begin to gain commissions. After a series of affairs, she believed she would obtain greater freedom as a married woman and entered into a marriage of convenience with John Ellington Brooks, an English homosexual. After the death of her mother and brother in 1902, Romaine Brooks inherited a large fortune and, as her husband tried to gain access to this, she fled to England and prevented his pursuit of her by payment of an annual allowance. Now able to practise her art, she worked in London and St Ives, Cornwall. It was there that she evolved her palette of black and white, with infinite gradations of grey. After settling in Paris, she became part of the sophisticated society of intellectuals and lesbians, where in 1915 she met Natalie Barney, the daughter of Alice Barney (*q.v.*), with whom she had a relationship of over 40 years. She painted many portraits of friends, which appeared in her first solo show in 1910. Other subjects included young, often androgynous women, for a number of which the dancer Ida Rubinstein was the inspiration. Sexual ambiguity is a hallmark of much of the work of her most active period before the early 1930s. While there are elements of both symbolism and Whistler's asceticism, the overwhelming severity of both form and concept distinguishes her paintings from those of her contemporaries. Her success was recognised by the award of the Légion d'honneur in 1920, and by a series of exhibitions in London, Paris and New York. The dominance of modernist art led to increasing isolation and neglect until Natalie Barney persuaded her to donate many works to the National Collection of Fine Arts in Washington, DC, where a major retrospective in 1971 drew attention to her powerful paintings.

*Examples:* Mus. de la Ville, Paris; Smithsonian Inst., Washington, DC.

*Literature:* Bachmann; A. Breeskin, *R.B.: 'Thief of souls'*, Nat. Collection of Fine Arts, Washington, DC, 1971; A. Breeskin, 'The rare, subtle talent of RB', *Art News*, v79, Oct. 1980, 156–8; Cooper; DWB; *Fair Muse*; Fine, 1978; G. Greer, *The obstacle race*, London, 1979; Harris; *Notable American Women*; Petersen; Rubinstein; M. Secrest, *Between me and life*, New York, 1974; Tufts 1987; Vergine.

# BROWN, Deborah (1927–)

*Irish sculptor of abstract reliefs and later free-standing pieces in fibreglass*

Born in Belfast, she trained at the College of Art there in 1946–7 before enrolling at the National

College of Art in Dublin for three years. Later she undertook further study in Paris. Initially a painter, she began to make abstract reliefs from fibreglass, which were then mounted on a background painted in a single colour. Occasionally the fibreglass was coloured, but predominantly she relied on the changing effect of light to bring out the full potential of their forms. When Brown took the reliefs off the wall and began to make free-standing sculpture, this was still the vital element. In some instances the fibreglass was stretched to its limits, so that the fibres within it are clearly visible and the whole appears not as a solid but as a gauzy fabric suspended in the air. From 1966–9 Brown was a member of WIAC. She has exhibited extensively since 1948, with a series of solo shows since 1951.

*Example:* Belfast; Municipal G of Modern Art, Dublin.

*Literature: Irish women artists; Modern Irish painting*, Ulster Mus., Belfast, 1966.

## BROWN, L. See ROSSETTI, Lucy

## BROWNE, Henriette. (pseud. of Sophie de SAUX (alt. DESAUX) née BOUTEILLER) (1829–1901)

*French painter of genre, including religious themes, Eastern scenes and portraits; also an engraver*

Highly successful from the very start of her career, Sophie Bouteiller was the daughter of the Comte de Bouteiller and his second wife. During her widowhood, the latter had had to give singing lessons in order to pay for her son's education. She was therefore determined that her daughter should be able to earn her living. Sophie was educated at home by her mother and tutors. At 17 she elected to pursue art rather than music, and studied from 1849 with Perrin and from 1851 with Charles Chaplin, in whose all-female class she drew from the live model. All this was accomplished with the active support of her mother. She exhibited at the Salon from 1853 but because of a wish to separate her public and private lives – she married the diplomat Jules de Saux in that year – she adopted the name of her maternal grandmother. At her next appearance, in the Exposition Universelle of 1855, she was awarded a medal and sold the five works she had entered, including one to the Emperor Napoleon III and another for 4,000

francs. From this time on her success was assured. Her works were much sought after and fetched very high prices. In 1859, for example, her painting *Sisters of Charity* caused a sensation and sold for 12,000 fr. A second, smaller version was sold from her solo show in London that year for 30,000 fr. This exhibition established her in England as a painter of genre scenes, often of religious subjects and using children to convey pathos. In her paintings a few figures occupy much of the space and are often posed frontally. Such characteristics, combined with unusually large scale and Browne's extreme concern for realism, resulted in imposing images markedly different for those of her contemporaries. She began to travel in the late 1850s, initially to Holland, Italy and Constantinople, which resulted in a series of Eastern subjects, extended after visits to North Africa, Egypt and Syria during the next decade to include harem scenes and oriental children. In the 1870s she began to exhibit portraits, and those of women

**Henriette Browne** *Moorish girl with parakeet*, oil on canvas, 147.3 × 91.3 cm, Russell-Cotes Art Gallery and Museum, Bournemouth. (photo: Harold Morris)

were said to be particularly successful in showing the character of the sitter. She is unusual in turning to portraits relatively late in life. This was due to the large financial rewards brought by her genre work, which meant that she never had to supplement her income in this way. An exceptional contemporary subject was *Alsace 1870*, depicting an event from the Franco-Prussian war. She was also an accomplished engraver. She continued to exhibit at the Salon until 1878, and elsewhere until 1884, her paintings still obtaining high prices, notably in England. She seems, however, to have been little involved in organisations, with the exception of the Société National des Beaux-Arts of which she was one of three women founder members in 1862. This is just one of the indications of her fame. Indeed Elizabeth Butler (*q.v.*) made a special visit to her Paris studio in 1874.

*Examples:* Russell-Cotes Mus., Bournemouth; Nat. G, London; Manchester; WAG, Liverpool.

*Literature:* H. Béraldi, *Les graveurs du 19e siècle*, Paris, 1885–92; Clement; C. Clement and L. Hutton, *Artists of the nineteenth century*, 1879; *Dict. de Biographie Française*; *Englishwoman's J*, 1860, 85–92; Krichbaum; P. Nunn, *Victorian women artists*, London, 1987; Sellars; S. Tytler, *Modern painters*, London, 1873; Yeldham.

## BROWNING, Amy Katherine (1882–1978)

*English painter of figures, landscapes, still lifes and interiors in oil, watercolour and tempera*

Born in Bedfordshire, she was one of eight children. Her parents supported her wish to study art and at the age of 18 she studied at the Royal College of Art, winning a scholarship entitling her to free tuition. From there she went to Paris, where instead of joining a class she explored *plein-air* painting on her own. The effect of sunlight upon her subjects, captured in thick, glowing paint, was the main theme of her art. She received initial recognition in France. Her first exhibit at the Paris Salon in 1912 was awarded a silver medal, while only a few years later she achieved the gold, so that afterwards she was *hors concours* at the Salon. For the duration of World War I she taught at Camberwell School of Art. She had married the portrait painter, T.C. Dugdale, in 1916 and when he returned from the war they settled in Chelsea. Later they also acquired a rural home in Suffolk, which Browning preferred. There she cultivated the garden, which she painted. With no children to affect her output, she exhibited extensively in Britain, Europe and America. Chiefly interested in colour and movement, she explored them through the medium of light, capturing carefree sunlit moments or the rich harmonies of an interior. She was made a full member of the Royal Institute of Painters in Oils in 1912, but has been largely ignored by recent critics.

*Examples:* Glasgow; Manchester; Centre Nat. d' Art Moderne, Paris; Southport; Wolverhampton.

*Literature:* A. Bury, 'AKB–painter of happiness', *Apollo*, v56, Aug. 1952, 56–8; F.G. Mories, 'Artists of note: AKB', *Artist*, v23, 1942, 116–18; Waters; *Who's Who in Art*.

## BROWNLOW, Emma. (alt. BROWNLOW KING) (1832–1905)

*English painter of domestic and continental genre*

Brownlow was the youngest of three daughters, her father John Brownlow being secretary to the Foundling Hospital in Coram Fields, St Pancras. There seems to have been no tradition of art in the family and, although she clearly drew from an early age, there is no evidence that she received any training. From 1852 she exhibited a series of paintings based on the life of the orphans in the hospital, a theme she undertook again in the 1860s on receipt of commissions from benefactors of the hospital. Later in the 1850s the first examples of scenes of continental life appear, evidence of the beginning of her considerable travels. A two-month visit to Paris and Brittany with her sister in 1863 provided her not only with sketches of subjects but also with actual examples of their costumes. She acquired a large collection to take with her to England to provide her with authentic detail, on which she relied in her work. During the 1860s her output increased, so that instead of exhibiting two or three paintings each year, as she had done in the 1850s, she regularly entered up to 12 a year in both London and the provinces. In 1867 Brownlow married a theatrical singer, Donald King, and had four children between 1869 and 1872. Despite this she continued to paint and exhibit, partly because her husband could not be relied upon in financial matters, but no evidence exists of her exhibiting after 1877. Documentation about her prices and her patrons is also lacking. King's health became uncertain in the mid-1870s

although he did not die until 1886, but from the available evidence, Nunn concludes that Brownlow gave up her art for her family's health. During the 1890s and 1890s she moved around a good deal, and with her three surviving children went to New Zealand, first in 1888 and again in 1895. After visiting her married daughter in Ceylon, they all returned to England, settling in Kent, where Brownlow died on 1 January 1905.

*Example:* Foundling Hospital, London.

*Literature:* D. Cherry, *Painting women: Victorian women artists*, Art G, Rochdale, 1987; B. Nicholson, *The treasures of the Foundling Hospital*, Oxford, 1972; P. Nunn, *Victorian women artists*, London, 1987.

## BURROUGHS, Edith. née WOODMAN (1871–1916)

*American sculptor of figures, often for fountains or statuettes, and portrait busts*

A native of Riverdale-on-Hudson, New York, Edith Woodman was prodigiously talented. At 15 she began studying at the Art Students' League, New York under Augustus Saint-Gaudens, and within three years she was able to earn her own living by teaching and carving figures for churches. Her own preference was the design of statuettes and fountains. While in England in 1893 she married Bryson Burroughs, who later became the Curator of Paintings at the Metropolitan Museum, New York. During a two-year stay in France she studied under Injalbert and Merson, and became fascinated by examples of Gothic architecture on her travels in France and Italy. Until a second visit to France in 1909, when she came under the influence of Maillol, her work was characterised by realism of the body, combined with much detail elsewhere. Subsequently she aimed at a simplification which she achieved in works such as *On the threshold* (1912), which depicts a pubescent girl in a pensive mood. In 1915 she exhibited two major commissions at the Panama-Pacific Exposition and had a solo show in New York. A memorial exhibition was held by the National Sculpture Society.

*Example:* Brookgreen Gardens, SC; Metropolitan Mus., New York; Newark, NJ; Corcoran G, Washington, DC.

*Literature:* B. Burroughs, *Sculptures by EWB*, New York, 1915; M. Hill, *The woman sculptor: Malvina Hoffmann and her contemporaries*, Berry-Hill G, New York, 1984; Proske, 1968; Rubinstein.

## BUTENSCHØN, Ragnhild (1912–)

*Norwegian figurative sculptor*

Born in Ytre Enebakk, she trained at the Oslo School of Fine Arts, Aba Noak's painting school and at the Hungarian Art Academy in Budapest. After beginning to exhibit in 1937, she took part in several competitions, gaining the prize of honour for the Roosevelt monument in Oslo. Other commissions include a figurehead for MS *Baldrian*, religious subjects for churches and schools. She has also written articles on art for the magazine *Spectrum*.

*Example:* Cathedral, Hamar.

*Literature: Illustrert Norsk Kunstnerleksikon*, Oslo, 1956.

## BUTLER, Elizabeth Southerden (Lady). née THOMPSON (1846–1933)

*English painter of military scenes*

Her birth in Lausanne to English parents characterised the dual nature of her childhood, during which the winter months were spent in Europe, mostly on the northwest coast of Italy, and the summer months in Edenbridge, Kent. Her mother was a concert pianist and singer before her marriage, as well as a capable artist. Elizabeth Thompson's younger sister was Alice Meynell, the poet, writer and critic. Rigorously educated with an unusually wide curriculum by their father, the two girls were also encouraged in art. Elizabeth soon showed talent and from her earliest sketches was interested in colour, movement, soldiers and horses. When 15, she started weekly lessons in oil painting with Standish and enrolled briefly at the South Kensington Schools, before leaving as a result of the dull and repetitive work. At 19 she attended the Female School of Art in London, having already determined to be a military painter, a type of work rare at the time in England but one associated with the prestige of history painting. While there she assiduously drew classical casts and the clothed life model, but realising the importance of anatomy for her chosen métier, she also attended life classes with the nude model at another establishment. Her training was strongly biased towards drawing. Her earliest exhibited oil paintings were of religious subjects, although she was simultaneously producing watercolours with

military themes. With her second major military oil painting, *The Roll Call*, of 1874, Thompson swept to fame. People crowded to see the work to such an extent that a rail had to be installed to protect it. She was lionised by the press, superseding Henrietta Ward (*q.v.*) as the woman artist most written about. In 1877 she married Major (later Lieutenant-General Sir) William Butler, and two years later was proposed for election to the RA. No women had been even Associate members since the eighteenth century and, although Butler lost by only two votes, she was never again proposed for membership. During the 1880s her military subjects became more controversial, in line with the unorthodox views of her husband, notably on the Irish question. Her obligations impinged increasingly on her time, as she accompanied her husband on his postings abroad and with the birth of six children, one of whom died in infancy, but she nevertheless continued to exhibit at the RA in approximately alternate years until 1905. Few of her paintings sold until the revival of interest during World War I, when her activity increased. Many of her earlier paintings had depicted historical conflicts, including the Napoleonic and Crimean wars, although *Rorke's Drift* of 1880 was one of a number of contemporary colonial wars that provided her with material. As other artists began to paint similar subjects, Butler's approach was notable for her depiction of the courage of soldiers in defeat. Far from glorifying conflict, she demonstrated the effect of it on the ordinary soldier and could be said to have restored respectability to him in the eyes of society. After the death of her husband in 1910 she continued to live in Ireland, until her castle was confiscated by the Republicans in 1922. She then lived until her death with her married daughter in Gormanston Castle, Co. Meath, and was still working in the 1920s.

*Publications: Letters from the Holy Land*, London 1903; *From sketch book and diary*, London, 1909; *An autobiography*, London, 1922.

*Examples:* Russell-Cotes Mus., Bournemouth; Bury; Hull; Leeds; Nat. Army Mus., Tate G and V & A, London; Manchester; Nottingham; Sheffield.

*Literature:* Bachmann; Clayton; Clement; *DNB*; *DWB*; G. Greer, *The Obstacle Race*, London, 1979; M. Lalumia, 'Lady ETB in the 1870s', *WAJ*, v4/1, spring-summer 1983, 9–14; W. Meynell, 'The life and work of Lady B', *Art Annual*, 1898; P. Nunn, *Victorian women artists*, London, 1987; P. Usherwood and J. Spencer-Smith, *Lady B: battle artist*, Nat. Army Mus., London, 1987; P. Usherwood,

'ETB: the consequences of marriage', *WAJ*, v9/1, spring-summer 1988, 30–4; Yeldham.

## BUTLER, Mildred Anne (1858–1941)

*Irish painter of landscapes in watercolour and oil*

Born in Kilmurry, Co. Kilkenny, she was the youngest daughter of an army officer, himself an keen amateur painter of subjects from nature. During the 1880s she studied in London with the watercolourist Paul Naftel and at the Westminster School of Art under Philip Calderon. In the summers of 1894 and 1895 she worked under Norman Garstin at Newlyn, and the influence of this period of *plein-air* painting was to be a lasting one. She then returned to her native town, where she remained, apart from visits to Europe and England, for the rest of her life. She exhibited extensively in England and Ireland from 1889 and was elected an Associate of the RWS in 1896, becoming a full member in 1937, by which time she had almost ceased painting because of arthritis. She is best known for her watercolours, which included landscapes of Europe, Irish fields with cattle and gardens full of flowers. Much of her material was observed close to her house. She was successful at selling her works, although she did not need to do so for financial reasons, and a painting by her of 1896 was the first by a woman artist to be bought by the Chantrey Bequest. In addition to having royal and aristocratic patrons, she was active in artists' societies and was one of seven women on the 12-strong executive council of the Watercolour Society of Ireland. She was also involved in the formation of Dublin's municipal gallery.

*Examples:* Belfast; Hugh Lane Municipal G and Nat. G, Dublin; Tate G, London; Portsmouth; Rochdale.

*Literature: Irish women artists*; Mallalieu; *Who's Who in Art*; Wood, 1978.

## BUTTERFIELD, Deborah (1949–)

*American sculptor who constructs horses*

Born in San Diego, she studied at the University of California, Davis for both her BA and MFA (1973), with an intervening period at the Skowhegan School of Painting and Sculpture in Maine. Her work consists of variations on the theme of the

horse in different poses and on different scales, built up from a range of materials from mud and straw to steel. The treatment is strong and heroic, avoiding the potential sentimentality of the image. Like Susan Rothenberg (*q.v.*), Butterfield regards her images as 'metamorphic self-portraits'.

*Literature:* M. Gedo, 'DB', *Arts Mag.*, Nov. 1983, 9; C. Robins, *The pluralist era*, New York, 1984; *Standing ground: sculpture by American women*, Contemporary Arts Centre, Cincinnati, 1987.

## CAHN, Miriam (1949–)

*Swiss artist producing large-scale black chalk drawings in which facture is as important as the images*

Cahn attended the Gewerbeschule in her home city of Basle from 1968 to 1973, later studying in Paris from 1978 to 1979. For some years she has been working in black chalks, blocks of which she now has specially made. The ritualistic nature of her process of making art begins with scraping the block with a knife in order to obtain a pile of chalk dust. Having transferred this to the paper laid flat on the table or the floor, she then works the dust into the paper with her hands, making marks with her fingers and adding strokes of chalk from the block. During the process she is barely able to see what she is doing through the dust and only when the surplus is removed at the end do the images become apparent. Many are female figures, or animals and children; others are of mask-like faces. Behind and around the main images a setting of indistinct plants and trees is placed but without perspective. Her choice of female figures is deliberate and reflects the influence of the women's movement. In addition, some of her works are subtitled *menstrual work*, for Cahn is conscious of a variation in her creative energies during her monthly cycle. The process she adopts, which she describes as exhausting, involves physical and mental faculties, and requires intuition and dynamism rather than calculated preparation. She now lives in West Berlin and has exhibited extensively in Europe, including the 1984 Venice Biennale and in several exhibitions where the theme has addressed gender.

*Examples:* Kupferstichkabinett, SMPK, Berlin.

*Literature:* MC: *arbeiten 1979–83*, Kunsthalle, Basle, 1983; *Das Verborgene Museum*; S. Eiblmayr, V. Export & M. Prischl-Maier, *Kunst mit Eigen-*

*Sinn: Aktuelle Kunst von Frauen*, Vienna & Munich, 1985; S. Nairne, *State of the art*, London, 1987.

## CALLENDER, Bessie. née STOUGH (1889–1951)

*American sculptor of animals*

One of a farming family from Wichita, Texas, she studied first at the Art Students' League, New York. After her marriage, she accompanied her husband, who was a foreign correspondent with the *New York Times*, to Paris. Once there she took the opportunity to work under Antoine Bourdelle at the Académie de la Grande Chaumière and then apprenticed herself to carver Georges Hilbert, an important animal sculptor, for three years. She found inspiration for her birds and animals, which she usually carved in marble or granite, in the zoo and in Egyptian art. Almost all her work dates from the period in Paris (1926–9) and London (1929–40) as she was subsequently unable to work because of recurring cancer.

*Examples:* NMAA, Washington, DC.

*Literature:* H. Callender, *Fun tomorrow: the story of an artist and a way of life*, 1953; Withers, 1979.

## CALLERY, Mary (1903–77)

*American sculptor of semi-abstract linear figures in metal*

Born in New York and brought up in Pittsburgh, Callery came from a wealthy family. Having become interested in sculpture at 12, she began to study at the Art Students' League in New York in 1921 under Edward MacCartan. Two years later she married Frederic Coudert, but continued her studies. A daughter was born and Callery was subsequently divorced. The decade from 1930 was spent in Paris, initially studying with Jacques Louchansky, under whom she produced classical figure sculpture, but later becoming part of Picasso's circle. She found the experience of seeing his works one of lasting influence. From 1934 to 1936 she was married to Carlo Frua d'Angeli of Milan. Forced to return to America in 1940, she enjoyed a succession of solo shows in New York over succeeding years. It was during the 1940s that her work acquired its distinctive open appearance, with attentuated, interweaving figures. At this time

she collaborated with the painter Fernard Léger, against whose patterned backgrounds of primary colours Callery's slender, frieze-like figures were placed. Callery believed that colour enriched sculpture. Although perhaps best known for those works in which the figure is in a delicately balanced posture, she produced a variety of work, ranging from portraits and sculpture done from a model, including acrobats, to pieces which are schematic abstractions but still imbued with dynamism. She has carried out many large architectural commissions and was asked to execute a sculpture – a mobile fountain – for the United States Pavilion at the Brussels Exposition in 1958.

*Publications:* 'The last time I saw Picasso', *Art News*, Dec. 1960, 40–4.

*Examples:* Wingate Public School, Brooklyn, New York; Public School no. 34, E 12th Street, and MOMA, New York.

*Literature:* P. Adams & C. Zervos, *MC: sculpture*, New York, 1961; Krichbaum; Mackay; Rubinstein.

## CAMERON, Shirley (1944–)

*English sculptor and performance artist*

Born in Oxford, Cameron trained at Sutton School of Art, Surrey, from 1959–62, before attending St Martin's School of Art, London for four years. She then taught art at Swansea and Camarthen colleges of art until 1972, when awards from the Arts Council enabled her to devote all her time to her art. Most of her work since then has been in the area of performance, much of which is with her partner, Roland Miller. They took part in many events in Britain and abroad during the 1970s, sometimes with Cameron's two daughters. Since 1981 she has worked with Monica Ross (*q.v.*) and Evelyn Silver as part of the Sister Seven group. Together they have worked on issues affecting aspects of women's lives, performing in town centres and factories, where they developed their events with the women workers. Cameron tries to bring art to wider audiences, as happened during the residency at Rochdale, Lancashire, and to use the performance to make women more aware of their experience in society.

*Publications:* 'Knitting performances', in G. Elinor *et al., Women and craft*, London, 1987.

*Literature:* K. Dunthorne, *Artists exhibited in*

*Wales, 1945–74*, Cardiff, 1976; Parry-Crooke; *Scale for sculpture*, Serpentine G, London, 1978; *Triple transformations*, Art G, Rochdale, 1985.

## CAMP, Sokari Douglas (1958–)

*Nigerian-born sculptor of dancers and masquerades who works in England*

Born in Buguma, Nigeria, Camp trained in California in 1978–9, before coming to England, where she studied for three years at the Central School of Art and Design and from 1983 to 1986 at postgraduate level at the Royal College of Art. During this time she won a number of awards. Her first exhibition in London took place in 1982, and since then she has participated in solo and group shows in many parts of Britain. Camp has undertaken residencies in London and Nottingham. She explores her Nigerian heritage through making images of dancers and masquerades in the Kalabari tradition of her home town, at the same time placing them in the context of Western art. However, Camp's figures are not immobile like Western sculpture but, animated by concealed motors, they move in time to drumbeats.

*Literature: Conceptual clothing*, Ikon G, Birmingham, 1987; *Sekiapu*, Africa Centre, London, 1987.

## CANTALUPO, Patrizia (1952–)

*Italian painter of elemental and symbolic landscapes and still lifes*

Born in Fivizzano, Massa-Carrara, Cantalupo lives and works in Rome, where she had her first solo show in 1979. Since then she has exhibited alone and in group shows throughout Italy and in Paris. Her paintings, although identifiable as landscape or still life, are also metaphors for varieties of human emotion, often violent and tormented and with sexual undercurrents. So *Embrace* is a travesty of the image conjured up by the title and is instead predatory and brutish. The settings are vaguely reminiscent of familiar places, but stand for states of mind.

*Literature:* R. Bonfiglioli, 'Basilea: PC', *Flash Art* (Ital. edn.) no. 114, June 1983, 72; L. Meneghelli, 'Mantova officine e ateliers 3: Casa del Mantegna', ibid. 68.

## CANZIANI, Estella (1887–1964)

*English painter of portraits, landscapes and figure subjects; also an illustrator and muralist*

She was the daughter of the painter, Louisa Starr (*q.v.*), and therefore encountered positive support in her intention of becoming an artist. After initial instruction from her mother she attended the school of Arthur Cope and Erskine Nicholl, followed by the South Kensington Schools, from where she obtained her entry to the RA Schools, winning several medals during her student days. Her mother died in 1909 and Canziani herself never married, so supported herself by her art. She therefore exhibited widely in London, Liverpool, Paris, Venice and Milan. She stayed with her Italian father's family for the preparation of her books on traditions of regions of Italy, which she wrote and illustrated. She also illustrated other books. During World War I she painted watercolours for future scientific and medical use, and also made splints and casts of unusual cases, again for future research. She was interested in applied art, and at some stage was a member of both the Arts and Crafts Society and of the Society of Mural Decorators and Painters in Tempera. She was elected an Associate of the Royal Society of British Artists in 1919 and a full member in 1930.

*Publications: Costumes, traditions and songs of Savoy*, Piedmont; *Through the Apennines and lands of the Abruzzi* (English, French and Italian eds); *Round about Three Palace Green*, London, 1939 (autobiography).

*Literature:* P. Nunn, *Canvassing*, London, 1986; *Who's Who in Art*.

## CANZIANI, L. See STARR, Louisa

## CAPPA, B. See BENEDETTA

## CARPENTER, Margaret Sarah. née GEDDES (1793–1872)

*English painter of portraits, genre and miniatures*

Margaret was the second of six children of Capt. Alexander Geddes, a cousin of the Scottish painter Andrew Geddes. She received her first lessons in drawing in her native Salisbury. Lord Radnor allowed her to copy the works in Longford Castle, and it was he who advised her to send her work to the Society of Arts in London. She was awarded a gold medal for one study of a boy's head. Again, following Radnor's suggestion, she went to London in 1814 and exhibited at the British Institution and the RA, a routine she sustained from 1818 until 1866, with totals of 147 genre pictures and landscapes at the former and 50 portraits at the latter. In 1817, whilst in London she married William Carpenter, a bookseller and publisher. During the early 1830s she also exhibited at the Society of British Artists and, much later, she sent her works to the SWA from the second year of its existence in 1858. Despite the fact that he was prosperous and that she had five children, including twins, between 1818 and 1824, Margaret Carpenter continued her pattern of working, becoming steadily better known and more highly regarded. Two of her sons and one daughter became artists and received their initial training from her. Critics were consistent in their praise for the natural and lifelike qualities of her portraits, which derived their strength from the figure itself, dispensing with accessories and backgrounds. In her own time, her portraits of women and children were renowned, but only examples of some of her male sitters can be traced today. During the peak of her career, from 1837 to 53, her works were seen as comparable to those of Van Dyck and a case was made that she should be admitted to membership of the RA. Her 'vigour' of execution was often referred to. Her portraits are unaffected and show none of that self-conscious posing which detract from both sitter and artist. Carpenter was one of the few British women to exhibit at the Paris Exposition Universelle in 1855. Her husband died in 1866. His post at the British Museum, that of Keeper of Prints and Drawings, brought her a pension of £100 a year until her death in 1872.

*Example:* National Portrait G and V & A, London.

*Literature: AJ*, Jan. 1876, p. 6 (obit.); D. Cherry, *Painting women: Victorian women artists*, Art G, Rochdale, 1987; Clayton; Clement; *DNB*; P. Nunn, *Victorian women artists*, London, 1987; W.S. Sparrow; Wood, 1978; Yeldham.

## CARPENTIER, Madeleine (1865–after 1939)

*French painter of portraits, flowers and fruit, mainly in watercolours and pastels*

Parisian by birth, Carpentier trained at the Académie Julian with Constant, Lefebvre and Bonnefoy.

At the age of 20 she began a long exhibiting career at the Salon, winning several awards, including a gold medal in 1930. She exhibited for the last time in 1939.

*Examples:* Bordeaux; Mus. de la Ville, Paris.

*Literature:* Clement; Edouard-Joseph; A. Hirsch, *Die Bildenden Künstlerinen der Neuzeit*, 1905; J. Martin, *Nos peintres et sculpteurs*, Paris, 1897; W.S. Sparrow.

## CARRINGTON. née Dora Houghton CARRINGTON (1893–1932)

*English painter of figures, landscapes and still lifes associated with the Bloomsbury group; also an illustrator and designer*

Unlike most of the women in this volume, Carrington hardly exhibited at all and ultimately sacrificed her art to the people in her life. Although a considerable body of work has been identified, an unknown amount remains lost. Born in Hereford, she was the fourth of five children of Samuel Carrington, a retired engineer in his mid-fifties, and Charlotte Houghton Carrington, who had studied art in London when younger. In 1903 the family settled in Bedford, where Carrington's teacher suggested she should pursue art. At 17 she began to study at the Slade, and as her way of seeing was naturally linear, she benefitted from the teaching of Henry Tonks and Fred Brown that placed emphasis on accurate draughtmanship. A lack of confidence in her own work persisted into maturity, and much of her artistic struggle derived from the feeling she had that her own vision would be improved by elements from the Post-Impressionists. In 1915 Carrington met the writer Lytton Strachey, one of the Bloomsbury group, and despite his age, educated background and homosexuality, she fell in love and their companionship became the dominant feature of the rest of her life. She lived with Strachey, first at Tidmarsh Mill, near Pangbourne, Berkshire, from 1917 to 1924 and then at Ham in Wiltshire. As with others in the Bloomsbury circle, relationships were not straightforward, and in 1919 she and Strachey both fell in love with Ralph Partridge, a friend of one of her brothers. He moved in to make a *ménage à trois*, and then insisted on marriage with Carrington. Despite her refusal on principle, Strachey finally persuaded her to go ahead and they were married in 1921. By the end of that year she was in love again, with writer and critic Gerald Brenan.

What she lacked in all her partners – except Brenan – was someone with whom to discuss art. Neither Strachey nor Partridge regarded her painting as important nor helped her to find the space in her life to carry it out. Nevertheless the early years at Tidmarsh and the period of her affair with Brenan were productive in terms of her painting. From her student days she had also been interested in design: she worked for Roger Fry's Omega Workshop, and afterwards undertook numerous commissions for the decoration of items of furniture for friends. She also produced woodblocks, including some for the recently established Hogarth Press. At Ham, where she undertook the whole decorative scheme, she tried her hand at other crafts, including bookbinding and tile and plate decoration. Crucially all these required less investment of time than did her painting. In the later 1920s her output of paintings diminished, partly because of the demands of craft commissions and of the people around her; but she had by then lost confidence. Both Partridge and Strachey had other attachments, and she lost that sense of security which enabled her to paint successfully. When Strachey died of cancer in 1931, her depression and introspection increased until her suicide shortly before her 39th birthday. Considering the circumstances of her life, there is a relatively large body of work, inspired by Post-Impressionism, but varied and experimental. It was only at a retrospective exhibition in 1970 that her work was seen together for the first time.

*Publications: Carrington: letters and extracts from her diaries*, D. Garnett (ed.), London, 1970.

*Literature:* N. Carrington, *C: paintings, drawings and decorations*, London, 1978; N. Carrington, *Selected letters of Mark Gertler*, London, 1965; G. Elinor, 'Vanessa Bell and DC: Bloomsbury painters', *WAJ*, v5/1, spring-summer 1984, 28–34; M. Holroyd, *Lytton Strachey: a biography*, Harmondsworth, 1971; Petersen; Vergine; Waters; J.J. Wilson, 'So you mayn't ever call me anything but C', *Massachusetts Review*, v13/1, 1972, 291–7.

## CARRINGTON, Leonora (1917–)

*English-born Surrealist painter and writer who lived in France and Mexico*

Although Carrington was born into a conservative, Roman Catholic business family in Lancashire, rebellion characterised her reaction to education and

to the high society in which she was expected to move. During a visit to Italy as a teenager she began to paint and in due course her reluctant family allowed her to study in London with Amédée Ozenfant in 1936. Fascinated by reproductions of the works of Max Ernst, she encountered him at the opening of his London exhibition in 1937. Together they returned to Paris, where they lived for the next two years. This relationship enabled her to begin painting themes drawn from childhood: elements from the Bible, Celtic myths, fairy stories, satires on aristocratic society, alchemical symbols all combined with magic and fantasy to form a whimsical narrative. Animals became an increasingly important part of her vocabulary, most notably the white horse, which had strong personal associations for Carrington through the Celtic background of her Irish mother. The motif also appears in her first published short story in 1937. She used animals to mediate between the human being and the unconscious. In the south of France on the outbreak of war, they were visited by many other Surrealists, including her friend, Léonor Fini (*q.v.*). However, when Ernst was arrested in 1940, she suffered a mental breakdown in Spain. After a series of traumatic incidents, including an encounter with Max Ernst, now with a new partner, Peggy Guggenheim, in Lisbon, she took refuge in the Mexican consulate in Madrid, where she knew one of the diplomats. She entered into a marriage of convenience with him in order to be able to obtain a passage to New York, where she arrived in 1941. Her paintings and writings from this period reflect the pain of her rejection by Ernst. In 1942 she settled in Mexico with her husband, where she came to know a number of European artists, including Remedios Varo (*q.v.*). The two women became very close and helped each other to explore ideas they shared about life as a journey of exploration on many levels. Carrington resumed painting about 1945, having her first solo show three years later in New York. Often painting in egg tempera, she sought a language in which to express her discovery of new psychic experiences. She continued to write and in due course married again and had two sons. From the 1950s she employed images of the female creator, sometimes as alchemist, in which the mundane task of cooking is transformed into a metaphor for creativity. The latter became a major theme, explored through symbols and myths, but with women at the centre. In 1962 she was commissioned to execute a large mural in the Museum of Anthropology in Mexico City, and she has had many exhibitions in her adopted country and elsewhere.

*Publications:* see *Literature* below.
*Example:* NMWA, Washington, DC.

*Literature:* Bachmann; W. Chadwick, 'LC: evolution of a feminist consciousness', *WAJ*, v7/1, spring-summer 1986, 37–42; W. Chadwick, *Women artists and the Surrealist movement*, London, 1985 (bibl. and list of publications); Fine, 1978; Heller; NMWA catalogue; Petersen.

## CASSATT, Mary Stevenson (1844–1926)

*American Impressionist painter of figures, who worked in Paris*

One of the best known of all women artists of this period, Cassatt played a role within the Impressionist movement that has only recently been reassessed. Born in Allegheny City, near Pittsburgh, she was the fourth of six children. After four years with her family in France, she returned to Philadelphia and at the age of 11 began her artistic training. She enrolled at Pennsylvania Academy in 1861 and studied there for four years. Aware of the necessity of working in Europe, like her male contemporaries, she finally persuaded her father to allow her to go to Paris in 1866. She studied privately with several artists and travelled within Europe. Two years later she was one of only two American women to exhibit at the Salon, although she did so under her middle name. By 1873 she was sufficiently established to open her own studio, but at about the same time discovered the work of Degas; 'it changed my life', she wrote. Degas too noticed her work in the 1874 Salon, and by 1877, when he invited her to exhibit with the Impressionists, her work was already too highly coloured for the Salon. Her version of Impressionism centred on the figure, presented unsentimentally. Her subjects were taken from the life of middle-class women and children around her. After her parents and invalid sister Lydia moved to Paris in 1877, the latter became her favourite model. At this crucial time in her career, Cassatt had to nurse her sister, who died in 1882, followed by her parents, but nevertheless succeeded in gaining increasing recognition. She exhibited in most of the Impressionist exhibitions, in commercial galleries where she had solo shows from 1891, and in America. She was commissioned to paint one of the two major wall-paintings for the Women's Building at the 1893 Chicago Exposition. Shortly before this she had encountered Japanese woodcuts, which had inspired her to experiment with a series of prints. These enabled her to move away from the

lively brushstroke with its sense of immediacy towards a more tranquil image. For some time she had also been encouraging her rich American friends, most notably Louisine Haveymeyer, to collect works by the Impressionists, and was instrumental in the formation of a number of important collections of these paintings. After the turn of the century she painted less frequently, but still remained an ardent supporter of women's suffrage and other radical causes. Indeed, her support for Dreyfus caused the end of her long-standing friendship with Degas.

*Examples:* Kupferstichkabinett, SMPK, Berlin; Boston; Art Inst., Chicago; Cleveland, Ohio; Newark, NJ; Metropolian Mus., New York; Philadelphia Pittsburgh; Corcoran G, Nat. G and NMWA, Washington, DC.

*Literature:* Bachmann; Clement; *Das Verborgene Museum; DWB;* Fine, 1978; Harris; Munro; *Notable American Women;* G. Pollock, *MC,* London, 1980; Rubinstein; Tufts, 1987; Weimann.

## CASSAVETTI, M. See ZAMBACO, Maria

## CASTIGLIONE-COLONNA, Duchess of. See MARCELLO

## CATLETT, Elizabeth (1915–)

*American-born figurative sculptor in wood, bronze and stone, and printmaker who is concerned with exploited groups*

Catlett's grandparents were ex-slaves and her father died before her birth, but Catlett and her brother and sister all benefited from her mother's passionate belief in education. After being rejected by the Carnegie Institute of Technology in Pittsburgh because of her race, she enrolled in 1933 at Howard University, Washington, DC, and, inspired by Diego Rivera's murals, was briefly involved in a government project. Catlett's early career was punctuated by periods of teaching followed by further study. She was the first sculpture student to gain an MFA at Iowa University in 1940. Studying ceramics at Chicago in 1941 she met and married the artist, Charles White. The move to New York brought her into contact with a group of black intellectuals in Harlem and the realisation

that she was not alone as a black artist. Nevertheless as a wife she did not receive due critical attention. Her study included a period with Zadkine, and she taught at a night school in Harlem, where the thirst for knowledge on the part of ordinary working people resulted in a decision, to which she has adhered ever since, to make her work accessible to them. In 1946 an award enabled her to visit Mexico to prepare for a series of prints and sculptures on the lives of black women. By this time her marriage was at an end, and she returned to Mexico later that year to begin teaching in the government art school and to learn the indigenous method of terracotta sculpture. In 1947 she married painter and printmaker, Francisco Mora, and had three sons. From then until 1955 her chief work was in prints, because she had neither the space nor time for sculpture. Her work in this medium was always less abstract, and her series *The Black Woman* (1946–7) imbues the basically realistic subject with her own memories and experiences, so that the result is a form of expressionism not for aesthetic reasons but from the power of her feelings. When her third son began school, she returned to sculpture, initially through woodcarving. The theme of the black woman as mother, and that of woman generally, dominated the following years and still persists. As with Henry Moore, Catlett produces variants on the motif in different materials and in styles which vary from classical to almost abstract in moods of solemnity and playfulness. In 1959 Catlett was appointed professor of sculpture at the National School of Fine Arts, later becoming head of department until her retirement in 1976. During that period she won a great many awards, but during the 1960s was declared an undesirable alien by America due to her former political connections. She became a Mexican citizen in 1963, and was allowed back into America only in 1971 after a campaign on her behalf; many exhibitions resulted. From 1966 she carried out a number of major public commissions. Her prints of the seventies contain an urgency and a sense of struggle which is reminiscent of those of Kollwitz (*q.v.*). Like this German artist she identifies with those unable to fight the system which exploits them and for Catlett these are 'blacks, Mexicans, women and poor people'. The need to serve people through her art has, if anything, intensified in the later years.

*Examples:* Mus. de Arte Moderno and Nat. Polytechnic Institute, Mexico City; New Orleans; Schomberg Center and Studio Museum, Harlem, New York; Narodni G, Prague; Howard University, Washington, DC.

*Literature:* E.C. Fax, *Seventeen black artists*, New York, 1971; T. Gouma-Peterson, 'EC: the power of uman feeling and of art', *WAJ*. v4, spring-summer 1983, 48–56; S. Lewis, *The art of EC*, Claremont, Calif., 1984; Petersen; Rubinstein; Watson-Jones; Withers, 1979.

## CAZIN, Marie. née GUILLET (1844–1924)

*French sculptor of figures and painter of rural genre, landscapes and animals*

Born in Paimboeuf, Loire Inférieure, she trained at the École de Dessin with Juliette Bonheur (*q.v.*), and then with Jean Cazin, whom she later married. Her sculptures are in bronze and stone, and for the last 30 years of the century she was one of the most prolific female genre painters in France. She selected rather picturesque details from rural life, which were well-liked. She exhibited at the Salon from 1876 to 1914, and won a gold medal at the Exposition Universelle in Paris in 1889, and a silver medal at that of 1900.

*Example:* Mus. d'Orsay, Paris.

*Literature:* Edouard-Joseph; W.S. Sparrow; Yeldham.

## CHADWICK, Helen (1953–)

*English mixed-media, installation and performance artist who often deals with the female body and autobiographical concerns*

During the years 1973–6, when she attended Brighton Polytechnic, Chadwick reacted against the fashionable norm of abstraction by producing soft small objects based on parts of the female body. These were then translated into performances which questioned and mocked stereotypical attitudes towards women and men, such as one which took place during her postgraduate year at Chelsea School of Art (1976–7), in which four performers were encased in soft sculpture reproductions of domestic appliances. A change of direction in the early 1980s resulted in part from her own experience of unemployment at a time of general recession and rapidly rising unemployment in Britain. *Model institution* was based on the interviews at the offices of the Department of Health and Social Security which all unemployed people have to submit to. Further autobiographical works followed, with explorations, in *Ego geometria sum*, of significant objects from her childhood, such as a piano, a tent, a child's shoe, all of which had contributed to the person she was at the age of 30. Her recent work has been controversial, for along with a complex use of traditional symbols, indicating the fruitfulness of maturity, the way in which the body was incorporated was open to traditional and voyeuristic interpretations. Much of the motivating force behind Chadwick's work derives from the need to confront tensions in her own life, such as the conflict between individual will and forces over which she has no control.

*Literature:* M. Althorpe-Guyton, 'HC', *Art Monthly*, no.100, Oct. 1986, 18–19; S. Eiblmayr, V. Export & M. Prischl-Maier, *Kunst mit Eigen-Sinn: Aktuelle Kunst von Frauen*, Vienna & Munich, 1985; *Of mutability: HC*, ICA, London, 1986.

## CHAMBERLAIN, Brenda (1912–71)

*Welsh painter of figures and the seashore; also a writer*

Born in Bangor, she was permanently inspired by seeing Gauguin's work when on a visit to Copenhagen in 1930. The following year she entered the RA Schools, where she studied for five years. This was almost the only period in her life when she did not live near the sea. On completion of her course, she married fellow artist John Petts and with him set up the Caseg Press in Llenllechid, in Snowdonia. She began to write poetry in 1939. A move to Bardsey Island in 1947 marked the start of a period of extensive exhibiting, both in groups (from 1948), including WIAC, and solo (from 1951). From 1961 to 1967 she lived on the Greek island of Hydra and pursued there her favourite subjects of children, fishermen, boats and objects found on the sea shore. At times these images were combined with text, with the appearance of collage but in reality all paint. In 1967 she returned to Bangor, where she continued to remain detached from fashionable styles.

*Examples:* Univ. College, Bangor; Nat. Mus. of Wales, Cardiff; Merthyr Tydfil.

*Literature:* K. Dunthorne, *Artists exhibited in Wales, 1945–74*, Cardiff, 1976; E. Rowan, *Art in Wales: an illustrated history, 1850–1980*, Cardiff, 1985; *BC: island artist*, Mostyn Art G., Llandudno,

1988; J. Piercy, 'BC: an island artist,' *WASL J.*, no.27, Feb/Mar 1989, 22–4.

## CHAMPION-METARDIER, Isabelle (1947–)

*French painter of semi-abstract expressionist works*

Her first studies were undertaken at the Ecole des Beaux-Arts in her home city of Tours, after which she attended the Ecole Nationale Supérieure at Paris until 1972. Her first solo show was held in 1977, and during the early 1980s her career acquired an international dimension, with contributions to exhibitions in several European countries. Since 1977 Champion-Métardier has produced brilliantly coloured paintings in which some elements are recognisable. Some contain figures with large birds appearing at the same time or separately. They are painted with long, sometimes jagged, brushstrokes, so that the effect is of a fantasy world where everything is in motion. A series from 1983 was entitled *Apocalypse suite*.

*Literature:* S. Eiblmayr, V. Export & M. Prischl-Maier, *Kunst mit Eigen-Sinn: Aktuelle Kunst von Frauen*, Vienna & Munich, 1985; *Künstlerinnen International 1877–1977*, Schloss Charlottenburg, Berlin, 1977; C. Millet, *Peinture en pluie*, 1977, G. Stevenson et Palluel, Paris, 1977; M. Thomas, 'Elle aime les étoiles et les soucoupes volantes: IC-M', *Beaux-Arts Magazine*, v.15, July–Aug. 1984, 68–9; A. Tronche, *Marseilles, art présent: catalogue de l'exposition de la Vieille Charité*, Marseilles, 1983.

## CHAPIN, Cornelia van Auken (1893–1972)

*American sculptor carving animals and figures directly in stone*

The daughter of wealthy parents, Chapin was born at their summer home in Waterford, Connecticut, but educated privately in New York. School visits to the Egyptian Collections at the Metropolitan Museum and frequent travel in Europe developed her awareness and knowledge of art. After pursuing various interests, including flying – for she was one of the first women to gain a pilot's licence – she decided in the early 1920s to concentrate on sculpture. She studied with Gail Corbett and was exhibiting animals at the NAD by 1930. From 1934 to 1939 she was in Paris, initially studying with Hernandez, who taught her stone carving. Pushing her block of stone and

tools in a small cart, she would often work at the zoo, developing the method of carving directly without the use of drawings. In 1936 *Tortoise*, exhibited at the Salon d'Automne, had won her election to that society, the only foreigner and the only woman so honoured that year, as well as gaining her the Anna Huntington prize from NAWA in New York. The following year at the Paris Exposition she won the second grand prize. Forced by the outbreak of war to return to New York, she shared a studio with Marion Sanford (*q.v.*) and enjoyed a series of solo shows. During the war she was a founder member of the Artists for Victory group, which tried to support artists in England. She generally depicted young animals with muscles still soft and skins smooth. The technique of direct carving precluded protruding parts and favoured the reduction to simple shapes. It also led to the retention of the individuality and sense of the living animal. Small creatures such as the frog were enlarged to reveal both the detailed formation on the skin and also the animal's character. In due course she went on to portray the human figure. Many prizes, exhibitions and election followed, including membership of both the NAD and the National Sculpture Society.

*Examples:* Brookgreen Gardens, SC; Brooklyn; Cathedral of St John the Divine, New York; Pennsylvania Academy of Fine Art, Philadelphia; Nat. Zoological Gardens, Washington, DC.

*Literature:* Archives of American Art; J. Lemp, *Women at work*, Corcoran G, Washington, DC, 1987; Mackay; Proske 1968.

## CHARRETIE, Anna Maria. née KENWELL (1819–75)

*English painter, initially of flowers and miniatures in watercolour, but later of figure subjects and portraits in oil*

A Londoner by birth, she was the daughter of an officer in the department of stamps and taxes. Her initial knowledge of drawing was gained from her ordinary schooling and was therefore somewhat rudimentary. While her obituary states that she then took lessons with Valentine Bartholomew, the flower painter, exhibiting at the RA as an amateur from 1839, Clayton implies that she was not active in art until her husband's ill-health forced her to take it up professionally about 1850. She had married Capt. John Charretie, who worked for the East India Company, in 1841. Because the

normal training was too long for her in these circumstances, she effectively taught herself by copying from paintings in the National Gallery. Here she encountered other students, including those from the RA, who helped her with advice. Clayton recounts how she received a few lessons for low fees from a woman she met there; Petteys identifies this as Anne Bartholomew (*q.v.*). In 1852 she had an oil painting accepted by the RA and went on to exhibit regularly in London, Scotland and the provinces. She showed at the SWA and through the society gained the commission for her largest work, the portraits of the children of J.D. Harris. During the 18 years her husband was an invalid and after his death in 1868, she undertook many portraits in order to provide an income. In a professional career of 23 years, she produced nearly 80 paintings. She was at her best when painting women, girls, and old china. She died unexpectedly of heart disease.

*Literature: AJ*, 1876, 12 (obit.); Clayton; Clement; D. Foskett, *Dictionary of British miniature painters*, New York, 1972; P. Nunn, *Victorian women artists*, London, 1987; Wood, 1978.

# CHASE, Marian Emma (1844–1905)

*English painter of landscapes, wild flowers and genre*

The Chase family were all artistic: Marian's father was a pupil of Constable, her mother, Mary Ann, painted watercolour landscapes and had exhibited in London until her marriage, and her sister Jessie was also an artist. Taught by her father, Marian also had the benefit of the advice of the many artists who visited their home. This proved to have its disadvantages as Marian's landscapes so closely resembled those of her father that people did not believe she had painted them. She therefore determined to adopt different subject matter, attended life-drawing classes and received lessons from Margaret Gillies (*q.v.*). However, she chiefly painted flowers, in the 1870s concentrating on wild ones. She exhibited from 1866, taking part in the Earls Court International Exhibition of 1871 and the Paris Exposition of 1889. In 1875 she was elected member of the Royal Institute of Painters in Watercolour. She spent all her life in London.

*Example:* V & A, London.

*Literature:* Clayton; *DNB*; Mallalieu; P. Nunn, *Victorian women artists*, London, 1987; W.S. Sparrow.

# CHASE-RIBOUD, Barbara Dewayne. née CHASE (1936/9–)

*American sculptor working in bronze combined with wool and silk*

Chase-Riboud benefited from parents and grandparents who were determined that she should have every opportunity. Her father's artistic ambitions had been frustrated because of his colour, while her mother was a Canadian who married young and began her own career when in her forties. Thus from the age of seven Chase-Riboud attended art classes at the museum in her native city of Philadelphia. Ten years later she won a prize offered by a magazine for a woodcut which was subsequently bought by MOMA, in New York. She studied at Temple University, Philadelphia, where she was the only black student in the art school. After some time working on a magazine she won a fellowship that enabled her to go to Rome for a year. While there she went on impulse to Egypt, staying three months and finding the experience overwhelming. On her return to America, she studied at Yale for her MFA, obtained in 1960, after which she returned to Europe. While in Paris, she met and married newspaper photographer, Marc Riboud, and had two sons. Much of the next few years were spent accompanying him, but the periods spent in the Far East were to prove decisive when she resumed sculpture in the mid-sixties. She wanted to fuse Oriental and African influences with Western ones, an ambition symptomatic of her wish to combine opposing forces, whether male/female, hard and soft textures or black/white. Wishing to execute figures of African masked dancers, she asked fibre artist Sheila Hicks to make curtains of ropes with which she could veil the legs. Thus began the combination of bronze and textile, but the hanging fibres became knotted, braided and corded, traditional techniques used on African masks. In later works the wool and silk were also cast in bronze, while retaining their characteristics. Chase-Riboud remains in Paris, but exhibits in both France and America.

*Examples:* Newark, NJ; Metropolitan Mus., Schomberg Center and MOMA, New York; Centre Nat. des Arts Contemporains and Centre Nat. d'Art Moderne, Paris.

*Literature:* C. Dover, *American Negro art*, New York, 1960; Fine, 1973; Heller; Munro; Petersen; C. Robins, *The pluralist era*, New York, 1984; Rubinstein; I. Waller, *Textile sculptures*, London, 1977; Watson-Jones.

**Ann Chernow** *Legacy*, pencil on paper, 63.4 × 94 cm, collection of the artist. (photo: courtesy of the artist)

## CHERMINOVA, M. See TOYEN

## CHERNOW, Ann (1936–)

*American painter of women derived from films of the 1930s and 1940s*

Born in New York City, she was brought up in Rochester, NY, where from the age of seven she attended children's classes at the local museum until the family moved back to New York City in 1945. Also musically gifted, she chose art rather than music as a career when she went to college. At New York University she read art education and painting, and has since maintained these two activities. During her first marriage and the arrival of two sons she continued to paint at home, having her first solo show in 1959. The women in her paintings are never alone, but the groups of people in her earlier works were smaller – three or four – whereas more recently the numbers have been larger. Their activity is based on the particular image from the film she wishes to explore.

This necessitates seeing the film several times and making preliminary drawings. After researching the costume of the period, she brings in a model who resembles to some extent the star of the film. In a series of 1982 she posited a link between a line a Nubian queens, all called Candace, and the long lists of female characters in Busby Berkeley films. Drawing attention to the many ways in which images are transmitted, she is also interested in image multiplication, so that her painting of the mid-1980s concentrate on women in crowd scenes. Since 1974 she has been associate professor and head of the art department at Norwalk Community College, Connecticut. In this capacity she has served on many panels and given guest lectures in addition to an extensive exhibiting record and the award of many prizes. She has also published several volumes of poetry.

*Examples:* Mattatuk, Conn.; New Britain, Conn.; Skopje, Yugoslavia; Utah; NMWA, Washington, DC.

*Literature:* L. Alloway, *AC*, Alex Rosenberg G, New York, 1984; *The Candace series*, Alex Rosenberg G, New York, 1982; NMWA catalogue.

## CHEVSKA, Maria (1948–)

*English figurative painter deriving imagery from her experience of being female*

A Londoner by birth, Chevska studied at Oxford Polytechnic for a year before spending 1968–72 at the Byam Shaw School of Art. Teaching part-time, she lives and works in London. Her first solo show was in 1979, and she has contributed regularly to group shows since 1981. Her work is based on the consciousness of having been brought up female in a society where this is devalued. Through her work she aims to understand herself better and hopes to communicate that insight to her spectators. She applies paint thickly in urgent, broad strokes, to depict positive images of women. The contexts are often mythical rather than realistic.

*Example:* Bolton.

*Literature:* A. Bonshek, 'Feminist romantic painting: a re-constellation', *Artists' Newsletter*, May 1985, 24–7; *Landscape, memory and desire*, Serpentine G, London, 1984; *Pandora's Box*, Arnolfini G, Bristol, 1984.

## CHEWETT, Jocelyn (1906–79)

*Canadian-born sculptor who produced figures and, later, geometrical abstract work in Ireland and Paris*

Born in Weston, Ontario, she emigrated to England with her family in 1913. In due course she attended the Slade School of Art from 1927 to 1931 and followed this with two years in Paris, where she studied with Brancusi and Zadkine. After her return to London in 1935, she married the painter Stephen Gilbert. They moved to Paris in 1938, but in 1940 went to Ireland, where they spent the rest of the war. Chewett, who exhibited with the White Stag Group in Dublin, which consisted largely of exiles from wartime Europe, was possibly the most avant-grade sculptor working in Ireland in these years. Her earlier statuettes of biblical and mythological figures became stylised to the point of abstraction, an aspect which became more evident after 1950, when she was influenced by the work of Malevich. By that time Chewett and Gilbert had settled in Paris again, and it was there that Chewett met the Belgian sculptor, Vantongerloo, contact with whom confirmed her direction towards geometrical abstraction. She first exhibited with the AIA in London

in the mid-1930s and subsequently in Paris, featuring in many post-war group exhibitions.

*Literature: Irish women artists;* Krichbaum; Mackay.

## CHICAGO, Judy. (pseud of Judy COHEN) (1939–)

*American feminist artist working in a variety of media*

One of the best known of the early feminist artists in America, Chicago belonged to a family in Chicago in which equality was taken for granted. To fellow art students in Los Angeles she seemed merely aggressive. She married writer Jerry Gerowitz in 1961, but he was killed in a road accident in 1962. As a postgraduate student, she encountered the hostility of male students towards the women there and saw the departure of many less robust than herself, but her own large, brightly coloured paintings, in which she was trying to work through her feelings about the deaths of her father and husband, were greeted with derision in an era of Minimalism. Nevertheless she gained her MFA in 1964 and married sculptor Lloyd Hamrol. She herself was turning to sculpture and began to establish to reputation as an artist, although the critics failed to see the female sexual imagery in her works, reading them as abstract. In obtaining to evolve a post at Fresno State College, she began the first feminist art course in America. The following year she joined Miriam Shapiro (*q.v.*) at California Institute of Arts, where they developed a Feminist Art Program as a separate option. The two of them used consciousness-raising sessions to make the women aware of social conditioning. With their students and several invited artists from the area, they evolved the project *Womanhouse*. Taking over a derelict house they renovated it to create rooms and environments which dealt with aspects of women in contemporary society. Criticism from the male members of staff caused Chicago to leave and set up the Feminist Art Program in Los Angeles, where the keynotes were teaching women technical skills and making them aware of women artists of the past. This led on to Chicago's next major project, *The Dinner Party* (1974–9), which eventually involved many other artists, mostly women, who came to work on the project. The triangular table contains place settings for 39 named women of achievement from the past, each with individualised needlework runner and china plate. The plates were Chicago's designs. She wanted to restore crafts traditionally associated with women to mainstream fine art. The central

core imagery of many of the plates has aroused considerable controversy, but it is an intrinsic belief of Chicago's that this is a celebration of femaleness. In subsequent works Chicago has explored spiritual and mystical aspects of creation which led to *The Birth Project*. Here needlework is again used and many women have created scenes in stitchery designed by Chicago. Following the problems of exhibiting a large-scale installation. Chicago aimed to minimise those difficulties. She has been criticised for gaining the kudos from the work of others by exhibiting both these projects under her name alone. Chicago's work, theories and personality arouse varied reactions, but she remains a highly visible artist.

*Publications: Through the flower*, New York, 1975 (autobiography); *The Dinner Party*, New York, 1979 (2 vols); *The Birth Project*, New York, 1985.

*Literature:* S. Caldwell, 'Experiencing *The Dinner Party*', *WAJ*, v1/2, fall 1980-winter 1981, 35–7, *JC: the second decade, 1973–1983*, ACA G, New York, 1984; L. Lippard, 'JC's *Dinner Party*', *Art in America*, Apr. 1980, 115–26; L. Lippard, *Get the message*, New York, 1984; C. Robins, *The pluralist era*, New York, 1984; Rubinstein; C. Snyder, 'Reading the language of *The Dinner Party*', *WAJ*, v1/2 fall 1980-winter 1981, 30–4.

## CHRYSSA. (pseud. of Vardea MAVROMICHAELI) (1933–)

*Greek-born sculptor using metal, plexiglass and neon lights who lives in America*

Born in Athens, Chryssa graduated in social studies before pursuing art in 1953 in Paris by attending the Académie de la Grande Chaumière. Not attracted by post-war European art, she studied in California in 1954–5 where she encountered the work of Jackson Pollock. Moving to New York, she almost immediately anticipated many later developments for which other artists are credited. Her casts from cardboard packing cases anticipate Minimalism, for they are blank except for the slight indentation of the letter T. As early as 1956 she made sculptures from plastic letters arranged in shallow boxes, and bronze reliefs from typefaces, thus anticipating the work of Jasper Johns. She used repeated imagery of everyday items in the way that Andy Warhol was to make famous. In 1961 she had two solo shows in New York, including one at the Guggenheim Museum. Fascinated almost to the point of obses-

sion by Times Square, she learnt how to make signs from neon lights, and was the first to use these as an integral part of the sculpture. She explored endless variations, using timers, colours, repeated forms and using light in conjunction with other clean, cool materials, which culminated in the *The Gates of Times Square* (1964–6), a three-metre pyramid construction. She has also exhibited in Europe, including Dokumenta 4 exhibition in 1968 in Kassel, and has carried out many commissions.

*Examples:* Albright-Knox G, Buffalo, NY.

*Literature:* N. Calas, 'C and Time's Magic Square', *Art International*, v6/1, Feb. 1962, 35–7; V. Campbell, 'C – some observations', *Art International*, v17/4, Apr. 1973, 28–30; Heller; S. Hunter, C, New York, 1974; P. Restany, C, New York, 1977; Rubinstein.

## CHUHAN, Jagjit (1955–)

*Indian-born painter who lives in England and produces semi-abstract works which derive their inspiration from nature*

Born in India, she was trained in England. Chuhan studied at the Slade from 1973 to 1977 and is currently based in the northwest of England, having a studio in Manchester and a teaching job at Liverpool Polytechnic. She has had a series of solo shows since 1984. Her paintings are often large and influenced by Indian culture. Images of nature, particularly from the garden of her childhood, are transformed into evocations of tropical vegetation and the cycles of the seasons by means of rhythmical sweeps of colour. The imagery of fertile nature is also intended as a parallel to female power.

*Literature: Secret spaces: paintings and drawings by JC*, Art G. Rochdale, 1986.

## CHURBERG, Fanny (1845–92)

*Finnish painter of landscapes and still lifes in bright colours and an almost Expressionistic technique*

Regarded as the first Finnish female artist of note, she was born in Vaasa, where her father was a doctor. She lost both parents by the time she was 20, but thanks to the foresight of her father she was financially independent and was able to re-

ceive tuition from Alexandra Frosterus and Emma Gylden in Helsinki, before spending 1867–8 in Düsseldorf as the pupil of Carl Ludwig. After two years working on her own and exhibiting in Helsinki, she returned to Ludwig for three further years. After 1874 she settled in her native country, but made several visits to Paris. During the 1870s her landscapes were remarkable for their broad free-handling of colours, with prominent features indicated by a few sure brushstrokes, and a reduction in detail which is remarkable in paintings of this date. They anticipate many of the developments of the Fauves and Expressionists in the early years of the twentieth century. She gave up painting about 1880 and took up journalism, becoming a founder member of an organisation that still exists seeking to promote the indigenous crafts of Finland.

*Example:* Helsinki.

*Literature:* B. von Bonsdorff, 'Finnish painting from 1840–1940', *Apollo,* May 1982, 372; *Sieben Finnische Malerinnen,* Kunsthalle, Hamburg, 1983.

## CIOBOTARU, Gillian. née WISE (1936–)

*English Constructivist sculptor of geometrical forms*

It was while studying at the Wimbledon School of Art and the Central School of Art in London from 1954 to 1959 that Ciobotaru independently encountered the theories of Biederman, an American abstract artist and theorist whose ideas were based on De Stijl and Constructivism. Through these she came into contract with the British group of Constructivists which included Anthony Hill, Victor Pasmore, and Kenneth and Mary Martin (*q.v.*). An interest in post-Bauhaus work being carried out in Europe took her to the art school at Ulm, to Holland and to Paris, where she came to understand the theosophical ideas behind the geometry of De Stijl. She began to exhibit with the British group in 1961 and contributed to shows in England and abroad. In 1968–70 two separate fellowships enabled her to make extended visits to Prague and Leningrad. At the Hayward Annual in 1978 she was one of the all-women selection group and co-ordinated the Constructivist section. Commissions include a screen for the liner *Queen Elizabeth II.* She works in a variety of materials, including steel, wood, vinyl sheets, perspex and thread. With these she produces variations on planar and linear constructions on large and small scales.

*Examples:* Eastbourne; Tate G and V & A, London; University Hospital, Nottingham.

*Literature: Hayward Annual '78,* Hayward G, London, 1978; Nottingham, 1982; Parry-Crooke.

## CITRON, Minna. née WRIGHT (1896–)

*American painter and printmaker in both figurative and abstract styles*

Born in Newark, New Jersey, Citron was married with two children before she became seriously involved in art. Living in Brooklyn, she first studied there in 1924, before proceeding to the School of Applied Design for Women (1925–7) and the Art Students' League (1928–35), both in New York. Like Isabel Bishop (*q.v.*), Citron was strongly influenced by the emphasis on technical proficiency taught by Kenneth Miller and she became one of the '14th Street School', using genre subjects from the streets around Union Square. For this period Citron tried to reconcile the demands of being a wife, mother and artist, but in 1934 she divorced her husband. She was fortunate that her studios were in the same buildings as like-minded artists, firstly in East 14th Street and then in Union Square, where Bishop also had her studio. Citron's first solo show in 1935, entitled *Feminanities,* consisted of satirical works showing the triviality of many female activities at that time. Under the New Deal, she taught painting in New York before joining the mural section in 1938, completing three large murals for post offices in Newport and Manchester, Tennessee. This project enabled her to express her broader social awareness, which led to an increasing concentration on pictorial values. This presaged her move into abstraction, although during World War II she exhibited more drawings of young women, now become responsible people enlisting for service. Her printmaking activities began in Stanley Hayter's Atelier 17 in New York during the war and she later pioneered a three-dimensional surface in her prints. She also incorporated accidental marks into her designs after working with some of the European emigrés at Hayter's. At the age of 90 she was still working every day, producing new works and recycling old ones by cutting them up for collages.

*Literature:* K. Marling & H. Harrison, *7 American women: the Depression decade,* Vassar College G, Poughkeepsie, 1976; Rubinstein.

## CLARKE, Dora (1890/5-after 1964)

*English sculptor of figures and heads in wood, stone, ivory and bronze*

Little is known about Clarke's early life, except that she was born in Harrow, Middlesex, and at the precociously early age of 15 began to study at the Slade under Henry Tonks. In the early part of her career she executed portrait busts on commission, and began exhibiting in 1916 at an increasing number of venues. Her appearances at the RA began in 1923 and continued for 36 years. At some point she married Admiral G.B. Middleton, but continued to use her own name professionally. The year 1927–8 was spent in Kenya. During this time she made many drawings from which, on her return to London, she produced many bronzes and woodcarvings, including several of African women. From that time carving became her chief technique, using mostly hard woods but also sperm-whale teeth. She was a member of WIAC, SWA and the Royal Society of British Artists.

*Examples:* Conrad Memorial Hall, Bishopsbourne, Kent; Albright-Knox G, Buffalo, NY; Manchester.

*Literature:* Deepwell; Mackay; Waters; *Who's Who in Art.*

## CLARKE-HALL, (Lady) Edna. née WAUGH (1879–1979)

*English painter of figurative subjects and flowers*

Born in Shipbourne, Kent, Edna Waugh was the tenth of 12 children in a clerical family. When in 1888 her father gave up his ministry in order to concentrate on his work for the National Society for the Prevention of Cruelty to Children, the family moved to St Albans. Edna's sketches of incidents observed here so impressed William Clarke-Hall, a barrister involved with NSPCC business, that he suggested to her parents that she should receive training in art. Accordingly she attended the Slade School of Art from 1894. Her study under Henry Tonks developed her innate drawing ability to a high level, and in 1897 she won a scholarship for a watercolour of *The rape of the Sabines.* She married William Clarke-Hall, who was 13 years her senior, in 1898 and settled first in Surrey and, from 1902, at Upminster Common in Essex, where she lived for the rest of her life. Although before their marriage William had wanted her to continue painting as before, his attitude

changed and for the next 20 years she was aware of his disapproval both of her subject matter – people and the natural world around her – and her medium. She had turned to watercolour as the ideal medium for conveying with fluidity and radiance the spontaneity of her responses to the subject. Nevertheless she exhibited at NEAC from 1899 to 1914. Two sons were born in 1905 and 1910 but she incorporated them into her routine and her paintings. After World War I a mental breakdown resulted in a psychiatrist urging William to allow Edna to practise her art with more freedom. He immediately arranged a studio for her in London, where she went three days a week. This marked the start of the second phase of her art. Now content, she experimented with print-making and, from 1924, had a series of solo shows particularly at the Redfern Gallery. A severe bout of her recurring rheumatism necessitated a winter spent in Egypt in 1926, and the many watercolours she executed there formed the basis of her 1930 London show. After William's death in 1932 she became increasingly dependent on sales of her work, but also farmed the fields around her house. During World War II her London studio was bombed and her house damaged. For the last 25 years of her life her niece lived with her. Clarke-Hall produced prints, pen and ink drawings as well as watercolours. Her best-known illustrations were those for *Wuthering Heights.*

*Examples:* Fitzwilliam Mus., Cambridge; British Mus., V & A, National G and Tate G., London; Sheffield.

*Literature:* G. Greer, *The obstacle race*, London, 1979; A. Thomas. *EC-H 1879–1979*, Graves Art G, Sheffield, 1985; *Who's Who in Art*; Wood, 1978

## CLAUDEL, Camille (1864–1943)

*French sculptor of figures*

The oldest of three children of a registrar, she was born in Fère-en-Tarenois, Aisne, although the family moved several times during her childhood. Camille, her sister Louise and her brother Paul were educated to a relatively high standard by a private tutor, but even as a child Camille loved to model in clay. Her father became aware of her precocious talent when he saw a *David and Goliath* she produced at the age of 12, but it was only after a protracted struggle that she persuaded her parents to allow her to study in Paris. Mme Claudel accordingly set up home with the three children in Paris

in 1882, while M. Claudel remained at his present post. Camille Claudel attended the Académie Colarossi, where the following year Rodin came to teach. She first exhibited at the Salon in 1883, and two years later joined Rodin's studio as an assistant, specialising particularly in the execution of works in marble, but also working on the *Gates of Hell*. She modelled for him, and they became lovers. Claudel was often accused of derivative work, a factor which caused her to change to a more classical style after 1893, and only recently has the originality of sculptures such as *The Wave* and *The Gossips* led to a revaluation of her output. Her portrait busts, figures and miniature scenes show great technical facility, most notably in the intractable materials such as onyx. Gaudichon observes four characteristics which are present in varying proportions throughout her career; naturalism, tradition, theatricality and the anecdotal, but her critical history has suffered from her proximity to Rodin. She continued to exhibit in Paris and abroad. The tension caused by Rodin's attachment to his life-long companion, Rose Beuret, resulted in Claudel breaking off her relationship in 1898 and becoming increasingly reclusive, at one stage destroying her own sculptures, until in 1913 she was confined to a mental asylum for the rest of her life.

*Example:* Mus. Rodin, Paris; NMWA, Washington, DC.

*Literature:* A. Delbée, *Une femme*, Paris, 1982; Edouard-Joseph; B. Gaudichon, M. Laurent & A. Rivière, *CC*, Mus. Rodin, Paris, 1984 (full bibl.); Heller; NMWA catalogue; R.-M. Paris, *CC*, NMWA, Washington DC, 1988; Petersen; A. Rivière, *CC*, Paris, 1984; K. Sandor, *CC – Auguste Rodin: Künstlerpaare – Künstlerfreunde. Dialogues d'artistes – resonances*, Bern & Fribourg, 1985.

## CLAUSEN, Franciska (1899–)

*Danish painter and collagist of abstract or semi-abstract works*

Since the village of Aabenraa, where Clausen was born, was then part of Germany not Denmark, her artistic training began in Weimar in 1916. It would seem that after further studies in Copenhagen, she went to Munich, where from 1921–2 she attended Hans Hofmann's school. In the latter year she settled in Berlin, and mixed in avant-garde circles, where she came to know Moholy-Nagy and El Lissitsky, who reinforced her tendency towards abstraction. At this period her paintings were either abstractions or the objective and simplified representation of objects, almost in the style of *Neue Sachlichkeit*. In 1923 she studied with Archipenko, before moving to Paris where, with a group a Swedish artists, she attended Léger's Académie Modern. Here she experimented with breaking up the image of everyday objects and letters, and in 1926 took the logical step from this to collage. This had the effect on her paintings of making almost abstract two-dimensional compositions out of the arrangement of recognisable but simplified forms, somewhat in the style of Purism. Perhaps suffering from a lack of confidence, she rejected Léger's offer of a solo show in 1928, although she had already represented Denmark at the international exhibition at the Société Anonyme in New York. In the 1930s her participation in the Circle and Square Group encouraged her abstract works, and the influence of artists like Mondrian and Sophie Taüber-Arp (*q.v.*) can be discerned. On her return to Denmark in 1932, she mixed with the Surrealist group, although she did not entirely agree with their philosophy, and exhibited in the Cubism-Surrealism exhibition in Copenhagen in 1935. Later she returned to realist portraits. In 1980 she was living in the village of her birth.

*Example:* Silkeborg.

*Literature:* Edouard-Joseph; Harris; Vergine.

## CLAXTON, Adelaide. (alt. TURNER) (1835/40-after 1900)

*English illustrator, wood engraver and watercolourist*

The younger of two artistic daughters of the oil painter Marshall Claxton, Adelaide was born in London, but spent the years 1850–58 travelling in India, Egypt and Australia with her sister Florence (*q.v.*) as their father looked for more prosperous artistic work. Apart from a few months at Carey's School of Art in London Adelaide was self-taught. Both sisters were obliged to seek employment for financial reasons and both worked in the area of designing illustrations on wood for a variety of publications. From 1862, Adelaide designed many character subjects, based particularly on situations in the upper middle and aristocratic classes. She also made ghost subjects a speciality, some of which she exhibited at the SWA. She illustrated not only books but chiefly weekly and monthly journals, including *London Society*, *Echoes*, *Period* and *Bow Bells*. For the *Illustrated Times* she

designed an important series called *Hours of the day and night in London*. She was one of the leading artists for the magazine *Judy* from its first publication. Side by side with this activity she also exhibited watercolours from 1863, which were so popular that she often had to produce several versions. In 1874 she married George Turner. The main biographical source was written in the following year, so it is difficult to determine the effect marriage had on her output. There is little trace of her exhibiting after 1876, but she continued at least some illustration work.

*Publications: A shillingsworth of sugar plums*, 1867; *Brainy odds and ends*, 1900.

*Example:* WAG, Liverpool.

*Literature:* Clayton; Mallalieu; P. Nunn, *Victorian women artists*, London, 1987; Sellars; Wood, 1978.

## CLAXTON, Florence. (alt. FARRINGTON) (1835/40–?)

*English designer and illustrator*

Older sister of Adelaide (*q.v.*), she was a pioneer in being the first women to make drawings on wood for a weekly magazine. Women who had engraved designs before her had not been employed by weeklies, with the associated conditions of 'deadlines, drudgery and nightwork'. She made her debut in the *Illustrated Times* in 1859 with a full-page illustration called *Miserable sinners*. She also contributed to *London Society* and many other journals and books. She carried out watercolour drawings, which were frequently large-sized heads of girls, and these were exhibited at the Dudley and other London galleries. Although Clayton maintains that she retired from art after her marriage in 1868, she regularly received favourable reviews of her witty sketches at the SWA into the 1870s, still under her maiden name. Indeed in 1871, she published 100 drawings under the title *The adventures of a woman in search of her rights*.

*Literature:* see under Adelaide C.

## CLOUGH, Prunella (1919–)

*English painter of abstractions based on industrial landscapes*

Clough was born in London, but her studies at the Chelsea School of Art were interrupted by

the outbreak of war in 1939 and never resumed. Working on her own during wartime clerical jobs and afterwards in East Anglia, she moved from still lifes to depicting workers in factories and lorry drivers in their cabs as an attempt to place the human figure in a modern context. By the end of the 1950s the strong structure remained, but the subject matter, although identifiable, was part of a two-dimensional arrangement on the picture plane. The figures disappeared to leave abstract paintings based on a few selected elements which were often geometrical in format. These included factory gates, wire, fences and discarded industrial gloves. She works from observation, combining parts of items seen on different occasions and absorbing the sense of the place generally, offering no moral view on the urban scene. Although initially appearing abstract her paintings occupy the very borderline between abstraction and figuration. She has exhibited consistently from the late forties in Britain and abroad, and has acquired an impressive reputation. In 1976 a retrospective was held in Edinburgh.

*Examples:* Aberdeen; Birmingham; WAG, Liverpool; Tate G and V & A, London; Manchester; Oldham; Toledo, Ohio; Wakefield.

*Literature: PC: new paintings, 1979–82*, Warwick Arts Trust, London, 1982; Krichbaum; Nottingham, 1982; Parry-Crooke.

## COE, Sue. née Susan COKE. (1951–)

*English-born painter of political themes who works in New York*

Coe trained initially at Chelsea School of Art in London from 1968 to 1971, and spent the following three years at the Royal College of Art before moving to New York in 1974. Influenced by the bitter cartoons of James Gillray, as well as by artists such as Dix, Grosz and Meidner, she produced politically informed paintings in a distorted style which is often called Neo-Expressionist. Her themes included South Africa, anti-war subjects such as Greenham Common peace camp, capitalism and oppression. The production of cartoons and illustrations for magazines and newspapers, including the *New York Times*, often provide the catalyst for her paintings. She teaches political illustration at the School of Visual Arts in New York and is a member of the People's Workshop for Art, a group of artists who assist organisations concerned with social conditions, the environment and political struggle. She is one of the few

contemporary painters whose principal and uncompromising aim is to convey a political message in her work.

*Literature:* H. Cotter, 'SC: witness', *Arts Mag.*, Apr. 1985, 124–5; *Images of labour*, Smithsonian Inst., Washington DC, 1983; E. Lucie-Smith, *The art of caricature*, London, 1982; *Women's images of men*, ICA, London, 1980.

## COKE, Dorothy Josephine (1897–1979)

*English painter and engraver of landscapes, town scenes, still lifes, animals and portraits*

Coke was the daughter of a tea exporter in Southend, Essex. She attended the Slade from 1914 to 1918, during which time she won a prize for figure composition. While she was still a student her watercolours attracted the notice of Sir Muirhead Bone, who was one of the organisers of the War Artists' scheme. He bought two of them and presented them to the Imperial War Museum. She became a member of NEAC in 1919 and exhibited with them and elsewhere in London and the provinces between the wars. In 1940 she had the unusual distinction for a woman of being appointed an official war artist and was given the task of depicting the women's services. During the war she had moved to Brighton, where she also began to teach at the College of Art, remaining until her retirement in 1963. Although trained in oils, she preferred drawing and watercolour. Landscapes dominate her subject matter. They reveal a strong sense of design within the composition. She was elected an Associate of the Royal Watercolour Society in 1935 and a full member in 1943.

*Example:* Imperial War Mus., London.

*Literature: Exhibition of paintings and drawings by some women war artists*, Imperial War Mus., London, 1958; Waters; *Who's Who in Art.*

## COLQUHOUN, Ithell, née Margaret Ithell COLQUHOUN (1906–88)

*English Surrealist artist*

Born in Shillong, Assam, Colquhoun was educated at boarding school in Cheltenham. It was not until she was 21 that she began four years of study at the Slade, which was followed by periods spent in private ateliers in Paris and Athens. In 1933 she met André Breton and Salvador Dali in Paris and assisted Dali at the International Surrealist Exhibition in London three years later. It was then that she decided to join them. She was one of those British artists who naturally inclined towards visionary art, like William Blake, but who happened to coincide with the Surrealists. Her early paintings dealt with mythological and biblical themes, but she also wanted to tap the unconscious through automatic techniques. From the late 1930s she produced a series of paintings resulting from dream-like states, such as *Scylla*, which was suggested by her own view of her body in the bath. Her exploration of fantastic plants in the 1940s was carried out using frottage, fumage and other techniques which she developed. She was clearly familiar with the ideas of the European Surrealist group, but was more critical of their attitude to women than many of the other Surrealist women artists. A number of her paintings specifically parody Surrealist eroticism, including an unambiguous reference to castration. While the British Surrealists were active, she contributed articles and poems to the *London Bulletin*. In 1943 she married Toni del Renzio, then editor of the Surrealist magazine *Arson*, but the marriage ended soon after the war finished. Her insistence on pursuing her interest in the occult led to her break with the London Group and she moved to Cornwall. There first in Lamorna and, from 1956, in a house above the sea near Newlyn, she was able to continue her experiments with form and medium. Plants continued to interest her; her home and garden housed a luxuriant collection of flora. In the 1960s she evolved collages based on discarded items and the type of work she called 'convulsive landscape'. From 1970 she incorporated imagery from the occult and alchemy into her works and designed a set of Tarot cards. Her interest in Dada and automatic techniques remained a feature of her output. Throughout the years she continued to write articles, topographical books, a novel and poetry. She had many exhibitions in Britain and abroad.

*Publications: The living stones: Cornwall*, London, 1957; *The goose of Hermogenes*, London, 1961; *Grimoire of the entangled thicket*, Stevenage, 1973.

*Examples:* Bradford; Cheltenham; Southampton.

*Literature: British women Surrealists*, Blond Fine Art, London, 1985; W. Chadwick, *Women artists and the Surrealist movement*, London, 1985; *IC: paintings and drawings, 1930–40*, Parkin G., London, 1970; *IC: Surrealism*, Orion G, Newlyn, Cornwall, 1976; G. Hedley, *Let her paint*, City Art G, Southampton, 1988; Nottingham 1982; *Salute to British Surrealism, 1930–50*, Minories G, Colchester, 1986;

*Surrealist spirit in Britain*, Whitford & Hughes G, London, 1988; Vergine.

## COMAN, Charlotte, née BUELL (1833–1924)

*American painter of landscapes who introduced
Barbizon painting to America*

Born in Waterville, New York State, she was the daughter of the owner of a tannery and shoe factory. Her early life was conventional; she married young and travelled west with her husband to share the rough lifestyle of the pioneers of a frontier town in Iowa. After a few years her husband died and she herself became almost totally deaf. Despite these tragedies, she determined to do something constructive and when nearly 40 decided to study art. Her first instruction was from the respected landscape painter, Brevoort, and she followed this with almost ten years in Europe, initially in Paris and then in Holland. Admiring the style of the *plein-air* landscape painters Corot and Daubigny, she lightened her palette and eliminated detail. By 1875 she had begun to exhibit at the NAD, and was represented at the 1876 Philadelphia Centennial Exposition. On her return to New York in the early 1880s, she set up a studio and abandoned her Barbizon subjects in favour of American landscape. Initially working in a tonalist style, she created atmospheric works usually with one predominant colour, green or blue. She continued to develop her ideas until the age of 90, her later works being broader views, with a high viewpoint and horizon, but retaining a strong poetic atmosphere. Coman was a prolific artist and exhibited extensively. She won many prizes, including three from the National Association of Women Painters and Sculptors, and was elected an Associate of the NAD in 1910. She signed her works with her initials and surname.

*Examples:* Metropolitan Mus., New York; NMAA, Washington, DC.

*Literature:* Clement; Rubinstein; W.S. Sparrow.

## COOK, Beryl (1937–)

*English so-called naive painter of people conducting everyday activities*

A completely self-taught artist, she began to paint in the early 1960s. Fascinated by the details of life around her, she portrayed everyday scenes in her native Plymouth, often capturing a humorous moment. Her style and colouring are robust while the plump figures with cyclindrical limbs are reminiscent both of Stanley Spencer and of Léger, although the sole influence to which she admits is the television cartoon characters, the Flintstones. The scale of many paintings is large, and Cook's social observation is penetrating, whether dealing with her local community or that of New York, which she visited in 1983. Her paintings are not strictly documentary but details observed on several occasions may be combined in one work. Her fondness for observing others derives in part from her admiration of flamboyance while being aware of her own inhibitions.

*Publications: The Works*, London, 1978; *Beryl Cook's New York*, London, 1985.

*Literature:* Nottingham, 1982.

## COOKE, Jean (1927–)

*English painter of figures mainly in oil*

Born in Lewisham, she trained at the Central School of Art and Craft from 1943 to 1945, and at Camberwell School of Art and Goldsmiths' College (1945–9). After setting up a pottery workshop in Sussex from 1950 to 1953, she returned to the Royal College of Art until 1955. These years at the RCA coincided with the beginning of her marriage to painter John Bratby, and two sons were born in 1956 and 1960. This was a difficult period for Cooke to cope with, for Bratby was becoming known for his 'kitchen sink' paintings, while her normally prolific output was curtailed by domestic tasks. Nevertheless she continued to paint, and exhibited at the RA and elsewhere from 1957. Her first solo show took place in 1963. In the years when her children were small she still succeeded in showing an average of three each year at the RA, but it is noticeable that after her divorce in 1966 the number of paintings she exhibited there more than doubled. She has said that although she is dependent on nature for her inspiration, she never knows how a painting will finish and allows fresh views and insights to alter the work as it proceeds. She was elected an Associate of the RA in 1965 and a full member in 1972.

*Literature:* Leicester G, London, 1964; Parry-Crooke.

## COOKESLEY, Margaret Murray
## (c. 1860–1927)

*English painter of Middle Eastern, especially Egyptian, subjects, together with portraits, genre, historical and animal themes, at times combined*

Although born in Dorset, she trained in Brussels with Leroy and Gallais, followed by a period at the South Kensington Schools, where she studied anatomy. She travelled widely and lived in Newfoundland and San Francisco. On a visit to Constantinople she obtained the commission for a portrait of the Sultan's son. This brought her many honours from the Sultan. Another portrait was of actress Ellen Terry in the role of Imogen. Among her animal pictures was *Lion tamers in the time of Nero*, for which she was awarded a medal. She exhibited actively from 1884 to 1915.

*Examples:* WAG, Liverpool; Sheffield.

*Literature:* Clement; Sellars; Waters; Wood, 1978.

## COOL, Delphine de. née FORTIN.
## (occasional pseud. Arnould de COOL)
## (1830–c. 1911)

*French painter, sculptor, lithographer and director of a women's art school*

Born in Limoges, she trained with her father and was able to work with ease in a variety of media. She exhibited regularly from 1859, at first in Paris and then additionally abroad, winning many awards, including a bronze and a silver medal in the Paris Expositions Universelles of 1878 and 1889 respectively. She also took part in the Chicago Exposition of 1893. Her earliest works consisted of miniatures and portraits, after which she developed painting on porcelain, working at the Sèvres factories from 1860 to 1870. In 1866 she published an instruction book on this technique. Her sculptures were largely portrait busts and medallions, and she was also an active lithographer. She was therefore well qualified to set up her own art school for women, which she did in 1895, one of an increasing number in Paris run by and for women.

*Publications: Traité de peinture sur porcelaine*, Paris, 1866.

*Literature:* M. Bunoust, *Quelques femmes peintres*, Paris, 1936; Clement; M. Elliott; G. Lechevallier-

Chevignard, *La manufacture nationale de Sèvres*, Paris, 1908; W.S. Sparrow; Yeldham.

## COOPER, Eileen (1953–)

*English figurative painter who depicts the female body and ideas of motherhood*

Cooper was born in Glossop, Derbyshire and studied in London, first at Goldsmiths' College (1971–4), and then at the Royal College of Art (1974–7). After a year's teaching at Falmouth School of Art, Cornwall, she settled in London. Beginning to exhibit in group shows as soon as she had completed her first degree, she has had several solo shows since 1979. From the start her paintings have dealt with the female body, but in a schematic way which removes voyeurism from the images. The emphasis is on the strong outlines and the figures, often in awkward poses, are set in psychological space, that of dreams, imagination and intense psychic states. Imagery includes acrobats, swings and ladders, but above all flying, all used as symbols of emotional states, including that of a sexual relationship. The early works show her views as positive and optimistic.

**Eileen Cooper** *Surfacing*, 1988, oil on canvas, 122 × 137 cm, private collection. (photo: courtesy Odette Gilbert Gallery, London)

After the birth of her first child her imagery reflected the experiences of pregnancy, childbirth and parenthood for father and mother and the colours became richer. There is a disregard for visual reality in favour of a reorganisation of scale, motif and symbol, so that Cooper's work provides a real alternative treatment of the female body. She also deals with the question of being a woman artist and the benefits or otherwise of also being in a sexual relationship at the same time. Like Mary Kelly (*q.v.*), Modersohn-Becker (*q.v.*) and Kollwitz (*q.v.*), she has drawn on her personal experience of being a mother and an artist to produce a powerful language.

*Literature:* M. Ball & T. Godfrey, *Figuring out the 80s*, Laing Art G, Newcastle-upon-Tyne, 1988; K. Deepwell, 'EC at Blond', *Artscribe*, July/Aug. 1985; A. Hill, 'Flying: EC', *Artscribe*, no. 41, June 1983, 20–5; E. Lucie-Smith, C. Cohen & J. Higgins, *The new British painting*, Oxford, 1988.

## COOPER, EMMA. née WREN. (1837–c. 1912)

*English painter, best known for birds and flowers*

As a child of five in Buntingford, Hertfordshire, she demonstrated a prodigious natural talent. Having had instruction only from a drawing master at school, she first took up art seriously in the mid-1860s by designing and executing a variety of presentation cards and title pages of bibles. These quickly sold, as did her first picture, which she sent to the SWA. In 1858 she had married and Clayton implies that for the next seven years she had little time to study art. This successful début had encouraged her, and she profited from advice from the artistic Coleman family, who lived nearby. Study at Heatherley's School of Art in London followed and, in the 1870s she attended life classes. In 1866 she was elected a member of the SWA, and from 1870 began to win awards from exhibitions in London and the provinces until at least 1893. She excelled at painting birds and flowers and was compared with William Henry Hunt. She taught herself miniature painting, often done on ivory, and she also painted on vellum. Cooper keenly supported higher education for women, and in order to assist others wrote a manual on the art of illumination, which went through four editions before 1875. Although Cooper's domestic circumstances are not known, the types of work she undertook would bring a secure income, and certainly in publishing this book at a low price she demonstrated an awareness that women needed to be able to make a living.

*Publications: Plain words on the art and practice of illumination*, London, 1868.

*Literature:* Clayton; Mallalieu; Wood, 1978.

## CORBAUX, Fanny. née Marie Francoise Doetter CORBAUX. (alt. Doetyer, Doetger) (1812–83)

*English painter of portraits and miniatures in oil and watercolour*

The childhood of Fanny Corbaux and her sister Louisa (*q.v.*) seems to have been spent mostly abroad. Their father was a well-known mathematician, but in 1827 disaster struck the family. Sources vary as to whether his mind failed or whether the family lost their property, but certainly at the age of 15 Fanny had to adopt some means of earning an income for the family. Her choice of art accorded with her natural talent, for in that same year the self-taught artist won the first two of many prizes. In 1830 she won a gold medal and was made an honorary member (only men could be full members) of the Society of British Artists. Later she became an elected member of the New Watercolour Society. She exhibited at both societies and from 1829 to 1854 at the RA and elsewhere. Her last exhibit was at the Exposition Universelle in Paris in 1855. The vast majority of her works were portraits and many were also miniatures. She took up this form of art because she needed to earn money quickly and regularly, for herself and her mother, who lived with her. She illustrated two books and became known for lithography after the publication in 1837 of a print of the singer Emma Albertazzi as Zerlina in Mozart's *Don Giovanni*. Indeed she tended to favour female subjects in her work. Later Corbaux took up biblical criticism, initially as a recreation, but eventually became a scholar in her own right, contributing papers to societies and journals such as the *Journal of Sacred Literature*. In 1870 she was awarded a pension of £30 a year in recognition of her researches in sacred literature and her attainments in biblical languages. She was described by a contemporary as 'small, cheerful and charming'.

*Publications:* illus. in T. Moore's *Pearls of the East*, London, 1837 and *Cousin Natalia's tales*, London, 1841.

*Example:* British Mus., London.

*Literature: Athenaeum* 1883, 192 (obit.); Clayton; *DNB*; E. Ellett, *Women artists of all ages and countries*, 1859; D. Foskett, *Dictionary of British miniature painters*, New York, 1972; Mallalieu; P. Nunn, *Victorian women artists*, London, 1987; Wood, 1978.

## CORBAUX, Louisa (1808-after 1881)

*English painter and lithographer of children and pet animals*

The older sister of Fanny Corbaux (*q.v.*), she too apparently took up art when the family's financial position demanded that she earn a living. She exhibited from 1828 to 1881 at the main London galleries. She seems not to have competed with her sister in subject matter, but her choice was of necessity limited to matters that would be popular and sell well. She wrote an instruction book for amateur painters, which must have arisen from her own experiences.

*Publications: Amateur's painting guide*, London, 1852.

*Literature:* Clayton; Mallalieu; Wood, 1978; Yeldham.

## COURIARD, Pelagia Petrovna. née VOKHINA (1848–98)

*Russian landscape painter*

Nothing is known about this artist before she trained with L.F. Lagorio in St Petersburg. She won her first award in 1876 and continued to win prizes throughout the 1880s, exhibiting in Moscow, Vienna, Berlin and the St Petersburg Academy, of which she became an honorary member in 1882. In the same year she founded the first Russian society for women artists.

*Examples:* Russian Mus., Leningrad; Tretyakov Mus., Moscow.

*Literature:* Krichbaum; *Lexikon der Frau*.

## COWAN, Judith (1954–)

*English sculptor using references to past cultures in order to confront contemporary problems*

After gaining a BA from Sheffield Polytechnic (1977) and MA from Chelsea School of Art (1978),

London-born Cowan spent a year in Italy on a Rome scholarship. Her earlier pieces reflect her encounter with Roman and Etruscan artefacts, particularly with the adoption of the traditional vessel shapes. These accorded well with her wish to produce hollow forms because they contain both public and private spaces. Inside some, disrupting expectations, she placed mythical monsters, some of which also appear on their own, at times on a smaller scale climbing over a light bulb or switch. Most of her works are made of resin and sand, which allow for smooth moulded shapes, although more recently she has sometimes added aluminium or bronze. The variety of vessel shapes she has produced include a boat in which stands the branch of a tree cast in bronze and a disconcertingly large bucket or jug. In her use of mythical and imaginary animals, such as *Blue bird-man* (1985), she produces images of considerable menace. Cowan has won several prizes and exhibited regularly since 1977.

*Example:* Town Hall, West Ham, London.

*Literature:* M.R. Beaumont, 'JC, Amanda Faulkner', *Arts Review*, Sept. 1987, 630–1; JC, Ikon G, Birmingham, 1982.

## CRIDDLE, Mary Ann. née ALABASTER (1805–80)

*English painter of literary scenes, portraits and historical subjects*

As a child in Colchester she was not allowed to draw either at school or, after her father's death when she was 13, at home. Trying to avoid the restriction she rose early, but these first efforts in oil were largely unsuccessful. Eventually her mother consented to her receiving instruction from Hayter in 1824–6, and over the next six years she won four prizes, including the first large gold medal awarded for ten years for her painting *The visit to the Astrologer*. In 1836 she married Harry Criddle; four years later her brother died and she adopted his three sons, having one of her own in 1844. Yet throughout this period she exhibited regularly at the RA and other galleries. In 1846 doctors pronounced oil paints injurious to her health. Undeterred she took lessons in watercolour painting from Sarah Setchell (*q.v.*), and in only three years was elected an Associate of the Royal Watercolour Society, in due course becoming a full member. She had many patrons from

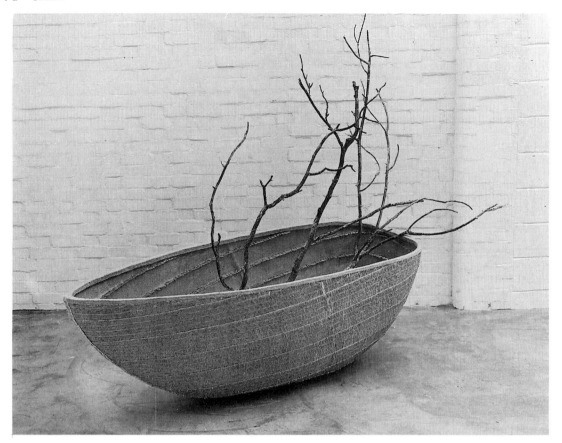

**Judith Cowan** *Brittle winds*, 1987, bronze, gum acacia pulp, sand, aluminium, 165 × 273 × 145 cm, collection of the artist.
(photo: Julian Cowan)

the nobility, and Baroness Burdett-Coutts pur-
chased several of her works. She entered a cartoon
for the competition for the decoration of the new
Houses of Parliament in 1847, and was repre-
sented by several works in the 1862 Great Exhibi-
tion at Manchester. She also exhibited in America.
Her literary subjects were based on sources such
as Milton, Tennyson, George Eliot, Shakespeare
and the New Testament, but she rarely carried
out illustrations. As a result of executing minia-
tures, she went partially blind in 1852 and was
forced to rest, but by 1854 she was painting again.
Her husband died in 1857. Her career showed
great tenacity in the face of many difficulties.

*Literature:* illustrated in A. Catlon and M. Catlon,
*The children's garden and what they made of it*,
London, 1865, Clayton; Mallalieu; Wood, 1978;
Yeldham.

## CRILE, Susan (1942–)

*American abstract painter of areas of flat colour, often
with two or more canvases conjoined*

Born in Cleveland, Ohio, Crile studied first at Ben-
nington College, Vermont, where Vincent Longo
encouraged her in colour and colour theory. While
at New York University from 1962 to 1964 she
learned from abstract artist Esteban Vicente that
the placing of shapes is crucial to the construction
of space within the painting. She began as a realist
painter, producing still lifes and interiors in which
the formal relationships were defined solely in
terms of colour. By the later 1960s the highly col-
oured oriental rugs which had been backgrounds
to the still lifes became subjects themselves and
gradually assumed abstract qualities of their own,
taking on the appearance of landscape. In 1976–7

Crile began to produce irregularly shaped canvases and to join canvases together. Initially these were of the same size, but more recently the size has varied. They may be placed end to end or at right angles. The painted areas are full of ambiguous space created by illusions of depth opening up in one sector, deliberately architectural in some works, only to be denied in another. There is a tension between the flatness of the canvas and the illusionistic recession and approach conjured up by the paint. She has exhibited in solo shows since 1971.

*Examples:* Albright-Knox G, Buffalo, NY; Brooklyn Mus. and Metropolitan Mus., New York; Carnegie Inst., Pittsburgh; Hirschhorn Mus. and Phillips Collection, Washington, DC.

*Literature:* E. Frank, 'SC: the shapes of change 1975–9', *Bennington Review*, no. 7, Apr. 1980, 46–59; E. Frank, *Movable light: SC's recent paintings*, Cleveland Center for Contemporary Art, Cleveland, Ohio, 1984; C. Langer, 'SC,' *Arts Mag.*, v62/10, summer 1988, 93; S. Langer, SC, Graham Modern G, New York, 1985 (bibl.).

## CUMMINS, Pauline (1949–)

*Irish artist who works in a variety of media, including knitting*

Cummins graduated from the National College of Art and Design in her native Dublin in 1969, having studied both painting and ceramics. Two themes have guided her work so far; one is conveying the physical and psychological well-being of which women are capable, given the right circumstances, while the other is to make her art accessible to more people. This has led her to choose different formats in which to present her work, as well as a variety of locations, rather than the traditional gallery. Her early works consisted of large, bright and loosely handled paintings of women dancing. For the first of her tape/slide productions she drew on her own experience of pregnancy and motherhood, in which she emphasised the creativity of motherhood and the physical fulfilment which pregnancy brought her. She has also endeavoured to deal with a happy sexual relationship without recourse to traditional artistic imagery, which has been evolved by men. As part of this she has knitted images into an Aran cardigan and incorporated these into another tape/slide programme. In 1987 she presented this in Boston and New York. Among her awards was a travel scholarship in 1985.

*Literature: Eye to eye*, Women Artists' Slide Library, London, 1986; *Irish women artists*.

## DADIE-ROBERG, Dagmar (1897–?)

*Swedish sculptor of figures, including nudes*

Dadie-Roberg trained in her native Stockholm with Akzap Gudjan, exhibiting there from 1925 and in Paris from 1926 in both official Salons and commerical galleries. Her portraits include a black granite head of the Princess of Martinique, while her figures are given a biblical or mythological title, including *Salome* and *Woman slave of life: Man slave of himself*. Her nude figures were said to have a firm and vigorous line.

*Literature:* Edouard-Joseph; Mackay.

## DAMON, Betsy (1940–)

*American performance artist*

A New Yorker by upbringing, Damon gained her MFA at Columbia University. In 1972 she established a Feminist Art Studio at Cornell University, Ithaca, and there began to work with students on performance art. It was not until 1975 that she carried out performances in public. In the mid-1970s she was also involved with the Women's Building in Los Angeles, and it was her experiences here which led her to a perception of time as a 'series of historical cycles'. Her involvement with the women's movement led to the performance of *The 7,000-year-old woman*, in which she celebrates women's energy over the years. The precise form of this performance varied each time, but often she would tie to herself numerous bags containing powder such as flour or sand. These would be pierced or cut off during the performance. Subsequently she continued to deal with aspects of time in the context of female myths, and all have a ritualistic form. Related pictographic drawings of mystical activities have been produced. Through raising her son, she has come to consider male experience. She has served on the editorial collective for *Heresies*, where in the issue on lesbian art and artists, she described herself as a performer, sculptor and mother.

*Literature:* Cooper; L. Lippard, *Overlay: contemporary art and the art of prehistory*, London, 1983; Roth.

## DANKO, Natalia Yakovnievna. (alt. DANKO-ALEXSEYENKO) (1892–1942)

*Soviet ceramic sculptor of figures*

Born in Tbilisi, Ukraine, Danko studied at the Stroganov Institute of Fine Arts in Moscow from an apparently very early age, attending from 1900, and then in several ateliers there and in St Petersburg. The most important of these for her future work was that of Kusnetsov, where she evolved her small ceramic figures. However, she also worked on a large scale, for between 1909 and 1914 she executed reliefs for aristocratic homes in Moscow and St Petersburg, and produced the decoration and reliefs for the Russian Pavilion at the Rome Exposition of 1910. From 1914 to 1941 she worked for the Imperial (from 1918 renamed State) Porcelain Factory, and from 1919 was the director of the sculpture workshop. From this same year she also exhibited in the Artists' Commune shows, performed in the theatre and wrote plays for a puppet theatre. She maintained the literary side of her activities, as secretary of the Leningrad poets' association in 1925, writing stories for children and the history of the porcelain factory in which she worked. Altogether she produced over 300 small figures and groups of ordinary working people in simple, bright colours, creating a fusion of folk and porcelain traditions, with perceptive social and pychological characterisations. She gave the figures a feel of great spontaneity by capturing her subjects in mid-movement. Occasionally she returned to larger-scale projects, as in 1936–7 when she designed reliefs for the underground station of Sverdlov Square in Moscow.

*Example:* State Mus. of Ceramics, Moscow.

*Literature:* Ju. Ebin, *NYD*, Moscow, 1955; W. Mandel, *Soviet women*, New York, 1975; Vergine.

## DAVIDOVA-MEDENE, Lea (1921–)

*Soviet sculptor, mainly in granite*

Primarily a portraitist, she experimented with styles in order to find the most satisfactory means of capturing the physical and psychological characteristics of the sitter. A Latvian by birth, she was awarded the title of Merited Artist of the Latvian Soviet Socialist Republic in 1966.

*Examples:* Russian Mus., Leningrad; Riga.

*Literature:* A. Baranenkova, *LD-B*, Riga, 1968; W. Mandel, *Soviet women*, New York, 1975.

## DAW, Leila (1940–)

*American environmental artist who uses mapping techniques and sky-drawing, documented in different forms*

Daw gained her BA from Wellesley College, Massachusetts, in 1962, after which she undertook additional study at the Boston Museum School of Fine Arts and the Maryland Institute. After marriage and the arrival of her children, she became a graduate teaching assistant at Washington University in St Louis, and gained her MFA in 1974. After temporary posts, in 1976 she was appointed a professor at Southern Illinois University, where she still teaches. The basis of all her work is the concept of mapping, in a literal and symbolic sense. She explores themes of travel, change and orientation in time and location. Rivers, especially the Mississippi, often appear intended both as themselves and as metaphors for the journey through life. From 1979 she has evolved sky-drawing projects, in which an agricultural aircraft, modified to emit smoke, traces a path which maps out, for example, the possible former course of a river, or invisible forces in the landscape. These projects are documented by photographs, diagrams, paintings, collages and artist's books. The paintings are unstretched canvases with images and printing, combined with veils of diaphanous cloth, strings and other material. The idea of layering in both a physical and metaphorical sense is always present. Since 1974, Daw has exhibited widely particularly in Missouri and Illinois and has had, *inter alia*, two solo shows at Soho 20, the women's gallery in New York.

*Literature:* M. King, 'St Louis; LD', *Art News*, v86/4, Apr. 1987; E. LaRose, 'LD' *Women Artists' News*, v10/4, June 1985; *Sky art '83*, Mass. Inst. of Technology, Cambridge, Mass., 1983.

## DEBILLEMONT-CHARDON, Gabrielle. née DEBILLEMONT (1860–1947)

*French pastellist and miniature painter, mainly of portraits*

The daughter of a composer, she was born in Dijon. Her early manifestation of talent was encouraged by her family and by the age of 18 she had passed the necessary examinations to become a drawing teacher. Only a few years later she became head of a drawing school in Paris. After seven years she decided to work as a freelance artist and, in the belief that she could pro-

**Gabrielle Debillemont-Chardon** *Deux vieux paysans*, 1894, watercolour on ivory, 10.2 × 14.2 cm, Walker Art Gallery, Liverpool. (photo: John Mills (Photography) Ltd)

duce better miniatures than many who made their living from this branch of art, she studied with Pommeyrac, miniature painter to Napoleon III, and Lévy. She exhibited regularly from 1877 at the Salon, winning a variety of awards. She also exhibited in England between 1897 and 1913 at the RA, the Royal Society of Miniature Painters and the Walker Art Gallery, Liverpool. She worked actively to instruct others, particularly women, running a popular atelier and publishing a treatise on miniature painting. She was deeply involved in the Union des Femmes Peintres et Sculpteurs, becoming its vice-president. Her style was more natural than was usual in miniatures and, by her work, she broadened the appeal of such painting. She introduced humble figure into miniatures as well as techniques usually thought appropriate only to larger-scale paintings. She was one of the few miniaturists whose work was bought by the state. She was elected member of the Société des Artistes Français in 1897, became president of the Société de la Miniature and Chevalier de la Légion d'honneur.

*Examples:* WAG, Liverpool; Manchester; Mus. d'Orsay, Paris.

*Literature:* Clement; Edouard-Joseph; Sellars; O. Uzanne, 'Mme D-C's miniatures', *Studio*, v48, 1910, 210–16; G.C. Williamson, *History of portrait miniatures*, 2 vols, London, 1904.

## DEHNER, Dorothy Florence (1901–)

*American abstract sculptor in bronze and wood*

Like other women artists, Dehner was overshadowed in her work by that of her husband, David Smith, and it was only after her divorce in 1950 that she was able to establish an independent reputation. Born in Cleveland, Ohio, into a family where many interests were encouraged, she was mainly involved in music and dance, and studied the latter at the University of California in Los Angeles. In 1922 she travelled to New York to study drama, but at the same time her lifelong interest in drawing moved on to the making of abstract collages. After a year spent travelling

alone in Europe in 1924–5, she returned to New York and enrolled at the Art Students' League. It was there that she met Smith, whom she married in 1927 and who then also attended classes there. Inspired by the discovery in the early 1930s of African art and the welded work of Julio Gonzales, Dehner and Smith travelled to Europe in 1935, before settling in the United States at Bolton Landing. Dehner was still producing two-dimensional figurative works, perhaps because she did not want to be seen to compete directly with her husband. After her divorce, she taught and exhibited mainly in New York for several years. On remarrying (to Ferdinand Mann) and moving to Croton-on-the-Hudson in New York State, she began working on a number of major bronzes, made by the lost-wax method, which were first exhibited in 1957. During the sixties two series of bronzes with the titles *Totem* and *Wellfleet* were completed and her achievements recognised by many solo shows and museum purchases. In the early seventies two fellowships enabled her to work in lithography, but after her husband died in 1974 she began working in a new medium, wood. Her constructed sculptures were free standing and unpainted. With her energy undiminished, she has begun in her eighties to work with yet another new material, Corten steel, while continuing with watercolours and small bronzes. Many of her pieces are basically geometrical, but with interruptions from other forms or irregularities which create unexpected, and at times mysterious, formations.

*Examples:* Boston; Cleveland; Columbus, Ind.; Storm King Art Center, Mountainville, NY; Metropolitan Mus., Public Library, and MOMA, New York; Seattle; Hirschhorn Mus., Washington, DC.

*Literature:* J. Marter, 'DD', *Arts mag.*, v53/7, Mar. 1979, 4; J. Marter 'DD' *WAJ*, v1/2, fall 1980-winter 1981, 47–50; Munro; Watson-Jones.

## DELACROIX, Pauline. née GARNIER (1863–1912)

*French painter of genre and portraits in oil and pastel*

A native of Paris, she trained with her brother Jules and her husband, Henri Eugène Delacroix. Exhibiting regularly from 1878, she won many prizes, including two medals in the 1900 Paris Exposition, one for an oil painting, the other for a watercolour. She was a member of the Société des Artistes Français and the Union des Femmes Peintres et Sculpteurs, serving as the latter's vice-president from 1894 to 1900 and carrying off its chief prize in 1885. Like many French women artists in the 1890s, she was concerned that more women should have the opportunity to earn a living, and to this end she published an instruction book on watercolour painting.

*Publications: Un cours d'aquarelle, en trois états, sans professeur.*

*Examples:* Amiens; Arras; Toulouse;

*Literature:* Clement; *Lexikon der Frau*; J. Martin, *Nos peintres et sculpteurs*, Paris, 1897.

## DELASALLE, Angele. née De JAREY (1867–after 1938)

*French painter of many subjects but particularly figures, including biblical scenes and those with wild animals, city views, and portraits*

Although there was no tradition of art in the modest French family into which she was born, she studied in her native Paris at the Académie Julian, exhibiting from 1888, and from 1895 winning a series of increasingly prestigious awards. These included a *bourse de voyage* in 1899, which enabled her to visit Holland and England. The year 1903 brought election as an Associate of the Société des Artistes Français, and in due course she became a full member not only of this but also of the Société Nationale des Beaux-Arts and, in 1926, Chevalier de la Légion d'honneur. Her work is based on careful observation of nature. Her painting *La Forge* (1910) reveals the precise depiction of the molten metal, the glow from which illuminates the whole scene, as well as the weariness of the workers. She imbued her subjects with energy and vitality to the extent that 'her sex cannot be detected in her work; in fact she was made the first and only woman member of the International Association of Painters under the impression that her pictures, signed simply "A. Delasalle", were the work of a man.' Her portraits included the celebrated mathematician Mme Clémence Royer (Nantes) and one of her teachers, Benjamin Constant. She painted views of Paris, which are made atmospheric by the treatment of light, and also of Amsterdam and London. She also produced engravings of landscapes, animals and figure subjects.

*Examples:* Bremen; Cassel; Nantes; Mus. de la Ville de Paris, Mus. d'Orsay and Petit Palais, Paris; Pau; Town Hall, Poitiers; Rouen.

*Literature:* M. Bunoust, *Quelques femmes peintres*, Paris, 1936; Clement; B. Dufernex, *Mag. of Art*, v26, 1902, 349–54; Edouard-Joseph; *Lexikon der Frau*.

## DELAUNAY, Sonia. née Sofia ILINITCHNA TERK. (alt. DELAUNAY-TERK) (1885–1979)

*Russian-born abstract painter and designer for whom colour was the most important element*

Delaunay is now one of the better-documented women artists of the twentieth century, her critical reputation having previously been neglected because of the emphasis traditional historians put on the work of her husband. Born in Gradihzhsk, Ukraine, she was adopted at the age of five by an uncle who lived in St Petersburg and whose surname she then took. From 1903 to 1905 she studied drawing in Karlsruhe, and then with four young female compatriots she went to Paris to attend the Académie de la Palette. Immediately impressed by Gauguin, Van Gogh and the Fauves, Delaunay began producing original and highly coloured paintings. In order to avoid the pressure from her family to return and marry she contracted a marriage of convenience with the eminent art dealer Wilhelm Uhde in 1909, the year after he gave her the only solo show she had before 1953. They divorced a year later so that Sonia could marry Robert Delaunay, a partnership which was mutually supportive. At this time they were both working towards a non-figurative use of colour, but whereas Robert continued to produce only easel paintings and therefore remained critically more visible, Sonia extended her explorations into a 'revitalised dialogue between art and life'. Over the years she designed sets for theatrical and ballet products, including Diaghilev's *Cleopatra*, textiles, fashions, interior décor, and posters, in addition to collages and paintings. After the birth of her son in 1911, she created an abstract design from patchwork and when the family had to move to Spain during World War I it was Sonia who contributed most to their income through her designs. She was overseeing the production of her own textiles, coats and tapestries by 1924, and some of her designs were shown at the Paris International Exposition of Decorative Arts the following year. Both Robert and Sonia were active participants in the Abstraction-Création Group in Paris during the 1930s and were commissioned to execute murals for a pavilion at the Paris World Fair of 1937. Robert died in 1941. For Sonia, whose energy for art and life continued long after this, the belated nature of the recognition of her work was not important. For her, art and life were inextricable, and she was not interested in the cult of the individual genius and personal originality. She exhibited more of her paintings in later years, and was given a retrospective in Paris in 1965. In 1975 she was awarded the Chevalier de la Légion d'honneur.

*Examples:* MOMA, New York; Centre Nat. d'Art Moderne, Paris.

*Literature: Abstraction-Création*, Mus. de la Ville de Paris, 1978; Bachmann; A. Cohen, *SD*, New York, 1975; *DWB*; J. Demase, *SD, Rythmes et couleurs*, Paris, 1971, Eng. trans. Greenwich, Conn., 1972; *L'avant-garde au féminin 1907–30*, Arcturial, Paris, 1983; J. Marter, 'Three women artists married to early modernists', *Arts Mag*, v54, Sept. 1979, 88–95; Petersen; C. Rendell, 'SD and the expanding definition of art', *WAJ*, v4/1, spring-summer 1983, 35–8; *Rétrospective SD*, Centre Nat. de l'Art Moderne, Paris, 1967; *Russian women artists of the avant-garde*, G Gmurzynska, Cologne, 1979; Vergine.

## DELISSA JOSEPH, L. see JOSEPH, Lily.

## DEMONT-BRETON, Virginie Elodie. née BRETON (1859–1935)

*French painter of rustic life, especially that of a fishing community, but also of portraits, historical and religious scenes; a vigorous campaigner for women artists*

She was one of three children of painter Jules Breton, and was born at Courrières, Pas-de-Calais. Her artistic pedigree was considerable, for three uncles and four cousins (including three women) were all distinguished artists. Like her siblings she drew from an early age, but from 13 her father began a steady course of training. Rosa Bonheur (*q.v.*) was presented to her as a role model. In 1873 she produced the first of a series of still-life paintings, graduating to figure subjects in 1876. In 1880 she married one of her father's pupils, Adrien Demont, and moved to Montgéron. In the same year she began exhibiting at the Salon and obtained the first of many awards she was to receive during her exhibiting career, which extended to 1934. From 1883 she was placed *hors*

*concours.* That year also brought a gold medal from the world exhibition in Amsterdam. About this time she and her husband spent the summers at Wissant, a small fishing village in Normandy, where in 1891 they were to build a house. It was here that she found the inspiration for many of her works. Her main subjects were women and children; but unlike the naturalism with which Elizabeth Forbes (*q.v.*) transcribed the fishing community in Newlyn, Demont-Breton made her women more noble and heroic in stature, even when engaged in everyday tasks. In the 1890s her subject matter became broader as she produced historical and religious subjects. The latter consisted both of biblical events and of themes endowed with religious symbolism. In the 1880s she became actively involved with women's art education, contributing to the Union des Femmes Peintres et Sculpteurs from 1887 and receiving many women artists at her studio. She worked hard to obtain the entry of women into the École Nationale des Beaux-Arts and to make them eligible for the prestigious Prix de Rome. She became the second president of the UFPS in 1894 and remained in office for at least ten years. In 1904 Clement listed a formidable number of other organisations with which Demont-Breton was involved; member and honorary president of the Alliance féminin, and the Alliance septentrionale; member of the Société des Artistes Français and the Verein der Schriftsellerin und Kunstlerinnen, Vienna; committee member of the Central Union of Decorative Art at the American National Institute; founder member of the Sociéte populaire des Beaux-Arts and de Bienfaisance de l'Allaitement maternel. By 1930 further societies are mentioned, two of them reflecting her other activities as a writer and poet. From the mid-1890s she began to achieve wide recognition and accumulate a variety of honours including that of Officier (later promoted to Chevalier) de la Légion d'honneur in 1894. She increasingly exhibited abroad, including the 1893 Chicago Exposition, and many of her works were purchased by private collectors in America. Two daughters were born in 1886 and 1888, the younger – Adrienne – herself becoming a well-known artist, and a third in 1901. She divided her time between Montgéron and Wissant, where she died seven years after her husband. A measure of her success is given by the fact that her works fetched between 10,000 and 25,000 fr. in 1930.

*Publications: Les maisons que i'ai connues,* 4 vols, Paris, 1926 (autobiography).

*Examples:* Amiens; Anver; Arras; Berlin; Boulogne; Douai; Dunkirk; Ghent; Lille; Minneapolis; Mus. d'Orsay, Paris.

*Literature:* Clement; *Dict. de Biographie Française;* Edouard-Joseph; M. Elliott; T. Garb, '*L'art féminin*: the formation of a critical category in late nineteenth century France', *Art History,* v12/1, March 1989, 39–65; A. Hirsch, *Die Bildenden Kunstlerinnen der Neuzeit,* 1905; Krichbaum; J. Martin, *Nos peintres et sculpteurs,* Paris, 1897; E. Montrosier, *Les artistes modernes,* Paris, 1881–4; W.S. Sparrow; Weimann; Yeldham.

## DEWING, Maria Richards. née OAKEY (1845–1927)

*American painter of flowers and still life*

Dewing was the fifth of ten children born in New York. Her father was an importer, while her mother was a well travelled and educated woman who had mixed in fashionable circles in America and London, and who wrote articles for periodicals. Growing up in such an intellectual atmosphere, Maria Oakey first intended to be a writer, but at the age of 17 turned to painting. After her mother and sister had gained her father's approval, she studied at the Cooper Union School of Design for Women in New York from 1866, and from 1871 to 1875 attended the Antique School of the National Academy of Fine Arts. At the end of that period she took part in the formation of the Art Students' League, where she was already attracting attention for her use of rich colour and broad, energetic brushstrokes. During the 1870s she produced mainly figurative works, including portraits, in oil and watercolour. After her marriage to the figure painter, Thomas Dewing, in 1881, and the birth of a daughter in 1885, she turned increasingly to still life. No doubt this was partly for practical reasons, as she no longer had long uninterrrupted periods in which to work, but also resulted from a wish not to compete with her husband, already known as an outstanding figure painter. Many of her outdoor flower paintings were executed at their summer home in New Hampshire between 1885 and 1903, an environment which she seems to have found particularly inspiring. She became a keen gardener and studied each plant in great detail, although she avoided precise depiction and veered towards an impressionistic style, which she seems to have developed independently of foreign influence. Devices she

employed to great effect were the close-up view looking up at a plant, and the tilting up of the flower to fill the picture plane, with depth implied through the overlapping of forms. Her familiarity with oriental art is revealed through her asymmetrical compositions and cropping of the image. Highly regarded by her contemporaries, she won a medal at the 1893 Chicago Exposition and the 1901 Pan-American Exposition, and solo shows were held at the Pennsylvania Academy in 1907 and Knoedlers in 1914. Despite her success, at the end of her life she regretted having abandoned figure painting.

*Publications:* As MO, *From attic to cellar; a book for young housekeepers*, 1879; as MOD, *Beauty in Dress*, 1881; *Beauty in the household*, 1882.

*Examples:* NMAA, Washington, DC.

*Literature:* J. Martin, 'The rediscovery of MOD', *FAJ*, v5, summer 1976, 24–7, 44; J. Martin, 'Portraits of flowers; the out-of-door still-life paintings of MOD', *American Art Review*, v4, Dec. 1977, 114–8; Rubinstein; Withers, 1979.

## DICKSEE, Margaret Isabel (1858–1903)

*English painter of historical and domestic genre*

She was one of three artist children of Thomas F. Dicksee, who painted portraits and historical genre. After initial training with her father, she entered the RA Schools at the same time as Stanhope Forbes, La Thangue, Alfred Gilbert, Ernest Normand and Henrietta Rae (*q.v.*). Because at that time the RA Schools did not allow women access to the undraped model, Margaret Dicksee took the initiative in remedying this deficiency. She proposed to the other students that they should set up a life-class of their own on co-operative principles. This was enthusiastically agreed to and was run in the evenings in the studio of her brother Frank in Fitzroy Square. She exhibited from 1881 in the main London galleries, including the RA. In 1892 she revealed knowledge of an earlier woman artist by depicting the introduction of Sir Joshua Reynolds to Angelica Kauffman, one of the other co-founders of the RA. This was one of several paintings in which she depicted incidents from the lives of famous artists.

*Literature:* *AJ*, v49, 1897, 55, 65, 82; *AJ*, 1903, 370 (obit.); A. Fish, *Henrietta Rae*, London, 1906; *Lexikon der Frau*; W.S. Sparrow.

## DIEHN, Kate. née BITT (1900–)

*German figurative artist working within the tenets of Neue Sachlichkeit*

Born in Berlin, she was already receiving drawing instruction by the age of 14. Married to a dentist in 1919, she undertook further study at the Dresden School of Art from 1929 to 1931 and independently with a pupil of Kokoschka. The regrouping of the art section of the German Socialist party took place at this time, and she contributed to their exhibitions until they were banned by the Nazis. Her charcoal drawings from this period are stark objective studies of heads. Even with full-length figures, the emphasis is on the expressionless faces. After the war she was one of the founder members of the Plastic Arts division of the Cultural Association for the German Democratic Renaissance. She has had many exhibitions and in 1980 was still living in Rostock.

*Literature:* Vergine.

## DIENES, Sari. née CHYLINSKA (1898–)

*Hungarian-born mixed-media artist working in America*

Although born in Debrocen, Hungary, she was brought up in Budapest, where she first trained as a concert pianist until she was diagnosed as suffering from tuberculosis and a less strenuous career was advised. She studied art in Paris with Léger and Lhote and, after her marriage to Paul Dienes, a mathematician and poet, she continued her studies with Henry Moore while living in London. At one stage she was also assistant director of Ozenfant's Academy in New York, an activity she continued when the outbreak of war forced her to remain in America; she also taught at other New York art schools. Her early figurative paintings soon became Surrealist biomorphic forms. Her first solo show took place in 1942 and many others followed. Publicity in the mid-1950s about her new method of carrying out gravestone rubbings using inks and rollers led to a commission to preserve some prehistoric Indian carvings by the Columbia River. In her art she used this technique to make rubbings of Manhattan pavements, walls and manhole covers. After a fire destroyed much of the work in her studio, Dienes spent most of 1957–8 in Japan, where she studied woodblock printing and also became fascinated by Zen philosophy. Since then she has worked indepen-

dently of all fashions, but an underlying factor is the unifying of random phenomena; in this respect she acknowledges her debt to Marcel Duchamp. She has produced assemblages, including work in boxes, made from all kinds of discarded items; as well as ceramics and readymades, she has created environments. These included the garden around her studio at Stoney Point, New York, where she has made a rock river, a bottle stream and striped-earth mounds. She is also a poet, and a member of the women's co-operative gallery in New York, AIR.

*Literature:* J. Arbeiter, 'Chance and change in the art of SD', *WAJ*, v7/2, fall 1986-winter 1987, 27–31; K. Chambers, 'SD: in celebration of change', *Craft Horizons*, Apr.–June 1964, 19–22; C. Miodoni, 'The natural order of things; SD', *Women Artists' News*, v8, fall 1982, 18–19; Munro; *Out of context*, Thorpe Intermedia Center, Starkhill, NY, 1986; M.C. Richards, 'The bottle gardens of SD', *Craft Horizons*, v22, Sept.–Oct. 1962, 24–5.

## DIETRICHSON, Mathilde. née Johanne Mathilde BONNEVIE. (alt. BONNEIR) (1837–1921)

*Norwegian painter of genre, portraits and landscape*

Born in Kristiania, she was first taught by David Arnesen there before studying for four years (1857–61) in Düsseldorf with Mengelberg and Tidemand. In 1862 she married the art historian and author Lorentz Dietrichson, by whom she had one child. They travelled extensively in Europe, and Mathilde undertook further studies as they went: in Rome (1862–5), Stockholm (1866–75), where she studied at the Royal Academy, Germany where she studied in Berlin, as well as Paris and Munich. She exhibited her sentimental and humorous paintings in Norway and other European countries, and contributed to the Paris Exposition of 1878. During the 1880s and 1890s the family visited the Far East and travelled again in Europe. In the 1880s she tried to renew her art by closer attention to realism and exhibited many scenes from her journeys.

*Examples:* Gothenburg; Nat. G, Bymuseum and Kunstindustrimus, Oslo; Stockholm.

*Literature:* Clement; A. Wichstrom, *Kvinner ved staffeliet*, Oslo, 1983.

## .DISKA. (pseud. of Patricia DISKA) (1924–)

*American-born sculptor in stone who works in France*

Born in New York, Diska graduated in economics from Vassar College in 1944. At the end of the war she travelled to Paris as a research assistant for a relief organisation, but she began devoting her spare time to drawing by the Seine, and in 1947 decided to become a sculptor. She trained at the Académie Julian with Joseph Rivière. From the beginning she has produced large-scale sculptures by carving directly onto the stone, for she finds the hardness of the material imposes a vigour and a discipline. The pieces are abstract, some with geometrical elements, some totems, but predominantly they are irregular natural forms which may resemble things organic or geological. The majority of them are site-specific and many have been acquired for schools in France. Some of these have been specifically conceived for the pupils to play with, thus breaking down the idea of the inaccessibility of modern art. Her daughter was born in 1967, and in 1969 she settled in Lacoste, Vaucluse. By executing her works *in situ* using local stone, she avoided many of the practical problems and expenses associated with sculpture. However, in the mid-1980s an injury forced her to abandon this in favour of metal sculpture as her main working medium. In 1985 she was commissioned to carry out a monument to the Resistance at Saint-Ouen. She has exhibited widely in France and abroad, and has taken part in many international sculpture seminars.

*Examples:* Sculpture garden, Chateauvert, Var; Palm Springs, Calif.; Mus. en Plein-Air, Paris; Mus. d'Art et d'Industrie, Saint-Etienne; public gardens, Vitry-sur-Seine.

*Literature:* M. Hichisson, 'PD: sculptress', *Architectural Ass. J.*, v80, no. 892, May 1965, 336–7; Krichbaum; Watson-Jones.

## DISMORR, Jessica Stewart (1885–1939)

*English painter of abstract works who was associated with Vorticism*

Dismorr was born in Gravesend, Kent, but her family moved to Hampstead during the early 1890s. She trained at the Slade in 1902–3, and some time afterwards (*c.* 1905–8) became a pupil of Max Bohm. She spent the first of several long periods in Paris from 1910 to 1913, during which time she attended the Académie de la Palette, where she was taught by Metzinger, J-E. Blanche

and Fergusson. At the same time she produced the illustrations for the magazine *Rhythm* in 1911, and began exhibiting in both London and Paris in 1912. She encountered Percy Whyndham Lewis in 1913, and when she returned to England she joined the group which met at the Rebel Art Centre in London. This group was founded in 1914 by Lewis but failed due to his lack of business sense. She was a signatory of the Vorticist manifesto, which appeared along with reproductions of members' work in the first issue of *Blast*, through which the group hoped to shake the British public out of their conservative views on art. As well as undertaking voluntary service in France during World War I, she was represented at all the key Vorticist events: the 1915 exhibition, the second issue of *Blast* (July 1915) and the Vorticist exhibition in New York in 1917. Her works from this time are highly coloured and semi-abstract, with strong geometrical tendencies typical of the Vorticists. After the war she continued to publish poems and articles. Elected a member of the London Group and the 7 & 5 Society in 1925, she was one of the few English painters in the 1930s to evolve a completely abstract style. In 1937 she exhibited with the Allied Artists' Association in

**Jessica Dismorr** *Woman in a pink dress*, oil on gesso, private collection. (photo: courtesy Mercury Gallery, London)

their abstract show. Three retrospectives have been held since her death.

*Literature:* R. Cork, *Theory and design in the first machine age*, 2 vols, London and Bedford, 1975; Deepwell; Vergine.

## DONAGH, Rita (1939–)

*English painter of formal, restrained but ultimately political works*

Although born in Wednesbury, Staffordshire, Donagh has Irish ancestry, and this factor became the catalyst for many works in the 1970s based on the conflict in Northern Ireland during those years. She had spent six years (1956–62) at King's College, Durham University (later the University of Newcastle-upon-Tyne) and at the age of 25 became a full-time lecturer at Reading University. Since 1973 she has lectured part-time at both the Slade and Goldsmiths' College. Although she had exhibited in the late 1950s, her appearance at the John Moores' exhibition at Liverpool in 1972 and a solo show the same year really mark the start of her mature career. Her works appear austere, with a restrained use of colour and thinly painted. They evolve gradually through many preparatory works, and in this process acquire several layers of meaning, referring not simply to one violent incident. The canvas is often partitioned into distinct, but geometrical areas in which the more definite image – for example, a body shrouded in newspapers on a pavement – is echoed by a different, often almost an outline, treatment of the shape in another area of the canvas. Characteristic too are dots or lines, which function compositionally, but are never arbitrary, deriving from a variety of related information. Yet this restraint conceals the strong feelings which motivate the artist and which are an essential prerequisite to her working process. 'My interest is in the idea and my work is an offshoot from the pursuit of that idea.' She has exhibited widely in Britain and abroad.

*Literature: Hayward Annual '78*, Hayward G, London 1978; Nottingham, 1982; Parry-Crooke.

## DONAS, Marthe. (alt. TOUR-DONAS; TOUR-D'ONASKY) (1885–1967)

*Belgian painter of Cubist and then abstract works*

Donas first trained at the Academy in her native city of Antwerp. She escaped from the German

invasion in 1914 by travelling first to Ireland, where she studied stained glass techniques, and then in 1916 to Paris. There she was influenced by Cubism and after working with Lhote and Archipenko became a member of the Section D'Or group of Cubist artists in 1919. Through exhibiting with them she met Herwath Walden, founder of the Der Sturm Gallery, and supporter of modern art, who purchased several of her paintings and gave her a solo show in Berlin in 1920. Of all the male Cubist artists, her version of Cubism is closest to that of Juan Gris, in the way the objects are seen from different angles within stongly differentiated planes. By 1921 she was verging on abstraction, despite titles such as *Dancer*. From that year she contributed regularly to Katherine Dreier's (*q.v.*) Société Anonyme in New York and her works, influenced by De Stijl, became abstract. She apparently ceased painting in 1927 for 20 years. Her contribution to Cubism has never been fully assessed.

*Literature:* Edouard-Joseph; Krichbaum; Petersen; Schurr; Vergine.

## DOWNING, Edith E. (1857–after 1910)

*Welsh sculptor of reliefs, statuettes, figure groups and portrait busts*

Born in Cardiff, she studied at the South Kensington School under Lanteri, continuing her training at the Slade and in Paris. She settled in London and exhibited from 1890 to 1910 in London, Glasgow, Liverpool and Paris. Apart from portrait busts, her subjects were chiefly religious and allegorical, with titles like *Music sent up to God* (bronze, 1897), *Childhood and motherhood* (bronze, 1905) and *St Cecilia* (relief, 1910). Her chief work was a marble altarpiece with 32 alabaster figures, made for a church in Worinbridge, Hereford.

*Literature:* Clement; Krichbaum; *Lexikon der Frau*; Mackay.

## DREIER, Katherine Sophie (1877–1952)

*American painter, patron and promoter of modern art*

In comparison with Alfred Steiglitz' promotion of European and American modernist art at his 291 Gallery in New York, Dreier's tireless activity for the same cause through the founding of the Société Anonyme has been ignored. The fifth surviving child and youngest daughter of socially prominent German-born parents who lived in Brooklyn, Dreier had the advantages of wealth tempered by awareness of the social responsibility which that entailed. The Dreiers were a close-knit family and all were highly educated and encouraged to be independent and ambitious. Dreier began a weekly art class when 12 and attended the Art Students' League from 1895 to 1897. Soon after this both her parents died, but all the children were left financially secure. For the next 15 or 20 years Dreier's intention of becoming a painter ran parallel with service in several charities; and together with her sisters she was also increasingly active in the suffrage campaign. In 1900 she joined her sister Dorothea as a student at the Pratt Institute in New York and in 1902–3 they travelled together to Europe to visit museums. On her return she began to study with Walter Shirlaw, and in 1905 her first commission, an altarpiece, was installed. She subsequently studied with Collin Paris in 1907 and two years later moved to London where she settled in Chelsea. While there she met Edward Trumbull, also an artist, but their marriage in Brooklyn in 1911 was soon annulled on the grounds of Trumbull's bigamy. A further year spent in Europe in 1911–12 encompassed a solo show in London, a tour of Germany and study in Munich with Britsch, whom she regarded as her most formative teacher. On her return to New York Dreier exhibited two paintings in the Armory Show of 1913 and was so impressed by the liveliness of the modern art she saw she decided to work for its promotion in America. She began a co-operative mural worshop in the Morris-Ruskin tradition, and was a co-founder of the Society of Independent Artists. This brought her into contact with the New York Dadaists, including Marcel Duchamp, with whom she remained close friends until her death. Together they determined to found an organisation for 'the promotion of the study in America of the progressive in art'. In April 1920 the Société Anonyme opened its doors at 19 East 47th Street and effectively became the first museum of modern art in America. Not only did it introduce over 70 European artists to America, but it also sent out travelling exhibitions throughout America and sponsored lectures, conferences and publications. Advised by Duchamp, Dreier also purchased works of art for a permanent collection which was given to Yale University in 1941. In her own painting, Dreier was working in a nonobjective style by 1918, the year of her psychological protrait of Duchamp, in which each shape and colour was chosen to embody different as-

pects of his personality. She believed that art should have a spiritual meaning, and many of her works show 'free-hand geometric patterns set in backgrounds of colour perspective and interwoven in the general framing of the abstract theme' (Duchamp). Like Kandinsky, she saw music as a parallel to abstract art, and an exhibition of her *Variations* was held at the Annot (*q.v.*) School in Germany in 1935, two years after a New York retrospective. After the Wall Street crash in 1929 her funds were much more limited and she moved to a house in Reading, Connecticut and resumed her painting, spending most of 1930–3 in Paris, where she belonged to the Abstraction-Création group. Unable to retire completely, she continued to promote a variety of activities, including an exhibition of 13 women artists in 1934–5, and herself undertook lectures, correspondence and writing, despite a debilitating illness which troubled her for the last ten years of her life. It is her achievements in the promotion of modern art that are her most enduring legacy.

*Publications:* See below under *Literature*.

*Examples:* MOMA, New York; University of Yale.

*Literature:* R. Bohan, 'KSD and New York Dada', *Arts Mag*, v51/9, May 1977, 97–101; *The Collection of the Société Anonyme*, Yale University Art G, New Haven, 1950 (lists Dreier's publications and exhibitions); *Notable American women*, v4 (bibl.); Rubinstein; A. Saarinen, *The proud possessors*, New York, 1958; Tufts, 1987.

## DREXLER, Rosalyn (1926–)

*American painter of Pop Art in the 1960s*

Coming to painting via the unusual route of wrestling, Drexler presented contemporary subjects showing people in action. She depicted them in a flat, commercial style with strongly contrasting colours based on the format of the news photograph, but the plain backgrounds create a sense of isolation, her comment on society at the time. Figures of authority are made to appear foolish. From 1962 Drexler had many solo shows but in the 1970s she turned to writing and film criticism. Her work begins to redress the balance of male artists who predominate in Pop art but has been given insufficient attention.

*Example:* Hirschhorn Mus., Washington, DC.

*Literature:* D. Bourdon, 'A bout with RD', *Village Voice*, 6 May 1965; Withers, 1979.

## DRIGGS, Elsie (1898–)

*American painter and maker of mixed-media constructions, known principally for her Precisionist paintings*

Born in Hartford, Connecticut, Driggs trained at the Art Students' League, New York, from 1919 to 1925 and then in Rome with Maurice Sterne. On her return to America she enthusiastically joined the depiction of modern American life and produced canvases of industrial and urban landscape. Like other contemporaries she used the image of the bridge, in her case *Queensborough Bridge* (1927), to represent modern America. In *Pittsburgh* the blast furnace dominates the scene. Although chiefly known for this work, Driggs has continued as an active artist ever since. In the 1930s her work became figurative, and about 1937 she executed a mural for a Louisiana post office. She married artist Lee Gatch and, having no studio in the 1940s and 1950s, she turned to collage. She found herself in that position familar to many women artists of having to work in her kitchen and had to change medium in order to maintain any continuity of work. Still working in her eighties, she made mixed-media constructions, combining painting, drawing, found objects and photographs.

*Example:* Whitney Mus., New York.

*Literature:* M. Friedman, *The Precisionist view in American art*, Walker Art Center, Minneapolis, 1960; J. Loughery, 'Blending the classical and the modern: the art of ED', *WAJ*, v7/2, fall 1986-winter 1987, 22–6; Rubinstein; S. Yeh, 'ED', *Arts Mag.* v54, May 1980, 3.

## DRINKER, Catharine Ann. (alt. JANVIER) (1841–1922)

*American painter and illustrator of biblical, mythological and historical scenes, who was an important teacher of art*

Although born in Philadelphia, she was brought up in the Far East, where her father became a merchant. At his death in 1857, the family returned to America, Drinker herself taking over command of the ship at one point because the captain was drunk. (She had been trained in navigation by her father, a former sea captain.) Only a year later her mother died and Drinker was forced to provide for her brother, sister and grandmother. While running her mother's school, she began to

study at the Maryland Institute. She then moved to Philadelphia, where she again taught in a girls' school while studying, this time at the Pennsylvania Academy under the Dutch painter Van der Whelen and Thomas Eakins. While there she wrote to the governing body requesting a life-drawing class for serious women students. She was related to Cecilia Beaux (*q.v.*), who studied with Drinker at the beginning of her career and was important in providing her with a role model. Drinker was also employed to give a series of lectures at the Pennsylvania Academy on the subject of perspective, and this was the first occasion upon which a woman taught at that institution. Beaux later became the first full-time female lecturer there. Ater the age of 37 Drinker married Thomas Janvier. She continued to work, winning a major award in 1880, but she travelled also a good deal with her husband, particularly to southern France. She also began to write and to make translations of French books, reflecting the breadth of her abilities.

*Publications: Practical keramics for students*, Philadelphia, 1880; *London news*, 1904.

*Literature:* C. Beaux, *Background with figures*, Boston, 1930; Rubinstein.

## DUBOURG, Victoria. (alt FANTIN-LATOUR) (1840–1926)

*French painter of flowers*

This Parisian painter had a long and distinguished career. She studied first at the Louvre, and then with Henri Fantin-Latour, whom she married in 1876, although she continued to exhibit under her own name. She exhibited for over 40 years (1868–1909) in Paris, and in several London galleries between 1882 and 1899. Her flower paintings won several awards and election to the Société des Artistes Français. She spoke fluent English and German and shared her husband's love of music. After her husband's death in 1904, she catalogued and promoted his work, although the extent to which financial circumstances dictated this is not known.

*Examples:* Grenoble; Mus. d'Orsay, Paris; Pau; Rheims.

*Literature:* Bachmann; Clement; Edouard-Joseph; M. Gibson, 'The "admirable" Fantin-Latour', *Art News*, v82, 1983, 68–72; W.S. Sparrow; Wood, 1978.

## DUCHAMP, Suzanne (1889–1963)

*French Dada artist and abstract painter*

Suzanne Duchamp's history could so easily have been lost, coming from such a family of artists and participating in a movement like Dada in which traditionally no place has been allotted by historians to female participants. She was the granddaughter of a famous painter and engraver, Emile Nicolle, and three of her bothers became well-known artists within the modernist movement. Born in Blainville, Seine-Inférieure, she began to paint at the age of 16. In 1912 she exhibited her first work at the Section d'Or exhibition. On the occasion of her marriage to the Dada painter Jean Crotti she executed an *Unhappy readymade* by proxy for Marcel Duchamp as his present to her. Suzanne Duchamp participated in the Dada movement throughout its Parisian phase. The year 1921 saw the height of Dada activity in Paris and she was involved in signing manifestos, organising exhibitions and soirées, and in showing her own work in both the Salon d'Automne and the Indépendants. Together with composers such as Poulenc and the dancer Isadora Duncan she was a co-signatory of a work by François Picabia. In 1921 Duchamp and her husband launched Tabou-Dada, of which they remained the only adherents. This seems to have been a more spiritually orientated form of abstract art. During the 1920s Duchamp enjoyed several solo shows in Paris and exhibited in New York, initially with Katherine Dreier's (*q.v.*) Société Anonyme and again in the latter's *Thirteen Women Artists* show of 1934. Duchamp also featured in the 1937 *Femmes Artistes d'Europe* exhibition in Paris, and was elected a member of the Union des Femmes Peintres et Sculpteurs. Her contribution to the Dada movement was forgotten until the documentation was reassembled for the Düsselfdorf exhibition of 1958.

*Literature:* Edouard-Joseph; Schurr, vl; Vergine.

## DUFAU, Hélène. née Clementine Hélène DUFAU (1869–1937)

*French painter of portraits, genre and mythological scenes*

Leaving her native Quinsac in Gironde, she enrolled at the Académie Julian at the age of 20, where she worked under William Bouguereau and Robert-Fleury. She exhibited from 1895, winning a series of prestigious awards leading to a

*bourse de voyage* in 1898, a silver medal in the 1900 Exposition and the status of *hors concours* in 1902. Her early works are characterised by strong vibrant colours, but these were superseded by an elegant line in conjunction with a lighter palette and smaller brushstrokes. The forms began to dissolve into the surrounding space in a way reminiscent of some Impressionist work. In 1906 and 1908 she received commissions for two series of large decorative panels, the second of which consisted of four allegorical panels representing the sciences, which were installed in the Salle des Authorités at the Sorbonne in Paris. She also illustrated novels by Rosny and Paul Adam, and designed a number of posters. Her mature style contained elements of the Intimistes but with a more decorative tendency. She was extremely successful, winning election to the Société des Artistes Français and in 1909 becoming a Chevalier de la Légion d'honneur. In 1937 she was one of the select group of French artists invited to contribute (as opposed to submitting to a jury) to the large *Femmes Artistes d'Europe* exhibition held in Paris.

*Examples:* Bordeaux; Cambrai; Nantes; Mus. d'Orsay and Mus. de la Ville, Paris; Pau; Rouen.

*Literature:* Clement; Edouard-Joseph; *Le livre des peintres exposants*, Paris, 1930; Schurr, vl; W.S. Sparrow.

## DUFFIELD, Mary Elizabeth. née ROSENBERG (1819–1914)

*English painter of flowers and still lifes in watercolour*

She was one of five children of the landscape painter and miniaturist, Thomas E. Rosenberg, of Bath, Avon, among whose many pupils were all his own children. At the age of 15 she possessed an extensive collection of plants, so her father trained her as a flower painter, the only one among his children, and in that same year she won a medal from the Royal Society of Arts. Her recorded exhibiting career stretches from 1848 to 1912, when she was 93, but it may have begun earlier, for until 1857 she exhibited only in the West country. In 1850 she married the still-life painter William Duffield and they carried out some paintings jointly. His speciality was the depiction of food, but this was the cause of his premature death. Having lost his sense of smell, he was unable to detect the decomposition of a dead stag which he was painting in his studio. Mary Duffield had continued her career after marriage and was able to sustain herself by her painting.

She was elected a member of the Royal Institute of Painters in Watercolours in 1861, by which time her younger sister, Frances Rosenberg Harris, was already a member.

*Publications: The art of flower painting*, London, 1856.

*Examples:* V & A, London.

*Literature:* Clayton; Mallalieu; *Who's Who*: P. Nunn, *Victorian women artists*, London, 1987; Wood, 1978.

## DUNBAR, Evelyn Mary (1906–60)

*English painter of figure subjects, landscapes, portraits and some murals*

Dunbar began to study art in her home town of Rochester, Kent before pursuing it further at Chelsea School of Art. A county scholarship enabled her to spend four years at the Royal College of Art from 1929. In her final year there she carried out a commission for some large murals in a school at Brockley, Kent. Murals remained an interest of hers, but few commissions of that kind were available. Although the only other recorded Dunbar mural is that for the Training College, Bletchley in 1958–60, she nevertheless was a member of the Society for Mural Painters. Apart from carrying out oil paintings, she collaborated on the illustration of two books on horticulture. By 1939, the National Gallery had purchased one of her paintings and it may have been through this that she was commissioned as an official war artist in 1940. She depicted scenes of the Women's Land Army, particularly recruits being put through intensive dairying courses, and also depicted other women's services. In 1942 she married Dr Roger Folley, an agricultural economist, who was then in the RAF. After the war he returned to an academic post at Wye College, so they settled in Kent. Dunbar became a member of NEAC in 1945, and from 1950 was a visiting lecturer at Ruskin College, Oxford. Her works from this period were portraits and carefully observed scenes of everyday life, of which *The fish queue* is the most important. A solo show was held in 1953.

*Examples:* Imperial War Mus., London; Manchester; Sheffield.

*Literature:* Deepwell; P. Dunford, 'ED 1906–60', *WASLJ*, no. 27, Feb/Mar 1989, 20–1; *Exhibition of paintings and drawings by some women war artists*, Imperial War Mus., London, 1958; Waters.

## DUPRÉ, Amalia (1845–1928)

*Italian sculptor of religious subjects*

Born in Florence, she demonstrated a natural facility for modelling as a young child. When her father, the sculptor Giovanni Dupre, noticed this he began to teach her. As her skills developed she continued to work with him, collaborating on some sculptures. Independently, she executed a series of funerary monuments and religious figures. For the Duchess of Ravaschieri she carried out a statue of the Madonna receiving an angel; for the Cavaliere Aleotti, a Sister of Charity, and for her parents' tomb at Fiesole, near Florence, she reproduced a version of one of her father's most famous sculptures, the *Pietà*. She took over her father's work for the facade of Florence cathedral, completing the figure of *St Zenobius* and creating a new conception of that of *St Reparata*. One of her best-known sculptures was the figure of the painter Giotto as a boy. She was a corresponding member of the Academies of Fine Art in Florence and Perugia.

*Example:* Cathedral, Florence.

*Literature:* A. Aleardi, *Giotto fanciullo, statua di AD*, Treviso, 1886; L. Callari, *Storia dell'arte contemporanea italiana*, Rome, 1909; Clement; A. Conti, *Illustrazioni delle sculture e dei mosaici della facciata del duomo di Firenze*, Florence, 1887; Mackay; A.R. Willard, *History of modern Italian art*, London, 1898.

## DURANT, Susan (c. 1820–73)

*English sculptor of statues and portrait busts*

Durant was born in Devon in the early 1820s. Unusually she took up sculpture as an amateur, although the circumstances which allowed this are not known. Despite that fact that she appears to have had a private income, her success at this level determined her to become a professional artist. She studied with Baron Henri de Triqueti in Paris, and from 1847 until her sudden death she was a regular exhibitor at the RA. From its second exhibition in 1858, she also sent works to the SWA, and at the same time sent to one or two other London galleries. Her early works were predominantly portraits, including a self-portrait (1853) and *Harriet Beecher Stowe* (1857). Such works provided the means of building up a clientele that would in turn bring the commissions for the statues, such as *The negligent watchboy of the vineyard catching locusts* (1860) and the *Faithful shepherdess* (1863), which was commissioned by the Corporation of the City of London for the Mansion House. She contributed two statues to the Great Exhibition of 1851, and her *Robin Hood* (1856) was seen at the Art Treasures of Great Britain exhibition in Manchester in 1857. About 1865 she was introduced into the royal circle and for the last eight years of her life produced a large number of portrait medallions, busts and other commissions for the royal family. Durant's monument to King Leopold I of Belgium, one of the earliest commissions from Queen Victoria, (1865–6) is in St George's Chapel, Windsor. At the same time she worked on seven portrait medallions of members of the royal family, which were exhibited in 1866–8 and then incorporated in the decoration of Wolsey's Chapel, now known as the Albert Chapel, Windsor, on which Durant and Triqueti worked for two years. Durant was further involved in the royal family through teaching sculpture to the queen's daughter, Princess Louise (*q.v.*). Her relationship with the royal family seems to have been similar to that relative informality enjoyed from the late 1840s by another sculptor of royalty, Mary Thornycroft (*q.v.*). A description of Durant in 1866 reveals her easy but well-informed conver-

**Susan Durant** *Princess Louise*, 1866, plaster, 50 cm diameter, Royal collection. (Reproduced by gracious permission of Her Majesty the Queen)

sation, and her striking appearance: 'a tall and very comely young woman, apparently under thirty [she was actually over forty] . . . with rounded limbs . . . flashing face and massive rippling chestnut hair; erect, highcouraged and superbly drest [sic] . . . her talk was worthy of all this . . . . And withal she was full of graceful fun'. She died on New Year's Day 1873 at Triqueti's house in Paris, leaving her bust of Dr Elizabeth Garrett Anderson to be shown posthumously at the RA.

*Examples:* Albert Chapel and St George's Chapel, Windsor.

*Literature: AJ*, 1873, p.80 (obit.); Clement; R. Gunnis, *Dict. of British sculptors, 1660–1851*, London, 1968 (orig. pub. 1851); Mackay; Yeldham.

## DURRANT, Jennifer (1942–)

*English abstract painter*

Durrant spent the first four years of her training at the College of Art in her home town of Brighton, Sussex and then, in 1963, began a further three years at the Slade. From being a 'Young Contemporaries' prizewinner in 1966 she has steadily established herself though a series of exhibitions. Her primary concern is paint and painting as a series of aesthetic choices. She paints with her large canvases stretched flat on the floor, working on several at the same time. She is concerned with texture and colour, using marks as compositional devices to balance the painting.

*Examples:* Boston, Mass.; Rochdale.

*Literature: British painting 1952–77*, RA, London, 1977; *Hayward Annual 1979*, Hayward G, London, 1979; J. McLean, 'Aspects of contemporary British painting: a painter's view', *Arts Magazine*, no. 56, v13, Nov. 1981–Jan. 1982, 28–31; *The new generation: a curator's choice*, André Emmerich G, New York, 1980; Parry-Crooke; C. Titterington, 'JD at Nicola Jacobs', *Artscribe*, no. 39, Feb. 1983, 56–8.

## EAKINS, Susan. née MACDOWELL (1851–1938)

*American painter of portraits and figure subjects*

The fifth of eight children, Susan Macdowell was born in Philadelphia, where she spent most of her life. As an engraver, her father knew many artists and encouraged his daughter's ambition by giving her a studio in the attic. He and other members of the family often posed for her during her years as a student at the Pennsylvania Academy (1876–82). She deliberately chose to study there with Thomas Eakins, after having seen his controversial realism. As leader of the students she requested an additional life class for women (which was granted), and she also won two prizes during her time there. After her marriage to Eakins in 1884, she never promoted herself, although she continued to paint, if sporadically, and both artists had studios in their Philadelphia home. Her time was of necessity limited since she relieved Eakins of many administrative tasks, in addition to carrying out her domestic responsibilities. She became a photographer, and used her photos as reference material for her paintings. Some have been identified, but there is speculation that some of her photographs have been attributed to Eakins. Her good-humoured personality was tested during the time when Thomas was forced to resign his teaching post because of his insistence on working from the nude model, and after this he sold little work. After his death in 1916, Susan Eakins had a second and prolific period of creativity. Her earlier paintings had frequently been sombre, with rich earth colours, but her later ones are brightly coloured and the paint is handled more freely. It is as though her natural optimisim had reasserted itself. She continued to paint until the end of her life.

*Example:* Pennsylvania Academy of Fine Art, Philadelphia.

*Literature:* S. Adelman & S. Casteras, *SME 1851–1938*, Pennsylvania Academy of Fine Art, Philadelphia, 1973; Bachmann; D. Davis, 'The unknown Eakins', *Newsweek*, 28 May 1973, 10; Fine, 1978; Heller; Rubinstein; Tufts, 1987.

## EARDLEY, Joan (1921–63)

*Scottish painter of tenement children and landscapes in a semi-abstract and expressionist style*

Eardley's parents were Scottish although she herself was born in Sussex. Her father committed suicide when she was seven, an event which still threatened her equanimity in the 1950s. The family, which now consisted entirely of women, settled in Glasgow in 1940, when Eardley began

her training at the School of Art there. She was an unconventional figure, with her short hair and trousers instead of the usual kilt. During this early period she also travelled in Europe, most notably Italy. After an interlude late in the war as a joiner's labourer, she began her paintings of Glasgow tenements and their occupants, particularly children. They demonstrate considerable sympathy and identification with the poor, for Eardley always believed that a painting should go beyond a mere visual record and succeeded in combining sympathetic understanding with the eye of an artist. She continued to travel abroad with various women friends whom she painted; men are rarely her subjects. From 1950, as she began to achieve acclaim, Eardley divided her time between Glasgow and the village of Catterline, on the northeast coast of Scotland, gradually increasingly the proportion of time which she spent there. For most of the time there she painted outside, sometimes literally tying herself and her easel down so that she could capture the height of the storm. Obsessed by the weather, she wanted to paint its every mood. Her style might be called gestural and expressionist, factors which have led to critics associating her with American and European Expressionists. Her techniques were developed independently and, although she may have derived assurance from a knowledge that others were working in similar ways, Hall suggested that while belonging to the Scottish tradition, she transcended it. The colours are bright, punctuated by accidental and deliberate marks that help to convey her response to the subject. While the children are the main subject of her early paintings, her landscapes are almost completely devoid of human presence. She was already dying of breast cancer when the Royal Scottish Academy made her a full member, a sign of belated recognition.

*Examples:* Aberdeen; Cecil Higgins Art G, Bedford; Birmingham; Herbert Art G, Coventry; City Art Centre and Scottish Nat. G of Modern Art, Edinburgh; Glasgow; Huddersfield; Kendal, Cumbria; Tate G, London; Middlesborough; Paisley; Perth; Nat. G of New Zealand, Wellington.

*Literature:* W. Buchanan, *JE*, Edinburgh, 1976; Cooper; D. Hall, *JE*, University Art G, Stirling, 1969; M. Jacobs & M. Warner, *Phaidon companion to art and artists in the British Isles*, Oxford, 1976 (under Glasgow and Catterline); Nottingham 1982; C. Oliver, 'JE and Glasgow', *Scottish Art Review*, v14/3, 1974, 16–19, 31; C. Oliver, *JE, a retrospective*, Talbot Rice Centre, Edinburgh University, 1988.

## EBERLE, Abastenia. née Mary Abastenia St Leger EBERLE (1878–1942)

*American sculptor of ordinary New York figures at their daily activities, a parallel to the Ash Can school of painting*

Eberle's Canadian parents were living in Webster City, Iowa, when she was born, but she was brought up in Canton, Ohio. Her first formal studies were with one of her father's patients, and another local teacher, Frank Vogan. During the Spanish-American war, her father's service as an army surgeon took the family to Puerto Rico, but from 1899 she spent three years in New York at the Art Students' League, paying her way with prizes and awards. It was there that she became friendly with Anna Hyatt (*q.v.* under Huntington), with whom she shared a studio and collaborated on several works, Hyatt completing the animals and Eberle the figures. Her first visit abroad was to Naples in 1907 and, although she followed the traditional academy course, she was fascinated by life in the streets. On her return to America, she settled in New York, aware of the bustle of the city and its inhabitants, as she had been in Naples and Puerto Rico. Taking her subjects from the poor Lower East side, in 1908 she exhibited four small genre statuettes at the NAD. Many of her subjects were children, often at play; and with her depiction of a woman with windblown skirt sweeping, entitled *The windy doorstep* (1910), she won a prize at the NAD for the best sculpture by an artist under 35. The social comment in her work became more explicit, with examples such as *The white slave*, one of two works at the Armory Show in 1913. She was also an ardent suffragist and a socialist. In her flat on Lower East side, she turned one of her rooms into a playroom for the local children. She exhibited regularly in both New York and the Pennsylvania Academy, and was included in three international exhibitions in Europe. A visit to France in 1913 left her still largely unaffected by modernist art. Nevertheless, the honesty of her subjects was something unique in sculpture at that time, but she is rarely considered by writers on the Ash Can School. Further awards and solo shows followed, and in 1920 she was elected an Associate of the NAD. By then a heart condition had severely incapacitated her and she did little work thereafter.

*Examples:* Brookgreen Gardens, SC; Art Inst., Chicago; Metropolitan Mus., and Whitney Mus., New York; Corcoran G, Washington, DC.

*Literature:* Bachmann; S. Casteras, 'AE's *White*

*Slave'*, *WAJ*, v7/1, spring-summer 1986, 32–7; Heller; M. Hill, *The woman sculptor: Malvina Hoffman and her contemporaries*, Berry-Hill G, New York, 1984; J. Lemp, *Women at work*, Corcoran G, Washington, DC, 1987; *Notable American women*; L. Noun, *ASLE: sculptor (1878–1942)*, Des Moines Art Center, Des Moines, Iowa, 1980; Proske, 1968; Rubinstein; Tufts, 1987; Withers, 1979.

## EDELSON, Mary Beth (*c.* 1945–)

*American performance artist concerned with spirituality and the great goddess*

Little is known about Edelson's early life or why she came to be an artist. She was educated at the Art Institute, Chicago and Indiana University before completing her MFA at New York University. From as early as 1961, when she had her first child, she has been exploring ideas to do with the goddess, one aspect of which is 'exorcising the patriarchal creation myth through a repossession of the female visionary faculties'. This is essentially a holistic enterprise involving complete harmony of mind and body, and artists such as Edelson, Damon (*q.v.*) Saar (*q.v.*) and Sjoo (*q.v.*) use the female form as image and for rituals. In 1969 the family moved to Washington, DC, and her paintings conjured up images of something forbidden. A key exhibition took place in 1973, when she discussed her work with 22 other people, then asking them the sort of work they would like her to produce. From these conversations came her reworking of Leonardo's *Last Supper* with the disciples' faces replaced by those of living American women artists with further photographs placed all round the edge of the canvas. This taught her that she needed to use feminist art to glorify women, and in order to do this she wanted to make her art more accessible. She has used her own body both as a visible representation of the goddess and as a symbol for Everywoman, evolving rituals around the idea of the body as the house of wisdom. In two performance of the late 1970s, she mourned *Our lost herstory*, and the *9 million women burnt as witches in the Christian era*. Living in New York, she has been a member of the women's co-operative gallery AIR, and has served on the collective for the feminist art magazine *Heresies*.

*Publications:* 'Pilgrimage/See for yourself', *Heresies*, spring 1978; 'See for yourself: feminist spirituality in holistic art', in C. Spretnak, *The politics of women's spirituality*, New York, 1981.

*Literature:* J. Burnham, 'MBE's Great Goddess', *Arts Mag.* Nov. 1975, 75–8; L. Lippard, 'Caring: five political artists', *Studio International*, May–June 1977, 197–207; L. Lippard, *Overlay: contemporary art and the art of prehistory*, London, 1983; Petersen; Roth.

## EDGCUMBE, Ursula (1900–84)

*English sculptor then painter in oil*

Born in Sandy, Bedfordshire, she was the daughter of Sir Robert and Lady Edgcumbe. She trained at the Slade from 1916 to 1921, and her career in sculpture included solo shows from 1935. She had many commissions including a war memorial at Zennor in Cornwall, and stone carvings and a plaster ceiling at Bibury Court, Gloucestershire. After 1940 she gave up sculpture and turned to painting, in which she was equally successful. She was a member of the selection committee for WIAC exhibitions and she also showed with the London Group, and at the Leicester Galleries.

*Example:* Zennor, Cornwall.

*Literature:* Waters; *Who's Who in Art*.

## EDWARDS, Mary Ellen. (alt. FREER; STAPLES) (1839–1908)

*English painter and illustrator of children and genre subjects*

Mary Ellen Edwards was born at Kingston-upon-Thames, Surrey. Her artistic ability, inherited from her mother's family, was apparent by the age of nine, but her desire to became a professional artist was firmly discouraged. Undeterred she continued to draw and paint, until at 12 a family friend presented her with materials for oil painting. After this she rarely worked in watercolour. She was essentially self-taught, for her only formal training consisted of one term at the South Kensington School of Art. When she was of the age to be eligible for training, her family were living on the Isle of Man, where no artistic facilities were available. Social convention precluded young women living independently in London while they studied. Nevertheless she was successful, for her first submissions to the RA were well received. From 1862 she was represented by several works almost every year. She became better known

after 1965 when her RA painting, *The Kiss*, was published as an engraving. Like Florence and Adelaide Claxton (*q.v.*), she also drew on wood, her first print being published in the *Illustrated Times* in 1859. Her engravings, normally signed MEE, appeared in most of the leading journals of the time, both as illustrations to serials and as her own pictures. She was a prolific book illustrator, as well as a contributor of 36 works to the RA between 1862 and 1908, and to several other galleries. She married John Freer in 1866 and her only child was born in November 1867. Her husband soon became ill and died in 1869. Yet there was no interruption to her output; indeed she turned to her work for consolation. Three years later, she married John Staples. She may well have been widowed again, for in 1886 she was exhibiting once more under her maiden name. In these uncertain circumstances she was fortunate in being able to have an independent income, and she bcame extremely successful, although we do not know to what extent she had to capitalise on contemporary tastes in order to retain financial security. Contemporary critics spoke of her possessing feeling and sentiment without falling into affectation.

*Examples:* Belfast; V & A, London.

*Literature:* Clement; Mallalieu; P. Nunn. *Victorian women artists*, London, 1987; R.E. Sketchley, *English book illustrators of today*, London, 1903; W.S. Sparrow; Wood, 1978 (under Staples).

## EHRENEWEISEN, H. VON. See REBAY, Hilla.

## ELWES, Catherine (1952–)

*English performance and video artist active in the women's movement*

Born in France to English parents, Elwes began her art education in 1969 but this has been interspersed with full-time work in other professions. Her training took place at Lanchester Polytechnic, Coventry, and in London at the Slade and the Royal College of Art. In 1976 she became a member of the Women Artists' Collective, and much of her work has been informed by the women's movement. In 1979 while at the Slade, she explored the isolation of menstruation by confining herself into a glass-fronted compartment for several days while she bled, 'concentrating on physical and psychological changes as a source of knowledge and creative energy'. In 1980 she was one of the organisers of the landmark exhibitions *Women's images of men* and *About time*. The latter consisted of performance works of which Elwes contributed one for the theme of time runs through many of her works. In several she has also confronted her Roman Catholic and bourgeois upbringing. Now working exclusively with video, she also teaches and writes.

*Publications:* Essays in S. Kent and J. Morreau (eds) cited below.

*Literature: About time*, ICA, London, 1980; S. Kent and J. Morreau (eds), *Women's images of men*, London, 1985; R. Parker & G. Pollock, *Framing feminism*, London, 1987.

## EMMET, E. See RAND, Bay (Ellen).

## EMMET, Lydia FIELD (1866–1952)

*American painter of figures in interiors and landscapes, as well as portraits, especially of children*

Lydia Emmet was one of three sisters who all became artists and who were the third of five generations of women artists in their family. Encouraged by their mother, 17-year-old Lydia travelled to Europe with her sister Rosina (*q.v.* under Sherwood). Once in Paris, they attended the Académie Julian, and Lydia at least also studied privately with Collin and Frederick MacMonnies, who with his artist wife Mary (*q.v.* under Low) had a studio at Giverny, near Monet's home in France. Back in her native New York in 1885 Lydia Emmet studied at the Art Students' League from 1889 to 1895 with tutors who included Kenyon Cox and William Merritt Chase. The latter was an influential teacher of the 'fast brush' school, under whom many leading women artists studied, for he regarded them as professionals. He also ran summer schools at Schinnecock Hills from 1891, where Rhoda Nicholls and Lydia Emmet acted as his assistants, Emmet conducting the preparatory classes. From Chase she learnt to work directly from nature and to map out quickly a spontaneous composition. Areas of white, especially clothes, in her paintings show an Impressionistic technique and she de-

monstrated facility at handling figures within a landscape. In the early part of her career she painted many subjects, and in 1893 was selected to paint one of the four smaller frescoes for the Women's Building at the Chicago Exposition. The subject was the personification of *Art, science and literature* as contemporary women. Two of her oil paintings were also exhibited there, one of which won a bronze medal. This was one of many such awards which she won in international expositions over the years. She painted prolifically and became increasingly in demand as a society portrait painter, notably of children. She began building her summer home, Strawberry Hill at Stockbridge, Mass., in 1905, and until her 80th year she swam in the pond there every day. She exhibited actively and was made an Associate member of the NAD in 1909, followed three years later by full membership.

*Examples:* Metropolitan Mus., New York; Nat. G, Washington, DC.

*Literature:* M. Elliott; M. Hoppin, *The Emmets: a family of women painters*, The Berkshire Mus., Pittsfield, Mass., 1982; R. Pisano, *The students of W.M. Chase*, Heckscher Mus., Huntington, NY, 1973; Tufts, 1987; Weimann.

## EMMET, R. See SHERWOOD, Rosina.

## ENGELBACH, Florence. née NEUMEGEN (1872–1951)

*English painter of landscapes, flowers, figure subjects and portraits*

Born in Spain of English parents, she trained at the Westminster School of Art, the Slade and in Paris during the 1890s and initially established her career by painting portraits. She first exhibited at the RA in 1901, but after her marriage, the following year, and the birth of two daughters there was a gap in her career. Resuming art seriously in the early 1920s she exhibited widely in Britain and Paris, including several solo shows at the Beaux-Arts and Leicester Galleries from 1931 and 1939 respectively. In 1932, when she seems to have been living in Warwickshire, she was elected member of the Royal Institute of Painters in Oil.

*Examples:* Birmingham; Blackpool; Bristol; Co-

ventry; WAG, Liverpool; Tate G, London; Newcastle-upon-Tyne; Wolverhampton.

*Literature:* Deepwell; *FE*, Leicester G, London, 1939; Sellars; *Who's Who in Art*.

## ERMOLAYEVA, Vera Mikhailovna (1893–1938)

*Soviet Suprematist painter and illustrator*

Born in Petrovsk, Saratov, she attended school in St Petersburg, after which she studied with Mikhail Bernstein. She mixed with painters in the Union of Youth and through them became interested in popular art, particularly in banners. She shared the same aesthetic ideas as Kasimir Malevich and continued to do so until 1926. After the 1917 revolution her flat became the meeting place for many modernist artists, including the poet Mayakovsky. After graduating from the Archaeological Institute in Petrograd in 1917, she worked in the City Museum there in 1918–19. At the same time Ermolayeva organised a workshop for the production of small editions of illustrated books, of which the covers and illustrations were linoprints. This closed in 1919, when she was sent to Vitebsk as director of the Institute of Art, where she remained for four years and became a friend of Nina Kogan (*q.v.*). She invited Malevich to lecture and promoted avant-garde art. At this time her own works were shown at the exhibitions of the Suprematist Unovis (Union for New Art) Group in Moscow (1920–1) and at the major Russian exhibition in Berlin in 1922. In 1923 she returned to Leningrad, where she became director of the colour laboratory at Inchouk (Institute of Artistic Culture) for three years. At the end of this period she began to move away from Suprematism, although her figurative work of the early 1930s still retained its influence. She took up the illustration of children's books, at which she had been successful in the 1920s. During the Stalinist era she was imprisoned and probably died in a concentration camp.

*Literature:* E. Kovtun, 'Khoudozhnitsa knigi, VME', *Iskousstvo knigi 68–9*, no. 8, Moscow, 1975; *L'avant-garde au féminin 1907–30*, Artcurial, Paris, 1983; *Russian women artists of the avant garde*, G. Gmurzynska, Cologne, 1979; Vergine.

## ESCOBAR, M. See MARISOL.

## EXTER, Alexandra Alexandrovna. née GRIGOROVICH (1882–1949)

*Russian constructivist painter and stage designer*

Exter was one of the more active and important personalities of the Russian avant-garde. Born in Belestok, Ukraine, she graduated from the Kiev School of Art in 1906, and first exhibited the following year with the Blue Rose Group in Moscow. As a result of a fictitious marriage with a cousin, she was able to obtain a passport and make her first visit to Paris in 1908. Through her contacts she was able to meet many of the Cubists and Futurists. She spent much of the next four years travelling in Western Europe, and this enabled her to disseminate information about contemporary art on her return to Russia. At this time she used ideas from Cubism and Futurism to give greater control to her naturally exuberant colour, and she achieved some success with exhibiting her landscapes and urban scenes in Paris, Russia and Italy. The years 1913–4 were divided between Paris and Russia, and her work became more abstract, using large planes of colour. While sharing a studio with Soffici in Paris, she experimented with collage, using publicity material of various kinds, and from this followed her involvement with stage design in 1916 and with paintings in which she analysed visual rhythms of shape and colour. In 1918 she ran a course on colour and space at the Kiev School of Art, and also taught at her own studio in Odessa (1917–18) and in Kiev (1918–21), where some abstract designs were made for occasions such as the first anniversary of the revolution. Several of her pupils became outstanding stage designers. Throughout this period, and until 1924, she was engaged in costume and set designs as well as painting and exhibiting. She participated in all the major avant-garde exhibitions. For her there was no strict division between these activities, for in all she was exploring her interest in abstract structure. In 1924 she went to live permanently in France, where she continued to be active as a designer for the theatre.

*Examples:* Kunstbibliothek, Berlin; NMWA, Washington, DC.

*Literature:* Bachmann; M. Dabrowski, *Contrasts of form: geometric abstract art 1910–80*, MOMA, New York, 1985; *Das Verborgene Museum*; *DWB*; Fine, 1978; Harris; *L'avant-garde au féminin 1907–30*, Artcurial, Paris, 1983; NMWA catalogue; Petersen; *Russian women artists of the avant garde*, G Gmurzynska, Cologne, 1979; A. Strausberg, 'Renaissance women in the age of technology', *Spare Rib*, no. 19, 1973, 38–40; Vergine.

## FACCIOLI-LICATA, O. See LICATA-FACCIOLI, Orsola

## FALKENSTEIN, Claire. née LINDLEY (1908–)

*American abstract sculptor in welded metal with fused glass*

Brought up in North Bend, a small village on Coos Bay, Oregon, she first encountered art at the home of the owner of the wood mill where her father was a manager. She graduated from the University of California at Berkeley in 1930, and while teaching to support herself went on to produce abstract sculptures of textured ribbons of clay. At this stage she was already interested in opening up the volume of traditional sculpture. In the early 1940s her interlocking wood pieces, called *Exploding volumes*, could be moved into different formations by the spectator. Having learnt to weld, she proceeded to make both wire sculpture and jewellery and also spent some months in Hayter's Atelier 17 in New York. Soon a teaching appointment took her to California School of Fine Arts, where she was a colleague of several Abstract Expressionists and became particularly influenced by the ideas of Clifford Still. In 1950 she went to Paris, where she remained for 13 years. There abstract artists were trying to evolve a less geometrical form of art, and Falkenstein began welding stove pipe wire into sculpture, which gradually became larger and more open. Her choice of material was dictated by simple economics, as she had little money. With several other Americans, including Sam Francis, Falkenstein benefited from the support of the intellectual Michel Tapié, who introduced her to modern scientific ideas. Through him a group show in Rome was arranged in 1958, and Falkenstein was asked to design a bannister for the stairs in the gallery. Since she was trying to evolve a technique she called topology – 'a form which connects matter and space, conveying the idea of the continuous void in nature' – she fused lumps of coloured glass with copper tubing. Her own invention, she adopted this medium in her later commissions, including the gates for Peggy Guggenheim's *palazzo* in Venice. The shapes derive from recollections of natural forms, particularly those found on the beach. Returning to America in 1962 with a European reputation, she settled in Venice, California and in the following years executed a number of large-scale commissions. In most of these she produces a unit which can then

be repeated endlessly, a never-ending screen, not unlike the idea of Minimalist sculptors.

*Examples:* Shopping precinct, Coos Bay, Oregon; Tate G, London; Long Beach, Calif.; St Basil's cathedral, Los Angeles; Guggenheim Mus., New York; Phoenix, Ariz.; Carnegie Inst., Pittsburgh; San Diego; San Francisco; Guggenheim Mus., Venice, Italy; NMAA, Washington, DC.

*Literature:* N. Larinde, 'CF', *WAJ*, v1/1, spring-summer 1980, 44–55; O. Lerman, 'CF invites us to complete the circle', *Arts Mag.* v56/5, Jan. 1982, 64–7; Mackay; Rubinstein; M. Tapié, *CF*, Rome, 1958; Watson-Jones.

## FARNHAM, Sally. née JAMES (1876–1943)

*American sculptor of equestrian statues, war memorials and portrait busts in bronze and marble*

As a child in Ogdensburg, NY, she spent much time riding and was familiar with the anatomy of horses and dogs. Her father, a famous trial lawyer, took her with him on several visits to Europe, during which she became familiar with works in the major museums, but found herself particularly drawn to sculpture. At the age of 20 she married the painter and designer of silverware, Paulding Farnham, but it was not until 1901, when she was recuperating from an illness, that she began to model. Although encouraged and advised by the painter Frederick Remington, their friend and neighbour, she was otherwise self-taught. While raising her three children she opened a studio and began to develop her own technique, proceeding from statuettes to painted busts and then to large-scale pieces. She exhibited at the NAD, the National Sculpture Society and other venues. A series of prestigious commissions established her in the forefront of her profession, beginning with four large relief panels for the Pan-American Union in Washington, DC, which encompassed the discovery and settlement of America (1910). Other notable commissions included the equestrian figure of Simon Bolivar, unveiled in 1921, which the Venezuelan government placed in Central Park, New York. The distinguished figures who sat for her included three American Presidents (Roosevelt, Harding and Hoover).

*Examples:* Brookgreen Gardens, SC; Central Park, New York; war memorial, Fultonville, NY; Corcoran G, Washington, DC.

*Literature:* J. Lemp, *Women at work*, Corcoran G,

Washington, DC, 1987; N. McMein, 'We do the President', *The Ladies' Home J*, v38/8, Aug. 1921, 13, 60–5 (McMein was a friend of SF, who sketched President Harding while SF modelled him); Proske, 1968; Rubinstein.

## FASSETT, Cornelia Adele. née STRONG (1831–98)

*American painter of portraits*

An example of a woman artist who became the principal income earner for her family, Cornelia Strong was born in Owasco, NY, and only after her marriage at the age of 20 to the Chicago photographer-artist, Samuel Fassett, did she begin to train as an artist. After initial study in watercolour painting with the Scottish artist James Wandesforde, she travelled in Italy and Paris between 1852 and 1855, becoming the pupil of artists such as Mathieu, La Tour and Castiglione. Returning to Chicago, the Fassetts raised a family of eight children, but parallel with this Cornelia painted portraits and Samuel ran a photographer's studio. On another visit to Europe in 1866, they were accompanied by their four oldest children and a maid. After his studio was damaged in the big Chicago fire of 1871, Samuel Fassett took a job with the Treasury Department, which involved moving to Washington, DC in 1875. This was the key to Cornelia Fassett's success, for portraits were in great demand. In addition to her many individual ones, she is best known for two large group portraits: one was of the Supreme Court Justices, and was exhibited at the Philadelphia Centennial in 1876; the other was a huge undertaking requiring 196 individual portraits. This was an historical record of *The electoral commission of 1877* (1879), depicting the decision after the tie in the 1876 presidential election. She included members of the Press and herself sketching in the foreground.

*Examples:* Senate wing, Capitol, Washington, DC.

*Literature:* Clement; Rubinstein; Tufts, 1987.

## FAULKNER, Amanda (1953–)

*English painter of women who is trying to forge a radical imagery*

Faulkner is one of several young painters who are returning to the image of woman but imbuing it

with entirely new connotations. Born and brought up in Dorset, she travelled to South America on leaving school and worked with an anthropologist while living with native Indians in the Andes for about 18 months. While there she was struck by the influence of the art of Mexico and Ecuador, and on her return she began to study art, first at Ravensbourne College of Art and then as a postgraduate at Chelsea School of Art, 1982–3. Some prints from that year were seen by a gallery owner, and since then she has had a series of exhibitions that have made her well known in a comparatively short time. She works mainly in pastel, but the colours are not the soft delicate ones associated with that medium. The chief image in all her works is woman, often with a baby, but she reveals the other side of the coin of motherhood. Instead of the idealised traditional view, Faulkner shows babies as demanding little monsters, while surrounding the mother is a host of images redolent of punishment, pleasure and problems. She confronts the multiple roles that women have to play, and distorts and invents when necessary in order to depict the complexities of physical and mental relationships. Faulkner's women have energy and potential, which external forces prevent them realising.

*Examples:* V & A, London.

*Literature: Arts Review*, 17 Feb. 1984 & 1 Feb. 1985; W. Januszczak, *Guardian*, 1 May 84; W. Januszczak, 'Sister of mercy?', *Studio International*, Jan. 1985, 12–13; S. Kent, *Flash art*, March 1985; E. Lucie-Smith, C. Cohen & J. Higgins, *The new British painting*, Oxford, 1988.

## FAUX-FROIDURE, Eugénie Juliette. (1876–?)

*French painter, chiefly of flowers and fruit*

Born at Noyen, Sarthe, she studied with several male artists, including G. Saintpierre. She exhibited at the Salon and elsewhere in France from 1886, and from 1898 she won a series of awards, including one at the Paris Exposition of 1900 and the chief prize from the Union des Femmes Peintres et Sculpteurs, of which she later became the vice-president. She was also a member of the Société des Artistes Français, at whose salons she was declared *hors concours*, and of the Association of Professors of Drawing in the City of Paris; she was also made a Chevalier de la Légion d'honneur.

Her works were characterised by freshness and clarity, and several were bought by the state.

*Examples:* Commerey; Le Mans; Tunis.

*Literature:* Clement; Edouard-Joseph.

## FAYERMANN, A.C. See BARTHOLOMEW, Anne

## FEARON, Hilda (1878–1917)

*English painter of figure subjects and landscapes*

Born in Banstead, Surrey, she studied in Dresden from 1897 to 1899, and then at the Slade from 1899 to 1904. However, she regarded the most formative part of her training as that under Algernon Talmage in St Ives, Cornwall, when she painted many pictures in the open air. She lived in London and began to exhibit at the RA in 1908, contributing each year and on one occasion having no less than three paintings hung in the favoured position 'on the line'. She also exhibited in Paris and at the Carnegie Institute, Pittsburgh, receiving an award at each. Her subjects are often girls indoors, either at a table or in a ballet class. The interiors are cool in colour and feelings, and she delights in depicting the clarity and shine of china and glass. In her landscapes she conveys the feeling of sun and wind. She was elected a member of the Royal Institute of Painters in Oil.

*Literature:* Edouard-Joseph; C. Marriott, 'The paintings of Miss HF', *Studio*, v63, Oct. 1914, 27–34; Waters.

## FEDOROVITCH, Sophie (1893–1953)

*Russian-born painter and designer for ballet and theatre who worked in England*

Born in Minsk, the daughter of a government official, Fedorovitch spent part of her childhood in Krakow, Poland. She studied painting at a private school in Moscow and at St Petersburg Academy. On her arrival in England in 1920 she at once began exhibiting with the London Group and with the 7 & 5 Society from its inception in 1926. She also exhibited frequently in Paris and had a solo show in London in 1928. She spent much of the 1920s in France and Italy, and at one time was earning her living in Paris as a taxi driver. She

became attracted to the Russian ballet in London, and her drawings done in Cecchetti's ballet classes were noticed by Marie Rambert, the founder of the ballet company. Through her she met Frederick Ashton, the choreographer, who asked her to design the costumes and sets for a ballet in 1926. The partnership went so well that she designed 11 of his ballets and abandoned painting in 1932, destroying much of her earlier work. Over the years she worked with most of the major figures in opera, ballet and theatre, and was a major contributor to British stage design. In 1940 she became a British citizen. Although she had a London studio, she spent most of her time in the small village of Brancaster in Norfolk. An exhibition of her theatre designs was held in 1938, and in 1951 she became an adviser to the Sadler's Wells company.

*Examples:* Sadler's Wells Theatre, Royal Opera House and V & A, London.

*Literature: SF, 1893–1953 a memorial exhibition,* V & A, London, 1955.

## FELL, Sheila (1931–1980)

*English painter of landscapes*

Born in Aspatria, Cumbria, she was brought up among the sweeping landscape of the Lake District in a community where coal-mining and the manufacture of agricultural machinery were the chief industries. There was no family connection with art and her parents accepted her enrolment at art school because her grant was more than she could have earned locally. Trained first at the age of 16 in nearby Carlisle for two years, she went to St Martin's School of Art in London from 1949 to 1951. She had the first of several solo shows at the Beaux-Arts Gallery in 1955. She won a prize in the junior section of the first John Moores' Liverpool exhibition in 1957, but 1958 marked a turning point for Fell. She not only won a travelling scholarship, which enabled her to visit France, Italy and Greece, but also obtained a teaching post at Chelsea School of Art. Her chief concern has been landscape and her principal subject her native village, although she also painted subjects from Yorkshire and Wales, where she could capture the effects of the changing light on the earth, whether moors or mountains. Her work from the late 1950s was very dark, as she tried to create mood and to convey to others the characteristics of Aspatria. Influenced by Van Gogh and Auerbach, she built up in thick paint a construction of verticals and

horizontals in her compositions, in which all the elements were interrelated. Gradually her palette became lighter and her work acquired an increased sense of distance. The landscape was now seen filtered by memory, conveyed by an intense and unlocalised light. She built up a consistent record of exhibiting and among the awards she received was one in 1970 for research into mural painting. In 1974 she was elected a full member of the RA. She died suddenly as the result of an accident.

*Example:* WAG, Liverpool.

*Literature:* Nottingham, 1982; Parry-Crooke; Sellars.

## FERLOV, Sonja. see MANCOBA, Sonja

## FESENMAIER, Hélène (1937–)

*American painter and sculptor of predominantly abstract works who lives in England*

Born in New Ulm, Minnesota, Fesenmaier is one of the few artists who produces both painting and sculpture as an exploration of one idea. Her father was a surgeon and her mother studied at the Art Institute of Chicago. Both parents believed that to be an artist was something special, and for a while Fesenmaier rebelled against the pressure to take up art. She graduated in 1959 from Smith College, Massachusetts, and obtained her BFA at Yale University School of Art and Architecture two years later. During the 1960s she lived and worked in New York, where in 1964 with three other painters she formed the New York Studio School of Drawing, Painting and Sculpture. The following year she spent seven months painting in Holland, and later visited archaeological sites in Greece, Peru and the Yucatan. This experience made her return to the model, but during a year (1969–70) spent working in Caracas, Venezuela she had no access to models and so began building wooden constructions that she would then draw. After that year she moved to England, where she has lived ever since. She has exhibited regularly in Europe and America. From making drawings of sculpture, she began to incorporate the paint into the construction itself, so that the sculpture of the 1970s is not only painted, but canvases are part of the construction. On reflection she realised that this was a reaction against the dominance of the picture plane, and by taking the image off the wall, she

could include the wall as part of the construction. In 1979 she was commissioned by the Victoria and Albert Museum, London, to construct a sculpture to stand outside the museum during their exhibition *The open and closed book*. In the 1980s she has continued to explore the interplay between the media, as well as the problems of the imagery of the crucifixion. In 1985 she exhibited a paraphrase of Mathias Grünewald's altarpiece to which were attached wooden objects and tools. Through the awareness that Jesus Christ was a carpenter, crucified on a wooden cross made by other carpenters, she has come to depict and include the tools of her own trade in her work. Her approach is now even more oblique and subtle than such an analysis suggests.

*Examples:* Baltimore; Fitzwilliam Mus., Cambridge; Caracas; V & A, London; MOMA, New York; San Francisco.

*Literature: Artscribe*, July/Aug. 1985, 60–1; *4 American sculptors working in Britain*, University of East Anglia, Sainsbury Centre for the Visual Arts, Norwich, 1981; M. Gooding, 'Iconographies: Aitchison, Fesenmaier, Spero', *Art Monthly*, May 1987, 17.

## FINI, Léonor (1908/18–)

*Surrealist painter and, later, theatre designer and illustrator who lives in France*

Born in Buenos Aires to parents of Spanish, Italian and Argentinian descent, she was brought up from the age of two in Trieste. The evidence about her early years and arrival in Paris is chronologically contradictory, although there is agreement that while in her teens Fini decided to become a painter. Although her earlier formal education was spasmodic, not least because of her rebellious nature, she had visited many European museums in addition to those of Italy. Largely self-taught, she exhibited her early paintings in Trieste and Milan, where she received several portrait commissions and encountered other artists and writers, including De Chirico and Carrà. Their belief in the importance of an object beyond its physical appearance confirmed her own way of thinking. At some date between 1932 and 1936 she arrived in Paris and came to know the Surrealists. Although she shared their liking for the unconventional and was herself experimenting with automatic drawing, she refused to submit to the leadership of André Breton and to participate in group activities.

There were too many factors in their attitudes towards women that she could not countenance, nor could she accede to shared goals. Nevertheless she remained friendly with a number of individual Surrealists, including Leonora Carrington (*q.v.*), and exhibited with them from 1936. During World War II Fini was in France and, from 1942–7, in Italy, continuing to paint. Her works combine observation and precise rendering with an imaginary world. They often contain images connected with death, a phenomenon which did not frighten her, for in Trieste she had contemplated bodies in a mortuary, but which for her was attractive because of its stillness. Conversely she also felt aware of the latent power in decaying vegetation, symptomatic of the cycles of regeneration in nature. Recent writers have analysed her representation of women, which included priestess-guardians and sphinxes. Fini has rejected interpretations of her work as either separatist or lesbian, preferring an ambiguous sexuality, or the Surrealist reconciliation of opposites. From 1958 the surfaces of her works changed from their former smoothness to a more textured effect in all or part of the painting, and the predominantly female subjects became more enigmatic. After the war she returned to France, where she still lives. Her involvement with theatre design began during the war, and she abandoned the high fashion jewellery which she had designed and sold in the 1930s; over the years she also wrote poems and stories and produced illustrations.

*Literature:* Bachmann; W. Chadwick, *Women artists and the Surrealist movement*, London, 1985; *DWB*; *LF*, G Civica d'Arte, Bologna, 1983; Harris: Heller; E. Lauter, 'LF: preparing to meet the strangers of the New World', *WAJ*, v1/1, spring-summer 1980, 44–9; Petersen.

## FISH, Janet (1938–)

*American realist painter of transparent everyday objects*

Fish's mother was a sculptor and her grandfather a painter, so she always wanted to be an artist. Born in New England, Fish studied sculpture and printmaking at Smith College, Northampton, Massachusetts and proceeded to Yale University in 1960. Always tending towards realism, she found herself isolated because of the prevailing pre-eminence of abstraction, a situation which was exacerbated by her choice of so-called feminine subject matter. She changed to painting, and the grounding in

Abstract Expressionism she received has proved invaluable to her mature work. Marriage to another painter soon ended, but a second marriage to a non-artist also failed because she disliked the conventional domestic role and her husband disliked her success as an artist. Because of difficulties in finding models, she began to paint glass objects on her table and cellophane-packaged fruit from the supermarket. She was chiefly concerned with the play of light on surfaces. Gradually she set up more complex still lifes, on mirrors, glasses partly filled, views through the window seen through the glasses. Her Abstract Expressionist training reveals itself in the quality of paint on the picture surface and the way in which the marks can exist independently of the image. The complexity of coloured reflections and surface marks has increased in recent paintings. Although choosing domestic objects to paint, she is not seeking to make a social comment.

*Literature:* A. Ellenzweig, 'JF', *Arts Mag.*, Oct. 1976, 12; C. Nemser, 'Conversation with JF', *FAJ*, fall 1976, 4–10; L. Nochlin, 'Some women realists' in *Women, art and power, and other essays*, New York, 1988; Rubinstein; E. Tufts, 'The veristic eye', *Arts Mag.*, Dec. 1977, 142–4.

## FITZ-JAMES, Anna Maria. (alt. FITZJAMES) (*fl.* 1852–86)

*English painter of flowers and fruit*

Born in Bath, she came to London with her mother after the death of her father in the late 1850s. Having to find a means of earning her living she determined to become a teacher of art and, to this end, took lessons with the flower painters Valentine and Anne Bartholomew (*q.v.*). One of Fitz-James' paintings, which was displayed in order to attract pupils, found a purchaser in no less a person than the still life painter William Hunt, who asked to meet the artist. Only after they had been friends for two years did he consent to instruct her, as he had refused to take pupils in the past. About the time of his death in 1864 she sent her first works to the SWA. This proved a successful venue, bringing sales and commissions. In 1867 she was asked to make so many copies of one particular work that she requested permission from the owner of the original to have an edition of chromolithographs made. The fact that 200 copies at 10s 6d each were sold is indicative of the way in which artists could obtain useful income

from such editions. In the same year she met John Ruskin, who admired the texture of her fruit and predicted a brilliant future for her. Soon after this she was elected to membership of the SWA. From 1870 she was more occupied with commissions and with pupils, but continued to exhibit there until 1886.

*Literature:* Clayton; Wood, 1978.

## FLACK, Audrey (1931–)

*American photo-realist painter*

Like Janet Fish (*q.v.*) and other realist painters of the 1960s, Flack found that not only was it difficult to find appropriate teaching but also that her work was derided. Born in Washington Heights, New York, she won an award to take her to Cooper Union. By 1951 she had gone to Yale University at the invitation of Josef Albers, who was trying to attract the best students, but who failed to win Flack over to the cause of abstraction. Her realism remained muted in the interests of achieving her MFA, but on reverting after graduation she was scorned by her male contemporaries. She rejected abstraction on the grounds that it was not understood by most people, and took for her model the baroque woman sculptor, Luisa Roldan (1656–1704) whose statue of the weeping Madonna is carried round the streets of Seville followed by crowds of worshippers. Finding that she was inadequately trained for realist painting she enrolled at the Art Students' League, where Philip Pearlstein was a fellow student of realism. Flack did not remain in the studio with the model as he did, but depicted topical events such as anti-war marches and she was the only one openly to use a photograph, which happened to be one of the Kennedy assassination taken from a newspaper. Persisting on this route, she worked from projected slides and began to use airbrushes to gain the effect of the light on the canvas. In addition to portraits she began a series of still lifes depicting familiar and personal objects. These included jewellery, rich materials, lipsticks and playing cards. When analysed the pictures are a contemporary version of the Dutch *vanitas* paintings of the seventeenth century, in which the objects are symbols of the brevity of life and the triviality of human activity. Towards the end of the 1970s she painted Marilyn Monroe seen as representative of sexist attitudes to women, and *World War II*, which was based on a photograph of a concentration camp by Margaret

Bourke-White. It is her genuine involvement with what she paints that distinguishes her from the other photo-realists.

*Publications: AF on painting*, with introductory essay by A.S. Harris and L. Alloway, New York, 1981.

*Literature:* Heller; L. Meisel, *Photorealism*, New York, 1980; C. Nemser, 'AF: photorealist rebel', *FAJ*, v4/3, fall 1975, 5–10; Petersen; C. Robins, *The pluralist era*, New York, 1984; Rubinstein; E. Tufts, 'The veristic eye', *Arts Mag.*, Dec. 1977, 142–4.

## FLORENCE, Mary Sargant. née SARGANT (1857–1954)

*English painter of figure subjects and landscapes, murals in tempera; also active in the suffrage and peace movements*

Mary Sargant was one of six children of an eminent barrister, two of whom – Mary and Francis – would become artists. After private schooling, she studied at the Slade under Legros, and then in Paris with Merson. In 1888 she married an American musician, Henry Smyth Florence, returning to New Jersey, where a son and a daughter were born. She continued to practise art, exhibiting in New York in 1891, but the following year her husband died and she returned to England with her children. Thereafter she lived in Marlow, Buckinghamshire in a house which she designed and decorated. Little of her activity is recorded until 1910, except for exhibiting with the New English Art Club in 1894 and at the Pennsylvania Academy of Fine Art in 1898. From 1910 she exhibited with the former a series of working cartoons and tempera studies for fresco projects she had carried out. These included a series for Oakham Old School (1910), of which her brother Walter was the headteacher; a series of appropriate New Testament scenes for the school hall in Bourneville (1913); and four banners from a set of five depicting a fairy story (1916). The mural for which she is perhaps best known is that in Chelsea Old Town Hall. A competition for this was held in 1911, Mary Florence being one of four winners chosen from 66 entries. Her fresco depicted *Celebrities in Science, Religion and Politics* from the borough, one of the set subjects. It was executed in 1913–14 and is still *in situ*. It was about this time that she is documented as being active in the suffrage movement, although she may have been involved earlier. By 1913 she was a member of the

National Union, the Women's Freedom League and the Women's Tax Resistance League; she had also been 'twice sold up to protest against taxation without representation'. In 1915 she attended the Women's International Congress at the Hague as a member of the British General Committee. Her correspondence indicates pacifist sympathies. With C.K. Ogden, she wrote the pamphlet *Militarism versus feminism*. She also wrote on artistic matters, contributing a number of articles on colour theory to the *Cambridge Magazine*. More specifically she worked out a series of relations between colour and musical harmonies, and her ideas were finally drawn together in a book published in 1940. Meanwhile, she continued to exhibit her paintings, winning a medal at the Panama Pacific Exposition of 1915, and showing at the RA between 1930 and 1950.

*Publications:* Editor of *Papers of the Society of Painters in Tempera 1925–35*, v3, London, 1935/6; *Colour co-ordination*, London, 1940; co-author with C.K. Ogden and M.S. Marshall of *Militarism versus feminism* (1915), reprinted London, 1987.

*Examples:* Old Town Hall, Chelsea, London; Shakespeare Centre (formerly part of Oakham School), Oakham, Leicestershire.

*Literature: American Art Annual* vv. 1–7, 12, under Sargant Florence; *Who's Who in Art*; Wood, 1978.

## FOLEY, Margaret (1827–77)

*American sculptor of reliefs, portrait busts, idealised heads and a large fountain*

Born in Vermont, she became a teacher at her former school in Vergennes. In the early 1840s she joined the exodus to the textile mills at Lowell, Massachusetts, where there were lectures, concerts and a lending library, providing the only opportunity for many women to gain an education. While working in one of the mills, Foley carved wooden bobbins for the looms and contributed prose and poetry to a magazine which had been established by the enterprising women workers. By the mid-1840s Foley had moved to Boston, hoping to earn her living by carrying out portrait cameos; but after some time she returned to Lowell, where she could take in pupils. Finally in 1860 she had saved enough to travel to Rome, where she rented a studio not far from those of Hosmer and Lewis (*qq.v.*). There she made cameo-

portraits for tourists and for a series of notable sitters, including the poet Henry Longfellow, Julia Ward Howe (best remembered for writing the 'Battle hymn of the Republic'), the singer Jenny Lind and Senator Charles Sumner. She exhibited such medallions at the Dublin exhibition of 1865, the Paris Exposition of 1867 and at the RA. In London she also exhibited with the SWA. Parallel with these she developed her free-standing sculpture, including some ideal or historical characters. The fountain which she exhibited at the Philadelphia Centennial in 1876 was originally commissioned for an outdoor site in Chicago, but Foley released the commissioner after the widespread fire of 1871 and converted the design to an indoor setting. Her friendship with an English couple, William and Mary Howitt, was of mutual help and together they rented a house in the Tyrol during the summers, but Foley's health declined and she predeceased the elderly couple.

*Examples:* St Joseph's Hospital, Lowell, Mass.; Horticulture Center, W. Fairmount Park, Philadelphia; NMAA, Washington, DC.

*Literature:* AJ, 1878, 101–3; Bachmann; Rubinstein; E. Tufts, 'MF's metamorphosis: a Merrimack female operative in Neo-classical Rome', *Arts Mag.*, Jan. 1982, 88–95; Tufts, 1987.

## FOLLETT, Jean. née FRANCES (1917–)

*American assemblage artist who mainly uses discarded metal items*

Follett's training was in two phases: first in painting at the School of Art in her home town of St Paul, Minnesota from 1936 to 1940, and secondly study with Hans Hofmann in New York for four years from 1946, followed by a year in Paris with Léger and Zadkine. On her return to New York, she began to apply paint very thickly and to attach found objects to the paint. These might be wood, metal or string and varied considerably in size. The found objects then became predominant, arranged into fantastic and mechanical figures in black and white reliefs. She is credited with influencing John Stankiewicz, a fellow student at Hofmann's, in the use of junk objects for art.

*Examples:* Whitney Mus. and MOMA, New York.

*Literature:* T. Hess and E. Baker, *Art and sexual politics*, New York, 1973; Rubinstein; Watson-Jones.

## FORANI, Madeleine Christine (1916–)

*Belgian sculptor influenced by South American and African art*

Born in Arlon, Forani originally studied archaeology, but in 1942 entered the Academy of Art at Brussels in order to pursue sculpture under Marnix d'Haveloose. Her training was interrupted by internment by the Nazis in Dachau concentration camp, but she survived and in 1947 resumed her studies with Zadkine at the Académie de la Grande Chaumière in Paris. She first exhibited in Naples in 1949, and in 1953 she was a national prizewinner in the competition for the *Monument to the Unknown Political Prisoner*. The following year she travelled to what was then the Congo (now Zaire), where she was struck by the power of the indigenous sculpture. She subsequently visited both North and South America, where she pursued this interest in non-Western art.

*Literature:* G. Carandente *et al.*, *Knaurs Lexikon der modernen Plastik*, Munich and Zurich, 1961; Krichbaum.

## FORBES, Elizabeth Adela. née ARMSTRONG (1859–1912)

*Canadian-born painter of rural genre who depicted scenes of the fishing community at Newlyn, Cornwall*

Born in Ottawa, Elizabeth Armstrong was the only daughter of a government official who died when she was a young girl. She came to England at the age of ten with her mother, living with an uncle in Chelsea. Part of her education took place at the South Kensington School of Art, before she and her mother returned to Canada. At 18 she visited friends in America and decided to study at the Art Students' League in New York for two or three years. It was here that she encountered artists such as William Merritt Chase, who had studied in Europe and admired the *plein-air* painters of rural scenes such as Millet and Bastien-Lepage. Subsequently she and her mother travelled in Europe, staying principally in Munich and, more importantly for her subsequent work, Pont-Aven in Brittany in 1882. Her first exhibited works were seen in London in 1883. In 1884–5 she divided her time between London, to which she was recalled by her uncle but found uncongenial, and Zandvoort, near Haarlem, where she spent the summer of 1884 with Chase and his students. It was here that she

carried out many of the drawings she later worked out in drypoint back in London. Some were exhibited in 1885 at the RA and the Royal Society of Painter Etchers, and were done before Armstrong and her mother settled in Newlyn in the autumn of 1885. Since there were no printmaking facilities there, any subsequent etchings had to be printed in London. This aspect of her work had brought her into contact with Sickert and Whistler, but this was a friendship of which Stanhope Forbes did not approve. She had met Stanhope soon after her arrival in Newlyn, and one source states that within three months they were engaged. This relationship might therefore explain the cessation of her printing activity after 1886, since it necessitated contact with the two men who Stanhope Forbes disliked. If this is so, her output was restricted by the prejudice of her fiancé. Nevertheless until their marriage in August 1889, Armstrong spent time in London and St Ives, but became well liked by all the Newlyn artists. Elizabeth had a mobile studio made for her to enable her to paint out of doors in the less clement weather. She always preferred to execute the painting outside rather than working it up in the studio from sketches. Her works done after her second Breton visit of 1891 reveal a broader brushstroke. Her son Alec was born in 1893, but her output continued unabated. Her earliest exhibited works had included children and she soon realised that she had a particular facility for this subject. It recurs in a variety of media, providing the basis for two solo shows in London on this theme in 1890 and 1904. These contributed towards her election as an Associate member of the Royal Watercolour Society. In 1899 she and her husband opened a school of painting in which they both taught. This attracted a succession of students, many of them women, who formed the basis of the second generation of the Newlyn School. Elizabeth Forbes was also involved in a number of literary activities; she published two articles for the *Studio* and wrote and illustrated a children's book. She also composed poetry, and edited a magazine called *The Paperchase* for two or three issues in 1907. She successfully combined marriage, a child and an artistic career, which all early critics stressed was important in its own right, not because she was a woman or Stanhope Forbes' wife.

*Publications:* 'On the slope of a southern hill', *Studio*, 1900, v18, pp. 25–34; *King Arthur's wood*, London, 1904.

*Examples:* V & A, London (prints); Manchester; Orion G, Newlyn; Wolverhampton.

*Literature:* Mrs Lionel Birch, *Stanhope A. Forbes and Elizabeth Stanhope Forbes*, London, 1906; Gladys B. Crozier, 'ESF.' *AJ*, 1904, 382–4; C. Fox and F. Greenacre, *Artists of the Newlyn School 1880–1900*. Newlyn G, Newlyn, 1979; C. Fox and F. Greenacre, *Painting in Newlyn 1880–1930*, Barbican G, London, 1985; *The last romantics: the romantic tradition in British art: Burne-Jones to Stanley Spencer*, Barbican G., London, 1989; F. Wedmore, *Etching in England*, London, 1895; *Who's Who 1912–13*; C. Wood, *Victorian Panorama*, London, 1976.

## FORTESCUE-BRICKDALE, E. See BRICKDALE, Eleanor

## FOX, E. See BRIDELL-FOX, Eliza

## FRANCIS, M. See THORNYCROFT, Mary

## FRANK, Mary. née LOCKSPEISER (1933–)

*American sculptor in wood and clay, and printmaker*

Frank was born in London, the daughter of painter Eleonore Lockspeiser and, because of the outbreak of war, they went to America in 1940, leaving her music critic father behind. In 1949 she studied at Martha Graham's studio and with Max Beckmann. On a visit to Paris in 1950 to see her father she met her future husband, the photographer Robert Frank, and lived in several European countries for short periods. Her son was born in 1951 and her daughter in 1954. Back in New York, she attended Hofmann's School and by the mid-fifties began to carve abstract wood pieces. During summers spent at Cape Cod, she drew dunes and bird figures inspired by the sight of people lifting their arms when in the sea. From these she went on to produce small bronzes of buds unfolding, flowers and tree shapes. She returned in the late 1960s to the theme of the sea-shore in plaster sculptures built up in slabs to represent the waves. Soon after she separated from her husband in 1969, she turned to clay, a material which her mother had also used. From this change of medium came a series of ideas for which she often had to invent the necessary techniques. The scale of her works became larger and she felt confirmed in this by the discovery of

the terracotta army in China in 1974. Using clay slab constructions, she produced hollow figures or reliefs, many of women. The death of her daughter in an air crash resulted in a more powerful imagery, and each work encapsulates an experience or a sensation. She now lives in the Catskills with her partner and has a young son. She has exhibited consistently in many solo and group shows since 1960.

*Examples:* Akron; Art Inst, Chicago; Kalamazoo, Mich.; Storm King Art Center, Mountainville, NY; Whitney Mus., Metropolitan Mus. and MOMA, New York; Worcester, Mass.

*Literature:* Munro; Watson-Jones.

# FRANKENTHALER, Helen (1928–)

*American Abstract Expressionist painter*

Now a well-known and documented figures, Frankenthaler has not always received full credit for her influential role in American abstract art. She was the youngest of three daughters, her parents being talented and motivated towards encouraging their children. Her father, who was a judge in the New York Supreme Court, died when she was 11. She studied art at Bennington College, Vermont, under Paul Feeley, taking jobs in the art world during vacations. She then returned to New York and studied art history at Columbia University. At this time Abstract Expressionism was dominant and Frankenthaler entered the art world through meeting the critic, Clement Greenburg. He introduced her to John Myers, whose gallery showed the work of Larry Rivers, Grace Hartigan (*q.v.*) and others painting figures in a loose Abstract Expressionist style. She had her first show in 1951, at a time when she was mixing with the circle of artists around Greenberg and had visited Pollock and Krasner (*q.v.*). It was her painting *Mountains and sea* of 1952 which marked the start of her new technique of staining the unprimed canvas. She worked on the floor with paint often thinned to the consistency of watercolour and, using a variety of implements, pushed and poured the paint. This technical breakthough gave her the freedom of the watercolour painter to record the gesture. The edges of some forms are allowed to bleed into the next shape, while others are controlled. Frankenthaler has always accepted the accidental in her works. The earlier works are more calligraphic in that there are more marks applied to them rather than simply areas of stained canvas. In 1958 she married painter Robert Motherwell and took on the care of his daughters. When Maurice Louis and Kenneth Noland saw *Mountains and Sea*, they realised its importance in opening up new possibilities, but the critical response remained poor until Frankenthaler won first prize at the Paris Biennale. Within a year she had a major solo show in New York, was one of four artists representing America at the Venice Biennale in 1966 and at the Montreal Exposition in 1967, and was accorded a full retrospective at the Whitney Museum in 1969. Divorced in 1971, she tried a variety of other media during that decade while continuing with her painting, which became more controlled and even symmetrical for a brief period. Despite her abstract aims the completed works may suggest a subject which leads to the title. Recent works are larger and inspired by visits to the West coast. These are executed in thicker paint of a paste-like consistency which is applied with rollers and produces drips and lines which enhance the resemblance to rocky cliffs. Frankenthaler herself says she is searching for new levels of meaning in her art.

*Examples:* Whitney Mus., New York; Hirschhorn, Washington, DC.

*Literature:* Bachmann; *DWB*; Fine, 1978; *HF*, Whitney Mus., New York, 1972; Heller; Munro; B. Rose, *HF*, New York, 1970; Rubinstein; Withers, 1979.

# FRASER, Laura. née GARDIN (1889–1966)

*American sculptor who was a distinguished medallist and who also produced large-scale sculpture and fountains, often of animals*

Daughter of the watercolourist, Alice Tilton Gardin, who also founded an art school, Laura Gardin was born in Chicago. She studied at the Art Students' League, New York, from 1907 to 1911, and in 1913 married her tutor, James Earle Fraser. They evolved a very successful partnership from their studios in Westport, Connecticut, and during World War I, Laura Fraser was a captain in the Ambulance Service Motor Corps. In 1916 she won the first of many major awards, the Barnett prize of the NAD. Her sculptures are often of animals, including racehorses and polo ponies, some of the smaller statuettes being for trophies, and others of heroic size for outdoor sites. Despite these achievements she became best known as a medallist, and received commissions and won

competitions to execute many commemorative ones, including the George Washington Bicentennial medal, the Morse medal for the American Geographical Society, that for the centenary of the American Numismatic Society, and the coinage for the Philippines in 1947. Her medals are distinguished by their sense of design and fidelity to the subject. Despite her many commissions she also exhibited the other works she produced, including some with the National Association of Women Painters and Sculptors. Her last work, unveiled in the year of her death, was three bronze panels on the history of America for the US Military Academy, West Point. Her outstanding contribution in her field was recognised by election to the NAD, the National Sculpture Society and the National Institute of Arts and Letters.

*Examples:* Wyman Park, Baltimore; Brookgreen Gardens, SC; Delaware Park, Buffalo; T. Roosevelt Bridge and Corcoran G, Washington, DC.

*Literature:* J. Lemp, *Women at work*, Corcoran G, Washington, DC, 1987; Proske, 1968; Rubinstein.

## FREYTAG-LORINGHOVEN, Else von. (Baroness) (1874–1927)

*German Dada artist and poet active mainly in New York*

Such an eccentric character as Freytag-Lorinhoven should not strictly be categorised. Born in Swinemünde in Germany, of a noble family, she married the German Baron von Freytag-Lorinhoven and they arrived in New York early in 1914. At the outbreak of war the baron, who was a pacifist, returned to Germany but committed suicide soon afterwards. Bored with her existence, Freytag-Lorinhoven began to model for artists, including Henri, Bellows and Glackens, and as her money ran out she found the needed this income. She mixed with the avant-garde artists and writers; she was a friend of Marcel Duchamp, poet William Carlos Williams and writer Djuna Barnes. She began to make collages and assemblages out of scrap materials. Of the two that survive, one is a portrait of Duchamp. From 1918 her poems were published in *The Little Review*, edited by Margaret Anderson. She observed no conventions in any aspect of her life and became well known for her idiosyncratic dress, which was featured in the publication *New York Dada* with such examples as her shaved head, painted red, on which was placed an inverted coal scuttle. Other hats were frequently trimmed with fruit, vegetables and

candles. In 1923 she returned to Berlin, for she had tired of New York, but her money had vanished with inflation and the rest of her life was spent in great poverty. At one stage she was reduced to selling newspapers in the street. Some Parisian friends took pity on her and installed her in a flat there, but she died of gas poisoning one night in 1927.

*Example:* MOMA, New York.

*Literature:* G. Biddle, *An American artist's story*, Boston, 1939; A. Churchill, *The improper Bohemians*, NY, 1959; J. Flanner, *Paris was yesterday*, New York, 1972; M. Josephson, *Life among the Surrealists*, New York, 1962; Vergine.

## FRINK, (Dame) Elizabeth (1930–)

*English sculptor of male figures and heads in bronze*

Frink is one of the most eminent sculptors in Britain today. Born in Thurlow, Suffolk, she trained at Guildford School of Art in 1947 and then from 1948 to 1951 at Chelsea School of Art, where one of her tutors was Bernard Meadows, who had been Henry Moore's assistant. Her early works were predatory birds and warrior figures with rough, craggy surfaces, which quickly brought her recognition. She had her first solo show at the age of 21, and in 1953 was one of the national prizewinners in the international competition for the *Monument to the Unknown Political Prisoner*. Her work has tended to evolve through certain themes, so the *Warrior* heads gave way in 1967 to the *Goggle heads*, sinister and aggressive, wearing goggles to conceal their identity. The male figure, and certain animals such as the horse, have also been constant themes. Frink works by applying plaster soaked cloths to a wire armature. In this way she can work quickly, as she prefers, and control the surface of the finished bronze. Over the years her surfaces have become smoother and the bronze is actually filed down. In between phases of sculpture, Frink produces drawings and lithographs, notably of wild horses and their riders in the Camargue, where she lived from 1967 to 1973 and where she kept a horse. She has received many commissions for site-specific sculpture, including religious works, since 1957 and was given a major retrospective at the RA in 1984.

*Examples:* Lectern, cathedral, Coventry; Kennedy Memorial, Dallas, Texas; altar cross, Catholic cathedral, Liverpool; Tate G, Dover St and Paternoster Square, London; Alcock and Brown memorial, air-

port, Manchester; MOMA, New York; St Mary's church, Solihull; Hirschhorn Mus., Washington, DC.

*Literature*: S. Kent, B. Robertson *et al.*, *EF sculpture: catalogue raisonné*, Salisbury, 1984 (bibl.); Nottingham, 1982; Parry-Crooke.

## FRISHMUTH, Harriet Whitney (1880–1980)

*American sculptor of bronze figures in motion*

Born in Philadelphia, but brought up in Europe, Frishmuth settled in Paris with her mother in 1900, where she studied briefly with Rodin and Injalbert. Between 1902 and 1904 she worked as an assistant to Professor von Euchtritz, before returning to America and enrolling at the Art Students' League, New York. Her early work, mainly small functional objects such as bookends, was exhibited in Paris and America from 1903. Her first important commission, a portrait, came in 1910, but it was the depiction of dancers, male and female, which was to provide the key to her development of a series of lyrical figures. Using professional dancers as models she selected poses which showed the transition from one movement to the next. Whether they were statuettes or nearly life-size, all show a joyous vitality which made them popular with patrons and won for Frishmuth many prizes and awards throughout her long career. These included full membership of the NAD and the National Sculpture Society.

*Examples*: (Most sculptures exist in editions of varying sizes) Brookgreen Gardens, SC; Albright-Knox G, Buffalo, NY; Dayton, Ohio; Metropolitan Mus., New York; Rochester, NY.

*Literature*: C. Aronson, *Sculptured hyacinths*, privately printed, n.d.; M. Hill, *The woman sculptor: Malvina Hoffman and her contemporaries*, Berry-Hill G, New York, 1984; Proske, 1968; R. Talcott, 'HWF' *Nat. Sculpture Review*, v29, 1980, 22–5.

## FULLER, Lucia. née FAIRCHILD (1870–1924)

*American painter of portraits and figure subjects, best known for her miniatures*

Her first training in art took place at the Cowles Art School in her native Boston, but from 1889 she studied under W.M. Chase at the Art Students' League, New York. By 1893 she was sufficiently well known to receive a commission for one of the four smaller murals for the Women's Building at the Chicago Exposition. In the autumn of that year she married Henry Fuller, who was also a painter but who never achieved the prominence of Lucia. Two children were born in 1895 and 1897, but Lucia and her husband lived increasingly separate lives. Although she painted in several media and sizes, her reputation was obtained through her miniatures of portraits and figure compositions painted in watercolour on ivory. With three other artists who independently had revived this form of art, she founded in 1899 the American Society of Miniature Painters and succeeded in gaining for it the approval of the larger art institutions. In the same year she was among the first women elected to the American Society of Painters, and in 1906 she became an Associate of the NAD. She won medals at the Paris Exposition of 1900, the Buffalo Exposition of 1901, and two gold medals at the St Louis Exposition of 1904. Her membership of two New York suffrage societies is also recorded, reflecting the independent spirit which informed all her undertakings. However, while in her mid-thirties she was stricken with multiple sclerosis and her activities became increasingly curtailed.

*Publications*: 'Modern American miniature painters', *Scribner's*, v67, Mar. 1920, 381–4; 'Frances Grimes', *Arts & Decoration*, v14, Nov. 1920, 34, 74; 'The miniature as an heirloom', *Arts & Decoration*, May 1922.

*Literature*: Clement; M. Elliott; *Notable American Women*; Rubinstein; Weimann.

## FULLER, Meta Vaux. née WARRICK (1877–1968)

*American figurative sculptor dealing particularly with black aspirations and a concern for humanity*

Meta Warrick, who was the youngest of three children, was introduced to art through her father. Both parents, who ran several successful barber's and hairdressing shops in Philadelphia, encouraged her, and in 1894 she won a scholarship to the Pennsylvania School of Industrial Art. Her relief of 37 figures won her a year's postgraduate study. She went to Paris in 1899, where she stretched her limited financial resources to a stay of several years, studying first at the École des Beaux-Arts, then the Académie Colarossi, and

receiving encouragement and advice from Rodin. Her works of this period have a strong religious or moral content. She returned to Philadelphia, but racial prejudice denied her success until 1907, when a commissioned work for the Jamestown Tercentennial exhibition, containing 150 figures on the theme of the advance of black people in America, won a gold medal. Marriage to Dr Solomon Fuller in 1909 and the birth of three sons at their Framington home reduced her output, although it was at this time that she began to use Afro-American models. Her career continued for another 50 years, with her later prolific output more restrained than her early work. Surmounting personal difficulties, which included nursing her husband through his final illness and contracting tuberculosis, she continued to work until well into her eighties, receiving many awards.

*Examples:* Mus. of Afro-American history, Boston; Cleveland, Ohio; Library and Union Hospital, Framingham; Schomberg Center, and New York Public Library, New York.

*Literature:* S. Dannett, 'MWF.', *Profiles of Negro womanhood*, v2, 1966; Fine, 1973; *Notable American Women*; Petersen; J. Porter, *Modern negro art*, (1943) 1969; Rubinstein.

## FULLER, Sue. née Caroline Susan FULLER (1914–)

*American sculptor making geometric constructions with thread in transparent plastic forms*

When Fuller became a painting student at the Carnegie Institute in her home town of Pittsburgh in 1932, she won prizes for her American Scene watercolours. It was only on a visit to the Degenerate Art exhibition put on by the Nazis in Munich in 1937 that she suddenly became fully aware of modernist developments in Europe. Back in New York she joined the experimental printmaking workshop, Atelier 17, and through teaching children's classes at the Metropolitan Museum she met Anni Albers (*q.v.*), whose weaving rekindled Fuller's dormant interest in thread, which she had inherited from her mother. After incorporating threads into prints, she made her first construction on a frame of wooden pegs in 1946. Technical problems with both string and frame led to lengthy research, at times funded by awards, and in the end to completely new techniques. By 1960 she was using polypropylene thread around

which translucent plastic was poured. She sees her string curves as 'linear geometric progressions . . . [the] visual poetry of the infinity in the space age'. She has exhibited extensively since 1951.

*Examples:* Art Institute, Chicago; Tate G, London; Metropolitan Mus., Guggenheim Mus., Whitney Mus. and MOMA, New York; St Louis.

*Literature:* R. Browne, 'S.F.: threading transparency', *Art International*, v16/1, Jan. 1972, 37–40; Rubinstein; Watson-Jones.

## GABAIN, Ethel Leontine. (alt. COPLEY) (1883–1950)

*English lithographer and painter of portraits and figures, notably of women; a war artist*

Born in The Hague to English parents, Gabain trained at the Central School of Arts and Crafts and at the Slade. She was exhibiting at the RA by 1908 but seems to have first attracted attention as a lithographer. She pursued her studies in Paris in 1909. After her marriage in 1913 to artist John Copley she had joint exhibitions with him for a number of years. Critics were quick to contrast 'her feminine elegance' with his 'masculine force and intensity'. From 1927 she began to acquire a reputation for her oils, many of which included women with wistful, even melancholy expressions. A series of portraits of famous actresses in character included Flora Robson as Lady Audley, for which Gabain was awarded the De Lazlo silver medal in 1933. She was elected to membership of the Royal Society of British Artists (1932), the Royal Institute of Painters in Oils (1933) and was vice-president of the SWA. Appointed as an official war artist in 1940 she was first sent to draw evacuees from the East End of London as they left the capital's railways stations and also in their rural foster homes. Subsequently she produced lithographs of working women, but, unlike other women artists such as Evelyn Dunbar (*q.v.*), Gabain depicted them in traditionally male occupations. She travelled the country in order to gather material for women working as ferry pilots and lumberjacks or clearing bomb damage and filling sandbags. The commission for such works resulted partly from the introduction of conscription for women and partly from the desire of Lady Norman, who was in charge of the women's work section of the War Artists' Advisory Committee, to make women's increased participation more evident. In 1944 Gabain also contributed to the medical

records by depicting the precise technique of a particular treatment for burns. She continued to exhibit until 1949 and, as a member of WIAC, her work was shown posthumously in their jubilee exhibition in 1950.

*Examples:* Kupferstichkabinett, SMPK, Berlin; Imperial War Mus., London; Manchester; Sheffield.

*Literature:* M. & S. Harries, *The war artists*, London, 1983; *Paintings and drawings by some women war artists*, Imperial War Mus., London, 1958; Waters; *Who's Who in Art.*

## GARDNER, Elizabeth Jane. (alt. BOUGUEREAU) (1837–1922)

*American-born painter of religious, allegorical and genre subjects who worked in Paris*

Born in Exeter, New Hampshire, Gardner had a traditional education, but was inspired by one of her teachers, Imogene Robinson, to accompany her in order to study art in Europe. They set off in 1864, but when Gardner arrived in Paris she found that none of the academies accepted women as pupils. Undeterred she decided to adopt male attire, for which she, like Bonheur (*q.v.*), required a permit from the chief of police; and thus disguised she enrolled at the government School of Drawing at the Jardin des Plantes, and later at the Gobelins Tapestry School. As a result of her deception she obtained the same training as the male artists, with no concessions made for the fact that she was female, as happened when the academies accepted women. Gardner maintained that it was through the intervention of her teacher, the academic painter William Bouguereau, that the Académie Julian finally opened its doors to women, closely followed by other private ateliers. Soon the first four female students at Julian's were joined by many others. Gardner was the first American woman to exhibit in the Salon (1866) and to win a medal (1877). Her traditional smoothly modelled paintings were close in style to the work of Bouguereau, but she avoided his sensual nudes. Two of her paintings won medals at the Philadelphia Centennial of 1876, another at the Paris Exposition in 1889, and her *Soap bubbles* was one of the most frequently reproduced works from the Chicago Exposition in 1893. Gardner and Bouguerau, a widower with two children, fell in love but, because of the objections of his mother they did not marry until after she had died in 1896, when

Gardner was 58. Surprisingly she then ceased painting, but resumed her output of four paintings a year in 1905, when Bouguereau had died, until rheumatism eventually slowed her down. During World War I she spent most of her time helping French soldiers. Although she was a contemporary of Cassatt (*q.v.*), Gardner's style and content remained firmly in the academic tradition and her paintings commanded high prices.

*Examples:* Philbrook Art Center, Tulsa, Okla.

*Literature:* Clement; M. Elliott; *Fair Muse*; M. Fidell-Beaufort, 'EJGB: a Parisian artist from New Hampshire', *Archives of American Art J*, v24/2, 1984, 1–7; Rubinstein; Tufts, 1987; Weimann.

## GARRARD, Rose (1946–)

*English feminist performance artist who also produces associated painting and sculpture*

Born in Bewdley, Worcestershire, Garrard studied at Birmingham Polytechnic and Chelsea School of Art from 1966 to 1970, when she obtained a scholarship to study at the École des Beaux-Arts, Paris, for a year. Producing fibreglass figures, she began exhibiting as early as 1967. The desire to make images of herself which were positive led to an 18-month respite in 1972–3, after which a flow of highly imaginative works appeared, in which she used a wide variety of media, including video, sound tapes, and live performance. Using autobiographical material as a starting point, she employs narrative and myth to explore both the personal and the social, particularly as they affect women and women artists. Recurring images of a bird, a gun, a statuette of the Madonna and Child, all significant objects in her childhood, are incorporated into the broken frames of reworked self-portraits by four women artists from the past (*Frameworks*, 1983). Incidents from her life are transformed into narratives of patriarchy in order to demonstrate the need for new, positive, models for women. She deconstructs traditional male prerogatives of power and creativity in, for example, an exploration of the Pandora myth. She has exhibited and performed throughout Britain and in Europe, and has been awarded several residencies.

*Literature: About time*, ICA, London, 1980; *Conceptual clothing*, Ikon G, Birmingham, 1987; S. Eiblmayr, V. Export & M. Prischl-Maier, *Kunst mit Eigen-Sinn: Aktuelle Kunst von Frauen*, Vienna & Munich, 1985; *RG: between ourselves*, Ikon G, Birmingham, 1984.

## GARWOOD, Tirzah. née Eileen Lucy GARWOOD. (alt. RAVILIOUS) (1908–51)

*English artist best known for her wood engravings*

She gained her unusual name by being the third child of four and nicknamed Tertia, which was misheard by a grandmother. Her father was an army officer and the family were comfortably off. Born in Gillingham, Kent, but brought up in East-bourne, she began to attend the local school of art at the age of 17, where for the last two years she concentrated on wood engraving under Eric Ravil-ious. Although she was exhibiting with the Society of Wood Engravers from 1927, Ravilious' contacts gained her commissions from the BBC and various publishers. After Eastbourne, she attended the Central School of Art and Design, but in 1930 she married Ravilious and her career took second place to his. In 1932 they moved to Essex to share a house with artists Eric and Charlotte Bawden, where Tirzah helped the latter to design and make marbled papers. She had three children but dis-liked domesticity. She returned to art after Eric was lost on a mission as a war artist in 1942, and not long afterwards underwent a mastectomy. The last eight years of her life were very productive and after her remarriage in 1946 and a move to Hampstead, she made many collages. In the last year of her life she completed 20 small oil paint-ings. She was a keen observer and many of her engravings were humorous observations of social quirks.

*Literature*: A. Ullmann, *The wood-engravings of TR*, London, 1987.

## GAUDRIOT, Michele (1955–)

*French abstract painter*

Gaudriot is Parisian by birth, her mother being a teacher, her father a cartographer. It was he who introduced her to sketching as a child, and when she left school she was torn between enrolling at the École des Beaux-Arts and pursuing literary studies. In the end she read English and taught for several years at the University of Paris. During this time she continued to paint, initially in water-colour and pastel, then turning to oil. She travelled widely in Europe and America from the mid-1970s, visiting museums. When she began to exhibit her dynamic, brightly coloured canvases, they received considerable acclaim, to the extent that she was able to give up her teaching post in favour of full-time painting in 1984.

## GILDER, Helen. née DE KAY (1848–1916)

*American painter of portraits, still lifes and figure subjects who was instrumental in encouraging the education and practice of women artists*

At first a private pupil of Winslow Homer and John La Farge, she later enrolled at the Cooper Union and the NAD, where in 1871, she and her friend, Maria Oakey (*q.v.* under Dewing), attended the first life-drawing class open to women. The two then shared a home and a studio, much to their parents' displeasure, until de Kay's marriage in the later 1870s to Richard Gilder, a poet and editor of *Scribner's* and *Century* magazines. Toge-ther they exerted considerable influence on literary and artistic taste in America in the late nineteenth century. Their New York home became a rende-vous for artists returning after a period of study in Europe, and for others including Cecilia Beaux (*q.v.*) and Mary Foote. As a result they were in a position to organise an alternative to the academic tradition of the NAD, and in 1877 formed the Society of American Artists, among whose aims was the express intention of encouraging women artists. Two years earlier, Helen Gilder was one of the founder members of the Art Students' League, which was to be a focal point for the training of many women. Initially there was a majority of women on the board of control, but the pro-portion diminished later. Ironically, Gilder's own artistic production was severely curtailed by family responsibilities.

*Literature*: C. Beaux, *Background with figures*, Boston, 1930; C. Clement and L. Hutton, *Artists of the nineteenth century*, 1879; *Nineteenth-century American women artists*, Whitney Mus. (downtown branch), New York, 1976; Rubinstein.

## GILES, M. See JENKIN, Margaret

## GILI, Katherine (1948–)

*English sculptor of figure-based pieces in forged metal*

Born in Oxford, Gili spent four years at Bath Academy of Art (1966–70) and then attended the advanced course at St Martin's School of Art in London (1971–3). Characteristic of the latter course

at that time was an emphasis on abstract sculpture which was constructed rather than carved or moulded. After seeing the sculptures of Matisse and Gonzales on a visit to Paris, she began to experiment with the manipulation of steel, turning also to using pieces of plate steel which lent themselves to this treatment. By the late 1970s Gili, along with other ex-St. Martin's students had become dissatisfied with the self-referential nature of metal sculpture and its reliance on aspects such as outline, which derive from painting. Gili then began to use heavier pieces of steel, instead of sheets, and to make dense, compact sculptures which did not disguise their actual weight, instead of spreading forms which appeared deceptively light. Through looking at earlier examples of figurative sculpture, Gili realised the potential of returning to the figure as a subject. Using active movements of the model as the source, she began to produce a series of sculptures in forged steel. During this process the steel is heated until yellow, removed and beaten, twisted and manipulated in three dimensions while it is still malleable. Separate pieces of steel have to be forged together, under these conditions, to make a coherent whole. Gili works closely with her model, seeking to retain the dynamism of the original movement in the final work. She has exhibited since 1973.

*Literature: Hayward Annual 1979*, Hayward G, London, 1979; V. Knight, *Have you seen sculpture from the body?*, Tate G, London, 1984.

## GILLESPIE, Dorothy Merle (1920–)

*American sculptor using ribbons of brightly painted metal*

Born in Roanoke, Virginia, she was the second daughter in a family of four children. Her father, who worked in industry, realised her artistic talent and her intellectual precociousness. While reading an encyclopaedia she discovered Rosa Bonheur (*q.v.*), who became her role model. From 1938 to 1942 she attended a commercial art course at Maryland Institute of Art, and then in 1943 she achieved her childhood ambition of settling in New York. She enrolled at the Art Students' League and studied etching with Hayter. The paintings from this period are now lost, but from the artist's description they were thickly painted, highly coloured, semi-figurative compositions. Her marriage in 1946 to restaurant owner Bernard Israel, who

has always been supportive, and the birth of three children, reduced the time available for painting, although once the children were at school she was able to work through the day. However, she always believed in the importance of financial independence and took various paid jobs as an art director in industry, teaching and lecturing. She also designed several restaurant interiors. During these years her paintings became abstract and were often based on a few geometric shapes, while the titles and colours indicated landscape. She began to take her paintings off the wall by constructing wooden cubes with each side a painting. Several of these could then be stacked or arranged in a variety of ways. By 1966 she had started to cover the surfaces with mylar (a material developed for satellites), which is light, reflective and immensely strong. An exhibition that year consisted of many variations on the American flag, with appropriate background music and photographs. Through cylindrical forms she came to work with large rolls of paper, with fabric, and with metal covered by mylar. It is this last combination which enabled her to produce the ribbon-like brightly coloured pieces which, although they hang on the wall, are fully three-dimensional. From the early 1970s Gillespie was active in the women's art movement, working particularly for the Women's Interart Center in New York and curating a series of exhibitions of women artists. She has also completed several mural commissions. She has received a number of honorary awards for her contributions to these activities.

*Examples:* Birmingham, Ala.; Darmstadt, W. Germany; Fort Wayne, Ind.; Huntsville, Ala.; Newark, NJ; Guggenheim Mus., New York; Raleigh, NC; Roanoke, Va.

*Literature:* G. Bolge, 'The painting/sculpture connection', *WAJ*, v3/2, fall 1982–winter 1983, 54–6; N. Edgar, 'DG', *Arts Mag.*, v52/3, Nov. 1977, 23; A. de Lallier, 'DG: the shape of festivity', *WAJ*, v3/2, fall 1982–winter 1983, 49–54; V. Rembert, DG's way: the past encountered', *Arts Mag.*, Oct. 1981, 148–53; V. Rembert, 'DG', *Arts Mag.*, Apr. 1983, 8; Watson-Jones.

## GILLIES, Margaret (1803–87)

*Scottish painter of domestic and literary genre scenes in watercolour, portraits and miniatures*

Born in London, she was the third daughter of a Scottish merchant. Her mother's health was poor

and she died when Gillies was eight. Shortly afterwards her father lost his money, so Margaret and her sisters were adopted by their uncle Lord Gillies, an eminent judge with no children of his own. In this way they grew up mixing in literary and artistic circles. They had continued to visit their father in London and, when he remarried, Margaret and her sister Mary decided to rejoin him and make careers for themselves. The eldest sister had married and settled in India. Mary became a writer and Margaret began to study art about 1820 with Frederick Cruickshank. She began by executing portrait miniatures as a reliable way of securing an income and through her Edinburgh contacts she obtained many commissions. Beginning in 1839, she painted several portraits of William, Mary and Dora Wordsworth, staying with them at Rydal Mount, Cumbria. They remained good friends for a number of years. She sent her first portrait to the RA in 1832 and over the next 29 years exhibited 101 paintings there. Some 46 of these were shown between 1841 and 1851, among them one of Charles Dickens (1844). In 1844 engravings were published of some of her portraits of literary figures, including Wordsworth, Dickens and Harriet Martineau. During this decade she also began to produce subject pictures, and it may have been her desire to increase her output in this direction which led her in 1851 to study under Ary and Henri Scheffer in Paris for a short period; she certainly exhibited fewer and fewer portraits after this visit. In 1852 she became a lady member of the Old Watercolour Society and began exhibiting more widely. She sent two works to the Paris Exposition of 1855, and contributed to the SWA from 1858. By this time she was renowned for her painting and remained so when Clayton was writing in 1876. Her increasing number of genre scenes, whether based on literature or observation, enhanced her popularity. In about 1859 Gillies returned to Scotland and visited the Isle of Arran, which became the setting for many scenes of rustic genre among her later works. She travelled widely in the 1860s, and this is reflected in the travel sketches from Florence, Ireland, France, and the Isle of Wight as well as Arran, which make up the greater part of her output in these years. In 1870 her sister, with whom she had lived throughout her life, died. Despite her age, Margaret continued to travel and paint, exhibiting her last work in the year of her death. Yeldham states that an analysis of her subject matter, apart from portraits, reveals a passionate interest in women, whether they were peasants, middle class, literary or historical figures, and the dominant mood was one of sorrow.

*Examples:* British Mus., Nat. Portrait G, and V & A, London.

*Literature:* D. Cherry, *Painting women*: *Victorian women artists*, Art G, Rochdale, 1987; Clayton; *DNB*; M. Howitt, *An autobiography*, London, 1889, v2; P. Nunn, *Victorian women artists*, London, 1987; *The Times*, 26 July 1887 (obit.); Yeldham.

## GINESI, Edna (1902–)

*English painter of landscapes, crowds at leisure, and flowers*

Ginesi studied first at the College of Art in Leeds, the city where she was born. There she was a friend and contemporary of Barbara Hepworth (*q.v.*). She proceeded to the Royal College of Art, from 1922 to 1924, and in her final year she won a travel scholarship which enabled her to visit Holland, Belgium, France and Italy. In 1926 she married Raymond Coxon, but continued to exhibit in London, the provinces and abroad. She was given her first solo show in 1932, and became a member of the London Group in 1933. In addition, in 1931–2 she designed sets for the Camargo ballet. She continued to travel in Europe and visited America, where she also exhibited. She was in Spain during the civil war and served as an ambulance driver in World War II. In the early 1930s her small canvases were covered with flat, pale tones, but later she simplified her subject matter, her colour became bolder and the handling of paint looser, so that she conveyed a new liveliness and freedom. Although she carried out many landscapes of her native Yorkshire, she also depicted the Welsh mountains and American scenery when travelling there. In addition she executed many drawings and monotypes.

*Examples:* Leeds; Tate G, London; Manchester; Wakefield.

*Literature:* Deepwell; *EG*, City Art G, Bradford, 1956; Waters; *Who's Who in Art*.

## GLEICHEN, Feodora Georgina Maud. (Countess) (1861–1922)

*Sculptor of figures, memorials, portrait busts and medallions*

One of two artist daughters of Count Victor Gleichen (known 1861–85 as Admiral Prince Victor of

Hohenlohe-Langenburg), who was a sculptor as well as a naval officer. In addition to instruction from her father, who encouraged all his daughters to adopt a profession, she studied for four years at the Slade under Legros and then in Rome, and was a regular exhibitor at the RA from 1892 until her death. The family lived in St James's Palace, London, since they were related by marriage to Queen Victoria. Not surprisingly therefore a number of works of the royal family were commissioned from her. Apart from portrait busts there was a life-size statue of the Queen shown surrounded by children, and produced for the children's hospital in Montreal in 1895, and a memorial to Edward VII at Windsor. There are works by her in many countries, in the form of memorials, decorative panels for buildings and single figures. In England her best-known statue is that of *Florence Nightingale* (1914) in Derby, while the only work in London is the *Diana fountain* in Hyde Park. She also carried out allegorical figures, including *Peace* and *Satan*, and a few religious works. She enjoyed experimenting with complicated techniques. A hand mirror of jade and bronze, for example, won her a medal at the Paris Exposition of 1900; she also exhibited in Chicago in 1893. Shortly before her death, France gave her the award of Chevalier de la Légion d'honneur and she was posthumously made the first woman member of the Royal Society of British Sculpture. She never married and died in St James's Palace. A memorial prize for British women sculptors was established in her name.

*Examples:* Foundling Hospital, Cairo; Ladies' College, Cheltenham; Derby; Osborne House, Isle of Wight; cathedral, Khartoum; Hyde Park, London; Monchy-le-Preux; Jubilee Hospital, Montreal; Sydney; Windsor.

*Literature:* Birmingham Public Sculpture Index; Clement; *DNB*; M. Spielmann, *British sculpture and sculptors of today*, London, 1901; *The Times*, 23 Feb. 1922 (obit.); Weimann.

# GLEICHEN, Helena (Lady) (1873–1947)

*English painter of landscapes and animals, especially horses*

Twelve years younger than her sister Feodora (*q.v.*), Helena too lived for a time in St James' Palace and remained unmarried. Her supportive father having died, her more conservative mother would initially allow her to attend an art school at which only animals were painted, so she attended Calderon's. After winning a scholarship to pay for her second year's tuition, she enrolled at the Westminster School of Art and was also a private pupil of Arthur Lemon. From early in life she had been fascinated by horses and hunting, and this provided her with many of her subjects. She exhibited very actively from 1899 to 1933 at a variety of London venues and in France and Italy. In World War I she served for ten months with an ambulance unit in France, after which she was for two years joint commander of a British X-ray unit on the Italian front. For her services she was awarded the Italian medal for military valour and made an OBE. In 1934 she gave her recreation as shooting.

*Publications: Contacts and contrasts*, London, 1940 (autobiography).

*Literature: Paintings and drawings by some women war artists*, Imperial War Mus., London, 1958; Waters; *Who's Who in Art*.

**Feodora Gleichen** *Diana fountain*, (detail) 1899, bronze, Hyde Park, London. (photo: P. Dunford)

## GLOAG, Isabel Liliane (1865–1917)

*Scottish painter of literary, mythological and genre subjects*

Born in London of Scottish parents, she went to the St John's Wood School of Art, intending to train at the RA Schools. Subsequently deciding that this was too conservative, she went to the Slade. Poor health made it impossible for her to attend regularly, so instead she studied under Ridley, worked in the South Kensington museums and at a later date went for a time to Paris, working under Collin. Despite her health she produced a great deal of work over a wide range of subjects, exhibiting from 1889 to 1916. In addition to painting she also drew cartoons, designed posters and stained glass windows.

*Examples:* Wellington, New Zealand.

*Literature:* Clement; J. Grieg, 'IG and her work', *Mag. of Art*, v26, 1902, 189–93; Waters; Wood, 1978.

## GLUCK. née Hannah GLUCKSTEIN (1895–1978)

*Anglo-American painter of a wide range of subjects, including music-hall and theatrical entertainers, boxing scenes, still lifes and androgynous figures*

Gluck was born in London, her father being a wealthy entrepreneur and her American mother a talented musician. She herself was set on a musical career until she saw a portrait by Sargent, which made her determined to become an artist. She had already attended St John's Wood School of Art from 1913 to 1916 as part of her traditional middle-class education but, following her change of ideas, she travelled to the artists' colony in Newlyn, Cornwall, where she was advised and encouraged by, *inter alia*, Laura Knight (*q.v.*) and Dod Procter (*q.v.*). Realising that she could not compromise with her family's conventional ideas, Gluck left home with little money, cut her hair short and dressed as a man. Adopting her pseudonym, she worked for a period in Selfridge's department store, carrying out instant portraits. Her own paintings covered many subjects, and some reflected her travels. Her portraits contain little colour, employing black, white and grey to model the features. She was friendly with Romaine Brooks (*q.v.*), who painted her portrait under the title *Peter, a young English girl*. In her self-portraits,

Gluck *Self-portrait*, 1942, oil on canvas, present whereabouts unknown. (photo: Fine Art Society Ltd.)

Gluck often wears male attire and a hat, although she destroyed several of these in the less tolerant 1940s and 1950s, when her lesbianism would have been regarded as freakish. After she had enjoyed exhibitions in 1926 and 1937, she had no solo show again until 1973, and a memorial exhibition was held in 1978.

*Literature:* Cooper; D. Souhami, *G: her biography*, London, 1988.

## GOLDTHWAITE, Anne Wilson (1869–1944)

*American painter and printmaker, chiefly of figures and everyday scenes, but also of landscape, buildings and animals*

The oldest of four children, Anne Goldthwaite was born in Montgomery, Alabama. Her father was a lawyer there, but died when Goldthwaite was 12. Shortly afterwards, her mother also died and the four children were brought up with great

affection by different relatives. Goldthwaite drew from childhood, but it was only when she reached her twenties that an uncle persuaded her to train as a professional artist, a course of action he was prepared to pay for. Accordingly she enrolled around 1898 at the NAD, where the strongest influence upon her was Walter Shirlaw. She travelled to Paris in 1906, and through Gertrude Stein saw the work of Cézanne, Matisse and Picasso, although she studied with Friesz and Guérin. While there she saw Diaghilev's Russian ballet, and Isadora Duncan. Through Duncan's sister, Goldthwaite met and drew many dancers. Her works include many portraits of her friends and acquaintances executed in a few economical lines. Forced by forebodings of war to return to New York in 1913, she exhibited in the Armory Show and as a result obtained two commissions from Katherine Dreier (*q.v.*). While maintaining her studio in New York, she spent most summers in Montgomery. Her paintings and etchings of figures, whether seated or going about their daily activities, convey the sense of heat and the characteristics of life in the south. From 1915 she began to win prizes and growing recognition. This resulted in her teaching at the Art Students' League from 1922 until just before her death. During the 1930s she painted murals under the government projects, and in 1937–8 was president of NYSWA. She made an outstanding contribution to printmaking, producing more than 320 prints between 1885 and 1942, and served several times as the chair of the American Printmakers' Group.

*Examples:* Atlanta, Ga.; Baltimore; Brooklyn, NY; Art Inst., Chicago; Columbus, Ohio; Indianapolis; Los Angeles; Minneapolis; Whitney Mus. and Metropolitan Mus., New York; Newark; Worcester, Mass.

*Literature:* Bachmann; A. Breeskin, *AG, 1869– 1944*, Mus. of Fine Arts, Montgomery, 1977; A. Breeskin, *AG: a catalogue raisonné of the graphic work*, Mus. of Fine Arts, Montgomery, 1982; *Notable American Women*; Rubinstein; Withers, 1979; A. Wolf, *New York Society of Women Artists 1925*, ACA G, New York, 1987.

## GOLUBKINA, Anna Semionova (1864–1927)

*Russian figurative sculptor*

Born into a peasant family in Zaraisk, Riazan, she studied in the Moscow Institute of Painting and the St Petersburg Academy before travelling to Paris in the early 1890s. While attending the Académie Colarossi, she met Rodin and studied with him. Her early exhibits of heads reveal his influence, although her subject matter was Russian. She was the first sculptor in Russia to depict workers, and to execute a bust of Karl Marx (1905). She continued to exhibit widely in Paris from 1893 until at least 1908. On her return to Moscow she took part in the annual exhibitions of the Society of Artists. Although much of her work was academic in character she demonstrated a fine delineation of character. Later she was influenced by Expressionist work, which she used to complement her strong socialist commitment. Her work from after 1917 contains themes from folk legends and symbolic subjects. She had a solo exhibition in Moscow in 1905 and retrospective shows were held in 1944 and 1964. Her home is now a state-maintained museum. She was the first of a number of exceptional Russian and Soviet women sculptors.

*Examples:* Literary and Artistic Club, Moscow; Tretyakov Mus., Moscow.

*Literature:* V. Kostin, *ASG*, Moscow and Leningrad, 1947; Krichbaum; S. Luk' ianov, *Zhin' ASG*, Moscow, 1969; Mackay; W. Mandel, *Soviet women*, New York, 1975.

## GONCHAROVA, Natalia Sergeevna (1881–1962)

*Russian modernist painter of Cubo-Futurist and abstract works, and designer of sets and costumes for the theatre and ballet*

Goncharova was born near Tula into a noble family, her father being the court architect. The intellectual tradition in the family meant there was no opposition to her wish to study art, and at the age of 17 she began three years at the Moscow Institute of Painting, Sculpture and Architecture. Working initially under the sculptor Troubetskoi, she then turned to painting. A fellow student was Mikhail Larionov, who became her lifelong companion, but they did not marry until they were both 74. They were active in experimenting with modernist styles from early in the century. Goncharova drastically simplified her paintings under the influence of Russian ikons and folk art to create flat scenes of the everyday life of peasant communities. The impact of Cubism and Futurism led her to evolve a style that combined stylistic

elements of each with subject matter that was both everyday and modern, such as electric lamps, a laundry and a printing press. One development of this style resulted in the production of Rayonist paintings around 1913, which continued her use of bright colours. She participated in a series of exhibitions from 1906, including the Russian section of the Salon d'Automne in Paris. Through this she met Diaghilev, who in 1911 asked her to design sets and costumes for the Russian ballet in Paris. Leaving Russia in 1915, she settled permanently in Paris in 1917 after a period in Spain. She executed further designs for Diaghilev until his death in 1920, after which she continued to work for other companies. Indeed from this time her work for the theatre was predominant and she produced few paintings. Her later designs were characterised by rich colour and patterning, deriving from the early influences of ikons and native Russian decorative arts. Although suffering from severe arthritis, she responded to the Russian launch of the first sputnik in 1957 with a series of bold abstractions on the theme of cosmic space.

*Examples:* Tate G, London; Guggenheim Mus., New York; NMWA, Washington, DC.

*Literature:* Bachmann; *DWB*; Cologne, 1979 (bibl.); Fine, 1978; C. Gray, *The Russian experiment in art 1863–1922*, London and New York, 1962; Harris; Heller; NMWA catalogue; Petersen; E. Tufts, *Our hidden heritage: five centuries of women artists*, New York, 1974; Vergine.

## GONZALES, Eva (1849–83)

*French Impressionist painter of figures in indoor and outdoor settings*

One of two daughters of a well-known novelist, Eva was encouraged to paint by her father. Initially she studied with the academic painter, Charles Chaplin, who ran all-female classes, but later rented a studio not far from where Manet lived. Gonzales was introduced to Manet through Alfred Stevens, the painter, and after this she both worked with him and posed for him. It was in his studio that she encountered the Impressionist, Berthe Morisot (*q.v.*). She exhibited regularly at the Salon from 1870, and also became known in England and Belgium. Although her early work resembles that of Manet, she did not adopt the brighter colours of his later years. Her subjects reflect the lifestyle of her own circle, where models were readily available. In 1879

she married the engraver, Henri Guérard, whose collection of Japanese prints may have contributed to the fluidity of her line. Her later paintings show greater signs of spontaneity, resulting from her acqaintance with several of the Impressionists, but she herself did not live long enough to develop this strain, for she died shortly after the birth of a son in 1883. Guérard organised a retrospective exhibition at which more than 80 paintings were shown.

*Literature:* Bachmann; P. Burty, *Catalogue des peintures et pastels de EG*, Salons de la Vie Moderne, Paris, 1885; T. Garb, *Women of Impressionism*, Oxford, 1986; Harris; Heller; Petersen.

## GOODMAN, Julia. née SALAMAN (1812–1906)

*English portrait painter*

Born in London, she was the eldest child of 12 sons and two daughters of Simeon and Alice Salaman. After private schooling she expressed a desire to paint, receiving lessons from Robert Falkner, a pupil of Reynolds. In the tradition of art training at the time, she copied old masters, albeit very successfully, but she soon moved on to portraits for which she received many commissions. Altogether she exhibited over 1,000 portraits, despite marriage to a city merchant and the birth of seven children. Her exhibiting career spans nearly seven decades, from 1838 to 1901. Her sitters included many prominent people and were executed in oil and pastel. In 1836 she painted the artist Fanny Corbaux (*q.v.*). She died in Brighton, and was buried in Golders Green cemetery, London.

*Literature:* *AJ*, 1907, 64 (obit.); *DNB*; *Jewish Chronicle*, 4 Jan. 1907 (obit.); *Lexikon der Frau*; Wood, 1978.

## GORDINE, Dora (1906–)

*English sculptor of bronze heads and figures*

Born in St Petersburg, she studied music before turning to sculpture. She pursued her training in Paris, receiving considerable encouragement from Maillol. By the age of 20 she was attracting critical attention with her bronze figures and heads, and in 1928 the Leicester Galleries in London gave her

a solo show. After exhibiting in Berlin in 1929, she was commissioned to carry out sculptures for the new town hall in Singapore and she spent the next five years in the Far East. These were to prove decisive for she became convinced of the importance of the convex in sculpture, and this influenced the future form of her work. In 1936 she married the Hon. Richard Hare, then a diplomat and later Professor of Russian at London University, and designed the house in which they lived. It incorporated a studio and a sculpture gallery. From 1937 to 1960 she exhibited regularly at the RA, showing several figures or busts each year, and also with the Allied Artists Association and elsewhere. In addition to her sculpture she lectured on Eastern art, and in 1947 spent a year in Hollywood lecturing and carrying out commissions. She was elected a full member of the Royal Society of British Sculptors in 1949.

*Example:* Tate G, London.

*Literature:* DG, Leicester G, London, 1945; Mackay; B. Read & P. Skipwith, *Sculpture in Britain between the wars*, Fine Art Society, London, 1986; Waters.

**Dora Gordine** *Sultana*, between 1930–5, bronze on wooden base, private collection. (photo: Fine Art Society Ltd.)

## GORDON-BELL, Ophelia. née Joan Ophelia GORDON-BELL (1915–75)

*English sculptor in bronze, stone and terracotta, and painter in watercolour*

A career in art was perhaps rather inevitable for Gordon-Bell, the daughter of the animal painter, Winifred Gordon Bell and Lawrence Bell, the etcher. After her parents separated, Gordon-Bell and her mother lived as paying guests in the house of an aunt, and were dependent on the sale of paintings for their income. Understandably Gordon-Bell's training began early and she studied at the Regent Street Polytechnic from the age of 15. She made her début at the RA in 1935 with a relief of the *Ride of the Valkyries*, and by 1938 was attracting critical attention through her exhibits in London, Glasgow and Edinburgh. Commissions also came her way. On the outbreak of war she joined the First Aid Nursing Yeomanry in Manchester. In 1940 she married the landscape artist W. Heaton Cooper and moved to his base in Grasmere, Cumbria. The arrival of four children and the absence of her husband in the armed services during the war prevented her continuing with her sculpture. Although she began to work again in later years, she found it difficult to claim time and space for her art. Her later sculpture was predominantly religious in subject. Her premature death was caused by cancer.

*Examples:* Abbot Hall Art G, Kendal; chapel of Anglican convent of St. Denys, Warminster.

*Literature:* W. Heaton-Cooper, *Mountain painter: an autobiography*, Kendal, 1984; Mackay; Waters.

## GOSSE, Nellie. née Ellen EPPS (1850–?)

*English painter of landscapes*

The second of three artist daughters of a London doctor, Nellie was the sister of Laura Alma-Tadema (*q.v.*). There was no opposition to her desire to paint, which had been evident from childhood. Sources vary as to the form her instruction took. According to her daughter, she attended Queen's College in Harley Street where she became friendly with Catherine, daughter of Ford Madox Brown (*q.v.* under Hueffer), and Theresa Thornycroft (*q.v.*). After several years there she became a pupil of Ford Madox Brown and through him met some of the Pre-Raphaelites. Clayton, however, who was writing much nearer

the period in question, states that instruction from Cave Thomas was supplemented by drawing in the British Museum several days each week for three or four years. This was then followed by lessons with Alma-Tadema from 1870, when he became engaged to Laura. Whichever was the case, Nellie was determined to devote her life to a career in painting and had decided not to marry. Accordingly when the writer Edmund Gosse began to court her she firmly discouraged him, a situation which lasted many months. Nellie spent several months in Southern France and Northern Italy in 1873-4. When she eventually agreed to marry Gosse, he assured her that he did not object in the least to her continuing to paint. They were married in August 1875 and had three children by 1881. Their youngest child, Sylvia (q.v.), became an artist. Nellie Gosse first exhibited in 1871 and continued to do so until at least 1890, mainly in London, but occasionally in Paris. She also wrote art criticism.

*Examples:* Mesdag Mus., The Hague.

*Literature:* Clayton; K. Fisher, *Conversations with Sylvia*, London, 1975; Wood, 1978.

## GOSSE, Sylvia. née Laura Sylvia GOSSE (1881–1968)

*English printmaker and painter of figure subjects and still lifes*

Since Sylvia Gosse was the daughter of painter Nellie Gosse (q.v.) and the writer Edmund Gosse, as well as the niece of Laura Alma-Tadema, after whom she was named, it was not surprising she became an artist. She studied at the St John's Wood School of Art and at the RA Schools (1903-6). Two years later she met Walter Sickert and broke with her father over the question of pursuing a career. Sickert remained a friend for the rest of his life, although he at times depended on her and took advantage of her kindness. At first she studied with him, but only a little later she was running his art school with and, to some extent, for him, although she was called the co-principal and her name appeared on the door with his. She exhibited extensively in London in many galleries, had the first of many solo shows in 1913 and was a founder member of the London Group in 1914. After the death of Sickert's second wife in 1920, Gosse looked after him, and she also helped his third wife, Thérèse Lessore (q.v.), to care for

him in the last years of his life. She raised £2,000 in 1934 to enable him to work without financial worries. Her own work was well received and she was elected to Associate and full membership of both the Association of the Royal Society of Painters and Engravers and the Royal Society of British Artists. Her subjects included town scenes, interiors (often with female figures), and continental scenes based on her many visits to Dieppe. In 1952 she moved from London to Hastings, where she continued to work up to the last year of her life.

*Examples:* Aberdeen; Fitzwilliam Mus., Cambridge; Eastbourne; Leicester; WAG, Liverpool; British Mus., Tate G, Nat. Portrait G and V & A, London; Ashmolean Mus., Oxford; Sheffield; Southampton; Stoke-on Trent.

*Literature:* Deepwell; K. Fisher, *Conversations with Sylvia*, London, 1975; G. Hedley, *Let her paint*, City Art G, Southampton, 1988; Sellars; H. Stokes, 'The etchings of SG', *Print Collectors' Quarterly*, 1925, 314-38; Waters; *Who's Who in Art*.

## GRAVEROL, Jeanne (1907–)

*Belgian Surrealist painter*

Born in Elsene, she was the daughter of Symbolist artist Alexandre Graverol and studied at the Belgian Academy in Brussels. She met Belgian Surrealist René Magritte in 1949 and some of her works soon after this show his influence; but she became best known for her paintings and collages of fantastic flowers and plants. She had many exhibitions which established her reputation as a leading painter of the visionary.

*Literature:* P. Colinet *et al.*, *JG*, Verviers, 1953; Krichbaum; G. Orenstein, 'Women of Surrealism', *FAJ*, spring 1973.

## GRAVES, Nancy. née STEPHENSON (1940–)

*American sculptor of cast bronze images derived from natural and manufactured objects*

Now one of the most acclaimed of her generation of artists, Graves has worked in a variety of media and materials. Born in Pittsfield, Massachussetts, where her father was the museum director, she

spent much time as a child among the varied exhibits. Interests formed at that stage of her life underlie much of her subsequent work. Graves gained a BA in English literature at Vassar College before going to Yale University School of Art and Architecture in 1961 for both her BFA and MFA. A year spent painting in Paris on a Fulbright scholarship was followed by a period in Florence, when she studied taxidermy and eighteenth-century wax models of animals and humans. The life-size camels that resulted from this investigation provided the material for her first one-person show in 1969 at the Whitney Museum in New York. This was followed by displays of bones and skeletons, evidence of her interest in anatomy, palaeontology and anthropology and exploring means of expressing these. From 1972 to 1976 she turned to making films and to painting. However, a commission restored her interest in sculpture, and from 1979 she has used direct casting in bronze to make replicas of objects from leaves and seed pods to crab claws, scissors and chair backs. Since 1980 she has worked directly with the separate cast forms, without preliminary drawing, welding them together and applying colour. The foundry where her work is cast developed a range of brightly coloured patinas. She has also used polyurethane paint and more recently has achieved enamelled sculptures. The period since 1979 has seen the production of large numbers of these open coloured sculptures on a variety of scales. They appear organic, but are at the same time fantastic. Her art would have been impossible without surrealism in the juxtaposing of disparate objects from many cultures. Graves has had many exhibitions in Europe and America and has received several awards for artistic achievement.

*Examples:* Neue G im Alten Kurhaus, Aachen; Akron; Albright-Knox G, Buffalo, NY; Art Institute, Chicago; Wallraf-Richartz Museum, Cologne; Fort Worth; Houston; Metropolitan Mus., Whitney Mus., Guggenheim Mus. and MOMA, New York; Nat. G, Ottowa; Corcoran G, Washington, DC.

*Literature:* L. Cathcart, *NG: a survey 1969–80*, Albright-Knox G, Buffalo, NY, 1980; E. Frank, 'Her own way: the daring and inventive sculptures of NG', *Connoisseur*, v85/2, Feb. 1986, 54–61; L. Lippard, 'Distancing: the films of NG', *Art in America*, Nov.–Dec. 1975, 78–82; L. Lippard, *Strata*, Art G, Vancouver, 1977; Petersen; W. Saunders, 'Hot metal', *Art in America*, v68/6, summer 1980, 86–95; M. Shapiro, 'Nature into sculpture: NG and the tradition of direct casting', *Arts Mag.*, Nov. 1984, 92–6.

## GREATOREX, Eliza. née PRATT (1820–97)

*Irish-born painter and printmaker, chiefly of landscapes who worked in America*

The third daughter of a Methodist minister, Eliza Pratt was born in Manor Hamilton, Co. Leitrim. Although orthodox, the sisters were encouraged in music and writing. In either 1836 or 1840 the family moved to New York, where Eliza married the musician, Henry Greatorex, in 1849. Two daughters were born in 1851 and 1854, and the family moved a good deal; but despite this Eliza Greatorex joined an amateur art club in New York and by 1855 was exhibiting pen and ink landscapes at the NAD. The Irish subjects may indicate that she visited Ireland in the later 1850s. The sudden death of her husband in 1858 resulted in her looking to art for the means of supporting herself and her children. She sold her work and taught in a girls' school for 15 years, exhibiting frequently at the NAD, the Pennsylvania Academy, and elsewhere. At the same time she was also a pupil of William Wotherspoon and of the Scottish landscape painters, James and William Hart, in New York, and in 1861–2 she studied in Paris. Recognition of her achievements came with election to Associate membership of the NAD in 1864 or 1869. Together with her daughters, both of whom also became artists, she spent an increasing amount of time travelling, particularly in Europe. She began to publish series of engravings based on her journeys, most notably of historic houses and natural landscape, and these clearly provided her with a steady income. Her business sense was apparent in her enterprises in connection with the centennial celebrations, which included the publication of a book of her engravings and paintings, with notes by her sister, in addition to the 18 sketches at the Philadelphia Exposition. Dissatisfied with the way in which her sketches were translated by the engravers, she determined to learn the technique herself, and for this purpose studied with Charles Henri Toussaint in Paris in 1879. She exhibited at the Salon on several occasions and in Berlin in 1891. She died in Paris, in the same year as her younger daughter. Her elder daughter, Kathleen Honora, remained in Paris and enjoyed considerable success.

*Publications: Homes of Oberammergau*, 1872; *Summer etchings in Colorado*, 1873; *Etchings in Nuremberg*, 1875; *Old New York, from the Battery to Bloomingdale*, 1875; *Souvenir of 1876*, 1876.

*Literature:* Clement; *Irish women artists*; *Notable American Women*; Rubinstein.

## GREENAWAY, Kate. née Catherine GREENAWAY (1846–1901)

*English painter of children and scenes from folk tales in watercolour and illustrator of children's books*

Born in London, she received her first training from her father, a wood engraver, before attending the South Kensington Schools, where she was a contemporary of Elizabeth Thompson Butler (*q.v.*). Later she enrolled for life classes at Heatherley's, and in 1871 was one of the first students at the Slade. She began to exhibit in 1868 but only a relatively small proportion of her works were seen in this way. She was known initially for her designs for illustrations in magazines such as the *Illustrated London News* and *Little Folks*. In 1879 she wrote and illustrated a book for children called *Under the window*, which sold over 150,000 copies and was translated into French and German. Clement revealed that this and the three books which followed brought her $40,000. These and other books were published in association with the printer and publisher Edmund Evans, along with a series of annual almanacks from 1883 to 1897. In 1889 she was elected full member of the Royal Institute of Painters in Watercolour and she showed 12 drawings at the Paris Exposition. She was also represented at the Chicago Exposition in 1893. Her admirers included the royal family, the Empress of Germany and John Ruskin, who wrote her over 500 letters. She depicted an imaginary world which appealed to a sense of nostalgia, and her paintings of children's clothes were taken up by manufacturers. Despite her success she was a shy person, who had a small number of close friends.

*Publications: Under the window*, London, 1879 etc.; for full list see Engen below.

*Examples:* Belfast; WAG, Liverpool; British Mus. and V & A, London; Manchester; Ashmolean, Oxford; Lady Lever Art G, Port Sunlight.

*Literature:* Bachmann; Clement; *DNB*; R. Engen, *KG*, NY, 1976 (list of publications, books illustrated and bibl.); Mallalieu; A. Moore, *A century of KG*, London, 1946; Sellars; M. Spielmann, *KG*, London, 1905.

## GREENE, Gertrude. née GLASS (1904–56)

*American abstract painter and sculptor and founder member of several associations for the promotion of abstract art*

Born in Brooklyn, New York, she studied for two years at the Leonardo da Vinci School in New York. On leaving in 1926 she married the painter Balcomb Greene, and during the next five years they spent several periods in Vienna and Paris familiarising themselves with modernist art. Her early works were figurative sculptures influenced by both Cubism and Expressionism; but with an awareness of Constructivism and De Stijl her work became increasingly crisp and geometrical. In the early 1930s she began to work in sheet metal and wood, producing a number of reliefs, often painted, which in many ways are direct precursors of work of the 1960s. Interested in exploring the spatial relationships between forms, she was fascinated by the Constructivist and Suprematist works shown in New York in 1936. She taught herself to paint and make collages. Keen to promote abstract art in America, she was a founder member – with Rosalind Bengelsdorf (*q.v.*) and Alice Mason (*q.v.*) – of the American Abstract Artists, and three other associations with similar aims. From the 1940s she and her husband lived in a house they built themselves on a deserted cliff on Long Island, where they entertained many artists and other intellectuals. A pioneer of abstract reliefs, metal sculpture and textured paintings, Greene had her career cut short by cancer.

*Literature:* T. Armstrong *et al.*, *200 years of American sculpture*, Whitney Mus., New York, 1976; Rubinstein.

## GREENWOOD, Marion (1909–70)

*American painter, highly acclaimed for her murals of the 1930s*

Born in Brooklyn, New York, Greenwood had such prodigious talent she won a scholarship to the Art Students' League, New York, at the age of 15. After four years there, a portrait sale paid for a visit to Paris, where she attended the Académie Colarossi. Back in America, her portraiture continued to provide her income, as did sketches for the *New York Times*, while she learnt lithography and spent some months in artist colonies. The first woman muralist to be commissioned by the Mexican government, she spent a year observing the Tarascan Indians before attempting the 70-square-metre fresco of Indian life at the University of San Hildalgo in Morelia in 1932–3. Her grounding in portraiture enabled her to achieve authenticity, a factor which led to the

employment of Greenwood and her sister Grace on a section of a mural in Mexico City. Under this influence her work took on a more revolutionary character. Through these murals, Greenwood became involved with a Relief Art Project in which she depicted the right of collective bargaining achieved under the New Deal legislation, and completed several other murals portraying optimism in the new social programme. In World War II Greenwood and Anne Poor (*q.v.*) were the only women appointed by the government as war artists. After this she concentrated mainly on easel painting, having a solo show in 1944, the first of many exhibitions in America and abroad. Her prints and portraits in particular brought her many awards, including membership of the NAD in 1959. She did, however, complete two further murals, at the University of Tennessee at Knoxville and at Syracuse University. The latter depicted women from different parts of the world, and was developed from sketches made during her extensive travels. Like her earlier murals, it revealed her longstanding commitment to the underprivileged. She was killed in a road accident.

*Literature:* K. Marling & H. Harrison, *7 American women: the Depression decade*, AIR G, New York. 1976; Rubinstein; H. Salpeter, 'MG: an American artist of originality and power', *American artist*, v12, Jan. 1948, 14–19.

## GRIGORIADIS, Mary (*c.* 1942–)

*American painter using patterning and texture*

Graduating first from Barnard College in 1963, Grigoriadis studied at Columbia University under Paul Feeley for her MA. Until 1966 she worked in acrylic, but then turned to oil, fascinated by its physical properties. By 1971 she had arrived at her vocabulary of symbols: geometrical shapes combined to form unpredictable yet ordered patterns in rich texture and glowing colours. From a series of 30-centimetre-square canvases she selects one or two to translate into one of 180-centimetre-square. The technical process she uses, of sanding down eight or 12 layers of oil paint, is lengthy, but is fundamental to the quality of colour achieved. In the 1970s her compositions existed within broad patterned borders, but more recently these have been dispensed with in favour of an emphasis on the centre of the painting, recalling tabernacles and Greek icons, a heritage she acknowledges. A visit to the USSR confirmed this direction. The

death of her father in 1983 also had a considerable effect on her work, and it is the personal basis of her patterning which has enabled it to outlast what was connected by critics with the New York Pattern and Decoration Group in the mid-1970s (see under Kozloff). She is a member of the AIR women's co-operative gallery in New York.

*Literature:* J. Marter, 'MG', *Arts Mag.* Nov. 1984, 11; C. Robins, 'MG', *Arts Mag.* Sept. 1978, 3; C. Robins, *The pluralist era*, New York, 1984.

## GROSSMAN, Nancy (1942–)

*American sculptor working on leather-bound figures and heads*

The eldest of five children, she was born in New York City, but at the age of six her Italian mother and Jewish father moved out to nearby Oneonta, where they lived in an extended household with the families of two aunts. After a rather turbulent childhood, she elected to be an artist without being fully aware of what it involved. She began to attend the Pratt Institute in New York at 18, but to remain on after the family finances deteriorated she had to ignore her father's demand to return home. In order to finance her course she won a scholarship and found a job. In 1965 she began a series of drawings of intestine-like coils, cogs and wheels, which included several on stereotypes of women. From the start she had been concerned with the failure of communication between men and women, people and nature. The visceral quality of these drawings, together with intimations of violence, was strengthened in collages with found objects, often tubing or laces. It was not until 1968 that she made her first three-dimensional leather-covered figures. Since then she has produced a series of these covered figures and heads, with zips and belts. The versions vary in attitude from aggressive to pitiable, but arouse strong feelings in spectators. They are not always specifically male, but Grossman has said she uses the male figure to comment on something general in society, frequently death and destruction. More recently she has dispensed with the leather covering, producing bronze sculpture with a similar surface texture.

*Examples:* Hirschhorn Mus., Washington, DC.

*Literature:* D. Kuspit, 'NG', *Artforum*, v23/4, Dec. 1984, 85–6; C. Nemser, *Art talk*, New York, 1975; Rubinstein; Watson-Jones; Withers, 1979.

## GRUNDIG, Lea. née LANGER (1906–77)

*German artist of politically orientated prints and drawings*

Like Käthe Kollwitz (*q.v.*), with whom she has much in common, Grundig's output was almost entirely in black and white. Born into a family of Jewish merchants, Grundig had a somewhat erratic training in art. Her two years at the Dresden School of Art (1922–4) were largely unsuccessful and she failed the examination to the Academy. The most formative part of her education was in Gussmann's school in Dresden from 1924 to 1926. There she met Hans Grundig, whom she married in 1928, and became increasingly active politically. Her works from this period show desolate urban scenes or isolated individuals, but she did not shy away from more brutal subjects, with starving people or victims of violence. As a member of the Communist party she was arrested on several occasions after the Nazis came to power, but continued to express her political opinions in series of prints until in 1939 she was interned. However, she escaped the following year and made her way towards Palestine. While in a refugee camp, she organised an exhibition by the inmates and in this way maintained her artistic practice in unpromising circumstances. From 1943 she exhibited in Israel and later in New York and Paris. In 1949 she succeeded in returning to Dresden and was reunited with her husband. Made a professor at the School of Figurative Arts in Dresden in 1950, Grundig showed a continued political protest in her work of the late 1950s, this time against nuclear weapons. She had many exhibitions in the USSR and Eastern Europe, including a joint one with her husband in the year of his death, 1958.

*Publications: Gesichte und Geschichte*, Berlin, 1978 (orig. pub. 1958).

*Examples:* Landengalerie and Berlinsiche G, Berlin.

*Literature: Das Verborgene Museum; LG*, Landengalerie, Berlin, 1973; Krichbaum; Vergine.

## GUIDI, Nedda (1927–)

*Italian abstract sculptor and ceramicist*

Born in Gubbio, Marche, she lives in Rome. After working in other materials she began to use clay in 1960, and for four years experimented with using very thin layers to create forms. She then moved to geometric shapes and evolved the concept of a module or unit which could be used to build up sculptures by being combined in different ways.

*Literature:* Krichbaum; *Künstlerinnen International, 1877–1977*, Schloss Charlottenburg, Berlin, 1977.

## GUILD, Emma Marie Cadwalader. (alt. CADWALADER-GUILD) (1843–1912?)

*American painter and sculptor of portrait busts in marble and bronze*

A native of Zanesville, Ohio, she was self-taught in art, apart from having anatomy lessons with Dr Rimmer in Boston. She achieved early success, exhibiting mostly in European cities, including Munich, Berlin and London. Among her sitters were members of several European royal families, the painter G.F. Watts, Peter Brotherhood, inventor of the torpedo engine, and the British prime minister, Gladstone. She also executed mythological figures, bronze reliefs and still lifes in oil.

*Literature:* Clement; *International Studio*, v27, Dec. 1905, supp. 44–6; Krichbaum.

## GUTIERREZ, M. See BLANCHARD, Maria

## GUYON, Maximilienne. (alt. GOEPP) (1868–1903)

*French painter of figure subjects and portraits, and teacher of art*

A Parisian by birth, she trained at the Académie Julian, and at the age of 20 received a bronze medal at the Salon for her painting *The Violinist*. Other awards followed at the Expositions Universelles of 1889 and 1900, and in 1894 she won a *bourse de voyage*. She married and settled in Paris, where she was a successful and prolific portrait painter, who brought out the individual characteristics of her sitters. Towards the end of her short life, she enjoyed a stay in Brittany, which resulted in genre and fishing scenes. She had a high reputation as a teacher and is reported as having many women in her class; she also taught Princess Mathilde. She was a member of the Société des Artistes Français, the Société des Aquarellistes Français and the Salon jury.

*Literature:* Clement; J. Martin, *Nos peintres et sculpteurs*, Paris, 1897.

## HALE, Ellen Day (1855–1940)

*American painter of portraits, figures and landscapes; also a printmaker*

Born in Worcester, Massachusetts, Ellen Hale came from a distinguished intellectual family. As an only girl with seven younger brothers, she was heavily occupied with domestic matters. Her Unitarian minister father encouraged and supported her, both morally and financially. The great-niece of Harriet Beecher Stowe, author of *Uncle Tom's Cabin*, she probably received her first instruction in art from her aunt, Susan Hale, who was both artist and author. After a period with Dr Rimmer in Boston in 1873, she proceeded to William Hunt's classes in Boston from 1874 to 1877, where she became friendly with his assistant, Helen Knowlton (*q.v.*), with whom she travelled to Europe in 1881. In Paris she studied with Jean Jacques Henner and Emile-August (sic) Carolus-Duran, enrolling at the Académie Julian on two subsequent visits in 1882 and 1885. Working in London for several months, she lodged with American painter, Anna Lea Merritt (*q.v.*). During her travels she sent home articles for publication in a Boston newspaper. From the late 1880s she began to teach in order to provide some security of income, and at this time she began to spend her summers at Rockport, Massachusetts, where she lived with Gabrielle Clements, a Philadelphia artist who taught Hale the technique of etching. She produced many etchings from 1885, participating in the revival of the medium in America. Sales from portraits and commissions for church decorations supplemented her finances. From 1902 to 1909 she acted as hostess for her father in Washington, DC while he was chaplain to the US Senate, and during this period drew President Theodore Roosevelt and other well-known politicians. After a period caring for elderly parents, she began to travel with renewed energy, including the Middle East in 1929, and continued painting into her eighties, even from a wheelchair after breaking her hip. Her early works show the influence of Hunt, but the experience of Paris enabled her to develop more independently, with greater solidity and finish.

*Examples:* Boston; NMWA, Washington, DC.

*Literature: Fair Muse*; N. Hale, *The life in the studio*, Boston, 1957; M. Hoppin, 'Women artists in Boston 1870–90', *The American Art J.*, winter 1981, 17–46; NMWA catalogue; Tufts, 1987.

## HALE, Lilian. née WESTCOTT (1881–1963)

*American painter of single figures in interiors, portraits and landscapes*

Encouraged by her mother, Lilian Westcott received her first training in the art school in her native Hartford, Connecticut. By 1902 she had completed the course at the Boston Museum School with Elizabeth Stevens, Tarbell, William Chase, and Philip Hale, the younger brother of Ellen Hale (*q.v.*), whom she married shortly afterwards. According to the account of their daughter, Lilian was the more successful artist, with more portrait commissions than she could complete. Exhibiting frequently from 1903, notably at the Pennsylvania Academy, she won many awards including a gold medal at the Panama-Pacific Exposition of 1915, and was elected an Associate of the NAD in 1927, with full membership coming four years later. After her husband's death in 1931, Hale began to spend the summers with her sister-in-law, Ellen. She paid her first visit to Europe in 1963. Both Lilian and Philip Hale admired Vermeer, with whom Lilian shared a preference for the single figure in an interior. Her paint is applied in a way which verges on that of Impressionism, creating soft-edged forms reflecting the effects of light. There are hints of oriental influence in some works.

*Examples:* Boston; N. Carolina Mus.; Pennsylvania Academy, Philadelphia.

*Literature:* R. Berry, 'LWH – her art', *American Mag. of Art*, v18, Feb. 1927, 59–69, C. Davidson, 'Boston painters, Boston ladies', *American Heritage*, v23, Apr. 1972, 4–17; N. Hale, *The life in the studio*, Boston, 1957; *The Pennsylvania Academy and its women, 1850–1920*, Pennsylvania Academy of Fine Arts, Philadelphia, 1973; Tufts, 1987.

## HALICKA, Alice (1889–1975)

*Polish painter, collagist and designer working a style derived from Cubism*

Born into the family of a wealthy doctor in Krakow, she was brought up in the South Tyrol by her

grandparents after the death of her mother when she was seven. On leaving school, she went to Munich and enrolled at the Academy, but it was Paris which attracted her. She arrived there in 1912, and attended the Académie Ranson, where Symbolists Denis and Sérusier taught. After her marriage to the painter Louis Marcoussis in 1913, their apartment became the rendezvous for many modernist painters, writers and critics, and continued to be so for the Surrealists. While Marcoussis was in the army during the whole of World War I, Halicka was able to work without interruption at her Cubist still lifes, but on his return Marcoussis dissuaded her from accepting an important contract from the dealer Zborowski. In addition, he counselled her to abandon the Cubist direction she had been following and of which he did not approve. She obeyed to the extent of destroying half her work and storing the other half in the Normandy house where she had been living. Fortunately she rediscovered these 50 years later. After this enforced change of direction she began to produce fabric designs, which provided a much-needed income. She also created collages on wood from materials, sometimes adding drawn elements. She began to travel, returning to her native country, and visiting England where she was received by Roger Fry, Vanessa Bell (q.v.), and Duncan Grant. She began to exhibit again from 1924, with some success in both painting and collage. She illustrated several books, for her collages had revealed her ability to capture incidents and convey sometimes humorous ideas. During the 1930s she began to exhibit internationally, and from 1935 to 1938 was in America, where she carried out designs for two ballets and had several solo shows. After World War II she resumed exhibiting and had retrospectives in Poland and Paris.

*Examples:* Mus. du Petit Palais, Geneva.

*Literature:* Schurr, v3; Vergine.

## HALSE, Emmeline (1856–1930)

*English sculptor of statues and reliefs in marble, plaster and terracotta*

Born in London, she received a thorough training under Lord Leighton at the RA Schools (where she won two silver medals and a prize of £30) and at the École des Beaux-Arts under Bogino. She exhibited from 1878 in both cities, specialising in classical figures and reliefs. From her studio

in Chalfont St Giles, Buckinghamshire, she produced a wide variety of works, from tiny wax figures to life-size statues in marble, portraits busts, studies of children, medallions and poetical reliefs. Apart from portrait commissions, her works were purchased by institutions and churches. For the British Museum she restored the Hermes statue, which was then placed beside a cast made from the original. Some of her late works are of genre subjects.

*Examples:* Glasgow; St Bartholomew's Hospital, London; St John's church, Notting Hill, London.

*Literature:* Clement; Mackay; Waters.

## HAMBLING, Maggi. née Margaret HAMBLING (1945–)

*English painter of figures and landscapes*

Born in Suffolk, she began to study at only 15 with Cedric Morris and Lett Haines, whom she still regards as her most formative influence. In 1962 she attended Ipswich School of Art for two years, then Camberwell School of Art from 1964 and finally the Slade from 1967 to 1969. A travelling scholarship then enabled her to visit New York, and she returned to a period of experimentation with various avant-garde forms of expression. However, in 1972 she realised that her real wish was to paint the figure. Her handing of paint is free and the colours are bright, but she leaves areas of white ground between the coloured lines and marks of colour. Hambling's first solo show was in Suffolk in 1967, and since then she has exhibited regularly.

*Examples:* Nat. Portrait G, London.

*Literature:* E. Feinstein, 'MH', *Modern painters*, v1/2, summer 1988, 27–8; *MH*, Serpentine G, London, 1987; Parry-Crooke.

## HAMMOND, Harmony (1944–)

*American abstract sculptor working with fabric using processes of wrapping and binding*

Born in Chicago, she attended Milikin University, Decatur, Illinois before gaining her BFA from the University of Minnesota in 1967. Influenced by the way artists such as Oldenburg and Rauschenberg use discarded items, and particularly by the work of Eva Hesse (q.v.), Hammond uses recycled

fabric, often thin and stringy. Over a wood and metal armature, the fabric is wound round, and then painted with acrylic, latex rubber or other materials. The process of binding is important in itself, as Hammond sees this as a means of self-discovery and reaching out to link art and life. As a feminist she deliberately chooses non-traditional materials and methods in order to avoid the élitism inherent in Western culture and to share her experience of being female with the spectator. She believes that women are part of nature, but not nature as it has been defined in paintings by men: nudes and landscapes. A number of her works have been based around shapes resembling ladders, others are grids (yet another feature Hammond shares with Hesse), but they are not merely inanimate objects. They evoke a presence and a community when several are together. Hammond has exhibited since 1973 in both alternative and establishment galleries.

*Publications: Wrappings: essays in art, feminism and the martial arts*, New York, 1984.

*Examples:* Denver, Colo.; Indianapolis; Everson Mus., Syracuse, NY.

*Literature:* S. Langer, 'HH: strong affections', *Arts Mag*, v57/6, Feb. 1983, 122–3; L. Lippard, 'Binding/bonding', *Art in America*, v70/4, Apr. 1982, 112–18; A. Raven, *Harmonies: an essay on the work of HH*, Klein G, Chicago, 1982; Rubinstein; Watson-Jones.

## HAMNETT, Nina (1890–1956)

*English painter of figures, landscapes, interiors and portraits*

Born in Tenby, South Wales, Hamnett had a strong, rebellious personality from childhood, and it is as a Bohemian that she is now usually remembered. Because her conventional family moved around, her formal education was irregular, but while living in Dublin she went to classes at the School of Art in about 1904. After her father lost his money the following year, she was expected to train in order to earn her living. In 1905 she enrolled at Pelham's School of Art, London, and then at the London School of Art, where the teaching was done along the lines of the French academies. From the age of 22 she spent as much time as possible in Paris, where she mixed with a group of avant-garde painters and sculptors. She revelled in Bohemian life although this led her to overlook the hardships of poverty and squalor in her later account. She herself was almost permanently hard up, and many of her return visits to England coincided with exhibitions, sales from which would finance her for a few more months. She had a series of solo shows from 1918 until the early 1930s, with the last taking place in 1948. The artists she knew often used each other as models for reasons of economy and several representations of Hamnett by artists such as Sickert and Royer Fry exist, together with a torso by Gaudier-Brzeska now in the Tate Gallery, London. Hamnett worked in Fry's Omega Workshop during World War I, and he included her in the 1917 exhibition, *The new movement in art*, confirming her adherence to a modernist style. She is a confident draughtswoman, her drawings revealing fluency and humour. Her telling line and simplified forms derive in part from contact with Modigliani, but her adherence to a basic structure resulted from Fry and French art. Her direct style matched her personality, but her painting was meticulous. Her subjects reflect her friends and the everyday scenes she encountered in cafés. Because she liked to watch people, her portraits convey much more of the sitter's character than a physical likeness. The heads appear almost sculptural in their robustness. After the outbreak of World War II, Hamnett lived in London, where she continued her Bohemian lifestyle. In later life, she became over-dependent on alcohol and died after falling from the window of her flat.

*Publications: Laughing torso*, London (1932), 1984; *Is she a lady?* London, 1955.

*Examples:* Doncaster; Hull.

*Literature:* D. Hooker, *NH, Queen of Bohemia*, London, 1986; D. Hooker, *NH and her circle*, Parkin G, London, 1986; Petersen.

## HARDIE, Gwen (1962–)

*Scottish painter of radical images of the female body*

Gwen Hardie found immediate acclaim in 1984 and is part of the renaissance of Scottish painting in recent years. Born in Newport, Fife, Hardie followed both undergraduate and postgraduate training at the Edinburgh College of Art. On the completion of this in 1984 she gained a scholarship which enabled her to study in West Berlin, where she at first studied with Georg Baselitz, but then remained on as an independent artist, thanks to further scholarships. The decision to study

abroad came from a wish to test her own ability to cope and the wish to detach herself from the Scottish element in her painting. She abandoned the application of paint with a brush, first for a sponge, and then for her hands and fingers. From the beginning her intention, arrived at independently of feminist theory, was to re-invent the female image – and her own image – not from the external point of mere appearance but in order to 'make visual and tactile equivalents of states of being, to uncover layers between me and the outside world'. Originally depicting monumental paintings of parts of the body, she has now opened up the body to make visible the internal organs, vagina, uterus, and Fallopian tubes, not for narcissistic reasons but in order to designate and articulate 'the richness of woman's inner space as a structure of knowing'. She works mostly in oils and her works are brightly coloured. Her first solo exhibition took place in 1984, and the following year she carried out a portrait commission for Jean Muir, the fashion designer.

*Examples:* Scottish Nat. G of Modern Art, Edinburgh; Metropolitan Mus., New York.

*Literature: GH: paintings and drawings,* Fruitmarket G, Edinburgh, 1987; *The vigorous imagination,* Scottish Nat. G of Modern Art, Edinburgh, 1987.

### HARDY, Annie. née Anne Eliza HARDY (1839–1934)

*American painter of still lifes*

The only daughter and youngest of four children, Hardy was born in Bangor, Maine, where her father and his sister were professional artists. She began her career by accident, after her father asked her to copy one of his paintings, and he remained her principal instructor. At some stage, however, she travelled to Paris, where she studied with Jeannin and was also a pupil of the American painter, Thayer. Throughout her long career, she painted still lifes, which combined a strong sense of composition with a precise style to achieve a *trompe-l'oeil* effect. These found a ready market and assured her of financial independence. She worked in her father's studio until his death in 1888 and thereafter lived in South Orrington, Maine. Failing eyesight meant that her last paintings do not achieve the atmosphere of freshness which is the hallmark of her earlier works.

*Examples:* Public Library, Bangor, Me.; Colby College Mus. of Art, Waterville, Me.

*Literature: Notable American Women;* Rubinstein; *Women pioneers in Maine art,* Joan Payson, Whitney G, Westbrook College, Portland, Me., 1981.

### HARMAR, Fairlie. (alt. Lady HARBERTON) (1876–1945)

*English painter of landscapes, town and figure scenes, and still lifes*

Born in Weymouth, Dorset, she trained at the Slade, painting in both oil and watercolour. She exhibited from 1906 to 1940 at a variety of provincial and London galleries, but also extensively abroad, including Buenos Aires, Brussels, Pittsburgh, Paris, Venice and New Zealand. During World War I a work of hers was bought by the Imperial War Museum. She became a member of NEAC in 1917 and subsequently of the Royal Society of British Artists. Her marriage to Viscount Harberton took place in 1932 (he died in 1944) but this did not affect her output. She lived for some time in Cheyne Walk, Chelsea, the haunt of several other women artists at the time.

*Examples:* Birmingham; Imperial War Mus., London; Manchester.

*Literature:* Deepwell; Waters; *Who's Who in Art.*

### HARPER, Alison (1964–)

*Scottish painter of women through the exploration of myth and spirituality*

Another of the group of highly acclaimed young Scottish painters, Harper was born in Glasgow and as a child already revealed her ability to draw. Her parents supported and encouraged her decision to train as an artist, and from 1981 to 1985 she attended the Glasgow School of Art. After a summer at the Salzburg Academy she spent a year in Oslo (1985–6) on a scholarship. Initially satirising the depiction of women by Munch, she moved towards a more positive representation of woman, using goddess figures to symbolise wisdom, creativity and strength. She also uses certain symbols – the unicorn, the bull, the fish and the mermaid – to represent male and female principles and to explore the unconscious as a site of the formation of such ideas. Her paintings depict monumental heads or figures with androgynous features trying to overcome the physicality of

the body in order to achieve greater things. Harper now lives and works in Glasgow, and has exhibited since 1984, with a solo show in Oslo in 1986.

*Literature: Art in exile*, School of Art, Glasgow, 1987; *Glasgow girls*, Boundary G, Glasgow, 1987.

## HARRISON, Maria (c. 1823–1904)

*English painter of flowers in watercolour*

The daughter of Mary Harrison (*q.v.*), she was born in Liverpool, but grew up in London. Mary would send her children to draw each day in Kensington Gardens. Mary Harrison clearly intended that her children should grow up able to earn their living, so after reaching a suitable stage with her mother's teaching, Maria was sent to Paris for about two years to continue her training there. She began exhibiting in 1845, and only two years later was elected a member of the Royal Watercolour Society. In addition, she taught art in London schools. She was astonishingly prolific, exhibiting 439 works at the RWS alone between 1845 and 1893, and continuing to submit work at other venues until 1900. She sent a painting to the Paris Exposition in 1889. Her sister Harriet was also known for her brilliant flower painting.

*Literature:* See under Mary Harrison.

## HARRISON, Mary. née ROSSITER (1788–1875)

*English painter of flowers, especially wild flowers with birds' nests and grasses; founder member of the New Watercolour Society*

**Mary Harrison** *Basket of flowers*, 1864, watercolour on paper, 37.4 × 49.5 cm, Walker Art Gallery, Liverpool. (photo: John Mills (Photography) Ltd)

A remarkable Liverpudlian, she was the daughter of a wealthy hat manufacturer. She was entirely self-taught and began painting only on her honeymoon in 1814, when she was the first English woman to be allowed to copy in the Louvre. Her first child was born in Amiens the following year, whereupon she returned to England. Her husband, who had joined a partnership in a brewery, lost most of his money and, despite having 12 children, she took up painting to support the family. She became a popular teacher in Liverpool and beyond as far as Chester. She moved her family to London in 1829, where she became a prolific and successful artist. In 1831 she joined some friends in setting up the New Watercolour Society (later known as the Royal Institute of Painters in Watercolour), of which she remained a member all her life. She began by painting cut flowers in somewhat artificial arrangements, as was the fashion, but increasingly from the 1820s preferred to depict growing plants, particularly wild ones, in a natural habitat. On visits to France during the 1830s and 1840s she met the writer Georges Sand and other celebrities. In many ways she was one herself, for her works were highly sought after, and Queen Victoria purchased two paintings. She exhibited a total of 322 paintings during her 42 year exhibiting career, which continued until the day of her death. Indeed she died having just ensured that her exhibits for the winter exhibition at the Royal Institute of Painters in Watercolour had been dispatched. Her four surviving children, including Harriet and Maria (q.v.), were all professional artists, taught by her.

*Examples:* Coll. HM Queen; WAG, Liverpool.

*Literature:* Clayton; *DNB*; Mallalieu; P. Nunn, *Victorian women artists*, London, 1987; Sellars; Wood, 1978.

## HARTIGAN, Grace (1922–)

*American Abstract Expressionist painter working with some figurative elements*

Born and brought up in Newark, New Jersey, in an Anglo-Irish family she married at 17 and had a child within a year. Both her husband and parents urged her to take evening classes in art, but she continued in a frustrated way to try to draw. During the war, with her husband serving in the forces, she became an industrial draughtswoman and through a colleague discovered artist

Isaac Muse, who taught the drawing methods evolved by Nicolaides. After four years' study with him, and a move to New York, which involved letting her husband have custody of her son, she came to know many of the as yet unknown Abstract Expressionists. After painting abstracts in a gestural way, being discovered by Clement Greenburg and beginning to exhibit, albeit under the name George Hartigan, she felt the need to assess her position. After a year spent freely reworking paintings by earlier European painters such as Velasquez and Rubens, she joined a group of young artists who sought to combine figuration with the experience of Abstract Expressionism. By 1960, when she remarried, she was cited as the most celebrated woman painter in America for her gestural paintings, into which are incorporated elements from the real world, often the city streets. With changing fashions in art the limelight shifted, but since about 1970 she has been working on series of figures, often female, based on children's colouring and cut-out books. One series was of film stars, while a more recent one was of *Queens* and *Empresses*. In these highly coloured, calligraphic works she uses a drip veil technique, staining on to sized canvas previously coated with white paint by applying thin washes which run in rivulets over the painted figures.

*Examples:* Metropolitan Mus., Whitney Mus. and MOMA, New York; Hirschhorn Mus., Washington, DC.

*Literature:* Bachmann; L. Campbell, 'GH's Great Queens and Empresses (1983)', *Arts Mag.*, Jan. 1984, 87–9; C. Nemser, *Art talk*, New York, 1975; Petersen; Rubinstein; Withers, 1979.

## HATOUM, Mona (1952–)

*Palestinian video and performance artist working in England*

Born in Lebanon, Hatoum was visiting London in 1975 when the outbreak of the civil war prevented her from returning. After studying at the Byam Shaw School of Art (1975–9) and the Slade School of Art (1979–81), she has focused her performance, video and installations, on the theme of division between two worlds. She identifies herself as a black artist, sharing in a past of colonialisation and oppression. From 1982 she produced a series of physically exhausting performances in

which her own body represented the oppressed people, and many of the situations and details reflect the experience of her native country. She forces the spectator to reconsider received notions of victimisation. She has worked with a number of women's groups and has presented her work in Europe, America and Canada.

*Literature:* Anon., 'MH: body and text', *Third text*, autumn 1987, 26–33; *Along the lines of resistance: an exhibition of contemporary feminist art*, Cooper G, Barnsley, 1988; *Contemporary clothing*, Ikon G, Birmingham, 1987.

## HAVERS, Alice Mary. (alt. MORGAN) (1850–90)

*English painter of figure and religious subjects, genre and landscape*

Born in Norfolk, she was the third daughter of Thomas Havers of Thelton Hall. She was brought up in the Falkland Islands, of which her father was manager, and in Montevideo. On her father's death in 1870 she returned to England and began her training at the South Kensington Schools, where her work gained her the award of a free studentship in the first year. She married the painter Frederick Morgan in 1872, the year she first exhibited, but continued to use her own name. They lived in St John's Wood, London. She worked extremely hard, for in a career of only 18 years she exhibited widely in London, Glasgow and elsewhere. At the RA alone she showed 33 works, many of which were large figure subjects. She had three children, whom she would use as models where appropriate. One source reveals that she would never employ a model who had sat for a male artist. In 1888 she took her children to Paris for several months in order to be in direct contact with the latest styles of French painting, and while there she exhibited in the Salon and the Exposition Universelle. Many of her subjects concern the lot of women, particularly in rural village communities. She also illustrated some of the stories written by her sister, Mrs Boulger, who was better known under her pseudonym of Theo Gift. Alice Havers died suddenly at the age of 40.

*Examples:* Cardiff; WAG, Liverpool; Norwich; Rochdale; Sheffield; Southport.

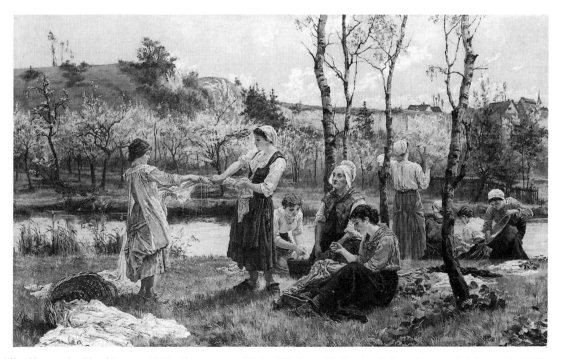

**Alice Havers** *Les Blanchisseuses*, 1880, oil on canvas, 110.2 × 183.8 cm, Walker Art Gallery, Liverpool. (photo: John Mills (Photography) Ltd)

*Literature:* D. Cherry, *Painting women: Victorian women artists*, Art G, Rochdale, 1987; *DNB*; H. Furniss, *Some Victorian women: good, bad and indifferent*, London, 1923; Mallalieu; P. Nunn, *Victorian women artists*, London, 1987; Sellars; W.S. Sparrow; Wood, 1978.

## HAVERS, Mandy (1953–)

*English sculptor of torsos and bodies, often male, in leather*

Born in Portsmouth, she trained at Lanchester Polytechnic, Coventry (1972–5) and pursued post-graduate studies at the Slade School of Art (1976–8). Havers recounts how she found her imagery during temporary work in a hospital in 1972. She became fascinated by the human body at all stages of its development, particularly when isolated within medical machinery, such as incubators, X-ray and dialysis machines. After experimentation and a re-examination of the work of artists such as Leonardo da Vinci, Mathias Grünewald and Francis Bacon, she started to work with leather in 1976. Gradually she evolved a hand-stitching technique that enabled her to control the surface contours of muscles and tendons. Framing the torsos and bodies are structures reminiscent of machines but sufficiently ambiguous to be interpreted for good or harm, cure or torture. Her approach to the male body is similarly ambivalent, enabling viewers to interpret it as they wish. Exhibiting regularly since 1975, Havers has also taught at the Slade.

*Literature:* S. Kent & J. Morreau (eds), *Women's images of men*, London, 1985; E. Lucie-Smith, *Art in the seventies*, London, 1980; *Women's images of men*, ICA, London, 1980.

## HAYLLAR, Edith (1860–1948)

*English painter of middle-class family life*

One of four sisters who all practised art at some time in their lives. From 1875 they lived in Wallingford, Berkshire, where they studied with their father, James. The family house formed the setting for many paintings by father and daughters. Edith Hayllar's subjects are carefully observed events in the life of a comfortable but unassuming middle-class family. She exhibited from 1882 to 1897 at the RA and other leading London venues, as did her sisters. In the 1880s the top price for her works at the Society of British Artists was £42. Around 1900 she married the Rev. Bruce Mackay and ceased painting.

*Literature:* Bachmann; D. Cherry, *Painting women: Victorian women artists*, Art G, Rochdale, 1987; Harris; P. Nunn, *Victorian women artists*, London, 1987; C. Wood, 'The artistic family Hayllar', *Connoisseur*, v186, 1974, pt. 1: Apr., 266–73 & pt. 2: May, 2–10; Wood 1978.

## HAYLLAR, Jessica. (also Kate and Mary) (1858–1940)

*English painter of interiors, genre and flowers*

Sister of Edith (*q.v.*), Jessica was the eldest of the four daughters and had the longest professional career. She exhibited from 1879 not only in London but also widely in the provinces. Her paintings show the tranquil interior of the family home and are painted in a style which conveys pleasure in the tactile qualities of the objects depicted. Where individuals are present, they were modelled from local people or members of her family. About 1900 she suffered an accident which confined her to a wheelchair, and thereafter she painted chiefly flowers, particularly azaleas. She continued to exhibit until 1915. The other two sisters were Kate and Mary. Kate exhibited flowers and still lifes from 1883 to 1898, when she gave up painting to become a nurse. Like Jessica she never married. Mary exhibited 15 works of genre and still life in the 1880s, married a Mr Wells and gave up painting except for miniatures of children.

*Examples:* Jessica Hayllar: Rochdale.

*Literature:* As for Edith Hayllar.

## HAYNAU, E. von. See ROSÀ, Rosa

## HEEMSKERCK, Jacoba Berendina van Beest van (1876–1923)

*Dutch painter of Expressionist landscapes and portraits, and printmaker*

One of the most important artists from The Hague, after initial instruction from her father,

she attended the Academy there from 1897 to 1900. After this she appears to have studied with several artists, whose names vary in the sources, before going to Paris in 1904. There she worked for six months with Carrière. Although subsequently based in The Hague, she travelled extensively and at times spent considerable periods in other places, including Berlin. Her Expressionist works are often linked with those of the German Expressionists, and the connection was maintained by her close friendship with Herwath Walden, the Berlin dealer and supporter of modernist art. Van Heemskerck also benefitted from her closeness to the avant-garde critic and collector, Maria Tak van Poortvliet, who espoused the cause of the Dutch Expressionists. By 1914 she had established a sound reputation for her landscapes and figure subjects. Her post-war work saw a change in direction to commissions for mosaics and stained glass windows. Throughout her career she exhibited actively.

*Examples:* Kupferstichkabinett and Nat. G, SMPK, Berlin; Berlinische G and Bauhaus-Archiv, Berlin; Gemeentemuseum, The Hague; Middelburg; Mus. Boymans-van Beuningen, Rotterdam; Utrecht.

*Literature: Das Verborgene Museum; JBH,* Gemeentemuseum, The Hague, 1982; Krichbaum.

## HELENIUS, Ester (1875–1955)

*Finnish painter of interiors, still lifes, portraits and landscapes in a brightly coloured, freely handled style*

After a childhood in Lappträsk, Nyland, and schooling in the Swedish town of Viipuri, Helenius studied at the Drawing School in Helsinki under Hélène Schjerfbeck (*q.v.*) from 1892 to 1898. Although she had already begun to exhibit in 1896, she spent several months in 1899–1900 studying in Italy and Paris, where she worked under Carrière. Her affinity with the French capital was such that she continued to return at intervals over the next 40 years. On some of her visits she studied at the academies of the Grande Chaumière and Colarossi, as well as with Bourdelle. From the painting she encountered in France came her brilliant colours and spontaneous, often Expressionistic brushstrokes. To this she brought her knowledge of Finnish folk-art traditions. Her love of light and colour are combined effectively in a number of church interiors in which light streams through the windows which are the focal point of

the composition. Another favoured motif was puppets. From 1936 to 1937 she taught at the Free Art School in Helsinki and received her first solo show in 1938. She continued to work until 1954.

*Examples:* Hämeenlinna; Atheneum, Helsinki.

*Literature: Sieben Finnische Malerinnen,* Kunsthalle, Hamburg, 1983.

## HENNINGS, Emmy. (alt. HENNINGS-BALL; BALL-HENNINGS) (1885–?)

*German maker of satirical dolls and puppets, and performer active in the Dada group; also a writer of poetry and prose*

Born in the North German port of Flensburg, she described herself in a book as 'a seaman's child'. Documentation on her is sparse, for she is seen only in connection with her partner, Hugo Ball. Nevertheless she wrote several books about herself, although these exist only in German at present. After the death of her first child and desertion by her husband, she joined a theatrical troupe. She left a second child with her mother while she undertook tours within Germany and abroad as a performing artist. Arrested soon after the outbreak of World War I on a charge of forging passports, she was released after six weeks. Sympathising with the pacifists, she returned to the Munich nightclub where she had been performing, before joining Ball (whom she had met in Munich in 1913) in Berlin. There she earned her living as a performer and artist's model until she fled with Ball to Zurich. Once again she was the main provider, although Ball played the piano for her singing once he felt safe from arrest. In January 1916 they opened the Cabaret Voltaire, and through it Hennings intended from the start to make provocative attacks on society. She carried this out by singing aggressive songs in a similar manner and by reading her poems. By 1916 she had also begun to make dolls and puppets, conveying through them her fundamentally negative philosophy. The puppets were made from ordinary household objects and their precise role in the soirées remains unclear. After her introduction of them, others within the group took up the potential of satirical puppet shows. In July 1916 Henning and Ball suddenly left Zurich for six months, and by the time they returned a new interest in the more mystical aspects of Christianity was evident in Hennings' performances. Nevertheless she made a break with the Dada group in Zurich in June 1917

and began to publish several novels and book of poetry. Little is known about her later life.

*Publications: Das Fluchtige Spiel*, Einsiedeln, 1942; *Ruf und Echo: mein Leben mit Hugo Ball*, Einsiedeln, 1953.

*Literature:* H. Ball, *Flight out of time: a Dada diary*, New York, 1973, trans. A. Raimes; T. Rugh, 'EH and the emergence of Zurich Dada', *WAJ* v2/1, spring-summer 1981, 1–6.

## HEPWORTH, Barbara (1903–75)

*English abstract sculptor in stone and wood*

Hepworth was fortunate to be part of an enlightened family in Wakefield, West Yorkshire, where music and literature were a normal part of the environment and her parents believed in the same education for their daughters as their son. After attending Leeds School of Art, where she was a younger contemporary of Henry Moore, and the Royal College of Art, she won a scholarship which enabled her to spend two years in Rome. At this time she also married artist, John Skeaping and later had a son, Paul, who was killed in 1953. Her broadly figurative works began to be exhibited in 1928. In 1931 she visited Paris with Ben Nicholson and was struck by the work of Brancusi and Arp. Reviving the tradition of carving, Hepworth's sculpture consisted of simple forms, singly or in small groups, at first geometrical but increasingly organic. She opened up the solid centre of sculpture by piercing the stone in 1931. In 1933 she married Nicholson and had triplets. They moved down to St Ives in Cornwall for increasing periods of time. While the children were small she, unlike Nicholson, found it difficult to allocate the necessary time to her sculpture and, although she continued to work, her output diminished for several years. In the 1940s, when her sculpture was often inspired by landscape, she introduced string forms into the hollow centres of some pieces. She was one of the originators of the publication *Circle* (1937), and was involved in several avant-garde groups in London and Paris. She gained many commissions for site-specific sculpture and began to use bronze for some of these works in the 1960s. By then she had become internationally known for her visual metaphors for human experience and natural phenomena, and received many awards.

*Publications: A pictorial autobiography*, Bath and New York, 1970.

*Examples:* Aberdeen; Birmingham; Bolton; Bristol; Albright-Knox Art G, Buffalo; Lehmbruck Mus., Duisberg, W. Germany; Harlow; Leeds; Leicester; Tate G, London; Minneapolis; MOMA and UN Plaza, New York; Ottowa; Mus. Boymans-van Beuningen, Rotterdam; cathedral, Salisbury; Stavanger, Norway; Toronto; Hirschhorn, Washington, DC.

*Literature:* Bachmann; A. Bowness, *BH: drawings from a sculptor's landscape*, Bath, 1966; A. Bowness, *BH, 1960–9*, London, 1971; *DWB*; Fine, 1978; A. Hammacher, *BH*, London, 1968; C. Nemser, *Art talk*, New York, 1975; H. Read, *BH: carvings and drawings*, London, 1952; Withers, 1979.

## HEPWORTH, Dorothy. See PREECE, Patricia

## HERBELIN, Jeanne Mathilde. née HABERT (1820–1904)

*French painter of miniatures*

Born in Brunoy, Seine-et-Oise, she was the daughter of a French general. From an early age, she was taught painting by her uncle, J.H. Belloc, and at 18 she visited Italy. Her ambition was to paint large pictures but, according to Clement, Eugène Delacroix intervened and persuaded had to devote herself to miniatures. As a result, she was the first artist to introduce the broader handling and wider range of tones into French miniature painting, and the Musée du Luxembourg purchased its first-ever miniature from her. She exhibited at the Salon from 1840 to 1877, receiving many awards, and from 1855 was allowed to exhibit *hors concours*, without submitting to the jury.

*Examples:* Mus. d'Orsay, Paris.

*Literature:* Clement; E. Ellet, *Women artists in all ages and countries*, London, 1859.

## HERFORD, Laura. née Anne Laura HERFORD. (alt. HEREFORD) (1831–70)

*English genre painter*

Laura Herford is best known as the first woman to gain admission to the RA Schools. She had trained at Heatherley's in London and also attended the life-drawing classes organised by Eliza Bridell-Fox

(*q.v.*). She then submitted the required drawings to the RA admissions committee with only her initials. Her letter of acceptance was addressed to A.L. Herford, Esq., and there was some consternation when she arrived to take up her place in 1860. Huish suggests that she had previously written to Lord Lyndhurst, pointing out the inaccuracy of his statement on the availability of free training at the RA for all citizens. He had taken this up with the government, who had in turn questioned the president of the RA, Sir Charles Eastlake. He was in sympathy with the case, and during a subsequent interview with Laura Herford he suggested the scheme of the initials. After her training there she exhibited throughout the 1860s at the main London galleries. She was the aunt of Helen Allingham (*q.v.*), and advised and supported her niece, providing the formal recommendation for her entry to the RA Schools.

*Literature:* D. Cherry, *Painting women: Victorian women artists*, Art G, Rochdale, 1987; Clayton; Clement; Harris; M. Huish, *The happy England of Helen Allingham*, London, 1903, repr. 1985; P. Nunn, *Victorian women artists*, London, 1987; W.S. Sparrow; Yeldham.

## HERMES, Gertrude (1902–)

*English sculptor, designer and illustrator*

A versatile artist who was able to work over a wide range of scale, Hermes studied at the Beckenham School of Art, Kent, for a year (1919–20) before spending 1922–5 at Leon Underwood's School in London, where she met Henry Moore and Eileen Agar (*q.v.*). At the beginning she studied wood engraving but decided to take up sculpture in 1924. After her marriage in 1926 to Blair Hughes-Stanton (they were divorced in 1933), she collaborated with him on several illustration projects. She was a member of the Gregynog Press and became well known for her illustrations. Parallel with this she executed portrait busts, decorative fittings and other sculptures. Her largest commission was for the Shakespeare Memorial Theatre, Stratford-on-Avon in 1932, for which she carried out a carved stone fountain, door furniture and a mosaic floor. She also executed a ten-metre-high sculptured glass window for the British Pavilion at the Paris International Exhibition of Arts and Industry of 1937, and three glass panels for a similar site at the New York World Fair of 1939. Elected a member of the Society of Wood Engravers

**Gertrude Hermes** *Snake and tortoise*, 1932, wood engraving, 22 × 14.5 cm, Walker Art Gallery, Liverpool. (photo: John Mills (Photography) Ltd)

in 1933 and of the London Group in 1935, she was one of seven engravers chosen to represent Britain at the Venice Biennale in 1939. She spent most of World War II in North America. During her career she also taught at several London art schools, including St Martin's, the Central School and the RA Schools.

*Examples:* V & A, London; Rochdale; Shakespeare Memorial Theatre, Stratford-upon-Avon.

*Literature:* Deepwell; Mackay, *The Thirties: British art and design before the war*, Hayward G, London, 1980.

## HERON, Hilary (1923–76)

*Irish sculptor in wood, metal and stone*

Dublin-born, she trained at the National College of Art, where she won the Taylor scholarship

three times. As a student, she was influenced by Henry Moore, Barbara Hepworth and ancient non-European sculpture. Then in 1948 the award of the Mainie Jellett (*q.v.*) travel scholarship enabled her to see Romanesque carving in France and Italy. Her most radical work dates from the 1950s, when her great energy and her feeling for materials emerged most strongly in her metal work. In the 1960s her work became more relaxed and sometimes humorous or whimsical. She exhibited from 1945, and in 1956 was chosen as one of the two artists to represent Ireland at the Venice Biennale. Critics have remarked on a certain lack of cohesion in her work overall, but admit this is difficult to substantiate without a major retrospective exhibition, which would enable her sculpture to be seen as a body of work.

*Examples:* Jury's Hotel, Dublin.

*Literature: Irish women artists.*

## HESSE, Eva (1936–70)

*German-born Minimalist sculptor who lived in America, working chiefly in latex, fibreglass, string and rubbery synthetics*

Despite the brevity of her career – five years of mature work before her death from a brain tumour – Hesse's stringy, rubbery, formal and yet emotionally intense works made her one of the most original and influential sculptors of the period. Born in Hamburg, her parents fled with Eva and her younger sister to New York in 1939. Her parents soon divorced and Eva chose to live with her father and his second wife, becoming an American citizen in 1945. She was deeply affected by her mother's suicide the following year. Her serious approach and her talent were acknowledged at the Pratt Institute, the Art Students' League (1952–4) and the Cooper Union (1954–7). Two further years at Yale School of Art and Architecture, still as a painting student, brought to the fore the conflict between formal and emotional concerns which would be resolved only in her mature work. Back in New York, she began to exhibit her drawings, always more successful than her paintings, from 1961, the year in which she married sculptor Tom Doyle. Her work developed little as she suffered the familiar problem of being an artist's wife, but in 1964 a visit they made to Germany for a year proved crucial. It was here that she began to make her first sculptures with string and found objects, and it is from

this point that her mature work can be dated. Back in America, her marriage ended, she began to work on more geometric themes in series of drawings and sculptures of grids, spheres: 'repetition in an unrepetitive way'. Her use of such devices, together with her later use of layering, detail and anatomical associations, contributed to the theories of an innately female imagery in abstract art propounded by some American feminists in the mid-1970s. The formalism of these was subverted by the use of stringy components, carrying visceral and erotic connotations. From 1967 this aspect became dominant over the more austere forms, and she turned to more flexible materials of various kinds. Her first solo show was held in 1968, and other signs of success were appearing when she first became ill in 1969. Despite having to stay in hospital, she produced some of her most important pieces during the last year of her life. She was the first woman artist to be given a retrospective by the Guggenheim Museum, New York. Through her conviction that life and art cannot be separated she has provided a model for later women artists, and although she never declared herself a feminist she was aware of the consequences of being female in the art world.

*Examples:* Wallraf-Richartz Mus., Cologne; Kaiser Wilhelm Mus., Krefeld; Milwaukee; Whitney Mus. and MOMA, New York; Ridgefield, Conn.

*Literature: EH: a memorial exhibition,* Guggenheim Mus., New York, 1972; L. Lippard, *EH,* New York, 1976 (bibl.); L. Lippard, 'EH: the circle', *Art in America,* May-June 1971, reprinted in L. Lippard, *From the Center,* New York, 1976; L. Lippard, *Strata,* Art G, Vancouver, 1977; C. Nemser, 'An interview with EH', *Artforum,* May 1970, 59–63; *Notable American Women,* v4.

## HICKS, Nicola (1960–)

*English sculptor of animals in straw and plaster*

Hicks was born in London, her mother, Jill Tweed, being a sculptor and her father, Philip Hicks, a painter. She has always drawn, but was such a rebellious pupil at school that she had to attend evening classes to gain the qualifications to apply to Chelsea School of Art in 1978. After five years there she went to the Royal College of Art (1982–5), and while there married a jazz pianist and songwriter. She began exhibiting in 1982, but since 1985 has participated in many group and several

solo shows. Chosen by Elizabeth Frink (*q.v.*) in 1984 as 'the most promising newcomer' for an exhibition, she has many private patrons. Her rough textured animal sculptures are sometimes mythological beasts, at others existing wild and domestic animals. She also exhibits vigorous charcoal drawings of animals.

*Literature:* M. Beaumont, 'The Hayward Annual', *Arts Review*, May 1985, 279; B. Bhegani, 'A life in the day of NH', *Sunday Times*, Oct. 1986, 110; review, *Flash Art*, summer 1985, 58.

## HILEY, Muriel B.G. (1906–)

*Welsh sculptor of portrait busts, medals and reliefs*

Born in Cardiff, Hiley was the daughter of an architect and archaeologist. From 1926 to 1929 she attended Goldsmiths' College in London before proceeding to the RA Schools from 1929 to 1934. In 1929 she began her extensive exhibiting career and, in addition to several medals won at the RA Schools, she was awarded the Feodora Gleichen (*q.v.*) prize for women sculptors in 1932. Commissions came quickly for portrait busts and memorial tablets, including a bust for St Paul's cathedral (1929), a commemorative plaque for the jubilee of Brooklands race track (1957) and a large-scale copy of the World Cup for Wembley Stadium (1966). In addition to many other commissions, she carried out portrait drawings, especially of children, medals for the Royal Mint and coats of arms. She continued exhibiting until at least 1969.

*Examples:* Birmingham; Nat. Mus. of Wales, Cardiff; St Paul's cathedral (bust of W. Cockerill), St Clement Danes church (memorial tablet to Challis Winney) and Imperial War Mus., London; Newport, Gwent.

*Literature:* K. Dunthorne, *Artists exhibited in Wales, 1945–74*, Cardiff, 1976.

## HILL, Amelia Robertson. née PATON (1820–1904)

*Scottish sculptor of figures and animals*

She was born in Dunfermline, the sister of painter Noel Paton. It is not known how she trained but most of her work identified so far dates from the mid-1860s to the 1880s. She executed a variety of subjects, including genre and animal statuettes (some in wax), memorials, statues and portrait busts. Her sitters included Thomas Carlyle, Sir David Brewster and Richard Irven of New York. She executed the memorial to Regent Murray at Linlithgow, and her statue of David Livingstone was erected in Edinburgh in 1876. It was said to be the first statue by a woman to be put up in a public place in Britain. She married the painter and pioneer photographer, David Octavius Hill, and they lived in Edinburgh. She exhibited there over a number of years.

*Examples:* Dunfermline (Robert Burns); Princes Gardens, Edinburgh.

*Literature:* *AJ*, Apr. 1874; Clement; Mackay; S. Tytler, *Modern painters*, London, 1873.

## HILLER, Susan (1942–)

*American-born mixed-media artist working in England who questions existing forms of art and codes of representation*

Hiller's training at Smith College in Northampton, Massachusetts and Tulane University (1961–5) was in anthropology, and she carried out field work in South America. Disillusioned with the academic discipline, because of the political uses to which it was put, she decided to build on the painting she had done as an option on her course. Parallel with this she continued to explore aspects of anthropology which were concerned with apparently trivial cultural artifacts; and it was only later that she incorporated this into her work to the exclusion of more conventional forms of art. She then came to Europe, and has lived and worked in London since 1967. Her principal themes of identity, gender, representation and language are explored through combinations of drawing, photographs, printed texts, video, automatic writing, painting and sculpture. Many of her works are presented in large-scale installations, and may differ each time they are shown. *10 months* (1977–9) was based on profile photographs of her abdomen during pregnancy, *Fragments* (1976–8) on broken pieces of Pueblo Indian pottery made by women, *Monument* on memorial plaques of ordinary people who died in heroic self-sacrifice, and *Belshazzar's feast* on subliminal methods of communication. She has exhibited many times with regular solo shows since 1973.

*Examples:* Tate G, London.

*Literature:* G. Brett *et al., SH, 1973–83: the muse my sister,* Londonderry, 1984 (bibl.); *Hayward Annual '78,* Hayward G, London, 1978; S. Kent & J. Morreau, *Women's images of men,* London, 1985; C. Lacey, *SH: Belshazzar's feast,* Tate G, London, 1985 (bibl.).

## HILTUNEN, Eila (1922–)

*Finnish sculptor, firstly in marble and then iron*

One of a generation of ambitious Finnish women sculptors, she was born in Karelia. After studying at the Helsinki Academy from 1942 to 1946, she travelled through Europe and America. Many of her early works were traditional naturalistic portrait busts of Finnish artistic and political figures and war memorials. She married the photographer, Otso Piettinen, and had to look after her children. A feeling of confinement by domestic matters endangered her health but also inspired her to experiment with new materials and techniques. During the 1950s, she began to use iron and change her subject matter, so that a surreal quality was introduced into her work. The discovery of the welding technique and a travel scholarship to America, which both occurred in 1958, were particularly important. Welding enabled her to simplify figurative forms and develop an alternative set of values to those of her earlier work. With metal strips providing the essential form, the space within and between these became a dynamic force. Working on both small and large scales, she received a number of site-specific commissions, and her first abstract sculpture won the 1962 competition for the Sibelius monument in Helsinki.

*Literature:* Krichbaum; Mackay; G. Schildt, *Modern Finnish sculpture,* London, 1970.

## HIMID, Lubaina (1954–)

*Tanzanian-born painter and mixed-media artist working in London who has played a leading role in organising the showing of work by women artists of colour*

Born in Zanzibar, she was brought to England as a baby. She studied theatre design at Wimbledon School of Art from 1973 to 1976, after which she worked on various theatrical productions and interior designs. In 1982 she began two years of research for an MA on 'young black artists in Britain today', which documented the situation she had already experienced. As a result she began in 1983 to organise exhibitions to make black women's art more visible. Through the Black Artists' conference in 1982 she met Sonia Boyce (*q.v.*), whom she selected for her first exhibition. Himid's large-scale female figures offer powerful images symbolic of black women who have struggled against oppression in its many forms. She now makes installations which comment acerbically on current politics in government and the art world through the use of her own and black people's history.

*Literature: Along the lines of resistance: an exhibition of contemporary feminist art,* Cooper G., Barnsley, 1988; S. Nairne, *State of the art,* London, 1987; *The thin black line,* ICA, London, 1985.

## HÖCH, Hannah. née Johanne HÖCH (1889–1978)

*German collage artist who, early in her career, participated in the Dada movement*

The eldest of five children, she was born in Gotha, where her father was a senior employee in an insurance firm. In 1912 she moved to Berlin, attending the glass design course at the School of Applied Arts. Her exposure to modernist art began with a visit to the Futurist exhibition at the Der Sturm Gallery. On the outbreak of World War I she worked with the Red Cross in her home town before returning to Berlin in 1915 in order to study at the State School of the Museum of Applied Arts under Emil Orlik. At that time she met the Viennese artist Raoul Hausmann and, as a result of visiting the Der Sturm Gallery exhibitions of modern art and attending woodcut classes, she began to experiment with non-objective art, both painting and collage, and made a number of stuffed dolls which are both playful and show a taste for the absurd. Until 1926 she earned her living doing lettering and illustrations. With others such as Heartfield, Huelsenbeck and Grosz, she became increasingly disillusioned by the war and German society, but her role in the Dada activities in Germany, which began early in 1918 was constrained by her stormy relationship with the jealous Hausmann, and it was only after they had separated in 1922 that she made artistic contacts in her own right. Indeed her role in the movement was played down by the men in the group, and critics accepted this until the late 1960s, when Höch's work first began to receive serious atten-

tion. Avoiding the Dada performances, she preferred to use photomontage and collage in order to come to terms intellectually with the horrors of war. This enabled her to remain outside much of the petty jealousy existing between the men. A walking tour undertaken in 1922 acted as a catharsis after the years of repressing her personality with Hausmann. A close, uncomplicated friendship with Kurt and Helma Schwitters was more supportive, complemented from 1926 by nine years with the Dutch woman writer Til Brugman. After discovering photomontage with Hausmann, Höch became the first person to use it consistently throughout her career. She collected reproductions from a wide variety of sources but was able to organise the elements into a coherent and artistic whole, while the content was critical, sarcastic and ironical. She transformed figures and in the process opened up imaginary worlds, showing a way out, without escapism, of the contemporary situation. The suspension of gravity was stimulated by her encounter with aerial photography early in the 1920s, and her interest in space continued throughout her life. Plants also became a frequent motif, whether converted into monsters or machines. By the mid-1920s her technique had expanded to include some painted areas and a wider range of materials rather than only photographs; but political subjects returned in 1931 with the impending threat of the Nazis. An exhibition of her work due to take place at the Bauhaus in 1932 was cancelled and, as her friends emigrated, she moved to the north of Berlin where no one knew her. Plants invaded her house in a way which resembled Schwitter's Merzbau architecture. In the post-war period Höch availed herself of the wealth of colour magazines which appeared, and also worked fruitfully in oil, watercolour and drawings in a range of styles from abstract to Surreal. It is, however, in her collages that the techniques first evolved in Dada persist most clearly. Hating dogmatism and loving freedom, she retained a provocative spirit to the end of her life. Many exhibitions of her work were held both before and after her death.

*Examples:* Kupferstichkabinett and Nat. G, SMPK, Berlin; Berlinische G, Berlin.

*Literature:* Bachmann; J. Beckett, *The Twenties in Berlin*, Annely-Juda G, 1978; *Das Verborgene Museum*; Harris; *HH*, Mus. d'art Moderne de la Ville de Paris and SMPK, Berlin, 1976; *HH*, Goethe Institut, London, 1986; *Künstlerinnen International, 1877–1977*, Schloss Charlottenburg, Berlin, 1977; Petersen.

## HODGKINS, Frances (1869–1947)

*New Zealand painter of landscapes, still lifes and figure subjects, who worked in England*

Born in Dunedin, New Zealand, Hodgkins' father was not only a solicitor, but also an amateur painter with many contacts among European academic artists. After some instruction from him, she proceeded to the local art school in 1895. Determined to come to Europe she earned the money for her passage by selling quickly executed watercolours and illustrations. Her first reaction to England in 1900 was unfavourable, and she rapidly moved on to France, joining sketching classes in Brittany, and travelling to North Africa, a visit she subsequently regarded as one of the most formative events in her artistic development. The paintings from this journey led to her first solo show in London, with the Fine Art Society. Few of her works before 1915 still exist, but we know that with a knowledge of late nineteenth-century French art she was exploring the theme of light, both natural and artificial. She travelled a good deal, dividing her time between France and England, and, to a lesser extent, Holland and Italy. In 1910 she joined the staff at the Académie Colarossi, where she was the only woman. At the outbreak of World War I she settled in England, which was to remain her base for the rest of her life. It was not easy for her to make a living in the post-war period in Britain, where modernist art was slow to gain a following. She executed some portraits which revealed an increasingly freer and more expressive style. In the summers she taught watercolour classes, which were attended by many women. Between 1923 and 1926 she lived in Manchester, and in 1925 she received some commissions from the Calico Printers' Association. Returning to London in 1927 she became involved with other modernist contemporaries and was a member of the London Group and the 7 & 5 Society. In 1929 a gallery owner, Lefevre, paid her a salary to enable her to paint as she wished. By the time he retired in 1932 she had secured a contract with him, and soon became very successful, enjoying many solo shows. It is for the work of this last period that she is remembered. Her subjects remained landscapes and still lifes, handled freely and with expression. After her death several retrospectives were held, and she has been one of the few women artists to be given an exhibition at the Tate Gallery.

*Examples:* Adelaide, Australia; Bristol; Dunedin, New Zealand; Ferens Art G, Hull; WAG, Liver-

pool; Tate G, London; Whitworth G, Manchester; Sheffield; Southampton; Wellington, New Zealand.

*Literature:* K. Deepwell, 'Women in the 7 & 5 Society', *WASL J.*, Apr.–May 1988, 10–12; M. Evans, *FH*, London, 1948; A.R. Howell, *FH: four vital years*, London, 1951, E. McCormick, *Portrait of FH*, NY, 1981; C. Rendell, 'FH', *WASL J.*, Feb.– Mar. 1988, 25; *Ethel Walker, FH, Gwen John*, Tate G, London, 1952.

## HODGSON, Carole (*c.* 1940–)

*English sculptor of organic pieces derived from the figure and landscape who works in Wales*

After training at the Slade School of Art, Hodgson taught at Reading University from 1964 to 1971. Although she still continues to teach and work in London, she has another studio and her source material in west Wales. After producing metal sculptures of elongated curved pipes in the 1960s, she spent a number of years making large numbers of drawings of the Welsh countryside, in which her main preoccupation was with light which dissolved the rocks and trees into semi-abstract images. More recently she has returned to sculpture, in addition to the drawings, firstly on a small scale, but increasing to life size. Many of these forms originate in the Welsh landscape, although they are transformed by a process of reduction and refinement into allusive representations.

*Literature:* B. Wallworth, 'CH', *Arts Review*, v31/23, 23 Nov. 1979, 652; S. Winter, 'CH', *Artscribe*, July 1977.

## HOFFMAN, Malvina Cornell (1885–1966)

*American sculptor of figures*

An enormously prolific sculptor, Hoffman achieved international distinction through single-minded devotion and hard work. Born in her mother's native city of New York, she was the fifth and youngest child of talented and supportive parents. Her father was an English musician, her mother an amateur pianist and linguist. After attending the Women's School of Applied Design and the Art Students' League in New York, she turned to sculpture; two early works exhibited in 1909 and 1910 marked the start of her career. Following her father's death, Hoffman and her mother went to

Paris, where she was determined to study with Rodin. After considerable persistence, she succeeded in convincing him of her seriousness and studied with him for a total of three years, interspersed with learning bronze casting and anatomical studies. They remained good friends for many years, and Hoffman was asked to organise his memorial exhibition. During World War I she became secretary of the American-Yugoslav Relief Society, travelling extensively in the Balkans to establish the true nature of the deprivation there. A close friendship with the dancer Anna Pavlova resulted in the creation of a number of sculptures of her and other Russian dancers in which she sought to convey movement and immediacy. From 1923 to 1925 she was occupied with the commission for two enormous figures to be installed at the BBC at Bush House in London. Possibly the largest commission ever given to one artist was made in 1929, when the Field Museum in Chicago asked her to record the racial types of the world. More than two years' travelling in remote countries, under difficult conditions, resulted in the collection of over 100 figures and heads of men, women and children from four continents, which was opened in 1933. The journey was photographed by her husband, musician Samuel Grimson, whom she married in 1924 and divorced in 1936. Throughout her career she produced an enormous number of figurative works of all kinds in a naturalistic style. Fascinated by people, she was led to probe into the personalities of all those she depicted, rendering her sitters with great detail. She won many awards between her first honourable mention at the Paris Salon in 1910 and her retirement in 1963. Her elections to membership included the NAD, the National Sculpture Society, the National Institute of Arts and Letters, and the National Association of Women Painters and Sculptors.

*Publications: Heads and tales*, New York, 1936; *Sculpture inside and out*, New York, 1939; *Yesterday is tomorrow: a personal history*, New York, 1965.

*Examples:* Brookgreen Gardens, SC; Mus. of Arts and Sciences, Brooklyn; Mus. of Science, Buffalo; Field Mus., Chicago; Imperial War Mus. and Bush House, London; Metropolitan Mus., American Mus. of Natural History, New York; Luxembourg Gardens and Mus. d'Orsay, Paris; Stockholm; Corcoran G, Washington, DC.

*Literature:* Bachmann; M. Hill, *The woman sculptor: MH and her contemporaries*, Berry-Hill G, New York, 1984; J. Lemp, *Women at work*, Corcoran G, Washington, DC, 1987; Mackay; L. Nochlin, 'MH:

a lifetime in sculpture', *Arts Mag.*, Nov. 1984, 106–10; *Notable American Women*, v4; Petersen; Proske, 1968; Rubinstein; Tufts, 1987.

## HOLM-MØLLER, Oliva (1875–1970)

*Danish painter of figures in nature, mytholigcal and biblical subjects*

After teaching in the Danish Folk High Schools, Holm-Møller decided to become a professional artist in 1901. She trained at the Women's Art School in Copenhagen – the female section of the Royal Academy – studying first sculpture and then painting and printmaking. Influenced by the Danish symbolist Willumsen and the Mexican muralist Orozco, she expressed her own spirituality through scenes in which figures appear in harmony with nature, each dependent on the other for survival. She accepted that male standards prevailed in the professional art world and sought to gain achievements in those terms. Through her friendship with the younger artist Jens Neilson she was able to travel widely, including Africa, the Himalayas and Mexico, where a lone woman would have aroused comment. In 1931 she won a competition for a mural scheme for the women's dormitory at Copenhagen University. Because of her refusal to conform to conventional femininity some contemporary critics derided her.

*Example:* Copenhagen.

*Literature:* I. Christensen, 'Early twentieth-century Danish women artists in the light of De Beauvoir's *The Second Sex*', *WAJ*, v9/1, spring-summer 1988, 10–15.

## HONE, Evie. née Eva Sidney HONE (1894–1955)

*Irish painter of abstract compositions, landscapes and religious subjects; also a designer of stained glass*

Born in Dublin, she had several artistic forebears. At the age of 11 she suffered from infantile paralysis, and had to struggle against poor health for much of her life. Nevertheless, her determination to succeed was considerable. Her training began at the Byam Shaw School of Art in London, but she also worked with both Sickert and Meninsky. It was on the latter's advice that she went to Paris,

accompanied by her close friend, Mainie Jellett (*q.v.*). Their study, first with Lhote and secondly with Gleizes in 1921, made them the chief exponents of modernist art in Ireland, and as such the objects of some derision. They continued to return to Paris and to Gleizes for ten years, although in 1925 Hone, who was very religious, joined an Anglican community in Cornwall for a short time. She soon returned to painting, later converting to Roman Catholicism and leading a revival in religious art in Ireland. She became a member of the Parisian group Abstraction-Création in 1931. After the 1930s she abandoned abstract art, although her figurative works showed clear signs of her Parisian training in the expressive brushstroke and freedom of handling. With Jellet she was one of the founders of the Irish Exhibition of Living Art, an annual show of contemporary art, which still exists. This was one of the ways in which she helped younger artists, apart from the example of her work. Brighter colouring distinguished her work from that of Jellett, and her interest in colour led to her involvement with stained glass from 1933. For some time she was a member of the Tower of Glass, a stained-glass co-operative. Her designs showed more affinity with medieval glass than that of her contemporaries, but at the same time she incorporated lessons in shape and colour she had learnt from Gleizes. She spent much of her life in the Dower House, Marlay, Rathfarnham, which provided the subject for a number of later paintings.

*Examples:* Belfast; Crawford, Cork; Nat. G & Hugh Lane Municipal Art G, Dublin; St Michael's church, Highgate, London; Eton College chapel, Berkshire; All Hallows' church, Wellingborough.

*Literature:* Abstraction-Création, 1931–6, Mus. Nat. d'Art Moderne, Paris, 1978; Deepwell; S. Frost, *A tribute to EH and Mainie Jellett*, 1957; *EH*, Trinity College G, Dublin, 1958; *Irish women artists*; Krichbaum; H. Pyle, *Irish Art, 1900–50*, Municipal Art G, Crawford, 1975.

## HORN, Rebecca (1944–)

*German performance and video artist, sculptor and, more recently, film-maker*

Born in Michelstadt, she studied at the Hochschule für Bildende Kunst in Hamburg. Since the early 1970s she has explored a number of parallel themes through a wide range of media, from relatively

traditional to radically experimental. Despite this she has avoided fragmentation and the different works, while autonomous, can be seen as forming integral parts of one story. This diversity also precludes her identification with a particular section of the art world, for critics have found her work difficult to classify. Through the use of dreams, imagination and memories, she explores qualities which are apparently oppositional, for one of her themes is the inadequacy of forms of communication. A number of motifs reappear in several works: peacock feathers, twins, a table which dances the tango. There are also objects that feature in the two films she has made, which exist independently as works of art. Horn spent some time working in New York.

*Literature: Conceptual clothing*, Ikon G, Birmingham, 1987; J. Debbaut, 'L'empire de sens selon RH.', *Art Press*, v104, June 1986, 24–7; *Falls the shadow: recent British and European art*, Hayward G, London, 1986; *RH*, Serpentine G, London, 1984; Krichbaum.

## HOSMER, Harriet Goodhue (1830–1908)

*American sculptor of idealised figures in marble*

The foundation of Hosmer's pioneering role in studying and working in Rome was laid in childhood. Born in Watertown, Mass, she was the only child of four to live to adulthood. After she had lost a sister and her mother – in 1834 – to tuberculosis, her father, a doctor, decided on a regime of outdoor exercise for her at a time when this was discouraged for girls. His radical scheme resulted in an independently minded, physically tough young woman, whose ability to model was encouraged towards a profession by the English actress Fanny Kemble. As one of the first women sculptors, there was no prescribed course for Hosmer to follow. After lessons in technique from Boston sculptor, Paul Stephenson, and anatomy lessons at a medical school, she executed her first independent piece. On seeing this, the American actress Charlotte Cushman urged her to go to Rome and, after sending daguerrotypes of her work to the English sculptor, John Gibson, she was allowed to work with him from 1952 as his only pupil. There she was able to gain a number of commissions so that after 1854, when her father could no longer support her financially, she was economically independent. This was particularly true after the success of her small sculpture *Puck*,

of which over 50 copies were commissioned at $1,000 each. The first of a number of American women sculptors who went to Rome to study and who were called the 'white marmorean flock' by Henry James, Hosmer was a strong enough character to withstand the accusation in the British Press that Gibson had executed her statue of *Zenobia*. After a libel suit, the claims were withdrawn. Many of her subjects were female, including a statue of Isabella for the 1893 Chicago Exposition; but her commissions included her huge statue of Senator Thomas Hart Benton for St Louis, fountains and a set of gates. In Rome she mixed in expatriate circles which included Elizabeth and Robert Browning. Her contact with the British aristocracy resulted in a good deal of her later life being spent in their households. Her output diminished after 1880, partly due to a change in fashion, and around 1900 she returned to her native town. Although she was a professional sculptor who sometimes wore trousers, her unimpeachable personal life and general sociability enabled people to accept her and her achievements.

*Publications: HH: Letters and memoirs*, New York, 1912, C. Carr (ed.).

**Harriet Hosmer** *Puck*, c. 1858–9, marble, 77 cm high, Walker Art Gallery, Liverpool. (photo: John Mills (Photography) Ltd)

*Examples:* Public Library and Mus. of Fine Arts, Boston, Mass.; Wadsworth Athenaeum, Hartford, Conn.; WAG, Liverpool; Forbes Mag. Collection, New York; NMAA, Washington, DC; Free Public Library, Watertown, Mass.

*Literature:* Bachmann; A. Faxon, 'Images of women in the work of HH', *WAJ*, v2/1, 1981, 25–9; Fine, 1978; W. Gerdts, *The white marmorean flock*, Vassar College Art G, Poughkeepsie, 1972; *Notable American Women*; P. Nunn, *Victorian women artists*, London, 1987; Petersen; Rubinstein; L. Taft, *History of American sculpture*, New York, 1903; Tufts, 1987; Weimann.

## HOUGHTON, Georgiana (1814–84)

*English painter who through spiritualism produced abstract works in the 1860s*

Born in Las Palmas, Grand Canary, she was the seventh child of a merchant and subsequently spent most of her life in London. She apparently underwent artistic training, of which details are not known, but had abandoned 'secular' painting on the death of a much-loved sister in 1851. Eight years later she heard of the possibility of communicating with spirits, a fact she did not see as contradictory to her devout Christian faith, and in 1861 she began to produce automatic drawings during her communication with the spirit world. First with crayons and then with paint, she portrayed swirling abstract representations of spiritual flowers and fruit. From these she moved to a linear network of coloured spirals, curves and vortices. She began to show her works to other spiritualists in 1863, and in 1871 put her life savings into an exhibition of 155 of her paintings at the New British Gallery, London. Not surprisingly, it was a failure, and friends made a collection of £50 to assist her financially. Between 1872 and 1877, she served as a medium for a photographer, but he turned out to be the second person to take advantage of her naive trustfulness and was denounced as a fraud. Her surviving paintings are mostly small and the majority are abstract. She kept a diary of her spiritualist activities and through a benefactor was able to publish three books in the early 1880s. Most of her life was spent in genteel poverty. Producing some of the earliest abstract works in Europe, her paintings influenced other artists interested in spiritualism. Similar examples produced by artists such as the Swede, Hilma af Klint (*q.v.*), may have inspired

the work of the early modernists such as Kupka and Kandinsky.

*Publications: Evenings at home in spiritual séance,* London, vI 1881, vII 1882; *Chronicles of the photographs of spiritual beings,* London, 1882.

*Examples:* Victorian Spritualists' Union, Melbourne, Australia.

*Literature:* T. Gibbons, 'British abstract painting of the 1860s: the spirit drawings of GH', *Modern Painters*, v1/2, summer 1988, 33–7.

## HOUSHIARY, Shirazeh (1955–)

*Iranian-born abstract sculptor working chiefly in metal and wood, who lives in England*

Born in Shiraz, Iran, Houshiary studied theatre design there before settling in Britain and taking up sculpture. From 1976 to 1979 she was a student at Chelsea School of Art and then spent a year at Cardiff College of Art before returning to London. A consistent influence is her own culture, and Sufism in particular. In the early 1980s she made imaginary figurines of clay and straw on a wooden armature loosely drawn from Middle Eastern myths and European literature. Since about 1983 she has begun to use copper or zinc sheets, sometimes coloured with acid and retaining the wooden frame. By mixing the organic and the geometrical, she aims to show that stability is an illusion. She has been included in many exhibitions of contemporary sculpture and has had a series of solo shows since 1980.

*Literature:* M. Compton, *New Art*, Tate G, London, 1983; *Current affairs: British painting and sculpture in the 1980s*, MOMA, Oxford, 1987; *SH*, MOMA, Oxford, 1988; M. Newman, 'New sculpture in Britain', *Art in America*, Sept. 1982, 104–14, 177, 179; Venice Biennale catalogue, 1982.

## HOW, Julia Beatrice (1867–1932)

*Scottish painter, best known for her depictions of babies*

Beatrice How was born in Bideford, Devon, although her family were silversmiths from Edinburgh. Her parents died when she was quite young, and by 1890 she had determined to become an artist, although we do not know if she had an

**Shirazeh Houshiary** *Enclosure*, 1987, copper and molten solder, 259 × 400 × 400 cm, (foreground) and *My occidental exile*, 1988, copper, sulphur, pure crystal quartz, molten solder and water, courtesy of the Lisson Gallery, London. (photo: Sue Ormerod)

adequate private income. She attended the Herkomer School at Bushey for three years before moving to Paris, where she studied at the Académie Delacluse and became part of the young café society in Montparnasse. Her early paintings depict in dark tones the interiors of peasant cottages and portraits of peasants, a result of her visits to the coasts of Holland and Brittany. She established a studio at Etaples for a while. Gradually her paintings became more colouristic, with a wider range of brighter hues. Her subjects changed to still lifes, female nudes and babies. She was aware of the Intimiste work of Bonnard and Vuillard and her baby pictures belong to that tradition rather than that of Victorian sentimentality. She depicts the everyday tasks associated with caring for a baby and the involvement of mother and child through these. She worked in pencil, pastel and oil, contrasting a bright object with more neutral tones, using a fragile transparent technique and subtle gradations of colour. She became well known in France, exhibiting from 1902 at the salons and had several solo shows. She also exhibited in Pittsburgh, where she gained an award in 1914, and Glasgow. Her work was seen later in England, with a touring memorial show in 1935, and she remained virtually unknown. In 1932, while visiting her aunt in England, she sustained a fall and died a few weeks later.

*Examples:* Tate G and V & A, London; Mus. d'Orsay, Paris.

*Literature: AJ*, 1900, 284; Edouard-Joseph; *BH*, Fine Art Society, Edinburgh, 1979; W.S. Sparrow; Wood, 1978.

## HOWARD-JONES, Ray (1903–)

*Welsh painter of rocky coastal areas predominantly in Pembrokeshire*

Born in Penarth, South Wales, Howard-Jones had an artistically talented mother. Her father was a veterinary surgeon who also trained racehorses, but he was left an invalid after World War I and Howard-Jones was adopted by her uncle and aunt, who lived nearby. She was encouraged to take up outdoor activities and treated in the same way as her brother. At the age of 17 she began four years of training at the Slade School of Art under Henry Tonks. While there she won many prizes, but personal illness and the necessity of caring for her invalid aunt and mother meant that her output at this period was restricted. Nevertheless she had a solo show in 1935 and at this time also experimented with collage. During World War II some of her scenes of the Cardiff docks were purchased, and she was also commissioned to record the fortified islands in the Bristol Channel, and was thus one of the few women war artists not to paint women's activities. Her family responsibilities ended and her house was bombed, so she moved to London and was employed as a medical draughts-woman. Six months spent in Arbroath, Scotland, initially through having won a place at a summer school under James Cowie, was a formative period. She became increasingly interested in still life subjects and views through windows. By this time she had met photographer Raymond Moore, who became her partner for over 20 years. In 1949 they began a series of visits to the effectively uninhabited island of Skomer, off the coast of Pembrokeshire. This provided the basis for many of her best-known works of turbulent seas, wild skies and the rocky island with its sea birds. She worked in gouache, watercolour, oil and pastel. From 1959 she lived at St Martin's Haven, on the coast nearby, with Moore until his marriage in 1971 and then alone. After the war she exhibited regularly, notably at the Leicester Galleries, but also at the RA and in Paris. Certain modernist tendencies are apparent in her work, and she always remained ready to experiment, producing some near abstracts, using found objects in addition to working occasionally in mosaic. A close friend of artist David Jones, she shared with him a deep religious faith and the ability to write poetry. This faith intensified in her later years to the point where she took vows as an oblate at an Anglican Benedictine community.

*Publications:* 'Philip Wilson Steer', *Burlington Mag.*, 1942; *Poems and stories*, 1968.

*Examples:* Aberdeen; Bristol; Burton-on-Trent; Nat. Mus. of Wales, Cardiff; Glasgow; Grange church, Edinburgh; Haverfordwest; Imperial War Mus., London; Glynn Vivian G, Swansea.

*Literature:* E. Blunson Hall, 'The art of RH-J', *Anglo-Welsh Review*, summer 1968; K. Dunthorne, *Artists exhibited in Wales, 1945–74*, Cardiff, 1976; M. Vincentelli, *RH-J*, Castle Mus., Haverfordwest, 1983.

## HOXIE, Vinnie. née REAM (1847–1914)

*American sculptor, primarily of statues, best known for that of Abraham Lincoln in the Capitol, Washington, DC*

Born in Madison, Wisconsin, she was one of three children of a government surveyor and a mother of Scottish descent. At the beginning of the civil war, the family went to Washington, DC, where Vinnie Ream became a government clerk. On visiting the studio of the sculptor Clark Mills, in the Capitol in 1863, she knew she had found her vocation and, within a few hours of first touching clay, she had produced a medallion of an Indian chief's head. On the strength of this, she became a part-time pupil of Mills. Because of her prodigious natural talent and her fortunate location she was soon executing portrait busts of eminent men. Through these patrons she obtained daily half-hour sittings over five months for a bust from President Lincoln, who took pity on a poor girl trying to make her own way in the world. Consequently, when the competition for the Lincoln Memorial statue was held after the President's assassination in 1865, Ream's entry won the $10,000 award because the resemblance was so close. That an 18-year-old girl should win so prestigious an award was greeted with hostility and disbelief. After completion of the plaster model, Ream went to Rome with her parents, who were now financially dependent on her, in order to carry out the marble version. She remained abroad for two years, studying briefly in Paris, before setting up her studio in Rome, where her youthful enthusiasm and her dedication to work

**Vinnie Ream Hoxie** *Sappho*, bronze replica of marble version dating from 1865–70, 168 × 60.5 × 53 cm, tomb of Vinnie Hoxie, Arlington National Cemetery. (photo: P. Dunford)

made her socially successful. The Lincoln was unveiled in January 1871. A second major commission was awarded to her in 1875, when she overcame fierce competition for an heroic bronze statue of Admiral David Farragut, which was erected in Farragut Square in Washington, DC in 1881. During the time when she was working on this she had been persistently courted by Lt. Richard Hoxie, whom she eventually married in 1878. Although it is often stated that in deference to his wishes she gave up sculpture after the Farragut statue, it has been shown that she was involved in the 1893 Chicago Exposition, where three of her large neo-classical style works were shown in the Women's Building, despite her express refusal. Her final commission came in 1906, by which time she was already ill with kidney failure. Her grave in Arlington National Cemetery is marked by a bronze replica of her sculpture, *Sappho*.

*Examples:* City Hall, Brooklyn, NY; Capitol, NMAA, and Farragut Square, Washington, DC.

*Literature:* Archives of American Art, Washington, DC; Bachmann; W. Gerdts, *The white marmorean flock*, Vassar College Art G, Poughkeepsie, 1972; G. Hall, *VR: the story of the girl who sculptured Lincoln*, New York, 1963; Heller; J. Lemp, 'Vinnie Ream and Abraham Lincoln', *WAJ*, v6/2, fall 1985-winter 1986, 24–9; *Notable American Women*; Petersen; Rubinstein; Tufts, 1987; Weimann.

## HUDSON, Nan. née Anne Hope HUDSON (1868–1957)

*American painter of city and country scenes almost all of France, with some genre and portraits, who worked in England and France*

Born in New York, when her mother and father were 37 and 41 respectively, she never spoke of her childhood. Her maternal grandfather was an engraver. She was brought up in Washington, DC, but lost her mother when she was nine and her father in 1892. After this she would have had a private income, which enabled her to choose her life-style, and she elected to study painting. Accordingly she went to Paris about 1893, studying with Aman-Jean and Carrière, and it was there in 1894 that she met Ethel Sands (*q.v.*), who was to be her lifelong companion, and another close friend, Hildegard Trevelyan. She exhibited at various Paris Salons from 1899 to 1913, as well as in London. Hudson and Sands divided their time between France and London, where they knew Sickert well and were members of the Fitzroy Street Group, but were kept out of the Camden Town Group in 1910–12 by the ban on women members. Hudson was a founder member of the London Group, which superseded it, as well as an exhibitor with NEAC from 1909 to 1914, and also had a joint show with Sands at the Carfax Gallery in 1912. During World War I, she became a nurse and organised volunteer medical assistants in northern France, while continuing to exhibit sporadically with the London Group and WIAC. She suffered one of several crises of confidence about her painting at this time, a state which rendered her unable to complete a painting or to exhibit. In 1920 Hudson and Sands bought a house in Château d'Auppegard in Normandy and spent much of their time there. Hudson was meticulous about the house and a keen gardener, so the place absorbed all her creative energies for some years.

Resuming painting in 1926, she continued to exhibit in London. With the outbreak of war in 1939, she was forced to leave Normandy and at 71 once again took up nursing. After the war, she returned to Château d'Auppegard, restored the house and gave it to a Breton family. Unfortunately too few of her pictures have survived to reconstruct a chronological development, but she always worked with dry paint, usually applied in discrete squarish dabs, with perhaps only two or three main colours in a work, then evolving gradations of tone.

*Examples:* Tate G, London.

*Literature:* W. Baron, *Miss Ethel Sands and her circle*, London, 1977; Cooper.

## HUEFFER, Catherine. née BROWN (1850–1927)

*English painter of portraits, landscape and genre in oil and watercolour*

The younger daughter of the Pre-Raphaelite painter, Ford Madox Brown, and his second wife, she was the sister of Lucy Brown Rossetti (*q.v.*). She was trained by her father at the same time as her sister and Maria Spartali Stillman (*q.v.*), and was at the same school as Nellie Epps Gosse (*q.v.*) and Theresa Thornycroft (*q.v.*). When she was 19 her watercolour, *At the opera*, was highly praised at the RA and hung in a favourable place. In 1872 she married the author Dr Frank Hueffer, and they travelled to France and Italy. Afterwards she exhibited in Manchester and Liverpool rather than London.

*Literature:* Clayton; Mallalieu; P. Nunn, *Victorian women artists*, London, 1987; Wood, 1978.

## HUGUES, Jeanne. née ROYANNEZ (1855–*c.* 1914)

*French sculptor of figures and portrait busts*

Born in Paris, she was able to study under another woman, Laure Coutan. She exhibited at the Salon from 1886 to 1911 and at Chicago in 1893. Her chief works are *Jean de Valbelle* (an episode from the battle of women at Marseilles in 1524), and *Abandon*, a work in plaster. She married the author and poet Clovis Hugues.

*Literature:* Edouard-Joseph; M. Elliott; J. Martin, *Nos peintres et sculpteurs*, Paris, 1897.

## HUNJAN, Bhajan (1956–)

*Kenyan-born painter working in England*

Hunjan studied at Reading University from 1975 to 1979 before taking a two-year post-graduate printmaking course at the Slade School of Art and also studying ceramics. She has exhibited regularly since 1979 but mainly in the context of black artists, a problem faced by all artists of colour in Britain. Her work reflects her experiences as a woman and as an Asian, but through partly figurative, partly abstract, works, uses colour and shape in a symbolic way.

*Literature:* *Numaish exhibition of Asian women artists' work*, The People's G, London, 1987.

## HUNTER, Alexis (1948–)

*New Zealand-born painter and photographer trying to establish positive models for women, who works in London*

Born in Auckland she trained for four years at the Academy there before coming to England in 1972. At first she painted before and after her work in a film studio, but about 1976 turned to using serial photography to express her reactions to the position of women in society, focusing in particular on violence against women. Hunter introduced her own hands into many of the works to break down the barrier between artist and model, and also to parody the fragmentation of women's bodies in advertising. Often the surface would be smeared, rubbed or attacked during the succession of slides or photographs, as in *The Marxist's wife still does the housework* and *Alone we failed*. The large *Approach to fear* series (1976) is just one of her works which attacked devices used by the mass media to portray women. In the early 1980s she returned to painting and has been concerned with evolving positive role models for women, often through the use of myth. She deals with female creativity and in doing so caricatures many of the traditional tenets of the art world and male artists. She has been involved in a number of women's groups, particularly in the 1970s.

*Literature:* *Hayward Annual '78*, Hayward G,

London, 1978; L. Lippard, *Issue*, ICA, London, 1980; L. Lippard and M. Richardson, *AH: photographic narrative sequences*, Edward Totah G, London, 1981; S. Nairne, *State of the art*, London, 1987; *Sense and sensibility*, Midland Group G, Nottingham, 1982.

## HUNTER, Margaret (1948–)

*Scottish expressionist painter of figures, frequently women, often subjugated by circumstances*

Hunter, who was born in Ayrshire, was discouraged by her school from pursuing a career in art because of the inherent insecurity. Instead she worked as a industrial draughtswoman for five years until the birth of her first child in 1969; a second child was born in 1970. It was not until 1981 that, newly separated from her husband, she applied to Glasgow School of Art. Her four years there while a single parent involved much dedication, but at the end she was able to study in Berlin under Georg Baselitz in 1985–6. Stimulated by the cosmopolitan atmosphere and the variety of people she met, but at the same time isolated initially by the language, she drew constantly. Her earlier work involved the use of animals as surrogates for the human condition, but increasing confidence lessened the need for such symbolism.

**Alexis Hunter** *The cry of Muroroa*, 1987, oil on canvas, courtesy of Odette Gilbert Gallery, London.

Her economical drawing often shows figures frag-
mented by unknown forces. She has exhibited in
group shows since 1983 and had her first solo
show in 1986.

*Examples:* Scottish Nat. G of Modern Art,
Edinburgh.

*Literature: Art in exile,* School of Art, Glasgow,
1987.

## HUNTINGTON, Anna Vaughn. née HYATT (1876–1973)

*American sculptor of animals, mainly on a monumental
scale; founder of the Brookgreen Gardens sculpture park
and museum*

Born in Cambridge, Massachusetts, she was the
third child of an eminent palaeontologist and an
amateur painter. The arts were encouraged at

**Anna Hyatt Huntington** *Fighting stallions,* 1950, aluminium, 457.5 × 366 × 193.2 cm, Brookgreen Gardens, South
Carolina (photo: courtesy of Brookgreen Gardens, Murrells Inlet)

home and her father taught her to observe the structure of living things with scientific accuracy, while her mother, who often executed the illustrations to her husband's books, encouraged her to draw what she observed. Initially a talented violinist, she discovered sculpture at the age of 19, when helping her sister Harriet to model a dog in clay. From her childhood she loved animals and became an expert horsewoman. Primarily self-taught in sculpture, she studied only briefly with Henry Hudson Kitson in the late 1890s and a little later at the Art Students' League, New York. There she met Abastenia Eberle (*q.v.*), with whom she collaborated in 1904–5 on at least two monumental works, Eberle doing the figures and Hyatt the animals. She often modelled her subjects in zoos and circuses. After travelling in France and Italy for four years, she returned to New York in 1911 and began a long and extremely successful career. Not in the least sentimental, her works adapted the model to reveal the essential form of the particular animal. They appear both singly and in groups, feeding, resting and in motion. In 1923 she married – in her studio – Archer Huntington, a wealthy Spanish scholar and poet, who encouraged her work. Together they collaborated on various philanthropic projects, including the protection of wild animals. Through his interests, Anna Huntington came to know Spain, which in turn inspired her with several subjects. For some years after 1927 her output was diminished because of tuberculosis, but a retrospective show in 1936 included no less than 171 of her sculptures. She received numerous awards, including the Chevalier de la Légion d'honneur, the gold medal of both the American Academy of Arts and Letters and the Pennsylvania Academy. The scale of her works gradually became smaller as monumental works went out of fashion. Many of her medium-sized works were ideal for garden sculpture, while her statuettes made the work available to a different kind of patron. In addition to her sculptural achievements, she is also important for the sculpture garden at Brookgreen in South Carolina, which she and Archer Huntington founded in 1931. In this project they were able to combine patronage of traditional sculpture of figures or animals with the preservation of the indigenous flora and fauna.

*Examples:* Brookgreen Gardens, SC; Dallas; Riverside Drive and Hispanic Society of America, New York; Corcoran G, Washington, DC.

*Literature:* Bachmann; *Brookgreen Bulletin*, v13/3, 1983; *Brookgreen J.*, v15/4, 1985; *Fair Muse*; M. Hill, *The woman sculptor: Malvina Hoffman and her con-*temporaries, Berry-Hill G, New York, 1984; J. Lemp, *Women at work*, Corcoran G, Washington, DC, 1987; *Notable American Women*, v4; Petersen; Proske, 1968; Rubinstein; E. Schaub-Koch, *L'oeuvre de AHH*, Paris, 1949; Tufts, 1987; Withers, 1979.

## IPCAR, Dhalov. née ZORACH (1917–)

*American painter and sculptor*

The daughter of artists Marguerite (*q.v.*) and William Zorach, she was born in Windsor, Vermont, but since 1923 has lived in Robinhood, Maine, where her parents established their studio home and where Ipcar later lived with her husband, the artist Adolph Ipcar. Her parents were anxious that her natural talent should not be restricted by formal teaching, and allowed her to work as she wished. Rejecting modernist styles, she began by producing solidly composed works in a bold figurative style and by the age of 21 she had had a one-person show at MOMA, New York and gained a mural commission from the government. The vibrant happiness of the works of the 1930s lead into her later depictions of a magical world not only in painting, but also in illustrations and soft sculpture. She has had over 40 solo shows and is still active.

*Examples:* Metropolitan Mus. and Whitney Mus., New York.

*Literature: Women pioneers in Maine Art, 1900–45*, J.W. Payson G, Westbrook College, Portland, Me., 1985.

## ISERBYT, Georgina (1915–)

*Belgian painter of figure and marine subjects*

Although born in Birchington, Kent, Iserbyt is Belgian in repect of her family and training. She trained under Georges van Zevenbergen, whom she later married. With a formidable reputation as a painter, she was also honorary professor and the chief instructor in painting at the Académie Royale des Beaux-Arts in Brussels, one of the trustees of the national collections of art, and represented her country on UNESCO's National Council for the Plastic Arts. Many official portraits have been commissioned from her, and she is one of only 15 artists chosen to portray the king and queen of Belgium. She has received many official

honours for her rich and glowing canvases. She has also painted sea pictures, symbolic in intent rather than narrative. Other paintings are entirely the product of her fantasy, but even in her more apparently realistic subjects there are often hints of another reality.

*Examples:* Brussels; Ghent.

*Literature:* J. Collard, *50 artistes de Belgique*, n.d.; *GI*, G. Kintz, Brussels, 1978; *GI*, G Alifican, Brussels, 1988; S. Rey, 'GI: les ivresses de l'imagination', *La libre Belgique*, 11 Mar. 1988.

## ITASSE, Jeanne. (alt. Mme BROQUET) (1867–?)

*French sculptor of figures, reliefs, memorials and portrait busts*

A Parisian by birth, she was a pupil of her father, who observed her modelling clay when she was a small child. She was extremely gifted and first exhibited at the Salon from 1886. She won many awards from 1888, including a *bourse de voyage* in 1891 for *The Egyptian harpist* and at the Expositions Universelles of both 1889 and 1900. She was also awarded a medal in Chicago in 1893. Several of her works were purchased by the state and placed in ministerial offices or provincial museums. She worked very hard, exhibiting at least one large piece almost every year. In 1894 she executed a monument for the tomb of her father. She was elected member of the Société des Artistes Français and later joined the jury for the salon awards.

*Examples:* Agen; Cemetery of Père-Lachaise, Paris (tomb of father); Opéra, Paris (bust of Marie Salles, an eighteenth-century dancer).

*Literature:* Clement; J. Martin, *Nos peintres et sculpteurs*, Paris, 1897.

## JACQUEMART, Nelie Barbe Hyacinthe. (alt. JACQUEMART-ANDRÉ) (1841–1912)

*French painter of portraits, religious subjects and genre; also a sculptor and collector of art*

Born in Paris, she trained with Cogniet and began exhibiting at the Salon when she was 22. She very quickly became famous for her portraits and received many commissions. When Carolus-Duran could not accept any further requests for portraits,

people came flocking to Jacquemart instead. She was able to convey the character of her different sitters, and through her own warm personality many of them became her friends. She married Edouard André, a banker and avid art collector, and together they purchased many works which she bequeathed to the state, together with their mansion, which is today known as the Musée Jacquemart-André.

*Examples:* Mus. Jacquemart-André, Paris; Palais de Versailles.

*Literature:* J. Claretie, *Peintres et sculpteurs contemporains*, Paris, 1873; Clement; C. Clement and L. Hutton, *Artists of the nineteenth century*, 1879; Schurr, v3.

## JANVIER, C.A. See DRINKER, Catharine Ann

## JARAY, Tess (1937–)

*English abstract painter evoking movement and tension through a variety of basically geometric forms*

Since her emergence from training at St Martin's School of Art (1954–7) and the Slade (1957–60), Jaray has maintained a continuous investigation into aesthetic problems. Her large firmly structured paintings of the early 1960s, several executed while on a French government scholarship, were at the same time flat abstractions and evocative of space and it is this tension which is the basis of much of her work. The initial impetus for much of her works lies in motifs from architecture, landscaped gardens and Islamic art. The coloured planes become smaller shapes, sometimes in pairs, and appear to float against the fluid space of the background. Believing that 'every part of the painting should be active' she tries to reconcile 'apparently mutually exclusive forces – of movement, stillness and change'. She was commissioned to carry out a mural for the British Pavilion at Expo '67 in Montreal. She has taught at the Slade since 1968, and exhibited in group and solo shows since 1973.

*Example:* Rochdale.

*Literature:* G. Baro, 'TJ's mural for Expo '67', *Studio International*, Mar. 1967; *Hayward Annual '78*, Hayward G, London, 1978; R. Kudielka, 'TJ: new paintings', *Art International*, summer 1969; Nottingham, 1982; Parry-Crooke.

## JAREMA, Maria (1908–58)

*Polish painter of abstracts, sculptor, stage designer and book illustrator*

In both sculpture and, later, in painting, Jarema moved towards a geometric abstraction. Despite her early death, she achieved considerable recognition. She was born in Stary Sambor, near Lvov, her brother Joseph also being a painter. Before the end of her six years at the Krakow Academy of Fine Arts (1929–35) she had joined him in the experimental theatre group Cricot, which he had founded. This interest in the theatre was to remain with her, although her later participation was as an award-winning designer of sets. This activity remained parallel to her other work throughout her career. At first a sculptor, she experimented with non-objective forms, but also worked in a more realistic idiom for the portrait busts and public monuments which provided her income. By the early 1940s she had turned to painting. Using motifs of figure subjects and still lifes, her work became increasingly abstract and geometrical during that decade as she became more aware of modernist art in Western Europe. She executed many monotypes in which the influences of Expressionism and Surrealism appear. She produced series of paintings in the 1950s with titles such as *Words*, *Penetrations*, and *Filters*, in which the exploration of movement and colour had ousted all representational elements. She exhibited extensively throughout Europe in both solo and group shows, and was married to the writer Kornel Filipowicz.

*Examples:* Czestochowie; Lodz; Torun; Wroclaw.

*Literature:* H. Blum, *MJ*, Krakow, 1965; A. Oseka, 'The art of MJ', *Polish perspectives*, no.2, 1963, 29–34; M. Perebski, *MJ* Warsaw, 1958; *Slownik Artystów Polskich*, vIII, Wroclaw etc., 1979.

## JARRARD-DIMOND, Terry Sue. née JARRARD (1945–)

*American sculptor of wall-hangings of metal and fabric through which she explores spatial complexities*

Born in Slater, South Carolina, she trained at Winthrop College, Rock Hill, and later took her MFA in textile sculpture at Clemson University, again in her home state, graduating in 1979. She started exhibiting in 1978 and since 1982 has won a number of awards. She usually constructs her wall-hangings on a framework of fencing wire and aluminium sheeting in a grid-like formation. These thin metal sheets are covered with patterned fabric, and sometimes paints or sequins are added and fabric is knotted around the wire. The interplay between the patterns, paint and knotted fabric within the shallow depth creates a variety of illusions of space and depth.

*Example:* Columbia, SC.

*Literature:* S. Hyatt & T. Mangum, 'The ceremonial structures: thinking clearly in terms of emotion', *Fiberarts*, v9/4, July–Aug. 1982, 66–8; Watson-Jones.

## JELLETT, Mainie. née Mary Harriet JELLETT (1897–1944)

*Irish painter of Cubist abstracts who was also the first chair of the Irish Exhibition of Living Art (IELA)*

Jellett played a crucial role in the development of Irish art through her activities as artist and organiser. The eldest of four daughters, she was born in Dublin and from childhood was known as Mainie. After instruction from governesses and private art tutors, she enrolled at the local metropolitan school of art in 1915. After two years she went to London, where she studied under Sickert at the Westminster School of Art until 1919. Under his influence she developed a sureness of drawing and sense of colour which led to the award of two prizes in Dublin, in 1920 and 1921. This provided her with sufficient money to undertake further study in Paris and effectively ended the early phase of her art. In Paris she became a pupil of Lhote, who first brought her into contact with Cubism; but the following year with her friend Evie Hone (*q.v.*) she worked with Gleizes, whom Jellett regarded as a more extreme exponent of Cubism. Like Jellett, Gleizes possessed a strong sense of both spiritual and social commitment and the lessons proved to be reciprocal, for in instructing the two Irish women Gleizes admitted a realisation that art was not simply a formalist exercise but should also satisfy spiritual needs. After her return to Dublin, Jellett continued to visit Gleizes each summer until 1932. She and Hone exhibited Cubist paintings to considerable derision at the Dublin Painters' Society, for the style was unfamiliar. It was therefore a period of some isolation, for there was no one with whom she could discuss her ideas. Hone's letters reveal that even she depended on Jellett for the resolu-

tion of some of her artistic problems. Although their paintings at this time are almost indistinguishable, Jellett followed the principal of translation and rotation expounded by Gleizes, which resulted in bold compositions with large planes, some with decorative areas of spots or stripes, painted in bright colours. By the mid-1920s Jellett's compositions became more complex, and after 1930 semi-figurative motifs appear. This marks the start of a return to visual reality brought about by the commissions she received, by the life-classes she taught at this time, and by the influence of Chinese art. She produced landscapes, seacapes, religious subjects and genre. Throughout these years Jellett promoted contemporary art in her country. Her efforts came to fruition with the establishment in 1943 by a group of women and men of the IELA, of which Jellett became the first chair. She became ill with cancer later that year and, after her death early in 1944, the chair was taken over by the equally tireless Norah McGuiness (*q.v.*).

*Publications:* 'My voyage of discovery' in E. MacCarvill, cited below.

*Examples:* Belfast; Nat. G, Dublin.

*Literature: Abstraction-Création, 1931–6*, Mus. de la Ville de Paris, 1978; S. Frost, *A tribute to Evie Hone and MJ*, Dublin, 1957; *Irish women artists; MJ: a retrospective exhibition of paintings and drawings*, Hugh Lane Municipal G, Dublin, 1962; *MJ*, Neptune G, Dublin, 1974; E. MacCarvill, *MJ: the artist's vision*, Dublin, 1958; H. Pyle, *Irish art, 1900–50*, Municipal Art G, Crawford, 1975.

## JENKIN, Margaret. née GILES (exh. 1892–1912)

*English sculptor of figures and memorials*

Nothing is known about her until she trained under Lanteri at the South Kensington Schools in the late 1880s. She won many prizes in national art competitions in 1892–4 and was 'well-represented' at Chicago in 1893. In 1895 her statuette entitled *Hero* won a competition held by the Art Union, Lord Leighton having selected her model from among the sketch models. It was cast in bronze the following year and offered as a prize in the Art Union lottery. It is a spiralling composition which combines fine detail without overloading the small (51.5 cm) statuette. About 1899 she married Bernard Jenkin, but continued her efforts

unabated, showing two ambitious works in the years immediately following: *In Memoriam* (1900), a life-size marble sculpture, and *After 1900 years and still they crucify* in 1901. She also designed decorative items, such as a salt-cellar, which were exhibited in the Arts and Crafts Society shows. She was interested in the use of sculpture in conjunction with architecture, and carried out a terracotta frieze, no longer extant, for a house in Newgate Street, London.

*Literature:* S. Beattie, *The new sculpture*, New Haven and London, 1983; Clement; M. Elliott; *Mag. of Art*, 1901, 504.

## JERICHAU, Elizabeth Maria Anna. née BAUMANN (1819–81)

*Originally German but Danish by marriage, she was a painter of portraits, notably of royalty, religious and genre subjects*

There is disagreement about the precise place of birth and the nationality of Jerichau. The most plausible account is that she was born in Warsaw to educated and distinguished German parents. Her mother was a poet, and Elizabeth's sister, Rosa, established a notable reputation as a professor of sacred music. It was at the age of 17, after her engagement to a Russian officer had ended, that she pursued her interest in art. She studied in Düsseldorf under Sohn and Stilke, exhibiting her first painting in 1845. In the same year she travelled to Rome, where in 1846 she married the eminent Danish sculptor Jens Jerichau. The revolution in 1848 forced them to leave Rome and they settled in Copenhagen. In Rome Jerichau had abandoned Polish genre scenes in favour of life-size figurative subjects of various kinds. Through her friendship with Princess Alexandra of Denmark, who became Princess of Wales on her marriage, Elizabeth Jerichau gained many royal portrait commissions. She had eight children, but she and her husband both travelled extensively in the course of their work: Egypt, Turkey, Iran and Greece. All the time she retained her studio in Rome, where on one occasion she was requested to take her painting of the Christian martyrs in the catacombs to an audience with the Pope. She was immensely successful, producing what were then regarded as the most prestigious subjects; mythological, historical and literary subjects, together with royal portraits. In addition she painted women from the countries she visited.

She also wrote about her travels. Two of her children were artists. Hans Christian Andersen was a family friend and would read his new stories to her children; he also wrote a biography of the Jerichaus. Elizabeth Jerichau exhibited all over Europe, winning many awards and, as in London in 1871, often had the equivalent of a solo exhibition. She was a member of the Royal Academy of Copenhagen.

*Publications: Jugenderinnerungen* (Memories of youth), 1874; *Pictures of travel*, n.d. [between 1874 and 1881].

*Examples:* Nat. G, Berlin; Copenhagen; Düsseldorf; Gdansk; Gotenburg; Hamburg; Hanover; Leipzig; Stockholm.

*Literature: AJ*, 1863, 152; *AJ*, 1871, 165; Clayton; Clement; Krichbaum; P. Nunn, *Victorian women artists*, London, 1987.

## JETELOVA, Magdalena (1946–)

*Czech sculptor in iron and wood*

Born in Semily, she trained at the Prague Academy from 1965 to 1971, but spent 1967–8 studying at the Accademia della Brera, Milan under Marino Marini. On a basic iron framework her works include fantastic wooden versions of familiar items such as stairs and houses. These are used as vehicles for ideas and associations. The wood, frequently oak, is left rough hewn. Jetelova has exhibited internationally since 1971, and from 1985 has lived in West Germany.

*Literature:* M. Compton, *New art at the Tate G*, Tate G, London, 1983; S. Eiblmayr, V. Export & M. Prischl-Maier, *Kunst mit Eigen-Sinn: Aktuelle Kunst von Frauen*, Vienna & Munich, 1985; *MJ*, Serpentine G, London, 1985; 'MJ – Riverside Studios, London', *Studio International*, v198, Dec. 1985, 44–6.

## JEWELS, Mary. née TREGURTHA (1886–1977)

*English naïve painter of imaginative scenes based on her Cornish background*

It was through her contact with visiting artists in her home town of Newlyn, Cornwall, that Jewels began to paint. After her husband was killed in

the war, soon after their marriage in 1918, she was encouraged to take up painting by Cedric Morris in 1919. Entirely self-taught, she had her first solo show in London through Augustus John and Christopher Wood, and continued to paint and exhibit for many years. She shared a cottage with her sister, Cordelia, who was the first wife of sculptor Frank Dobson, and thus enjoyed a secure domestic base. She became acquainted with Barbara Hepworth (*q.v.*) and Ben Nicholson when they moved to Cornwall in 1939, and ten years later she founded the Penwith Society of Arts with Wilhemina Barns-Graham (*q.v.*).

*Literature:* A. Bowness, 'MJ and naive painting', *Painter and Sculptor*, v1/3, autumn 1958; *Cornwall, 1945–55*, New Art Centre, London, 1977; *St Ives, 1939–64*, Tate G, London 1985; *MJ*, Art G, Newlyn, 1977.

## JOHANSON, Patricia (1940–)

*American sculptor who constructs sculpture paths and gardens*

As a child in New York, she was taken on walks in the parks every Sunday. In her teens she was fascinated by the arcs of rockets tested at Cape Canaveral (now Kennedy), where her engineer father then worked. Because of the Depression, her mother had been unable to develop her artistic talent, and was a natural feminist. Johanson and her sister were therefore encouraged to try all kinds of artistic activities. After studying at Bennington College, Vermont, she took an MA in art history and a degree in architecture in order to understand the structural problems in the works she wanted to produce; she was also still painting large abstracts. It was not until the late 1960s that she began producing site-specific pieces which explored the idea of line, through paths and tracks. A commission from *House and Garden* magazine in 1970 for designs for five fantasy gardens, led to the construction of one, *Cyrus Field*, on her own land. She had by then married art historian, Eugene Goossens, and had her first son, whom she strapped to her back while working in the countryside. (A second son was born in 1978.) Since then she has received a series of commissions to construct sculpture paths, each of which resembles, for example, a bird or animal when viewed from the air. In addition to the pathways, which are made from a variety of materials and usually on a vast scale, she also constructs sculpture to be incor-

porated into the trail. She has exhibited the draw-ings of the projects as well as of the plants she encounters in the terrain.

*Examples:* Visitors' Center, Indian Point, NY.

*Literature:* Munro; Rubinstein; S. Torre, *Women in American architecture*, New York, 1977.

## JOHN, Gwen. née Gwendoline Mary JOHN (1876–1939)

*Welsh painter of female figures, children, interiors and cats*

A little-known painter in her own lifetime, Gwen John has emerged from the shadow of her flam-boyant bohemian brother Augustus and has been the subject of a number of recent studies. She was born in Haverfordwest, Pembrokeshire, but her artistic though invalid mother died when Gwen was eight, after which she was brought up by a series of governesses under the eye of her very conventional father, who was a solicitor. In 1895 Gwen was finally able to follow her younger brother to the Slade School of Art, where she formed several long-lasting friendships with other women students. With two of them she moved in 1898 to Paris, where she studied under Whistler. Although she returned to London, by 1904 she had settled in Paris, where the artistic and social atmosphere was less restricted. In order to finance herself, she modelled for other artists, including Rodin. The two artists became lovers, although the relationship was not an easy one. From 1909 the American collector John Quinn bought all that he could from her, and in this way she was repre-sented at the Armory Show in America in 1913. Gwen John was, however, reluctant to part with her work. In addition to her slow pace of produc-tion, her output was variable. Her conversion to Roman Catholicism after her affair with Rodin re-sulted in paintings of nuns, or people in church, which accorded with her established repertoire of interiors and single female figures. Her small paintings were the result of personal involvement with the subject, in muted tones of a limited range of colours. She conveyed the sense of privacy that she maintained about her life, which became in-creasingly reclusive. Her close friendships with several women during her life, as well as the fact she modelled for known lesbian artists, have led to speculation about her sexuality; but her most passionate feelings for Vera Oumançoff in the 1920s were not reciprocated. During the last years of her life she painted little, although many flower studies were found in her studio at her death.

*Examples:* Aberdeen; Nat. Portrait G and Tate G, London; Manchester; MOMA, New York; Shef-field; Southampton.

*Literature:* Bachmann; S. Chitty, *GJ*, London, 1981; Cooper; *DWB*; Harris; Heller; C. Langdale, *GJ*, New Haven & London, 1987; C. Langdale & D. Jenkins, *GJ: an interior life*, Barbican G, London 1985; Petersen; M. Taubmann, *GJ*, Ithaca, NY, 1985 & London, 1986.

## JOHNSON, Adelaide. née Sarah Adeline JOHNSON (1859–1955)

*American sculptor of portrait busts, notably of women prominent in the suffrage movement*

The oldest of three children born to the third mar-riage of each of her parents, Johnson was brought up in Plymouth, Illinois. At an early age she at-tended the St Louis School of Design, winning two prizes in a state competition for woodcarving at the age 17. Changing her name to Adelaide, she continued her studies in Chicago, maintaining herself by undertaking decorating jobs. Indeed, for much of her life her financial circumstances were straitened, but compensation for an accident enabled her to travel to Europe, and in 1883–4 she studied in Dresden and Rome. In Rome she maintained a studio for a quarter of a century, with others at various times in Carrara, London, Chicago, New York and Washington, DC. Her feminist and suffragist ideas developed early, leading her to create a series of busts of American suffragists and other prominent women, four of which were exhibited in the Women's Building at the 1893 Chicago Exposition. In 1896 in her studio, she married an English businessman, Alexander Jenkins, who adopted her surname and who, like Johnson, was a vegetarian and interested in spiri-tualism. During their marriage they were often apart and they divorced in 1908. Johnson's dream of installing a monument to the women's move-ment in the US Capitol was eventually realised in 1921. Throughout her life, she founded and supported a variety of women's organisations. After the 1930s her career diminished and she experienced financial distress, leading almost to eviction. At two points in her life she falsified her age but the dates given here are the actual years of her birth and death.

*Examples:* Metropolitan Mus., New York; US Capitol and Smithsonian Inst., Washington, DC.

*Literature: Notable American Women*, v4; Petersen; Rubinstein; Weimann.

## JOHNSON, Marie (1920–)

*American artist producing figurative constructions and environments on the subject of race*

Born in Baltimore, Johnson first trained as a junior schoolteacher, before gaining a degree in art education from Morgan State College in 1952 and later an MA from San Jose State College, California. She subsequently joined the staff at San Jose as assistant professor. She expresses in her works the potential and the frustrations of the Afro-American people. Some of her works are plywood cut-out figures, painted to resemble a familiar type of black person and dressed in discarded clothes, while in others she evolves an environment, or setting, for one or more figures. Undeterred by the impersonality of much art, she has been consistently concerned with human values. This is reflected also in her many activities in the community, undertaken in addition to her teaching and exhibitions.

*Literature:* Fine, 1973.

## JONAS, Joan (1936–)

*American performance artist*

Her initial studies were in sculpture and the history of art at Mount Holyoke College and the Boston Museum School, and she took her MFA at Columbia University, New York, the city where she now lives. Finding the static object too limiting, Jonas became interested in dance in the mid-1960s. From dance and the theatre, particularly Japanese theatre, which she encountered in 1970, Jonas took the more visual aspects. In the late 1960s she produced several performances using mirrors to explore spatial illusionism. In outdoor performances, this theme was pursued further, relying on the distorted depth of field available to the spectators who were kept several hundred metres away. She began to incorporate video into the work in 1972, and since then has introduced a wide variety of materials and techniques into her many performances. During some she carries out drawings, so that some permanent objects remain

afterwards. Sometimes she uses assistants for her re-interpretations of stories; some were children's fairy stories resulting from a commission and others included science fiction. The latter, *Double lunar dogs*, was a comparatively complex production, with a cast and technical assistants, and for the first time Jonas was willing to allow the audience a narrative.

*Literature:* D. Crimp, 'JJ'S performance works', *Studio International*, July–Aug. 1976, 10–12; H. Junker, 'JJ: the mirror stated', *Art in America*, Feb. 1981, 87–93; C. Robins, *The pluralist era*, New York, 1984; Roth.

## JONES, Lois Mailou (1905–)

*American painter of figures and landscapes, often regarded as the first important black woman painter*

Although she is now highly esteemed, Jones none the less encountered discrimination during her career. Born in Boston, she won four successive scholarships to the Museum School of Fine Arts, Boston and was one of the few black graduates. When she applied for a teaching post there she was rejected on the grounds of race. Instead she worked as a textile designer and took advanced courses at three universities before a scholarship enabled her to go to Paris, where she studied at the Académie Julian in 1937. She began to paint landscapes and still lifes influenced by Cézanne. The return to the racial prejudice of America encouraged her to deal with several subjects on this theme. From 1930 until her retirement in 1977 she taught at Howard University, Washington, DC, and in that role taught many important black artists, including Alma Thomas (*q.v.*), Howardena Pindell (*q.v.*) and Elizabeth Catlett (*q.v.*) In 1953 she married the Haitian painter Louis Vergniaud Pierre-Noel and subsequently depicted many aspects of Haitian life and landscape in a style more angular and abstract than her earlier work. In the early 1970s a year spent visiting several African countries led to the incorporation of African imagery into bold, flat compositions. She has had many solo shows and has consistently worked to achieve the recognition of black artists as American artists.

*Examples:* Boston; Brooklyn; Corcoran G, Hirschhorn Mus. and Phillips Collection, Washington, DC.

*Literature:* Fine 1973; E. Gaither, *Reflective moments: LMJ: retrospective 1930–72*, Mus. of Fine

Arts & Mus. of the Nat. Center of Afro-American Artists, Boston, 1972; B. La Duke 'LMJ: the Grande Dame of African-American art', *WAJ*, v8/2, fall 1987-winter 1988, 28–32; Petersen; Rubinstein; Withers, 1979.

## JONES, Louie Johnson (1856–after 1912)

*Welsh painter of animals, especially horses*

Louie Jones was born in Holywell, Clwyd, and undertook training in Cheltenham, Chester, Calderon's School of Animal Painting and St John's Wood School. At Calderon's she won the chief scholarship. On completion of her training she received a commission for a 50-metre-long freize at Cheadle Royal, Cheshire, in which she depicted 68 horses in natural surroundings. She had exhibitions in London at Colnaghi's on several occasions, and through this contact she received commissions from owners of horses. She also executed portraits of people and decorated a number of churches with large-scale paintings; in 1907–10 she worked on a church at Holywell. Some of her animal paintings were engraved.

*Examples:* Cheadle Royal, Cheshire; Holywell church; Council Chamber, Mold (portrait).

*Literature: Lexikon der Frau;* T.M. Rees, *Welsh painters*, Cardiff, 1912; Wood, 1978.

## JONES, Nell. née CHOATE (1879–1981)

*American painter of landscapes and genre in oil and watercolour*

Born in Hawkinsville, Georgia, she was the daughter of an army captain. On his death in 1884, the family moved to Brooklyn, where Nell Choate spent the rest of her life. Initially a school teacher, it was only in the 1920s she began to study art, encouraged by her husband, the painter and etcher Eugene Jones. She attended the Adelphi Academy in Brooklyn and was the private pupil of several artists. Exhibiting from 1927, she achieved acclaim for her Impressionist scenes of France, Italy and Brooklyn. A scholarship in 1929 enabled her to spend a year in Fontainebleau and a period of study in England. A return to Georgia in 1936 provided her with the inspiration for her paintings of the next two decades, and she evolved a simplified, Expressionist style, using vibrant colour and rhythmic forms. Her subjects are black labourers,

either working or at leisure, and she endows her black women with power and dignity. Active in many organisations concerned with art and women, she was, *inter alia*, president of both the National Association of Women Artists and the American Society of Contemporary Artists, winning many prizes and receiving awards in recognition of her services. She exhibited extensively both in America and abroad.

*Examples:* Atlanta, Ga.; Fort Worth.

*Literature:* B. Chambers, *Art and artists of the South*, SC, 1984; *Eight Southern women*, County Museum of Art, Greenville, S. Carolina, 1986.

## JONQUIERES, T. See ALALOU-JONQUIERES, Tatiana

## JONZEN, Karin. née LOWENADLER (1914–)

*English-born sculptor of figures and portraits in stone and bronze*

A prolific and now much acclaimed sculptor in England, Jonzen maintained her devotion to the classical human figure throughout the vogue for abstraction. Born in London to Swedish parents, she was, unusually, sent to the Slade by her parents although she herself was rather reluctant to go. At this stage she admired the early modernists such as Brancusi, as well as ancient Greek sculpture. The many prizes she won at the Slade for both painting and sculpture enabled her to spend a fourth year there in 1936–7 and she became the runner-up in the Prix de Rome at the early age of 22. With two other women art students she visited Italy and Paris, before being sent by her parents to Sweden for a year. At this period she was carving in stone, and on her return to London produced the *Pietà*, which won the 1939 Prix de Rome. During the war she became an ambulance driver and in 1944 met and married the painter, Basil Jonzen. Her son, Martin, born in 1947 became a painter and himself won the Prix de Rome in 1974. Gradually Karin Jonzen gained exhibitions and patrons, so that in 1948 she was awarded the Feodora Gleichen (*q.v.*) prize for the best woman sculptor by the Royal Society of British Sculptors. From 1950 she received increasing numbers of commissions for site-specific sculpture for the new schools and other civic developments taking place in Britain at the time. Early in the 1950s she was seriously ill

for over a year with tuberculosis, and towards the end of that decade suffered a difficult period encompassing both her divorce and a decline in commissions for figurative work, apart from portraits. Among her sitters were Malcolm Muggeridge and Dame Ninette de Valois. At a result of the proliferation of abstract art, a number of her commissions were for churches, where representation was still important. Financial security was achieved only in the early 1970s, when editions of statuettes made by the cheaper method of cold casting began to sell, and her personal life was changed by marriage to a Swedish poet she had first met in 1938 and believed had died in the war. Despite prevailing fashion, Jonzen has persisted with her timeless figures with textured surfaces, and with the return to figuration in the later 1970s there has been renewed interest in her work.

*Publications: KJ – sculptor*, London, 1976.

*Examples:* Brighton; Bradford; Selwyn College chapel, Cambridge; Glasgow; St Mary's church, Golders Green; cathedral Guildford; WAG, Liverpool; Guildhall forecourt, London; church of St Mary-le-Bow, Cheapside, and Swedish church, Harcourt St, London; Southend.

*Literature:* Mackay; Sellars; *Who's Who in Art*.

## JOPLING, Louise. (alt. JOPLING-ROWE; ROMER). née GOODE (1843–1933)

*English painter of figure subjects, portraits and landscape*

She was one of nine children of a Manchester civil engineer. Her father enforced a strict regime of lessons and music practice on his children and would not allow Louise to draw, believing this to be a selfish pastime. At the age of 17 she married Frank Romer, a civil servant, who in 1865 was appointed private secretary to Baron Rothschild in Paris. It was the baroness, herself an accomplished amateur painter, who realised Louise's talent and advised her to take lessons at the atelier of Charles Chaplin, who ran a class for women only. This she did during 1867–8, also studying with Alfred Stevens, and reaching a level where two chalk drawings of heads were accepted at the 1869 Salon. Domestic problems then intervened, for in the same year her husband was dismissed from his post and deserted her. Left alone with two small children, she returned to England but for financial reasons could not pursue her studies,

so she determined to use her art in order to earn a living. Needing to become known to potential patrons she began at once to send paintings to the RA and elsewhere, and gradually gained an increasing number of commissions. She would have liked to paint landscapes, but economic necessity meant that she had to devote most time to the more lucrative field of portraiture. Even after she married the painter Joseph Jopling in 1874 – an arrangement undertaken at least partly to obtain greater financial security (her first husband had died in 1873) – they spent time and energy supporting a social life because it was the means of obtaining commissions. A third child was born but her output continued unabated. She exhibited not only in London, but also sent works to the Paris Expositions of 1878 and 1889 and the Philadelphia Centennial of 1876. As she became established she painted more genre subjects and gave some of her portraits an allegorical interpretation. Her success also brought requests from families who wanted art instruction for their daughters, and, after the death of her husband in 1884, she opened a school, as the numbers were too great for private tuition. This enterprise also provided her with another source of income. She continued to run to school after her third marriage in 1887 to a lawyer, George Rowe. Realising from her own experience the need for teaching, she published an instruction manual in 1891. She also wrote several short stories and poems. She was a member of the SWA, the Pastel Society, a founder member of the Society of Portrait Painters and the first female member of the Royal Society of British Artists. She continued to exhibit at the RA until 1916.

*Publications: Hints to amateurs*, London, 1891, reprinted 1911; *Twenty years of my life*, London, 1925.

*Examples:* Rothesay Mus., Bournemouth; National Portrait G, London; Manchester.

*Literature:* D. Cherry, *Painting women; Victorian women artists*, Art G, Rochdale, 1987; Clayton; Clement; Nottingham, 1982; P. Nunn, *Canvassing*, London, 1986; P. Nunn, *Victorian women artists*, London, 1987; W.S. Sparrow; Wood, 1978.

## JORDAN, Eithne (1954–)

*Irish painter of loosely handled figures*

A Dubliner, she studied at Dun Laoghaire School of Art. Her early paintings were landscapes heavily influenced by Abstract Expressionism, but these

gradually gave way to figures. A series of paintings of swimmers enabled her to merge the figures with their surroundings. Allegorical subjects then appeared, in particular Beauty and the Beast, along with approaches to motherhood which were clearly influenced by the women's movement and personal experience. The child becomes a small tyrannical beast and the mother is overwhelmed by the male figure. The sombre colours of the allegorical works gave way to brighter ones, although the figures still seem weighed down by their environment, as did the swimmers. Active in the promotion of art and young artists, she was a founder member of the Visual Arts Centre, a co-operatively run studio space for artists which is funded by the Arts Council and Dublin Corporation. She has also taught at the National College of Art in Dublin and was awarded a scholarship to study in Berlin. She has exhibited since 1979.

*Literature: Irish women artists.*

## JORIS, Agnese. (pseud. ALTISSIMI) (1850–1922)

*Italian painter in oil, pastel and watercolour; also an engraver*

Born in Rome, she was taught by her brother, Pio Joris, and also attended the Institute of Fine Arts in the city, where she became a professor in 1881 and taught painting. From 1890 she received several awards. After King Umberto I had been assassinated in 1900, she painted a portrait of him in the form of a triptych and sent this as a gift to his widow.

*Literature:* Clement; A. Comanducci, *Dizionario illustrato*, 3rd ed., Milan, 1966.

## JOSEPH, Lily. (alt. Delissa JOSEPH). née SOLOMON (1864–1940)

*English painter of portraits, landscapes and interiors*

The sources vary considerably about this artist. However, she was not the sister of the painters Abraham, Simeon and Rebecca Solomon, as has been suggested. She was born in London, her father being a leather merchant, and she studied at the South Kensington Schools and Ridley Art School. She married the architect Delissa Joseph, whose name is amalgamated with hers in a variety of ways. Nevertheless, she had a long exhibiting career from 1889 to 1938 at several London galleries and at the Salon of the Société des Artistes Français in Paris, where she won several awards, including a silver medal in 1929. She also exhibited with NEAC and was given a solo show at the gallery of the Royal Society of British Artists at which there were over 80 paintings. She is known to have executed a series of paintings of interiors of the National Gallery. She was active in other spheres too, for she was at various times the first president of the Hammersmith and West Kensington Women's League, art critic of the *Women's Gazette*, and manager of the London School Board. At the age of 70 she listed her recreations as motoring, golf and caravanning.

*Literature:* Edouard-Joseph; *Who's Who in Art*; Wood, 1978.

## JUKES, Beth. née Edith Elizabeth JUKES (1910–)

*English sculptor in wood, stone and terracotta*

Born in Shillong, Assam, where her father was serving as an army doctor, she was educated in England. She attended the Royal College of Art from 1928 to 1932, where she studied under Henry Moore. She exhibited regularly at the RA from 1935 to 1966 and at other leading galleries. She produced mainly heads, including portraits, and figures in clay and stone. During World War II she qualified as a nurse, and from 1947 she taught for some years at the Sir John Cass School of Art. Although little is known of her now, she was elected a full member of the Royal Society of British Sculptors in 1948.

*Literature:* Mackay; Waters; *Who's Who in Art*.

## JÜRGENS, Grethe (1899–)

*German painter of figures and town scenes in the style of Neue Sachlichkeit*

Born in Holzhausen, she began in 1919 to study graphic art under Burger-Mühlfelds, a seminal figure in New Objectivity, at the School of Applied Arts in Hanover, where fellow students included Gerta Overbeck (*q.v.*) and Ernst Thoms. During the difficult economic climate of the 1920s she earned her living as a publicity designer in

industry while producing crisply painted works, often of half-length figures. Her aims were identical to those of the German Association of Revolutionary Figurative Artists (Asso) and the German Communist party and, in common with other Hanover artists, the political element was a crucial determinant in her works. Through painting she exposed the deficiencies she perceived in society. The angular rather flattened style of the mid-1920s gave way after 1930 to more rounded forms. From 1929 she gave up her design job in order to paint full-time, and it was from her studio that the magazine of the Hanover Group was published from late 1931 until mid-1932. After a solo show in Braunschweig in 1932, she became involved in organising other exhibitions and travelled to Italy in order to produce illustrations for a Cologne newspaper. The production of illustrations and book covers continued until after World War II, when her paintings once more became acceptable and retrospectives were held in 1951 and 1961. In 1980 she was still living in Hanover.

*Literature: Neue Sachlichkeit*, Landes G, Hanover, 1976; Vergine.

## KALKREUTH, Maria. (Countess).
## (alt. Marie KALKREUTH) (1857–97)

*German painter of portraits, genre and religious subjects*

Although she was born in Düsseldorf, her family soon moved to Munich, where she studied with her father, Stanislaus von Kalkreuth, her brother, and Zimmerman. She continued to work in Munich, exhibiting there and in Berlin from 1888 to 1896. She was a member of the Society of Women Artists in Berlin. With a painting of *Christ raising a repentant sinner* she won a silver medal at Chicago in 1893; this painting was subsequently purchased for the Protestant church at Dachau, the town where she died at the age of 40.

*Literature:* Clement; M. Elliott; Weimann.

## KARLINSKY, Elizabeth. (alt. KARLINSKY-SCHERFIG) (1904–)

*Austrian-born painter who worked in Denmark*

Daughter of the painter, Anton Karlinsky, Elizabeth Karlinsky was born in Kasten. Her formal training began in 1921 when she enrolled at the

Kunstgewerbeschule in Vienna. There she encountered the revolutionary teaching of Franz Cisek (see under Klien). After exhibiting in the 1925 International Applied Arts Exhibition in Paris, she won a prize for a kinetic glass window in 1926 and made her first visit to Paris. After replacing Erika Klien in a teaching post while Klien was on maternity leave, Karlinsky spent 1928–30 in New York, where she again encountered Klien. There she executed a series of watercolours in which she conveys the many sensations of the city according to the guidance of Cisek: 'The disparate jumble of letters, in their wide diversity of scale, are whirled together into a revolving sequence, a single image, itself suggestive of a turning record or a reel of film' (Garmey, 1987). In 1931 she settled in Denmark, where she married the poet and painter Hans Scherfig and has since exhibited regularly.

*Examples:* Stateen Mus., Copenhagen; Historisches Mus. der Stadt, Vienna.

*Literature:* S. Garmey, *Movement and the city: Vienna and New York in the 1920s*, Rachel Adler G, New York, 1987.

## KARLOWSKA, Stanislawa de.
## (alt. BEVAN) (1876–1952)

*Polish painter of town scenes, landscapes, still lifes and interiors*

She came from an ancient land-owning family of Czeliewy, near Lowicz, an area famous for its richly patterned textiles. She studied first in Warsaw and Krakow and then at the Académie Julian in Paris in the mid-1890s. It was there that she met the English painter Robert Bevan. After their marriage in 1898 they lived in England, mostly in London, until Bevan's death in 1925. They were both founder members of the London Group, with whom they exhibited for many years. They visited Poland soon after their marriage and again in 1921. When the opportunity arose, they worked to support the Polish people, and during World War I their home became a meeting place for Poles. De Karlowska had a strong feeling for colour and composition, which emerged in her many scenes of London. In the twenties and thirties the titles of her landscapes reveal the journeys she made, to Anglesey, Brittany (1931–2) and particularly to the southwest of England. She exhibited from 1900 to 1940 in London, including with WIAC, and had a solo show at the Adams Gallery in 1935. She continued painting until at least 1947.

*Examples:* Aberdeen; Southampton.

*Literature:* G. Hedley, *Let her paint*, City Art G, Southampton, 1988; Krichbaum; *Selected paintings by Robert Bevan and S de K 1876–1952*, Polish Library, London, 1968.

## KATZEN, Lila (1932–)

*American abstract sculptor in metal*

Although Katzen was born in New York, her maternal grandfather was a court artist in St Petersburg in Russia, and it was he who taught her as a young child to work with a range of sculptural materials. However he was unable to earn a living from his works and after the death of Katzen's father, when she was three, the three children were put in an orphanage. When she was seven the family were reunited and lived in Brooklyn, although life was still far from easy. At the age of 15 she sold some theatre designs and later worked for a commerical artist. Despite the lack of encouragement from her family she was accepted by the Cooper Union, initially in the evenings only so that she could retain her employment. After six months she began to win scholarships so was able to study full time. In the late 1950s she applied fluorescent paint to sheets of plastic which were lit from underneath, and these explorations with light and floors persisted throughout the 1960s. By 1968–70 she was constructing large environments with coloured sands, fluorescent material, including pools of liquid in vinyl pockets, and ultraviolet lights. It was only in 1970 that she began working with metal, producing large abstract pieces from sheets of metal. Since then she has received a number of commissions for site-specific sculpture. Her husband is very supportive, which enabled her to continue working while her two children were young.

*Literature:* Munro; Watson-Jones.

## KAZOVSZKIJ, El (1948–)

*Soviet-born maker of installations and theatrical scenery who lives in Hungary*

Born in Leningrad, she has lived in Hungary since the 1960s and it was there that she undertook her training, spending 1970–7 at the Budapest Academy of Fine Arts. At the start of her career she produced paintings and drawings full of spiky angular lines. About 1980 the compositions developed into three dimensions, forming installations with groups of assorted objects. A recurrent motif, important to the artist, is a dog which acts as a locus for past experiences, relationships and guide to actions. The installations often consist of dog silhouettes, statuettes of various kinds, usually grouped on low items of furniture such as stools. The linear quality is introduced through string and tape wound around and between the constituent parts. Earlier installations are often used as part of a new work, creating a generative process which links with the idea of cult and ritual which the artist is seeking to reconstruct. This aspect of her work explains her interest in the theatre and performance. Exhibiting since 1976, she won several prizes in the early 1980s.

*Literature: Contemporary visual art in Hungary*, Third Eye Centre, Glasgow, 1985; J. Frank, 'Naive, avant-garde, Pop', *New Hungarian Quarterly* v14, 1976, 60.

## KEANE, Tina (*c.* 1948–)

*English performance artist who also makes videos and films*

Active in the women's art movement from early in the 1970s, Keane belonged to several of its groups. With the Women's Workshop of the Artists' Union, she collaborated with others on playground projects in order to make art more accessible and socially relevant, factors which were instrumental in her changing from painting to performance as a medium in 1974. She believed this was a more direct way of communicating social issues which affect the roles of women. Aware of the dangers of coinciding with the traditional image of woman as spectacle, Keane deliberately avoids using her body in ways which could be ambiguous. In several performances she has involved her daughter. Keane has stressed the importance to her of the support from women's groups, and this is why she has consistently participated in panel discussions, the organisation of exhibitions and other such activities within the women's movement.

*Literature: About time*, ICA, London, 1980; S. Eiblmayr, V. Export & M. Prischl-Maier, *Kunst mit Eigen-Sinn: Aktuelle Kunst von Frauen*, Vienna & Munich, 1985; R. Parker & G. Pollock, *Framing feminism*, London, 1987.

## KEEGAN, Rita (1949–)

*American painter and mixed-media artist who works in London*

Born in New York to a Dominican mother and Canadian father, she took her BFA at San Francisco Arts Institute, graduating in 1972. Important role models were provided by two members of staff, Imogen Cunningham and a black painter, Mary O'Neill. Between 1964 and 1967 she studied fashion illustration and costume design, elements which re-emerged in Keegan's paintings. Since she settled in England in the late 1970s, her main concern has been the portrait and particularly, for practical and other reasons, the self-portrait. Using pattern, colour, jewellery and other objects, she constructs layers of symbolic meaning which include topics such as world trade (a dress of African cloth, produced in Germany for the African market) or the positive representation of African women. In addition to exhibiting, Keegan has been active in several artists' groups, including Women's Work, as an art gallery administrator and is currently organising material on women artists of colour for the Women Artists' Slide Library (see under Barrie).

*Publications:* 'RK', *Women Live*, spring 1988, 19–21; 'An update on Black women and WASL [Women Artists' Slide Library]', *FAN*, v2/8, autumn 1988, 29.

*Literature:* C. Rendell, 'Actual lives of women artists: RK', *WASL J*, Oct.–Nov. 1987, 10–11.

## KELLY, Mary (1941–)

*American-born feminist artist working consciously in a highly political manner with texts and objects to question society's ideas about women*

From early in the 1970s Kelly has played a prominent role in the women's art movement and sought to participate in the art establishment in order to show up its assumptions about women and its definitions of art. Born in Minnesota, Kelly studied for her BA in St Theresa's College in her home city, then moved to Florence (1963–5) for her MA and then, from 1968, carried out further postgraduate work at St Martin's School of Art in London, where she now lives. From 1970 to 1976 she was involved in making several films in which her socialism and feminism were integrated. Her interest in the division of labour in society, begun

in the film *Nightcleaners*, also emerged in an exhibition in 1975. Kelly became well known with the exhibition of *Post-Partum Document*, begun in 1973, in which she investigated the relationship of mother and child in British society through her experience as a mother, taking the period from the birth of her son until he went to school. This is documented by objects, diagrams, theoretical texts and diaries, and questions assumptions about motherhood, the acquisition of gendered identity and about art. There are no images of mother or child. This work aroused much critical controversy when exhibited in the later 1970s. Subsequently Kelly has worked on the question of women aging in *Interim*, which by the use of texts and objects again avoids the representation of women. Her theoretical basis and rigorously intellectual approach can also be seen in her articles. She has taught in a number of institutions, and contributes to many symposia on women and art. She has exhibited widely in Europe.

*Publications:* 'Women's practice in art', *Audio arts*, v3/3, 1977; 'The state of British art' [transcript of introduction to a debate held at the ICA, London, on 'The crisis in professionalism'], *Studio International*, 1978, 80–2; *Post-Partum Document*, London, 1983 (also contains several critical essays by other writers, and a bibliography); 'Beyond the purloined image', *Block*, no.9, 1983, 68–72.

*Examples:* Tate G, London; Zurich.

*Literature: Hayward Annual '78*, Hayward G, London, 1978 (bibl.); *MK: Interim*, Fruitmarket G, Edinburgh, 1986 (bibl.); K. Linker, *Difference: on representation and sexuality*, New Mus. of Contemporary Art, New York, 1984; L. Lippard, *Issue: social strategies by women artists*, ICA, London, 1980; R. Parker and G. Pollock, *Old mistresses; women, art and ideology*, London, 1982; R. Parker and G. Pollock, *Framing feminism*, London, 1987; Parry-Crooke.

## KEMP-WELCH, Lucy Elizabeth (1869–1958)

*English painter of horses, country work and war subjects. Former principal of Bushey School of Art*

The eldest of two daughters of a Bournemouth solicitor, Lucy remained a close companion of her sister Edith throughout their lives. Their artistic mother encouraged their drawing from an early age, as did their father, a keen amateur naturalist. Until he became ill with tuberculosis in 1877, he

took Lucy on sketching trips in the nearby New Forest and from the beginning she loved to draw the wild ponies there, as well as domesticated horses. She became a competent rider. By the age of 14 she was exhibiting her work locally and sold her first painting at 16. She studied anatomy with a vet and from zoological text books, and took a few lessons with local painters. In 1891 the two sisters gained admission to Herkomer's School of Art at Bushey, Hertfordshire, where the individual attention and friendly atmosphere proved ideal for them after the death of their mother, early in their second term, left them orphans. Lucy began exhibiting large-scale paintings of horses at the RA in 1895 and received increasingly favourable press reviews, some of which compared her with Rosa Bonheur (q.v.). This reputation was confirmed by the purchase of a work for the Tate Gallery in 1897 for the then phenomenal price of £525. Outdoor scences were painted *in situ*, Kemp-Welch evolving a type of packing case which enabled her to leave her huge canvases on the site while she was not working on them. Nominated on several occasions for membership of the RA, she regarded election to the Royal Society of British Artists as poor compensation. In 1914 she became the first president of the Society of Animal Painters. Their inheritance had enabled Lucy and Edith to buy a house in Bushey, so when in 1900 Herkomer became too ill to teach, Lucy Kemp-Welch took over the running of the school. She intended this as a gesture of gratitude for his support over the years and in the same spirit purchased the school from him in 1907. For several years she took up to 50 pupils, but the destruction of some of the buildings in a fire in 1911 enabled her to reduce the numbers until she sold the school in 1926. Authoritarian in her approach, she regarded teaching as something which threatened to interfere too much with her painting, and from 1914 she spent more time away. World War I brought her a number of commissions, including one from the Imperial War Museum and a panel for the Royal Exchange in London, celebrating women's war-time work. In the late 1920s and 1930s Kemp-Welch travelled with a circus, an experience which provided a source for many paintings. Her oils became smaller, partly because she had to fit them in the caravan in which she lived while in tour. After this she lived more quietly, nursing her sister until her death in 1941. Edith had been an excellect miniaturist, but because of her health she had always kept house for Lucy. Lucy's companion for the last years of her life was Margaret Frobisher, a former pupil who had taken over all the clerical work of running the

school at Bushey in 1920. Kemp-Welch continued to exhibit until 1949 when her eyesight began to fail. Now little known, her paintings are full of energy and belie the considerable degree of technical facility necessary to hold together the large compositions.

*Publications: In the open country; studies and sketches by LK-W*, London, 1905.

*Examples:* Bristol; Exeter; WAG, Liverpool; Imperial War Mus., London; Rochdale; Sheffield; Victoria, Australia.

*Literature:* Clement; D. Messum, *The life and work of LK-W*, London, 1976; *Paintings and drawings by some women war artists*, Imperial War Mus., London, 1958; Sellars; W.S. Sparrow; Wood, 1978.

## KENNET, Kathleen Young (Lady). (alt. SCOTT) née BRUCE (1878–1947)

*English sculptor of portrait busts, figures and memorials*

The youngest of 11 children of a country vicar, Kathleen Bruce was born in Carlton-in-Lindrick, Nottinghamshire and lost her half-Greek mother, who in her youth had posed for Dante Gabriel Rossetti, when only a few weeks old. Brought up by a strict elderly uncle in Edinburgh, on his death in 1892 she had £72 per annum with which to pay for schooling and all her living expenses. Having to earn her living she expected to become a teacher, had not a cousin suggested that she should cultivate her talent for drawing. About 1896 she went with two friends to study in Paris at the Académie Colarossi, where they attended life-classes with male models and where, soon after their arrival, Kathleen Bruce won a competition in which the prize was free tuition. In due course she met Rodin and regularly visited his studio. Through him she met Isadora Duncan, the dancer, and became her close friend for several years. Moved by the suffering in areas of northern Greece and Yugoslavia, she volunteered in 1903 for relief work. She completed six months before succumbing to typhoid. While convalescing she spent eight months in Italy, followed by five months in Greece in 1906. She settled in a small flat in London in 1907 and began to draw and sculpt portraits. In 1908 she married the Antarctic explorer, Capt. Scott, and their son Peter was born the following year. After Scott had departed on his last expedition, Kathleen Scott continued with her sculpture. Public commissions increased from this time, and by 1911 she had a Bond Street dealer. Capt. Scott

died early in 1912, but it was not until nearly a year later that news of this reached his wife as she was sailing to New Zealand to meet him. From this time she not only maintained her output of sculpture, but had also to deal with the consequences of the polar expedition and the winding up of its finances. During World War I she set up a front-line hospital in France and then worked in an armament factory, sculpting in her spare time. This was her least prolific period. By 1919, however, her work was well known and she had many friends among eminent politicians, explorers, artists and intellectuals. In 1922 she married Hilton Young, then an MP, and had a second son the following year. Later he became Lord Kennet. Her first solo London show took place in 1927, but this belies her long-established reputation. In 1935 King George V commissioned his bust from her. She was elected an Associate member of the Royal Society of British Sculptors in 1928 and a full member in 1937, when she was the first woman to serve on the council. Her works consisted of busts, statues, memorials and statuettes. These last tended to be figures of children or young men with symbolic titles such as *The kingdom is within*. She was a very independent woman who from time to time throughout her life felt the need to escape abroad alone and was able to do so. Although devoted to her children, she was not unduly hampered by them as she always had a nursemaid and other domestic help.

*Publications: Self-portrait of an artist*, London, 1949.

*Examples:* Birmingham; Dover (Charles Rolls); Lichfield (Capt. Smith of the *Titanic*); WAG, Liverpool; Waterloo Place (Capt. Scott); forecourt, St Dunstan's church, Strand (Viscount Northcliffe); Imperial War Mus., London; Portsmouth (Capt. Scott); Sheffield.

*Literature:* Birmingham Public Sculpture Index; Mackay; *Who's who in Art*.

### KERKOVIUS, Ida (1879–1970)

*Latvian painter of semi-abstract landscapes, interiors and still-lifes*

One of 11 children of a rich and cultured family in Riga, she enrolled at a local private school of art in 1899. Four years later she spent five months at Hoelzel's atelier in Dachau before being recalled by her family because of her too serious approach

to art. After obeying their wishes she succeeded in gaining her freedom in 1908, when she went to Berlin and then to Stuttgart, where Hoelzel was now professor. She began to exhibit in 1911 in various German cities and her position as Hoelzel's assistant enabled her to meet many students who would become important modernist artists. Enrolling at the Bauhaus in 1920, she attended for one term in each of the next three years, firstly under Johannes Itten on the preliminary course and then in the weaving workshop. She was establishing herself with several solo shows when her work was declared degenerate by the Nazis, and in 1934 she left Germany to travel in many European countries. In 1944 her Stuttgart sfudio and most of her work was destroyed in a bombing raid. She exhibited again after the war, and continued to travel extensively. On her 80th birthday she was made an honorary professor and given a major retrospective in Würtemburg.

*Examples:* Bauhaus-Archiv, Berlin.

*Literature: Das Verborgene Museum;* Krichbaum; K. Leonard, *IK: Leben und Werk*, Cologne, 1967; Vergine.

### KERNN-LARSEN, Rita (1904–)

*Danish painter whose interests coincided with those of the Surrealists during the 1930s*

Born in Hillerod, she studied first at the Academy in Copenhagen and then in Paris with Fernand Léger in 1930–1. In the same year that she had her first solo show in Copenhagen – 1934 – she encountered the Danish Surrealist group and from early in 1935 she exhibited with the Surrealists in Oslo, London and Paris. In 1937 a meeting with Peggy Guggenheim led to an exhibition at the latter's London gallery the following year. While she lived in London during World War II, she attended meetings and participated in exhibitions with the English Surrealists. In common with Colquhoun (*q.v.*) and, particularly, Rimmington (*q.v.*) she used underwater motifs to explore the path by which the unconscious manifests itself in nature. Another favoured theme was that of the *femme-arbre* (the use of tree forms to symbolise women), which could be used symbolically, but at the same time showed an affinity for the north European romantic landscape tradition. After the birth of her only daughter in the later 1930s, Kernn-Larsen produced an image of tree-like forms, two of which have human feet, to convey

her feeling of the primeval process of childbirth. In common with other Surrealists, objects transmute in her paintings, so that knots in the trees in *The primrose path* change into eyes, and then eggs. By 1947 her interests no longer coincided with the orthodox Surrealist line maintained by André Breton, although she continued to paint, dividing her time between Denmark, England and France.

*Literature:* W. Chadwick, *Women artists and the Surrealist movement*, London, 1985.

## KESERÜ, Ilona (1933–)

*Hungarian painter, book illustrator and theatrical designer*

Born in Pecs, she began to receive artistic instruction when only 13, under Ferenc Martyn. In 1950 she attended the Secondary School of Fine Arts in Budapest, before proceeding to six years at the Academy there, studying fresco design. Recognition came first in 1966 at a time when she was producing gestural abstract paintings. At this period in Hungary there was a renewed interest in native folk traditions, and Keserü found in folk art certain motifs which she could adopt and develop in her own way. One such came from seeing heart-shaped tombstones set upside down in the earth in a remote cemetery. This shape, often simplified to a double wave, provided a continual source of ideas. She has also worked in three dimensions with sewn pictures and monumental sculpture, which feed in turn into her theatre designs. Now teaching at the University of Pecs, she has represented her country at international exhibitions and enjoyed a series of solo shows since 1975.

*Literature:* L. Beke, 'The painter and the tombstones', *New Hungarian Quarterly*, v12, 1971, 43; *Contemporary visual art in Hungary*, Third Eye Centre, Glasgow, 1985; J. Frank, 'IK's lyrical objectivity', *New Hungarian Quarterly*, v25, 1984, 95.

## KESSELL, Mary (1914–)

*English painter of landscapes, figure subjects, a war artist, mural decorator and illustrator and designer*

Born in London, she studied at Clapham and then the Central School of Art and Design (1937–9). In the closing weeks of World War II, Kessel was commissioned as an official war artist to go to Europe in order to make drawings of refugees. By the time she started work the war was over and as a result she was able to spend some months in Germany, particularly in Berlin, and made sketches of the Belsen concentration camp. Her first solo show was held in 1950, and by 1964 her paintings, although based on landscapes, were almost abstract. She was active in several artistic fields, teaching jewellery design at the Central School, a field in which she won second prize in an international competition, and later lecturing at the London College of Printing. She also designed posters for London Transport. She is married to the artist Tom Eckersley.

*Examples:* Imperial War Mus., London.

*Literature:* MK, Leicester G, 1964; *Paintings and drawings by some women war artists*, Imperial War Mus., London, 1958; Waters.

## KIELLAND, Else Christie (1903–)

*Norwegian painter of landscapes*

Born in Bergen , she was a pupil from 1923 to 1927 at the Oslo Academy, where she worked under Christian Krohg, Strøm and Revold, and from 1936 to 1938 worked under Georg Jacobsen. She often travelled abroad to study, particularly to Italy, Paris and Greece, but she also visited Berlin, London and Egypt. She exhibited extensively from 1929, when her first solo show was held, and won several scholarships over the years.

*Publications:* 'Kitty L. Kielland' (q.v.), *Urd*, 1943, 376–8.

*Literature: Illustret Norsk Kunstnerleksikon*, Oslo, 1956.

## KIELLAND, Kitty. née Christiane Lange KIELLAND (1843–1914)

*Norwegian painter of atmospheric landscapes*

Kitty Kielland decided on a professional career in art relatively late. After some exercises in copying in her native town of Stavanger, she studied briefly with Morten Müller in Christiania (now Oslo) in 1872, but left the following year to study under Professor Gude in Karlsruhe. There the instruction included working from the live model and painting in the open air. From 1875 to 1878

she lived in Munich and was active in the Norwegian artists' group there, while working under Eilif Peterssen and Hermann Baisch. Around 1880 she moved to Paris, studied with Léon Pelouse, and met Harriet Backer (*q.v.*), whose close friend she became. The two women shared a home there and made several summer visits together: Brittany in 1881, Jaeren in 1884, Risør in 1885 and Fleskum, outside Christiania, in 1886. These visits enabled her to develop a form of painting which was distinctively Norwegian, while still retaining links with the European tradition. From 1885 she produced paintings of almost deserted landscapes, revealing the quality of light peculiar to the long Scandinavian summer evenings, often using a large area of still water as a central motif. This amounted to a new development in Norwegian painting and was called the mood landscape. She exhibited in Paris from 1879, winning a medal in 1889. However, the rejection of a version of an already successful painting of hers led to great self-questioning and to the gathering of a group of former Munich-based Norwegian artists at Fleskum in 1886. The work these artists produced that summer marked not only the establishment of Norwegian *plein-air* painting, but also signalled the start of a Symbolist interpretation of the landscape. Keilland, however, always remained rooted in realism. She settled in Norway permanently in 1889, ceased exhibiting in Paris after 1890, and sent her work instead to Oslo, where she had a solo show in 1911.

*Examples:* Oslo; Stavanger.

*Literature: Dreams of a Summer Night*, Hayward G, London, 1986; E.C. Kielland, 'KLK', *Urd*, 1943, 376–8; M. Lange, 'Fra den hellige lund til Fleskum. KLK og den nordiske sommernatt', *Kunst og Kultur*, v60, 1975, 69–92; M. Lange, *Harriet Backer, 1845–1932 KLK, 1843–1914*, Stifelsen Modums Blaafarvevaerk, Åmot, 1983; A. Wichstrøm, *Kvinner ved staffeliet*, Oslo,1983.

## KIKI DE MONTPARNASSE. (alt. Alice PRIN) (1901–?)

*French model, singer and painter*

The career of Kiki shows marked similarities to that of Suzanne Valadon (*q.v.*) in that both came from working-class origins and through modelling came to practise art. Born in Burgundy, Kiki moved to Paris as a child. By the end of the war in 1918 she was mixing with the intellectuals in Montparnasse. She sang in most of the well-known bars and toured America as a singer in 1924. She

posed for a number of artists and photographers, including Foujita, Man Ray and Per Krohg. Her paintings, mostly of female figure subjects, show a strong sense of colour and a naïve style. By 1926 she was exhibiting her paintings and had a solo show in 1930. Flanner described how her first exhibition at the Sacre du Printemps created an 'impression of simplicity, faith and tenderness'. She published her memoirs in 1929.

*Literature:* S. Benstock, *Women of the Left Bank, Paris, 1900–1940*, London, 1987 (orig. pub. 1986); Edouard-Joseph; J. Flanner, *Paris was yesterday, 1925–39*, New York, 1972, London 1973.

## KING, E. See BROWNLOW, Emma

## KING, Jessie M. (1875–1949)

*Scottish illustrator specialising in symbolic and imaginary subjects, including medieval legends*

Jessie King was born in Bearsden, near Glasgow, her father being a Presbyterian minister who strongly opposed any practice of art by his daughter, to the extent that she hid drawings done at school in the hedge on her way home. How she persuaded her father to let her attend Glasgow School of Art is not known, but she studied there at a time of tremendous activity centred about the principal, Francis Newbery. It was he who decided that King's particular talent, with its linear emphasis, would be harmed by the usual curriculum and allowed her to attend only some of the classes, including the life room. Despite this, she was an enormously versatile artist, who turned her hand to designing batik dresses for commercial production, and to lettering and book covers. She exhibited from 1897 and in 1902 won a gold medal at the Turin Exhibition of Decorative Art. At the same time she secured two major commissions for illustrations from the Bodley Head publishing house. During the course of these a more mature and confident style became evident. Her subject matter, dictated by the texts, was medieval legends and accorded with her own rather Gothic imagination. She was familiar with the work of certain Pre-Raphaelites, Botticelli and Japanese prints, as were all Glasgow students. In 1908 she married the versatile designer, E.A. Taylor, whom she had met at Glasgow, and the following year their only daughter was born. From 1911 to 1914 they lived in Paris, where King produced many drawings of streets and churches, washed over

with colour. After seeing the Russian ballet and the designs of Léon Bakst, King's colour became relatively bolder. It was in Paris that she learnt the technique of batik, which gave her the opportunity to work on a larger scale (her normal format was not larger than 20 × 27 cm), and when the war forced her to leave Paris, she continued with this work from her house in Kirkudbright. Indeed, she became such an authority that she wrote a book on the subject. After the war, she and her husband returned to their Paris studio for some months each year until 1928, when their daughter decided to go to Glasgow University instead of art school. Each summer was spent on the Isle of Arran, where King and Taylor ran a summer sketching school, but King also produced many watercolour landscapes. In addition, she illustrated many books, including some she wrote herself, and provided covers or endpapers for others, painted china and designed a wide range of products. She continued to be artistically active until the end of her life.

*Publications: How Cinderella was able to go the ball: a brochure on batik*, London, 1924; for books illustrated see below under Oliver.

*Examples:* Kunstbibliothek, SMPK, Berlin; WAG, Liverpool.

*Literature:* A. Callen, *Angel in the studio*, London, 1979; Clement; *The last romantics: the romantic tradition in British art: Burne-Jones to Stanley Spencer*, Barbican G, London, 1989; C. Oliver, *JMK, 1875–1949*, Scottish Arts Council G, Glasgow, 1971, (full bibl. and list of books illustrated); Sellars; W.S. Sparrow; R. Watson, 'Miss JMK and her work', *Studio*, v36, 1902, 176–88.

## KITSON, Theo Alice. née RUGGLES (1871–1932)

*American sculptor of vigorous monuments, war memorials and equestrian statues*

Born in Brookline, Massachusetts, she began her career early and after studying in Paris won honourable mentions in the Exposition Universelle of 1889 and the Salon of 1890. She then pursued her studies with the English-born sculptor, Henry Kitson, whom she married in 1893. In the same year she had no fewer than four works, including two nude studies, exhibited at the Chicago Exposition. The Kitsons moved to Framingham, Massachussets, while maintaining studios in Boston. Because of poor health Henry Kitson's output was limited, but Theo was well able to support them

**Theo Kitson Ruggles** *The Hiker: monument to Spanish-American war veterans*, bronze, Memorial Drive, Arlington D.C.. (photo: P. Dunford)

both. During her career she was commissioned to produce many monuments, and portrait busts for the battlefield at Vicksburg. Her robust figures were praised for their spirited rendering and able composition.

*Examples:* Framingham, Mass.; Grand Rapids City; Penn Valley Park, Kansas City; Admiral Hopkins Square and Roger Williams Park, Providence, RI; Avenue of Heroes, Arlington Cemetery, Washington, DC.

*Literature:* Archives of American Art, Washington, DC; Rubinstein; L. Taft, *History of American sculpture*, 1903.

## KLAVUN, Betty. née Elizabeth BEEBE (1916–)

*American sculptor of large open constructions mainly for outdoor sites*

Klavun's career as a sculptor began only after she had spent 15 years raising four children and had divorced her husband. She graduated from

Bennington College, Vermont in 1938, after which she ran her own costume shop and designed sets until her family arrived. Soon after resuming her studies in 1960 she turned to sculpture and at her first group show the following year exhibited angular relief constructions in corrugated cardboard. It was in 1970 that she found her new direction in the making of large constructions, mainly in wood and metal, into which fed her experience of designing both theatre sets and children's playgrounds. There is an element of play in her works, for they can adopt a variety of identities in the spectator's imagination.

*Examples:* Artpark, Lewiston, NY; Children's Psychiatric Center, Ward's Island, New York; Civic Center Plaza, Scottsdale, Ariz.

*Literature:* N. Edgar, 'The dream space of BK', *Craft Horizons*, v33/1, Feb. 1973, 26–8; Munro; Watson-Jones.

## KLIEN, Erika Giovanna (1900–57)

*Austrian painter concerned with the analysis of movement who worked in New York*

Born in Borgo di Val Sugano, Trentino in the South Tyrol, Klien was fortunate that her father's successive moves round the country in his capacity of station master brought the family to Vienna when she was 18 and able to attend the School of Applied Arts. In the *Kinetismus* workshop of Franz Cisek, Klien, along with Karlinsky (*q.v.*) and Marian Ullmann, eagerly followed his radical method of teaching art. He encouraged students to release emotions, to capture sounds, smells or sensations and to study movement in a way which did not convey merely the impression as Futurism had done, but which demonstrated the actual rhythms through and beyond objects. In 1922 Klien showed eight works in the only exhibition of this type of art, such was its unpopularity. By 1924 she was producing complex puppet theatres, where she attempted to produce actual moving pictures for the backdrop and side panels of the theatre in addition to making the puppets 'flash by in a rapid succession of . . . images'. Through assisting with the organisation of an exhibition of new theatrical techniques she met several of the Russian Constructivists. She was awarded first prize for designing a set of stamps in 1925, while at the same time she was producing collages with words and shiny and reflective paper. One of her works was purchased by Katherine Dreier (*q.v.*) for the Société Anonyme. Other interests she pur-

sued were the art of children and art education. During her maternity leave she was replaced by Elizabeth Karlinsky, whom she met again in New York where she went in 1929. Unlike Karlinsky, Klien remained there for the rest of her life. In order to provide an income, she taught part-time in several schools, including a course on kinetic construction. In addition she continued to produce her analyses of motion, making detailed studies of moving objects so that she could show in dancers, birds in flight or machines the movements that were too rapid for the eye to see. Overall her work has a strongly geometrical form, in some cases totally abstract.

*Literature:* S. Garmey, *Movement and the city; Vienna and New York in the 1920s*, Rachel Adler G, New York, 1987; Vergine.

## KLINGHOFFER, Clara (1900–70)

*Austrian-born painter and lithographer who worked in England and America*

Born in Lemberg, she was brought to England as a baby. She spent just over a year in 1919–20 at the Slade and, although she subsequently enrolled at the Central School of Art, she spent much of the time working on her own. Indeed her first solo show in 1919 was a considerable success and a string of others followed during the 1920s in London, in Amsterdam and Venice. She was elected a member of NEAC in 1933. She had married the writer J.W.F. Stoppelman in 1926, and they spent several years in Holland in the early 1930s before moving to America on the outbreak of war.

*Examples:* British Mus. and Tate G, London.

*Literature:* Deepwell; *CK and Mark Gertler*, Leicester G, London, 1932; Waters; *Who's Who in Art*.

## KLINT, Hilma af (1862–1944)

*Swedish painter of Symbolist and abstract works based on her experience and belief in spiritualism*

Born into a distinguished scientific family, she was as a young child interested in mathematics, botany and portrait painting. From an early age she experienced extra-sensory phenomena and became seriously interested in spiritualism at the age of 17. In 1882 she enrolled at the Stockholm Academy for five years, after which she worked

professionally as a landscape and portrait painter. During the 1890s she became the principal medium in a group of female spiritualists who began to produce automatic drawings, both individually and collectively. Her spiritualism and her art began to unite around 1906 with the production of abstract paintings. Unlike the slightly later ones of Kandinsky, af Klint's were, she believed, the result of unconscious forces for which she acted as a form of medium. Encounters with new material therefore had to be absorbed into her subconscious before they could be reflected in her work. The works from this period vary greatly in size and degree of abstraction. Figurative ones are sometimes anatomically incorrect, because they were executed in a trancelike state, and even afterwards af Klint did not attempt to amend them for this would have been false to the spirit inspiring her. In 1912, after a four-year cessation of her work, she resumed painting, but now played a more active role. A familiarity with theosophy led her to paint under the inspiration of her visions and made her increasingly independent of her spirit leaders. After the death of her mother in 1920, af Klint was able to move to the south of Sweden and to travel. She renewed her acquaintance with Rudolph Steiner during a visit to Switzerland, but his revised theories contradicted her fundamental approach to art, causing a crisis which lasted two years. From 1922 she began to paint plants but in a way which attempted to express her inner feeling as she studied them, while the use of colour was influenced by Steiner's theories. After abandoning conventional painting in 1906, she never exhibited her spiritualist paintings and forbade their showing for 20 years after her death. In all there are over 1,000 works.

*Examples:* The collection of her works is kept together, as she requested, in the Stiftelsen H. af Klints verk, Jarna.

*Literature:* A. Fant, 'The case of the artist HaK', in *The spiritual in art; abstract painting, 1890–1985,* County Museum of Art, Los Angeles, 1986.

## KLUMPKE, Anna Elizabeth (1856–1942)

*American painter of figures in interiors and in landscapes, and portraits; biographer of Rosa Bonheur (q.v.)*

Although now remembered in her role as the companion of Bonheur's last years, Klumpke's own considerable talents as a painter tend to be overlooked. Born in San Francisco, she was brought up in Switzerland by her independent and strong-willed mother after her parents separated. Although she had known of Bonheur since she was a small child, by the time Klumpke met the painter in 1887, Bonheur had also heard of Anna and her three eminent sisters; Augusta was the first woman doctor to work in a Paris hospital and carried out research into paralysis; Dorothea was an astronomer with a doctorate in mathematical science; Julia was a composer and violinist. The family had moved to Paris to facilitate Augusta's entry into medical school, but this also enabled Anna to enrol at the Académie Julian in 1883–4. In 1885 she received her first award at the Salon and in 1888–9 she won two of the highest awards at the Académie and became the first woman to win the Temple gold medal at the Pennsylvania Academy. She exhibited in many European cities and returned to work in Boston as a portrait painter and teacher. Corresponding with Bonheur, she asked if she could paint a portrait of the older artist, and in 1897 she returned to Europe, having received Bonheur's assent. At the time, Bonheur was still distressed at the death of her former partner. Klumpke's intelligence and cheerfulness, attested by Clara Clement, writer on art and women artists, won Bonheur's lasting affection and the commission to write her biography. Klumpke sacrificed her own art to Bonheur and, after organising a memorial exhibition, Klumpke spent the next 30 years at By, the estate she inherited from Bonheur, returning to San Francisco in 1932. She was awarded the Cross of Officier de la Légion d'honneur in 1936. Her portrait of Bonheur, painted in 1898, demonstrates her characteristic use of dark colours with rich gradations of tone, contrasted with brightly lit areas.

*Publications: Rosa Bonheur; sa vie, son oeuvre,* Paris, 1908; *Memoirs of an artist,* Boston, 1940, L. Whiting (ed.).

*Examples:* Metropolitan Mus., New York; Philadelphia; Nat. Portrait G, Washington, DC.

*Literature:* Clement; Cooper; Petersen; Rubinstein; Tufts, 1987;

## KNIGHT, Laura (Dame). née JOHNSON (1877–1970)

*English painter of figure scenes, especially beach, ballet and circus themes*

Born in Long Eaton, Derbyshire, Laura was the youngest of three daughters. Their parents having

separated, the children lived with their mother and grandmother. When they were small their mother went to Paris to learn to paint, and after her return she taught painting. Despite this they were increasingly short of money and knew great hardship. Laura began art classes at Nottingham School of Art, where in the first life class she met Harold Knight, her senior by four years. Their mother was determined that her daughters should be able to earn a living so that they need not marry. By 1893 both her mother and grandmother had died, and the two sisters lived in a variety of poor lodgings. Laura went out to teach and attend classes, while her sister, who suffered poor health, kept house. By the age of 16 Laura had won silver and bronze medals, as well as other prizes from the South Kensington Schools for her portrait drawings, which were submitted externally. It was in 1894 that the sisters and Harold discovered the Yorkshire fishing village of Staithes, which they continued to visit and later to live in over a period of 13 years. In 1903 Laura Johnson had her first picture accepted at the RA, and on the proceeds of the works they sold there she and Harold were married. They spent six weeks in Laren, Holland to which they returned for a year in 1906. With their horizons broadened by this visit, they left Staithes the following year for Newlyn in Cornwall. There they entered the active artistic community through the Forbes' (*q.v.*), and Laura Knight began her lifelong friendship with Dod Procter (*q.v.*). Her Newlyn paintings depict predominantly children and, from 1910, female nudes on the beach. The bright colours and lively brushwork reflected her carefree state of mind. She exhibited regularly in London and established her reputation, so that by 1913, the Knights owned their own house and had three servants. The outbreak of war changed this, however, as Harold's pacifism was not well received, and in 1918 they set up home in London. This move brought Laura Knight into closer contact with what were to become her main subjects in succeeding decades: ballet, circuses and gypsies. Through working backstage, she came to know well many of the famous Russian dancers, including Pavlova. In the early 1930s she spent several months touring with Bertram Mills' circus, drawing animals, audiences and the performers whose life she shared. In a similar way she drew aspects of gypsy life, which were based on a close knowledge of the people and their way of life. In the meantime she received increasing recognition of her work. Her medal-winning works at Pittsburgh and the Panama-Pacific Exposition in 1915 contributed to her selection as a judge for the international art

exhibitions at the Carnegie Institute in Pittsburgh in 1922 and 1927. She became the second woman to become an Associate of the RA (1927) and the first since the founding members of 1768 to become a full member (1936). She was also elected member of the Royal Watercolour Society (1928), the Royal Society of Painters and Engravers (1932), became president of the SWA, and was made a DBE in 1929. From about 1942 she worked as an official war artist, painting scenes at an RAF station, as well as private commissions. In 1945 she was selected to paint the Nuremburg war trials. After the war she continued painting scenes of people relaxing, often on Hampstead Heath, and working from models in the studio. She always maintained a separate studio from her husband. Laura Knight's initial determination as an artist came from her mother and family circumstances. She was not hindered by her marriage, as she had no children and both partners were free to travel. Both she and Harold benefited to some extent from each other's contacts.

*Publications: Oil paint and grease paint*, London, 1936; *The magic of a line*, London, 1965 (autobiographies).

*Examples:* Birmingham; Brighton; Nat. Mus. of Wales, Cardiff; Doncaster; Dundee; Hull; Leeds; WAG, Liverpool; Imperial War Mus., Nat. Portrait G and Tate G, London; Manchester; Newcastle-upon-Tyne; Nottingham; Harris Mus., Preston; Rochdale; Sheffield.

*Literature: DNB; DWB;* M. Cole, *Women of today,* New York, 1968 (orig. pub. 1938); C. Fox, *LK,* London, 1987; C. Fox and F. Greenacre, *Painting in Newlyn, 1900–1930,* Barbican G, London, 1985; M. & S. Harries, *The war artists,* London, 1983; Nottingham, 1982; Sellars; Waters.

## KNIGHTS, Winifred Margaret. (alt. MONNINGTON) (1899–1947)

*English painter of landscapes and religious subjects*

Born in London, she trained at the Slade from 1915 to 1917 and again from 1918 to 1920, winning the Slade scholarship, which enabled her to study in Rome. She remained in Rome for most of the next five years, marrying another painter, W.T. Monnington, in 1924. She exhibited in London, but although she was made a member of NEAC in 1929 she never exhibited at the Club and resigned two years later. She received a number of commis-

sions for religious works, including a painting of St Martin for Canterbury cathedral.

*Examples:* St Martin's chapel, cathedral Canterbury.

*Literature:* M. Day, *Modern art in Church; a gazetteer*, London, 1982; Deepwell; Waters.

## KNOWLTON, Helen Mary (1832–1918)

*American painter of landscapes, figure subjects and portraits; also a teacher of art*

Born in Littleton, Massachusetts, she and her eight siblings were brought up in Worcester, Massachusetts, where their father was editor of the local newspaper and served as mayor. In the early 1860s Knowlton went to Boston to study painting, opening her own studio in 1867. The following year she was one of a small group of women artists who requested William Morris Hunt, a painter in an experimental style based on Barbizon premises, and a highly respected member of Boston art circles, to run a class. In the later part of 1871, Hunt put Knowlton in charge of the class so that he could return to his own work, although he still came frequently to comment on the students' work. Knowlton continued with her own painting at this time, producing landscapes in the Barbizon manner, but she also taught other classes. Teaching was an economic necessity for her and remained a central preoccupation for 25 years, but of all Hunt's female pupils she exhibited the most regularly, contributing to the Boston Art Club almost every year between 1873 and 1897. Her style resembles that of Hunt, with broad masses, dark tones, bold brushwork and a tendency to flatten forms. In 1881 she spent nine months in Europe with Ellen Hale (*q.v.*), although after that time she concentrated on portraiture, benefiting from Frank Duveneck's advice in this field. She began to write regularly for the *Boston Post* as an art critic and for other papers, and her biography of Hunt was published in 1899. Little is known of her later life.

*Publications: Talks on art*, Boston, vl, 1875 & v2, 1883; *Hints for pupils in drawing and painting*, Boston, 1879; *The art-life of W.M. Hunt*, Boston, 1899.

*Examples:* Boston; Worcester, Mass.

*Literature:* M. Hoppin, 'Women artists in Boston 1870–1900: the pupils of William Morris Hunt', *American Art J.*, winter 1981, 17–46; *Notable American Women*; Rubinstein.

## KNUTSON, Greta (1899–1983)

*Swedish painter and writer who participated in Surrealism in Paris before developing an abstract style*

Training initially with the painter Wihelmsson from 1917, she proceeded to the School of Fine Arts in her native Stockholm. Like many other Scandinavian artists, she continued her studies in Paris, working under Lhote. After her brief marriage to the Dadaist Tristan Tzara in 1925 (they separated in 1926 and were formally divorced in 1942), she produced a few works in that mode, of which almost none survives. More important was her participation in all the Surrealist exhibitions in Paris between 1927 and 1932. She also exhibited regularly in Stockholm, particularly from 1928 with the abstract group known as Optimisterna and with solo shows in both capitals from 1929. Unable to leave France on the outbreak of war, she spent those years in Aix-en-Provence, continuing an extensive programme of exhibitions in the post-war years. Parallel with this activity was her career as a writer, in which she explored themes similar to those in her paintings. Chief among these were the androgyne and the ambiguity of illusion and reality.

*Literature:* Vergine.

## KOBRO, Katarzyna (1898–1951)

*Russian-Latvian born Constructivist sculptor who worked in Poland*

Born in Moscow of Russian-Latvian descent, she studied in Moscow from 1917 to 1920. Her interest in the modernist developments there is proved by her membership in 1919 of the Moscow Constructivist group Obmokhu, and in 1920 of Malevich's Unovis (Union for New Art) Group in Vitebsk. By the end of that year she was married to another modernist sculptor, Vladislav Strzeminski, and they both taught until 1922 in a Smolensk art school based on Malevich's principles. At this time her Suprematist sculptures consisted of a few geometric shapes placed in dynamic tension with each other. After she and Strzeminski settled in Poland in 1922, later becoming Polish citizens,

Kobro began a series of white-painted space compositions in which the sculpture opens out into the surrounding space. She became a member of the Blok and Praesens groups in 1924 and 1926 respectively, and helped to found the ar [revolutionary artists] group in 1929. From 1928, she used the numerical formula of the Golden Section for these structures (N = 8/5). With the aim of dissolving mass and space as separate entities, she employed the formula to establish a developmental principle throughout the work, thus imbuing a sense of rhythm. Colour was reintroduced and they became increasingly interested in the evolution of a functional architecture, paralleling some of the ideas of the Dutch De Stijl group. During the 1930s they jointly published several manifestos and theoretical essays, and from 1933 Kobro was a member of the Abstraction-Création group based in Paris. From 1931, she taught at an industrial school for women in Lodz, and had her only solo show in Krakow in 1935. In 1939 the Kobros fled with their baby daughter from the German invasion, but had to return to Lodz, where they suffered under the German regime. Many of Kobro's works were destroyed as 'degenerate art', although some have subsequently been reconstructed.

*Example:* Lodz.

*Literature: Abstraction-Création, 1931–6*, Mus. de la Ville de Paris, 1978; *Constructivism in Poland, 1923–36: Blok–Praesens–ar*, Mus. Folkwang, Essen, 1973; *Dir 20er Jahre in Osteuropa*, G. Gmurzynska, Cologne, 1975; Krichbaum; M. Schipper, 'KK: innovative sculptor of the 1920s', *WAJ*, 1/2, fall 1980–winter 1981, 19–24; *Three pioneers of Polish avant-garde*, Art Mus., Funen, 1985; Vergine.

## KOENIG, Ghisha (1921–)

*English sculptor of figures, especially factory workers in terracotta, plaster and bronze*

Koenig was born in London, her mother being Polish and her father a Russian Jew. Leo Koenig was a writer and art critic who exerted a strong influence on his daughter. Although poor, the family entertained many intellectual and political friends at their home; Bomberg and Chagall were particularly close to her father. Shortly before the outbreak of war she was awarded a scholarship to Hornsey College of Art (now part of Middlesex Polytechnic). Following this she served for four years in the army (ATS) and after the war resumed her artistic studies at Chelsea School of Art under

Henry Moore. He successfully conveyed to her that to be an artist required a long, hard commitment and this, rather than his style or content, was a lasting influence on her. In the early 1950s Koenig married Dr Emanual Tuchman, who set up the first medical group practice in Britain in St Mary Cray in Kent, where they settled. In the post-war years, this minor industrial area was being expanded with new factories and housing for people from some of the blitzed parts of London. It was these factories which provided Koenig with the subject matter for her art for both practical and ideological reasons; the models were cheap, and the representation of the working class coincided with her socialist beliefs. Although she admired abstract art, she felt that artists should follow their own ideas rather than the prevailing fashion. Koenig also felt that after World War II the dignity of humanity needed to be reasserted. Rather than being an outside observer, she clocked in with the other workers and remained in the factory for many months, so that she came to understand the people and the processes. Her early reliefs and sculptures show a particular concern with the social grouping of workers, often centred around a workbench. In the late 1950s her studies of miners showed firstly the enfolding nature of the tunnel and later the men separated from one another. Her reliefs and sculptures from the 1960s showed the workers in their workspace, confined by machinery or partitions. Although the people, often women, are generalised because of Koenig's simplification of form, she nevertheless intends to convey a strong humanitarian impulse and an awareness of gender difference. Conscious of the way her mother worked to support her father's writing, she stresses the co-operation her husband has always given, both towards her art and in sharing the upbringing of their daughter. Koenig has exhibited regularly since 1953.

*Examples:* Middleheim, Belgium; Sheffield; St. John's church, Wandsworth, London.

*Literature: Art for society*, Whitechapel G, London, 1978; G. Brett, *GK–sculpture 1968–86*, Serpentine G, London, 1986.

## KOGAN, Nina Osipovna. (alt. Nana IOSIFOVNA) (1887–1942?)

*Soviet Suprematist painter*

Little biographical information exists before the three years (1919–22) she spent teaching in the

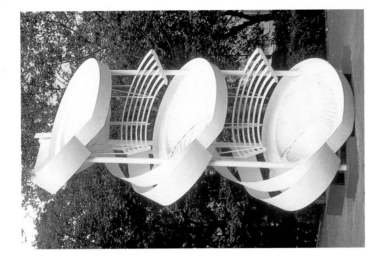

**Alice Aycock** *Three-fold manifestation,* 1987, Central Park, New York. (photo: courtesy of the artist)

**Eileen Agar** *Family trio, c.* 1934, oil on canvas, 92 × 86 cm, private collection. (photo: courtesy of Whitford and Hughes, London)

**Susan Crile** *Through the looking glass*, 1982, oil on canvas, 243.2 × 182.3 cm, private collection. (photo: courtesy Graham Modern, New York)

**Nancy Azara** *Orange votive*, 1987, wood, oil paint and gold leaf, collection of the artist. (photo: courtesy of the artist)

**Elizabeth Blackadder** *Figures and still life, Kyoto,* 1988, watercolour and gold leaf, 99 × 125.5 cm, private collection. (photo: courtesy of the Mercury Gallery, London)

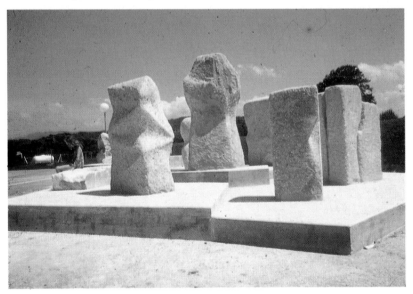

**Diska** *Chess game* (detail, the white pieces), 1979, stone and concrete, secondary school, Crest, south of France. (photo: courtesy of the artist)

**Elizabeth Forbes** *The primrose wood*, oil on canvas, 107 × 82 cm, private collection. (photo: courtesy of Whitford and Hughes, London)

**Claire Falkenstein** *Gates to the Peggy Guggenheim Foundation, Venice, 1960*, welded metal and glass. (photo: John Dunford)

**Margaret Hunter** *Lines of continuity*, 1988, mixed media on cloth, 155 × 122 cm. private collection. (photo: courtesy of the artist)

**Dorothy Gillespie** *Sounds of the rain dance*, 1988, enamel on aluminium, 170 × 142 × 35.5 cm. collection of the artist. (photo: courtesy of the artist)

**Mary Grigoriadis**  *By the sea*, 1988, pastel on paper, 67.5 × 92.5 cm, private collection. (photo: courtesy of the artist)

**Gwen Hardie**  *Interlock*, 1988, acrylic on paper, 70 × 100 cm, collection of the artist. (photo: courtesy of the artist)

**Erika Klein** *Tango*, 1925, casein on canvas, 150 × 100.2 cm, private collection. (photo: courtesy of Rachel Adler Gallery, New York)

**Rita Keegan** *Put on your red dress*, 1986, mixed media, 304 × 365 cm, collection of the artist. (photo: courtesy of the artist)

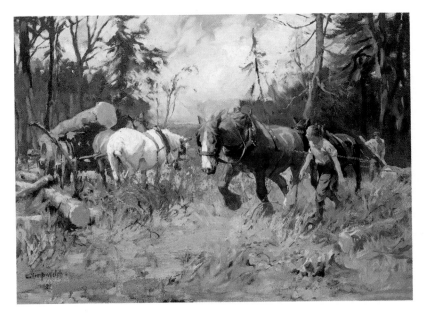

**Lucy Kemp-Welch** *Timber hauling in the New Forest*, 40.5 × 59 cm, private collection. (photo: courtesy of David Messum, London)

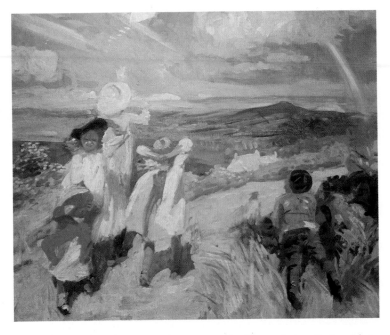

**Laura Knight** *Flying a kite*, 1910, oil on canvas, 72 × 85 cm, private collection. (photo: courtesy of Whitford and Hughes, London)

She glances at the menu, then at the door, intent but not impatient. "Sorry I'm late". I begin to make excuses, "Never mind, you waited last time," she embraces me, "it's good to see you." Her presence calms me as it always has, for nearly fifteen years. I ask her if that's possible. She says it must be since we met in 1968. Then we sail across the crowded harbour and cast anchor at our favorite table, our island by the window where we reminisce; then plan. Do the translation, exchange the manuscripts, write the article, promote the project, her project my project, our intervention. But first, we order two hors d'oeuvres and savour compliments about our clothes, our hair, then launch complaints about our lovers, them, the men, uncomprehending others on the mainland, distant, unpredictable, paling to insignificance against our monument—unfailing friendship. After that, as usual we share one dessert, have many cups of coffee and give good advice. "I'll tell you something if you promise not to say a word to anyone," she looks elated. "So you've finally found the right one?" "Don't be cynical, I can't help thinking that there must be something better, something more!" "And is there?" "Yes, and no, but now I don't know what to do." "Because he's married?" "Mmm." I tell her to forget it, stop procrastinating, finish the book. "The problem is, you have a Don Juan Complex." "Don Juanita," she corrects me and we laugh. Same familiar conversation, same delicious laughter. She goes on, "Don't you ever wonder what you're missing?" "Yes, but work is all that matters at the moment." "Well, a change might help." "The only change I need is time to do it." "Then, stop teaching." Seems so easy, so convincing when she says it. "And the money?" "Let him make it for a while." Absurd idea, and still, I want to hear it. They are closing, asking us to leave. The light is almost gone. Somehow the island now looks greener, fresher, but the seagulls sound more mournful. I protest, "We've just begun." The manuscript, the article, the buried treasure. "Next time," we both agree. I take her arm and then look back, everything two girls could long for—a boat, a cave, a castle and someone else to do the cooking. "Could there ever be another place as wonderful as this?" "Of course not," she replies.

**Mary Kelly** *Interim part I* (detail), 1986, silkscreen print, negative, perspex, 1 of 6 panels, collection of the artist (photo: courtesy of the artist)

**Mary Lloyd-Jones**  *Meteor*, 1985, dyes on calico, 152 × 152 cm, collection of the artist. (photo: courtesy of the artist)

**Mary Miss**  *South Cove*, (detail of 2½ acre site), 1988, Battery Park City, New York. Work done in collaboration with Stanton Ekstut, architect, and Susan Child, landscape architect. (photo: courtesy of the artist)

**Jenny Montigny** *La réfectoire, c.* 1907, oil on canvas, 78 × 98 cm, private collection. (photo: courtesy of Whitford and Hughes, London)

**Gina Pane** *Ladder for the martyrdom of St. Lawrence: partition pour un corps inadié*, 1985, glass, wood, iron, copper and charcoal, private collection. (photo: courtesy of Galérie Isy Brachot, Paris and Brussels)

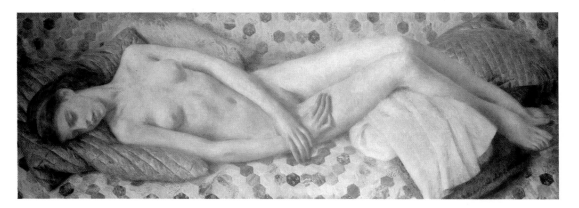

**Dod Procter** *Light sleep*, 1934, oil on canvas, 61 × 163 cm, private collection. (photo: courtesy of Whitford and Hughes, London)

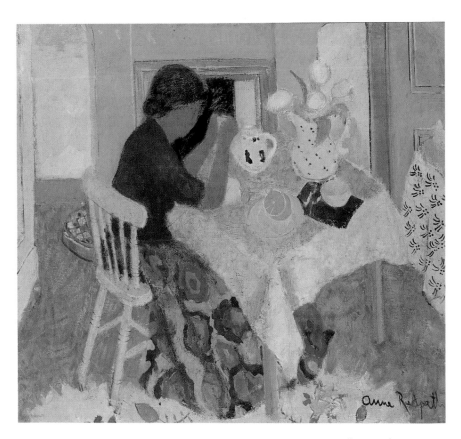

**Anne Redpath** *Figure at a table*, 1943, oil on canvas, 78.5 × 109.5 cm, private collection. (photo: courtesy of the Mercury Gallery, London)

**Edith Rimmington**  *Relative strength*, 1950, watercolour and ink on paper, private collection. (photo: courtesy of Whitford and Hughes, London)

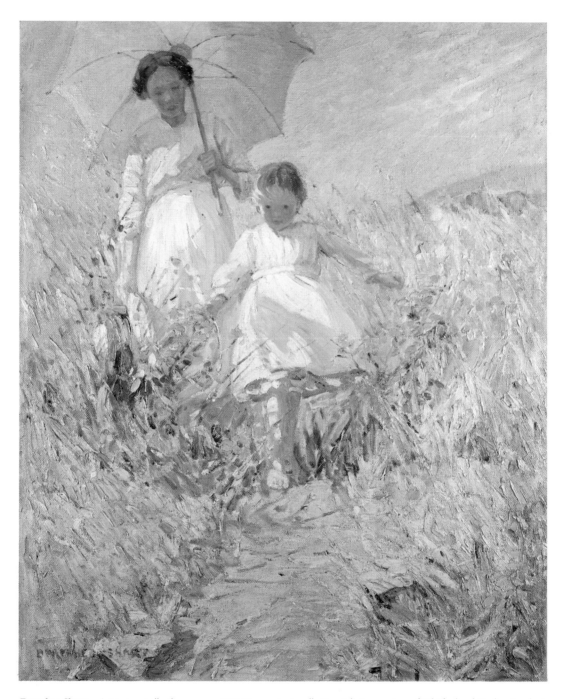

**Dorothea Sharp**   *A morning stroll*, oil on canvas, 86 × 71 cm, private collection. (photo: courtesy of Whitford and Hughes, London)

**Athena Tacha** *Streams*, 1975, sandstone and pumice rocks, 304 × 608 × 912 cm, Plum Creek, Oberlin, Ohio. (photo: courtesy of the artist)

Popular Art Institute in her home town of Vitebsk, where Chagall was the director. There she was in charge of the preparatory studies section and worked with modernist artists, including Malevich. She was a member of Unovis (Union for New Art) and exhibited in Berlin in 1922 at the show of Russian art. Her programme for the application of Suprematism to graphic art was published in 1920 in the first issue of *Unovis*, produced by Malevich's pupils. While in Vitebsk she produced a Suprematist ballet, in which Suprematist coloured shapes were set in motion on the stage. She produced Suprematist paintings, in which the coloured planes were given completely flat surfaces, and designed items such as wallpaper. She remained at Vitebsk after the departure of Malevich, later moving to Leningrad, where she continued to exhibit until 1941.

*Literature:* J. Bowlt, 'Malevich and his students', *Soviet Union* (publ. Arizona State University), v5/2, 1978, 256–86; *L'avant-garde au féminin, 1907–30*, Artcurial, Paris, 1983; *Russian women artists of the avant garde, 1910–30*, G Gmurzynska, Cologne, 1979 (includes text of article mentioned above); L. Shadowa, *Suche und Experiment*, Dresden, 1978 (includes text of article mentioned above); Vergine.

## KOHLMEYER, Ida Renee. née RITTENBERG (1912–)

*American abstract painter and sculptor*

Although Kohlmeyer has become one of the best-known abstract artists from the south, she did not begin her career until she gained her MFA from Tulane University, New Orleans at the age of 44. Initially a representational painter it was through contact with Hans Hofmann in Provincetown that she turned to abstraction, a direction confirmed in 1957 when she became a colleague of Mark Rothko at Newcomb College in New Orleans. From the early sixties the edges of her bands of colour became softer and more blurred, bringing into play the element of negative space. Within these paintings evolved certain geometric shapes, which became a kind of symbolic alphabet over the surface. She also began to incorporate these images on to sculptural furniture, and although she reverted to painting in the 1970s, she has more recently resumed her brightly painted three-dimensional work. In 1980 she received one of the coveted awards for distinction in the arts from the Women's Caucus for Art, and in 1984 she was selected as the Louisiana Woman of Achievement.

*Examples:* Atlanta, Ga.; Corcoran G, Washington, DC.

*Literature:* C. Donnell-Kotrozo, 'IK: pictographic grids that feel', *Arts Mag.*, v54/8, Apr. 1980, 188–9; R. Green, 'New Orleans: IK Month', *ARTnews*, summer 1985, 104–6; *IK: a retrospective exhibition*, High Museum of Art, Atlanta, Ga., 1972; Rubinstein; Watson-Jones; Withers, 1979; T. Wolf, 'IK: new dimensions', *Arts Mag.*, v56/8, Apr. 1982, 98–100.

## KOLLWITZ, Käthe. née SCHMIDT (1867–1945)

*German printmaker and sculptor, working in an Expressionist style*

One of the better-known and documented women artists, Kollwitz came from a family whose views encompassed equality of the sexes and social concern. Born in Konigsberg, East Prussia, she trained at women's art academies in Berlin and Munich, at the Académie Julian in Paris, and visited Rome and Florence. She married a doctor who worked among the poor in Berlin. She exhibited from 1893 in Berlin, her first success being in 1898 with her series of prints entitled *The Weavers*, which dealt with the suppression of a workers' revolt. This controversial subject resulted in her gold medal being withheld for a year. Other prints, both individual and in series, demonstrated her concern for the poor and oppressed. Death was a recurring motif, whether of a child by starvation or on the battlefield. Her son was killed in World War I and her grandson in World War II, and this strengthened her pacifism. A famous poster designed by her proclaims 'Nie wieder Krieg' (no more war). Her sculpture, which included funerary memorials, expressed similar ideas. She was the first woman member of the Prussian Academy (1919) but resigned under pressure in 1933. Her work was banned by the Nazis in 1936, partly because of her pacifism, although she continued to work.

*Examples:* Kupferstichkabinett, Nat. G, SMPK, and Berlinische G, Berlin.

*Literature:* Bachmann; B. Bonus Jeep, *Sechzig Jahre Freunschaft mit KK*, Bremen, 1963; *Das verborgene Museum*; DWB; Fine, 1978; Harris; Heller; M. Kearns, *KK: woman and artist*, Old Westbury, NY, 1976; H. Kollwitz (ed.), *KK: Tagebuchblätter und Breife*, Berlin, 1949 (Eng. trans. by R. & C. Winston, Chicago, 1955); H. Kollwitz (ed.), *Ich sah die Welt mit*

*liebvollen Blicken*, Hanover, 1968; Petersen; Tufts, 1974.

## KOONING, Elaine de. née FRIED (1920–89)

*American Abstract Expressionist portrait painter, sculptor and art critic*

The oldest of four children of Irish-German ancestry, she was brought up in Brooklyn. From an early age she was taken to museums and given reproductions of paintings by Rosa Bonheur (*q.v.*) and Elizabeth Vigée-Lebrun. From the age of six her drawing revealed precocious draughtsmanship, which led to her enrolling at the Leonardo da Vinci School and the American Artists' School, both in New York, from the age of 17. There she studied sculpture and painting. Through one of her tutors she had become the private pupil of Willem de Kooning, who advised her to change from social realism to still lifes, through which he expounded ideas about spatial concepts. They were married late in 1943 and became part of the group of pioneer abstract painters of the early 1940s. However, Elaine de Kooning continued to carry out portraits alongside her more abstract works. But these were not commissions, so to increase their income she began to write art criticism, for which she gained a considerable reputation. Parallel with the portraits were a series of faceless male figures, often engaged in sport, executed in the same vigorous style. Following an amicable separation from her husband, de Kooning went to Alberquerque, New Mexico as a visiting professor, and from this period came a series of huge canvases covered with brilliantly coloured slashing brushstrokes. Although abstract in appearance they were based on sketches of bullfights. Returning about 1960 to portraits of standing men, she was commissioned to paint President Kennedy. The sittings resulted in a series of studies, for de Kooning has always preferred to work quickly and continuously. In the midst of the project the President was assassinated (1963). Unable to paint for a year afterwards she turned to sculpture, and while teaching at the University of California discovered a particular casting technique used by the local foundry. Fourteen bronzes resulted from that year, including several crucifixes. She returned to painting and, in the mid-1970s to lithography, but remains best known for her portraits. Catalysts for paintings and prints in the 1980s have been a statue of Bacchus in the Luxembourg Gardens in Paris and the prehistoric images of animals in the caves at Lascaux. Reunited with her husband, in 1983 she was invited to be the first artist-in-residence in the Mount Holyoke College, South Hadley, Massachusetts, print-publishing programme. With the vogue for abstraction diminished, her works are seen increasingly in major exhibitions.

*Publications:* 'Venus, Eve, Leda, Diana *et al.*', *Art News*, v52, Sept. 1953, 20; 'De K's memories', *Vogue*, Dec. 1983, 352–3, 393–4.

*Literature:* Fine 1978; *Graphic muse*; Munro; Rubinstein; I. Sandler, *The New York School*, New York, 1978; R. Slivka, 'E de K.: the Bacchus paintings', *Arts Mag.*, v57, Oct. 1982, 66–9; R. Slivka, 'Painting Paleolithic', *Art in America*, Dec. 1988, 135–9.

## KOZLOFF, Joyce. née BLUMBERG (1942–)

*American abstract painter combining hard-edge and pattern painting*

Brought up in Somerville, New Jersey, she studied at the Art Students' League, New York and the Carnegie Institute in Pittsburgh. After a period in Florence, she gained her MFA from Columbia University, New York in 1967. In that year she visited Spain, where she first became fascinated by Islamic patterns at the Alhambra in Granada. Over the next two years she came to reject both the form and content of the then-fashionable hard-edge Minimalist painting. She began to incorporate patterns taken from traditional fabrics from a variety of cultures, not only Islamic, but also Greek and Mexican. Her use of pattern came at a time when the women's movement in art was beginning, and Kozloff recognised that she was trying to reintegrate fine art with decorative art, which had been traditionally associated with women. She was also establishing her right to paint as she wished, rather than in the dominant trend, although this risked – and received – the derision of male critics. Joining with like-minded artists she was a founder member of the New York Pattern and Decoration Group, which first met early in 1975, organised its own exhibition the following year and gained a foothold in the newly opened Holly Solomon Gallery. Some of Kozloff's canvases are based on one pattern with a border, while others combine several patterns with some plain areas. She has also carried out schemes for whole rooms. Married to critic Max Kozloff in 1967, she has one child. She has taught at several

universities. In the 1980s she has developed patterning in the medium of ceramic tiles.

*Literature:* A. Goldin, 'Pattern and print', *Print Collectors' Newsletter*, v9, Mar.–Apr. 1978, 10–13; *Graphic muse*; P. Johnston, *JK: visionary ornament*, University Art G, Boston, 1986 (bibl.); Rubinstein.

## KRAMER, Louise (*c.* 1942–)

*American sculptor who has moved from abstract to figurative work*

Kramer trained initially at the Cooper Union, before taking her MA at Hunter College, also in New York. She attended both the University of Pennsylvania and a graduate workshop at the Pratt Institute, New York. Known during the 1960s and 1970s for her experimental minimal sculpture, she has, since the early 1980s, become increasingly figurative and her work has acquired social and personal orientations. These took the form of flat metal sheets cut to form silhouettes of the subject, together with drawings. In her more recent work she drew directly on archival accounts of an episode that took place in Auschwitz, in which four women were hanged. The personal anger evoked by the incident led Kramer to produce not only the flat wall works but also to move fully into three dimensions. Kramer has exhibited in America and abroad, and is a long-standing member of the women's co-operative in New York, the AIR Gallery.

*Literature:* K. Linker, 'LK', *Arts Mag.*, v51/9, May 1977, 14.

## KRASNER, Lee. née Lenore KRASSNER. (1908–85)

*American Abstract Expressionist painter*

One of a large Russian-Jewish family which had recently emigrated to America, she was born in Brooklyn. Both parents worked in their greengrocery store, and money was not plentiful. Deciding early on to be an artist, she held tenaciously to this ambition despite a lack of encouragement, and began three years at the Cooper Union in 1926. Persistence carried her through the following three years at the conservative NAD. Her exhilaration at the sight of European modernist art at the opening of MOMA in 1929 was renewed when she worked as a waitress in the Greenwich Village café where modernist artists and critics met. Realising she did not want to teach, Krasner was able to be a professional artist from 1933 to 1943 through the government schemes organised during the Depression. Through these she met a number of other women artists, and the New York area of the Federal Art Project itself was headed by a woman. The murals she carried out accustomed her to working on a large scale. Her final moves towards abstraction were initiated by studying with Hans Hofmann during the period 1937–40 and discovering the ideas of the theorist, John Graham, through his book *System and dialectics of art*. It was thanks to Graham that in 1942 Krasner met Jackson Pollock, who had by then transferred to painting what she herself was already achieving in drawing. Soon they were living together, but a difficult period ensued for Krasner, particularly after their marriage in 1945. She had to provide a supportive environment for Pollock, who was undergoing psychoanalysis, but she refused to give up her art in order to earn a living as the wives of many other modernist artists had done. When they moved to Easthampton, Long Island, she worked in the bedroom while Pollock had the larger space in the barn. She abandoned working from nature, a decision she later came to see as a mistake, and in an effort to force the image from the canvas she over-worked the surface until it was grey. By the late forties, her 'little image' paintings, consisting of a network of black hieroglyphics, were beginning to show her the way forward but, as Pollock became more successful, her work was increasingly ignored. Her determination carried her through to making collages from her earlier drawings and paintings, and these were exhibited in 1955. Another difficult period followed, with Pollock's insecurity leading to increasing alcoholism and his death in a car accident in 1956. During the next 18 months Krasner produced 17 large canvases, all with references to nature, particularly spring, in their titles, but the reaction to Pollock's death, the ensuing litigation and her own poor health resulted in dark sombre paintings. After a serious operation in 1963 she finally began to establish herself as a painter of power and feeling and to overcome the prejudices of the art establishment. Subsequent works show large arcs of bright colours, with an overall impression of things organic. Her later success led to a revaluation of her role in the formative years of Abstract Expressionism, for she had been omitted from many accounts.

*Publications:* see Whitney Mus. catalogue below.

*Examples:* Dallas; MOMA, New York; NMWA, Washington, DC.

*Literature:* Bachmann; Fine 1978; Harris; Munro; NMWA catalogue; C. Nemser, *Art talk*, New York, 1975; B. Robertson, *LK: paintings, drawings and collages*, Whitechapel G, London, 1965; B. Rose, 'LK and the origins of Abstract Expressionism', *Arts Mag.* Feb. 1977, 96–100; Rubinstein; M. Tucker, *LK: large paintings*, Whitney Mus., New York, 1974 (bibl.).

## KROHG, Oda. née Ottilia LASSON. (alt. ENGELHARDT) (1860–1935)

*Norwegian painter of figures, portraits and landscapes*

Born in Oslo, she married Jorgen Engelhardt in 1881 and had two children. Three years later she began to study with Christian Krohg in Paris, and after her divorce in 1888 she married him and had two more children. Exhibiting from 1886 in Paris, Oslo, Stockholm and Copenhagen, she was very much aware of current developments in French art. These found a way into her paintings, which fell into two strands: a version of Impressionism and bold, striking compositions, some of which reveal a knowledge of Japanese art. During the 1890s her output was restricted by her family concerns, although she had two joint exhibitions with her husband in Christiania (now Oslo) in 1890 and 1892. From 1895 to *c.* 1907 the Krohgs lived in Paris, and from this time Oda Krohg's paintings are predominantly portraits, many of which are now in official collections. In 1906 she received a state travel scholarship.

*Examples:* Nat. G, Oslo.

*Literature:* A. Wichstrom, *Kvinner ved staffeliet*, Oslo, 1983.

## KRUGER, Barbara (1945–)

*American artist using mass-media subjects and quotations to question social stereotypes, particularly of women*

Kruger's mother was a legal secretary and her father a chemical technician in Newark, New Jersey, where she was born. They suffered considerable harassment because they were Jewish. After a year at Syracuse University, her father died, so she returned to live at home and studied at the Parson's School of Design, where Diane Arbus was one of her tutors. A greater influence was Marvin Israel, both a graphic designer and an artist, who had contacts in the high-fashion magazine world. After a year Kruger left Parsons, and in 1967 gained a job as a second designer on the magazine *Mademoiselle*. Within a year the main designer had left and Kruger found herself at 22 in charge of designing a national fashion magazine, a job which she retained for four years. All this time she was fascinated and intimidated by the art world, dominated by men and Minimalism, and it was not until she saw some fibre sculpture by Magdalena Abakanowicz (*q.v.*) that she realised that pluralism in art could exist. Her first explorations in art took the form of large fibre hangings, and sewn canvas wall pieces, highly coloured and decorated with ribbons, sequins and feathers. She began to exhibit and had her first solo show in 1974. A series of paintings in 1975, paralleled her growing political involvement through a group called Artists Meeting for Cultural Change, where she encountered Marxist writers on art, notably Walter Benjamin and Roland Barthes. It was not until 1977 that she moved to the combination of photograph and text, originally in separate frames, but later one superimposed on the other. Believing that art and life cannot be separated, she looks for her material whenever she goes out. The juxtaposition of the terse words and the simple but telling black-and-white image are 'a series of attempts to ruin certain representations and to welcome the female spectator into the audience of men'. Many of the slogans are addressed to an unidentified but often malevolent audience referred to as 'You'. Although Kruger is a feminist, these slogans are not specifically addressed to men or women, but the meaning will differ for each spectator. By using mass-media images she aims to communicate ideas about social and political power to people who are not familiar with art, and for this reason a number have been reproduced and pasted on advertisement hoardings in cities in Europe and America.

*Literature:* C. Squiers, 'Diversionary (syn)tactics: BK has a way with words', *ARTnews*, Feb. 1987, 76–85; *We won't play nature to your culture: works by BK*, ICA, London, 1983.

## KUBICKA, Margarethe. (née STANISLAVOVA) (1891–?)

*German painter and illustrator of social and political themes*

She began her art training at the age of 20 at the art academy in her native Berlin. During her two years there she met her husband, the painter and writer, Stanislav Kubicka. Kubicka taught in schools, but in her spare time was politically and artistically active. Both she and her husband belonged to a number of left-wing artists' groups and were supporters of the *Novembergruppe*. In 1919 she became a member of the Spartakus Group and an official member of the Communist party. Until 1933 she continued to exhibit with the *Progressiven* Group. On the outbreak of war her husband returned to his native Poland but was killed by the Gestapo in 1943. Kubicka was also arrested but was later released. Social and political themes dominate Kubicka's work. From a starting point in realism, her style changed with the influences of Cubism and Constructivism. In her paintings after the mid-1920s the compositions consist of crystalline planes which succeed in existing both independently as a grouping of abstract forms and as the component parts of a subject which is just recognisable. Her retirement from teaching in 1956 marked the start of a period of considerable creative activity.

*Examples:* Berlinische G, Berlin.

*Literature: Das Verborgene Museum*; H. Ohff, *MK*, Neuer Berliner Kunstverein, Berlin, 1976.

## LABOWITZ, Leslie (1946–)

*American performance artist concerned with violence against women*

Since 1976 Labowitz has worked co-operatively with other women, and primarily with Suzanne Lacy (*q.v.*). After studying at the Otis Art Institute in Los Angeles, Labowitz spent four years in Germany, attracted by the work of Joseph Beuys. The performances she evolved there, including *Menstruation Wait* (1971), were already evidence of her feminist concerns, and on her return to California she began collaborative works with the feminist community in Los Angeles. She has worked on performances with several organisations, including Women Against Violence Against Women. Their targets have included the exploitation of images of women on record covers. With Lacy she evolved a public ritual to mourn the victims of the Hillside strangler rape-murders and to resist the menace of such violence. This was performed outside Los Angeles city hall in 1977 and received national media coverage. Together

Labowitz and Lacy formed a loose affiliation of women's groups to sponsor public performances which deal with issues facing women, but particularly aspects of violence.

*Publications:* 'Record companies drag their feet', *High Performance*, June 1978; 'Developing a feminist media strategy', *Heresies*, no. 9, 1980; with S. Lacy, 'Mass media, popular culture, and fine art: images of violence against women' in N. Buchanon (ed.), *Social works*, ICA, Los Angeles, 1979.

*Literature:* L. Lippard, *Issue: social strategies by women artists*, ICA, London, 1980; M. Roth (bibl.).

## LACY, Suzanne (1945–)

*American performance artist, usually working in collaboration with others on issues concerning women*

After graduating in zoology in 1968, Lacy studied psychology at Fresno State College, California. While there she encountered Judy Chicago's (*q.v.*) Feminist Art Program, and went on to gain her MFA on the Women's Design Program at the California Institute of Arts. Later she joined the staff of Chicago's Feminist Studio workshop in Los Angeles. Since 1976 she has worked frequently with Leslie Labowitz (*q.v.*). In the late 1970s she organised several city-wide events, such as *Three weeks in May* in Los Angeles, which concerned the prevalence of rape within the city, and one in New Orleans, which dealt with the non-ratification of the equal rights legislation. Parallel with such public works she also continues with individual work.

*Publications:* see also under Labowitz; 'Battle of New Orleans', *High Performance*, fall 1980.

*Literature:* L. Lippard, *Issue: social strategies by women artists*, ICA, London, 1980; M. Rosler, 'The private and the public: feminist art in California', *Artforum*, Sept. 1977, 66–72; M. Roth, 'Visions and Re-visions: a conversation with S.L.', *Artforum*, Nov. 1980, 42–5; Roth (bibl.); *Women look at women*, Muhlenberg College Center for the Arts, Allentown, Penn., 1981.

## LAMBA, Jacqueline (1910–)

*French painter who used automatism in Surrealist paintings of the 1930s; she also wrote poetry*

Documentation on Lamba is sparse, partly because of the way in which historians have diminished the contribution of all women Surrealists, partly because of her marriage to André Breton from 1934 to 1943 and partly because of her own dissociation from studies orientated towards the women of Surrealism. She was born near Paris and studied the decorative arts. At 15 she was already conscious of feeling in rebellion against all aspects of middle-class life. After her discovery in 1927 of the 1917 Russian revolution, she began to attend left-wing political meetings, which seemed dull to her in comparison with the original events. Two years later she came contact with Surrealism and found the writings of Breton a revelation. He was the first person she knew who tried to resolve poetic creativity with political awareness, whether militant or not. She found the defiant tone of his polemic liberating. They did not meet until May 1934, and were married later that year in a joint ceremony with Nusch and Paul Éluard. Lamba possessed a more sustained and active political involvement than other women associated with the Surrealists, attending a conference in Prague in 1935 and meeting Trotsky when she and Breton were in Mexico in 1938, although it has been argued that she subordinated herself to her role as Breton's wife. In her artistic work she believed that automatism was the key to the unconscious, and that only material from that realm should be allowed into visual forms of expression. Her semi-figurative works containing fantasy figures in rocky landscapes gave way to abstract automatic paintings related to those by Masson and Matta, the two other most consistent exponents of abstract Surrealism. After her separation from Breton, Lamba went to New York, where she had a solo show in 1944 in which her richly coloured prismatic paintings were exhibited. Other exhibitions followed, as did marriage to American sculptor and photographer, David Hare. More recently she returned to live in France.

*Literature:* W. Chadwick, *Women artists and the Surrealist movement*, London 1985; Vergine.

## LANDSEER, Jessica (1807–80)

*English painter, etcher and miniaturist*

Born in London, Jessica was one of seven surviving children of an engraver whose career was adversely affected by the unreasonable regulations governing engravers at the time. As a result he had plenty of time to teach art to all his children. The most famous member of the family was Edwin, but sisters Jessica and Emma (later McKenzie) both exhibited professionally. Jessica herself gave her birth date as 1810, but as her first exhibit at the RA was in 1816, when she exhibited a view of a Suffolk farmyard, this was regarded as unlikely and her baptismal date has been found to be 1807. Edwin who made his RA debut at the age of 13 was regarded as precocious, but the even greater talent of his sister has been overlooked. All Edwin's siblings, save one brother, gave in too much to him and their own lives suffered in various ways. As she was the oldest unmarried daughter, the burden of housekeeping fell upon Jessica. Her output was therefore smaller and arguably less developed than her early talent would indicate. She exhibited a total of 23 paintings at the RA and other London galleries, including a rare portrait of Edwin's dog Lassie in 1863. From the 1820s she also etched plates of his paintings and made a copy in miniature of at least one. As he did not approve of professional women artists, Edwin never encouraged her work and her mild nature was content to accede. He also kept her short of housekeeping money, so that it was only after his death in 1873 that she was able to buy new clothes, live in a larger house and run her own carriage.

*Literature: DNB;* C. Lennie, *Landseer*, London, 1976; P. Nunn, *Victorian women artists*, London, 1987; Wood, 1978.

## LANE, K. See WEEMS, Katherine

## LASERSTEIN, Lotte (1898–)

*German-born figurative painter who lives in Sweden*

Laserstein was born in Pr-holland, Prussia, her father being a pharmacist and her mother a gifted pianist and porcelain painter. After her father's death, her mother moved with her two daughters to Danzig (now Gdansk, Poland), where two of Lotte's aunts were artists. One ran an art school and it was here that Lotte Laserstein had her first lessons at the age of nine. Two years later she resolved to become an artist and never to marry. A move to Berlin in 1912 enabled Laserstein to set her sights on entry to the Berlin Academy and, encouraged by her mother, she was accepted in

1919. From 1920 to 1926 she worked under Erich Wolfsfeld, who came to regard her as his most outstanding pupil. Despite the persistent prejudice against women students, she was awarded a gold medal in 1925, while simultaneously studying art history and philosophy at the university. Inflation eroded the family's finances in the 1920s, and Laserstein was obliged to find paid part-time work in illustration and china painting. After establishing her own studio in 1925, she took in pupils and began to exhibit regularly. She quickly became known for her naturalist paintings, the early ones of which display muted colours, a precise representation of texture and a pervading sense of stillness. Whatever the size of the painting (one was over two metres wide), the figures are given monumentality. Under the Nazi regime, her mother's flat was confiscated; Laserstein could obtain art materials only with difficulty and was forced to close her studio in 1935. After visiting Italy, she settled in Sweden, where she still lives. The paintings she took with her enabled her to gain a solo show at a prestigious Stockholm gallery late in 1937. Through this she was able to set about establishing her reputation for a second time, still using the model, Traute Rose, with whom she worked for over 50 years in both Germany and Sweden. She supplemented her portrait commissions with illustration work and teaching. By the time she settled in Sweden, her style had become less linear, with a more fluid handling of the paint, softer brushstrokes and stronger contrasts of light and shade, all of which contribute to a more intimate atmosphere. In the 1950s she began to travel, visiting several European countries and America. A member of the Swedish Academy of Arts for over 50 years, Laserstein is renowned for her portraits and still paints at the age of 90.

*Examples:* Montreal; Stockholm; NMWA, Washington, DC.

*Literature:* G. Auty, 'Overdue tribute', *The Spectator*, 31 Oct. 1987, 45; C. & A. Stroude, 'LL and the German Naturalist tradition', *WAJ*, v9/1, spring-summer 1988, 35–9; J. Taylor, 'The lost ladies four', *The Times*, 10 Nov. 1987.

## LASSEN, Käte (1880–1956)

*German painter of figures, chiefly women and children from Danish farming communities, and landscapes*

Much of Lassen's work is centred on her native town of Flensburg, near the border with Germany and the small communities and barren dune-covered shores of the coast in that region. Her father was a goldsmith, and her mother, who came from an artistic family, supported her daughter's wish to become an artist. For one year she attended the Gewerbeschule in Hamburg before enrolling in 1898 at the Women's Art School in Munich to study portrait painting and graphics. Chief of the influences on her was Schmidt-Reutte, who aimed to achieve a monumental effect of the figures and emphasised the structure of the composition, although there are indications of an awareness of Art Nouveau and Impressionism in her work. While she was staying in Munich she met Gabriele Münter (*q.v.*) and during the summers painted in the countryside with other members of her class. Her studies concluded, she worked alone on the Baltic coast in the summer of 1904, producing figure subjects and landscapes with strong contours and flattened compositions. Her father built her a studio and converted a flat in the family house, where she was to live for the rest of her life. On a cycling expedition in 1904 she discovered an area of country called Thy, to which she regularly returned to paint and where the Danish farmers became her favourite models. Throughout her life she worked isolated from other artists, breaking off contacts with Munich colleagues, and even on a visit to Paris in 1908–9 she avoided other artists and their work. Instead she spent her time sketching figures in the streets, bars and variety halls. She set her own goals, and because she had an independent income she was free to forge her way of working. Until 1910 her style was based on Munich *plein-air* painting, and her subjects were women and girls alone or in small groups on dunes. Rather than engaged in everyday activities, they are depicted waiting, ready for whatever misfortune nature may visit on them. They are timeless portrayals and could be interpreted as reinforcing woman as a passive victim of circumstance. From 1910 this approach is explored in interiors, although she now began to receive the first of many commissions for mural paintings. In these works line is dominant and a monumental effect achieved. The symbolic elements from her earlier paintings had disappeared by 1920, and she began to pile the figures up on the picture surface and reduced the perspective. Her change in approach was caused by an encounter with the misery in Berlin in the aftermath of World War I and with some of the socially critical works of art appearing there. Men begin to feature in her works in scenes of the unemployed or war invalids. Through this period her works were in tune with the style and intentions of *Neue Sachlichkeit*,

yet by the time of the Nazi era, the authorities were able to use her paintings of Danish peasants, carried out from 1924, to reinforce their racist ideology. Her own position is not clear since a mural of a traditional sword dance which she executed in a Flensburg school was painted over after the war. In the post-war period she expanded her earlier work, designing church windows and receiving a number of commissions for these.

*Examples:* Nat. G, SMPK, Berlin; Flensburg.

*Literature: Das Verborgene Museum; KL*, Stadtisches Mus., Flensburg, 1980; C. Philipp & E. Lendvai-Dircksen, 'Repräsentantin einer weiblichen Kunsttradition oder Propagandistin des Nationalsozialismus?', *FrauenKunstGeschichte*, 1984, 167–83.

## LAURENCIN, Marie (1885–1956)

*French painter working with the Cubists who later turned to painting women, often actresses and dancers, and designed sets for ballet*

Now a well-documented but problematic figure among female artists, she came from a comfortable middle-class Parisian background. While attending drawing classes at the Académie Humbert, she met the then unknown Georges Braque, who endeavoured to persuade her against a career in china painting. Late in 1905 he took her to Picasso's studio and in this way she became an active participant in the discussions which took place there between artists and writers over the next few years. Her well-known portrait of Picasso, Fernande Olivier, herself and Apollinaire, from 1908, shows her early assimilation of Cubist premises but reworked in her own way. Laurencin's development as a painter was hindered by her association with the group, for her lover Apollinaire was the spokesman of Cubism but was unable to criticise her work in an objective way. The dominating presence of Picasso similarly provided little encouragement and support, although Gertrude Stein was one of the first collectors to buy her work. Laurencin parted from Apollinaire in 1913, and in the following year married a German art student, Otto von Waetjen. For the duration of the war they lived in Spain, where she met Maria Blanchard (*q.v.*). After a year spent in Germany in order to obtain a divorce, she returned to Paris in 1920 for her most prolific period as an artist. Her characteristic paintings have as their subjects

dancers, actresses and circus performers, evoked in a dreamy atmosphere of fable and folk tales. However, their delicate style and pastel colours have been described as embodying traditionally feminine sensibility. Nevertheless her designs for costumes and scenery for the Russian ballet production of *Les Biches* in 1924 were extremely successful, and were revived by Covent Garden for their 1964 production. She illustrated over 20 books and worked with fashion designer Paul Poiret.

*Examples:* Baltimore; Kupferstichkabinett, SMPK, Berlin; Boston; Tate G, London; MOMA, New York; Philadelphia; Toledo, Ohio; NMWA, Washington, DC.

*Literature:* Bachmann; *Das Verborgene Museum; DWB;* J. Fagan-King, 'United on the threshold of the twentieth-century mystical ideal: ML's integral involvement with Apollinaire and the inmates of the *Bateau Lavoir*', *Art History*, v11/1, Mar. 1988, 88–114; Fine, 1978; Harris; NMWA catalogue; Petersen; R. Sandell, 'ML: Cubist muse or more', *WAJ*, v1/1, 1980, 23–7.

## LA VILLETTE, Elodie. née JACQUIER (1843–?)

*French painter of marine views and landscapes*

Born in Strasbourg, she was the daughter of an army doctor, so her education took place wherever he was posted. She therefore trained in the town of Lorient under Coroller, at Strasbourg under Schuler (for three months) and at Arras under Dubois. She also encountered the *plein-air* landscape painter Corot and, through him, Jules Breton, who influenced her landscapes. Her husband, who was a captain in the army, encouraged her to continue her studies. She exhibited at the Salon every year from 1870 to 1914, winning awards in the Paris Expositions of 1889 and 1900. She became *hors concours* in 1889. She also exhibited in Vienna, Manchester, Barcelona, Amsterdam and Australia, as well as in the Expositions at Chicago in 1893 and St Louis in 1904.

*Examples:* Dunkirk; Lille; Morlaix; Mus. d'Orsay, Paris.

*Literature:* Clement; M. Elliott; *Le livre des peintres exposants en 1930*, Paris, 1931; J. Martin, *Nos peintres et sculpteurs*, Paris, 1897.

## LAZZARI, Bice (1900–1981)

*Italian abstract painter*

Venetian by birth, Lazzari was virtually self-taught for, although she was given every opportunity to pursue her interest by her parents, she attended the Academy at Venice briefly when 18 and studied graphic art for a year. In her early pastels she introduced the contradictory elements of ordered geometric lines with free calligraphic marks. From 1928 when her father died and she had to earn her living she went into the fashion industry and also designed furnishings and fabrics. In the late 1930s she produced a number of large decorative fabric panels for the décor for major exhibitions. In this field of interior design she was employed by architects, and was able to become economically independent only in 1949. Always an isolated figure in Italian art, she belonged to no group and showed no trace of influence from any artist. She married an architect and moved to Rome after World War II. She enjoyed widespread recognition over the last 15 years of her life.

*Literature: BL restrospettiva*, Palazzo Sturm, Bassano del Grappa, 1970; Vergine; M. Vescovo, *BL*, Milan, 1974.

## LAZZELL Blanche. née Nettie Blanche LAZZELL (1878–1956)

*American printmaker and painter who was an early exponent of abstract art derived from Cubism and Purism*

The ninth of a West Virginia family of ten children, Lazzell received an extensive education. Obtaining her first degree in 1898, she proceeded to study art and art history, and by 1905 possessed another two degrees. This is characteristic of her insatiable appetite for knowledge, which existed throughout her life. In 1908 she enrolled at the Art Students' League, New York, under William Merritt Chase, and in 1912 proceeded to Paris, where she had her first encounter with modernist art. Forced to return to America by the outbreak of war, she joined the community of those recently returned from Europe, which was growing in the traditional art colony of Provincetown, Massachusetts. There she learnt the newly discovered method of the Provincetown print, the one-block woodcut in which the whole design was carved on a single block with grooves in between the colours, so that

in the print a white outline was produced. This technique proved endlessly fascinating to Lazzell, who produced 138 such blocks during her career. She achieved acclaim for these prints from 1918 and was able to vary the colour values in each version of the print so that two were never identical. For more than 40 years she spent almost every summer, and some winters as well, in Provincetown, where she also began to teach her printing techniques. Further study in New York in the winters of 1916 and 1917 included colour analysis, and in 1923 she returned to Europe for two years to work under Léger, Lhote and Gleizes. During this time she became committed to abstract work, which was a logical development from her simplified flat planar woodcuts of Provincetown. In 1925, she produced a series of prints that are among the earliest non-objective prints in America. She used colour and form in ways which suggest depth, rather than the complete flatness of Cubism. In the 1930s she was employed in one of the government art projects, but she also expanded her repertoire of media into hooked rugs. Ever open to new ideas, she studied with Hans Hofmann when in her seventies, and was featured as one of four pioneer abstractionists in a 1949 exhibition. Lazzell's role in modernist American art has been almost entirely overlooked.

*Literature: Eight Southern women*, County Mus. of Art, Greenville, S. Carolina, 1986; J. Flint, *Provincetown printers*, NMAA, Washington, DC, 1983; A. Wolf, *New York Society of Women Artists 1925*, ACA G, New York, 1987.

## LEAPMAN, Edwina (1934–)

*English abstract painter*

Born in Hampshire, Leapman spent six years in the 1950s at the Slade and the Central School of Arts and Crafts. Financing herself through part-time teaching, she exhibited throughout the next two decades in group exhibitions of abstract artists, but it was not until 1976, when she was a prizewinner at the John Moores' exhibition at Liverpool, that her name became more familiar. She works by drawing parallel lines over the canvas with a paint-loaded brush. The appearance of the finished work depends on the colour and texture of the canvas, whether it is primed, and the thickness and colour of the paint. Her process is methodical, but relies on the fortuitous building of rhythm through the random accents caused by

the application of the paint and the texture of the canvas.

*Literature: Hayward Anuual '78,* Hayward G, London, 1978 (bibl.); S. Kent, 'EL at the New Art C', *Studio International,* Mar. 1974, review section, 12; S. Kent, 'EL', *Art Monthly,* Dec. 1976/Jan. 1977, 25; *EL,* Juda Rowan G, London, 1987; Parry Crooke.

## LEBEDEVA, Sarah Dmitrievna (1881–1968)

*Soviet sculptor of portraits, both busts and full-length, and figures, including nudes, statuettes, and figurines for porcelain*

Few details exist on her life other than in Russian, but she may have visited Paris, because her work contains elements of both Cubism and Impressionism, the latter being the longer-lasting influence. Among her female portraits is one of her contemporary, the sculptor Mukhina (*q.v.*). Other portraits include people who played important parts in Soviet history but were not politicians and

**Sarah Lebedeva** A sculpture portrait of sculptress Vera Mukhina, present location unknown. (photo: S. Belyakor Novosti Press Agency)

not always in political favour. She made no attempt to alter the forms of her models in order to make them accord with Western ideals of beauty. She received several state commissions, including monuments to Pushkin and Chekhov. No fewer than four of her works were chosen to illustrate articles in the *Great Soviet Encyclopaedia* of 1974, a singular honour for any artist, and a posthumous exhibition was held in 1969.

*Examples:* Russian Mus., Leningrad; Mus. of the Revolution and Tretyakov G, Moscow.

*Literature:* W. Mandel, *Soviet women,* New York, 1975; B. Ternovets, *SL,* Moscow and Leningrad, 1940.

## LE BROQUY, Melanie (1919–)

*Irish sculptor of stylised, simplified figures*

A native of Dublin, she attended both the National College of Art and the Royal Hibernian Academy School in that city before proceeding to the Ecole des Beaux-Arts in Geneva. She first exhibited in 1937 but, like many sculptors, found it hard to exhibit outside the RHA because of the preference for painting expressed by patrons and, therefore, dealers. However, since the early 1970s she has achieved recognition and considerable acclaim for her work, which although clearly in the modernist vein, is classical rather than aggressive. Some of her work has been included in exhibitions of religious art.

*Literature: MLB,* Taylor G, Dublin, 1986; *Irish women artists.*

## LEE, Caroline. née NOBLE (1932–)

*American monumental metal sculptor working in France*

Born and educated in Chicago, Lee went to France in 1958 after graduating from the Art Institute, Chicago. The thorough technical grounding in both casting and welding which she received benefited her more than working directly with artists, for the technicians were accustomed to working with artists and evolving new techniques. From 1959 onwards she exhibited in the Salon de la Jeune Sculpture every year until 1980, and in many other exhibitions. She has carried out many commissions for site-specific sculpture, notably in schools and universities, throughout France and in 1981 won

the prize for a monument to the Resistance organised by the city of Montreuil. Her works are semi-abstract versions of a basically recognisable object.

*Examples:* Place Croix de Chevaux, Montreuil; C. Nat. d'Art Contemporain and Mus. d'Art Moderne de la Ville, Paris; Place de France, Sarcelles.

*Literature:* G. Boudaille, 'CL' *Cimaise* no. 107, June–Aug. 1972, 42–50; Watson-Jones.

## LEESON, Lorraine (1951–)

*English artist who mainly works in community-orientated projects*

A Londoner, Leeson trained at St Martin's School of Art and Reading University. This was followed by a scholarship, which enabled her to study at the Hochschule der Bildende Kunst in Berlin. Since 1976 she has collaborated with Peter Dunn on many projects, including several concerned with London hospitals and health projects. She has run various community-orientated film and video workshops in East London, and during the early 1980s was involved in research connected with the redevelopment of the London docklands. Although she has exhibited in London, Edinburgh and West Germany, much of her work is directed towards trade unions and campaign organisers, who use her work in order to communicate with their public. The East London Health Project has published posters by Leeson and Dunn on health issues, and these have been distributed through the Labour party, community bookshops and similar organisations. As such, Leeson claims they are cultural products for use in the struggle for equality of class and gender, rather than art in the traditional narrow sense.

*Literature:* L. Lippard, *Issue: social strategies by women artists,* ICA, London, 1980.

## LEIGH-SMITH, B. See BODICHON, Barbara

## LEIGHTON, Claire Veronica Hope (1900/4–)

*English painter, wood engraver and illustrator*

Leighton was born in London, where her father was a writer. She trained at Brighton School of Art, the Slade (where she won a prize for portrait painting) and at the Central School of Arts and Crafts (where she learnt wood engraving under Noel Rooke). Although she continued to paint and exhibit, it was for her wood-engravings, particularly of rural subjects, that she was best known. In the 1930s her political commitment revealed itself through exhibiting with the AIA and illustrating the *New Left Review.* She wrote and illustrated books, several of which concern gardening. Her bold close-up views of garden tools recall the style of *Neue Sachlichkeit* and labourers are shown as heroic figures. In 1939 she emigrated to Connecticut and continued her work there. She is represented in many collections in Europe and America.

*Publications: How to do woodcuts and wood engraving,* London, [before 1934]; *The musical box,* London, 1932; *Four Hedges,* London, 1935.

*Examples:* Baltimore; Boston; Art Institute, Chicago; V & A, London; Manchester; Metropolitan Mus., New York; Nat. G, Ottowa.

*Literature:* Waters; *Who's Who in Art.*

## LEMAIRE, Madeleine Jeanne. née COLLE (1845/6–1928)

*French painter of landscape, portraits, genre and flowers in pastel and watercolour*

A native of Fréjus, she was taught by her aunt, Mme Herbelin (*q.v.*), and by Charles Chaplin in Paris, where she spent the rest of her life. She exhibited at the Salon from 1864, and over succeeding years amassed many awards and honours. She was one of only three women members of the Société d'Aquarellistes during the last 20 years of the century; in 1890 she was elected member of the Société Nationale des Beaux-Arts, and in 1906 became an Officier de la Légion d'honneur. She exhibited at the Chicago Exposition in 1893 and won a silver medal at the Paris Exposition Universelle in 1900. She was much sought after socially in the literary salons of the capital and many of the leading writers of the time gathered at her house. Indeed she illustrated some editions of Anatole France and Marcel Proust. Many well-known figures wanted their portraits from her regardless of price, and in 1873 her watercolours were fetching over 2,000fr. On the advice of Alexandre Dumas she produced countless pictures of roses so that she became known as the Empress of Roses. Today it is her genre pictures which are most highly

regarded, for most of her works included figures even if flowers were an important element. A daughter, Suzanne, became known as a flower painter, exhibiting from 1890 to 1914.

*Literature:* Clement; Edouard-Joseph; M. Elliott; J. Martin, *Nos peintres et sculpteurs*, Paris, 1897; Schurr, v2; Yeldham.

## LEMPICKA, Tamara de. née GORSKA (1898/1907–1980)

*Polish painter of portraits and figures in an elegant style combining elements of Cubism and Mannerism*

The early life of Lempicka is uncertain, including the date of her birth. It is known that she was one of two daughters born to the Gorska (or Gorski) family in or near Warsaw. Her sister Adrianne became an interior designer. Before the age of 20 Tamara married Tadeusz Lempicki, living in St Petersburg until 1917, when they moved to Paris. After the birth of her daughter Kizette, Lempicka studied painting with Maurice Denis and later with Lhote, a much more decisive influence. He combined traditional subject matter with the broad geometric planes of synthetic Cubism. From this combination, Lempicka evolved her paintings of the aristocratic, the famous and those who fitted in with her canons of beauty. In some respects these can be linked to the portraits by *Neue Sachlichkeit* artists in the 1920s. The influence of Mannerism, notably of Pontormo, can be seen in the elongation of the elegant figures, the shallow space, and, in later works, the juxtaposition of the figure with a rapid recession into a distant view of skyscrapers. Her own self-portrait of 1932 shows her at the wheel of a car, with close-fitting hat, an image of independence. Her first solo show in 1925 was followed by a series of others, but she also exhibited at major shows in Poznan and Pittsburgh. Her husband returned to Poland without her in the late 1920s, and she remarried in 1934. Her new husband was Baron Kuffner,a rich Hungarian aristocrat, and at the outbreak of war they settled in America. She continued to paint and, until the vogue for abstraction ousted figurative art, she also exhibited. In addition to her portraits, her most remarkable works are her female nudes executed in the tradition of Ingres, extolled by Lhote. They are langorous and sensual; particularly when several of these figures are closely interwoven in the shallow pictorial space and the atmosphere is suggestive of passionate relationships. She divided her time between Houston, Texas and Beverly Hills, California, with a wealthy and exotic life style, although during the war she contributed in various ways to the war effort, even enlisting as a staff sergeant in the Women's Emergency Corps at Beverly Hills. A retrospective in Paris in 1972 of 48 canvases from 1925 to 1935 has rekindled an interest in her work.

*Examples:* Beauvais; Petit Palais, Geneva; Orléans; Centre Nat. d'Art Moderne, Paris.

*Literature:* S. Bojko, 'T de L', *Art and Artists*, v15, June 1980, 6–8; Cooper; Krichbaum; K. de Lempicka-Foxhall as told to C. Phillips, *Passion by design: the art and times of T de L*, Oxford, 1987; G. Marmori, *T de L*. London, 1978.

## LESSORE, Thérèse (1884–1945)

*English painter of town and country scenes and theatre subjects*

Born in Brighton, she came from a distinguished family of artists. Her grandfather and her aunt were china painters for Wedgwood, and her father and brother were both artists. After early tuition from her father and her aunt, she attended the South Western Polytechnic Art School, followed by the Slade from 1904 to 1909, in her final year, winning the Melville-Nettleship prize. During these years she also carried out embroidery. She began to exhibit in 1912 with the Allied Artists Association and, from its foundation in 1914, with the London Group. She married artist Bernard Adeney in 1913, but this ended in divorce after several years. She was always interested in painting scenes with human interest and more particularly with capturing a fleeting movement, whether in markets, hop-picking or music-halls. Before they had met, Sickert wrote of her work, 'By some strange alchemy of genius, the essentials of their [the figures] beings and movements are torn from them and presented in ordered and rhythmical arrangements of the highest technical brevity and beauty.' Her first solo show was held in 1918, and her association with the Leicester Gallery began in 1924. The second phase of her work began when she met Sickert in 1924 and became his third wife two years later. Her work became strongly influenced by his, but both she and Sylvia Gosse (*q.v.*) carried out all the preparatory work on Sickert's paintings as he became older. Although she continued to exhibit, only after his death in 1942, while exposed to the bombing in London did she emerge into independence again.

**Therese Lessore** *Bath*, between 1938–45, oil on canvas, 63.8 × 76 cm, Walker Art Gallery, Liverpool. (photo: John Mills (Photography) Ltd)

*Examples:* Aberdeen; WAG, Liverpool; Manchester; Rochdale; Sheffield.

*Literature:* W. Baron, *The Sickert women and the Sickert girls*, Parkin G, London, 1974; Deep-well; *TL memorial exhibition*, Leicester G, London, 1946; Sellars.

## LEVENTON, Rosie (1949–)

*English sculptor using mixed media to create large-scale constructions and environments*

Leventon trained at Croydon College of Art from 1976 to 1979 before continuing with postgraduate work at St Martin's School of Art, London, for another year. While teaching part-time she has had a succession of group and solo shows since 1981. A number of her works have been based on historical or archaeological finds, but her sculptures are a reworking not a rebuilding. *Souterrain* (1986) derives from the Sutton Hoo burial ship, but distances itself from the anecdotal by poetic and symbolic association. Her references to ancient beliefs and to Shinto ideas derive from an anti-materialist and anti-rationalist philosophy. There is often an intimation of a visual journey, uncovering the layers of meaning as the archaeologist removes the layers of material. She specialises in site-specific sculpture.

*Examples:* Portland Sculpture Park, Portland, Dorset.

*Literature:* M. Garlake, 'The forest: Arnatt, God-win, Rothenstein, L', *Art Monthly*, Oct. 1986, 20–1; I. Winsby, 'RL' *Arts Review*, Aug. 1985, 455.

## LEVICK, Ruby Winifred. (alt. BAILEY) (*fl.* 1894–1921)

*Welsh sculptor of figures, statuettes, many for gardens, and reliefs*

Born in Llandaff, she studied under Edward Lanteri at the South Kensington Schools, a contemporary of an exceptional number of women sculptors there, including Margaret Jenkin (*q.v.*), Evelyn Moore and Gwendolen Lucy Williams (*q.v.*). She won a succession of prizes, including a gold medal in 1897 for a group of wrestling boys, which was at the RA the following year. Another group, of boys fishing (1900), was for sale in 1902 in plaster at ten guineas and in bronze for 25 guineas. Many of her bronze figures and statuettes were cast by J.W. Singer. She specialised in figures in action, including one group of footballers. Her talents soon brought commissions, and she carried out relief panels for several churches and other buildings. She married Gervase Bailey, also an artist.

*Examples:* Chapel of St Edmund, Hunstanton, Norfolk; St Brelade's church, Jersey.

*Literature:* S. Beattie, *The new sculpture*, New Haven and London, 1983; Clement; Mackay; *Mag. of Art*, 1901, 504; D. Martin Wood, 'A decorative sculptor; Miss RL (Mrs GB)', *Studio*, Mar. 1905, 100–7.

## LEWIS, Edmonia. née WILDFIRE. (alt. Mary Edmonia LEWIS) (1845–after 1911)

*American sculptor of figure subjects, particularly those associated with African or Indian themes, in a neo-classical style*

The daughter of a black father and a Chippewa Indian mother, she was probably born in Greenbush, Albany, in New York State. The place and dates of her birth and death vary in the different sources. Until the age of 12 she led a nomadic life, but after her parents died her older brother paid for her schooling in Albany and then for a course at Oberlin College, Ohio (1859–62). In 1863 she travelled to Boston with an introduction to an anti-slavery lawyer who, seeing her fascination with sculpture, introduced her to a local sculptor, Edmund Brackett. After some instruction in technique she proceeded alone, although there is a record of her asking Anne Whitney (*q.v.*), who had a studio in the same building, for some lessons. The sales of copies of a bust she made in 1864 of the leader of the first black regiment in the civil war enabled her to go to Europe, where she visited France and England before settling in Rome. There she joined Hosmer (*q.v.*) and other American women sculptors. Like them she executed portrait busts, including those of the poet Longfellow, and many other eminent Americans. However, her oeuvre differed from theirs because of her dual cultural heritage, and she explored subjects from the *Song of Hiawatha* and from the context of slavery. She also copied famous sculptures, as this was another lucrative aspect of a sculptor's work in Rome. In addition she executed some full-length statues of historical and mythological characters, including a moving depiction of Hagar, about whom Lewis wrote, 'I have a strong sympathy with all women who have struggled and suffered'. She exhibited six sculptures at the 1876 Philadelphia Centennial Exposition. With the fashion for neo-classical sculpture past, her activities are less certain. She returned to America occasionally, but spent most of her time in Rome, where she was last recorded in 1911.

*Examples:* Afro-American History Mus., Boston; grave of Dr Harriet Hunt, Mt Auburn cemetery, Cambridge, Mass.; NMAA, Washington, DC.

*Literature:* Bachmann; *DWB*; D. Driskell, *Two centuries of black American art*, County Mus. of Art, Los Angeles, 1976; Fine, 1978; L. Hartigan, *Sharing traditions: five black artists in nineteenth-century America*, NMAA, Washington, DC, 1985; Heller; *Notable American Women*; Petersen; Rubinstein; E. Tufts, *Our hidden heritage: five centuries of women artists*, New York, 1974; Tufts, 1987.

## LICATA-FACCIODI, Orsola. (alt. FACCIOLI LICATA) (1826–?)

*Italian landscape painter*

This Venetian artist was a popular painter in her own day. She trained in the Venice Accademia, where she won several medals. She married fellow painter Antonio Licata in 1848 and, despite having

several children, continued painting. In 1864 she became a member of the academies of Perugia and Venice; from 1867 she taught at the Royal Institute in Naples. Her style was regarded as vigorous and robust. In addition to landscapes, she also painted interiors of large buildings, especially churches.

*Examples:* Hamburg; Naples; Venice; Vicenza.

*Literature:* Clement; A. Comanducci, *Dizionario illustrato*, 3rd ed., Milan 1966.

## LIJN, Liliane (1939–)

*American-born sculptor exploring light and movement who lives in England*

A New Yorker by birth, Lijn came to Europe in 1955 and studied art history and archaeology in Paris in 1958. Abandoning this, she taught herself to draw and to experiment with sculpture. Back in New York in 1961–2, she made her first works using light and motion. These were followed by kinetic poems made in Paris in 1963–4 and two years in Athens experimenting with natural forces in sculpture. She settled in England in 1966 with her small son by the Greek sculptor, Takis. In due course she had two more children by her partner, Stephen Weiss. By this stage her interest in natural forces, particularly light, was determined. Using fluorescent liquids, she explored 'the reception of light, its reflection, refraction and eventual re-emission'. During the 1970s this interest focused on prisms, which were cut to different shapes, and sometimes set into stone. Her use of natural forces has also led her to study the scientific principles behind them and she has evolved a complex system to mobilise the figures, mainly goddesses, she made for her invited appearance at the Venice Biennale, which are activated by sound waves and incorporate lasers. She has executed some large works for outdoor sites. During the mid-1970s her campaign for more exhibitions of the work of women artists resulted in her being one of five women selectors for the 1978 Hayward Annual.

*Examples:* Bradford; Glasgow; V & A and Tate G, London; forecourt, public library, Norwich; C. Nat. d'Art Contemporain and Mus. de la Ville, Paris; Sheffield; Birchwood Science Park, Warrington, Lancs.

*Literature:* G. Brett, *Kinetic art*, London, 1969; *Hayward Annual '78*, Hayward G, London, 1978 (bibl.); A. Mackintosh, 'The functionalism of art', *Art and Artists*, Mar. 1973; Nottingham, 1982; R.

Parker and G. Pollock, *Framing feminism*, London, 1987.

## LINDEGREN, Amalia Euphrosyne (1814–91)

*Swedish portrait and genre painter*

Unusually for a woman at the time, Lindegren trained from 1845 in the lower school of the academy at Stockholm, the city of her birth, and also won a travel scholarship to Paris in 1849. There she studied with Cogniet and Tissier, after which she visited Munich, Düsseldorf and Rome. She was elected a member of the Swedish Academy in 1856 and was regarded as the foremost woman artist in the country. In addition to her own country, she exhibited in London and was made an honorary member of the SWA. Her paintings of everyday incidents with parents and children were extremely popular.

*Examples:* Göteborg; Gripsholm; Norrköping; Orebro; Oslo; Stockholm.

*Literature:* Clement; I. Ingelman, 'Women artists in Sweden', *WAJ*, v5/1, spring-summer 1984, 1–7; Krichbaum; *Kvinnor som malat*, Nationalmuseum, Stockholm, 1975.

## LION, Flora (1876–1958)

*English painter of figures, portraits, landscapes and flowers*

A Londoner by birth, she trained at the St John's Wood School in 1894 before attending the RA Schools from 1895 to 1899. She followed this with a period at the Académie Julian in Paris under J-P. Laurens. From this time she exhibited actively in London and Paris, but also in America, until 1957. Early reviewers of her work were enthusiastic and foresaw a successful future for her. She gained many portrait commissions from her Salon and RA appearances. Her election to the membership of several bodies followed: the Royal Institute of Painters in Oils in 1909 and a year later the National Portrait Society. In 1915 the Tate Gallery bought one of her paintings and she married, her husband adopting her name. She won the silver and gold medals of the Société des Artistes Français in 1921 and 1949. She also produced prints,

including lithographs and woodcuts, as well as the occasional mural.

*Examples:* British Mus., Imperial War Mus., Tate G and V & A, London.

*Literature:* Deepwell; *Paintings and drawings by some women war artists*, Imperial War Mus., London, 1958; Waters; *Who's Who in Art*; Wood, 1978.

## LITHIBY, Beatrice Ethel (1889–?)

*English painter of landscapes and figure subjects*

The daughter of Sir John Lithiby, she was educated at St Mary's College, Paddington before attending the RA Schools. In 1919 she was awarded an MBE for her war service with the Queen Mary's Army Auxiliary Corps and was also commissioned by the Women's Work Committee of the Imperial War Museum to make drawings of the wartime activities of that service. During the 1920s and 1930s she travelled in Italy, France and Ireland and exhibited her landscapes of those countries in many London galleries, including the SWA. She was elected a member of the Royal Society of British Artists in 1930 and awarded an OBE in 1944. During the 1950s she designed stained glass windows for a number of churches, including Johannesburg cathedral.

*Examples:* Imperial War Mus., London.

*Literature: Paintings and drawings by some women war artists*, Imperial War Mus., London, 1958; Waters; *Who's Who in Art*.

## LLOYD-JONES, Mary (1934–)

*Welsh textile artist and painter*

Born at Devil's Bridge, Dyfed, she studied from 1951 to 1955 at Cardiff College of Art, training as a teacher in her final year. After bringing up her family she began to exhibit in 1966, and has now contributed to many group exhibitions and over 20 solo shows. Beginning as a painter, she began to shift from merely applying paint to canvas to joining shapes of fabric as collage elements. Using ready-made materials, Lloyd-Jones pours, wipes and stains dyes onto pieces of fabric, which are then put together and textured by various means, including quilting, stitching, tearing and pleating. Although her major concern is with the landscape,

she is conscious of the links with traditional women's crafts and domestic tasks. Aware of the threat to the landscape, she produced a series of works in the early 1980s with titles such as *Wounded landscape*. Most recently she has moved away from wall-hangings to assembled pieces of irregularly shaped and dyed calico. She has completed several commissions for wall-hangings, has taught part-time and been employed as visual arts officer for Dyfed.

*Examples:* New Ely branch library, Cardiff; Cork; Library Arts Centre, Wrexham.

*Literature:* K. Dunthorne, *Artists exhibited in Wales, 1945–74*, Cardiff, 1976; *Out of isolation*, Library Arts Centre, Wrexham, 1985.

## LOEBER, Lou (1894–1983)

*Dutch painter in a geometric style close to De Stijl*

Loeber was the oldest of seven children of an Amsterdam paper dealer. Her father was also interested in art and would take his daughter to visit artists' studios and exhibitions, so there was no opposition to her decision, initially made at the age of nine, to become an artist. Indeed her father built her a studio in their garden before she enrolled at the Academy in Amsterdam in 1915. Her studies were terminated a year early in 1918 because her tutors would not support her independent explorations away from the canons of academic art. A charcoal self-portrait of 1918 already showed her inclinations towards simplification and abstraction, a tendency which became more manifest after 1920. Painterly qualities were eliminated in favour of an impersonal surface. Initially she retained recognisable subjects represented in a stylised geometrical form, but from the mid-1920s she also produced total abstractions. At the beginning parallelograms dominated the compositions, but later paintings place more emphasis on verticals and horizontals. In common with Mondrian and the other De Stijl artists she sought to express her spiritual ideals through art. An ardent pacifist and socialist, she believed that abstract forms were particularly suitable for the expression of spiritual ideas, notions which place her with the Russian Constructivists and the Bauhaus artists.

*Examples:* Graphothek, Berlin.

*Literature: Das Verborgene Museum*; *LL Ölbilder der 20er Jahre*, G. Brockstedt, Hamburg, 1973; *LL,*

*1894–1983, schilderijn, antwerpen en printen*, Mus. Commanderie van Sint-Jan, Nijmeegs, 1983.

## LONGMAN, Evelyn Beatrice (1874–1954)

*American sculptor of figures, monuments, reliefs and portraits in marble and bronze*

An outstandingly successful sculptor, she came from a family of six children near Winchester, Ohio. Her father was a poor musician and so, after rudimentary schooling, Longman was working full-time in Chicago by the age of 14. At the same time she attended evening classes at the art institute there and was inspired by the 1893 Exposition. Saving for six years enabled her to enrol at Mount Olivet College in Michigan, but after 18 months there she returned to Chicago in order to study under Lorado Taft. After graduating with highest honours in 1900, she worked in New York to assist MacNeil and Konti with decorations for the 1901 Buffalo Exposition. This led to a meeting with Daniel French, and she became the only female assistant he ever had. She then opened her own studio and scored a series of major successes. Her *Victory* for the St Louis Exposition of 1904 was placed on top of the central building. Two years later she won the competition for the bronze doors of the chapel of the US Naval Academy. Her style of a decorative but essentially classical approach was ideally suited to public sculpture of the time. Her best-known sculpture was the *Genius of Electricity* (1914–16), originally installed on top of the AT & T building in Manhattan (now in the vestibule of their new building there), and reproduced on the cover of all American telephone directories. In addition to monumental allegorical works at major expositions, which included collaborating with the famous architect, Henry Bacon, Longman also carried out portraits, including one of Thomas Edison. From about 1915 she began to execute figures which personified her conception of universal themes, and these brought further awards, including election as the first woman to be a full member of the National Sculpture Society. In 1920 she married Nathanial Batchelder, a head teacher in Windsor, Connecticut. Despite her standing, she moved her studio there and received many commissions for war memorials and other monuments in that state. She also carried out several friezes under one of the government art projects in 1933. Well known for her hard work and technical skill, she is said to have finished off all her marble sculpture herself after they had been roughed out by the carvers, a practice which was most unusual then. Her draughtsmanship is confident and vigorous. She retired to Cape Cod with her husband in 1949.

*Examples:* Brookgreen Gardens, SC; J. Herron Art Inst., Indianapolis; Metropolitan Mus., New York; NMWA, Washington, DC.

*Literature:* M. Hill, *The woman sculptor: Malvina Hoffman and her contemporaries*, Berry-Hill G, New York, 1984; NMWA catalogue; Proske, 1968; Rubinstein; L. Taft, *History of American sculpture*, New York, 1903; Tufts, 1987.

## LOUISE CAROLINE ALBERTA, (Princess). (alt. DUCHESS of ARGYLL) (1848–1939)

*English sculptor and watercolour painter*

The eighth child of Queen Victoria, she was, like all the royal princesses, actively encouraged to

**Princess Louise** *Portrait of Princess Amelia of Saxe-Coburg and Gotha*, 1869, plaster, 45 cm high, Royal collection. (Reproduced by gracious permission of Her Majesty the Queen)

paint. Louise was probably the most talented and dedicated of them all, and the only one to learn sculpture, which she did from Sir Edgar Boehme and Susan Durant (q.v.). She executed portrait busts, including a self-portrait, and figures, several of which she presented to her mother as Christmas presents. Her most public work is a statue in Kensington Gardens, of her mother as a young monarch, which was carried out in the 1890s. She married the Marquis of Lorne, later Duke of Argyll, who was a writer. During his term of office as Governor-General in Canada from 1878 to 1883 they actively participated in the arts, helping in the foundation of the Canadian Academy, whose collection of paintings formed the basis of the later National Gallery of Canada. Princess Louise exhibited her works in Canada as well as in London and Edinburgh, and in the Exposition Chicago in 1893.

*Examples:* Kensington Gardens and Nat. Portrait G, London.

*Literature:* Clayton; Clement; *DNB*; M. Elliott; B. Read, *Victorian sculpture*, London, 1982; J. Wake, *Princess L: Queen Victoria's unconventional daughter*, London, 1987.

## LOW, Bet (1924–)

*Scottish painter of semi-abstract landscapes and an active promoter of contemporary art in Scotland, particularly during the 1960s*

Born in Gourock, Low was one of the few wartime students at Glasgow School of Art to achieve the qualification in three years intead of the usual four. Ignoring family pressure to teach, she joined the newly founded Glasgow Unity Theatre, where she not only painted scenery, but also drew the actors. Her work from the immediate post-war years was based on people, and in many cases could be regarded as socially critical. Influenced at this stage by the German Expressionists and by Georges Rouault, she produced prints and glowing landscapes. At the end of the war she married another painter, Tom MacDonald, and with him participated in an Artists for Peace exhibition in Poland. Exhibiting with independent groups, some of which had left-wing political views, she was also instrumental in organising Glasgow's first open-air art show, and from 1963 to 1968 she was the chief founder and organiser of the Charing Cross Gallery, the first in Glasgow to be devoted to contemporary art. It acted not only as a show-case, but also provided a meeting place for artists. Throughout all this Low maintained her own artistic production and adopted landscape as her main motif, represented in an increasingly abstract form. Her discovery of Orkney in 1967 and, some years later, of the Hebrides, provided her with a regular summer base, for the combination of the summer light, the aurora borealis, and differing weather conditions formed the catalyst for her work up to the present day. Visits to other parts of Scotland, such as the islands of Rhum and Eigg, which inspired the late work of Winifred Nicholson (q.v.), brought about the evolution of her technique of working with pencil in a way which was closer to painting than drawing. Her palette is dominated by subtle shades of blue and green, with which she produces simplified equivalents of the original impression.

*Literature:* C. Oliver, *BL: paintings and drawings, 1945–85*, Third Eye Centre, Glasgow, 1985.

## LOW, Mary. née FAIRCHILD. (alt. MACMONNIES) (1858–1946)

*American painter of landscapes, figures and portraits*

Born in New Haven, Connecticut, she was the oldest of three children. After the civil war years, spent in New Orleans, the family moved to St Louis, where Fairchild, a gifted pianist, reluctantly became a school teacher to assist with the family finances. She discovered painting by chance when helping her mother to colour some photographs. Her mother had developed miniature painting as a hobby and now encouraged her daughter to attend classes at the university. Enrolling full-time from 1882, Fairchild led a successful deputation to the director requesting a life model for women students. That same director created a scholarship for her, which enabled her to study in Paris from 1885 to 1888, where she enrolled at the Académie Julian and worked in the atelier of Carolus-Duran. Her first painting was accepted at the Salon of 1886, and thereafter she exhibited regularly. In 1888 she married the as yet undiscovered sculptor, Frederick MacMonnies, and in the early days they survived on Mary's orders for old-master copies. Salon success in 1889 relieved the situation, and Frederick began his almost yearly visits of two or three months to New York in order to seek commissions. Mary continued to paint daily, and met the painter, Puvis de Chavannes, who admired her work. Through copying some Botticelli frescos

she was given the commission for one of the two major murals for the Women's Building in the 1893 Chicago Exposition, the other mural going to Cassatt (*q.v.*). This panel, together with her other paintings shown in Chicago, brought her international recognition. From 1894, the Macmonnies rented a house in France at Giverny for the summer, where Monet and other artist friends had settled and from 1898 they lived there permanently. Two daughters were born in 1895 and 1897, and their childhood is recorded in true Impressionist style, with brilliant colours freely handled, conveying a true sense of spontaneity. In 1909 Frederick and Mary ended their part-time marriage, and in November Mary married Will Low, an academic mural painter. Two months later they returned to America with her daughters, but because of their financial situation Mary Low was constrained to execute largely portraits. Low interfered with her work in various ways, and her painting lost its joyfulness, becoming tighter. Nevertheless, her prodigious skill as a portraitist kept her in the public eye. Both daughters trained at the NAD before they married.

*Examples:* St Louis; Terre Haute, Ind.

*Literature:* Archives of American Art, Washington, DC; Clement; M. Elliott; *Fair Muse*; Rubinstein; M. Smart, 'Sunshine and shade: MFML', *WAJ*, v4/2, fall 1983-winter 1984, 20–5; Weimann.

## LOWENSBURG, Verena (1912–)

*Swiss geometrical abstract painter*

Born in Zurich, she studied in Basle before enrolling at the École Moderne in Paris. She joined the Abstraction-Création group, which embraced the various non-figurative styles in France at the time. Her precise geometrically orientated art depended on colour as its crucial element, and Lowensburg became associated by critics and by other artists such as Kandinsky with the style known as Concrete Art, following the definition propounded in 1930 by Van Doesburg. Although she based her composition on visual perception, the relationship between objects and their relative sizes was governed by mathematical principals of proportion and ratio. From 1936 she participated in many exhibitions over succeeding decades throughout Europe.

*Literature:* W. Rotzler, *VL*, G Karin Fesel, Wiesbaden, 1977; Vergine.

## LUCANDER, Anitra Maria Ingeborg (1918–)

*Finnish painter and graphic artist working on the boundaries of abstraction*

After study at the Free Art School, Helsinki, Lucander spent some time travelling in Europe. Her recorded work begins in 1950 with her first exhibition, and during the following decade she produced paintings and collages based predominantly on still lifes. In the 1960s her work became more abstract, her pictures, some more suggestively figurative than others, dissolving into atmospheric studies with soft blurred edges in subtle tones of blue, green and grey. These lyrical abstractions gained her a number of awards and she exhibited internationally, including in the USSR and China. Her commissions include murals in a Helsinki primary school.

*Example:* Helsinki.

*Literature:* J. Boulton-Smith, *Modern Finnish painting*, London, 1970.

## LUCE, Molly (1896–1986)

*American Scene painter*

Born in Pittsburgh, she spent a happy childhood in Pennsylvania and New Jersey. Most of her life was spent in New England. After two years at Wheaton College, Norton, Massachusetts, she arrived at the Art Students' League, New York in 1916, studying there for most of the next six years. Her most influential teacher was Kenneth Hayes Millar. Nine months spent in Europe in 1922–3 were a revelation, giving her a different perspective on America; it enabled her to fuse together style and content in a coherent manner and to develop a sense of place that was more than simply descriptive. These works were exhibited in her first solo show, held at the Whitney Studio Club, established by Gertrude Whitney (*q.v.*), and were well received. One reviewer, Alan Burroughs a painter and historian and son of the curator of paintings at the Metropolitan Museum, introduced the term 'American Scene' with reference to her work. Through this encounter Luce and Burroughs were married in 1926, although Luce always used her own name professionally. Burroughs' work as a conservator at the Fogg Art Museum in Harvard took them to Europe later that year for several months, and on their return Luce's style had become bolder and more geometric, so that in

some works there is a feeling of Precisionism. By 1929 she had found her mature style, although within this there were variations. In the 1930s she tended to depict vast panoramas, with New England scenes in the foreground, which brought her the title 'the American Breugel'. Nevertheless there are themes in her work which demonstrate that she was painting from her experience as a woman. Two of the most interesting are *Allegory – life of the artist* (1932) and *Fortieth birthday* (1950). She was extremely successful, working for at least four dealers in the 1930s. The single figure, still with the landscape background, dominated many of her paintings from the 1940s, but this gave way to the use of a large single plant, bird or animal, and later still to the landscape seen through a screen, often of plants. There are fantastic elements in her work from the 1920s, but some of the paintings from the 1950s could be classed as wholly surreal. Much of her later work was done at her home in Little Compton, Rhode Island, and identity with a particular place is conveyed to the spectator. After 1950, her kind of painting became unfashionable and although she continued to paint until nearly 90, she only exhibited locally until she began to receive restrospectives from the late 1970s, when the change in taste allowed her reinstatement.

*Examples:* Metropolitan Mus. and Whitney Mus., New York; Carnegie Inst., Pittsburgh.

*Literature:* ML, School of Design, RI, 1979; *ML: eight decades of the American Scene*, Childs G, Boston, Mass., 1980; Tufts 1987.

## LUGOSSY, Maria (1950–)

*Hungarian sculptor of abstract, geometrical works in metal and glass*

Lugossy trained as a goldsmith at the Academy of Applied Arts in her native Budapest and pursued postgraduate studies between 1973 and 1975. Soon after this she began to produce medallions and small geometric sculptures in polished metal. By incorporating the reflective qualities of the metal into the compositions, she obtained, through the careful arrangement of positive and negative shapes, an enriching of the final effect. Since then she has preferred to use perspex and glass because of the potential of the transparency, and during the 1980s has gradually introduced organic elements into her work, although retaining a geometrical framework. Her sculpture has been awarded

several prizes and she has exhibited internationally since 1973, including a series of solo shows.

*Literature: Contemporary visual art in Hungary*, Third Eye Centre, Glasgow, 1985; J. Frank, 'Charm, irony, drama', *New Hungarian Quarterly*, v70, 1977; J. Frank, 'Motion, space, kinetics', *New Hungarian Quarterly*, v85, 1982; T. Mullaly, *ML*, Goldsmiths Hall, London, 1984.

## LUNDEBERG, Helen (1908–)

*American painter of a classical figurative style known as Post-Surrealism and hard-edge abstract works*

The elder of two daughters of second-generation Swedish Lutheran parents, Lundeberg was born in Chicago, four years before the family moved to California. Her mother's innate artistic sense was revealed through the clothes that she made and her father painted as a young man. Money was short because of the Depression, but a family friend paid for Lundeberg to attend art classes for three months in 1930. At the end of that time Lorser Feitelson took over the class, and money was found for her to continue her studies. Feitelson was a pioneer American modernist who had lived in Paris and known the Surrealists, but he also believed in studying Renaissance painters. Lundeberg exhibited her first work in 1931, and by 1933 she and Feitelson were together propagating their own version of Surrealism. Based more on the precise style of Magritte and Dali, it eliminated all additions by chance or automatism. Everything was logically planned but was metaphysical in the way in which it allowed for symbolism and the creation of an ambiguous atmosphere, as in a major work *Double portrait of the artist in time* (1935). This movement was called New Classicism by the artists when they issued a manifesto in 1934, but it was also known later as Post-Surrealism. Between 1933 and 1941 Lundeberg was employed on various government art projects, including several murals. During the 1950s her paintings, in which the subject was frequently space itself became increasingly abstract. By the end of that decade others were calling her work hard-edge, and it was included in several exhibitions of that style. She moved on to broad views of landscape, although never painted from nature. Initially she incorporated arches, a motif reminiscent of Giorgio de Chirico. Her colours became stronger and the scale larger, until one work was four metres wide. During the seventies she continued to explore the

imagined landscapes, without the arches, at the same time evolving a series based on her interest in astronomy and the cosmos, and exploring still lifes of recognisable objects in a dream-like setting. Until his death in 1978, Lundeberg worked with Feitelson, whom she had married, but a joint retrospective in 1980 revealed how each had evolved their own type of Post-Surrealism.

*Literature:* Heller; D. Moran, *HL: a retrospective*, Municipal Art G, Los Angeles, 1979; D. Moran, *Lorser Feitelson and HL: a retrospective*, MOMA, San Francisco, 1980; Munro; Rubinstein.

## LUNDGREN, Tyra (1897–1979)

*Swedish painter, sculptor and ceramicist*

She was an international artist in the sense of travelling and training in many European countries. Never marrying, she was free to go where she chose. She studied painting and sculpture initially in her own country, before working with the *Valori Plastici* group of painters in Rome, designing glass in Finland, Germany and Venice, and working in porcelain factories in Finland and at Sèvres in France. Unable to travel during World War II, she was allowed to work at the Gustavsburg factories in Sweden, for by now she was concentrating on larger stoneware sculpture and ceramic reliefs for the decoration of public buildings. During the 1940s and 1950s she carried out 13 polychrome stoneware reliefs, including one entitled *Famous women*, in a Stockholm girls' school. She exhibited extensively in both group and solo shows. In her last retrospective in 1978 a group of 15 self-portraits, previously unexhibited owing to self-doubt, was shown. Yet she was in every respect an extremely successful artist.

*Literature:* I. Ingelman, 'Women artists in Sweden', *WAJ*, v5/1, spring-summer 1984, 1–7; *TL: a life in art*, Swedish Academy of Fine Arts, Stockholm, 1978.

## LUZANOVSKI-MARINESCO, Lydia (1899–?)

*Russian sculptor of portraits, figures, groups and medals*

Born in Kiev, she studied at the School of Fine Arts in Bucharest and won the first prize for sculp-

ture in Romania's official Salon in 1924. She then proceeded to Paris, working under Bourdelle at the Académie de la Grande Chaumière and under Zadkine. She exhibited in Paris at the various salons and was represented by the Galérie Zak. Some of her works were allegorical (*Love*), others more realistic (*the Guitar Player*).

*Literature:* Edouard-Joseph; Mackay.

## LYDIS, Marietta. née RONSPERGER (1894–?)

*Austrian-born painter, engraver and illustrator who worked in Paris*

This Viennese artist was entirely self-taught. As a young woman she travelled extensively in Europe, the Middle East, America and Russia, spending a period of several years in Italy and Greece. These experiences gave her a visual repertoire but she lacked a language with which to express them. In her early works (1923–7), which included illustrations for the Koran and for books on Russia and Morocco, she tended to borrow an oriental style, enjoying the freedom of imagination which this allowed and accepting the constraints of stylisation. After she had settled in Paris in 1927, her style became more independent, and from this period came many of her representations of young girls and women. These representations in various media encompass series of innocent children criminals, prostitutes and lesbians. In this last series she challenged existing notions of the lesbian stereotype by showing them as ordinary human beings. By 1929–30 her style became simplified, relying on the use of line to create the form, and her colour became fresher and brighter. A series of *Madonna and Child* pictures paralleled large female nudes, some with allegorical or mythological titles, but none was anecdotal in its content. It was only at this stage of her career that she could bring herself to work with a model, but she found the experience rewarding psychologically as well as artistically. She exhibited extensively, published editions of her prints, and illustrated many books. Her prolific output in varied media soon brought her a considerable reputation.

*Examples:* Stedelijk Mus., Amsterdam; Uffizi and Gabinetto dei Disegni e Stampe, Florence; Mus. d'Art et d'Histoire, Geneva; British Mus. and V & A, London; Castello Sforzesco, Milan; Mus. d'Art Moderne de la Ville and Bibliothèque Nat., Paris; Utrecht; Albertina, Vienna.

*Literature:* Edouard-Joseph; *ML*, Leicester G, London, 1935; H. de Montherlant, *ML*, Paris, 1938.

## MACDONALD, Frances. (alt. MACNAIR) (1874–1921)

*Scottish designer and painter of figures and portraits*

One of two artistic sisters born in Kidsgrove, Staffordshire. In 1890 the family moved to Glasgow, which enabled Frances and her sister Margaret (*q.v.*) to attend the Glasgow School of Art as day students. Under the guidance of the principal, Francis Newbery, and his wife Jessie, who was a designer and embroiderer, the sisters had by 1895 established themselves as designers. They produced a range of objects using a variety of materials, from embroidered hangings to *repoussé* metal panels and clocks. They shared a studio which became a centre for artists and writers, including their contemporary Jessie King (*q.v.*). In 1895 Francis Newbery introduced the sisters to two fellow-students because of the similarity of their work. For the next four years Frances and Margaret MacDonald collaborated with Charles Rennie Mackintosh and Herbert MacNair on certain works, but the exchange of ideas provided a stimulating environment for all members of 'The Four'. The collective approach ended in 1899 when Frances married Herbert and they moved to Liverpool, separating the two sisters for the first time. Frances MacNair taught embroidery at the Liverpool Art Sheds from 1900 until 1909, when she returned to Glasgow to teach until 1911. In the late 1890s the female figures in the works of both Frances and Margaret were emaciated, even savage, but after 1900 the style became rounder and more tranquil. Their designs were more popular in Europe than in England until about 1905, after which few records exist. After the sudden death of Frances MacNair following a stroke, her husband destroyed much of her work.

*Examples:* Glagow; WAG, Liverpool.

*Literature:* A. Callen, *The Angel in the Studio*, London, 1979; J. Gear, 'Trapped women: two artist designers, Margaret and Frances MacDonald', *Heresies*, v1, winter 1978, 48–51; J. Gleeson-White, 'Some Glasgow designers and their work', *Studio*, v11, 1897, 86–100; *The last romantics: the romantic tradition in British art. Burne-Jones to Stanley Spencer*, Barbican G, London, 1989; Nottingham 1982; Sellars; *Studio*, v9, Dec. 1896, 202–3.

## MACDONALD, Margaret. (alt. MACKINTOSH) (1865–1933)

*English watercolour painter and designer*

The eldest daughter of John MacDonald of Chesterton Hall, Staffordshire, she was the sister of Frances (*q.v.*). The two sisters remained close throughout their period of training and together established themselves as designers in Glasgow. In 1896 'The Four', consisting of Frances, Margaret, Charles Rennie Mackintosh and Herbert MacNair, were invited by the Arts and Crafts Society to exhibit in London. The angular shapes and intense representations of women were not well received by a capital familiar with the innocuous forms of Walter Crane. However, from 1899 to 1905 there was considerable interest in their work from the continent, particularly in Vienna, where they were invited to furnish a room at the 1900 Secession exhibition. Two years later the work of 'The Four' found ready purchasers at the Turin International Exhibition of Decorative Art. Many articles, reviews and illustrations of their work appeared in journals. In 1900 Margaret MacDonald married Charles Mackintosh and began a period of collaboration with him. Scottish patrons for their version of Art Nouveau diminished from 1905, after which no illustrations of Margaret's work can be found. The detrimental effect of marriage on the careers of both Frances and Margaret is clear.

*Examples:* Glasgow.

*Literature:* See under Frances MacDonald.

## McEVOY, Mary Spencer. née EDWARDS (1870–1941)

*English painter of portraits, flowers and interiors*

The daughter of an army colonel, she was born in Freshwood, Somerset. She was a contemporary of Augustus and Gwen John (*q.v.*) at the Slade in the 1890s, and it was there that she met Ambrose McEvoy, whom she married in 1902. She exhibited from 1899 to 1910, when she seems to have ceased painting, but resumed work again on her husband's death in 1927, exhibiting until 1937. She showed her works at a wide range of venues, including both the RA and NEAC, the Women's International Art Club and the Salon in Paris, as well as having solo shows in London during both periods of her career.

*Examples:* Dublin; Tate G, London; Salford; Southampton.

*Literature:* Deepwell; Waters; *Who's Who in Art*; Wood, 1978.

## MACGREGOR, Jessie (1846/7 – 1919)

*English painter of historical and genre scenes*

Born in Liverpool, she came from an artistic family and was taught by both her mother and her grand-father before she began her formal training at the Royal Cambrian Academy. She proceeded to the RA Schools in 1870, where, two years later, she became only the second woman to win the medal for history painting. She began exhibiting in 1872 and, returning to her native city, had a studio built. There she produced a series of dramatic scenes taken from the Bible, literature, history and mythology, together with numbers of portraits

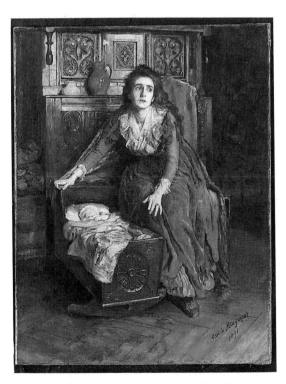

**Jessie MacGregor** *In the reign of terror*, 1891, oil on canvas, 92 × 72 cm, Walker Art Gallery, Liverpool. (photo: John Mills (Photography) Ltd)

under the guise of a mythological figure. These she exhibited until 1904 at the RA, SWA, Birmingham, Glasgow, Manchester and Liverpool. She also lectured on art, especially that of Italy, under the auspices of the Victoria University extension scheme, which involved considerable travel. Late in her career she began to work as an illustrator. She died in London.

*Examples:* WAG, Liverpool.

*Literature:* Clement; P. Nunn, *Victorian women artists*, London, 1987; Waters; Yeldham.

## McGUINESS, Norah (1903 – 1980)

*Irish painter of landscapes, and chair of the Irish Exhibition of Living Art from 1944*

Born in Londonderry, she studied at the Metropolitan School of Art, Dublin, and spent a short period at the Chelsea School of Art in London. Initially she worked as an illustrator, and it was only in the late 1920s that she decided to become a painter. In later years, she continued to produce illustrations because of the financial security they provided, but regarded painting as her main occupation. In 1929 she travelled to Paris to work with Lhote, as her friend, Mainie Jellett (*q.v.*), had suggested. In contrast to Jellett, McGuiness did not find his tuition of great help. During the 1930s she lived mostly in London and America, although she had her first solo exhibition in Dublin in 1936. Her paintings of these years consist of broad brushstrokes, the direction of which sets up the parameters of the composition. Producing chiefly landscapes and still lifes, and using a narrow range of colours, she determines relationships by tone. Details are eliminated and the pictures convey a sense of spontaneity. Settling in Dublin in 1939, she established a regular pattern of exhibiting. On the premature death of Jellett, McGuiness was elected chair of the Irish Exhibition of Living Art, which had been established only the previous year. It was the main venue for avant-garde art in Ireland until the later 1950s, and still exists, although McGuiness' involvement lasted into the 1970s. Outspoken and efficient, she acted as a spokesperson for contemporary art and continuously supported young artists. For a time, her painting tended to follow a predictable format, but after 1970 the introduction of a much brighter palette, notably white and a brilliant orange, reinvigorated her late work.

*Examples:* Belfast; Coventry; Hugh Lane Municipal G, Dublin.

*Literature: Irish women artists.*

## MACIAN, Fanny. née Francis Mathilda WHITAKER (1814–97)

*English painter of historical, literary and allegorical genre scenes; also Superintendent at the Female School of Art, London*

By the time she was appointed superintendent of the newly founded Female School of Design in London in 1842, MacIan was already an established painter. It is not known with whom she trained, but she was exhibiting by 1835, and during the 1840s she produced a series of highly acclaimed paintings of literary subjects which rivalled those of Setchell (*q.v.*). She was one of the first artists to depict the allegorical scenes which became so popular in the 1850s. Many of her paintings show women as their main characters; *Captivity and liberty* (1850) contrasted the imprisonment of two female gypsies and their children with the freedom of a bird. Her position as head of the Female School of Design therefore provided students with a strong role model. Under her tuition the standard of work produced by the students had so markedly improved that by 1847 the Female School was winning many of the prizes also open to the men's School of Design. The situation became so acute that a second set of prizes was introduced in order to save embarrassment to the male students. MacIan had insisted that potential pupils show the need to be able to provide themselves with an income. In this way, at least until 1852, when Henry Cole became director, middle-class girls merely seeking an accomplishment were excluded. The forcefulness which critics noted in her art was required in MacIan's dealings with the management committee which took over direction of the school in 1847. Callen points to indications of hostility towards the Female School over a period of years, in part because of its conspicuous success under MacIan and the equally obvious failure of the men's school. MacIan defended the Female School against the imposition of a restrictive curriculum thought suitable for female students. During the 15 years until her retirement in 1857, she not only continued to exhibit but also nursed her increasingly ailing husband, the painter Robert MacIan, until his death that year. She was given an annual pension of £100. There are no details about the later part of her life.

*Literature:* A. Callen, *The Angel in the Studio,* London 1979; D; Cherry, *Painting women; Victorian women artists,* Art G, Rochdale, 1987; Nottingham, 1982; P. Nunn, *Victorian women artists,* London, 1987; Wood, 1978; Yeldham.

## MACIVER, Loren (1909–)

*American independent semi-abstract painter*

MacIver was essentially a self-taught artist, her entire instruction consisting of having attended Saturday classes at the local Art Students' League, New York, from the age of ten. She adopted her mother's surname, which the latter had retained on marriage. MacIver married a former school-friend, the poet Lloyd Frankenberg, when she was 20, and some of her earliest paintings derived from their summer visits to Cape Cod, where they built themselves a house from driftwood. She was always inspired by ordinary things around her, whether in rural or urban situations, and she transformed these in various ways depending on her reaction to them. Because of this her style varies quite widely but is never derivative. Her colour is usually high key, but she obtains unusual effects by staining and other techniques. From 1936 to 1939 MacIver worked on government art projects and through these came to the notice of curator Alfred Barr at MOMA, New York. Her first solo show was held at the East River Gallery. In the 1940s she enjoyed considerable success with her now predominantly urban, and frequently broken or tattered subjects, and was thus able to undertake an extensive visit to Europe with her husband, which in turn provided her with further material. Following this she became particularly interested in reflections from the lights of New York on wet surfaces and the irridescent effects she could create. Her work is often described as poetic and dreamlike, but she uses many approaches and is one of the few genuinely independent artists of this period.

*Examples:* Detroit; Newark, NJ; Metropolitan Mus. and MOMA, New York; Hirschhorn Mus., Washington, DC.

*Literature:* Harris; D. Miller, *Fourteen Americans,* MOMA, New York, 1946; Petersen; Rubinstein; Withers, 1979.

## McKEOGH, Aileen (1952–)

*Irish sculptor who constructs landscape reliefs from a variety of materials*

After graduating from the National College of Art and Design in Dublin in 1976, McKeogh pursued her postgraduate work at Southern Illinois University, gaining her MFA in 1981. At this point her concern with the land showed itself in installations and larger sculptures. Her more recent relief sculptures are usually small in scale and extremely detailed. They reveal what happens below the surface of the earth as well as above, and demonstrate that the landscape is an interdependent system. In keeping with these ideas, the artist uses wood, together with found objects and natural materials. She has exhibited since 1976.

*Example:* Belfast.

*Literature: Irish women artists.*

## MACKINTOSH, M. See MACDONALD, Margaret

## MACMONNIES, M. See LOW, Mary

## MACNAIR, F. See MACDONALD, Frances

## MAMMEN, Jeanne (1890–1976)

*German painter, engraver and illustrator of Berlin society in the 1920s, particularly of lesbian themes*

Although she was born in Berlin, her wealthy family moved to Paris when she was five. In 1906 she enrolled at the Académie Julian, and later the École des Beaux-Arts. After attending classes in Rome in 1911, she began to exhibit watercolours in 1914. During World War I her family property was confiscated and she fled to Holland and thence to Berlin, where she arrived penniless. Taking a series of jobs she continued to draw and paint. After the war she shared a studio with her sister Adeline and began to obtain work for magazines. Her most productive period from 1924 to 1933 focused on the representation of woman as part of Berlin society in the 1920s. This varied from work for fashion and satirical magazines to that for homosexual and lesbian journals, as well as her own watercolours, many of which draw their subjects from the lesbian sub-culture of Berlin. She also produced posters and other material for lesbian clubs. In 1930 she was commissioned to carry out ten colour lithographs on *Variations of lesbian love* for the book *Lieder der Bilitis* by Pierre Louys. The project was banned by the Nazis in 1933, and during the war much of her work was destroyed. She herself escaped prosecution by leading a nomadic existence within Germany. After World War II she painted cabaret scenery in Berlin and joined a gallery group. During the 1950s her work became abstract, and her last exhibition was held in 1975.

*Examples:* Berlinische G and Nat. G, Berlin.

*Literature:* Cooper; *Das Verborgene Museum*; Vergine.

## MANCOBA, Sonja Ferlov (1911–)

*Danish abstract sculptor with a strong social philosophy*

Born in Copenhagen, she began training at the age of 19 with Hoyer, and in 1933 enrolled at the Academy for two years. Having had her first solo show, she subsequently went to Paris, where she attended the École des Beaux-Arts in 1937–8. Her sculptures are often almost symmetrical and she works intensively with convex and concave shapes. Her fascination for African art led her to base works on masks and this became a characteristic of Danish abstract painting, of which the Cobra movement was an offshoot, especially during World War II. In 1942 she married the black South African painter Ernest Mancoba. She always had very clear ideas about the relationship which should exist between art and society, and her dominant thoughts during the production of each work are revealed in titles such as *Resistance, Concentration*, and *Élan vers l'avenir*. She has exhibited extensively.

*Examples:* State Mus., Copenhagen; Holstebro; Silkeborg; Moderna Mus., Stockholm.

*Literature: Cobra, 1948–51*, Mus. Boymans van Beuningen, Rotterdam, 1966; U. Harder, *SFM*, Maison du Danemark, Paris, 1970; R. Olsen, *SFM* Copenhagen, 1971.

## MANGILLANI, Ada (1863–?)

*Italian painter of mythological, religious and historical genre scenes*

A Florentine by birth, Mangillani trained with Amos Cassioli. Her talent emerged early, for in 1879 at the age of only 16, her design for two figures to be executed in mosaic on the left door of Florence cathedral was very well received. Continuing to exhibit from this early age, she became famous for her brightly coloured scenes of Pompeian life, which gained her exhibitions in several European countries. The two gold medals she won were for a mythological and a religious painting. She also had considerable musical and literary gifts. She was married to Count Francesetti di Merzenile.

*Example:* Ferrara.

*Literature:* Clement; A. Comanducci, *Dizionario illustrato*, 3rd ed., Milan, 1966.

## MARAINI, Adelaide. née PANDIANI (1843–?)

*Italian sculptor of figures, portrait busts and reliefs*

Born in Milan, she was the daughter of sculptor Giovanni Pandiani, who was her only teacher. She subsequently based herself in Rome, where she produced a series of works, and exhibited in Italy and France from 1870. For a time she also worked in Lugano. Her *Sappho* was received with critical acclaim in Paris in 1878 and later the same work won her a gold medal in Florence. She carried out a number of funerary monuments and reliefs of religious scenes. She married an engineer, Clement Maraini, who died in 1905.

*Examples:* Protestant Cemetery, Florence.

*Literature:* Clement; Mackay.

## MARCELLO. (pseud. of the DUCHESS OF CASTIGLIONE-COLONNA) née Adele D'AFFREY (1836–79)

*Swiss-born sculptor of mythological and historical figures together with portrait busts; also a painter*

Born in Freibourg, she studied drawing with Dietrich and Fricero in Nice and sculpture with Imhof in Rome in 1844–5. She married an Italian duke and adopted her pseudonym when she began to exhibit in the early 1860s in order that her work might be judged on its merits. Working in bronze, marble and wax, she produced several dramatic works, including an early manifestation of the *femme fatale*, *Pythia* (c. 1870), who transmitted the messages from the oracle at Delphi. By aesthetic choice Marcello was French; she knew Degas and Morisot (*q.v.*) and exhibited at the Salon in Paris from 1863 to 1876. She also showed her work in Rome, Nice and at the RA in London. Despite her relatively short career she has been called one of the most important women sculptors of the nineteenth century.

*Example:* Philadelphia.

*Literature:* Clement; M. Gerstein, 'Degas' fans', *Art Bulletin*, v64, Mar. 1982, 106; H. Janson, 'Rodin was not the only one', *Portfolio*, v2, Sept.–Oct. 1980, 40–5 (response in Letter to the Editor by A. Comini in v3, Jan.–Feb. 1981, 4).

## MAREVNA. (alt. Marea MAREVNA; pseud. of Maria VOROBIEFF) (1892–1983/4)

*Russian-born figurative painter whose style was based on synthetic Cubism*

Born in Ceboskari, she was the illegitimate daughter of a Jewish actress, whose name she took, and a Russian noble, and at the age of two was adopted by a Polish aristocrat. Much of her childhood was spent in the Caucasus, where she was surrounded by evidence of Byzantine culture. At the age of 15 she enrolled at the Academy in Tbilisi and three years later settled alone in Moscow, where she attended the School of Decorative Arts and the Free Academy. Having encountered French art there, she travelled to Western Europe and began the nomadic existence which was to characterise the rest of her life. In 1911 she was a guest in Capri of Maxim Gorky, who gave her her pseudonym, but the focal point of her travels was Paris. Arriving there in 1912, she studied at the Académie Colarossi and the Russian Academy, which was frequented by artists such as Orloff (*q.v.*), Zadkine and Lipchitz. During World War I she lived with Diego Rivera and in 1919 had a daughter, whom she kept when Rivera returned to Mexico in 1921. After the death of her adoptive father in 1914 she was obliged for financial reasons to become an interior designer. Nevertheless she exhibited at the Salon des Indépendants from 1913 works which

domonstrated her own version of synthetic Cubism. Her subjects were almost all figures which she broke down into broad, brightly coloured, geometric planes. From 1920 she became better known and had a solo show in 1929, by which time her style had turned more towards the Post-Impressionist sources of Cubism. After 1945 she was based in London and wrote her autobiography. In the 1960s, when she travelled a good deal, she painted portraits of her Parisian friends of the 1920s. A succession of solo shows in several countries is evidence of her continuous activity.

*Publications: Life in two worlds*, London, 1952 (autobiography).

*Examples:* Petit Palais, Geneva.

*Literature:* M, Petit Palais, Geneva, 1971; Schurr, v1; Vergine.

## MARINETTI, B. See BENEDETTA

## MARISOL. (pseud. of Marisol ESCOBAR) (1930–)

*Venezuelan sculptor best known for her assemblages satirising American culture*

Born in Paris of Venezuelan parents, she was brought up in wealthy and cultured circles in Caracas and Los Angeles by her widowed father. She spent 1949 at the École des Beaux-Arts in Paris before returning to New York, but she rejected the Art Students' League in favour of Hofmann's classes in Provincetown. Her interest in social phenomena was pursued at the New School for Social Research in New York from 1950 to 1953, and she became one of the rebellious generation in Greenwich Village, although she was fortunate in having an income from her father. She began to exhibit but was so frightened by the publicity following her solo show with Leo Castelli in 1957 that she went to Rome for three years. Her work of those years was influenced by Pre-Columbian and Mexican artefacts. By the 1960s she adapted these simplified approaches to large figures and tableaux, which satirised aspects of American society and culture. These included *The Family*, *The Wedding* and *John Wayne*, and were often made of painted wood, which she decorated with real objects and sometimes put in real environments. Many of the women would have her own features,

and this quest for her own identity is a characteristic of her art. She was one of the very few women who contributed to Pop Art, and she became part of the rich social life of New York. She escaped again in the late 1960s, this time going to the Far East, turning to the depiction of fish, all endowed with a mask of her own face. However, since 1981 she has returned to New York and begun more satirical work.

*Examples:* Albright-Knox G, Buffalo, NY; Art Institute, Chicago; Mus. Ludwig, Cologne; Brooks Memorial Art G, Memphis, Tenn.; Whitney Mus, and MOMA, New York.

*Literature:* Bachmann; Fine, 1978; C. Nemser, *Art talk*, New York, 1975; Rubinstein; Watson-Jones; Withers, 1979.

## MARLEF, Claude. (pseud. of Marthe LEFEBVRE). née Andrea Josephine BOYER (1864–after 1922)

*French painter of portraits and mythological scenes in oil and pastel*

A native of Nantes, she drew from childhood and was trained with several eminent teachers: Roll, Dagnaux, Puvis de Chavannes and Constant. She married in 1890, but was widowed the following year and after this she devoted herself to painting. She exhibited annually from 1895 to 1922, winning a bronze medal in the 1900 Exposition and was made an associate of the Société Nationale des Beaux-Arts. Because she worked under a pseudonym, critics believed for some time that the 'bold vitality' of her style must be the work of a man. She specialised in portraits of women and was able to capture the principal characteristics of her sitters very rapidly, especially in pastel.

*Literature:* Clement; Edouard-Joseph.

## MARRABLE, Madeline (*sic*) Frances. née COCKBURN (1833/4–1916)

*English/Scottish painter of landscapes, figures and portraits; first president of the Society of Women Artists*

Born in London, she was the daughter of an army officer and his Scottish wife. Her mother died when she was young, whereupon her father became a merchant. Her uncle Ralph Cockburn was

an early member of the Old Watercolour Society and the first custodian of the Dulwich Gallery. There was therefore no difficulty with her family about her wish to study art and, through her uncle's contacts, she trained with Henry Warren, the president of the OWS. She learnt to paint in oils with the landscapist, Peter Graham, and began exhibiting in 1864. About this time she married architect Frederick Marrable, but he died in 1872 leaving her with two young children, and from then she supported her family by the sale of her works. As a landscape painter, she needed to travel and had done so in Europe with her husband, who had invented for her a specially folding easel, which apparently mystified French customs officers. After his death, she continued to travel in Italy, Switzerland, Austria and Ireland. Her preferred subjects were mountainous landscapes, especially with snow. She became involved with the SWA and in the late 1880s became its first president, a post she held until 1912. Her membership of several European artists' associations, including the Royal Belgian Society of Watercolours and the SWA in Vienna, is an indication of her standing among contemporaries. Edward VII and other members of the royal family commissioned paintings from her. Her daughter Edith also became a professional artist, specialising in flowers and participating in the SWA activities as well as exhibiting elsewhere.

*Literature:* Clayton; Mallalieu.

## MARS, Ethel (1876–after March 1956)

*American painter and printmaker, notably of café and street life*

A native of Springfield, Illinois, she studied at the Cincinnati Art Academy from 1892 to 1897. There, sometime after 1894, she met Maud Squire (*q.v.*), who became her lifelong companion. After regular visits to Europe from 1900 onward, they settled in Paris in 1906, where Mars soon became part of the art world and from Anne Goldthwaite's (*q.v.*) description soon abandoned her former conventional appearance. She exhibited at the Salon d'Automne from 1907 to 1913, was elected a member and served on their jury on several occasions. She was also a member of the Société Nationale des Beaux-Arts. Her authority was such that by 1912 newly arrived American women printmakers were ask-

ing her to instruct them. Her work with colour woodcuts intensified at this time. She produced strong simple images of women at work and leisure. At times she used vibrant colours like those of the Fauves, while she also executed works with a flatter, more decorative scheme. For a brief period on the outbreak of war she drove ambulances, but returned with Squire to America, where they settled in Provincetown. There her existing two-block technique gave way to the new one-block, with white outlines evolved in Provincetown in those years (see under Lazzell). She also made rag tapestries. The last 30 years of her life were spent in France, where she illustrated a number of children's books in collaboration with Squire.

*Examples:* Minneapolis; Provincetown; NMAA, Washington, DC.

*Literature:* J. Flint, *Provincetown Printers; a woodcut tradition*, NMAA, Washington, DC, 1983.

## MARSEEN, Ulrike (1912–)

*Danish sculptor, painter and critic*

Marseen was born in Brønderslev, where her father was a dentist. She was educated at the Academy in Copenhagen and with Bjerg. She has exhibited widely in Denmark and mainland Europe. In 1953 she won first prize in the Danish section of the international competition for the *Monument to the Unknown Political Prisoner*.

*Literature: Who's Who in Art.*

## MARTIN, Agnes (1912–)

*Canadian-born painter of subtle, abstract works often of grids made from thin lines of pencil or paint who works in America*

Born in Macklin, Saskatchewan, Martin passed her childhood on her father's wheat farm in Vancouver, her recollection of the vast open spaces there remaining with her always. At the age of 20, she emigrated to America, becoming a citizen eight years later. In 1941 she graduated from Columbia University, returning to get her MFA in 1954. During these years she spent some time both in New York, where for a time she taught

children in Harlem, and in New Mexico, where she taught part-time at the university. There she encountered native Indian artefacts and a dramatic landscape seen under the particular quality of light found in that region. This experience caused her to search for a symbolic form of representation, and she drew from some of the Abstract Expressionists, adding stylisation of the human form. She turned to abstraction in the late 1950s when she was back in New York and her neighbours included Ellsworth Kelly and Robert Indiana. The titles of paintings in her solo shows with Betty Parsons from 1958 revealed that the New Mexican landscape was still her source material. The move to the grid format around 1962 was in keeping with two strands in her personality – the preference for solitude and meditational philosophies, and for symmetry, ratio and order – together with a rejection of the excesses of Abstract Expressionism. Over the next five years she produced many paintings and drawings in which the grid lines are drawn or painted on paper or canvas which vary in their texture. The roughness of the material causes subtle variations in the lines and prevents them from being geometrically precise. Colours, where they occur, are pale and the whole effect is restrained. For these works, Martin has been called a precursor of Minimalism. Suddenly leaving New York in 1967 she spent six years in an isolated desert hut in New Mexico, writing and meditating. When she resumed painting in 1972, it was to produce large glowing canvases in which the gesso shines through the thin layers of paint, two basic colours plus white in each. While retaining elements from her earlier work, these later paintings suggested in addition landscape and climate, drawing attention to the sustenance she derived from this one particular geographical area where she still spends much of her time. She has lectured and exhibited extensively.

*Examples:* Aachen; Stedelijk Mus., Amsterdam; Atlanta; La Jolla; Tate G, London; County Mus. of Art, Los Angeles; Guggenheim Mus., Whitney Mus., and MOMA, New York; Hirschhorn Mus., Washington, DC; Worcester, Mass.

*Literature:* Bachmann; S. Delehanty and L. Alloway, *AM*, ICA, University of Pennsylvania, Philadelphia, 1973 (full bibl.); *AM: paintings and drawings 1957–75*, Arts Council, London, 1977 (bibl.); *AM*, Waddington G, London, 1986, (full bibl.); Petersen; Rubinstein; A. Wilson, 'AM, The essential form; the committed life', *Art International*, v18, Dec. 1974, 50–2.

## MARTIN, Mary Adela. née BALMFORD (1907–69)

*English sculptor of abstract geometrical reliefs*

Born in Folkestone, Kent, she studied at Goldsmiths School of Art from 1925 to 1929 and for the following three years at the Royal College of Art. It was there that she met and in 1930 married sculptor Kenneth Martin. At this stage she was a painter and clearly had not found the right style in which to work. During the 1930s she designed rugs for Heals, as Kenneth Martin had also supported himself by designing, but painted only spasmodically. Her sons were born in 1944 and 1946; her first abstract works date from 1950, with the precursors of them appearing in 1948, so it would not be strictly true to say that childcare prevented her from working. In 1951 she carved her first relief from cold plaster. It contained most of the elements which appear throughout her relatively short career; a basic grid, with square and rectangular protruding and recessed shapes, together with the wedge or tilt, as she called it, which gave the sense of movement. The early reliefs were white, but gradually first black and then red were introduced. Later works contain a more varied range of colours. Her reliefs were based on carefully worked out concepts, mathematical in basis, which became increasingly complex after 1961, when she introduced permutations. From 1956 she was involved in a number of architectural projects and wrote with increasingly frequency about her work. She and Kenneth Martin formed the core of the small group of British Abstractionists and provided each other with considerable mutual support, for their approach and philosophy were close. For Mary Martin the logic and processes were a means to achieving work which was always surprising for, however detailed the calculations, the final appearance always contained unpredictable rhythms, movement and, in the cases of the mirror reliefs, reflections. In the year of her death she won the joint first prize at the John Moores' exhibition in Liverpool.

*Publications:* see below under *Literature.*

*Examples:* Wall relief, Musgrave Park Hospital, Belfast; Exeter; Grenoble; Hull; WAG, Liverpool; wall reliefs, SS *Oriana*, P & O Co.; Tate G, London; wall relief, Stirling University.

*Literature:* M. Compton, *MM*, Tate G, London, 1984 (contains full bibl. and list of Martin's writings);

H. Lane, *K and MM*, Annely Juda Fine Art, London, 1987 (full bibl.); Nottingham, 1982;· Sellars.

## MARTINO, A. See BLUNDEN, Anna

## MARVAL, Jacqueline. (pseud. of Marie Joséphine VALLET) (1866–1932)

*French painter of figures, especially female, in a variety of settings in a brightly coloured and freely handled style*

The second of eight children born to two school-teachers at Quaix, near Grenoble, she herself initially qualified as a teacher in 1884. Her father had been an amateur painter and she began to paint at about 18. Her first paintings, of her parents and local landscapes, were signed Marie-Jacques. In 1886 she married a travelling salesman, Albert Valentin, but after the death of her six-month old son in 1890 the marriage broke up. She then lived with her grandmother, painting in her spare time, until in 1895 she met a young artist, François Girot, who was doing his military service. When he was discharged they went to Paris and attended Gustave Moreau's classes, where they met Matisse and Marquet. Another member of the group was Jules Flandrin, who became her companion for the next 20 years. She was now painting full-time and was part of group of artists including Bonnard, Vuillard, Roussel and Denis, who were supported by the Galérie Druet, where Marval had her first show in 1899. She adopted her pseudonym in 1900. Her career developed rapidly from this point; she exhibited no less than ten paintings at the 1901 Salon des Indépendants and her work was in demand from well-known collectors; the modernist dealer Vollard bought several of her paintings. She exhibited regularly in the Salon d'Automne and the Salon des Indépendants, with Apollinaire reviewing her work favourably on many occasions. In 1904 she was commissioned to paint the panels in the Théâtre des Champs-Elysées, where Diaghilev later performed with the Russian ballet. She exhibited in the Armory Show in New York in 1913. After Flandrin left her in 1919 she continued to paint, helped by her friendship with the Menier family, with whom she travelled to Biarritz and Deauville. Her personal unhappiness was compounded by the onset of cancer, and from the mid-1920s she became more reclusive. Nevertheless she continued to exhibit in France and many other countries and was selected for the 1937 exhibition of the *Femmes artistes d'Europe* in Paris. Most of her work was in oil, but she also carried out some successful lithographs and posters. A flamboyant and unconventional personality, she has been effectively ignored even though she was among the first artists to use colour in its own right, and her work anticipated that of artists such as Van Dongen by at least ten years.

*Examples:* Grenoble; Lyons; Mus. d'Orsay and Mus. d'Art Moderne, Paris.

*Literature:* Edouard-Joseph; *JM*, Crane Kalman G, London, n.d.

## MASON, Alice. née TRUMBULL (1904–71)

*American pioneer geometrical abstract painter*

Born in Litchfield, Connecticut, she spent long periods of her childhood travelling in Europe with her wealthy parents. While staying in Italy in 1921 she studied at the British Academy in Rome and as a result persuaded her parents to return to America in order that she might pursue her studies at the NAD. It was only when she studied under Gorky at the Grand Central Galleries School in 1927 that she became aware of modernist art, and this, combined with the revelation of the geometric design in Byzantine mosaics which she saw on a visit to Italy and Greece in 1928, resulted in her first abstract paintings in 1929. The following year she married Warwood Mason, a ship's officer, and had two children. Resuming painting in 1935, the following year she became a founder member with Gertrude Greene (*q.v.*) and Rosalind Bengelsdorf (*q.v.*) of the American Abstract Artists, and held several offices in this organisation at a period when abstract art was regarded with considerable hostility. Her works of the later thirties contain biomorphic forms reminiscent of some of the Surrealists, but an encounter with Mondrian in 1942 caused her to move towards geometric forms, but in subtle colours. In the same year she had her first solo show, but she suffered from a chronic lack of critical attention throughout the 1950s and 1960s. She continued to produce increasingly economical compositions, with a small number of rectangular shapes floating in front of a hazy ground, but became depressed about the paucity of recognition. This was compounded by the death of her son in 1958, and her later years were apparently marked by increasing isolation and dependence on alcohol. Paradoxically, her

first retrospective in 1973 spawned a series of other exhibitions and revitalised interest in her work.

*Publications:* 'Concerning plastic significance', *American Abstract Artists Yearbook*, 1938.

*Examples:* Whitney Mus., New York.

*Literature:* M. Brown, 'Three generations of artists: Anne Train Trumbull, ATM and Emily Mason', *WAJ*, v4/1, spring-summer 1983, 1–8; Harris; R. Pincus-Witten, *ATM retrospective*, Whitney Mus., New York, 1973; Rubinstein.

## MATTON, Ida (1863–1940)

*Swedish sculptor and medallist, landscape painter and poster artist*

Born in Gävle, she was first instructed in art at the technical school in Stockholm. Here she won two prizes and a travelling scholarship, which enabled her to attend the Académie Julian in Paris, where she studied with Chapu, Mercié and Puech. She exhibited in Paris, winning several awards, including the highest honour given by the Union des Femmes Peintres et Sculpteurs in 1903. Soon after this she returned to Sweden and executed many marble portrait busts. She also carried out figures, reliefs and monuments, including one for her home town. In addition she exhibited in London, Stockholm and Chicago.

*Examples:* Gävle; Town Hall and Theatre Royal, Stockholm.

*Literature:* Clement; Edouard-Joseph; Mackay.

## MEARS, Helen Farnsworth (1872–1916)

*American sculptor of ideal figures and portraits*

The youngest of three sisters, she was born in Oshkosh, Wisconsin. Her mother, a writer of poetry, plays and essays both before and after her marriage, was a strong influence on all three girls. Only the eldest daughter married and she had a short career as a bookbinder, while Mary became a writer and acted as lifelong companion and support to Helen, whose interest in sculpture from childhood was aided by her father, who made and sold farm implements. After seeing a photograph of a sculpture by Mears around 1890, the eminent sculptor, Saint-Gaudens, invited her to study with him, but the family could not afford

to send her to New York. Entirely self-taught, she won the commission for a monumental sculpture to represent the state at the 1893 Chicago Exposition. For this she worked with Lorado Taft in Chicago for six weeks and then for several months on her own. This sculpture won her a $500 dollar prize from the Milwaukee Women's Club, and further support from Alice Chapman, a wealthy woman interested in Mears' work, enabled Helen and Mary Mears to travel to New York so that Helen might study with Saint-Gaudens. After some years in the busiest sculpture studio in New York, in which Helen would have met many important patrons and artists, and with finance from Alice Chapman, the sisters spent two years in France and Italy. By 1898 Helen felt that she should become more independent of her mentor and, again with Alice Chapman's help, she took a studio in New York, where she executed a number of important commissions and won a competition for a three-metre-high statue of Frances Willard, a famous professor and leader of the Women's Temperance Union. This was unveiled in the US Capitol in 1905. After executing a portrait of the dying composer Edward MacDowell in 1906, Helen and Mary Mears were recipients of some of the first bursaries to enable creative people to work at the art colony founded by his widow. A major relief, the *Fountain of life*, won medals in several expositions but was never transferred into a permanent medium. Several later works, such as the statuette of a tired miner, give evidence of her search for a more realistic form of expression. After her sudden death, to which lack of money for food and heat contributed, a large number of works were found in her studio, and her sister spent many years raising money to have Helen's work cast and increase her reputation.

*Examples:* Milwaukee; Oshkosh; US Capitol, Washington, DC.

*Literature:* Archives of American Art; S. Green, *HFM*, Paine Art Center, Oshkosh, 1972; *HFM*, Paine Art Center, Oshkosh, 1970; *Notable American Women*; Rubinstein; Weimann.

## MELLIS, Margaret (1914–)

*Scottish painter and constructor of reliefs*

Born in China of Scottish parents, Mellis decided when very young to be an artist. While studying at Edinburgh College of Art under Peploe, she won several awards, including a travel scholarship which enabled her to visit Italy, Spain and Paris,

where she studied with Lhote. A two-year fellowship allowed her to remain in Edinburgh before she went to London in 1937 to study with the Euston Road Group. She married artist Adrian Stokes and lived in or near St Ives in Cornwall from 1939 to 1947. During this time, in addition to having two children of her own, she temporarily housed Ben Nicholson, Barbara Hepworth (*q.v.*) and their triplets after their escape from the London blitz. She also came to know Naum Gabo and Peter Lanyon. Originally a painter, in 1940 she began to work in collage and to carve reliefs, returning to painting at the time she separated from Stokes. These works were based on nature but were almost completely abstract. Her colour values were founded on an admiration for French painting, and these were intensified when in 1947 she married collagist Francis Davison and they spent the next three years in his family's deserted home at Cap d'Antibes in France. Living since then in Suffolk, she works intuitively trying ideas until forms and colours begin to react between themselves. The same basic process applied to the colour reliefs, which she started in 1970, and the driftwood reliefs, which she began from the late 1970s. Although exhibiting consistently, she suffered from a lack of critical attention, partly because of conservative British taste, until the later 1970s.

*Examples:* Scottish Nat. G of Modern Art, Edinburgh; Hull; Lodz, Poland; Tate G, London; Sheffield.

*Literature: Cornwall, 1945–55*, New Art Centre, London, 1977; *MM: a retrospective exhibition, 1940–87*, Redfern G, London, 1987; Nottingham, 1982.

## MERRITT, Anna. née LEA (1844–1930)

*American painter of figures in allegorical, literary and genre contexts who lived in England for much of her life; also an engraver*

Born into a wealthy Philadelphia family, Lea began to receive drawing lessons at the age of seven, and while touring Europe with her family in subsequent years was able to study in Paris, Rome and Dresden. Arriving in London in 1871, she became the pupil of the much older Henry Merritt, who guided and over-influenced her before and after their marriage in 1877. His death in the same year prevented her from carrying out her intention of abandoning painting. She exhibited at the RA and elsewhere for over 30 years and fostered contacts with her native country, returning regularly

to Philadelphia. She was represented in both the 1876 Centennial Exposition and in the 1893 Chicago Exposition, while 1890 her painting *Love locked out* was purchased for the Tate Gallery. In that year she settled in the Hampshire village of Hurstbourne Tarrant, which she immortalised in a book containing her etchings. She was elected a member of the Royal Society of Painters and Etchers, painted a mural for a Surrey church and executed numerous portrait commissions.

*Publications: Henry M: art criticism and romance*, London, 1879; *A hamlet in old Hampshire*, London, 1902.

*Examples:* Bury; Tate G, London.

*Literature:* D. Cherry, *Painting women: Victorian women artists*, Art G, Rochdale, 1987; G. Gorokhoff, *Love locked out; the memoirs of ALM*, Mus. of Fine Art, Boston, 1982; P. Nunn, *Canvassing*, London, 1986; P. Nunn, *Victorian women artists*, London, 1987; Rubinstein; W.S. Sparrow; *Who's Who*; Wood, 1978.

## MEYER, Agnes Ernst (1887–1970)

*American Dada artist, writer and supporter of modern art*

Born in New York, she was with Katharine Rhoades (*q.v.*) and Beatrice Wood (*q.v.*) the main woman participant in Alfred Stieglitz' 291 Gallery and various publications. She provided the financial backing for Steiglitz in the promotion of modern art, and it was largely at her suggestion that the magazine *291* was published, to which she contributed several articles, poems, including a visual poem, and translations. She knew Picabia and Duchamp while they were in New York. She is better known as a writer and promoter of modern art.

*Publications: Out of these roots*, Boston, 1953 (autobiography).

*Literature:* D. Tashjian, *Skyscraper primitives*, Middletown, Conn., 1975; Vergine.

## MEZEROVA, Julie W. (1893–?)

*Czech painter of flowers and figure subjects*

Born in Upice, she trained at the School of Fine Art in Prague. She exhibited there from 1920 and at

various salons in Paris from the later 1920s, as well as in Warsaw, Athens and Buenos Aires. She was a member of the Women's Art Club in Prague and showed at the UFPS in Paris. Her chief subjects are scenes from Bohemian life, but she also carried out portraits and still lifes in addition to illustrating books.

*Examples:* Prague.

*Literature:* Edouard-Joseph.

## MILROY, Lisa (1959–)

*Canadian-born painter of sets of everyday objects such as books, clothing, keys and fruit*

Born in Vancouver, Milroy trained for a year in Alberta, and another at the Sorbonne in Paris before coming to England in 1978. After a further year at St Martin's School of Art she spent three years at Goldsmiths College of Art, also in London. While intending to explore merely the visual qualities of the objects, her reproduction of sets of similar objects aims to emphasise the medium at the expense of the content. However, the realism of their depiction calls attention to the objects themselves in a way that has been called symbolic, sensual or fetishistic. Exhibiting since 1983, she has had solo shows in London, Paris and San Francisco.

*Literature:* L. Cooke, 'Taking the side of things', *Artscribe*, June–July 1986; *Current affairs: British painting and sculpture in the 1980s*, MOMA, Oxford, 1987; S. Kent, 'Fabrications not lies', *Artscribe*, Sept.–Oct. 1984, 40–5; S. Kent, *Problems of picturing*, Arts Council, London, 1984; E. Lucie-Smith, C. Cohen & J. Higgins, *The new British painting*, Oxford, 1988.

## MISS, Mary (1944–)

*American sculptor working on large-scale quasi-architectural pieces*

Miss is a New Yorker by birth, but her father's military profession meant that her childhood was spent in several different countries. She gained her first degree in 1966 from the University of California, and her MFA two years later from the Maryland Institute College of Art, Baltimore. She has exhibited extensively since 1970. It has been suggested that her architectural constructions derive from her childhood, when she experienced and explored many kinds of environments. Her early works were on a small scale and made from common materials but, as she became involved in outdoor projects, the scale of her work grew. She tried to place the sculptures in relatively isolated places, unexpected as locations for sculpture. By the late 1970s she was using construction sites, mines and power plants as sources of her imagery, as in *Staged gates* (1979), and it was at this juncture that she became aware of the question of public reaction. Although her imagery is complex and sophisticated, she believes it is accessible to the public, who can read it on different levels.

*Examples:* Allen Memorial Art Mus., Oberlin, Ohio; Everson Mus., Syracuse, NY.

*Literature:* A. Kingsley, 'Six women at work in the landscape', *Arts Mag.*, v52/8, Apr. 1978, 108–12; L. Lippard, 'MM: an extremely clear situation', *Art in America*, v62/2, Mar.–Apr. 1972, 76–7; *MM*, ICA, London, 1984; Rubinstein; Watson-Jones.

## MITCHELL, Joan (1926–)

*American Abstract Expressionist painter*

A contemporary of Elaine de Kooning (*q.v.*) and Grace Hartigan (*q.v.*), Mitchell had great success with large canvases in the 1950s. As a child in Chicago she was encouraged by her doctor father, who had been an amateur painter, and by her mother, who wrote poetry. Although a rebellious teenager, she found two years at Smith College difficult, but then in 1945 transferred to the Art Institute in Chicago, where she began producing paintings influenced by Cubism. She gained her MFA and also a travelling scholarship to France in 1948–9. Initially working in Paris, she found that the poor conditions in which she lived made her ill, so to recuperate she went to southern France. Back in New York, she was briefly married, and mixed with artists like Gorky and Willem de Kooning, whose work influenced her. The semi-abstract Parisian paintings became completely abstract, and in 1951 she was selected for the seminal Ninth Street Show, which made her known to a wider public. Following her first solo show the next year, Mitchell enjoyed great critical acclaim. Although an apparently gestural painter, she eschews automatic techniques and accidental elements, preferring to plan the composition with drawings, sketching on the canvas with charcoal before

painting and working slowly on whitish backgrounds. Since 1955 she has lived permanently in France with the French-Canadian painter, Jean-Paul Riopelle. Although she exhibited regularly at one gallery until 1965, her work became less popular during the reaction against Abstract Expressionism. However, her reputation has been re-established since 1973 with a series of major solo shows of her more recent paintings, which, although abstract, have been considered analogies of landscape. She works from a felt remembrance that takes form as she works, and she manipulates materials according to this feeling. On a visit to New York in 1981 she completed a series of lithographs in which her normally vigorous stroke was transferred to a new medium, using the white of the paper as a positive element in the portrayal of light.

*Examples:* MOMA, New York.

*Literature:* Bachmann; Fine, 1978; *Graphic Muse*; Heller; *JM*, Xavier Fourcade G, New York, 1986; Munro; C. Nemser, 'An afternoon with JM', *FAJ*, spring 1974, 6; Petersen; M. Pleynet *et al.*, *JM; choix de peintures, 1970–82*, ARC & Mus. d'Art Moderne de la Ville de Paris, 1982; Rubinstein; M. Tucker, *JM*, Whitney Mus., New York, 1974.

## MODERSOHN-BECKER, Paula. née BECKER (1876–1907)

*German Expressionist painter of figures and still lifes*

Born in Dresden, she began to learn drawing when her family moved to Bremen in 1888. After she had been sent to stay with relatives in London in 1892 in order to finish her education, she attended the St John's Wood School of Art, where she encountered unsegregated, rigorous classes aimed at training professional artists. This was unlike anything she had experienced in Germany, but on her return she enrolled in the School for Women Artists in Berlin. This was a traditional school, acceptable to her parents, but provided Becker with little other than a role model in Jeanna Bauck (*q.v.*). As soon as she came into a private income, Becker left and joined the art colony at Worpswede, a small village north of Bremen. There she studied with Fritz Mackenson, although the relationship was not an easy one, because Becker sought to convey her reactions to her subject matter, to give 'figurative expression' to her feelings, rather that to imitate nature. With her friend, Clara Westhoff (*q.v.*), she made her first

visit to Paris in 1900 and encountered contemporary modernist French art. On this and other visits to the city she studied at the Académie Colarossi, and in 1905 at the Académie Julian, visited exhibitions and realised that her vision of art was not an isolated one. Her broad handling of the paint, reduction of details and suppression of traditional devices such as chiaroscuro, which seemed so eccentric in Worpswede, now appeared as part of a contemporary reaction to society. In 1901 she married another artist at Worpswede, Otto Modersohn, and become responsible for his daughter. Her letters and diaries reveal the constant tensions between the different roles she had. In 1906 she left her husband and settled in Paris, but he persuaded her to return and she died three weeks after the birth of a daughter. The role of motherhood featured prominently in her work, not least because female models from the village were always available to her, but her interpretation of that role has been seen as more essentialist and less socially determined than that of, for example, Kollwitz (*q.v.*). She sought nevertheless to give her sitters individuality and dignity. A series of penetrating self-portraits covered the whole of her career.

*Examples:* Nat. G, SMPK, Berlin; Essen; NMWA, Washington, DC.

*Literature:* Bachmann; *Das Verborgene Museum*; Fine, 1978; Harris; E. Oppler, 'PM-B; some facts and legends', *Art J.*, v35, summer 1976, 346–69; G. Perry, *PM-B*, London, 1978 & New York, 1979; Petersen; D. Radycki, 'The life of lady art students: changing art education at the turn of the century', *Art J.*, v42, spring 1982, 9–13.

## MOLL, Marg. née Margarethe HAEFFNER (1884–1977)

*German painter and sculptor in a modernist idiom*

Moll was born in Mulhouse, Alsace, her father being an army officer. Her training began in 1902 and during the next three years she studied painting in Wiesbaden with Völker and sculpture at the Art Institute in Frankfurt with Louise Schmidt. She then became a private pupil of the painter Oskar Moll, whom she married the following year. From this time sculpture began to take precedence in her work in order to avoid direct competition with her husband and she only resumed painting after his death in 1947. Soon after their marriage they visited Rome before settling in

Berlin. In 1907–8 Marg Moll lived in Paris while she studied with Matisse as his first sculpture pupil. She continued to visit Paris regularly until 1914, becoming acquainted with Gertrude Stein, Sonia (*q.v.*) and Robert Delaunay, Picasso and other modernists. Her sculpture soon began to reflect her growing awareness of Cubism and she exhibited these works in Germany. World War I and the birth of two daughters prevented her travelling for several years. In 1925 her husband was appointed a professor at the Breslau Academy and the Molls became the centre of a large circle of modernist artists. An extended visit to Paris in 1928 marked the start of a new phase in her art. Through her knowledge of the work of Zadkine, Archipenko and Brancusi, she simplified her forms further, reducing the figure to a series of broad planes. She exhibited frequently at this period in both Paris and Germany. In 1933 Marg and Oskar Moll returned to Berlin, but their house was bombed in 1943 and much of their work destroyed. Oskar Moll died in 1947, following their return to Berlin. Marg Moll travelled within Europe and to America in succeeding years. During a visit to England in 1950–1, she became friendly with Henry Moore and exhibited with WIAC. In the post-war period she had many solo shows and retrospectives.

*Examples:* Georg-Kolbe Mus., Berlin.

*Literature: Das Verborgene Museum; MM, Kunstamt Tiergarten, Berlin, 1964; MM Bilder-Skulpturen-Skizzen, Düsseldorf & Berlin, 1974; I. Würtz (ed.), MM 85, Düsseldorf, 1969.*

## MONNINGTON, W. See KNIGHTS, Winifred

## MONTALBA, Clara (1840/2–1929)

*English painter of landscapes, interiors and city scenes in oil, but chiefly watercolour, often with a slightly melancholy air*

One of four highly talented artistic daughters of the painter A.R. Montalba, she was born in Cheltenham. Both parents were anxious that their daughters should develop their talents to the full,

**Clara Montalba** *Venice*, 1894, pastel and watercolour, 33 × 49.5 cm, Walker Art Gallery, Liverpool. (photo: John Mills (Photography) Ltd)

and every encouragement and opportunity was given to them. Clara studied for four years in France with Eugene Isabey. During this time and afterwards she travelled throughout the country but extensively in Normandy. Her career became an international one, for she exhibited from 1866 in many countries, and was received into the membership of a number of European art academies and watercolour societies. She took part in both the 1876 Phildelphia Centennial and the 1893 World's Columbian Exposition in Chicago. For many years she lived in Venice, and her paintings depict churches, shipping and canals from that city, which rewarded her with election to the Academy. She became an Associate of the Old Watercolour Society in 1874, and a full member in 1892. She died in Venice.

*Examples:* Leeds; Castle Mus., Norwich.

*Literature:* Clayton; Clement; *Connoisseur*, v.84, 1929, 263 (obit.); M. Elliott; Mallalieu; Nottingham 1982; P. Nunn, *Victorian women artists*, London, 1987; Weimann; *Who was Who, 1929–40*; Wood, 1978.

## MONTALBA, Ellen (*c.* 1846-after 1902)

*English painter of landscapes, genre and portraits*

The sister of Clara, Henrietta, and Hilda (*q.v.* all) and daughter of the painter A.R. Montalba, she was born in Bath, Avon, and trained at the Royal College of Art and South Kensington Schools. She exhibited from 1868 to 1902 in London, Glasgow and Liverpool. She travelled in France a good deal and, like her sisters, spent considerable periods of time in Venice. Her works were known for their strong colouring, and Venetian subjects gave her the scope to use this. She also executed some life-size portraits and occasionally drew illustrations for magazines.

*Literature:* P. Nunn, *Victorian women artists*, London, 1987; Wood, 1978.

## MONTALBA, Henrietta Skerret (1856–1893)

*English sculptor and painter of portraits and genre*

The sister of Clara, Ellen and Hilda Montalba (*q.v.* all), Henrietta was the youngest of the four artist sisters and the only one to take up sculpture. She

studied at the South Kensington Schools and, in addition to exhibiting in London, she showed several portrait busts at the International Glasgow Exhibition in 1888 and, with Clara and Hilda, she had work in the World's Columbian Exposition at Chicago in 1893. With her sisters she spent time in Venice and died there at the early age of 37, by which time she was already well known in Britain and Europe. Although she also painted, her most successful work was sculpture.

*Literature:* AJ, 1893, 363 (obit.); M. Elliott; P. Nunn, *Victorian women artists*, London, 1987; Weimann; Wood, 1978.

## MONTALBA, Hilda (1844/54–1919)

*English painter of landscapes and genre*

The sister of Clara, Ellen and Henrietta Montalba (*q.v.* all), Hilda trained at the Slade. Since this opened only in 1871, the conclusion could be drawn that she was born in the early 1850s and was the third of the four sisters. She must have been one of the first students there, for she exhibited from 1873 and continued to do so actively in London and the provinces, as well as at the Chicago Exposition in 1893. Like her sisters she worked in London and Venice, and like Henrietta and Clara she died in that city.

*Literature:* M. Elliott; P. Nunn, *Victorian women artists*, London, 1987; Weimann; Wood, 1978.

## MONTIGNY, Jenny (1875–1937)

*Belgian luminist painter of landscapes, portraits and still lifes in oil and pastel*

Montigny was born in Ghent, but little is known about her early life until she became a pupil of Emile Claus, following his luminist tendencies rather than his academic ones. She settled at Deurle, in luxuriant country beside the river Lys, and from here she travelled in Europe. Like a number of Belgian artists, she spent the years of World War I in England. The association with Claus was a personal as well as an educational one, but she established an independent form of work. Her most frequent subject was children playing in the sun, for she delighted in representing moving groups in which she could organise the forms through the handling of paint or pastel

in broad sweeps. She painted in softer tones but with a greater range of contrast than Claus and used hatching to a greater extent than he did, a technique perhaps deriving from her work in pastel. The children are never posed but captured as they come out of school or absorbed in their games. She exhibited frequently in Paris, and belonged to the Libre Esthétique group in Brussels around 1900 and the Vie et Lumière group there in 1914.

*Examples:* Ghent.

*Literature:* P. Colin, *La peinture belge depuis 1830*, Bruxelles, 1930; S. Polden, *A clear view: the Belgian luminist tradition*, Whitford and Hughes G, London, 1987; Schurr, v5; W.S. Sparrow; *Studio*, v87, 1924, 275, 279.

## MORAN, Mary. née NIMMO (1842–1899)

*Scottish-born painter and etcher of landscapes who lived in America*

Born in Strathaven, she emigrated to America in 1852 with her father after the death of her mother in 1847. By 1858 they had settled in Crescentville, Pennsylvania, next door to the parents of a teacher at the Pennsylvania Academy, Thomas Moran. In 1860 Mary Nimmo became his pupil and they were married two years later. Three children were born in 1864, 1868 and 1870. With their first child the Morans had made a study visit to Europe, including London, Paris and Italy. In 1870 they moved to Newark at the suggestion of their friend, Richard Gilder, who promised them work through *Scribner's Monthly* magazine, of which he was editor (see Helen Gilder). At this time domestic duties prevented Mary from exhibiting more than sporadically, although she at times travelled with her husband. It was only in 1879 that she began to experiment with etching, working directly from nature, and through the strength of her first series was elected to membership of the New York Society of Painter Etchers. Mary Moran's work was characterised as bold and vigorous, with dark masses contrasting with lighter areas, and having an ability to capture the particular quality of the light. She exhibited regularly and to great acclaim, clearly finding not only that the medium suited her temperamentally but also that it fitted in with her domestic duties more easily than painting. In 1882 the whole family visited England, met John Ruskin, who purchased many of their prints, and resumed their earlier European habit of following

the path of Turner. During the rest of the 1880s prints by both Morans were in great demand, and Mary Moran was represented in many major exhibitions, including the 1893 Chicago Exposition, where she received a medal, although her output diminished in that decade. She died of typhoid, after nursing her daughter through the same illness.

*Examples:* Newark, NJ; Cooper-Hewitt Mus. and Public Library, New York; Tulsa, Okla.

*Literature:* Bachmann; F. Benson, 'The Moran family', *Quarterly Illustrator*, Apr.–June, 1893, 67–84; M. Francis, 'MNM; painter-etcher', *WAJ*, v4/2 fall 1983-winter 1984, 14–9; C. Huber, *The Pennsylvania Academy and its women, 1850–1920*, Pennsylvania Academy, Philadelphia, 1974; *MNM*, Smithsonian Inst., Washington, DC, 1950; Rubinstein; Weimann.

## MORENO, Maria (1933–)

*Spanish realist painter*

After study at the schools of fine art in San Fernando and Madrid from 1954 to 1959, Moreno supported herself by teaching in schools in the capital city until 1971. With Antonio Lopez Garcia and Isabel Quintanilla (*q.v.*) she is one of the new generation of Spanish painters based in realism. Her subject matter is predominantly landscape, whether rural or in gardens, and possesses an intimate character. Many exhibitions of her work have been held in Germany.

*Literature:* Krichbaum; *Spanische Realisten*, G. Brockstadt, Hamburg, 1977.

## MORGAN, Evelyn Mary de. née PICKERING. (1855–1919)

*English painter of mythological and allegorical scenes, sometimes associated with the Pre-Raphaelites*

The eldest of three children of Anna Maria and Percival Pickering, a wealthy lawyer, she inherited her artistic ability from her mother's family and shared with her uncle, the painter Roddam Spencer-Stanhope, a taste for Italian Renaissance art. Her mother encouraged a love of learning in all her children and Evelyn received an exceptionally broad education for a girl at the time,

**Evelyn de Morgan** *Aurora Triumphans*, 1877–8, oil on canvas, 116.7 × 172 cm, Russell Cotes Art Gallery and Museum, Bournemouth. (photo: Harold Morris)

including Greek and Latin. She had a strong, lively personality, and her determination to paint seriously persuaded her parents reluctantly to employ a good drawing tutor. However, when he allowed her only to copy still lifes instead of teaching her anatomy as she wished, she registered her protest by producing a careful study of the male nude. The tutor resigned in protest at her unladylike behaviour. In 1873 she began to attend the Slade, where she studied under Edward Poynter. She won prizes for her life drawing as well as the Slade Scholarship in 1875, which she subsequently rejected, feeling the classes to be of no use to her. Despite the refusal of her family to finance her, she chose to study in Rome, where she lived alone from 1875 to 1877. Her paintings from this time reflect the moderating influence of Italian art on the classical severity of her early style. From this

period dates her bronze head of *Medusa*. She exhibited from 1877, but deliberately avoided the RA. Her large output was due to the long hours she worked, but gradually she established a reputation for herself. In 1887 she married William de Morgan, at that time a struggling potter in the tradition of William Morris. The sale of her paintings provided their income and the capitalisation of his workshop in Fulham. From 1893 to 1908 they lived in Florence, and this period saw Evelyn's first solo show in London, together with the final failure of the pottery enterprise and the beginning of William's career as a writer. His increasing success reduced the necessity for Evelyn to sell her work and, although she continued to paint as much as before, she was increasingly reluctant to exhibit her work. She consented to open her studio for the benefit of the Red Cross during

World War I, but none of the symbolic war pictures there was for sale. Her later works reveal the idea of spiritual development, of growth and struggle towards a better world. After William's death in 1918, Evelyn carried out a headstone for his grave. She still painted constantly, the habit of a lifetime, but had lost the will to live, and died the following year.

*Examples:* Birkenhead; Bournemouth; WAG, Liverpool; National Portrait G, London; Sheffield.

*Literature:* Clement; *The last romantics: the romantic tradition in British art. Burne-Jones to Stanley Spencer,* Barbican G, London, 1989; Nottingham 1982; P. Nunn, *Victorian women artists,* London, 1987; A.M.W. Stirling, *William de M and his wife,* London, 1922; Sellars; *Studio,* v19, 1900, 220–32.

## MORGAN, Norma (1928–)

*American painter and engraver of figures and landscapes*

Morgan was born in New Haven, Connecticut, her mother being a famous New York dress designer. By winning scholarships she was able to study at the Hans Hofmann School and the Art Students' League, New York, and had her first solo show in 1954. A black artist, she includes a black figure only occasionally in her paintings, but since the mid-1950s her main preoccupation has been depicting the moors of Scotland and northern England. Her frightening paintings from her early career resolved themselves into studies of erosion in paint and print in which the atmosphere is ominous, menacing and dramatic. Dividing her time between Europe and America, she wants to make Europeans more aware of American art.

*Examples:* MOMA, New York.

*Literature:* Fine, 1973.

## MORI, Marisa (1900–)

*Italian Futurist painter*

Florentine by birth, she studied with Casorati in Turin from 1925 to 1931. During this period she took part in many exhibitions and, with her interest in the concept of dynamism becoming more apparent in her paintings, it was logical that she should formally join the second generation of Futurists in 1932 and exhibit with them on many occasions. From 1933 she became fascinated by flying and began to abandon her former figurative style in favour of semi-abstract paintings in which she tried to capture the sensations of aircraft flight as the earlier Futurists had done with the car and the tram. Like Balla, she produced paintings which evoked musical experience, but she also explored female sensuality in a series of paintings which are unlike any other Futurist work. During the 1930s she exhibited in all the major Futurist shows in Italy and abroad, featured in three Venice biennales (1930, 1934 and 1940) and was also represented in the Italian section of the exhibition *Les femmes artistes d'Europe* in Paris in 1937. After 1940 she went back to a naturalistic style and, after her return to Florence following the war, she taught the history of design and appears to have ceased to exhibit.

*Literature:* B. Katz, 'The women of Futurism', *WAJ,* v7/2, fall 1986-winter 1987, 3–13; Vergine.

## MORISOT, Berthe (1841–95)

*French Impressionist painter, mainly of figures*

The youngest of three daughters of the prefect of Bourges, Berthe asked for drawing lessons at the age of 15. All three sisters received instruction from Chocarne, whose standards did not satisfy them. They studied with Guichard, and Corot, who was a family friend, advised on open-air painting. Both Edma and Berthe exhibited at the Salon in the 1860s, but the older sister had to abandon her art when she got married in 1868. Berthe continued to practise professionally, with the support of her family, although she was constrained by their conventions. She met Manet and posed for *The Balcony* in 1869. Her mature style emerged around 1870 with flattened space and broader modelling of forms. In 1874 she married Manet's brother, Eugène, and felt sufficiently independent to leave the academic Salon for the Impressionist group shows, which began that year. She contributed to these each year with the exception of 1879, when her only child, Julie, was born. Her house became a social centre for the Impressionists; Mary Cassatt (*q.v.*) was a good friend and shared her social class and lack of financial worries; Renoir was her daughter's guardian. Her later paintings show an increasingly broad

handling of paint, cool silvery light and tranquillity of mood. She painted few landscapes, due both to her indifferent health and to practical problems of a woman painting in the open air. Her outdoor scenes are therefore restricted to park and garden scenes, with figures occupied in simple recreational activities. Her models were often family and servants. Her husband died in 1892, but that year Morisot had a solo show and she continued painting until her final illness. Her work has been exhibited many times since her death.

*Examples:* Boston; Albright-Knox Art G, Buffalo; Chicago; Tate G, London; Metropolitan Mus., New York; Louvre, Paris; Doria Pamfili G, Rome; Toledo, Ohio; National G and Phillips Coll., Washington, DC.

*Literature:* K. Adler & T. Garb, *The correspondence of BM*, London, 1986 – new edition of the 1957 translation by Denis Rouart; Bachmann; Fine, 1978; T. Garb, *Women of Impressionism*, Oxford, 1986; Harris; Heller; L. Nochlin, 'Morisot's *Wet nurse;* the construction of work and leisure in Impressionist painting', in *Women, art and power, and other essays*, New York, 1988; J.-D. Rey, *BM*, Bergamo, 1982 (trans. S. Jennings); C. Stuckey & W. Scott, *BM: Impressionist*, Nat. G of Art, Washington, DC, 1987.

## MORREAU, Jacqueline (1929–)

*American-born figurative painter working in England on the representation of women from a feminist viewpoint*

Born into an artistic family, Morreau was attending art classes in Los Angeles by the age of 14. After art school she elected to study with the west coast artist Rico Lebrun. A period in Paris was followed by disillusionment at the impossibility of earning a living as an artist in Los Angeles. Since she now had a child to support, Morreau turned to medical illustration through which she gained a knowledge of anatomy. While employed as an illustrator, and later while married and bringing up children, her art was restricted to drawing and etching, but in due course she had more time to herself. The ideas she wanted to explore concerned a concept she refers to as 'metaphor-made-visible'. Through metaphorical scenes, some derived from mythology, she evolved an imagery which showed the multiple roles assumed by women. Influenced by Goya and Beckmann, she produced images of Siamese-twin women carrying out contradictory tasks, of Adam and Eve and several themes from Greek mythology, including the Fates and Pandora. Finding sympathy for her ideas among members of the women's art movement in London in the 1970s, Morreau also became one of the organisers of the first exhibition of feminist art in an establishment gallery in England. *Women's images of men* was held at the ICA in the autumn of 1980, and four years later the same group organised a touring exhibition of the work of women artists on the theme of Pandora's box. In addition Morreau has taken part in other exhibitions, but her concern with woman as her subject remains fundamental.

*Publications:* various essays in S. Kent and JM, *Women's images of men*, London, 1985, and *Pandora's Box*, Arnolfini G, Bristol, 1984; *JM: drawings and graphics*, Metuchen, NJ & London, 1986, with introduction by S. Kent.

*Literature:* S. Kent, *Paradise lost: an exploration of Greek myth*, Ikon G, Birmingham, 1983; S Kent, *Power plays*, 1984; *Women's images of men*, ICA, London, 1980.

## MOSES, Anna Mary. née ROBERTSON. (alt. GRANDMA MOSES) (1860–1961)

*American naive painter of landscapes*

Moses is an almost legendary figure, but it is difficult to believe that all her paintings were produced in her old age when arthritis made it impossible for her to continue working on the farm. Although she had painted as a child in Greenwich, New York, her creativity was subsumed into the decoration of her home during the period when she was bringing up her five surviving children (five others did not outlive infancy). Her early married life was spent in Virginia, but later the family returned to a small village in New York State. After her husband died and her children took over the farm in the 1930s, Moses found herself with time to spare and began to produce pictures in embroidery before taking up painting, in which she was strongly encouraged by her sister and children. Apart from a few private collectors, it was some years before major galleries realised the quality of the work of this self-taught woman. She then became something of a cult figure, appearing on television and meeting President Truman, and

**Jacqueline Morreau** *Three ages of Psyche*, oil on canvas, private collection. (photo: courtesy of Odette Gilbert Gallery, London)

was persuaded to write her memoirs. In her paintings she captured the traditional rural activities and the landscape in different seasons and weather.

*Publications: My life's history*, New York, 1952.

*Examples:* Metropolitan Mus., New York; Phillips Collection, Washington, DC.

*Literature:* Bachmann; *DWB*; J. Humez, 'The life and art of AMRM', *WAJ*, v1/2, fall 1980-winter 1981, 7–12; O. Kallir, *GM*, New York, 1973; *Notable American Women*, v4; Withers, 1979.

## MOSS, Marlow. (pseud. of Marjorie Jewell MOSS) (1890–1958)

*English painter of geometric abstract canvases and some reliefs in a style influenced by Mondrian*

Moss was born into an upper-class family in Richmond, Surrey, but the early loss of her father rendered family relationships permanently difficult. A talented musician, she suffered from tuberculosis, which entailed a period of inactivity. After

her recovery she attempted dance and then decided on painting but her family would allow her to be only an amateur. She left home and spent a year at the St John's Wood School of Art in 1916–7 before moving to the Slade. This she found too traditional and left in 1919 to live in solitude in Cornwall, away from distressing family communications. The chance discovery of a biography of Marie Curie changed her outlook, and in 1926 she returned to London, altered her appearance, style of dress and her name to denote a new start to her life. Her paintings from this period are a mixture of Impressionism and Cubism. She read widely, notably in philosophy, and in 1927 she decided to settle in Paris. After seeing the work of Mondrian that year, she tried to discover mathematical means of co-ordinating light, space and movement in a composition. She met him in 1929 and continued to do so regularly until he left Paris in 1938. She also studied with Amédée Ozenfant and Léger. From this time, she adhered to straight lines, limited colours and non-objectivity. She regarded light as an important source of energy, wishing to incorporate it into her paintings. She often used many layers of very thin white paint in order to obtain a luminous surface. In 1930 she introduced the double line to bring about a greater dynamism and to enrich the spatial relationships. Mondrian adopted this in some of his works from 1932. In order to retain elements of construction, she began in 1935 to add materials such as linen and wire to build up a relief effect, still in white. She returned to England in 1940 from Holland, where she had been at the outbreak of war, and settled again in Cornwall, where she remained until her death, although after the war she spent part of each year in France. Returning to the use of black lines in her paintings, she found that the study of architecture suggested the construction of metal reliefs. Some of these resemble her geometric paintings, but others contain curves derived from Max Bill's continuous loop and the works of Jean Arp. Her paintings contained more colour and the use of black diminished from about 1950. She exhibited regularly in France and England and had further solo shows in Zurich and New York. Since her death, several retrospectives have been held.

*Examples:* Tate G, London.

*Literature: Abstraction-Création 1931–6*, Mus. de la Ville de Paris, 1978; G. Greer, *The Obstacle Race*, London, 1979; Harris; *MM*, Stedelijk Mus., Amsterdam, 1962; *MM*, G Gimpel & Hanover, Zurich, 1973; Nottingham, 1982; Vergine.

## MOWBRAY, Joanna (1955–)

*English abstract sculptor who uses metal mesh*

Born in Kent, Mowbray obtained her BA from Exeter College of Art and her MA from Reading University in 1978. Since then a series of awards and fellowhips have enabled her to evolve clear simple, often geometrical, structures in metal mesh. She chose this material because it is both strong and open, veiling rather than dividing so that the sculpture is integrated into its location. She has been exhibiting since 1979, and many of her works are intended for outdoor locations.

*Examples:* Yorkshire Sculpture Park, West Bretton, Wakefield; Huddersfield.

*Literature: Outdoor sculpture*, Castle, Lincoln, 1986.

## MUCCHI-WIEGMANN, J.
## See WIEGMANN, Jenny

## MUKHINA, Vera IGNAT' EVNA (1889–1953)

*Soviet sculptor of figures and portrait busts in stone, bronze, steel and glass*

Born in Riga, she studied in Moscow before spending two years in Paris working under Bourdelle from 1912 to 1914. She also travelled in Italy. After the revolution she returned to Russia, where she participated in the state monumental propaganda project, under which statues and busts of the tsar and nobility were replaced by those of revolutionaries of all countries and periods. Her figures of workers and peasants showed great vigour and strength. However, she was extremely versatile for not only did she teach (1924–30) but also worked for the theatre, wrote about the theory of art and headed teams of sculptors working on, for example, some of the decorations on the tower building of Moscow University. Another collaborative work was a monument to the writer Maxim Gorky, on which she worked with two other women sculptors. In addition to her portrait commissions, a number of her works depict strong women, such as the *Woman partisan* sculpted during World War II, and the most familiar of her works, *Worker and woman collective farmer*. This 75-metre-high stainless steel sculpture was origin-

ally carried out for the Soviet pavilion at the Paris World Fair of 1937. It was adopted as the logo for the largest state-film studio and appeared at the beginning of each of its films and was thus familiar to millions of people who normally had little contact with art. Mukhina was married to the architect, Zamkov. She was heaped with honours: the Stalin prize five times, full membership of the Soviet Academy of Arts in 1947, and she bore the title People's Artist of the Soviet Union from 1946, to name only some.

*Examples:* Russian Mus., Leningrad; Tretyakov G and Permanent Fair site, Moscow.

*Literature:* R. Abolina, *VIM*, Moscow, 1954; W. Mandel, *Soviet women*, New York, 1975; A. Zotov, *M*, Moscow & Leningrad, 1944.

## MUNSKY, Maina Miriam (1943– )

*German hyper-realist painter who uses art to make social comments*

After studying initially at the School of Art in Braunschweig (1960–4), Munsky spent three years in Florence, before returning to gain her master's degree in Berlin (1967–70). She is married to the painter, Peter Sorge. Since 1967 she has dealt with the theme of medical operations. Many of the patients are women and an early series concerned birth. Following this were other types of operation, such as *Heart operation*, in which the cold blue tones and blank background indicate the subordination of the human being to technology.

*Examples:* Berlinische G and Neuer Berliner Kunstverein Artothek, Berlin.

*Literature: Das Verborgene Museum;* Krichbaum.

## MÜNTER, Gabriele (1877–1962)

*German Expressionist painter of landscapes and interiors*

The youngest of several children, Münter was born in Berlin. She soon tired of the Women's Academy in Düsseldorf, at which she had enrolled in 1897, so spent the next three years travelling in America, drawing her relatives and the scenery. Her parents had earlier emigrated to America but returned to Germany on the outbreak of the civil war. Since her mother's death in 1898 had left her with a private income, she decided to take up art.

Denied access to the Academy in Munich because of her gender, she began to attend Kandinsky's class at the Phalanx School. There she was taken seriously and her talent acknowledged and guided. With Kandinsky she travelled through Europe from 1903 to 1908, and during a two-year stay in France they were particularly struck by exhibitions of Gauguin's work and of that of the Fauves. By the time they settled in Murnau, in a house purchased by Münter for their summer retreats from the city, Münter had evolved her own style. Although Kandinsky had taught her how to execute paintings rapidly and how to use a palette knife, she introduced influences such as her collection of Bavarian behind-glass painting, and in general took a lower and often closer viewpoint to her subjects than did Kandinsky. She also worked closely with two other Russian artists, Von Werefkin (*q.v.*) and Jawlensky, who like her retained an interest in content, while Kandinsky moved towards abstraction. Münter's work has suffered from her close association with Kandinsky, for she has primarily been seen as a mere follower, an interpretation which fails to examine the precise sequence of events. The relationship with Kandinsky began to deteriorate shortly before World War I and the definitive break came in 1916, after which she painted little until the late 1920s, when she was encouraged by her new partner, intellectual Johannes Eichner. Working covertly under the Nazis, she promoted the work of Der Blaue Reiter (the Blue Rider group) from 1945 until her death.

*Examples:* Nat. G, SMPK, Berlin; GM Foundation and Municipal G, Munich; NMWA, Washington, DC.

*Literature:* Bachmann; A. Comini, 'State of the field 1980; the women artists of German Expressionism', *Arts Mag.*, v55, Nov. 1980, 147–53; *Das Verborgene Museum;* Fine, 1978; Harris; Heller; NMWA catalogue; Petersen; Vergine.

## MURPHY, Catherine (1946– )

*American realist painter of city scenes and figures*

Murphy was born in Lexington, Massachusetts, her father being an Irish musician who worked in a post office to support his family. From her training at the Pratt Institute (1963–7) she learnt to admire painters such as Van Eyck and Vermeer, and to work minutely over a surface. She then studied at the Skowhegan School of Painting

and Design. While at Pratt she met her husband, realist sculptor Harry Roseman, and they have supported each other's careers. Soon after Murphy was discovered by the feminist curator June Blum in 1971, her work became sought after and at the age of 30 she was given a retrospective. She works from nature, beginning her canvases with broad sweeps of paint, using increasingly finer brushes to work up the detail. Her subjects derive from the areas in which she has lived – Hoboken, Jersey City, Lexington and upstate New York – but they possess a mysterious, enigmatic quality which has been likened to that of Edward Hopper. Her figures, which include groups of her relations, are placed in an atmosphere almost of isolation from each other, although they are apparently ordinary people together in their gardens.

*Examples:* Hirschhorn Mus. and Phillips Collection, Washington, DC.

*Literature:* J. Gruen 'C.M.: the rise of a cult figure', *ARTnews*, Dec. 1978, 54–7; *CM*, Phillips Collection, Washington, DC, 1976; Rubinstein; Withers, 1979.

## MURRAY, Elizabeth. née HEAPHY (1815–1882)

*English watercolour painter of figure scenes based on her wide travels, who spent the later part of her life in America*

The daughter of Thomas Heaphy, court painter to George IV and president of the Society of British Artists, Elizabeth Heaphy was encouraged to draw from an early age. Under the instruction of her father she had access to anatomical figures and casts at home, but her talent was also considerable, so that while in Rome with her father, a brilliant future was predicted for her by Horace Vernet, then director of the French Academy in Rome. Firsthand knowledge of the works of Titian and Tintoretto in Venice increased the richness of her colouring. By the time her father died in 1825, she had already acquired a considerable reputation and led an independent life. A commission from Queen Adelaide, the wife of William IV, which required a visit to Malta, began her life of travel. Her scenes of Greek and Spanish life are interspersed with portraits of several royal families and aristocrats. In 1851 she married Henry Murray, then British Consul in Gibraltar, and accompanied him on a succession of postings, including that to Maine in 1864/5. During their 12-year stay

there, Murray set up a studio and became well known. Clayton asserts that she 'practically introduced watercolour painting of the modern school into the United States'. Her style was dashing and vigorous, but highly finished. She became best known for her Spanish themes, but she also wrote a book on painting and made much acclaimed visits to New York and Boston. She became a member of the Royal Watercolour Society in 1861 and later a member of the American Society of Watercolor Painters. She seems to have had many patrons, but few of her works can currently be located.

*Publications: Sixteen years of an artist's life*, London, 1859.

*Literature:* Clayton; Clement; Ellet; Mallalieu; P. Nunn, *Victorian women artists*, London, 1987; *Women pioneers in Maine art*, The Joan Whitney Payson G, Westbrook College, Portland, Me., 1981; Wood, 1978.

## MURRAY, Elizabeth (1940–)

*American abstract painter and printmaker*

Born in Chicago, Murray was brought up in Bloomington, Illinois. Her interest in art was encouraged both by parents and teachers, but the catalyst for her decision to become an artist was seeing a still life by Cézanne. She studied at the Art Institute, Chicago, and then pursued postgraduate studies at Mills College, Oakland, California, gaining her MFA in 1964. Her experience there as printmaking assistant enabled her to set up a print workshop while teaching in Buffalo, NY, before settling in New York in 1967. By the early 1970s she was depicting small forms repeated throughout the painting. Through the transitional phase of all-over wavy line paintings, Murray came to abstraction by 1974, beginning a series of rough-textured, softly coloured geometrical works, some of which were bisected to create a sensation of shifting space. The building up of texture through layers of compacted oil paint led to parts of the canvas being made to project into space, so that by the late 1970s the paintings resembled reliefs and were no longer a regular shape. Areas of different colour formed shapes which resembled objects in the visual world in the eye of the spectator. Her combination of line, surface, shape and colour became increasingly diverse and complex through the 1970s. Since 1980 she has produced both paintings and prints, some of her boldly col-

oured, gestural lithographs containing references to household items such as cups and fantastic figurative shapes.

*Literature:* R. Cohen, 'EM's colored space', *Artforum*, v21, Dec. 1982, 54; P. Gardner, 'EM shapes up', *ARTnews*, v83, Sept. 1984, 50–1; P. Gardner, 'When is a painting finished?' *ARTnews*, v84, Nov. 1985, 97; *Graphic muse*; Heller; C. Robins, *The pluralist era*, New York, 1984.

## MUTRIE, Annie Feray (1826–93) and MUTRIE, Martha Darley (1824–85)

*English painters of flowers and fruit*

Both sisters were born in Manchester, and first trained at the school of design there under George Wallis. Annie exhibited at the RA from 1851 and her sister from 1853. In the following year they both settled in London, where they established a considerable reputation in their particular field; they had many patrons, and the writer and critic John Ruskin admired their work. Neither married but they generated income from sales of their paintings. Annie's first exhibit, sold in 1851 for £20, fetched 70 guineas in 1863. Both sisters exhibited at the Philadelphia Centennial Exposition in 1876.

*Examples:* V & A, London; gallery of the Public Library, New York; Preston, Lancs.

*Literature:* Clayton; C. Clement and L. Hutton, *Artists of the nineteenth century*, 1879; Nottingham, 1982; P. Nunn, 'Ruskin's patronage of women artists', *WAJ*, v2, fall 1981-winter 1982, 8–13; P. Nunn, *Victorian women artists*, London, 1987; S. Tytler, *Modern painters*, London, 1873; Wood, 1978.

## MYERS, Ethel. née May Ethel KLINCK (1881–1960)

*American sculptor of small genre figures in bronze*

An adopted child, Ethel Klinck trained as a painter at the Chase School and the New York School of Art from 1898 to 1904. A New Yorker, she took the life of the streets of Lower East Side as her subject matter from the start. Not surprisingly she admired the city scenes painted by artists who would later be known as the Ash Can School and through a common interest in urban realism she met and, in 1905, married painter Jerome Myers. It was only then that she began to produce sculpture, since their studio was too small for two painters. She modelled statuettes in bronze, terracotta and plaster of caricatures of New Yorkers, particularly fashionable women, which are at the same time monumental. Like Abastenia Eberle (*q.v.*), she succeeded in evolving a sculpture capable of social commentary parallel to the two-dimensional work of artists such as Henri and Sloan. Whatever the social class of her subject, Myers depicted their clothes in broad energetic sweeps. She was one of the organisers of the Armory Show in 1913, and nine of her sculptures were exhibited there. Her work was also displayed in several major museums. Although there are divergences in the accounts of her later life, she seems to have then abandoned art for fashion design, possibly to support her family financially, although she resumed it in the 1930s, retiring in 1959. After the death of her husband in 1940 she undertook lecture tours from 1941 to 1943 to promote his work and ran a memorial gallery in New York.

*Literature:* Rubinstein; R. Tarbell, 'The impact of the Armory Show on American sculpture', *Archives of American Art J.*, v18/2, 1978, 2–11; A. Wolf, *New York Society of Women Artists*, ACA G, New York, 1987.

## NEEL, Alice (1900–84)

*American expressionist painter of portraits, figures and landscapes*

Neel was born in Merion, Pennsylvania, but her childhood was restricted by the discipline of her mother and by the lack of opportunity in the small town of Colwyn, where she was brought up. Although she had wanted from childhood to be an artist, her awareness of the precarious nature of the family finances led her to become a civil servant working for the air force. During those three years (1918–21) she attended evening classes at the School of Industrial Art, before enrolling at the Philadelphia School of Design for Women for four years; scholarships paid her fees after the first term. From 1925 her personal life came to the fore with her marriage to a wealthy Cuban, the birth of two children, one of whom died when a few months old, and the departure of her husband for a new life in Paris. For well over a year she was in a mental hospital, returning to painting

as a means of regaining her equilibrium. The paintings and drawings of this time are expressionist in form and content – impoverished mothers, malnourished children, fellow psychiatric patients – and have been likened to those of Munch and the German Expressionists in the distortions resulting from her own feelings. During the 1930s she was employed from time to time on government art projects but even then her painfully truthful paintings were unpopular. Over 60 paintings and 100 drawings from this period were destroyed by a jealous lover, and after some years in Greenwich Village in New York, Neel moved to Harlem where she remained for 25 years. During this period she had two sons, but persisted resolutely with her depiction of society though its people. Her images of pregnant women are among the few which show the true discomforts of this condition. Not flinching from the honest depiction of the effects of poverty and disease, her painting *TB Harlem* has been called a modern crucifixion. By revealing the effects on one individual of the disease then rampant in Harlem, she wanted to draw attention to the conditions in which all the people there were living. Her strongly figurative work was out of favour during the heyday of abstraction, but Neel continued to work until recognition belatedly arrived during the 1960s. From that period date many of her portraits of New York intellectuals such as art historian, Linda Nochlin. She was a ready convert to the burgeoning women's movement, which campaigned for her first solo show at a major museum, in this case the Whitney. Cited by Ann Sutherland Harris in 1977 as the most underrated American artist and the finest portraitist of the century, Neel was independent of styles and fashions, decreeing that life was her theme.

*Examples:* NMWA, Washington, DC.

*Literature:* Bachmann; Fine, 1978; Harris; Heller; P. Hills, *AN*, New York, 1983; Munro; *AN: the woman and her work*, Georgia Mus. of Art, Athens, Ga., 1975; NMWA catalogue; Petersen; Rubinstein.

# NEVELSON, Louise. née BERLIAWSKY (1899–1988)

*Russian-born American sculptor of abstract works in wood, steel, plexiglass and aluminium*

Nevelson was born in Kiev, but her Jewish family emigrated to America in 1905, and settled in Rockland, Maine. Her father's businesses in lumber and property were successful, and her parents encouraged the developments of her talents. By the age of nine she had already decided to be a sculptor, but in 1920 she married a New York businessman, thinking this would provide her with a means of escape. Her son was born in 1922 but the marriage was not a success. She began to attend the Art Students' League, New York, in 1929, and in 1931 made the difficult decision to leave her son with her family in order to attend Hans Hofmann's school in Munich for some months. On her return she separated permanently from her husband, sold her jewellery and spent a short time in Paris looking at the work of Picasso and at African sculpture. In 1933 she worked as an assistant to Diego Rivera, and through his wife, Frida Kahlo, she discovered Pre-Columbian art. In the 1930s she led a poverty-stricken existence with her son (who later became a sculptor) and achieved her first solo show in 1941. Soon after this she began to assemble sculpture from found objects made of wood, ten years before anyone else considered assemblage. Another period of obscurity followed the death in 1948 of the gallery owner who had supported her work for seven years. At this period she knew many of the artists who were working on the early Abstract Expressionist works, many of whom, like Lee Krasner (*q.v.*), were also immigrants. Her wooden assemblages based on a box format on to which other items were attached began to assume their now familiar form in the late 1950s. The possibility of stacking these into new large-scale constructions came to her and in her next show she painted all the forms matte black, so that the objects lost their original context. A series of works in white followed, including a commission for a church in Manhattan. Recognition came in many forms from the 1960s, but Nevelson broadened out into new materials such as steel. These are the only works for which she may require a preliminary model. Still active well into her eighties, there was an unofficial Nevelson festival in New York for her 80th birthday. Over the years she experienced many setbacks but her persistence resulted in the fact that she received more commissions than any other American sculptor.

*Publications:* LN *atmospheres and environments*, New York, 1980 (annotated bibl.).

*Examples:* Nat. G, SMPK, Berlin; Birmingham, Ala.; Art Institute, Chicago; Cleveland, Ohio; Dallas; Detroit; Nat. G of Modern Art, Edinburgh; Grenoble; Tate G, London; Los Angeles; Montreal; Guggenheim Mus., Metropolitan Mus., MOMA,

Whitney Mus., St Peter's church, Citicorp Center and LN Plaza, New York; Mus. d'Art Moderne, Paris; Kröller-Müller Mus., Otterloo; Rotterdam; St Louis; Corcoran G and Hirschhorn Mus., Washington, DC.

*Literature:* Bachmann; *Das Verborgene Museum*; *DWB*; Fine 1978; J. Lipman, *N's world*, New York, 1983 (bibl.); Munro; Petersen; Rubinstein; Watson-Jones; Withers, 1979.

## NEVINS, Blanche (alt. NEVIN) (1841–1925)

*American sculptor of monumental idealised figures and portrait busts*

Although Nevins was well known in her own day, many biographical details are now missing. A native of Philadelphia, she trained with Joseph Bailly and at the Pennsylvania Academy. She then apparently went to Venice. She was represented by two sculptures, prominently displayed, at the 1876 Centennial Exposition in her home city. These were life-size figures of *Cinderella* and *Eve*. She was active again in the preparations for the 1893 Chicago Exposition, being unsuccessful in the competition, which was won by Alice Rideout (*q.v.*), for the decoration and figures for the exterior of the Women's Building. Nevins described how her design showed woman evolving from her ancient bondage to the advanced ideas of the nineteenth century. However, her statue of *Maud Muller*, based on a poem by John G. Whittier, was exhibited.

*Examples:* US Capitol, Washington, DC.

*Literature:* C. Clement and L. Hutton, *Artists of the nineteenth century*, 1879; M. Elliott; Rubinstein; Weimann.

## NEWCOMB, Mary (1922–)

*English painter of poetic rural scenes and wildlife*

Born in Harrow, London, Newcomb graduated in natural sciences from Reading University in 1943, and taught in schools until her marriage in 1950 to Capt. Godfrey Newcomb. While bringing up her two daughters on a Norfolk farm, she began to paint and exhibit in local galleries in Norwich from 1953. Entirely self-taught, she brought her scientist's eye for observation to incidents around her in the countryside. Yet although precisely observed, her works were thinly painted understatements, visionary in the arbitrariness of scale, yet conveying a feeling of spontaneous pleasure in the observation of nature. Minor episodes such as *Very cold birds: one has just flown away and knocked the raindrops off* or *Small bridges are steeper than they look* lie in an essentially English tradition of painting, and in this respect she might be linked with Mary Potter (*q.v.*). Since having her first solo show in London in 1970, she has exhibited regularly in many countries.

*Literature: MN*, Crane Kalman G, London, 1982 and 1986.

## NEY, Elizabet. née Franzisca Bernardina Wilhelmina Elizabet NEY (1833–1907)

*German-born sculptor of figures – literary, historical and mythological – and portraits who lived in America for the second half of her life*

Born in Münster, Westphalia (then in Prussia), Ney was the daughter of a stonecutter and mason. When only eight, she determined to be a sculptor. Denied the chance to study in Protestant Berlin by her Catholic parents, she attended the Royal Bavarian Academy in Munich, provisionally at first as was the case for all women students, and from March 1853 as a regular student. She was ambitious and held strongly feminist views. Two years later came the chance to study with Rauch in Berlin, and the two years spent there brought her into contact with many famous people. During this period she met and fell in love with Edmund Montgomery, a Scottish medical student. Because of her opposition to marriage, it was only in 1863 that they were married, by which time each had become established in their respective professions. Ney retained her own name and refused to admit she was married, preferring the social stigma of an irregular liaison. While this was tolerated in Italy, where she worked in the mid-1860s, it was much more difficult when in 1867 she was summoned to Munich as court sculptor to Ludwig II of Bavaria. Hostile rumours about her relationship with Montgomery and a possible political intrigue caused them to flee to America late in 1870. Two sons were born in 1871 and 1872, but only the second survived. In 1873 they settled in Texas, and Montgomery devoted himself to his philosophical writings. Ney was an enthusiastic but eccentric mother, and there was a complete

rupture between her and her son when he grew up. She began to take up sculpture again and her first commissions came in 1890, for the Texas exhibit at the World's Columbian Exposition at Chicago in 1893. She actively campaigned for further work and was largely successful, receiving in 1901 $26,500 for four major sculptures, destined for the state Capitol and for Washington, DC. She made triumphant visits to Germany in 1902 and 1903, where she completed *Prometheus bound*. Her income enabled her to finance two long-standing ambitions: the publication of her husband's books and the execution of a statue of *Lady Macbeth* (1905), her literary heroine. Frequent visitors to her home included Caruso, Paderewski and Pavlova. She kept her hair short and wore a trouser-like garment when working in her studio, characteristic of her lifelong courage and strength of character.

*Examples:* EN Museum, Austin, Tex.; Berlin; Houston, Tex.; Munich; Ständehaus, Münster; Capitol and NMAA, Washington, DC.

*Literature:* Bachmann; E. Cutrer, *The art of the woman: the life and work of EN*, Nebraska, 1988; J. Fortune & J. Burton, *EN*, New York, 1943; A. Garrihy and P. Nunn, 'Woman, sculpture and heroism in the 19th century', *Feminist Art News*, v2/2, May 1985, 14–18; M. Goar, *Marble dust: the life of EN: An interpretation*, Austin, 1984; Heller; V. Loggins, *Two Romantics and their ideal life*, New York, 1946; *Notable American Women*; Rubinstein.

## NIATI, Houria (1948– )

*Algerian-born painter in oil and pastel of semi-abstract images who lives in London*

Niati was born in Khemis-Miliana, where her father worked as a landscape painter. She first obtained a diploma in community work in 1969 from the National School at Tixeraine. Over the next seven years, she worked for the Ministry of Youth, running workshops in her specialist subjects of art and music, and travelling to other North African and some European countries. After settling in England in 1977, she studied at Croydon College of Art from 1979 to 1982. Unable to afford to work anywhere other than her small bedroom, in 1982 she executed a series of large drawings in pastel. In vibrant colours she depicted imagery from her cultural heritage, informed also by Surrealism. In order to maintain spontaneity

she never makes preparatory drawings and any mark made on the paper becomes part of the final work, thus allowing for the element of chance. Philosophical ideas about the purpose of life and the fear of nuclear war also inform her work. She has exhibited frequently since 1983.

*Literature:* C. Drake, 'HN – paintings and pastels', *WASL J*, June–July 1988, 22; *1984–8 paintings and pastels by HN*, The Open Space, London, 1988.

## NICHOLSON, Winifred. née Rose Winifred ROBERTS (alt. DACRE) (1893–1981)

*English painter who explored the possibilities of light and colour through flower studies and landscapes*

Born into an aristocratic, cultured and artistic family, Winifred Roberts was brought up surrounded by many paintings of her great-grandmother, Mary Parke, on the walls of Castle Naworth in Cumberland and Castle Howard in Yorkshire. She therefore received nothing but encouragement in her wish to practise art, and exhibited an architectural watercolour at the RA in 1914 after she had attended the Byam Shaw School of Art for about four years. After war work making plaster casts for replacement limbs, she returned for a further period in 1918–19. A visit to India with her sister and uncle caused her to use violet in order to create space in her painting. This derived from the observation that 'Eastern art uses lilac to create sunlight'. During a visit to Oxford in 1919 she met the modernist artist Ben Nicholson, and they were married in London late in 1920. For their honeymoon they travelled to Italy, where they returned each year for several months from 1921 to 1924. A joint exhibition with Ben in 1923 was her most important show to date. Noted by the critics were her flowers on a window-sill with a view of the mountains, which was held together chiefly by colour harmonies. In 1923 Winifred and Ben bought a old farmhouse at Bankshead, Cumbria, which was to be Winifred's home for the rest of her life. Membership of the 7 & 5 Society from 1925 (Ben became chairman in 1926) brought Winifred a London outlet for her work and widened her circle of artistic friends. Through meeting Christopher Wood, Winifred and Ben went to St Ives in 1928, taking their first child, a son, born in 1927. A daughter was born in 1929 and a second boy in 1931, the year in which Ben left to live in London with Barbara Hepworth (*q.v.*). In addition

Christopher Wood, to whom she had been close, was killed in 1930. From this period when she was a highly respected member of the artistic community, Winifred's life became very difficult. She spent 1932–8 based in Paris with her children, although she went for part of each spring to Cannes, and spent the summer and autumn in Cumbria. This provided her with three distinct sets of light and colour throughout the year. In Paris she knew many modernist artists and was tempted into experimentation with abstraction, often using the oval or ellipse shape, and from 1935 to 1945 she exhibited these as by Winifred Dacre (a family name). She contributed an essay on colour to the publication *Circle* in 1937 in response to a request from Naum Gabo, who with Ben Nicholson and J.L. Martin edited it. This was the first article she wrote about her colour research. During the war she remained mostly in Cumbria, but in 1946 showed 40 paintings in a two-person show. Despite the demands of her children and her now elderly parents, she made time to visit Scotland with the poet Kathleen Raine. They usually went to the Orkneys or the Hebrides, for up to two months, for the quality of the light. Nicholson preferred light to shine through objects, to be dispersed and reflected, an effect which was most pronounced near stretches of water. Seascapes entered her repertoire through these visits, although frequently seen beyond the still life on the window-sill. In the 1960s a number of journeys to southern Europe, particularly to Greece with her artist daughter, Kate, occasioned a different set of colours from her earthy Scottish palette. In 1976 her investigation of light led her to purchase two prisms, through which she would look to find motifs for painting, discovering a spectrum of colour lying at the edge of objects which was not normally visible to the naked eye. As a result she began to plan a book about colour theory, which remained incomplete at her death, at which time she was still painting. A recent retrospective revealed the extent to which her contribution to abstract art and her use of colour had been overlooked.

*Publications:* Complete list in Tate G catalogue – see *Literature.*

*Examples:* Aberdeen; Bristol; Kettle's Yard, Cambridge; Nat. Mus. of Wales, Cardiff; Tate G, London.

*Literature:* J. Collins, *WN*, Tate G, London, 1987 (full bibl. and list of publications); Nottingham, 1982.

## NICZ-BOROWIAK, Maria (1896–1944)

*Polish artist producing paintings and reliefs influenced by Cubism*

While training at the Academy in her native city of Warsaw, she experimented with various modernist styles. Her entry into the Blok group, with whom she exhibited regularly, was marked by a stronger adherence to the principles of Purism, in which recognisable objects were depicted in a style deriving from Cubism. Her reliefs developed from a desire to enrich the surface of the painted geometrical forms, by gluing on natural materials, usually wood. These would be cut into the shape required rather than introducing further compositional elements. The architectonic implications of her reliefs were expanded by her involvement in theatre design and later, some architectural projects. A serious illness and family problems meant that she produced no art after 1930.

*Examples:* Lodz.

*Literature:* Vergine.

## NIERIKER, M. See ALCOTT, May

## NILSSON, Vera (1888–1978)

*Swedish Expressionist painter*

Born in Jöngköping, she was a pupil at the Technical School in Stockholm from 1906 to 1909 and then studied under Carl Wilhelmsson. Like many Scandinavian artists she spent some time in Paris, returning home in 1912. She began exhibiting in 1917, and by 1922 was invited to join the Phalanx group, in which there were few women members. She lived an unpretentious and reclusive existence, exhibiting only occasionally. Her style, however, is intense, with vibrant colours and the ability to capture a range of moods. Her treatment of the landscape gave the traditional genre a sense of foreboding and gloom, and of her political works, *Money against life*, painted during the Spanish civil war, was hailed as the Swedish *Guernica*. She was elected to the Swedish Academy in 1954, the first woman to be so honoured since 1889.

*Examples:* Skövde; Stockholm.

*Literature:* I. Ingelmann, 'Woman artists in

Sweden', *WAJ*, v5, spring-summer 1984, 5; *Kvinnor som malat*, Nationalmuseum, Stockholm, 1975.

## NISBET, Noel Laura (1887–1956)

*Scottish painter and illustrator of legendary, mythological and imaginary scenes*

Although Nisbet was born in Harrow, her parents were Scottish. Her father had taught art in Edinburgh before turning to writing, so Nisbet was encouraged in her choice of career and sent to the Clapham School of Art, where she carried off a host of awards. While there she met Harry Bush, whom she married in 1910. She began exhibiting at the RA in 1914, but during World War I she turned to the illustration of books, which brought her considerable renown. She excelled at illustrations to imaginative stories of all kinds, whether from Norse legends, Greek mythology or fairy tales. Her style and colouring were derived from the Pre-Raphaelites, with whom she also shared a love of medieval subjects. She was elected a member of the Royal Institute of Painters in Watercolour in 1926, exhibited extensively in London, the provinces and Canada, and among her private patrons was the Prince of Siam.

*Publications:* Works illustrated by NN include *Russian fairy tales*, 1915; *Cossack fairy tales*, 1916; *The world's heritage*, 2 vols, 1918 and 1919.

*Examples:* Bournemouth; Newport, Gwent.

*Literature: The last romantics: the romantic tradition in British art. Burne-Jones to Stanley Spencer*, Barbican G, London, 1989; *Memorial exhibition of Harry Bush (1883–1957) and NLN*, Leighton House, London, 1969.

## NORDGREN, Anna (1847–1916)

*Swedish painter of interiors, often of simple peasant homes, genre and portraits*

Born in Mariestad, she studied at the Stockholm Academy and at the Académie Julian in Paris in the late 1870s. There she was a contemporary of Marie Bashkirtseff (*q.v.*), of whom she painted a portrait in 1879. From 1880 until 1900 she worked in London, sharing a studio with the Canadian artist, Sophie Pemberton. It is not known exactly when she first exhibited, but her work appeared regularly at the Swedish Artists' Association in Göteborg from 1886, and in Paris in 1900 with the International Women Artists' Club.

*Examples:* Helsinki; Mus. Chéret, Nice; Stockholm.

*Literature: AJ*, 1900, 282–3; Schurr; *Kvinnor som malat*, Nationalmuseum, Stockholm, 1975.

## NØRREGAARD, Asta Elisa Jakobine (1853–1933)

*Norwegian painter of female figures in interiors, religious subjects and portraits*

A native of Oslo, she trained initially in the Berglien Art School in 1874–5, before becoming a pupil of Eiliff Petersson in both Munich and Oslo between 1875 and 1879. A scholarship enabled her to go to Paris in 1879, where she studied at the Académie Colarossi and at Mme. Trélat de Lavignes' Ladies' Studio. During her six-year stay in Paris, she exhibited from 1881 at the Salon. Her early subjects were religious compositions, which brought her a number of commissions in her native country. During the 1880s she loosened her brushstroke and produced a number of atmospheric interiors containing women reading or, in one notable example, a woman artist in her studio. These are reminiscent of the works of Backer (*q.v.*), but during the next decade portraits of the upper middle classes formed an increasing proportion of her output. She worked in both oil and pastel. Continuing to exhibit extensively she travelled to Italy in 1889–90, had several solo shows from 1893 and continued to work until at least the late 1920s.

*Examples:* Nat. G, Oslo; Trondheim.

*Literature:* A. Wichstrøm, *Kvinner ved staffeliet*, Oslo, 1983.

## NORTH, Marianne (1830–90)

*English painter who travelled the world to paint flowers in their natural habitat*

Her father, who came from a wealthy East Anglian background, was MP for Hastings, Kent, where

she was born. From childhood she drew flowers and remained predominantly self-taught, apart from a few lessons with Miss van Fowinkel and Anne Bartholomew's (*q.v.*) husband, Valentine. She travelled in Europe with her parents between 1847 and 1850. After the death of her mother in 1855, she and her father retained a London flat but spent much time in Europe and visited Syria and Egypt. When her father died in 1869, North was left with an income which guaranteed her independence and she determined to travel further afield. The rest of her life was spent on a series of journeys which covered many countries. She produced large numbers of paintings of native flowers in their natural surroundings and also wrote accounts of her experiences. By 1880 so many people wished to see her works that she rented a room in which to exhibit them. As a result of the demand she offered to build a gallery to house them and to give the paintings to the Royal Botanical Gardens at Kew in London. This opened in 1882 and within a month 2,000 copies of the catalogue had been sold. A further room was added in 1883. At the suggestion of Charles Darwin she went to Australia to record its flora, and there were few areas of the world where she did not venture, making her one of the most intrepid travellers of the Victorian era. She spent the last four years of her life quietly in Alderley, Gloucestershire, her health having deteriorated as a result of her travels. She introduced five species of plants to Europe and these are named after her. Although she wanted to record plants, she remains a flower painter rather than a botanical illustrator.

*Publications: Recollections of a happy life, being the autobiography of MN*, edited by her sister, Mrs John Addington Symonds, 2 vols, London, 1892; *Some further recollections of a happy life, selected from the journals of MN chiefly between the years 1859 and 1869*, edited by her sister . . . , London, 1893; *A vision of Eden: the life and work of MN*, Kew, Exeter, & New York, 1980 [selections from journals with a biographical chapter].

*Examples:* MN Gallery, Kew Gardens, London.

*Literature: AJ*, 1890, p.320 (obit.); *DNB*; M. Dickens, 'MN', *Cornhill Mag.*, no.1031, spring 1962, 319–29; *Mag. of Art*, 1882, 22; D. Middleton, *Victorian lady travellers*, London, 1965, 54–7; B. Moon, 'MN's Recollections of a happy life: how they came to be written and published', *Journal of the Soc. for the bibliography of natural history*, 8/4, 1978, 497–505.

# NOURSE, Elizabeth (1859–1938)

*American-born painter of European, particularly Breton, peasant life, figures and landscapes in oil, watercolour and pastel who lived in France*

The youngest of ten children, she was born near Cincinnati, coming from a family of Huguenot descent, although her parents had been converted to Catholicism. Her parents lost their money in the civil war, and Nourse was fortunate in the circumstances to have been well educated in art from an early age. In 1874 she enrolled at the McMicken School of Design, and her art was entirely formed during her seven years there. Determined to be a professional painter, she declined a teaching position at the school, but the following year both parents died and her twin sister married. After this her older sister, Louise, became her lifelong companion, attending to domestic and administrative matters while Elizabeth supported them both. Initially she did this by painting carved-wood panels, and through this she met Alice Barney (*q.v.*), who became both a patron and a pupil. By 1887, Nourse was able to take herself and Louise to Paris, where she enrolled at the Académie Julian. Succeeding years saw her travelling to Russia, Italy – where both sisters joined the Third Order of St Francis at Assisi – and Holland, in addition to Brittany and other rural areas of France. She exhibited at the Salon from 1888, and through American friends her works were shown and sold in her native country. Her only visit to America was for the 1893 Chicago Exposition, in which three of her paintings were shown. At least three-quarters of Nourse's Salon paintings were of peasant women and their children and, although she was among the first generation of American painters to concentrate on the figure, the theme of the peasant was at the height of its popularity in Salon art at this time. Nourse was not concerned with picturesque elements but with authenticity, and sought a genuine understanding of the lives of communities like the Breton peasants and the fisherwomen of Holland and Picardy. Unlike Beaux (*q.v.*), she did not regard them merely as subject matter. The Nourse sisters remained in Paris during World War I and helped the wounded and refugees with extraordinary energy and dedication, for which Elizabeth was awarded a plaque. In addition to raising money from others and donating her own paintings to charity, she was especially concerned to assist artists whose lives had been disrupted by the war. A mastectomy performed in 1920 was successful, but she did not exhibit after 1921, mainly because of the

radical changes in the art world around her. After Louise's death in 1937, Elizabeth lost the will to live and died the following year. A major exhibition of over 700 of her works was held in 1983.

*Examples:* Cincinnati; Detroit; NMAA, Washington, DC.

*Literature:* M. Burke and L. Fink, *EN: a Salon career*, NMAA, Washington, DC, 1983 (full bibl.); Rubinstein; Tufts, 1987.

## OAKLEY, Violet (1874–1961)

*American muralist, stained glass designer and illustrator*

Born in Bergen Heights, New Jersey, Oakley possessed artistic dynasties on both sides of her family. In her teens she overcame asthma by converting to Christian Science and, having been unable to attend school, was able to start training and eventually to undertake physically demanding mural cycles. After a period at the Art Students' League, New York, starting in 1892, she went to Paris, where she studied at the Académie Montparnasse with Aman-Jean and Collin. During a visit to England she encountered Pre-Raphaelite painting, which was to be a source of inspiration. Back in America, she joined Howard Pyle's class at the Drexel Institute, Philadelphia and found both her main artistic influence and her two lifelong friends, Jessie Willcox Smith (*q.v.*) and Elizabeth Shippen Green. Together the three of them set up house, at a time when this was extremely unorthodox. They took over larger residences as their incomes increased, and in 1902 moved into a house called the Red Rose, which was large enough to accommodate various parents and another close friend, who looked after the elaborate formal garden. Oakley had to support her widowed mother, and Pyle passed on to her several commercial jobs, including a collaborative one with Smith. At this stage the three were becoming known for their illustrations, but Pyle encouraged Oakley to attempt stained glass design, in which she was immediately successful. It was through the commission for 18 murals for the new state capitol at Harrisburg, Pennsylvania, that Oakley acquired her reputation as a muralist. It was easily the largest commission of its kind ever given to a woman. She toured Italy to study fresco cycles and decided to depict the story of William Penn. By using boldy outlined figures against neutral backgrounds, but in three-dimensional space, she made the events immediately comprehensible.

The reception of the murals in 1906 was tumultuous, and she was overwhelmed with further commissions. After 1911 she undertook the completion of the Harrisburg murals, the other commissioned artist having died, and this task took another 16 years. In addition she taught a mural painting class at the Pennsylvania Academy from 1913 to 1917. In 1927 Oakley travelled to Switzerland to draw the League of Nations in session, exhibiting her sketches in many countries in an effort to promote world peace. Many of her drawings were also included in her second book published in 1933. This sense of mission permeates her murals, particularly those of Penn, for she focused the panels on events which dealt with universal human values.

*Publications: The holy experiment*, 1922; *The law triumphant*, 1933.

*Examples:* Capitol, Harrisburg; All Angels church, New York.

*Literature:* Bachmann; Clement; H. Goodman, 'VO', *Arts Mag.*, v54, Oct. 1979, 7; *VO*, Mus. of Art, Philadelphia, 1979; Rubinstein; M. Schnessel, *Jessie Willcox Smith*, New York, 1977; *Women artists in the Howard Pyle tradition*, Brandywine River Mus., Chadd's Ford, 1975.

## O'KEEFFE, Georgia Totto (1887–1986)

*American painter of desert landscapes, bones, close-up views of flowers*

Probably the most successful woman painter, in the terms of the art establishment, in the twentieth century, O'Keeffe exhibited consistently throughout her career and never suffered the neglect of many of her female contemporaries. The oldest of three sisters who all became artists, she was born in Sun Prairie, Wisconsin. Both grandmothers had also been painters. The account of her early career, her meeting with Alfred Steiglitz and her role in the activities of his 291 Gallery, which was crucial for the exposure and promotion of modernist art in America, is well documented. After some years in New York and marriage to Steiglitz in 1924, she began to spent part of each year in New Mexico, living there permanently after Steiglitz's death in 1946. Her close-up paintings of plants and flowers during the 1920s and 1930s brought out a stream of Freudian interpretations from the critics, which she never refuted. When some members of the women's art movement extolled these works as expressions of essential femininity in the 1970s,

O'Keeffe was moved to reject this by publishing her autobiography. In later works she concentrated on scenes of the desert cliffs and crags, various sky effects and studies of dried bones she found in the desert. Although some works approach complete abstraction, others have superimposed elements such as a stark cross. She simplified the subject and aimed to represent it in strong colours which hold the composition together. Her work is represented in many museums and galleries.

*Publications: GO'K*, New York, 1976.

*Examples:* Metropolitan Mus., Whitney Mus. and MOMA, New York; NMWA, Washington, DC.

*Literature:* Bachmann; J. Castro, *The life and art of GO'K*, New York, 1985; *DWB*; Fine, 1978; L. Goodrich and D. Bry, *GO'K*, Whitney Mus., New York, 1970; Harris; Heller; Munro; L. Lisle, *Portrait of an artist: a biography of GO'K*, New York, 1980 (bibl.); NMWA catalogue; Rubinstein; Vergine.

## OLDS, Elizabeth (1896–)

*American painter, printmaker, illustrator and author of children's books*

Born in Minneapolis, she trained initially as an architect (1916–18) before transferring to the School of Art there (1918–20), until winning a scholarship to study at the Art Students' League, New York. She remained there for three years, working under George Luks, one of the original Ash Can painters. His strong draughtsmanship and readiness to search for his subject matter on the city streets coincided with Olds' own preferences. Seeking to establish an independent style, she travelled and studied in Europe. Much of the visit was financed by the first Guggenheim Fellowship for painting ever to be awarded to a woman for study abroad. Her return to America coincided with the Depression, and her choice of subjects reflected contemporary American life. A series of lithographs of a Nebraska stockyard (1934) brought out the formal geometrical elements of the scene, but many of her works revealed directly her sympathy with the ordinary people. A prominent member of the graphics section of the Federal Art Project (FAP) from 1935 to 1940, she argued for the publication of large quantities of low-cost prints so that art might be available to more people in the community. To this end she also joined the silkscreen section of the FAP in 1938. A socially committed artist, she used her skills to combine strong compositions with a social message. By the late 1930s her style had become interpretative rather than documentary, and this led to work for several left-wing magazines. She was a member of the American Artists' Congress in the late 1930s. After World War II, she produced regular illustrations for magazines, and wrote and illustrated six books for children, three of which won awards.

*Publications:* 'Prints for mass production', in *Art for the Millions*, Boston, 1973, F.V.O Connor (ed.).

*Examples:* Brooklyn Mus. and Metropolitan Mus., New York; Philadelphia.

*Literature:* K. Marling & H. Harrison, *7 American women: the Depression decade*, Vassar College G, Poughkeepsie, 1976; Rubinstein.

## OPPENHEIM, Meret (1913–85)

*Swiss Surrealist sculptor*

Oppenheim's role model was her grandmother, who had studied painting, written novels and been active for women's rights. Her father was a doctor with a rural medical practice who tried to apply Jung's psychological ideas to some of his patients. This early familiarity with Jung explains why Oppenheim pursued Jungian archetypes in her art rather than the ideas of Freud, which most of the Surrealists adopted. She went to Paris in 1932 and, after rejecting the academies, she met Giacometti and through him many other artists. He also encouraged her to make her first Surrealist object in 1933, the year in which she also posed for a series of nude photographs for Man Ray. Her uninhibited personality and love of Surrealist jokes created for her an image which was a hindrance to the evolution of her artistic maturity. Her most frequently reproduced work, the *Fur-lined tea cup* of 1936, which resulted from a chance remark during a café conversation, is often presented as her only work, whereas she produced a series of Surrealist objects and designer jewellery during the later 1930s. She regarded her paintings with more seriousness. These show a preference for images of nature, which she regarded as the source of female creativity. By 1938 she had returned to Basle and suffered from such severe depression until the early 1950s that she was unable to work. In 1959 she created a *Spring Feast* for a few friends to celebrate nature's fertility. Breton asked her to reconstruct this for a major Surrealist exhibition in Paris in 1960, the theme of which

was eroticism. The new context led to a misreading of the work as a banquet in which a naked woman was presented for consumption, thus ignoring Oppenheim's fundamentally egalitarian philosophy.

*Examples:* MOMA, New York.

*Literature:* Bachmann; W. Chadwick, *Women artists and the Surrealist movement*, London, 1985; B. Curiger, *MO*, Zurich, 1982; *MO*, Mus. der Stadt, Solothurn, 1974; Petersen; S. Sedgwick, *MO: Contributions to a culture*, unpublished BA dissertation, Sunderland Polytechnic, 1984; Vergine.

## ORLOFF, Chana (1888–1968)

*Russian-born figurative sculptor and engraver who lived in Paris and was influenced by Cubism*

Born in Staro-Konstantinov, Ukraine, she left her native country in 1904 intending to go to Palestine, as her family was Jewish; but she spent much of her life in Paris. Having trained at the School of Decorative Arts, she began to exhibit her sculptures of birds, female nudes and portrait busts in the various Paris Salons from 1910. Although her style was influenced by Cubism she retained recognisable, if stylised, detail on her forms. For financial reasons her early works were in wood, but as she became economically secure she also worked in marble and bronze. She had many solo shows throughout Europe, America and in Israel. Forced to flee to neutral Switzerland in 1942, she continued to work, and after 1945 she received several commissions in Israel for monuments honouring Jewish women and the Jewish underground movement. She was awarded the Chevalier de la Légion d'honneur. She died in Tel Aviv.

*Literature:* Edouard-Joseph; Krichbaum; Mackay.

## OROVIDA. (pseud. of Orovida Camille PISSARRO) (1893–1968)

*English painter and etcher, especially of animal subjects*

Both Orovida's parents were artistic; her father, son of the Impressionist painter, was the painter Lucien Pissarro and her mother was Esther (née Bensus(s)an) a printer, designer and wood engraver, and together they ran the Eragny Press. Orovida was born in Epping, Essex, and was effectively self-taught. She tried several art schools but found them all unsatisfactory, so determined to study alone with advice from her parents. She adopted her first name for professional purposes to avoid confusion with other members of the family. Her paintings were chiefly figure subjects and town scenes, themes she shared with the painters of the Fitzroy Street and London groups, with whom her father associated. By 1924 she had begun to paint on silk and linen prepared with methods learnt from a Japanese friend, although the tempera technique was her own. She enjoyed considerable success with a series of solo shows from the 1920s onwards, particularly at the Leicester Gallery, and was selected to represent Britain at international exhibitions in Venice and Paris. She exhibited at the RA from 1931 to 1967. She made her first etchings in 1914, and throughout her career these were to form an important part of her work. The chief subjects in this medium were animals, predominantly wild and active with titles such as *Migrating horses* and *Tigers drinking*; of the domesticated animals she preferred to represent cats.

*Literature:* *O*, Leicester G, London, 1935; *Three generations of the Pissarro family*, Leicester G, London, 1973; Waters.

## OSBORN, Emily Mary (1834–after 1913)

*English painter of figure subjects, genre scenes and portraits*

The eldest of nine children of a clergyman, Emily Osborn was born in London but lived until 1848 in West Tilbury, Essex. She hoped that the curacy in London her father then obtained would enable her to have access to instruction in art. Reluctantly her father allowed her to study at Mr Dickinson's Academy, later Leigh's, where she became friendly with Susan Durant (*q.v.*). After three months her father wanted to end the lessons but Mr Leigh allowed her to attend private lessons with another girl at his house, an arrangement which satisfied all parties. Her progress was rapid, for in 1851 her first painting was exhibited at the RA. Her career took a further step forward when in 1854/5 she received a commission for a portrait of Mrs Sturgis and her children, the most ambitious figure composition she had undertaken. In 1855 Queen Victoria purchased *My cottage door*, and the proceeds of these two sales enabled Osborn to build a studio extension onto her house. One of her best-known works, *Nameless and friendless*,

which concerned the struggles of a young woman artist, was exhibited in 1857. Another painting also dealing with the problems faced by poor but respectable young women, *The Governess*, was purchased by the queen in 1860. Osborn also depicted historical scenes, and *The escape of Lord Nithersdale from the Tower* (1861) was highly acclaimed and one of several of her paintings which were sold as engravings. At this time Osborn studied in Munich, and German themes appear in several works of the 1860s. Her success in this decade is marked not only by her sales and the choice of her work for engraving, but also by the award of several prizes. In 1866 she again went to the continent, studying for several months in Venice at the Accademia with Pilotti, before returning to Munich, where she remained for four years, still receiving Pilotti's advice. However, during the wars fought by Germany in 1869–71 she gave up painting up order to tend the wounded in Heidelberg. Afterwards she resumed exhibiting and divided her time between London and Glasgow, where she also had a studio for a while. Her work was not so well received, possibly because of the stronger influence of the continental schools on her work. She continued nevertheless to exhibit widely in London, the provinces and in Paris. From the mid-1880s most of her exhibits were landscapes, predominantly English but with some Algerian scenes. While in North Africa she may have visited Barbara Bodichon (*q.v.*) whose portrait she may have painted for Girton College, Cambridge in 1884. She was a member of the SWA until 1913, which is the last recorded date of her activity.

*Literature:* AJ, v30, 1868, 148; Bachmann; D. Cherry, *Painting women: Victorian women artists*, Art G, Rochdale, 1987; C. Clement & L. Hutton, *Artists of the nineteenth century*, 1879; J. Dafforne, 'British artists: their style and character, no. LXXV – EMO', AJ, v26, 1864, 261–3; Harris; L. Nochlin, 'Some women realists' in *Women, art and power, and other essays*, New York, 1988; Nottingham 1982; P. Nunn, *Victorian women artists*, London, 1987; *The Queen*, 4 Dec. 1880, 501; Yeldham.

## OSTROUMOVA-LEBEDEVA, Anna Petrovna (1871–1955)

*Soviet printmaker and watercolourist producing many town scenes*

Described as the most outstanding female printmaker, she was born in St Petersburg. Her first studies were undertaken at the Central School for Technical Drawing, where she learnt wood engraving, and then from 1892 she spent several years at the Academy of Arts there, for part of the time studying under Ilya Repin. From 1898 to 1899 she was in Paris, where she studied with Whistler. Thanks to her compatriot, Elizaveta Krouglikova, she enjoyed an immediate entrée into a cosmopolitan intellectual salon. Back in her home city, she worked in the graphic studio of the Academy, and it was owing to her work that there was a revival of the native Russian style of woodcuts, with vivid compositions and sharpness of line. She also carried out lithographs and coloured etchings, including many of St Petersburg, which were at the same time architectural and poetic. She taught from 1919 to 1935, and during World War II remained in Leningrad while it was besieged. In 1946 she was awarded the title of People's Artist of the Soviet Union and, on another occasion, the Red Banner of Labour.

*Examples:* Russian Mus., Leningrad; Tretyakov Mus., Moscow.

*Literature:* M. Alpatov, *The Russian impact on art*, New York, 1950; T. Mamanova, *Russian women's studies*, Oxford & New York, 1988; W. Mandel, *Soviet women*, New York, 1975; Schurr.

## OUDALTSOVA, N. See UDALTSOVA, Nadiejda

## OULTON, Thérèse (1953–)

*English painter of thickly textured, semi-abstract works*

Born in Shrewsbury, Shropshire, Oulton studied at St Martin's School of Art in London from 1975 to 1979 and at postgraduate level at the Royal College of Art from 1980 to 1983. Two separate year-long fellowships at Kingston Polytechnic and Winchester School of Art followed, during which time her first solo show produced the reaction among critics which rarely greets any young artist, but particularly a woman. She had, however, exhibited in the 1982 John Moores' exhibition at Liverpool and came to public attention with her RCA show in 1983. Since then she has established a considerable reputation. Her paintings consist of richly textured surfaces of interlacing brushstrokes, from which emerge poetic landscapes, many including architectural motifs such as small colonnades, or a

spiral staircase, inspired by a visit to Italy. She places equal emphasis on the subject and the surface on which she works without preliminary sketches, simply rubbing in any unwanted sections. 'I am concerned with the properties of the natural world, but from within.'

*Literature: Fool's gold*, Gimpel Fils, London, 1984; P. Kinmouth, 'TO: painting', *Vogue*, July 1984, 100–1; *Landscape, memory and desire*, Serpentine G, London, 1984; E. Lucie-Smith, C. Cohen & J. Higgins, *The new British painting*, Oxford, 1988.

## OVERBECK, Gerta (1898–1979)

*German painter of industrial scenes and portraits in the style of New Objectivity*

Born in Dortmund, she studied from 1915 to 1918 at Düsseldorf and became a qualified drawing teacher at the age of 20. Her most formative experience came in 1919–22, when, as a student at the School of Decorative Arts in Hanover, she met other artists, including Grethe Jürgens (*q.v.*) and Ernst Thoms, who were beginning to formulate the style of *Neue Sachlichkeit*. This was characterised by a precise, dispassionate rendering of everyday objects or urban scenes. After nine years of teaching in various Dortmund schools, Overbeck returned to Hanover in 1931 and joined the group of New Objectivity artists. Because of the economic insecurity of the time their activities were constrained and they received no critical attention. Most of her paintings show industrial landscapes, rendered impersonal and inhuman by the elimination of all figures and superfluous detail. She also painted portraits with the same objectivity as a way of commenting on society. Unable to practise under the Nazis, she moved to Cappenberg and in the late fifties followed a course in glass painting, spending the last two decades of her life executing many works on glass.

*Literature:* Krichbaum; W. Schmied, *Neue Sachlichkeit and Magischer Realismus, 1918–33*, Hayward G, London, 1979; Vergine.

## PAILTHORPE, Grace W. (1883–1971)

*French-born performance artist of Italian-Austrian descent, whose works focused on the body through pain and wounding*

Born in St Leonards-on-Sea, Essex, Pailthorpe trained as a doctor and during World War I served

as a surgeon. After four years of travel and some general practice in Australia, she returned to England in 1922, having discovered Freudian analysis. From this point she concentrated on the problems of delinquency and criminal psychology, and published two well-received books on the subjects. In 1935 she met Reuben Mednikoff (1906–76) and together they embarked on research into the therapeutic effects of art. By 1936 Pailthorpe had produced sufficient gouaches, drawings and oils to participate in the International Surrealist exhibition in London, where her work was much admired by André Breton. She exhibited again in the Surrealist Objects exhibition of 1937 and showed over 60 works at the Guggenheim Jeune Gallery, London in 1939. Her works have been described as 'the fragmentation and condensation of obsessional forms revealing the elemental desire for a return to the "primitive scene" ... [They] abound in dancing foetuses ... and powerfully toothed animals, all painted in stunningly autonomous colours'. At a famous meeting of the Surrealist group in Barcelona in 1940, the Belgian Mesens requested members to bear total allegiance to certain principles. A number, including Pailthorpe, Mednikoff and Colquhoun (*q.v.*) declined and were no longer involved in group activities, although they continued to produce Surrealist art. Pailthorpe spent the war in America and Canada, returning to England in 1946. She has been included in several retrospectives of English Surrealism since her death.

*Literature: British women Surrealists*, Blond Fine Art, London, 1985; W. Chadwick, *Women artists and the Surrealist movement*, London, 1985; *Salute to British Surrealism*, Minories G., Colchester, Essex, 1985; *The Surrealist spirit in Britain*, Whitford and Hughes G, London, 1988.

## PANE, Gina (1939–)

*French-born performance artist of Italian-Austrian descent, whose works focused on the body through pain and wounding*

Born in Biarritz, France, where her Austrian mother and Italian father had fled from Fascist Italy, she was brought up in France. She attended the École des Beaux-Arts in Paris, and her first performances and installations date from 1968. It was in 1971 that she began a series of performances, all of which involved wounding the body, often by means of a razor-blade. Other

consistent motifs were food (notably milk, rice, chocolate, mint and meat) and posture, and Pane has said that these, together with the wounds, function as an identikit for the flesh. She uses memories from childhood with which to make free associations with her themes, so that she continues to use fabrics which were significant at one point in her life. There is an ambivalence in her attitude to pain, in that she seems to incorporate the opposing polarities of pleasure and agony, and for this she was criticised by some feminists for failing to question traditional attitudes to the body. For both practical and intellectual reasons, the wounding performances could not continue indefinitely, and from 1981 Pane changed to works called *Partitions*. In these the body itself is absent, but is evoked by means of a series of assembled materials of all kinds, relying on the spectator to fuse in her mind the differing aspects presented. In *Martyrdom of St Sebastian from a painting by Memling/partition for a body* (1984) the body of the saint is not present but is conjured up through a swathe of red felt, a piece of glass in the form of the saint's body in the painting, a bow of wrought iron and lead and a drop of blood (red copper). These elements, arranged over seven metres of wall, form a reciprocal relationship, each being understood in the context of the others. The basic themes of the body, food and pain have not disappeared, but are now explored in a different way.

*Literature:* J. Barry and S. Flitterman, 'Textal strategies: the politics of art making', *Screen*, v21/2, 1980; L. Vergine, *GP: partitions: opere multimedia 1984–5*, Padiglione dell'Arte Contemporanea, Milan, 1985 (bibl.).

# PANKHURST, Sylvia. née Estelle Sylvia PANKHURST (1882–1960)

*English painter and illustrator whose artistic practice was integral to her political concerns, notably in the suffrage movement*

The second of five children, she was born in Manchester. Although her mother, Emmeline Pankhurst, is a more familiar figure through her suffrage campaign, Sylvia's father, a lawyer who worked tirelessly for social justice, had the greater influence on her childhood. The family moved to London in the mid-1880s, and their house was frequented by politicians and activists of a radical disposition. From early childhood Sylvia drew incessantly and in 1898 had just begin to take lessons in drawing when her father died. However, she won a free place at Manchester School of Art, where in 1902 she gained several prizes, including a travel scholarship. She chose to visit Italy, but on her return to Manchester divided her time between helping at home and in her mother's shop, and painting a mural scheme in a memorial hall for her father. This dichotomy was to characterise her life for some time. In 1903 she won a two-year scholarship to the Royal College of Art, and in London lived a frugal life devoted to study and political activities. After 1905 when the Women's Social and Political Union began the militant phase of its campaign, Pankhurst was drawn into the production of posters, banners and other materials, the campaign taking precedence over her studies, which ended in mid-1906. After her first period of imprisonment for her suffrage activities she had a rare holiday, returning to Venice with her sketch book. The first of her portraits of Keir Hardie, the socialist politician, probably dates from this time. The next year, she undertook a tour of industrial centres in England and Scotland in which she depicted women employed in factories, mills, potteries, agriculture and the fishing industry. These are some of the very few paintings of the interior of such workplaces, because there was thought to be no market for them. After six months she was back in London and involved once more in design work for the campaign as well as being increasingly active in political meetings and rallies. For the huge task of providing temporary decorations for the Women's Exhibition of 1909, which was to be held in an ice rink, she engaged several former students, including Amy Browning (*q.v.*), to assist her, although Pankhurst herself designed the scheme. Later that year she drew a good deal while nursing her brother in a fatal illness, and also began to write her first book. Her art now tended to be confined to lulls in the suffrage campaign, and during one of these periods she travelled to Southern Germany and Austria with two friends, painting villagers. On a suffrage visit to America in 1912 she hardly drew at all. With the outbreak of war and the growing destitution in the East End of London she realised that her art was a luxury she could no longer afford. Henceforth she was engaged in a series of political causes in Britain and later in Ethiopia, where she died.

*Publications: The Suffragette: the History of the Women's Militant Suffrage Movement*, London, 1911.

*Examples:* International Institute of Social History, Amsterdam; Mus. of London and Nat. Portrait G, London.

*Literature:* R. Pankhurst, *SP: artist and crusader*, New York & London, 1979; P. Romero, *SP*, New Haven & London, 1986.

## PARSONS, Betty. née PIERSON (1900–)

*American abstract painter, sculptor, art dealer and collector who was particularly influential in helping the Abstract Expressionists*

Born to a wealthy New York family, Pierson recalls seeing the Armory Show in 1913. In 1921 she married Schuyler Parsons, but two years later they went to Paris to get divorced. The marriage initially enabled her to study with Renée Praha, a traditional sculptor, and after her divorce she remained in Paris for a further ten years. She worked under Bourdelle and Zadkine while painting watercolours of Brittany in the summers. In Paris she mixed with many avant-garde artists and writers. Much of her private income was lost in the Wall Street crash (1929) and, on her return to America in 1933, she supported herself in Santa Barbara by teaching and exhibiting her watercolours. These were chiefly landscapes but evocative rather than descriptive. Three years later she came back to New York and began to learn the gallery business in Mrs Cornelius Sullivan's gallery. After running galleries for other people, she finally opened her own in 1946 on 57th Street, when Peggy Guggenheim departed for Venice and left Parsons her stable of embryonic Abstract Expressionists. Parsons, however, possessed a keen perception of her own and, in addition to showing her inherited artists like Pollock, Rothko, Still and Newman when they were at the beginning of their careers, she also helped many women artists, including Anne Ryan (*q.v.*), Barbara Chase-Riboud (*q.v.*), and Agnes Martin (*q.v.*). On the other hand she dropped Lee Krasner (*q.v.*) when Pollock left her for another gallery. In the meantime she herself also continued painting, and this side of her activities has become more prominent. After 1947 her own works became abstract and grew more thickly textured with impasto, but by the 1960s calmer patches of flat colour emerged from coloured backgrounds, along the lines of colour-field painting. After she changed from oils to acrylics in 1965 the surfaces became harder and the colour range brighter. Since settling in her cliff-top home on Long Island Sound, much of her inspiration has come from the scene around her. She works by selecting objects, such as stones, and after painting them she allows the shapes and colours on the canvas to suggest further developments. She has also used found items such as driftwood for her sculpture, which she constructs and then paints.

*Examples:* Smithsonian Inst., Washington, DC.

*Literature:* L. Alloway and B. Robertson, *BP: paintings, gouaches and sculpture, 1955–68*, Whitechapel G, London, 1968; K. Gamble *et al.*, *BP retrospective*, Art Mus., Montclair, New Jersey, 1974; S.L. Parsons, *Untold friendships*, Boston, 1955; Rubinstein; Withers, 1979.

## PATERSON, Emily Murray (1855–1934)

*Scottish painter of landscapes, coastal and river scenes who was associated with the Glasgow School*

Born to an Edinburgh solicitor, she undertook her first studies there, pursuing them further in London and Paris. The inspiration for her work came from her extensive travels throughout Europe, but her preferred areas were Brittany, Holland, Switzerland and Venice. She painted in both watercolour and oils, showing a fine sense of atmosphere, colour and light, considerable technical dexterity and an instinct for picturesque grouping. A characteristic of her work, whether landscape or flower picture, is the silvery tone. She exhibited very widely in England, Scotland, Europe and New Zealand. During World War I she painted a number of works which were subsequently acquired by the Imperial War Museum. She was elected member of several societies, including the SWA and the French and Scottish watercolour societies, and was still exhibiting in the year of her death.

*Examples:* Aberdeen; Mus. Royale de l'Armée, Brussels; Blackburn, Lancs; Cape Town; Dundee; Gray Art G, Hartlepool, Cleveland; Johannesburg; Leicester; Imperial War Mus., Barbican Art G and V & A, London; Paisley.

*Literature:* AJ 1907, 275; Mallalieu; *Paintings and drawings by some women war artists*, Imperial War Mus., London, 1958; *Studio*, v62, 1914, 236; *Studio*, v65, 1915, 105; *Studio*, v67, 1916, 59; *Studio*, v70, 1917, 44; Waters; *Who's Who in Art*.

## PAULI, Hanna. née HIRSCH (1864–1940)

*Swedish painter of figure subjects, landscapes and portraits*

Between 1881 and 1885 she trained at the Academy of Art in her native Stockholm, continuing her studies in Paris with Dagnau-Bouveret. Her extraordinary talent meant that she was an established artist by the end of that period. In 1887 she married another painter, Georg Pauli, and had three children, but continued to exhibit in Paris and Stockholm from 1886. In addition, she was represented at the Expositions in Paris of 1889 and 1900, and at Chicago in 1893. She was in Italy between 1906 and 1910 and may have studied in Rome, while travels in 1920–1 took her through Europe to North Africa. The Pauli house became a meeting place for Swedish intellectuals, of whom Hanna Pauli painted many portraits. She worked rather slowly, so her overall production was relatively small. Her paintings were noted for exquisite play of light over the people and objects.

*Examples:* Göteborg; Oslo; Stockholm.

*Literature:* Clement; M. Elliott; I. Ingelmann, 'Woman artists in Sweden: a two-front struggle', *WAJ*, v5/1, spring-summer 1984, 1–7; Krichbaum; *Kvinnor som malat*, Nationalmuseum, Stockholm, 1975.

## PEALE, Anna Claypoole (1791–1878)

*American painter of still life and miniature portraits*

Coming from the one of the great artistic families of eighteenth- and nineteenth-century America, Anna Peale was taught by her father expressly so that she could assist him with commissions, which she did increasingly as his eyesight failed. Around 1819 an uncle who took her to Washington DC found that she obtained more commissions than he did. She bowed to social convention and gave up painting on her two marriages, but outlived both husbands and continued to work until late in life. She exhibited at the Pennsylvania Academy every year from 1811 to 1842, and in 1824 she and her younger sister, Sarah (*q.v.*), were both elected members. In her miniatures she was able to achieve a great variety of texture and employed rich dark backgrounds to enhance the sitter's skin. On the whole her still lifes were executed in the early part of her career.

*Examples:* Peale Mus., Baltimore; NMWA, Washington, DC.

*Literature:* Bachmann; Fine, 1978; Harris; Heller; *Notable American Women*; NMWA catalogue; Petersen; Rubinstein; E. Tufts, *Our hidden heritage: five centuries of women artists*, New York, 1974; Tufts, 1987.

## PEALE, Sarah Miriam (1800–85)

*American painter of portraits and still lifes*

Younger sister of Anna Peale (*q.v.*), she too was born in Philadelphia and was taught by her father and actively supported by her uncle. Sometimes called America's first professional woman artist, she supported herself by her painting. Exhibiting at the Pennsylvania Academy, she became a member in 1824. The following year she settled in Baltimore, where she established herself as the leading portrait painter there for the next 21 years. To the firm drawing learnt from her father, she added an unassailable ability to represent material, whether lace, fur or satin, and a richer colour achieved through a glazing technique which may have been passed on by Rembrandt Peale, her European-trained cousin. In 1846 she moved to St Louis and was once again the foremost portrait painter, but carried out more still lifes in her later years. She apparently chose not to marry so that nothing should interfere with her career. She finally returned to her native town in 1878.

*Examples:* Peale Mus., Baltimore; Wadsworth Atheneum, Hartford, Conn.; Richmond, Va.; St Louis.

*Literature:* As for Anna Peale.

## PEPPER, Beverly. née STOLL (1924–)

*American monumental abstract sculptor in concrete and metal*

A child prodigy from a middle-class Jewish family in Brooklyn, she gained a degree in industrial and advertising design from the Pratt Institute, New York, at the age of only 17. Yet it was not until over 20 years later that she found her real medium. From 1942 to 1948 she worked as art director for several large advertising agencies and was financially successful. During that time she had married and had a child, but had also realised that the commercial world was not fully satisfying. She began to take evening classes at the Art Students'

League, New York, then divorced her husband and in 1948 went to Europe. In Paris she painted under Lhote and Léger, marrying the writer and journalist Bill Pepper, with whom she travelled widely in Europe and the Far East, settling in Rome in 1952 with her two small children. The impression left on her by Cambodian woodcarvings seen on a visit to the Far East in 1960 led her to abandon her socially orientated paintings and to try that medium for herself on fallen trees in her own garden. Two years later she was invited to exhibit a piece of welded sculpture at Spoleto, Umbria, along with David Smith and Alexander Calder. Undeterred by her ignorance of the technique, she set to work at once under the guidance of a craftsman iron worker. The process of welding drew her style away from expressionism to a more geometric visual language. Since then she has exhibited extensively in Italy and America, and now lives with her family in Todi, Umbria. Seeking to convey an enigmatic atmosphere in her works, she creates a powerful physical presence which 'is inwardly turned – seemingly capable of intense self-absorption'. During the 1960s she used the device of polished steel exterior surfaces which reflected their environment and thus made the sculpture almost invisible. Triangular forms dominated the next decade, constructed so that they appear solid from one side and light and open from another. Pepper also admits that the hollows and sharp protruberances contain sexual implications. During the 1970s, when funds were available for such projects, Pepper also constructed large environmental pieces with concrete. More recently she has turned to smaller-scale sculptures in metals with coloured hues which recall totem poles.

*Examples:* Albright-Knox G, Buffalo, NY; G d'Arte Moderna, Florence; Indianapolis; Milwaukee; Minneapolis; Metropolitan Mus. and MOMA, New York; Turin; Albertina, Vienna; Hirschhorn Mus., Washington, DC.

*Literature:* Heller; Munro; Rubinstein; W. Thompson, 'BP: dramas in space', *Arts Mag.*, v62/10, summer 1988, 52–5; Watson-Jones.

## PEREIRA, Irene. née RICE (1907–71)

*American geometrical abstract artist who sought to express equivalents for space and light through the use of layered transparent and opaque materials*

Born in Chelsea, Massachusetts, she was the second of four children of German, Dutch and Polish descent. Her mother's custom of sketching encouraged two of her daughters to make art their career. After several moves the family settled in Brooklyn, New York in 1917. The death of her father resulted in Rice becoming the family breadwinner at the age of 15. Deciding to take a secretarial course, she condensed three years' work into six months and found employment as a typist. Parallel with this job she attended evening classes in dress design, literature and art, before enrolling at the Art Students' League, New York in 1927. Through the Czech artist Jan Matulka, she encountered Cubism and other modern movements. A fellow student was David Smith, who remained a lifelong friend. In 1929 she married a Barbadian commerical painter, Humberto Pereira and they settled in Greenwich Village, Manhattan, where she spent most of the rest of her life. In 1931 she finished her studies and travelled alone to Paris, where she studied briefly with Ozenfant, who sought to reconcile realistic imagery with pure form based on Cubism. Proceeding to Italy and North Africa, she made an expedition into the Sahara desert, where she experienced an overwhelming sensation of space, analogous to that she already felt about light. These two elements were to provide her with the basis for her subsequent explorations. Back in New York, she first produced a series of paintings of nautical imagery and machines with an aura of Precisionism, and these led to the first of over 50 solo shows. During the Depression she taught in the Federal Art Project Design Laboratory in New York, which sought to continue the principles of the Weimar Bauhaus, and her own work became increasingly abstract as she tried to find ways of expressing light and space through materials rather than by illusion. Her first paintings on glass date from 1939, but by 1942 she was moving away from their more rigid geometry towards mixed techniques which allowed her to etch the surface with marble dust and sand. Through these processes she sought equivalents for modern mathematical and scientific concepts. A major step towards gaining the impression of depth came with the introduction of corrugated glass and the combination of several layers of this with plain glass and other media, including opaque paint, transparent varnish, and gesso. A broadening of her philosophical concerns is indicated by the cosmic titles of her works and the publication of several books expounding her ideas. Her personal life was rarely settled; married and divorced three times by 1959, she lost a sister in 1941 and had a mastectomy in 1943. The last few years of her life were spent in Spain in the care of her brother as her health declined. Her artistic

reputation was assured through her many exhibitions and selection for important group shows.

*Publications: Light and the new reality*, 1951; *The transformation of nothing and the paradox of space*, 1953; *The nature of space*, 1956; *The evolution of cultural forms*, 1966; all published New York.

*Literature:* Bachmann; J. Baur, *Loren MacIver and IRP*, Whitney Mus., New York, 1953; *DWB*; Heller; M. Hill and J. Brown, *IP's library: a metaphysical journey*, NMWA, Washington, DC, 1988; D. Miller, *Fourteen Americans*, MOMA, New York, 1946; *Notable American Women*, v4; Rubinstein; E. Tufts, Our hidden heritage: five centuries of women artists, New York, 1974; Withers, 1979.

## PERRY, Lilla. née CABOT (1848–1933)

*American painter of landscapes and figure subjects, including Japanese themes, in a style close to Impressionism*

The oldest of eight children, Lilla Cabot came from a prominent Boston family. She married Thomas Perry, a scholar and writer, in 1874. Originally a poet, she probably encountered art through the circle of her husband's friends, which included his brother-in-law, painter John La Farge. However, it was only after she inherited money from her father that she was able to become a private pupil of Robert Vonnoh in 1886. Some months later she enrolled at the Cowles School in Boston under Bunker. By painting portraits she earned enough money to take her husband and three daughters to Europe in style in June 1887. Over the next two and a half years, she studied at the Julian and Colarossi academies, but the catalyst for her development was friendship with Monet. After the Perrys returned to America they continued to summer in Giverny for ten years, where they were neighbours of Monet and came to know him well. Monet never took pupils, but advised Perry and she was able to watch him at work. She attempted to interest Americans in his work, but only La Farge appreciated Monet's paintings. Her considerable success is attested by her exhibiting record, which included the Salon, the Paris Exposition Universelle of 1900, Berlin, Florence, eight paintings at the 1893 Chicago Exposition and medals at the St Louis (1904) and Panama-Pacific (1915) expositions. In 1897 Thomas Perry accepted the post of professor at a university in Tokyo. Lilla Perry and her daughters joined him in 1898 and remained for three years. Aware that Japanese art and culture was fascinating Western Europe, Lilla avidly painted landscapes and a few portraits of eminent citizens in order to absorb all she could of that country. She caused a sensation there by painting out of doors. Many of her indoor subjects are of a single woman, reflecting Impressionism in her choice of everyday activities. The influence of Monet is particularly apparent in her landscapes, but even there she retained a clearer drawing and greater concern for volume and detail. After the Perrys purchased a farm in New Hampshire in 1903, Lilla Perry returned to painting landscapes. Her own work was one way in which Americans began to come to terms with Impressionism, but she also lectured on the subject. She published several volumes of poetry during her career.

*Publications:* 'Reminiscences of Claude Monet from 1899–1909', *American Mag. of Art*, v18/3, Mar. 1927, 119–25.

*Examples:* Fogg Art Mus., Harvard University; NMWA, Washington, DC.

*Literature:* S. Feld, *LCP: a retrospective exhibition*, Hirschl & Adler G, New York, 1969; Harris; Heller; NMWA catalogue; Rubinstein; Tufts, 1987.

## PERUGINI, Kate. née Catherine Elizabeth Macready DICKENS (1838–1929)

*English painter of genre and portraits*

One of the nine children of novelist Charles Dickens, she was called 'the Lucifer Box' by her father because of her tendency to carry out wild escapades. Although the family moved around the south of England a good deal, care was taken over the education of all the children, and Kate's desire to study drawing at the age of 12 was taken seriously and encouraged. She attended classes at Bedford College, and when her father had his portrait painted by Ary Scheffer during a stay in Paris in 1855–6, Kate was able to attend the sittings. After her parents' acrimonious separation in 1858, Kate went to live with her father, although this was not a successful arrangement. Consequently when the painter-turned-writer Charles Collins proposed to her she accepted this as a means of leaving an unhappy home. Despite her father's opposition, she refused to give way and was married in July 1860. Earlier that year she had posed for Millais for the woman in *The Black Brunswicker*. By 1870 Collins' health was failing and for the three years until his death from cancer

at the age of 45, Kate was nursing him as well as painting and selling her work, for they were in need of the income. After his death she continued to see the many artists and literary friends they had, and it was at Lord Leighton's house that she met Carlo Edward Perugini, an Italian painter who had taken British nationality, and they were married in 1874. Their son was born late in 1875 but died when seven months' old. Nevertheless, she continued to paint and exhibited at all the main London galleries, for she and Carlo needed the income from the sale of their work. Their financial situation remained precarious until the 1880s, when Kate's work became better known and she received increasing numbers of commissions, particularly for portraits of and subjects involving children. She sent one such work to the Paris Exposition of 1889 and was also represented at Chicago in 1893. Around 1912, the Peruginis moved to a house in Kensington, London, where there was a studio for each of them, but after Carlo died suddenly in 1918, Kate moved to a flat in Chelsea. As a result of the deaths of several brothers and sisters, Kate possessed many items associated with her father. Despite her lack of money she never sold these but gave them as presents. She continued painting into the early 1920s but her health deteriorated and she was an invalid for the last four years of her life. Nevertheless she remained cheerful and witty, and thus had many friends. One of her last visitors was Louise Jopling (q.v.).

*Examples:* Hertford.

*Literature:* Clement; *Connoisseur*, v84, 1929, 60 (obit.); M. Elliott; Mallalieu; P. Nunn, *Victorian women artists*, London, 1987; G. Storey, *Dickens and daughter*, London, 1939, repr. New York, 1971; Wood, 1978.

# PESTEL, Vera Efimovna (1886/7–1952)

*Soviet abstract painter*

After a conventional middle-class Muscovite upbringing, Pestel took up painting only after her marriage at the age of 18. She studied first at the Stroganov School of Art and then in Youon's atelier, but she was also able to travel to Western Europe in 1912–13, visiting Germany, Italy and France but studying en route in Munich at Hollosy's private school and in Paris at the studios of Le Fauconnier and Metzinger. Her visit coincided with that of Popova (q.v.) and Udaltsova (q.v.),

with whom she continued to collaborate closely back in Moscow. Although admiring Suprematism, Pestel preferred to work in a Constructivist Cubist style in which geometric planes occurred together with letters, numbers and fragmented objects. In due course these disappeared, leaving the skilled arrangements of colour and the strength of the composition to stand together. She participated in the modernist exhibitions in St Petersburg and Moscow and, like many of her compatriots, also began to design for the theatre. Although she was represented at the major exhibition of Russian and Soviet art in 1922 in Berlin, she had by then begun to turn towards figuration. Over the following years she belonged to the Makovetch group (1922–7) of Intimiste painters and exhibited with them. In due course she became interested in art taught to pre-school children, and spent many years in this field.

*Literature: L'avant-garde au féminin, 1907–30,* Artcurial, Paris, 1983; Vergine.

# PETERSEN, Jane (1876–1975)

*American painter of town and coastal scenes of America, Europe, North Africa and the Middle East, executed in watercolour and gouache*

A prolific and well-travelled artist, she was very famous in her lifetime, enjoying many solo shows. From her home town of Elgin, Illinois, she went in 1895 to the Pratt Institute in Brooklyn to begin her training. Graduation in 1891 was followed by a period at the Art Students' League, New York, after which she taught in various cities in eastern America. Her first visit to Europe came in 1907, when she took the opportunity to study with Frank Brangwyn in London, with Blanche in Paris (1908) and most importantly with the Impressionist, Sorolla, in Madrid (1909). The fact that she had exhibited at the Salon de la Société des Artistes Français when in Paris brought her two solo shows in Boston and New York in 1909. From Spain she began her travels as an independent artist in 1910, and by the end of that year she had completed 87 paintings in Egypt and Algeria for another solo show. From 1912 to 1919 she taught watercolour painting at the Art Students' League and travelled widely within America, depicting everyday town scenes in bright colours and broadly handled paint in a style influenced by French modernist painters of the late nineteenth and early twentieth centuries. She eliminated detail in favour of more emphasis on the picture plane, achieving a sense

of depth through the use of colour rather than tone, and she was able to capture the effects of light and movement, particularly on water. In 1924 she spent six months in Turkey, but after this her foreign travels were curtailed because of her marriage in 1925 to Moritz Phillip, an art patron. Thereafter her summers were spent in Ipswich, Massachusetts, and she began to turn to flower painting instead. Her later work was dominated by floral pictures, and her last solo show was held in 1946. She continued to paint, albeit more slowly as arthritis set in, until well into her eighties.

*Literature:* S. Feld, *JP: a retrospective,* Hirschl & Adler G, New York, 1970; Rubinstein; Tufts, 1987.

## PETHERBRIDGE, Deanna (1939–)

*South African-born artist of architecturally based draw-ings in indian ink who works in Britain*

As a child in Pretoria, she was fascinated by cer-tain buildings and by the sense of space in the veld. Her mother was trained as an artist, and as an amateur executed watercolours of flowers and buildings, as well as showing her daughter many reproductions of paintings. Having decided at the age of six to be an artist, she read painting and art history at Witwatersrand University. During the course she became interested in both Oriental art and that of the Italian Renaissance, but was unable to complete her master's degree in the history of art because of lack of material in South Africa on European art. Emigrating in 1960 she spent four months in Italy before arriving in England. Her paintings at this period were large gestural and expressionistic depictions of oppression in various forms, resulting from her concern over events in South Africa and Vietnam. Apart from teaching and other jobs, Petherbridge was rather isolated. She worked with shaped canvases and moved into sculpture in the mid-1960s. In 1967 she left to spend the next five years based on an island in the Cyclades. From there she visited North Africa and Egypt. Influenced by the intensity of the light, she began to draw, in indian ink, images based on architectural forms such as mosques, mud fortresses and huts. These forms also emerge in her *Cucurbitae* series, begun in 1972 and over-lapping with another series of 1973, *The Seven Citadels,* in which she explored the image of self-containment and enclosure. From this grew the idea of a large battle-piece with the citadel at the centre. *The iron siege of Pavia* emerged as a five-

panelled piece. In this and other works analogies can be seen with the drawings of Leonardo, but her references derive from a deep fund of know-ledge of architecture, weapons and the work of other artists, particularly those of the Renaissance. A more recent source of inspiration has been three visits to India in 1979, 1985 and 1986, resulting in many works of which the later ones condense and allude to their subject matter whereas the earlier ones are more literal. Her activities have diversified since the mid-1970s, when she began to write regularly as a critic, mostly for architectural maga-zines. In 1984 her drawn forms were metamor-phosed into three dimensions in the designs for the Royal Ballet's production of a new ballet, *A broken set of rules.* More recently she has introduced colour washes into her drawings.

*Publications:* See Fischer Fine Art catalogue cited below.

*Literature: Hayward Annual '78,* Hayward G, London, 1978; *DP drawings 1968–1982,* City Art G, Manchester, 1982; *Temples and Tenements: the Indian drawings of DP,* Fischer Fine Art, London, 1987 (full bibl.).

## PEYROL-BONHEUR, J. See BONHEUR, Juliette

## PFAFF, Judy (1946–)

*English-born sculptor, best known for her environments and installations, who works in America*

Born in London, Pfaff has lived permanently in America from 1959. After completing two univer-sity courses in subjects other than art, she gained her BFA from Washington University, St Louis in 1971 and her MFA from Yale University in 1973. Her first solo show was held the following year. Her early sculpture was a three-dimensional equivalent to Abstract Expressionist painting. At Washington University she had studied painting under Al Held, and her own early paintings were up to five metres long. She reinstated all the values which Minimalism suppressed: gesture, colour, illusion, representation and a personal iconography. Linear elements, such as wire and plastic tubing, were brightly coloured and fused together with hot glue, a technique which enabled her to improvise. Some of her solo shows consisted of environmental installations, such as *Deepwater* (1980). In the early 1980s her range of materials

expanded to include those which were not linear, such as plywood and plexiglass. There are references to various styles from the earlier part of the twentieth century, and also to places she has visited, which she uses as metaphors for sensations she is trying to communicate. Two visits to Japan in 1984 and 1985 led to a greater concern with the vortex and the underlying principle; in order to achieve a sense of spinning she employs a vocabulary of discs and hemispheres, combined with such elements as lattices, woks, supermarket signs and English and Japanese lettering. Her installations are all designed *in situ* and are dictated by the constraints of the site. She always works on a large scale; some recent reliefs jutted over two metres from the wall. Her colours are bold and lavish. She lives and works in Brooklyn, New York.

*Literature:* M. Auping, 'JP: turning landscape inside out', *Arts Mag.* Sept. 1982, 74–6; S. Gill, 'Beyond the perimeters: the eccentric humanism of JP', *Arts Mag.*, Oct. 1986, 77–9; *Graphic muse;* Heller; Watson-Jones.

## PHILLIPS, Helen (1913–)

*American-born figurative sculptor in wood, stone, clay and bronze who works in Paris*

A native of Fresno, California, she studied at the California Institute of the Arts from 1931 to 1935, and in 1936 went to Paris on a travelling scholarship. There she studied for a time at the Atelier 17, set up by the English artist S.W. Hayter, whom she subsequently married. They left France at the outbreak of war and spent a year in London before escaping the bombing by returning to America. There Hayter established his atelier in New York, where it was frequented by many artists who later became well known. Phillips had two daughters and exhibited on both west and east coasts until 1950, when she returned permanently to Paris. By showing her sculpture in the main venues such as the Salon de la Jeune Sculpture, she built up her reputation, the progress of which had been disrupted by the war. She was one of the eight winners in the French section of the competition for the *Monument to the Unknown Political Prisoner* in 1952, and two years later was given her first solo show. In 1958 she was one of four American artists selected for an exhibition in the American Cultural Centre in Paris.

*Examples:* St Joseph's, Sacramento.

*Literature:* Mackay; *Who's Who in Art.*

## PHILLIPS, Marjorie. née ACKER (1895–)

*American painter of still lifes and landscapes, art collector and administrator*

Marjorie Acker was born into a wealthy and cultured family in Ossining, New York State, which showed no opposition to her wish to study at the Art Students' League, New York, to which she commuted between 1915 and 1918. With rather advanced taste, she was a frequent visitor to Katherine Dreier's (*q.v.*) Société Anonyme when it opened in 1921. In that year she met Duncan Phillips, who had begun to form an art collection in the family mansion in Washington in memory of his father and brother. After their marriage, Marjorie Phillips moved to Washington and maintained two parallel careers. She was associate director (1925–66) and, after Duncan's death, director (1966–72) of the collection they had built up over the years. She also continued to paint, producing many still lifes, and lyrical landscapes which recall those of Pierre Bonnard, whom she much admired. Her attendance at baseball matches with her husband led to a series of paintings of this game, often in a floodlit setting. She participated in several major exhibitions and had a series of one-person shows in every decade.

*Publications: Duncan Philips and his collection,* Boston, 1970.

*Examples:* Boston; Whitney Mus., New York; Phillips Coll., Washington, DC.

*Literature:* Rubinstein; Withers, 1979.

## PICKERING, E. See MORGAN, Evelyn de

## PIFFARD, Jeanne (1892–)

*French sculptor of figures, birds and animals*

Piffard trained in her native Paris at the Julian and Grande Chaumière academies, before working with the animal sculptor Navalier. She specialised in direct carving and the use of coloured stone. She executed many biblical and classical figures, busts of her artistic contemporaries, as well as birds and animals, both singly and in groups. She exhibited actively in Paris, receiving an award in 1913 and in due course was elected a member of the Société des Artistes Français. Critics com-

mented on the vigorous but simplified realism of her works.

*Examples:* Mus. d'Art Moderne, Paris.

*Literature:* Edouard-Joseph; Mackay.

## PINDELL, Howardena (1943–)

*American artist involved in Process art through her multi-layered collages, and a professor at the State University of New York*

One of the few black women artists to have attended the most prestigious institutions for postgraduate work, Pindell received her MFA from Yale School of Art and Architecture in 1967. For a while she was curator of prints at MOMA, New York, before becoming a lecturer and later a full professor. Her work involves the combination of a clear structure, and initially this was often a grid over which were placed random marks. In 1969 she used a hole punch to pierce openings through which she sprayed paint. In due course she used all the small pieces which had been punched out to create reliefs of glued paper. She worked by adding layers of paper or different kinds of paint, glitter, talcum powder and other material to either paper or strips of canvas loosely sewn together. From the mid-1970s Pindell made her own paper into which ink was embedded. Her involvement in the women's movement came though the AIR women's co-operative gallery in New York, of which she was an early member (until 1976), through the collective of the journal *Heresies* and other groups. She exhibited in both black and white art exhibitions during the 1970s and has had several solo shows.

*Literature: Graphic Muse*; R. Lorder, 'Women artists on women in art', *Portfolio*, Feb.–Mar. 1980; C. Robins, *The pluralist era*, New York, 1984; Rubinstein.

## PINTO, Jody (1942–)

*American artist producing fantastic architectural sculptures and watercolour drawings based on the idea of a symbiotic relationship between the human body and architecture*

A New Yorker by birth, Pinto trained at the Pennsylvania Academy of the Arts and then gained her BA in 1973 at the College of Art, also in Phil-

adelphia. She described herself as a builder, combining sculpture and architecture but using them as metaphors for human emotions and experience. Thus a covered bridge in a park is in the form of a finger and *Serpentine Corridor* (1980) is simultaneously a connecting tunnel, a reclining figure and a snake. Other sculptures have titles which make the link between the body and architecture explicit: *Split tongue, Heart chambers*. For Pinto the combined mental and physical activity involved in the construction of these large-scale pieces is equated to making visible experiences, dreams and memories. She also allows for the action of the elements on the sculptures, and some concrete works have been seeded with grass. She also produces drawings and paintings of an androgynous athletic figure known as Henri (based on childhood memories of a performer called Henri La Mothe) through which she explores the 'unisexual nature of energy and the intellect' as he personifies in his acrobatic feats the passage of ideas. The sexuality of her work has at times led to critics misreading her works in terms of traditional male/female divisions, whereas she believes in a genderless or ambisexual experience of physical and intellectual activities. She has produced many outdoor sculptures, and exhibited in the 1980 Venice Biennale.

*Literature:* D. Cameron, *Extended sensibilities*, New Mus., New York, 1982; Cooper; J. Hugo, 'Situational scuptures for private performance', *Artweek*, v11/38, 15 Nov. 1980, 1; T. De Santis, 'JP', *New Art Examiner*, Jan. 1986, 61; J. Withers, 'JP', *Feminist Studies*, v11/2, summer 1985, 379–81.

## POLUNIN, Elizabeth V. née HART (1887–?)

*English painter of figures, portraits and stage designs*

Born in Ashford, Kent, her training was predominantly French. She studied in Paris at the Académie Colarossi, the Lucien Simon School and the École des Beaux-Arts. She then travelled to St Petersburg to study under Léon Bakst. While there she met the artist Vladmir Polunin, and after their marriage they lived in London. She exhibited widely in London, including the RA (1924–41), but is best known for her designs for sets and costumes for ballet and opera productions. She worked with Diaghilev's company in London, Paris and Monte Carlo, and was the designer for the first English production of Rimsky-Korsakov's *The snow maiden* for the Sadler's Wells company. She was elected a member of NEAC.

*Examples:* Imperial War Mus. and V & A, London; Manchester.

*Literature:* Deepwell; *Paintings and drawings by some women war artists*, Imperial War Mus., London, 1958; Waters.

## POOR, Anne (1918–)

*American painter of poetic realist landscapes and the only woman war artist in the US Army; also director of the Skowhegan School of Art*

Poor benefited from an extremely talented and supportive family. Her mother was a journalist, novelist and playwright, Bessie Breuer, who married her second husband, Henry Varnum Poor, when Anne was seven. Henry was an artist who encouraged Anne Poor and with whom she later collaborated on several occasions. Poor's aunt was also a painter. While still at school Poor attended the Art Students' League, New York, and her course at Bennington College included a year abroad. She went to Paris for this year (1937–8), and was able to see the World's Fair and to study under Jean Lurcat. After leaving Bennington, Anne Poor assisted Henry with government mural projects in Washington, and was then able to compete for her own work under the scheme, winning commissions for two post office murals. In later years she executed several other murals, including outdoor frescoes at the Skowhegan School of Painting and Sculpture, Maine. After a visit to the west coast she enlisted in the Women's Army Corps (WAC) in 1943, feeling that women should be involved in the war as well. After she joined, a special section was created for enlisted artists and she spent a year in the Pacific recording medical air evacuations, and in autumn 1945 she accompanied a group of medical technicians to China and Japan. The work required the ability to capture with the minimum of means the essentials of the subject. Her war art won her a prize in 1944, and in 1945 she was the only woman to exhibit in the National Gallery at Washington in a show of five US Air Force painters. Parallel with her war work, she continued to paint and exhibit her own work. After her discharge she taught at the Skowhegan Art School, which had been co-founded by her stepfather. In due course she became its director and a trustee. After the war her chief interest was landscape painting of the Hudson River. Economical in form and colour, she succeeds in conveying a sense of the scene rather than in recording detail. She also produced many still lifes of flowers, which deal with relation-

**Anne Poor** *Take care of my roses*, 1963, oil on canvas, 169.7 × 53 cm, private collection, courtesy Graham Modern, New York. (photo: Ellen Page Wilson)

ships of light, shape and colour rather than with mere description. She has won many prizes and exhibited actively throughout her career.

*Publications: Greece*, with text by Henry Miller and drawings by AP, New York, 1964; *Fragments of the sanctuary*, Nyack, NY, 1982 [colour etchings of Delos].

*Examples:* Brooklyn, New York; Art Institute, Chicago; Kalamazoo, Mich.; Whitney Mus., New York; Wichita, Kan.

*Literature:* S. Moore, 'AP', *WAJ*, v2/2, fall 1981-winter 1982, 50–3; *AP*, Graham G, New York, 1985.

## POPOVA, Liubov (1889–1924)

*Soviet pioneer abstract artist and designer*

Perhaps the best documented of the many Russian women artists involved in avant-garde art around the years of the 1917 revolution, Popova was born in Ivanovskoe, near Moscow, into a wealthy and cultivated family of tea merchants. She began to study art in Moscow in 1907–8 at classes given by two Russian Impressionists. Her visits to Italy, a stay in Paris and tours of medieval Russian towns from 1910 gave her an unusual breadth of learning and considerable visual sophistication. She was a pioneer in the evolution of a Russian combination of Cubo-Futurism and contributed to all the major modernist exhibitions from 1914 to 1921. Her architectonic compositions (1916–18) eliminated all sense of illusionistic space remaining from Cubist works. From 1915 she was in close contact with the artists around Malevich, but also made some reliefs after seeing those of Tatlin. Welcoming the revolution of 1917, she worked for several official organisations. In 1920 she joined the Institute of Artistic Culture (Inkhuk) which was instrumental in turning artists towards designing for mass production. Like Alexandra Exter (*q.v.*), she had also become involved in theatre design through teaching at Meyerhold's theatrical workshops, which led to her designing the sets and costumes for the production of *The magnanimous cuckold* in 1921. She also taught at the Moscow Art School, Vkhutemas. Of the two increasingly divergent positions adopted by artists, Popova believed that art should be accessible to everyone, and became involved in the design of fabrics, dresses, posters, book covers and for porcelain. She died of scarlet fever caught from her small son.

*Literature:* S. Barron & M. Tuchman, *The avant garde in Russia, 1910–30: new perspectives*, County Mus. of Art, Los Angeles, 1980; *DWB*; Fine, 1978; Harris; *Russian women artists of the avant garde, 1910–30*, G Gmurzynska, Cologne, 1979; Vergine.

## POTTER, B. See VONNOH, Bessie

## POTTER, Mary. née ATTENBOROUGH (1900–1981)

*English painter of still lifes, interiors, beach scenes and landscapes*

At the age of 16 Attenborough enrolled at the local school of art in Beckenham, Kent. Two years later she won a scholarship to the Royal College of Art, but elected instead to use this in order to obtain a bursary to the Slade, where she studied from 1918 to 1920 under Henry Tonks and Wilson Steer. From 1920 she exhibited with NEAC and in the same year became an early member of the 7 & 5 Society. Until 1924 she used her ability as a portrait painter to provide her with a living, but after this time she was able to concentrate on still life and landscape. Marriage to writer Stephen Potter, and the birth of two sons in 1928 and 1931, reduced the time available for painting, although the Thames at Chiswick, where they lived from 1927 to 1939 provided her with constant subject matter. Frequent moves during the war presented further problems, but post-war holidays at Brighton and Aldeburgh introduced beach scenes to her repertoire. The Potters moved to Aldeburgh in 1951 and as a result of friendships with Benjamin Britten, Peter Pears and other musicians associated with the Aldeburgh Festival she carried out some more portraits. Having divorced her husband in 1955, Potter remained in Aldeburgh until her death. The 1950s saw several changes in her works: their size increased and they became more abstract. The thick paint of the 1930s gave way to thin layers of a wide range of pale colours. She condensed the familiar subject matter to its essential qualities, dispensing with peripheral details. From 1951 she also received increasing recognition, with a series of solo shows and retrospectives. In the year of her death she was a prize-winner at the John Moores' exhibition in Liverpool.

*Examples:* Kirklees; Hull; Tate G, London; Manchester; Sheffield; Southampton.

*Literature:* M. Piper, *MP: paintings 1938–64*, Whitechapel Art G, London, 1964; Nottingham, 1982; *MP*, New Art Centre, London, 1986; *MP: paintings 1922–80*, Serpentine G, London, 1981; F. Spalding, 'MP', *Studio International*, 1977/3, 183.

## POUPELET, Jane (1878–1932)

*French sculptor of figures, especially women, and of animals*

Born in Saint-Paul-Lizanne, Dordogne, she trained initially at the Académie Julian in Paris, continuing her studies with Schneeg and then Rodin. Her first exhibit was a decorative fountain in 1900, which won her a coveted *bourse de voyage*. With this she travelled through Italy, a journey which was to have a profound impression on her. In addition to teaching drawing, she exhibited widely in the Salon de la Société Nationale des Beaux-Arts, the Salon des Tuiléries and the Salon d'Automne, becoming a jury member for all three. She also held the positions of vice-president of the SNBA in 1921 and president of the Fine Art Section of the International Federation of University Women. During World War I she helped the American Red Cross, dealing with those suffering from facial disfigurements. After the war she had a succession of solo shows in several European countries and also exhibited in New York at the NAD, the New York Society of Women Painters and Sculptors, and in a two-person show at the Whitney Studio. Her contribution to French art was recognised with the award of Chevalier de la Légion d'honneur. In 1937 she was chosen for the retrospective section of the *Femmes artistes d'Europe exhibition* in Paris. Her figures consist of simplified forms, with all anecdotal detail omitted. The purity of her sculptured forms and her drawing were much admired.

*Examples:* Mus. d'Orsay, Paris.

*Literature:* Edouard-Joseph; C. Kunstler, *JP*, Paris, 1930; Mackay.

## PREECE, Patricia (1900–?)

*English painter of figure subjects and portraits*

At 17 Preece went to the Slade, where she studied under the conservative Henry Tonks but her work was nevertheless highly praised by modernists Vanessa Bell (*q.v.*) and Roger Fry. While at the Slade she met Dorothy Hepworth, who was to be her lifelong companion, and the two artists were persuaded by Fry to go to Paris for the sake of their art. Preece studied under Lhote, while Hepworth attended the more conservative Académie Colarossi. They returned to England after four years in 1925, and two years later settled in Cookham,

Berkshire. Neither of them had a private income, but Hepworth's father bought her the cottage where they lived. Hepworth devoted herself and her art to Preece, for the majority of works exhibited under Preece's name were executed by Hepworth, while Preece, who was the more outgoing of the two, negotiated with dealers and attended private views. Their relationship withstood the episode of Preece's marriage to painter Stanley Spencer, who lived nearby. After Spencer persuaded Preece to marry him, she banned him from the house the next day and the marriage was never consummated. Important exhibitions of Preece's work (how much of this she had herself executed is not known) were held in 1936 and 1938. Clive Bell wrote the introduction to the later show, indicating a continuing interest in the work of Preece and Hepworth by the Bloomsbury group. In 1942 she was exhibiting with the AIA, and received a portrait commission from the War Artists' Advisory Commission. After the war she continued to exhibit at the RA and elsewhere until 1968.

*Literature:* Cooper; *Paintings and drawings by some women war artists*, Imperial War Mus., London, 1958; Waters.

## PROCTER, Dod, née Doris M. SHAW (1892–1972)

*English painter of figures, with some village scenes and still lifes, who was the third woman elected a full member of the Royal Academy since its foundation*

Born in London, she was brought up in Tavistock, Devon. Her father, a ship's doctor, was lost at sea when she was still a child, so the main influence in her formative years was her mother, who had as a student been regarded as the best painter in her year. Mrs Shaw took Dod and her brother to study at the painting school of Stanhope and Elizabeth Forbes (*q.v.*) at Newlyn in 1907. Apart from visits abroad she was to spend the rest of her life in Newlyn. Laura Knight (*q.v.*) arrived in Newlyn at the same time and the two became lifelong friends. Both enjoyed not only the painting but also the lively social life among the artists. Dod Shaw studied at the Académie Colarossi in Paris in 1910, accompanied by her mother. She was particularly interested in the work of Cézanne, Seurat and Renoir. Ernest Procter, whom she had met in Newlyn, was also a student at Colarossi's, and by the time they returned to Newlyn in 1911 they intended to marry the following year. Their

son Bill was born in February 1913, but Dod Procter was not maternal. When Ernest was away driving ambulances during the war she became depressed with having to manage the house and Bill on her own. A joint commission from a Chinese millionaire to decorate the Kokine Palace in Rangoon, awakened Dod's interest in travel, which she pursued with renewed vigour after Ernest's death in 1935. She began to exhibit at the RA in 1913 as Shaw, and from 1916 as Procter, continuing to send several works almost every year until 1969, a record which characterises her single-minded approach to painting. In the 1920s she painted many portraits, particularly of women. They have a solid sculptural quality, which has been attributed to the early influence of both Cubism and Picasso; 'I digested him well', she once said. There is a clarity and elimination of superfluous detail which is reminiscent of the contemporary *Neue Sachlichkeit* portraits. Her painting *Morning* was bought by the *Daily Mail* in 1927 before it reached the RA, where it was declared painting of the year and presented to the Tate Gallery. Dod Procter was elected an Associate of the RA in 1934 and a full Academician in 1942. She believed that one should do as one wished in life and painting and not be a slave to fashion.

*Examples:* Tate G, London; Newcastle-upon-Tyne; Swansea.

*Literature:* A. Bertram, 'Contemporary British painting: DP', *Studio*, Jan. 1929, 92–7; Deepwell; C. Fox and F. Greenacre, *Painting in Newlyn, 1900–1930*, Barbican G, London, 1985; *DP*, Leicester G, London, 1945; *Silver Bells and Cockle Shells*, Whitford & Hughes G, London, 1986; N. Welch, 'DP: a memoir', *The Cornish Review*, no.22, winter 1972, 37–42.

## PROUT, Margaret Millicent. née FISHER (1875–1963)

*English painter of landscapes, figures and flowers*

She was the oldest child and only daughter of the pioneer English Impressionist painter, Mark Fisher. Although born in Chelsea, she spent her childhood in a variety of country homes in England and France, staying quite long periods on the Normandy coast near Honfleur. As an older child she attended a series of schools in the rural parts of England to which her father's painting took the family, and whenever possible she painted with her father in the fields. She entered the Slade in the 1890s, forming part of the cohort of talented women students contemporary with Gwen John (*q.v.*). Studying under Fred Brown she acquired a reputation as one of the most outstanding students. After the Slade she taught life-classes at the Hammersmith School of Art, but her natural reticence had denied her the chance of other posts. In 1908 she married John Prout, who came from a Hertfordshire farming family. At the farm in Sawbridgeworth where they settled, she had plenty of opportunity to paint and from this period came many landscapes and cattle pictures. While her husband was in the army during World War I, Margaret Prout went to stay with her parents in Essex until her husband returned, having been injured at the Somme. In the various houses where they lived after this, Margaret and her husband created a series of flower gardens, which provided the subject matter of many of her paintings. She had exhibited with NEAC from 1909 and was elected a member in 1925. Her election to the Royal Watercolour Society followed in 1938 and that to Associate member of the RA in 1948. After the death of her husband in 1957, she lived at Hastings and then at Pett Level, also on the south coast. Far from retirement, her later years brought increasing recognition of her work, including a medal from the Paris Salon and the purchase of a painting by the Chantrey Bequest for the Tate Gallery. In her watercolours she developed new techniques, which included washing out her work under the tap, and using charcoal and chinese white to achieve striking and unusual effects. A retrospective exhibition was held at Worthing, Sussex in 1961, but she was still painting and exhibiting at the RA 42 years after her first exhibit there, when she died at the age of 88. A memorial exhibition of her work was held at the RWS Gallery in 1966.

*Examples:* Worthing, Sussex.

*Literature:* V. Lines, *Mark Fisher and MFP: father and daughter*, London, 1966; *Paintings by MFP, ARA, RWS, with a group by her father Mark Fisher, RA*, Art G, Worthing, 1961; Waters; *Who's Who in Art*.

## PULLINEN, Laila (1933–)

*Finnish sculptor of abstract works often combining two different materials*

One of the most international of Finnish artists, she has studied and worked in a number of

European countries. She was born in Terijoki (now Zelenogorsk), her father being an army officer. At the age of 20 she enrolled at the Helsinki Academy, and between 1955 and 1962 she studied in England, France and on two occasions in Italy, the second time spending a year at the Academy in Rome. This experience of the south of Europe was extremely influential, and she longed to be able to evoke the dynamic movement which she saw in Baroque art and architecture through a contemporary idiom. Experimenting with many different materials and techniques, she came to see that it was through the contrast between materials that she could best achieve this. Bronze was often one of these, and she evolved a sophisticated treatment of this material through building up complex shells of steel bands and wax, which she moulded by hand. Chosen to represent Finland at the 1964 Venice Biennale, she was also selected for the Montreal Exposition in 1967. For this she was commissioned to make a relief illustrating copper as one of her country's basic raw materials. Searching for an appropriate technique, she evolved a process of using small quantities of explosive to dent, pierce and mark the thick copper sheet. Refining the process to a precise science, she produced a number of pieces in this way. In contrast to the finish of her earlier works, these are three-dimensional equivalents to painters such as Tapies who produced rough, tactile surfaces in two-dimensional works, combining dynamism, strength even to the point of brutality. Pullinen found the stimulus to work derived from reacting against something, whether traditional working methods (she never makes preparatory models) or the artistic establishment or Finnish society, with which she contrasted that of Italy.

*Examples:* Town Hall, Helsinki.

*Literature:* G. Schildt, *Modern Finnish sculpture*, London, 1970.

## PURSER, Sarah Henrietta (1848–1943)

*Irish painter, collector and promoter of Irish art who was instrumental in the founding of the Municipal Gallery in Dublin and the beginning of art history as a university discipline in Ireland*

A dynamic and tireless woman, Purser refused to accept a conventional role and through her efforts and example opened many doors to younger women. Born in Dun Laoghaire, she grew up in a wealthy business family in Dungarvan. Her private education included a Swiss finishing school. However, in 1873 her father's business collapsed and she turned to painting in order to support herself, attending first the Dublin School of Art and then the Académie Julian in Paris. Her time there in 1878 coincided with Breslau (*q.v.*), with whom she shared lodgings, and Bashkirtseff (*q.v.*), in whose diaries she is described as 'peintre et philosophe'. Her style was robust and realist according to the Paris fashion of the time and she exhibited regularly in Dublin. Critics noted the combination of technical skill with analytical and intellectual prowess. In order to provide herself with an income, she undertook portraits and was soon in great demand by the British aristocracy, a task made easier by her social position. These tight and meticulous works, 'deaders' as she called them, brought her sufficient money by 1886 to enable her to travel, and on her visits to France she encountered Impressionism, which had a considerable effect on her style, notably in loosening her brushstroke. In addition to portraits, Purser painted flowers, interiors, landscapes and genre, including one of the few examples of industrial genre. By the turn of the century she was giving increasing time and energy to promoting other artists and art projects and her output diminished as a consequence, although she never abandoned it. Recognised as a powerful debater, her monthly salons were the gathering place for artists, writers and other intellectuals. Her considerable business acumen was put to the service of art and artists, such as the founding and management of a stained glass workshop, The Tower of Glass, in 1903, where many women artists like Evie Hone (*q.v.*) were employed. She also worked with Mainie Jellett (*q.v.*) for the acceptance of modernist art in Ireland, and to this end she assisted Hugh Lane in his efforts to found a gallery of modern art. After his death, she was one of the main protagonists in continuing to work for this goal, founding the Friends of the National Collections of Ireland in 1924 and appealing to the Irish President for the use of a particular building for the gallery. Having been elected an honorary Academician in 1890, in 1924 she was able to hold the honour by right, as it was now open to women as well. In addition, Purser was also a collector of art and patron of contemporary artists. In 1934 she persuaded her cousin to contribute with her towards an annual prize and scholarship to the best candidates in an examination in the history of European painting, to be awarded alternately by Trinity College, Dublin and University College, Dublin. As a result of this tuition began, and in

the 1960s both universities founded departments of art history under women.

*Examples:* Nat. G and Hugh Lane Municipal G, Dublin.

*Literature:* J. Campbell, *The Irish Impressionists: Irish artists in France and Belgium, 1850–1914*, Nat. G, Dublin, 1984; *Irish art in the nineteenth century*, Municipal School of Art, Crawford, 1971; *Irish women artists*; J.O'Grady, *SHP*, unpublished Ph.D. thesis, Nat. University, 1974; H. Pyle, *Irish art, 1900–50*, Muncipal School of Art, Crawford, 1975; J. White & M. Wynne, *Irish stained glass*, Dublin, 1963.

## PUTNAM, Brenda (1890–1975)

*American sculptor initially of putti-like children for garden settings, but later of figures in a style simplified through contact with modernist ideas*

Although she came from a literary family in Minnesota, her early demonstration of artistic ability led to her enrolling at the Boston Museum Art School when only 15. She remained there two years and then continued her studies at the Art Students' League, New York. When her father became librarian at the Library of Congress, she took further instruction at the Corcoran Art School and began to exhibit in 1910. For the next 15 years or so she became very successful with a series of sculptures for fountains and sundials based on a Renaissance-style representation of children, often with animals. She also carried out portraits, notably of musicians, which benefited from her own enthusiasm for music in that she captured the temperament of each person. Despite winning several prizes she became dissatisfied with her style, and about 1927 she spent a period in Florence. Ironically it was back in New York that she encountered the ideas of Archipenko whose work developed from Cubism, which led to the simplification of form and a reduction in detail. Her second phase was equally successful. Among her completed works was a *Memorial to the Women of Virginia*, the prize-winning design for a Congressional medal. Under the auspices of a government-funded scheme in the 1930s she completed a relief panel. From 1937 to 1943 Marion Sanford (*q.v.*) was her assistant and provided the illustrations for Putnam's book on sculpture, which was aimed at aspiring women artists. In 1936 she was elected a full member of the NAD, and also became a member of the National Sculpture Society. During World War II Putnam took a post as draughtswoman in an engineering factory, but a bout of shingles contracted during this period adversely affected her sculptural output.

*Publications: The sculptor's way*, New York, 1939; *Animal x-rays: a skeleton key to comparative anatomy*, [*c*.1947].

*Examples:* Brookgreen Gardens, SC; Corcoran G, Washington DC.

*Literature:* Mackay; Proske, 1968; J. Lemp, *Women at work*, Corcoran G, Washington, DC, 1987; *Sculpture by BP*, Brookgreen Gardens, 1937.

## QUERNER, Ursula (1921–)

*German figurative sculptor in wood and metal*

Initially trained in woodcarving, Querner began to study for her MA in 1947 at Lübeck. From the early fifties, she travelled to France several times in order to see Rodin's sculpture. At this time she was working in wood and clay in a realistic manner inspired by the German Expressionist sculptor, Lehmbruck. The award of the Rome prize in 1959 enabled her to learn bronze casting in Italy, where she also discovered the work of Manzù and Martini. A number of commissions enabled her to buy a studio on the Italian coast, where she produced a series of bronze *Divers* with rough surface texture and a more abstract conception of the figure than in her earlier work.

*Literature:* Krichbaum.

## QUINTANILLA, Isabel (1938–)

*Spanish realist painter of still lifes and interiors*

Having trained from 1954 to 1959 at the Schools of Fine Art in Madrid and San Fernando, Quintanilla spent three years (1961–4) in Rome. After she married the painter and sculptor, Francisco Lopez, the two artists, together with their friends Maria Moreno (*q.v.*) and Antonio Lopez Garcia, formed the new Spanish Realists, a group who are particularly well received in Germany, where they have exhibited many times. The distinctive feature of Quintanilla's interiors rests in the avoidance of a carefully arranged group of objects in favour of the corners of ordinary kitchens, with cookers and cupboards.

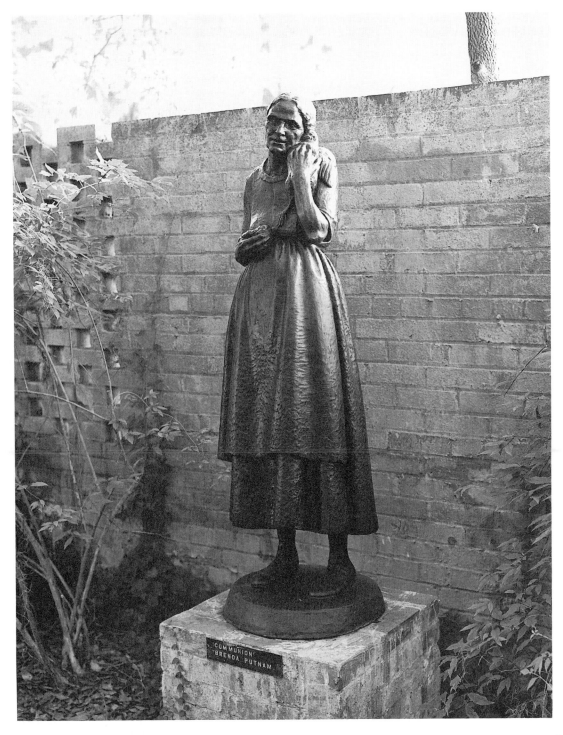

**Brenda Putnam** *Communion*, 1939, bronze, height 132.2 cm, Brookgreen Gardens, South Carolina. (photo: courtesy of Brookgreen Gardens, Murrells Inlet)

*Examples:* Nat. G, SMPK, Berlin.

*Literature: Das Verborgene Museum*; Krichbaum.

## RAE, Henrietta. (alt. NORMAND) (1859–1928)

*English painter of classical and allegorical subjects, often including female nudes*

Born in London, she was the youngest of seven children of a civil servant. Her mother was musically gifted and had at one time studied under Mendelssohn, so all the children were taught music. Henrietta's musical education was orientated towards making her a professional singer, not on the basis of talent but because all the children were instilled with the necessity for them to be able to earn a living, their father's income being insufficient to keep a family of adults. Henrietta watched an older sister being taught drawing by an uncle, and by the age of 13 she could think of nothing but art. The same uncle recommended that she receive training, whereupon her father spent her to Queen's Square (later Royal Female) School of Art. After two years of instruction in drawing, she decided to go to work in the Antique galleries of the British Museum, where there were many students aiming to gain entry to the RA Schools, and she supplemented this with attendance at evening classes at Heatherley's. She gained admission to the RA Schools in 1877, along with Margaret Dicksee (*q.v.*) and Ernest Normand. She exhibited from 1879 and at the RA from 1880. Although she painted landscapes, she also accepted portrait commissions because she needed to finance herself. This factor is reflected in her contributions to exhibitions in the early 1880s, but from 1883 other figurative work also appears. As a result of Normand selling a painting for 300 guineas, the two artists got married in 1884 and lived in Kensington. They were accustomed to working together and usually shared a studio. Normand was very supportive and it was at this point Rae decided to turn to mythological subjects. It was exceptional both for a woman painter to submit works based on the female nude, and to have them accepted. Her son was born shortly after the opening of the 1885 RA exhibition. During the following years she executed a series of large mythological paintings in which she deliberately set herself a variety of problems to solve. By 1890 both Rae and Normand suffered a crisis of confidence, which they resolved by study in

France, first at the Académie Julian, and then at Grez-par-Nemours, near Barbizon, where Rae encountered Impressionism, executing a number of landscapes under the influence of Monet. Although she did not persist in this style, the experience caused her to soften the edges of her forms, and *La Cigale*, her first major work after her stay in France, was hung on the line at the RA and received an award in Paris; the copyright was sold for engraving. Several further paintings were commissioned for reproduction as chromolithographs and engravings. The year 1893 was a notable time for Rae. In addition to works in the London exhibitions, she was represented in the Women's Building at the Chicago Exposition, gave birth to a daughter and was invited to be the first woman member of the hanging committee for the annual autumn exhibition at the Walker Art Gallery, Liverpool. In the same year they moved to Holland Park, where Normand's father built them a studio, including a glasshouse in which the effects of open-air paintings could be achieved. The next few years followed a similar pattern of painting and exhibiting, but in 1896 Rae and Normand fulfilled a longstanding ambition by making an extended visit to Italy. Mythological paintings were interspersed with commissions for portraits and for works for reproduction, and in 1900 Rae and Normand received commissions for two paintings (18m. × 12m.) for the Royal Exchange in London, part of a large scheme of 24 paintings initiated by Lord Leighton. Rae's panel showing the deeds of Dick Whittington contained 14 life-size figures. Her biographer emphasises that she achieved artistic success through hard work and succeeded in an area unusual for a woman in the late nineteenth century.

*Examples:* WAG, Liverpool; Royal Exchange, London.

*Literature: AJ*, 1901, 137–41, 302–7; D. Cherry, *Painting women: Victorian women artists*, Art G, Rochdale, 1987; Clement; A. Fish, *HR*, London, 1906; Nottingham, 1982; Sellars; *Who was Who, 1916–28*; Wood, 1978.

## RAMA, Olga Carol. (alt. CAROLRAMA) (1918–)

*Italian painter of familiar objects in a fantastic, quasi-surreal context*

Rama is a native of Turin. Her early works, from the late 1930s and early 1940s, contain everyday

objects, such as dentures, women's shoes, and urinals placed together in series with others of their kind seen from different angles with little or no background. This divorce from a context concentrates the spectator's attention on the objects, conveying the sense of 'objets-souvenirs fétiches'. Since 1945 Rama has been extremely successful, with many solo and groups exhibitions, invitations for the Rome quadriennals and Venice bienniali on several occasions and a major retrospective in Milan in 1985.

*Literature:* Vergine.

## RAND, Bay. née Ellen Gertrude EMMET (1875–1941)

*American painter of portraits and informal groups of family and friends*

The third of six children, she was born in San Francisco, where her lawyer father had moved in 1849. She was related to distinguished intellectual and artistic families on both sides, being a first cousin to the novelist Henry James, Rosina Sherwood (*q.v.*) and Lydia Emmet (*q.v.*). After her father's death in 1884, the family moved to New York, where Bay Emmet's passion for drawing was guided from an early age by Dennis Bunker. From 1889 to 1893 she attended the Art Students' League and spent one summer with William Chase in Long Island. By the age of 17 she was already contributing fashion sketches to *Vogue*. During a visit to Europe with her family in 1897 she met both John Singer Sargent (in London) and Frederick MacMonnies (in Paris), and spent three years studying under the latter. During this period, her acquisition of confident draughtsmanship brought her recognition which enabled her to set up her own studio in New York when she returned there in 1900. She immediately built up a thriving portrait business, so that by 1902 the art dealer Durand-Ruel was able to give her a solo show at a time when such events were most unusual. A late marriage when she was 36 to William Rand, a farm manager from Salisbury, Connecticut, and the birth of three sons in 1912, 1913 and 1914, did not impede her activities. Her children lived with her in New York during the school year and summers were spent on the family farm. A contemporary of Cecilia Beaux (*q.v.*), Rand too was more than a slick portraitist, able to give penetrating insight into her subject. She also carried out more informal works of her family and friends, which were seen only at a 1954 retrospective. As her fame spread, she gained commissions for official portraits and her output of over 800 works features many eminent people who sat for her. She won medals at the Expositions at St Louis (1904), Buenos Aires (1910), and the Panama-Pacific (1915), and in 1926 was elected an Associate of the NAD, with full membership being awarded in 1934. After the family lost its wealth in the Wall Street crash (1929), Rand's paintings, which had always been an important source of finance, now provided the only income. In order to pay for her sons' schooling she undertook a gruelling regime of commissioned portraits, for which she was eventually able to ask $5,000 each. In 1930 she is reported to have earned $74,000. However, this probably shortened her life, for she died of a heart attack at a relatively early age.

*Example:* Metropolitan Mus., New York.

*Literature:* M. Hoppin, *The Emmets: a family of women painters*, Berkshire Mus., Pittsfield, Mass., 1982; *Notable American Women*; *EER*, Berkshire Mus., Pittsfield, Mass., 1954; Rubinstein; Tufts, 1987.

## RANTANEN, Ulla (*c.* 1940–)

*Finnish painter and graphic artist*

Accepted at the Helsinki Academy at the age of 17, Rantanen had a prodigious drawing talent that had been evident from an early age. Her rhythmic wood engravings of the early 1960s gave way to large paintings displaying her sympathy for the poor and oppressed. She travelled in Europe and America seeing things which would only later emerge in her work. Studies of discarded objects followed but in the mid-1970s she came to terms with her rural upbringing. She integrated this with her social awareness, and the initial works of this phase show the effects of people on the landscape. This is achieved in a non-descriptive way by focusing on small items within a semi-abstract setting. A series of studies of single stones, but with an emphasis on the paint, varies from the dramatic *Sacrificial stone* to an ordinary pebble. The colours lie predominantly in a narrow range of black, brown, grey and white. She has received many awards and has represented Finland internationally. She was selected as Finnish artist of the year in 1985.

*Literature:* U. Pallasmaa, 'Beauty is irrelevant, disturbing', *Look at Finland*, v4, 1985, 6–11.

**Ulla Rantanen**  *Stones*, 1983, lithograph, Ateneumin taidemuseo, Helsinki.

## RAPHAEL, Antonietta (1900–75)

*Russian-born painter and sculptor who worked in Italy*

After the death of her father, who was a rabbi, in 1905, Raphael left her birthplace of Kowna in Lithuania and settled in London with her mother. She later became the pupil of Jacob Epstein, and after a brief stay in Paris in 1924 settled in Rome. In 1926 she married Mario Mafai, whom she had met while attending the Academy of Fine Arts in Rome, and they worked together, sharing a studio. Raphael first exhibited in 1929 and with Mafai spent the next four years in Paris and London, where Epstein had invited her to exhibit. Her paintings up to this point were a combination of a robust classicism and naïvety, but from 1933, when she returned to Rome, she took up sculpture, which shares some of these characteristics. Being Jewish she and her daughters suffered discrimination during the Fascist period and had to remain in hiding for some time. Helped by two patrons during and after this time, she remained in Genoa from 1939 to 1943 and from 1945 to 1951, devoting herself to sculpture. Back in Rome in 1952 she won a national prize in the competition for the *Monument to the Unknown Political Prisoner*, and finally began to receive critical attention. Since then she has exhibited extensively, both individually and in groups.

*Literature:* M. Foglio, *R*, Rome, 1978; Vergine.

## RAPIN, Aimée (c. 1860–?)

*Swiss painter of portraits in oil, pastel and sculptor of bas-reliefs who worked with her feet*

Rapin was born in Payerne, Vaud, with no arms. Her parents educated her well and it became evident that her prehensile toes compensated for the lack of hands. Her artistic talent was so

evident that at the age of 16 she began attending the École des Beaux-Arts in Geneva, where she studied both painting and modelling. Her concentration on portraits resulted partly from financial considerations and partly due to natural preference for evoking character and ennobling an ordinary task. *The Genevese Watchmaker* (1896), which encapsulated these qualities, was purchased by the government, and the city of Geneva was among those who commissioned work from her. She exhibited in Paris, Berlin and Munich in addition to her own country.

*Examples:* Geneva; Neuchatel.

*Literature:* Clement; *Studio*, 1903, 147–8.

## RAVERAT, Gwendolen Mary. née DARWIN (1885–1957)

*English wood engraver and illustrator*

Born in 1885, she was the daughter of George Howard Darwin, Charles Darwin's second son and Professor of Astronomy at Cambridge University. While training at the Slade (1908–11), she encountered some engravings by Thomas Bewick and was inspired to try this medium, which was not taught in any art schools at the time. After her marriage in 1911 to Jacques Raverat, a French illustrator, she learnt from him to think more in terms of composition. Eric Gill also influenced her to experiment with a more austere style. However, her interest in the tonal values of painting, which she continued to practise parallel with her engraving, prevented her using large areas of black or white. While they lived for some years in the south of France, her woodcuts show the effects of strong sunlight, which contributed to the objectivity of her later work. Many of her early subjects were taken from the stories of Hans Andersen, but landscapes are a consistent feature of her work. After her husband's death in 1927, Raverat brought up her two daughters and continued to receive a number of commissions, which included both landscapes at different seasons and representations of the myth of Daphnis and Chloe. From 1929 she became the art critic for *Time and Tide* and wrote a semi-autobiographical memoir of her family. She was made an Associate of the Royal Society of Painters and Engravers as early as 1920 and became a full member in 1934, but she was also a founder member of the Society of Wood Engravers. Her great technical facility meant that she was able to convey through an engraving very

subtle effects, such as the tonal values of ripples of water.

*Publications: Period piece*, London, 1952.

*Literature:* B. Clark, *Shall we join the ladies? Women wood engravers of the twentieth century*, Mus., Oxford, 1979; Deepwell; J. Fletcher, 'The woodcuts of GR', *Print Collectors Quarterly*, v18, 1931, 330–50; P. Jaffe, *Women wood engravers*, London, 1987; Waters.

## RAWSTHORNE, Isabel. (alt. LAMBERT) (c. 1910–)

*English figurative painter*

Rawsthorne is, like a number of women artists, better known as the subject of art. Her portrait was painted by Picasso, Derain and Francis Bacon, in addition to the anonymous figures for which she posed. The daughter of a merchant seaman, she attended Liverpool School of Art and then went on to the RA Schools. These she found too upper class and affected, so she left and became an assistant of Epstein. Thereafter she spent much of her life in France, where she was part of the avant-garde set around Picasso. While living with Giacometti she attended public life classes and posed for Derain in order to finance her own work. During the 1930s she married the journalist Sefton Delmer, only leaving France at the outbreak of war. During the war, she designed propaganda material for Delmer, who was head of black propaganda. In 1946 she married the composer and conductor, Constant Lambert, and through him she encountered a new subject, the ballet, which she drew and painted tirelessly. After his death, in 1951, she married his friend, the composer Alan Rawsthorne, who died in 1971. In the 1980s she is still exhibiting but, with failing eyesight, she is not able to paint so much.

## RAYNER, Louise. (also sisters Frances, Margaret, Nancy (1827–55), Rosa) (1832–1924)

*English painter, particularly in watercolour, of architectural subjects and landscapes*

The five daughters of Samuel Rayner, who painted watercolour interiors, all became artists and were initially instructed by their father. His wife also

executed engravings, particularly on black marble. Louise was later taught by Niemann, David Roberts and Frank Stone. Her early paintings were mainly oil interiors, exhibited at the RA around 1852, but she increasingly used watercolour for her architectural interiors, especially of churches, views of towns and landscapes. Her specialities were the old streets and alleys of towns such as Edinburgh, Hastings, Chester, and London. At some stage she visited northern France, where she painted a number of landscapes. She exhibited consistently with the SWA from about 1860. She was known for the gem-like quality of her colour and the precise capturing of texture and the effects of sunlight.

Nancy was also a talented artist, who received advice from Cattermole, David Cox, Samuel Prout, David Roberts and Frank Stone. Her output consisted of rustic figures and interiors and she was elected a Lady Member of the Royal Watercolour Society in 1850 at the age of 23. She exhibited there and at the RA before her premature death.

Margaret's work resembled that of her father, and her subjects included the interiors of old churches and architectural views, particularly in Sussex. She seems to have been something of a recluse and lived with or near Louise at St Leonard's-on-Sea, Sussex. She was elected member of the SWA and exhibited with the society from 1866 until 1890.

Frances (Mrs Coppinger) is a more shadowy figure. She seems to have trained only with her father and then gave up painting on her marriage.

Rosa painted figure subjects in watercolour, coloured photographs and was an art teacher. She exhibited infrequently but was still doing so in the mid-1880s, including at the SWA.

*Examples:* Louise: Birkenhead, Merseyside; Grosvenor Mus., Chester; Coventry; Derby; V & A, London; Newport, Gwent; Reading.

*Literature:* D. Cherry, *Painting women: Victorian women artists*, Art G, Rochdale, 1987; Clayton; Mallalieu; P. Nunn, *Victorian women artists*, London, 1987; *Queen*, 4 Dec. 1880, 500–1; Wood, 1978.

### REA, Betty. née BEVAN (1904–65)

*English figurative sculptor*

The daughter of a London doctor, Betty Bevan first studied painting at the Regent Street Polytechnic in 1922, but soon decided to transfer to sculpture. This she pursued from 1924 at the Royal College of Art, where Henry Moore was a studio teacher and became a friend. In 1926 she married James Rea and had two sons, in 1928 and 1931. In addition to her family and her sculpture, her strong social conscience induced her to undertake additional responsibilities. During the 1930s she was active in left-wing politics, including work for the Artists' Refugee Committee and holding the post of secretary of the Artists' International Association, 1934–6. During the war she taught art to children in the Midlands who had been evacuated from London, and a considerable number of her own works were bought by education authorities and institutions. After the war she moved to Cambridge, where she was able to devote more time to sculpture, although she continued her involvement in education and contributed appreciably to raising the standards of teaching art and craft in English schools. Her early works were direct carvings in wood and stone, but from 1949 she began to work in terracotta, and later modelled in clay for casting in *ciment fondu*, bronze resin or bronze. Her principal subject was the figure, singly or in groups, although she also undertook a few portrait commissions.

*Examples:* Coventry.

*Literature:* BR 1904–65, Zwemmer G, London, 1967.

### REBAY, Hilla. (alt. Baroness Hildegard Anna Augusta Elizabeth Rebay VON EHRENWEISEN) (1890–1967)

*German-born abstract painter who, after emigrating to America, was responsible for the formation of the Solomon Guggenheim collection and museum*

Rebay devoted her life to the promotion of abstract art, and her activities parallel those of Katherine Dreier (*q.v.*) in bringing modern European art to America. She was born in Strasburg, then in Germany, where her wealthy and cultured family encouraged her artistic interests. Enrolling at the Académie Julian in Paris at the age of 19, she discovered modernist art and became familiar with theosophy, which was to lead to a lifelong interest in oriental mysticism. While exhibiting with the modernist artists' groups in Munich, Cologne and Paris in the years before World War I, she had a meeting with Jean Arp in 1916 in Switzerland, which proved to be the turning point in her career.

He urged her to pursue her non-objective work and convinced her of the importance of this form of art. Through Arp she had two solo shows at the Der Sturm Gallery in Berlin, which included some abstract collages from 1917, and saw at this gallery many of the modernist works she later collected. It was through Der Sturm that she met Rudolph Bauer, infatuation for whom led her to overlook his derivative style and parasitic nature. Although she supported him financially for many years, and emotionally for a time, he disseminated false rumours in America during World War II to the effect that she was a spy. Emigrating to America in 1927 she was amazed to find little abstract art there and set about reversing this situation. Through family links she came to know Irene and Solomon Guggenheim, whom she persuaded to begin collecting European non-objective art. Eight years later, in 1937, their collection was such that the Guggenheim Foundation was established with Rebay as curator. In 1939, a provisional home for the museum was opened on East 54th Street, New York. As director, Rebay then organised the building of the permanent museum by Frank Lloyd Wright, completed in 1959. Guggenheim's death in 1949 left her vulnerable, and it has been suggested that the museum trustees forced Rebay to resign in 1952, subsequently operating a policy of purchasing modernist art in general, rather than only abstract art. Throughout this time, Rebay had continued to paint and exhibited in America from 1927 to 1962. Many of her themes and titles were derived from music. Although she remained active in the arts, her old age was spent in isolation and disappointment.

*Literature:* J.M. Lukach, *HR: in search of the spirit in art*, New York, 1983 (full bibl.); *Notable American Women*, v4; Rubinstein.

## REDFERN, June (1951–)

*Scottish painter of broadly painted monumental figures, often women*

Born in Fife, Redfern intended to be an artist from an early age and was encouraged by her parents and her school. After training at Edinburgh College of Art from 1968 to 1972, she taught for several years in a school. She continued her own work during this period, deriving her imagery from the urban working-class background of her pupils, with the occasional image from the mass media. Dissatisfied with this semi-realist approach,

Redfern began again by collaging her pastel drawings, and a residency at Cardiff College of Art in 1983 enabled her to gain a clearer perspective on her work and her philosophy. Her concern with religion in a broad sense, the unconscious, sex and death led to a series of large paintings, freely handled, with one or two figures, or only a head, occupying most of the canvas. As the National Gallery artist in residence in 1985–6, she had to work much more in the public domain, but it marked the start of a move away from the gestural technique. A series of single figures in watercolour washes, economically expressive, led to oils in which one or two monumental figures are seen against a background of thinly stained canvas. The concern with subject, particularly social themes, has re-emerged although facture is still of primary importance. During the 1970s she exhibited in several shows organised by the women's art movement, but now believes that intervention in the establishment is the most effective strategy for women artists.

*Examples:* Charlotte Engelhart Foundation, Boston, Mass.; Dundee; Scottish Nat. G of Modern Art and City Art G, Edinburgh; Nat. G, London; Middlesborough.

*Literature:* Cooper; *JR: to the river*, Third Eye Centre, Glasgow, 1985; A. Smith, *JR: new work*, Cartwright Hall, Bradford, 1987; Cooper; *The vigorous imagination*, Scottish Nat. G of Modern Art, Edinburgh, 1987.

## REDPATH, Anne (1895–1965)

*Scottish painter of landscapes, still lifes and church interiors in rich colours*

Born in Hawick, Redpath was the daughter of a tweed designer. After attending Edinburgh College of Art from 1913 to 1917, she won a travelling scholarship in 1919, which enabled her to visit Belgium, France and Italy, where she looked principally at fourteenth-century Sienese works. This preference for so-called primitive art was a characteristic which led her to admire folk art and traditional crafts, and to adopt some of their devices to achieve spontaneity in her own work. In 1920 she married James Michie, an architect, then working with the War Graves Commission, which necessitated residence in France. Later he became a private architect in the south of France, where they lived for a number of years and where Redpath was chiefly involved with her family. They

returned to Hawick in 1934, although her husband then worked in London. Encouraged by friends to continue working and exhibiting, Redpath painted local landscapes, still lifes and interiors reminiscent of Vuillard and Bonnard. As a substitute for the Mediterranean views she was accustomed to, she often painted inside some large greenhouses near her house. From the late forties she was able to travel more extensively and to paint more actively. A visit to the interior of Spain in 1951 proved seminal and, with the advent of abstract and expressionist styles, this contributed to the freer handling of paint from the mid-1950s. Her later works include many interiors of Mediterranean churches, with rich, glowing colours, all compressed, as was her custom, into a narrow pictorial space. She exhibited from 1919, and from 1947 until her death had a series of solo shows.

*Examples:* Scottish Nat. G of Modern Art, Edinburgh; Glasgow.

*Literature:* G. Bruce, *AR*, Edinburgh, 1974; Nottingham 1982; *AR memorial exhibition*, Arts Council, Edinburgh, 1965; *AR, 1895–1965*, City Art Centre, Edinburgh, 1972.

## REGINA. (pseud. of Regina Prassede CASSOLO) (1894–1974)

*Italian Futurist sculptor*

Probably the most successful of the women Futurists, she was born in Mede Lomellina, Pavia, where her parents ran a butcher's shop. Her father died when she was six, and four years later she was sent to a convent, where she showed particular talent for music. After studying art at the Brera Academy, she became a pupil of Giovanni Alloati in Turin. Her early works were in marble and bronze but in the early 1930s she began her lifelong exploration of the new and untried. While agreeing with the Futurist adulation of dynamism of the city, she rejected their obsession with the machine. The sculptures in her first solo show of 1931 consisted of subjects such as dancers, executed in tin, aluminium and sheet metal, captured in mid-movement. She shared the interest in creating the artistic equivalent of flight with other Futurists, executing a series of aluminium works on the theme, and her investigations with sheet metal and glass have been compared with those of Naum Gabo. After World War II she constructed increasingly abstract and geometrical sculptures from plexiglass sheets and other resins. For a short

time she was also interested in the graphic arts and was one of the first artists to create abstract lithographs (1948). She exhibited extensively in the post-war period.

*Literature:* M.B. Katz, 'The women of Futurism', *WAJ*, v7/2, fall 1986-winter 1987, 3–13; V. Scheiwiller, *R*, Milan, 1971; Vergine.

## REGO, Paula (1935–)

*Portuguese-born painter of figures and anthropomorphic animals who lives in London*

Born in Lisbon, Rego was struck as a child by strip cartoons in magazines and by the folk tales recounted by her grandmother. Having trained from 1952 to 1956 at the Slade School of Art, she returned to Portugal and established her reputation in a series of exhibitions in which she posited the use of narrative in the face of modernist hostility to this element in art. The animal figures may change their relative sizes and are not limited by rational considerations, a factor which may reflect a debt to Surrealism. Her primary aim is to use them to express psychological states. Her works can vary from a couple of figures to large works derived from the theme of operas or novels. More recent works show the reintroduction of illusionistic space around the figures, the elimination of the animals, and the creation of a potent atmosphere. Partly because the scenes are now more recognisable, the stillness which pervades them seems at times eerie, even menacing. She has four children, and returned to London to work in the late 1970s. She also teaches at the Slade.

*Literature:* A. Hill, 'PR' Artscribe, no.37, Oct. 1982, 33–7; *Current affairs: British painting and sculpture in the 1980s*, MOMA, Oxford, 1987; *PR*, Serpentine G, London, 1988; V. Willing, *PR paintings*, Edward Totah G, London, 1985.

## REGTEREN, Maria Engelina van. née ALTENA (1868–1958)

*Dutch painter and engraver of still life and town scenes*

Van Regteren studied at the State Academy of her native Amsterdam between 1893 and 1896 and became one of the nine women artists known as the *Amsterdamse Joffers* – the young ladies of Amsterdam – (see Ritsema). After this she settled

**Elaine Reichek** *Featherman and Stripedman*, 1986, mixed media, 165 × 295 cm, courtesy Carlo Lamagna Gallery, New York. (photo: Adam Reich)

in the province of Appeldoorn, from where she undertook many visits for her studies, journeys that included Rome, Prague and the south of France. Her first solo show was held in Amsterdam in 1903, and she became a member of the artistic societies Arti et Amicitiae and St Luke. In 1949 her work was featured in the Dutch section of the WIAC exhibition in London.

*Examples:* Amsterdam; Belgrade; The Hague; Rotterdam.

*Literature:* De Bois, *De Vrouwe en haar huis*, 1927; Krichbaum; *M.E. van R.A. and Oscar Mendlik,* Kunstzalen Franz Heekens, Haarlem, 1947; A. Plasschaert, *Korte geschichte der holl. schilderkunst*, Amsterdam, 1924; A. Venema, *De Amsterdamse Joffers*, Baarn, 1977.

## REICHEK, Elaine (*c*. 1950–)

*American artist working in formal ways with materials traditionally associated with women*

Born in Brooklyn, she underwent an orthodox formalist training at Brooklyn College under Ad Reinhardt, before going to Yale University for her BFA. In her first solo show in 1978, she demonstrated her concern with fabrics by incorporating organdie, mesh, coloured silk and metallic threads into a series of formal, at times mathematical, framed units. Combining art with childcare, the unitary approach was convenient, but also suited her intention of making a feminist statement by her choice of materials. A later serial piece called *Beds* (1980) also drew on the traditional female role of home-maker and connotations of craft but within a formal framework which places her work in the heritage of conceptual art. This aspect has been further pursued in her equation of knitting with building, paralleling patterns, diagrams and the finished article with a tinted photograph of a real building, transforming, for example, the White House into a baby's bonnet. Accompanied by documentation of the processes, her work has some similarities to that of Mary Kelly (*q.v.*). She is a member of the women's co-operative gallery AIR in New York, and has participated both in women only and establishment shows.

*Literature:* K. Chambers, 'ER', *Craft International*, Apr.–June 1985; J. Marter, 'ER', *Arts Mag.*, Jan. 1978, 7; C. Robins, *The Pluralist Era*, New York, 1984; M. Thompson, *ER: beds, quilting and knitting pieces*, Browson Art G, Manhattanville College, New York, 1980.

## REID, Nano (1905–81)

*Irish painter of landscapes and figure subjects in a modernist idiom*

Born in Drogheda, Co. Louth, she trained at the Metropolitan School of Art, Dublin. This was followed by a stay in Paris where, in 1927, she attended the Académie de la Grande Chaumière and, from time to time, the Colarossi. She then moved to England, attending both the Central School of Arts and Crafts and Chelsea Polytechnic, and it was not until 1930 that she settled in Ireland. Her early works are characterised by a bold, simple style, which gained her election to the Dublin Painters' Society and her first solo show, both in 1934. An exhibition of work by the Belgian painter, Marie Howet (1897–?), which Reid saw in Dublin in the mid-1930s, influenced the next phase of her work. Her style became more expressionist while at the same time emphasising linear qualities. The expressionism increased over the years, so that the works became almost abstract, despite a starting point in the visual world. Nevertheless, the gestural technique, and the energy of execution resemble that of the Abstract Expressionist action painters. Many of the landscapes are set in the Boyne valley near Drogheda and when these feature ancient monasteries or archaeological sites critics have suggested that mystical elements can be found in the paintings. With Norah McGuiness (*q.v.*), Reid was the most important woman painter involved with the Irish Exhibition of Living Art, the annual exhibition of contemporary art in Dublin, and in 1950 they were both selected as the first artists to represent Ireland at the Venice Biennale. She exhibited regularly and was given a retrospective in 1974–5.

*Examples:* Belfast; Municipal G of Modern Art, Dublin; Mus. and Art G, Santa Barbara.

*Literature: Irish women artists.*

## REMINGTON, Deborah (1935–)

*American painter of hard-edge abstractions which recall reflection of metallic spare parts, but which are based on oriental mysticism*

Remington was born in Haddonfield, New Jersey, her mother being an intellectual who mixed with illustrators and therefore encouraged her daughter to begin art instruction early in life. After the death of her stockbroker father, the family moved to California, where she attended the California School of Fine Arts in San Francisco from 1953 to 1957 at a time when west coast abstraction was a dominant style. Disillusionment with Abstract Expressionism led her to spend over two years in Japan (1957–9) studying calligraphy, while supporting herself by acting Westerners in Japanese films. After five more difficult years on the west coast, Remington went to New York and had her first solo show in 1967 at a gallery which supported her until its closure seven years later. Since then she has exhibited throughout America. Her mature style emerged in the mid-1960s, when she painted, in a limited range of white and a host of greys, shapes which although abstract were reminiscent of car parts and other vaguely familiar forms. A central, nearly symmetrical strongly outlined main image floats against a luminous background. Her works have been described as having a 'porthole effect' because of the impression of seeing though an opening into infinity. Since the late 1970s she has added a few strong colours to her palette. Although her works appear to have been executed with an airbrush, they are carried out in a traditional manner.

*Examples:* NMAA, Washington, DC.

*Literature:* M. Brumer, 'DR: fascinating contradictions', *Feminist Art J.*, spring 1974, 1–4; C. Robins, 'DR: paintings without answers', *Arts Mag.*, v51/8, Apr. 1977, 140–2; C. Robins, *The pluralist era*, New York, 1984; Rubinstein.

## RHOADES, Katharine Nash (1885–1965)

*American painter and poet, a central figure in the New York Dada group*

A member of a wealthy family she first studied art through private lessons begun at the age of 19. Around 1908, she travelled to Paris with her friends, the painter Marion Beckett and the sculptor, Malvina Hoffman (*q.v.*) and began at once to mix in avant-garde circles. On her return, she continued her rebellion against her orthodox and restrictive background and associated with the group around Steiglitz's 291 gallery. There she had her first solo show, consisting of Fauvist paintings, in 1915. Along with Agnes Meyer (*q.v.*), she helped with the publication of the periodical *291*, to which she contributed poems. Her illustrations and poems, some of which reveal her strongly held views about the position of women in society, were also published in *Camera Work*. Apart from published items, little early work

survived her destruction of it in the 1920s, but what exists reveals an interest in Cézanne and an awareness of the works of Picabia and De Zayas. When the New York Dada group formed, she played an active role and was cited by Tzara as one of the presidents of the movement. In 1915 Rhoades began a long association with the oriental art collection of Charles Freer, first as secretary, then as research associate and was involved with the formation of the Freer Gallery in Washington, DC.

*Literature: Avant-garde painting and sculpture in America, 1910–25*, Art Mus., Delaware, Ohio; 1975; A. Meyer, *Out of these roots*, Boston, 1953; D. Tashjian, *Skyscraper primitives*, Middletown, Conn., 1975; Vergine.

## RICHARDS, Anna Mary. (alt. BREWSTER) (1870–1952)

*American landscape and marine painter*

Born in Germantown, Pennsylvania, she was the sixth child of the marine painter, William Richards, who was a teacher of Fidelia Bridges (*q.v.*). Her mother, a Quaker and poet, taught all her children and fostered great intellectual achievement; one of her brothers was to win a Nobel prize for chemistry. Anna Richards exhibited, and sold, her first painting at the NAD when she was 14. A family move to Boston in 1888 enabled her to attend the Cowles Art School there, before proceeding to the Art Students' League, New York in 1889 to work under William Merritt Chase and La Farge, and to the Académie Julian in Paris in the 1890s. For a while she travelled round Europe painting and exhibiting with her father, but it was decided that she should make her own way as an artist. Accordingly about 1895 she settled in the village of Clovelly on the Devon coast, in south-west England. A period of nine years in Chelsea followed, where she came to know artists like G.F. Watts and began to paint Pre-Raphaelite allegorical paintings and to illustrate several of her mother's books. While in London she met and married William Brewster, a professor from Barnard College, New York and returned to New York. Their only child died when young, and after this they settled in Scarsdale, New York State. Another 40 years of prolific work lay ahead of Richards, who returned to her chief love, marine painting, often set on Rhode Island. During the sabbatical leaves of her husband, they travelled extensively in Europe and the Middle East, which resulted in over 2,000 landscape sketches. Richards had great technical facility, which, combined with her habit of painting in front of the subject, enabled her to capture particular qualities of light and weather.

*Examples:* New London, Conn.; Barnard College, New York; Public Library, Scarsdale.

*Literature:* W. Brewster, *A book of sketches by ARB*, 4 vols, New York, 1954–60; *'He knew the sea': William Trost Richards and his daughter ARB*, Mus. of American Art, New Britain, Conn., 1973; Rubinstein.

## RICHARDS, Frances. née CLAYTON (1901–85)

*English artist in many media who showed a preference for female figures often with children*

One of the many wives of artists who were also practitioners themselves, Frances Richards combined her roles of wife, mother and artist for many years. After attending her local art college in Burslem, Staffordshire, she won a scholarship to the Royal College of Art in 1928. While she was still a student, T.S. Eliot commissioned her to illustrate the *Book of Revelations* for the publishers Faber, and at the same time she completed a set of copper engravings for *The Acts of the Apostles*. In 1929 she married the artist Ceri Richards and had two daughters. Ceri became a well-known painter, while Frances worked in a wide range of media: etching, copper engraving, lithography, watercolour, collage, pen and ink and embroidery. By concentrating on what was essential she supported Ceri in his work, brought up her daughters, taught at Camberwell (1928–39) and Chelsea Schools of Art (1947–59), and continued exhibiting and gaining commissions such as a large embroidery collage for the liner *Orcades*. She had a series of solo shows, notably at the Redfern and Leicester galleries. Her subjects were often concerned with plants, children – she was devoted to the poetry of Blake throughout her life – and female figures. These themes are not used in a traditional way but to denote a calm strength, emanating from her conviction in the inner power of women. A natural feminist she supported left-wing politics. Active until the end of her life, she took to illustrating her own poetry and hand-painting the editions.

*Examples:* Cardiff; Tate G and V & A, London.

*Literature:* N. Cohen, 'Days of hope', *City Limits*, 8 Mar. 1985; K. Dunthorne, *Artists exhibited in Wales, 1945–74*, Cardiff, 1976; *FR*, Leicester G, London, 1964.

## RICHIER, Germaine (1904–59)

*French sculptor of Existential figures and menacing insect forms*

Born at Grans, near Arles in the south of France, she was one of four children of a vineyard owner. As a child she kept insects and made figures out of stones and cement. Despite parental opposition she enrolled at the School of Fine Arts in Montpellier, and after the three-year course went to Paris, where she studied with Bourdelle. Four years later she set up her own studio and survived financially by executing portrait busts. Recognition came from 1936 and Richier participated in the 1937 *Femmes Artistes d'Europe* Exhibition in Paris. In 1929 she married the Swiss sculptor, Otto Bänninger and, on the outbreak of war, they moved to Zurich, where Richier continued to teach and inspired a generation of women sculptors. Her post-war works of massive brooding figures and large-scale half-human versions of praying mantis and other insects brought her awards and international exhibitions. Sculptures from the early 1950s are more dramatic, full of pathos and suffering. Figures are isolated in an acceptance of pain, Richier's reaction to World War II. She collaborated with Hans Hartung and on another occasion with her friend Maria Vieira da Silva (*q.v.*) in the provision by them of a painted background for her sculptures, much as Callery (*q.v.*) did with Léger. In 1955 she married the French writer René de Soulier, who has tirelessly promoted her work. In the mid-1950s when it was discovered she had terminal cancer, she returned to the south of France but continued working as long as she could. She was made a Chevalier de la Légion d'honneur.

*Literature:* Bachmann; J. Cassou, *GR*, London, 1961; *DWB*; Fine, 1978; Heller; Mackay; Petersen; R. de Soulier, *GR*, Arts Club, Chicago, 1966; D. Sylvester, *GR*, Hanover G, London, 1955; E. Tufts, *Our hidden heritage: five centuries of women artists*, New York, 1974.

## RIDEOUT, Alice (1872–?)

*American sculptor of figures*

Rideout wanted to sculpt from her early childhood in Marysville, California. While attending high school in San Francisco, she was made a ward of the art collector, John Quinn, and became a pupil of Rupert Schmid. By 1891 she had studied sculpture for two years at the San Francisco School of Design and had received her first commission.

At this point she entered and won the competition for the relief and external sculpture for the Women's Building at the Chicago Exposition to be held in 1893. The contract was worth $8,200. On the pediment she depicted women's work in various walks of life in a style and context which avoided the traditional personifications of womanhood. She used men to rough out the figures, while she herself completed all the final stages herself. Nothing is known of her career after this.

*Literature:* M. Elliott; Weimann.

## RIES, Thérèse Feodorovna (1874–?)

*Russian sculptor of figures, allegorical works and portraits busts*

Born in Moscow, she first studied painting at the Academy there. Only five months after she began as a student she was awarded a gold medal. She then abandoned painting in favour of sculpture, and one month later her bust of *Ariadne* won great acclaim. Further prizes followed but Ries, dissatisfied with her own work, left for Paris. However, she settled in Vienna, studying under Prof. Hellmer. There she produced portrait busts, including one of Mark Twain, statues of saints, among them one commissioned by the government, and a remarkable *Witch*, described as 'a demoniac being, knowing her own power and full of devilish instinct. The marble is full of life'. The figure group of *The Unconquerable Ones*, shown at the Paris Exposition in 1900, won her a gold medal and was universally admired for its strength. Ries remained active in Vienna, winning further prizes, until 1938 when her Jewish origins caused difficulties and the Prince of Liechtenstein provided her with a studio in his palace. Her best-known work is the monument to Liszt in Vienna.

*Publications: Die Sprache des Steines*, 1928 (autobiography).

*Literature: AJ*, Special issue for Exposition Universelle, 1900, 294; Clement; Mackay; *Studio*, July 1901.

## RILEY, Bridget (1931–)

*English abstract artist exploring the optical effects of light and colour*

One of the best-known English women painters of her generation, Riley had effectively established

an international reputation by the mid-1960s. She was born and trained in London, at Goldsmiths', College (1949–52) and the Royal College of Art (1952–5), and soon found that her crisp compositions, initially of black and white, suited the taste of the abstract-orientated art establishment. The monochrome works play on the illusions of space and movement which can be set up and disorientated within the composition. Gradually she introduced a limited range of colours and, by producing infinite variations of tone, thickness and undulations of the stripes, the surface seems to be perpetually vibrating. In the later 1960s her work was categorised as Op Art, but her investigations of these effects have outlasted a passing movement and become part of the abstract strand emanating from hard-edge painting. From 1963 she has won a succession of awards, including the international prize for painting at the 1968 Venice Biennale. She has remained completely opposed to the women's movement, believing that both men and women artists have difficulties in their careers and that gender is irrelevant in the making of art.

*Publications:* 'The Hermaphrodite', in T. Hess & E. Baker, *Art and sexual politics*, New York, 1973.

*Examples:* Kupferstichkabinett, SMPK, Berlin; WAG, Liverpool; Tate G, London.

*Literature:* Heller; Nottingham, 1982; Parry-Crooke; Sellars.

## RILKE-WESTHOFF, C. See WESTHOFF, Clara

## RIMMINGTON, Edith (1902–)

*English Surrealist painter*

Born in Leicester, she studied at Brighton School of Art from 1919 to 1922. Four years later she married Robert Baxter and settled in Manchester, where he taught at the School of Art. She later destroyed most of her work from this period, which consisted of still lifes and figures in the style of Juan Gris. Her first known contact with the Surrealists came through participation in the 1937 Surrealist Objects exhibition in London and from this period she began to make automatic drawings. Moving to London, she had a studio in Camden and regularly attended the weekly meetings of the Surrealist Group at which Penrose and Mesens

were among those present. Many of her paintings show a fascination with the way in which the unconscious could be externalised through natural images. A pervasive theme in her work is the sea, the use of water as a metaphor for the creation of art also occurring in the paintings of other female Surrealists. Throughout the 1940s she joined in the activities of the English Group, contributing poems and illustrations to several publications as well as exhibitions. In 1967 she gave up painting in order to concentrate on photography.

*Literature: British women Surrealists*, Blond Fine Art, London, 1985; W. Chadwick, *Women artists and the Surrealist movement*, London, 1985; *Salute to British Surrealism 1930–50*, Minories G, Colchester, Essex, 1985; *The Surrealist spirit in Britain*, Whitford & Hughes G, London, 1988.

## RINGGOLD, Faith. née JONES (1934–)

*American painter and sculptor, dealing with social and political themes*

Faith Jones was born in Harlem, where her ambitious parents ensured their children were well educated. Her father worked for the sanitation department, while her mother designed and made clothes. In 1948 she went to City College in New York, returning, after marriage to a jazz musician in 1950 and the birth of two daughters in 1952, to gain her MFA in 1959. Two years later a tour of European galleries and museums with her children and her mother made her determined to set up her own studio. Her second husband encouraged her art for two years but then could not accept her seriousness. Her breakthrough came when she abandoned illusionism and took up elements of her black heritage. Her four-metre-wide mural of a street riot (*Die*, 1967), in which the flattened figures create a sense of pattern across the composition, led to a series of works with the American flag, for which she was found guilty of desecration in 1970. During the 1970s Ringgold was active in the women's art movement, working particularly for the fair representation of black women. Realising that these ideas were not reaching the black community she sought for a medium to which they would be able to relate and began in 1973 to make fabric figures. In these she included traditional African craft techniques, such as bead work. Starting with single female figures, she made a family of women. All are light and portable. More recently she has carried out performances with masks and soft sculptures.

*Literature: DWB;* Fine, 1973; L. Lippard, *Get the message,* New York, 1984; Munro; Petersen; C. Robins, *The pluralist era,* New York, 1984; Rubinstein.

## RITSEMA, Coba. née Jacoba Johanna (1876–1961)

*Dutch painter of still lifes, figures, interiors and portraits*

Ritsema was born in Haarlem, her father being a painter and lithographer. Initially she studied with her brother before attending the local art school from 1891 to 1893 and the State Academy in Amsterdam under August Allebé from 1893 to 1897. After completing her training, she returned to Haarlem for two years, but then returned to Amsterdam, where she came to know Thérèse Schwartze (*q.v.*). She became the leader of the group of women artists whom a critic referred to as the *Amsterdamse Joffers* (the young ladies of Amsterdam). In this she deliberately modelled herself upon Harriet Hosmer (*q.v.*) and the other women sculptors in Rome. The other members of the group included Lizzy Ansingh (*q.v.*), Jo Bauer-Stumpf (*q.v.*), Maria van Regteren (*q.v.*), Coba Surie and Betsy Westendorp. Ritsema also belonged to several other artists' associations, including the Arti et Amicitiae and the St Luke's in Amsterdam and the Pulchri Studio in The Hague. She had an illustratious career, winning, *inter alia*, the Prix d'honneur at the Paris World Fair of 1937 and receiving several state honours.

*Examples:* Amsterdam.

*Literature:* Krichbaum; *Kunst door vrouwen,* Stedelijk Mus. De Lakenhal, Leiden, 1987; A. Venema, *De Amsterdamse Joffers,* Baarn, 1977.

## ROBB, Carole (1943–)

*Scottish-born figurative painter working in London and New York*

Trained at the Glasgow School of Art and Reading University, Robb began exhibiting in 1966, but it was from 1979, with the award of the Rome Scholarship in painting, that her present work developed. Her year in Italy resulted in a series of six canvases based on the myth of Apollo and Daphne. The particular methods she used meant that she worked slowly. The paint handling varied from

washes to impasto mosaics of tiny brush marks, and the colours which created this space in the canvases included bleached yellows, earthy red and browns and a variety of blues, all set against subtle tones of white, off-white and cream. Further awards to work in America 1980 and 1981 led to the evolution of an American Apollo series as a parallel to the earlier one, but this was based on the people of the Appalachian mountains.

*Literature: Apollo and Daphne in Umbria,* Polytechnic G, Newcastle-upon-Tyne, 1982; *Women's images of men,* ICA, London, 1980.

## ROBERTSON, A. See MOSES, Anna

## ROBERTSON, S. See BISSCHOP-ROBERTSON, Suze

## ROCHE, Juliette (1884–after 1980)

*French painter who was a member of the Nabis and later participated in Dada*

Parisian by birth, she went first to the rigorous and well-respected Académie Ranson, where she studied under Denis, Valloton and Sérusier, who between them represented the two sides of the artistic debate defined by Apollinaire as order or adventure. Through them Roche became the youngest member of the Nabis Group, but in 1912 her discovery of Cubism led to a change of position. In 1913 she began to write poetry into which she incorporated printed readymades taken from newspapers or other forms of print. From this evolved typographical experiments and visual poems. Her marriage in 1915 to the Cubist painter Albert Gleizes caused her final rupture with Denis and Valloton. Her first solo show was held in 1914, but on the outbreak of war Roche and Gleizes, who were both ardent pacifists, moved to South America. From there they made their way to New York, where they mixed in the Dada circle around Picabia and Duchamp, whom Gleizes had known for some years. Roche published some poems and exhibited, but early in 1916 they were forced by her father to return to Barcelona, where they were later joined by Picabia. The brief flowering of Spanish Dada occurred in the second half of 1916 through the collaboration of Roche, Gleizes,

Picabia, Laurencin (*q.v.*) and Craven. Roche contributed to the four issues of *391* which appeared then before returning to New York to participate in the first exhibition of the Society of Independent Artists. Most of her work from this period consists of the innovative use of typographical devices, poetry and articles. From the 1920s she began to exhibit again rather than publish, a pattern which continued after World War II.

*Publications: Demi-cercle*, Paris, 1920. [collection of poems]; *Souvenirs*, Paris, 1980.

*Literature:* M. Sanouillet, *Francis Picabia et 391*, Paris, 1966; Vergine.

## ROCKBURNE, Dorothea (1934–)

*Canadian-born abstract artist who works in America*

Producing abstract works from her student days at Black Mountain College, N. Carolina, Rockburne never followed what was fashionable. Although much of her early career was spent in New York, and she knew some of the Abstract Expressionists, her own preference was for simple, understated work. She read widely, including philosophy, visited museums and largely cut herself off from the art world during the1960s. For a time, she ceased to paint, becoming interested in dance and participating in performances with the avant-garde dancer Yvonne Rainier, as well as Rauschenberg and Robert Morris, in a Greenwich Village theatre. Attracted by its apparent simplicity, logic and lack of subjectivity to the work of Minimalists, she encountered mathematical theories which linked with her own interests in mathematical modes as a means of exploring art. Since 1970 Rockburne has worked in series, often using the Golden Section as her starting point. Her paintings are not regularly shaped but often follow a regulated series of triangles, diamonds and other geometrical shapes. Working with a variety of media, including vellum, she folds her material into the requisite shape, creating a type of relief with the thickness of the layers. To this she may add simple drawn lines, but otherwise relies on the effect of the serial shapes and the shadows for her enigmatic effects. Rockburne has exhibited regularly since her first solo show in 1970.

*Examples:* NMWA, Washington, DC.

*Literature:* M. Brenson, 'The artist's eye: DR: a New-World painter views the masterpieces of Old-World innovators', *New York Times*, 29 Apr.

1988, C2; J. Gruen, 'DR's unanswered questions', *Art News*, Mar. 1986, 100; J. Gruen, 'Artist's dialogue: DR.', *Architectural Digest*, Jan. 1987, 46; J. Loughery, 'DR', *Arts Mag.*, v62/9, May 1988, 92; C. Robins, *The pluralist era*, New York, 1984; S. Sterling, 'DR', *NMWA News*, v6/2, summer 1988, 5.

## ROEDER, Emy (1890–1971)

*German sculptor of portraits, animals and figures*

One of the first women sculptors in Germany, she came from a family who were interested in art. In 1910 she began her art training in Munich, but a year later began to work under Bernard Hoetger in Darmstadt and moved with him to Fischerhude. In 1915 she went to Berlin, and three years later became a founder member of the *Novembergruppe*. In 1918 she also began to work with the sculptor Herbert Garbe, whom she married two years later. Enrolling at the Berlin Academy in 1920, she remained there for five years in the master class of Hugo Lederer. Her early works consisted mainly of portrait busts, which reflect not only her teachers but also her friends such as the Expressionist Erich Heckel. She later simplified her figures in a way which showed an awareness of Cubism and Expressionism. Her sculptures of horses were directly influenced by the paintings of Franz Marc. A fruitful period of activity was ended in 1933, when Hitler came to power – her work was included in the 1937 Degenerate Art exhibition – and she emigrated to Italy, returning to her native country in 1949. At the age of 60 she began to teach at the School of Art in Mainz, remaining for five years. At the same time she had many exhibitions, and won several prizes. She died in her home town of Wurzburg.

*Example:* Nat. G, SMPK, and George-Kolbe Mus., Berlin.

*Literature: Das Verborgene Museum*; Krichbaum; A. Kuhn, *ER*, Leipzig, 1921; Mackay.

## ROEDERSTEIN, Ottilie W. (1859–1937)

*Swiss painter of portraits, genre, still lifes and landscapes*

Born into a family of German descent, Roederstein initially studied art in her home city of Zurich, attending the same school as her compatriot, Louise Breslau (*q.v.*). She undertook further study

in Berlin and Paris, where she worked with the Salon painter, Henner. Second only to Breslau among her Swiss contemporaries, her portraits were described as psychologically acute, and she possessed considerable technical facility. She exhibited from 1887 to 1930.

*Examples:* Frankfurt; Mus. Elderfield, Lausanne; Zurich.

*Literature:* A. Hirsch, *Die bildenden Künstlerinnen der Neuzeit*, 1905; E. Kern (ed.), *Führende Frauen Europas*, new ed. 1930; Krichbaum; *Lexikon der Frau*; W.S. Sparrow; C. Tobler, *Zu 70 Geburtstag der Zürcher Malerin OWR*, Zurich, 1929.

## ROMANI, Juana H.C. (1869–1924)

*Italian painter of historical and allegorical figures, especially women, together with portraits*

It is not known when Romani, who was born in Velletri, went to Paris. However, she studied with Roybet and Henner and settled in Paris. She specialised in the depiction of women, and her French technique and rich colour 'are infused with the ardor of a Southern temperament'. One writer refers to her unconventional tastes and habits. She executed several versions of the popular late nineteenth-century figures, Judith, Salome and Herodias, imbuing them with a *fin-de-siècle* decadence. Her representation of women, however, also included more conventional types. She won sufficient prizes at the Salon to allow her to enter *hors concours*.

*Examples:* Mulhouse; Mus. d'Orsay, and Mus. de la Ville, Paris.

*Literature:* Clement; Edouard-Joseph; A. Hirsch, *Die bildenden Künstlerinnen der Neuzeit*, 1905; Krichbaum; J. Martin, *Nos peintres et sculpteurs*, Paris, 1897; W.S. Sparrow; *Studio*, v53, May 1913, 325–7.

## ROMER, L. See JOPLING, Louise

## RONNER, Henriette. née KNIP (1821–1909)

*Dutch-born painter of dogs and, particularly, cats, who worked in Belgium*

Ronner's father, mother, grandfather and aunt were all eminent artists. Not surprisingly she drew as a child, preferring animals, and when she was 12 her father, who was by then blind, began to teach her. She exhibited her first work at 16, and was soon considered to be established. She married in 1850, settled in Brussels, and for some 15 years painted dogs almost exclusively. From 1870 she turned to cats and soon acquired a formidable reputation. She devised a glass box to contain her subjects, into which she had placed a cushion and a toy, so that she could capture the movement of the animal. Apart from her own animals, cats were brought to her by eminent owners requiring portraits. Her reputation was formidable: she exhibited extensively in England and Scotland, in the Philadelphia Centennial in 1876 and at the Chicago Exposition in 1893. She was elected to numerous European academies, won countless prizes and received the Cross of the Order of Leopold from the King of Belgium. In her eighties she was still painting for several hours a day.

*Examples:* Mus. Royaux, Brussels; Hanover.

*Literature:* Clement; M. Elliott; *Mag. of Art*, 1903; Weimann.

## Roosevelt, Heidi. née Adelheid LANGE (1878–1962)

*American sculptor of Cubist works, both figurative and abstract*

A pioneer of modernist sculpture in America, Heidi Lange was born into a St Louis family of German descent. This heritage was strong, for after her father's death in 1882 her mother took her to Germany for six years. In 1898 she applied to study architecture in Munich, and after being rejected on account of her gender was reluctantly accepted at the Zurich Polytechnic Institute. From 1903 to 1905 she was employed by Theodore Link, architect of one of the buildings for the St Louis Exposition, through whom she gained numerous commissions. This ended with her marriage in 1905 to André Roosevelt, first cousin to President Theodore Roosevelt, for the lifestyle of the pioneer aviator, film director and explorer was anything but settled. After the birth of a daughter, their only child, the Roosevelts lived in Paris, from 1912. Through a friend of André – Picabia – Heidi came into contact with many modernist artists, including the three Duchamp brothers, Brancusi and Archipenko. Her architectural background made her feel an affinity with Cubism and she became a pupil of Duchamp-Villon. Such was her

progress that two of her works were accepted for the 1913 Salon d'Automne. Two apparently abstract statuettes of 1913–4 resulted from the overwhelming experience of seeing the Russian ballet in Paris. Influenced by Brancusi, she produced some wooden carvings. Returning to New York at the outbreak of war, she continued with a more independent exploration of abstract sculpture, incorporating contrasting geometric shapes and seeking to convey a sense of movement even though the works have figurative titles. Her *Tennis-player – serving* was purchased by the collector, John Quinn. She seems not to have exhibited after 1918, and for financial reasons her sculptures were not cast in bronze. She separated from her husband during the 1920s, after a very unsettled period, and practised architecture in a limited way in Thompson, Connecticut. She also continued to sculpt until the 1940s, when she turned instead to painting. Strongly independent and committed to her work, she understood the theoretical ideas behind Cubist sculpture and was willing to push this further in her own work. For this reason the lack of surviving work after 1918 is curious.

*Literature:* Archives of American Art; *Avant-garde painting and sculpture in America, 1910–25*, Art Mus., Delaware, 1975; *Vanguard American sculpture, 1913–39*, Rutgers University Art G, 1979.

**Ellen Rope** *Moberly memorial*, 1900, marble, Salisbury Cathedral. (photo: courtesy of the Dean and Chapter)

## ROPE, Ellen Mary (1855–1934)

*English sculptor, particularly of relief work and in architectural schemes*

Rope was born in Blaxhall, Suffolk. Two of her siblings also developed into artists: Dorothy became a sculptor, and George a painter. After instruction from a female pupil of John Ruskin and a period at Ipswich School of Art, she studied at the Slade under Legros from 1877/8–1884/5, also working independently in the British Museum. Only for her last term there did she attend the newly formed modelling class, and even after she left she began work as a painter and illustrator, rather than as a sculptor. However, after an early relief had been hung on the line at the RA, she devoted more and more time to sculpture. Her low plaster reliefs had a linear quality which was influenced by Legros and by early Florentine Renaissance sculpture. She was exhibiting by 1889 and quickly became established, for in 1893 she was commissioned to produce four two-metre spandrels with allegorical figures for the vestibule of the Women's Building at the Chicago Exposi-

tion of 1893. She succeeded in completing these within the two months allotted. She contributed a variety of works, from small decorative panels to an electric-light bracket, to each of the seven shows of the Art and Craft Society between 1889 and 1906. From about 1896 she worked for the Della Robbia pottery, Birkenhead, and later she was employed by architects Horace Field and Arnold Mitchell. She carried out work for a number of churches, including a memorial relief in Salisbury cathedral in 1900. For many years she worked in coloured plaster, producing works for schools and churches which could not afford marble or bronze. She exhibited actively in London, Glasgow and Liverpool, but many of her works are now lost or unidentified. The works for which she was most acclaimed showed children in religious or mythological contexts.

*Examples:* St Joseph's church, Aldershot; Blaxhall church; St Peter's church, Cricklewood; Ipswich; Merton church, Norfolk; cathedral, Salisbury.

*Literature:* S. Beattie, *The new sculpture*, New Haven and London, 1983; Clement; B. Kendall,

'Miss ER: sculptor', *Artist*, Dec. 1899, 206–12; F.J. Maclean, 'The art of EMR', *The Expert*, 13 July 1907, 251–2; *Mag. of Art*, 1900, 323–6; M. Spielmann, *British sculpture and sculptors of today*, London, 1901; *Who's Who in Art*.

## ROSÀ, Rosa. (pseud. of Edyth von HAYNAU. alt. ARNALDI) (1884–after 1980)

*Austrian-born artist in many media, but particularly drawing, who was a member of the Futurist group in Italy*

Despite the disapproval of her family, von Haynau attended the Academy in her native Vienna for two years. After her marriage to Ulrico Arnaldi she settled in Italy and adopted her pseudonym. She participated in the Florentine Futurist group from 1916 to 1918 as both a painter and a writer, sharing their interest in the occult and related scientific phenomena. Several articles deal with issues concerning women, and reveal her adoption of some of the arguments of Valentine de Saint-Point, the leading Futurist feminist theorist. Black and white was Rosà's chief means of expression but, except when she illustrated a text to be published, many of her drawings are lost, because the Futurists never gave that medium a high priority. She also produced painting, sculpture, ceramics, maps, book covers and textiles. During the 1950s she became fascinated by ancient Mediterranean cultures and, in addition to publishing several books on the topic, under the name of Edyth Arnaldi, she executed many paintings based on Etruscan and Roman art. Her exhibiting career stretched over 64 years, for she eventually retired at the age of 96 after a major show.

*Publications:* For details see Vergine.

*Literature:* M.B. Katz, 'The women of Futurism', *WAJ*, v7/2, fall 1986-winter 1987, 4–5; Vergine.

## ROSANOVA, O. See ROZANOVA, Olga

## ROSENBACH, Ulrike Nolden (1943–)

*German performance artist chiefly concerned with the representation of women*

Born in Salzdetfurth, she studied sculpture from 1964 to 1970 at the Düsseldorf Academy of Art. As a postgraduate student under Joseph Beuys, she was brought into contact with happenings and Fluxus. She also married and had a daughter. Since 1972 her videos and performances have made her the best-known German artist in this field, and she was included by Lucy Lippard in the touring exhibition *c. 7,500* in 1973. In some of her performances at this time she wore a traditional tall hat, which in the Middle Ages had signified subservience, but which by the Renaissance had become a symbol of equality and confidence. Believing woman to be a source of magical power, she has evolved a number of works based on mythology. Settled in Cologne, she founded a workshop of creative feminism and has contributed to many women's exhibitions as well as many personal shows.

*Literature:* S. Eiblmayr, V. Export & M. Prischl-Maier, *Kunst mit Eigen-Sinn: Aktuelle Kunst von Frauen*, Vienna & Munich, 1985; Krichbaum; *Künstlerinnen International 1877–1977*, Schloss Charlottenburg, Berlin, 1977; L. Lippard, *From the Center*, New York, 1976; A. Pohlen, *Zeichen und mythen*, Cologne, 1982.

## ROSLER, Martha (1943–)

*American video and performance artist who also produces serial postcards, artist's books and photographs*

Four years after gaining her BA from Brooklyn College in 1965, Rosler moved to the west coast and took her MFA at the University of California in San Diego (1974). In her performance works she deliberately selects a familiar situation so that her material does not mystify, because she wants to expose complex features of social life to a wide range of people. For several years in the mid-1970s she concentrated on the uses and abuses of food, particularly with regard to society's pressures on women and women's roles as producer and consumer in this area. She has also dealt with Chile and the Vietnam war through her 'decoys', the use and simultaneous subversion of a well-known cultural form through humour and coherent narrative. She has participated in group shows since 1971 and solo shows since 1973. She is also well known as a critic and broadcaster.

*Publications:* 'The private and the public: feminist art in California', *Artforum*, Sept. 1977, 66–72; 'For an art against the mythology of everyday life', *LAICA Journal*, June–July 1979. For complete list see *Issue* catalogue below.

*Literature:* L. Lippard, 'Caring: five political artists', *Studio International*, May–June 1977, 197–207; L. Lippard, *Issue: social strategies for women artists*, ICA, London, 1980 (bibl.); L. Lippard, *Get the message*, New York, 1984; Roth.

## ROSS, Monica (c. 1950–)

*English performance artist*

Born in Rochdale, Lancashire, Ross studied at Reading University from 1969 to 1973. She has consistently been involved in collaborative works with other women. In the mid-1970s she contributed to *Feministo* (see under Kate Walker), which set the pattern of her concern with the social position of working-class women in the home and at work. Another goal has been to break down the élitism of art and to show ordinary women that art can involve and interest them. While taking a variety of jobs to support herself and her daughter, she has continued to pursue opportunities to work with other women. In 1978 she joined Sue Richardson and Kate Walker to form Fenix, which performed at a variety of venues outside London until the early 1980s. In 1981 the Sister Seven Group was formed with similar aims and more recently she worked with Shirley Cameron (*q.v.*) and Evelyn Silver in a residency in Rochdale, where they set about a revaluation of women's work in the factories and in the home.

*Literature: Along the lines of resistance: an exhibition of contemporary feminist art*, Cooper G, Barnsley, 1986; L. Lippard, *Issue: social strategies by women artists*, ICA, London, 1980 (as Fenix); *Triple Transformations*, Art G, Rochdale, 1985.

## ROSSETTI, Lucy. née BROWN (1843–94)

*English painter of literary and mood pictures, characterised by unusual effects of light; in later years she turned to writing*

The eldest child of the Pre-Raphaelite painter, Ford Madox Brown, and his first wife, she was born in Paris. On the death of her mother in 1846, her father settled with Lucy and her younger brother in London. Having shown no particular inclination towards art, in the 1860s she stepped in to do the work of one of her father's assistants, who had omitted to complete a task. She carried it

out so competently that she was encouraged to study art seriously and received instruction from her father at the same time as her brother, her half-sister Catherine Brown Hueffer (*q.v.*) and Maria Spartali Stillman (*q.v.*). The three women continued to use each other as models and reappear in each other's paintings. She first exhibited in 1869, but only exhibited eight works altogether. She travelled abroad on several occasions: to Belgium and Germany with William and Jane Morris; to Italy with Mr and Mrs Bell Scott and William Rossetti in 1873, and it was here that Rossetti, who had first met Lucy in 1850, proposed to her and they were married the following year. They shared what were then rather unorthodox views, such as an interest in socialism. Lucy's last exhibited work dates from 1875, the year of the birth of her first child. The striking effects of light noted by critics imbued her works with a sense of drama, making them seem less realistic. The arrival of four more children, including twins, effectively ended her artistic career. After 1885, the onset of tuberculosis necessitated a good deal of travel and she turned to writing. She died in San Remo.

*Examples:* Wightwick Manor, Wolverhampton (National Trust).

*Literature:* Clayton; *DNB*; W. Fredeman, *Pre-Raphaelitism: a bibliocritical study*, Cambridge, Mass., 1965 (bibl.); *Mag. of Art*, 1895, 341–6.

## ROTHENBERG, Susan (1945–)

*American painter who uses a main image around which to base formal experiments and variations*

Born in Buffalo, New York State, Rothenberg gained her BFA at Cornell University in 1966, and pursued her studies at George Washington University and the Corcoran Museum School, both in Washington, DC. Settling in New York in 1967, she worked as an assistant to Nancy Graves (*q.v.*) in 1970, and had a daughter, whom she now brings up alone. Her preoccupations with monochrome, surface and a double or split image, already present in adolescence, re-emerged in 1973 with the first of her horse paintings. She had been impressed by Graves' monumental treatment of a single image, in her case a camel. For the next seven years she used the image of the horse to explore variations between part and whole, figure and depth, surface and depth, using only black, white and sienna. Geometric elements were intro-

duced, varying from the harsh black cross to a vertical division through the centre of the canvas. Only in the late 1970s did she recognise that the horse had been a substitute for the human figure, which gradually began to enter her work from this time, when she also changed from acrylic to oil. Her aim now is to 'reinvent the body to express an emotion', resulting partly from an interest in psychotherapy. Her relationship with her daughter, recollections of her childhood and events associated with relaxation are now evident in her work, although it is not narrative. She also expresses a feeling for different seasons for the year. Since the mid-1970s Rothenburg has exhibited in a number of prestigious group and solo shows.

*Examples:* Albright-Knox Art G, Buffalo; MOMA, New York.

*Literature:* C. Ackley, *SR: prints 1977–84,* Barbara Krakow G, Boston, 1984; *Graphic Muse;* Heller; H. Herrera, 'SR at Willard G', *Art in America,* Sept.– Oct. 1976, 108; *New image painting,* Whitney Mus., New York, 1978, (bibl.); M. Petzal, 'SR', *Art Monthly,* Mar. 1985, 15–17; E. Rathbone, *SR,* Phillips Collection, Washington, DC, 1985; C. Robins, *The pluralist era,* New York, 1984.

## ROZANOVA, Olga Vladimirovna. (alt. ROSANOVA) (1886–1918)

*Russian abstract painter, printmaker and collagist*

Born in Malenki, province of Vladimir, she studied from 1904 to 1910 at the Boshakov Art School and the Stroganov Art Institute in Moscow. After moving to St Petersburg the following year, she became an active member of the Union of Youth, contributing illustrations to their magazine and exhibiting with them (1911–14) while attending the Zvantseva School of Art in 1912–13. She was one of the first to adopt Futurist premises and to adapt it to her own style and subjects, which often included urban themes. She participated in almost every major modernist exhibition in Russia during this period as well as collaborating with the leading Futurist poets. She married one of them, Alexei Kruchenykh, in 1916, and they collaborated on further pieces, most notably two portfolios of poems and abstract collages of 1916. These combine geometrical pieces of fabric and translucent paper, which are more reminiscent of Malevich's Suprematist paintings rather than her early Cubo-Futurist style. She was at one stage a member

of his group Supremus. After the revolution she worked in IZO (the Fine Arts section of the Commissariat for the People's Instruction) and with Rodchenko organised the industrial arts section, for, like Popova (*q.v.*), she believed in the application of art to everyday life. While involved in setting up a new system of art schools throughout the country, she became fatally ill with diphtheria. Within a few weeks a retrospective exhibition was held of her work.

*Literature:* S. Barron & M. Tuchman, *The avant-garde in Russia, 1910–30: new perspectives,* County Mus. of Art, Los Angeles, 1980; M. Dabrowski, *Contrasts of form,* MOMA, New York, 1985; Fine, 1978; Petersen; *Russian women artists of the avant garde, 1910–30,* G Gmurzynska, Cologne, 1979; Vergine.

## RYAN, Anne (1889–1954)

*American abstract collagist using paper and textiles*

Despite enjoying only six years of artistic maturity, having found her medium at the age of 59, Anne Ryan made a distinctive contribution to American abstract art. She was the oldest of four children, and the only daughter of a wealthy Irish Catholic family in Hoboken, New Jersey, but her comfortable childhood was abruptly ended when her father died in 1902 and her mother committed suicide the following year. Brought up by her grandmother, she married William McFadden, a law student, after leaving college in 1911. Twins were born in 1912, and another son in 1919. Throughout these years she resented the traditional expectations of her roles, for she wanted to write, and after considerable strain, she was legally separated from her husband in 1923. From then she mixed with intellectuals and artists in New York and published a book of poems in 1925, while struggling to raise her children on a limited income. In 1931 she spent over a year in Majorca, where the cost of living was very low, and then met her older children again in Paris, where she saw contemporary painting for the first time. Back in New York she was inspired to begin painting in 1938 by the wealth of artistic activity around her, and was encouraged in her naïve still lifes and figures by a neighbour, Hans Hofmann. Her only formal training took place in 1941 at the printmaking workshop, Atelier 17 run by Hayter, where she encountered the European Surrealists. Her first solo show of prints took place that year,

and was followed by others throughout the 1940s. An exhibition of collages by Kurt Schwitters provided the catalyst for the transposition to that medium in 1948. Initially she used handmade papers in small works, revealing great sensitivity to tonal variations. She then began to incorporate fabric, eschewing all patterns which might be construed as feminine. Her work varies between a more geometrical classical style and an expressionist, painterly approach on the other. Her later works are larger and reveal a resolution of these two styles.

*Examples:* Albright-Knox Art G, Buffalo; Brooklyn Mus., New York; Smithsonian Inst., Washington, DC.

*Literature:* Bachmann; S. Faunce, *AR: collages*, Brooklyn Mus., 1974; *Notable American Women*, v4; Rubinstein; Withers, 1979.

## RYAN, Veronica (1956–)

*West Indian-born sculptor working in England, who uses natural objects to explore broader issues of human experience*

Born in Monserrat, Ryan came to England as a child and trained at the Bath Academy of Art (1975–8) followed by postgraduate work at the Slade (1978–80) and the School of African and Oriental Studies, London University (1981–3). She has exhibited actively since 1980, the year in which she also won a travel scholarship, and had her first solo show in 1984. Her early work inspired her to look at natural forms, which in turn have been incorporated into the sculptures themselves. They recall seed pods and exotic plants, using their pattern and texture to refer to ideas about the structure of society and human beings. Her tactile sculptures are life-sized and invite touch. She is also concerned with boundaries, and the way these can be drawn to include and exclude, to define and identify. As a result, her works contain shapes inside other shapes, contrasting hard and soft, repetitive and unique, luxuriance and austerity. She has participated in several important group shows since 1983, and in 1987–8 she was the artist in residence at Kettle's Yard, Cambridge Univerity.

*Literature: VR–sculpture*, Arnolfini G, Bristol, 1987; *VR*, Castlefield G, Manchester, 1987; *The thin black line*, ICA, London, 1985.

## RYYNÄNEN, Eva. née ASENBRYGG (1915–)

*Finnish sculptor in wood of figures and animals*

Born in Vieremä, North Savo, she was the second of five children of a farmer. As a child she carved tiny creatures from the chips of wood left from her father's construction of sleighs. After five years of study (1934–9) at the Ateneum School of Art in Helsinki, she had no money left, so obtained a job in the capital. In 1944 she married Paavo Ryynänen, who came from an old farming family, and thus renewed her links with her own rural upbringing. Agricultural themes have since formed the basis of much of her work, which depicts animals, people at work in the country and other aspects of rural life. Other subjects derive from the legends of Karelia and Finnish literature, in addition to religious subjects for church commissions. She works mainly with pine wood and always from one piece. For her the subject arises from the wood and she does not begin work upon a block until the image from that particular piece is clear in her mind. A major solo touring show in 1974 brought her to the attention of a much wider public and resulted in many commissions.

*Literature:* M. Laininen (ed.), *The flowering tree of Karelia: ER and her art*, Jyväskylä, 1980.

## SAAR, Betye (1926–)

*American artist making boxed assemblages and prints around the themes of the black experience and nostalgia*

Born in Los Angeles, she was the eldest of three children. Her father wrote plays and poetry but after his death in 1932, the family moved to Pasadena, where they were supported by an extended family. Saar had many opportunities as a child to engage in craft activities during the school holidays, but only made the conscious decision to become an artist when she was 34. Having originally graduated in 1949, she married an artist and had three daughters, and then enrolled in California State University to gain her teaching certificate. During this time she became so interested in printmaking that she decided to pursue this with an MFA, and began to win awards, a factor which may have contributed to her divorce. Late in the 1960s she encountered the work of Joseph Cornell. As she had already been placing her prints in deep frames and boxes and collecting

small objects, the influence of his boxes inspired Saar to move in the same direction. However, her work from the beginning was autobiographical with political overtones, clear from examples such as *The liberation of Aunt Jemima*. Other works deal with the memories of members of her own family, and their African background. From around 1970 the content became more introspective and nostalgic, concerning elements from her own childhood, and a wider range of objects was introduced. More recently she has produced collages with fabrics and colour xeroxes. Saar was given a solo shows at the Whitney Museum in 1975 and is currently a professor at the Otis-Parsons Institute in Los Angeles.

*Literature:* Munro; Petersen; C. Robins, *The pluralist era*, New York, 1984; Rubinstein.

## SAGE, Kay. née Katherine Linn SAGE (1898–1963)

*American Surrealist painter*

Born in Albany, New York State, she was the younger of two daughters of a conservative but wealthy father and a more unconventional mother. The latter often took Kay Sage on her European travels, so that her formal education was decidedly erratic. At the end of World War I her father despatched her to Italy on discovering her affair with a married man. Sage soon ended up in Rome, studying at various academies and schools there and painting with a group of male artists in the countryside. Marriage to an Italian prince in 1925 led to a virtual cessation of her painting until after her divorce in 1935. A move to Paris in 1937 saw the beginning of the abstraction of landscape. Initially influenced by Giorgio de Chirico, she included devices such as planking and scaffolding, strong shadows and spatial ambiguities with no human presence. Gradually her vast, empty landscapes from another planet evolved. The predominant tones are grey-blues; the forms are austere, precise and static, with an atmosphere of impending doom. Through the Surrealist Group in Paris, Sage met the painter, Yves Tanguy. They were married in America in 1940, and settled in Woodbury, Connecticut. Although they both adopted the scenario of the lunar landscape, Sage rejected Tanguy's use of biomorphic forms, her own architectural forms becoming more complex over the years. After Tanguy's death in 1955, she became more reclusive, although continuing to paint and write poetry until she underwent a double cataract operation in 1958. She never recovered from the loss of Tanguy and shot herself early in 1963.

*Publications:* See below under *Literature*.

*Examples:* Albany, NY; Denver; Mattatuck, Waterbury, Conn.; Walker Art Center, Minneapolis; Metropolitan Mus., Whitney Mus. and MOMA, New York; St Louis.

*Literature:* Bachmann; W. Chadwick, *Women artists and the Surrealist movement*, London, 1985; Harris; Heller; *Notable American Women*, v4; Rubinstein; *KS, 1898–1963*, Hubert F. Johnson Mus. of Art, Cornell Univ., Ithaca, 1977 (lists publ. and partial bibl.); Vergine; Withers, 1979.

## SAINT-PHALLE, Niki de (1930–)

*French sculptor of fantasy figures and architecture*

Born in Neuilly-sur-Seine, she was brought up in New York, where she became an American citizen. In 1950, depressed by the existing roles for women in society – she had been a débutante, married and had two children – she returned to France and began to paint. Her fascination with the fantastic architecture of Gaudi and a French postman's uninhabitable architectural forms emerged only in her own work later. During the 1950s she was more concerned with rebelling against stereotypical female roles in images of violence. After her marriage to sculptor Jean Tinguely in the mid-1960s she turned to more positive images of powerful and creative female figures, which culminated in the extensive series of *Nana* images, some of which were placed on the roof of the French pavilion at Expo '67 in Montreal. These polyester figures were painted with highly coloured patterns. In 1966 she collaborated with Per Olof Ultvedt and Tinguely to contruct a 'woman cathedral' in a Stockholm museum. It was large enough for people to walk inside, entering through the vagina, with a milk-bar installed in one breast. This demonstrated how women's bodies had been colonised by others. Since then she has undertaken many commissions, including some for children's playgrounds and a number of fountains. At her home in Tuscany she has been working since 1980 on a series of separate rooms in fantasy architecture inspired by the Tarot pack. In addition to her sculpture, she is involved with printmaking, film and theatre. Her more recent small sculpture raises doubts about her earlier feminist ideas; instead

of emphasising the personality and intellect of women some critics have seen a reversion to the body and its appearance.

*Publications: Tarot cards in sculpture*, Milan, 1985.

*Examples:* Graphothek, Berlin.

*Literature:* C. Drake, 'NdeS-P', *WASL J.*, Aug.–Sept. 1988, 26–7; *Das Verborgene Museum*; Krichbaum; Rubinstein; *NdeS-P: exposition rétrospective*, Centre Nat. d'art Moderne, Paris, 1980; Venice Biennale catalogue, 1988.

## SANDS, Ethel (1873–1962)

*American-born painter of interiors, figures and still lifes who lived in England and France*

Described as one of the pivotal figures in English cultured society for the first half of this century, Ethel Sands was born in Newport, Rhode Island, where her mother was a society beauty and hostess. The family came to England in the mid-1870s and remained there almost continuously until Mrs Sands died in 1896. In about 1894 Sands went to Paris to study under Carrière, and it was there that she met Nan Hudson (*q.v.*), who was to be her lifelong companion. As Sands was responsible for her younger brothers, she bought a house in Oxfordshire for the Christmas and summer holidays, dividing the rest of the year between Paris and the south of France. In 1900 Sands became a naturalised British subject. She exhibited at the Salon d'Automne of 1904, becoming a member in 1909. When in London, where Sands bought a house in 1906, she and Hudson mixed with the artists around Walter Sickert, who were influenced by the developments in recent French art. In 1911, however, these artists formed the Camden Town Group, which specifically excluded women. By then Sands was sufficiently well established to have a solo show in France and to have a painting purchased by the Contemporary Art Society and given to the Tate Gallery. In 1912 Sands and Hudson had a joint exhibition in London and became founder members of the London Group in 1913 on the demise of the Camden Town Group. During World War I, Sands and Hudson trained as nurses and ran a voluntary hospital near Dieppe in northern France, but continued to exhibit. They bought a house in Offranville in Normandy, which they restored and decorated with great pleasure, inviting Duncan Grant and Vanessa Bell (*q.v.*) to create a scheme for the wall facing the

gardens, while Sickert worked with Boris Anrep on their Chelsea house. Sands spent the 1920s between France and England, as well as visiting the Middle East, Africa and America. She continued to exhibit and had a number of solo shows. She became depressed after 1934, when a broken leg compounded worries about her finances and the threat of Hitler. During World War II she was again a nurse, and afterwards continued to travel extensively until the early 1950s, when Nan Hudson required more and more nursing. After Nan's death in 1957 she attempted to remake her life, becoming devoted in these last years to her painter niece, Catherine Sinclair. Through the bombing of her London home and the looting of her French residence, many of Sands' paintings have been lost. The chief influences on her work were Vuillard and Sickert, although she developed Vuillard's low-toned interiors to more brightly coloured ones with a dabbing brushstroke, which in turn gave way in the early 1920s to broadly painted areas of flat colour, a style which she then retained.

*Examples:* Tate G, London.

*Literature:* W. Baron, *Miss ES and her circle*, London, 1977; Cooper; Waters; *Who's Who in Art*.

## SANFORD, Marion (1904–86/7)

*American sculptor, particularly of women farm workers*

Born in Ontario, Canada, to American parents, she grew up in Warren, Pennsylvania. She enrolled at the Pratt Institute in New York in 1922, where she studied painting. After completing her course she designed stage sets and costumes but became increasingly drawn towards sculpture. She effectively taught herself from copious photographs of contemporary and historical sculpture, although for a short time she attended the Art Students' League, New York, where she learnt direct carving. From 1937 to 1940 she worked as an assistant to Brenda Putnam (*q.v.*) and drew the illustrations for the latter's autobiography. Later Sanford shared a studio with Cornelia Chapin (*q.v.*). She began to exhibit in 1937 although she had already sold portrait busts. Her chief subjects were women engaged on various agricultural tasks, whom she remembered from her childhood. These are rendered without any sense of anecdote and details are dispensed with in the interests of the overall form. The women are clothed in plain, fitted dresses which spread out in soft folds when required by the task depicted. She was elected a

member of the National Sculpture Association and an associate of the NAD.

*Examples:* Brookgreen Gardens, SC; Corcoran G, Washington, DC.

*Literature:* Proske, 1968; J. Lemp, *Women at work*, Corcoran G, Washington, DC, 1987.

## SARDEAU, Hélène (1899–1969)

*Belgian-born sculptor in bronze, wood, terracotta and plaster who worked in New York*

Born in Antwerp, Sardeau emigrated to America with her parents in 1913. After attending Barnard College, she continued her studies in New York at the Cooper Union, the Art Students' League (1921–2), and the School of American Sculpture (1924–5). In 1924 she exhibited clay portrait dolls depicting well-known actors and actresses in various roles, and the success brought by this first solo show enabled her to spend three years (1926–9) travelling in Europe. She then learnt various techniques of mask-making and won the commission to make the masks for a revival of a Greek play by Aeschylus at Delphi in 1927. In 1931 she married the artist George Biddle and two years later became an American citizen. During the 1930s she received several commissions for large mural sculptures, some jointly with Biddle, in New York, Rio de Janeiro and Mexico City. Working in a wide range of materials her subject was predominantly the human figure simplified and stylised. Her direct carving in wood shows particularly clearly her awareness of modernist art. She exhibited actively throughout her career with a succession of solo shows until 1964.

*Examples:* Metropolitan Mus. and Whitney Mus. New York; Pennsylvania Academy of Fine Art, Philadelphia; Corcoran G, Washington, DC.

*Literature: Fair Muse;* Rubinstein; J. Lemp, *Women at work*, Corcoran G, Washington, DC, 1987.

## SARTAIN, Emily (1841–1927)

*American painter and printmaker, best known for her role in women's art education*

The only daughter among eight children, she came from a family of engravers and artists. Her parents were English and emigrated to Philadel-phia in the early 1830s. Emily Sartain's artistic ability was encouraged by her father, who, after instructing her himself, sent her to the Pennsylvania Academy from 1864 to 1870. After this she spent four years travelling in Europe, exhibiting at the Salon in 1875. The Salon picture was awarded a medal at the 1876 Centennial Exposition. After returning to America, Sartain concentrated on mezzotint engraving, and from 1881 to 1883 was the art editor of *Our Continent*. Her chief contribution to art was as the Principal of the Philadelphia School of Design for Women from 1886 to 1920, when her niece succeeded her. Believing that designers should have the same rigorous education as artists, she transformed the type of instruction in this first school of industrial design for women in the country from the English mode to the French, from copying other works of art to working from the live model. She was also involved in other initiatives for women, particularly groups and meeting places, of which the most notable was the Plastic Club, the oldest art club for women still in existence, of which she was a founder and president (1899–1903, 1904–5). On two occasions she represented America at international congresses on industrial art. Despite all these activities she spent most summers in Europe. Overall her educational career was of greater significance than her art, although she continued to exhibit until the late 1880s, and twice won an award for the best painting by a woman at the Pennsylvania Academy exhibition.

*Examples:* Public Library, New York.

*Literature: DWB; Notable American Women;* Rubinstein.

## SAUNDERS, Helen (1885–1963)

*English Vorticist painter and poet*

The daughter of a director of the Great Western Railway, Saunders (sometimes incorrectly given as Sanders) was born in Croydon, Surrey. She attended the Slade School of Art in 1906–7, followed by a short period at the Central School. She began to exhibit in 1912 at the Friday Club and the Allied Artists' Association, and then became involved in the Vorticist Group around Wyndham Lewis early in 1914. She was a signatory of the manifesto which appeared in the first issue of *Blast* and contributed both poems and drawings to the war issue of 1915. Despite employment in a government office in London during the war, she

continued to paint and meet the other Vorticists. Although she is recorded by one participant as being devoted to Lewis and as having assisted him on the three abstract panels executed for the London restaurant, La Tour Eiffel, her style was distinctly different from that of Lewis. Since he would not have allowed any assistant who did not conform to his own style, the question of Saunders' collaboration must remain in doubt. Her abstract paintings reveal the addition of elements of Orphism to Vorticism, with a wider range of unusual colours, and curves often in the form of repeated semi-circles. Where figurative elements occur they are harsh and mechanistic. She has been criticised for a lack of coherence and organisation in her compositions, although her completely abstract works succeed in capturing the tension and balance between hectic movement and equipoise. The overall dynamic treatment of the theme of modern city life also coincides with the ethos of the other Vorticists. She certainly attempted many of the criteria set out for painting by Lewis in the first issue of *Blast*. She continued to exhibit with the disintegrating group, and was represented in the New York show in 1917. She returned to a more naturalistic style after 1920 and details of her subsequent activities are sparse.

*Examples:* V & A and Tate G, London.

*Literature:* R. Cork, *Vorticism and abstract art in the first machine age*, 2 vols, London, 1976; Deepwell; Krichbaum; Vergine.

## SAVAGE, Augusta Christine. née FELLS (1892–1962)

*American sculptor who was also influential in the promotion of black art*

Born in Green Cove, Florida, she was the seventh of 14 children of a house painter. Her father was a fundamentalist and discouraged his daughter's childhood interest in modelling the local clay into figures. Her first marriage in 1907 left her a widow with a small daughter, while her second to James Savage ended in divorce in the early 1920s, and her third husband died a few months after their marriage in 1923. Encouraged by local patrons to go to New York to train, she attended the Cooper Institute from 1921 to 1924, receiving a scholarship for her living expenses. Racial discrimination prevented her attending a summer school, a decision Savage fought with considerable publicity. She began her career in portrait sculpture, but for

some years had to take menial tasks in order to keep herself and contribute to her parents. She finally succeeded in winning two scholarships which would cover all her expenses in Europe, and studied at the Académie de la Grande Chaumière in Paris. Her work was exhibited in Europe to considerable acclaim. Back in New York in 1932 she set up a studio school of arts and crafts, which provided space for artists working on government projects. This received favourable publicity and Savage's work was in greater demand. Her commissions included a work for the New York World's Fair of 1939. Her portraits in plaster and bronze were much admired, but she also worked in wood, producing some allegorical and genre subjects. She was associated with a number of organisations which helped younger artists to establish themselves, having suffered for much of her life from racism and poverty.

*Publications:* 'AS: an autobiography', *Crisis*, Aug. 1929, 269.

*Literature:* R. Bearden and H. Henderson, *Six black masters of American art*, 1972; *Notable American Women*, v4; Petersen; Rubinstein.

## SCARAVAGLIONE, Concetta (1900–75)

*American sculptor in stone of monumental forms, often the female figure with animals or children*

The youngest of nine children of a poor Italian immigrant family, she grew up in New York. Encouragement at school overcame initial parental hostility to her training, and she trained at a free sculpture class at the NAD. When this closed, she had already started to win prizes, but in order to afford the tuition at the Art Students' League she worked in a factory. By 1925 she was exhibiting at the Whitney Studio Club and was the youngest original member of NYSWA. Although she carried out some portraits, she preferred to portray anonymous women and groups from memory, with only an occasional use of the model. Her figures are warm and intensely human, even when over life-size, and this quality emanated from her belief that art should be accessible to ordinary people. She was able to further these ideas when working on the Federal Art Project during the 1930s. Not only was she commissioned to make several large figures for public buildings, but she also organised an open-air sculpture show in New York in 1938 to which 39,000 visitors came. She had her first solo show in 1941, by which time she was already

well known. After the war she began to work in welded metals and in 1947 was awarded the Prix de Rome, which enabled her to study in the Italian capital for three years. After this her work became more experimental and abstract. Parallel with these activities was her career as a teacher, which lasted almost continuously from 1925 to 1967. Institutions where she taught include New York University, Sarah Lawrence College, Black Mountain College and Vassar College. Her career demonstrates that it was possible for those without a monied, middle-class Anglo-Saxon background to become succesful artists.

*Literature:* K. Marling and H. Harrison, *7 American women: the Depression decade*, Vassar College, Poughkeepsie, 1976; Rubinstein; A. Wolf, *New York Society of Women Artists 1925*, ACA G, New York, 1987.

## SCHAPIRO, Miriam (1923–)

*American pattern and decoration artist who has had a long association with the women's art movement and co-founded the Feminist Art Program*

A well-documented and established artist, Schapiro was born in Toronto, the only child of supportive parents. Her father was an industrial designer, who at one stage was director of the Rand School of Social Science in New York, while her mother, aunt and grandmother provided her with three strong role models. After two years at Hunter College, she went on to Iowa University for a total of six years up to 1949. During this time she met and married artist Paul Brach, who has been consistently supportive during their careers. In 1955 Schapiro had a much-wanted child, although she then had to face the inevitable inroads into her time, and the psychological effects of constantly working against society's expectations of her caused her to abandon her abstract expressionist style and begin her so-called shrine paintings – painted assemblages with a specific iconography. During the 1960s she was a convert to the women's movement, whose ideas crystallised in the painting *Ox* (1968). The sexual allusions in this work caused her to turn it to the wall for six months. She accompanied her husband to the University of California in 1970, and thus became involved in the establishment of the Feminist Art Program at the California Institute of the Arts with Judy Chicago (*q.v.*). She co-organised the Womanhouse project (1971), and this marked the start of her

adoption of pattern and collage as a conscious identification with women's traditional crafts such as patchwork. Returning to New York in 1976 she exhibited with the Pattern and Decoration Group of artists, which she had helped to set up (see under Kozloff) at a time when the austerity of Minimalism was still dominant in the art world. She believes that the meaning of her art lies in the lives of women of the past and that her collage elements are the needlework of forgotten women. As well as exhibiting regularly she still undertakes teaching, and has been involved with the New York Feminist Art Institute, the feminist journal *Heresies* and the Women's Caucus for Art.

*Publications:* 'The education of women as artists: Project Womanhouse', *Art J.*, spring 1972, reprinted in J. Loeb (ed.), *Feminist collage*, New York & London, 1979.

*Examples:* Hirschhorn Mus., Washington, DC.

*Literature:* T. Gouma-Peterson, *MS: a retrospective, 1953–80*, College Art Mus., Wooster, Ohio, 1980; Heller; Munro; Petersen; M. Roth, *The shrine, the computer and the dollhouse*, University of California, San Diego, 1975; C. Robins, *The pluralist era*, New York, 1984; Rubinstein; Withers, 1979.

## SCHAUMANN, Sigrid Maria (1877–1979)

*Finnish painter of landscapes and figures*

Born in Tchugujev in Russia, she was the daughter of an officer in the Finnish army, who was shortly afterwards posted to Radom in Poland. Her mother died in 1884 and the following year she returned to Finland with her father. She attended a private drawing school for girls between 1889 and 1896. She must have persisted a good deal on her own, helped by her first extended stay in Italy between 1899 and 1901. Although her first work was exhibited in 1901, she continued to spend periods of study abroad: from 1904 to 1906 in Dorph's atelier, Copenhagen; between 1908 and 1910 a further stay in Italy was followed by a period at the Académie de la Palette in Paris and a visit to Egypt. From the turn of the century her work took on a bolder, more Expressionist appearance. Early in 1913 her daughter, Elisabeth, was born, the result of an affair with business man, Edvard Wolff, who died shortly after the child's birth. From 1920 to 1949 she was an art critic for two newspapers, which provided her with a more secure basic income. Nevertheless she

continued to paint, travel and exhibit throughout Europe, winning many prizes and scholarships. During the thirties, her work continued to develop and she participated in the Finnish section of the 1937 exhibition *Les femmes artistes d'Europe*. Although termed by one writer a 'conservative modern' in the manner of Vuillard or Walter Sickert, she was highly esteemed by her contemporaries. Her subjects are always bathed in light and with time the bolder elements mellowed to create richly coloured, atmospheric paintings, while retaining a sense of underlying structure. In 1955 she was a founder member of the Prisma Group and exhibited with them until 1970, when she was 93. She dedicated her works first to her mother and later to her daughter, who died in 1967. Several retrospective exhibitions of her work took place during the later years of her life.

*Examples:* Cophenhagen; Göteborg; Helsinki; Oslo; Turku; Vaasa.

*Literature: Apollo*, 1982, 378; J. Boulton-Smith, *Modern Finnish painting*, London, 1970; *Sieben Finnische Malerinnen*, Kunsthalle, Hamburg, 1983 (bibl.).

## SCHEEL, Signe (1860–1942)

*Norwegian painter of portraits and* Intimiste *figures and interiors*

Initially a pupil of Christian Krohg, she spent the winters from 1881 to 1884 studying in Berlin. Intermittently returning to Krohg between 1884 and 1888, she travelled in 1888 first to Copenhagen and then to Paris, where she attended the Académie Colarossi. In 1892 she returned to Paris and studied with Puvis de Chavannes. She had begun exhibiting in 1884, and had a distinguished career in both national and international exhibitions. Her early compositions show a single woman or young girl, more rarely several, seated engaged in some tranquil occupation. The figures seem self-contained, not unlike the contemporary paintings of Harriet Backer (*q.v.*). The source for both artists would appear to be French; in Scheel's case a technique for conveying the effects of light derived from her study of Impressionism on subjects to which she had easy access. In 1895 she made the first of seven study visits to Italy. On the initial visit she looked at the early Renaissance painters in Florence, for some religious subjects as well as an increase in scale are evident in subsequent years. Later she also painted landscapes. From 1907 she

had a series of solo shows, a retrospective in 1936 and a memorial show in 1943. She was also the subject of an exhibition in 1960.

*Examples:* Nat. G, Oslo.

*Literature:* A. Wichstrøm, *Kvinner ved staffeliet*, Oslo, 1983.

## SCHILLE, Alice (1869–1955)

*American painter of landscapes, beach and town scenes in Europe, Africa and the Middle East, in a freely handled style*

Initially trained at the Art Academy of her native Columbus in Ohio from 1887 to 1889, Schille then travelled to New York to study at the Art Students' League under William Merritt Chase and Kenyon Cox. In 1893–4, while attending the Pennsylvania Academy, she encountered several members of the future Ash Can school, including Robert Henri. The last six years of the century were spent in Europe, where she studied at the Académie Colarossi, travelled extensively and became a friend of Gertrude Stein. From 1902 she evolved a pattern for the year, which continued until her retirement in 1942: she taught at Columbus Art School and spent the summers travelling and painting. She was a prolific artist, who exhibited widely and gained many awards. In 1932 she was hailed as Ohio's leading woman painter. During the 1930s and 1940s this intrepid traveller explored Central America and New Mexico. She preferred watercolour as her medium while travelling, and her lively paintings convey a sense of capturing the impression of a scene in a spontaneous and loosely handled manner.

*Examples:* Columbus, Ohio; Art Club, Philadelphia.

*Literature:* E. Clark, *Ohio art and artists*, Richmond, Va., 1932; *Fair Muse*; Tufts, 1987; G. Wells, 'AS: painter from the Midwest', *Art and Antiques*, Sept.–Oct. 1983, 67.

## SCHJERFBECK, Hélène Sofia (1862–1946)

*Finnish painter of interiors, figures, still lifes and self-portraits*

At the age of four, Schjerfbeck, who was born in Helsinki, suffered a serious accident, as a result of

which she was virtually unable to walk for several years. By 1873 she was able to attend the Drawing School of the Finnish Fine Arts Association, after four years of which she was fortunate enough to study with Adolf von Becker, who brought her into contact with French painting. At the age of 18, she went to Paris, attending first the Académie Trélat and then the Académie Colarossi. A visit to the artist colonies at Pont-Aven and Concarneau was to prove crucial to the development of her *plein-air* painting. In July 1887, encouraged by another artist, Marianne Stokes (*q.v.*), she went to St Ives in Cornwall, where she painted *The Convalescent*, which won a bronze medal at the Paris Exposition of 1889. Throughout her life she was beset by poverty and ill-health. This forced her to take up teaching posts and to resort to copying old masters. During the 1890s her own work became simpler, so that the subject matter – interiors, and figures of women and children, sometimes only a door – became the starting point for a spiritual exploration in colour and tone. In 1901 she and her mother (her father had died in 1876) moved away from Helsinki to Hyvinkää, a relatively isolated town. Although she kept in touch with artistic developments through journals, the evolution which took place in her art was independent of these. She refined and simplified her work, placing shapes and choosing colours with care. Nevertheless this isolation brought tension between her domestic duties and her wish to paint, resulting in a deterioration in her health. A meeting with art dealer Gösta Stenman led to her first solo show in 1917 in Helsinki and to her becoming known in Sweden. In the 1930s her still lifes contain softly edged shapes, balanced through colour and the use of textured paint. It is perhaps her late self-portraits which are the most remarkable; frankly recording her ageing appearance, they show her to be an artist of European significance. She was selected for the Finnish section of the 1937 exhibition *Les femmes artistes d'Europe*.

*Examples:* Helsinki; Oslo; Stockholm; Turku; Vaasa.

*Literature:* J. Boulton-Smith, *Modern Finnish painting*, London, 1970; *Dreams of a summer night*, Hayward G, London, 1985; L. Holger, 'The convalescent motif and the free replicas: HS's painting of a young girl', Ateneumin Taidemuseo, *Museojulkonisu*, v23, 1980, 40–45; *Sieben Finnische Malerinnen*, Kunsthalle, Hamburg, 1983 (bibl.).

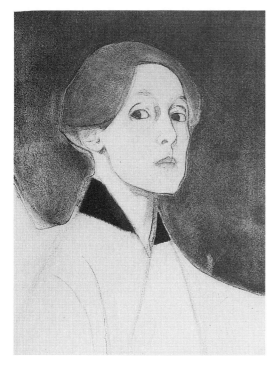

**Hélèn Schjerfbeck** *Self-portrait*, 1915, charcoal and watercolour, 47 × 34.5 cm, Turun Taidesmuseo, Turku.

## SCHNEEMAN, Carolee (1939–)

*American performance artist who uses her body to explore sexual and personal freedom*

Brought up in rural Pennsylvania and Vermont, Schneeman originally trained as a painter at the University of Illinois and Bennington College. Early on she became interested in women artists, particularly those who had been forgotten by history. She went to New York in 1962 with her husband, the composer James Tenney. Through his contacts she began to frequent the Judson Dance Theatre, and from 1964 became the first artist to work with dancers. During the previous two years she had experimented with environments and performance pieces – then highly structured – and was one of the first women to be involved in this form of art. Through her work with dancers she was able to achieve her aim of involving the body in her art. In 1964 her work *Meat joy*, which was seen in London and Paris as well as New York, explored the idea of improvisation in performance and the use of the body. Only in London, however, was she permitted to perform this in the nude. Her subjects are her own dreams

and those of her lovers. She has been described as transforming all the bodies in her performances into sexual organs, often by adding incongruous decorations, clothing, paint, grease and even food. Like some other body artists she risks being seen in the conventional terms of woman as spectacle, even though her underlying intentions are to open up new possibilities for personal expression. Her feminism led her to reinstate the Earth Goddess and to celebrate vulvic space. During her stay in London between 1970 and 1974 she also made films and produced artist's books. Since her return to New York in 1974 she has ceased her large performance pieces, but occasionally carries out solo work. She has also returned to painting, reviewing her earlier work and using it as the basis for new explorations. Her concern is still to demythologise the body. She has regularly taught courses on women artists and the representation of women.

*Literature:* T. Castle, 'CS: the woman who uses her body as her art', *Artforum*, Nov. 1980, 64–70; S. MacDonald, 'Interview with CS', *Afterimage*, Mar. 1980; Roth.

## SCHOENFELD, Flora. née IRWIN (alt. SCHOFIELD) (1873–1960)

*American painter and printmaker who worked in a modernist, at times Cubist, style*

Born in Lanark, Illinois, she trained at the School of the Art Institute, Chicago, from 1891. Her connection with the school lasted until 1904 as, at some stage, she began to teach the Saturday classes there. She also studied in Provincetown under Charles Hawthorn, Nordfeldt and William Zorach. However, after seeing modernist paintings at the Armory Show in 1913, she went to Paris and during the 1920s and early 1930s spent most of her time there, only returning to her lawyer husband twice a year. Her children lived with her in Paris and she was criticised for her independent stance. In Paris she studied with a number of artists, including Gleizes, Léger and Goncharova (*q.v.*). She exhibited in Paris, Chicago (where she showed the first abstract work accepted at the Art Institute) and Provincetown, where she spent several summers from 1916 to 1920. Even after her return to Chicago she continued to travel both within America and to Europe, and was an active member of

various societies, including NYSWA, of which she was the only non-resident member. She designed a modern-style home in Chicago, which served as a meeting place for artists, where she housed her collection of early modernist works by artists such as Gris and Orloff (*q.v.*). From the 1930s she used the name Schofield.

*Examples:* Michigan.

*Literature:* J. Flint, *Provincetown printers*, NMAA, Washington, DC, 1983; A. Wolf, *New York Society of Women Artists 1925*, ACA G, New York, 1987.

## SCHWARTZE, Thérèse (1851–1918)

*Dutch painter of portraits, with some genre and still life, in oil, watercolour and pastel*

She was the daughter of the Amsterdam portrait painter, Johan Georg Schwartze, and it was from him that she received all her early training. After his death, she went in 1875 to Munich and studied under Gabriel Max and Lenbach. After a year she returned to Amsterdam, where she received encouragement and advice from friends of her father, including Josef Israels. Her first visit to Paris in 1878 proved a disappointment; she found the artistic life inspiring, but could find neither a studio nor a teacher to suit her, so she returned to her native city. She paid another short visit two years later, but it was not until 1884 that she studied there, to the great benefit of her painting, and she began to work in pastel in 1885. During this time she was establishing a reputation as a portrait painter. She exhibited at the Salon from 1879, but it was only after her study period in Paris that she began to acquire awards. The self-portrait commissioned by the Italian government missed by two votes a gold medal at the Paris Exposition of 1889. She exhibited in Belgium, Spain and Germany as well as Holland and France, including a solo show in Amsterdam in 1890. She served on the jury of the international exhibition held in Amsterdam in 1883. Both she and her sister Georgina, who was a sculptor, were represented at the Paris Exposition of 1900. In addition to commissioning portraits from her, the Dutch royal family asked her to teach Princess Henry. She had many famous people among her sitters and always had more requests than she could execute. In 1906, at the age of 55, she married A. van Duyl. She provided a role model for later Dutch women artists such as Ritsema (*q.v.*).

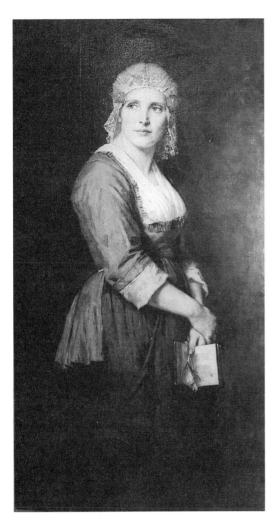

**Thérèse Schwartze** *Going to church: a Dutch peasant*, oil on canvas, 144.6 × 73.6, Russell Cotes Art Gallery and Museum, Bournemouth. (photo: Harold Morris)

*Examples:* Amsterdam; Antwerp; Russell-Cotes Mus., Bournemouth; Düsseldorf; Uffizi, Florence; The Hague; Leiden; Sidney; Valenciennes.

*Literature:* Clement; Krichbaum; F. Martin, *T van D: een Gedenkboek*, Amsterdam, 1921; Petersen; A. Venema, *De Amsterdamse Joffers*, Baarn, 1977.

**SCOTT, K. See KENNET, Kathleen**

## SCUDDER, Janet. née Netta Deweze Frazer SCUDDER (1869–1940)

*American sculptor of figures, fountains, reliefs, architectural ornaments and portrait busts*

The fifth child of a confectioner, she was born in Terre Haute, Indiana, and lost her mother at the age of five. Her misery was compounded by a stepmother unsympathetic to the tomboyish Netta. After she had shown a talent for art at Saturday drawing classes, her father paid for her to attend Cincinnati Academy of Art. After his death an older brother subsidised her third year to study, at the end of which she was ready to earn her living as a woodcarver. After dismissal from her factory job because the trade union would not accept female woodcarvers, Scudder was employed by Lorado Taft as one of several female assistants during the preparations for the 1893 Chicago Exposition, and through him she received her first two independent commissions. This period of intense activity was of great benefit and, as a result, she went to Paris and eventually persuaded Frederick MacMonnies to accept her as a pupil. She soon graduated to assistant and learnt low-relief modelling. Within a year shortage of money and professional jealousies forced her back to America, where after a bleak few months she began to gain sufficient medallion commissions to enable her to return to Paris. It was on a visit to Florence that she realised her true vocation: lively joyous statues and fountains for houses and gardens. From 1899 in her New York studio she quickly became successful and took an active interest in the suffrage campaign. From 1909 she lived mainly in France, with the exception of the war years when she served overseas from 1916 to 1918. She won many awards and in 1920 was elected an Associate of the NAD. Her style reflects the Beaux-Arts tendencies of the time and her female figures are of the slender, androgynous type popular in the 1920s. Her garden sculpture was a new conception and brought her greater rewards than any previous woman sculptor had enjoyed.

*Publications: Modelling my life*, New York, 1925.

*Examples:* Brookgreen Gardens, SC; Metropolitan Mus., New York; Mus. d'Orsay, Paris.

*Literature:* Bachmann; M. Hill, *The woman sculptor: Malvina Hoffman and her contemporaries*, Berry-Hill G, New York, 1984; *Notable American Women*; Proske, 1968; Rubinstein; Tufts, 1987.

## SEEFRIED-MATEJKOVÀ, Ludmila (1938–)

*Czech figurative sculptor who works in West Berlin*

Born in Hermanuv Mestec, she began her training in Prague in 1956. After a year in the sculpture class she took up stone carving. In 1964 she became a member of the Czech Artists' Association and exhibited in her home country until 1968. A scholarship enabled her to attend the Hochschule für Bildende Künste in West Berlin in 1967, and she attended Professor Lonas' master class in 1972 –3. Since then she has worked as an independent artist in West Berlin, participating in competitions and exhibitions and was awarded a retrospective in 1987. In the late 1970s she used a variety of materials to produce images of women. The use of resin for the figures enables her to achieve an absolute realism and she challenges female stereotypes by avoiding slim, young models.

*Examples:* Berlinische G, Berlin.

*Literature: Das Verborgene Museum.*

## SEMMEL, Joan (1932–)

*American painter of photo-realist views of the female body from a woman's view-point*

Born in New York, Semmel studied at the Cooper Union, the Art Students' League and the Pratt Institute. She accompanied her husband to Spain in 1963 and spent seven years there while her two children were young. When time allowed, she painted large, brightly coloured abstract expressionist works. Separated from her husband she returned to New York to encounter the early phases of the women's movement, which ended her sense of isolation. As a reaction to the exploitation of the image of women in the mass media, she sought to portray woman as an equal partner in sexual experience. Returning to figuration, she first depicted unnaturally coloured pictures of couples making love and, as no gallery would show these, she hired a gallery herself. In the mid-1970s she executed a series of photo-realist views looking down her own body, as she sees it in reality, not as she knows it to be from the mirror. The representation is neither vamp nor victim. More recently she has included expressionist areas of paint in such works.

*Literature:* L. Alloway, *JS*, Sharadin G, State College, Kutztown, Penn., 1980; S. Goodman, 'JS', *Artforum*, v51/9, May 1977, 35–6; Rubinstein.

## SEREBRIAKOVA, Zinaida Eugenievna. née LANSERE (1884–1967)

*Russian painter of figures*

With her father a sculptor, her mother a painter and many other relations involved in the arts, Zinaida Lansere was in an advantageous position. However, her father died when she was two and she, with her brother, was brought up in her mother's extended family, the Benois. Having drawn from an early age, she began formal studies in 1901 at the art school founded by Princess Maria Tenisheva and lead by Ilya Repin, who inculcated a solid course of study founded in an emphasis on drawing and an admiration for the Italian Renaissance. She subsequently attended classes with the portraitist, O. Braz, and travelled in Italy in 1902– 3. After her marriage to the writer Boris Serebriakov in 1905, she went to Paris with him. There she studied at the rather traditional Académie de la Grande Chaumière and copied paintings in the Louvre. Returning to Russia, she settled on the family estate in the country and had two boys, in 1906 and 1907, followed by two girls, in 1912 and 1915. Her early work shows local and personal subjects: portraits of members of the household, peasants engaged in agricultural activities and landscapes. She succeeded in conveying a strong sense of place in her calm, balanced compositions. Her best-known work is a self-portrait of 1909 entitled *À la toilette*. Like all her portraits it stresses what the artist has perceived rather than any insight into character. From 1913 to 1917 she produced larger works, often including nudes, a comparatively rare subject in Russia, even though her approach is an aesthetic rather than a realistic one. She used the nude for the designs for several monumental schemes. With three other women she was about to be designated Academician, but the award was never made because of the revolution in 1917. Her husband died in 1919 and her house was burnt down. Several difficult years followed, although her return to Petrograd (now Leningrad) in 1920 enabled her to develop studies of the theatre and ballet. For economic reasons she went to Paris in 1924, but the temporary expedient became permanent. She exhibited little but, although the Parisian art world was not interested in her classical approach, she was given a major exhibition in her native country in 1965–6. She died in Paris.

*Examples:* Russian Mus., Leningrad; Tretyakov Mus., Moscow.

*Literature:* A. Hilton, 'ZS', *WAJ*, v3/2, fall 1982–

winter 1983, 32–5; Krichbaum; V. Laphsin, *ZES*, Moscow, 1969; V. Kniazeva, *ZES*, Moscow, 1979.

## SERRANO Y BARTOLOME, Joaquina (late 19th century)

*Spanish painter of portraits, flowers, still life and genre*

Born in Fermoselle, she studied at the Madrid School of Arts and Crafts, and the School of Painting with Juan Espalter. She exhibited from 1876 and was elected member of the Society of Authors and Artists.

*Examples:* Soc. of Authors and Artists, Madrid; Murcia.

*Literature:* Clement.

## SETCHELL, Sarah (1803–94)

*English painter of humble life scenes, some from literature*

Born in Covent Garden, London, Setchell was the daughter of a bookseller who had wanted to be an artist. He collected books on art and wanted both his daughters to have a career in art. Sarah began by copying in the National Gallery and British Museum, helped by her father's criticism. Despite his positive attitudes, he discouraged her from painting the classical subjects she desired, guiding her instead towards homely and domestic ones. She also received some instruction in miniature painting on ivory from Louisa Sharpe. From 1831 she exhibited at the RA, Society of British Artists and, from 1834, at the New Society of Painters in Watercolour, to which she was elected a member in 1841. The work which established her reputation appeared the following year. This was *The momentous question*, a literary subject, which sold for 25 guineas, was engraved and the copyright sold for the same amount. Her output decreased after this due to problems with her eyesight. Her father died, and she gave some lessons to Mary Criddle (*q.v.*) at reduced fees. She sold the copyright of another painting in 1850, a period when she was exhibiting in alternate years. In 1860 she consulted an oculist in Switzerland, who must have given a pessimistic prognosis about her continuing to paint, for she then almost completely abandoned

professional work and went to live with her sister in the country. Both her literary subjects and portraits show her skill in depicting expression and situations of heightened emotion.

*Examples:* V & A, London.

*Literature:* Clayton; *DNB*; Mallalieu; Nottingham, 1982; *The Times*, 17. Jan. 1894 (obit.); Yeldham.

## SEVERN, Ann Mary. (alt. Lady NEWTON) (1832–66)

*English painter of portraits, figures and topographical landscapes in oil, watercolour and pastel*

Born in Rome, where her father, a painter of considerable repute, was the British consul, she showed an early interest in art. After instruction from her father, she received advice from George Richmond, who also employed her to copy his portraits. In 1855 she travelled to Paris in order to study with Ary Scheffer, and while there executed a portrait of the Countess of Elgin. This was greatly admired and resulted in many commissions on her return to London, including some from the royal family. She exhibited from 1852. In 1861 she married Mr (later Sir) Charles Newton, Keeper of Classical Antiquities at the British Museum, and with him toured the ancient sites in Greece and Turkey. She made many sketches which provided the basis for illustrations to her husband's books. She continued to exhibit after her marriage, although her husband disapproved of her professional practice. He was instrumental in causing her to change to oil painting from watercolours, which he derided. One source indicates that she tried to avoid marriage but that her wishes were overridden by her father, who was indebted to Charles Newton. It is suggested that her father, whose painting career had declined so drastically that his daughter's income was essential to the family, only became consul after recommendation by Newton, who had earlier worked in the consular service. In addition to portraits, Mary Severn specialised in figures of women. At the age of 33 she died from complications arising from measles, although there were suggestions that she was overworked by her husband.

*Examples:* British Mus. and Nat. Portrait G, London.

*Literature:* *AJ*, 1866, 100 (obit.); S. Birkenhead, *Against oblivion*, London, 1943; S. Birkenhead,

*Illustrious friends*, London, 1965; D. Cherry, *Painting women: Victorian women artists*, Art G, Rochdale, 1987; Clayton; C. Clement & L. Hutton, *Artists of the nineteenth century*, 1879; *DNB*; Mallalieu; Nottingham, 1982; P. Nunn, *Victorian women artists*, London, 1987; Wood, 1978 (under both Severn and Newton).

## SHAKESPEAR, Dorothy. (alt. POUND) (1886–1973)

*English artist producing Vorticist abstractions*

Shakespear was born in London, her father being a solicitor and her mother a novelist. Both her father and grandfather had been amateur landscape painters. Entirely self-taught as an artist, she specialised in watercolour, and began from the Victorian tradition. However, by 1912 she was clearly aware of the work of Cézanne, probably as a result of Roger Fry's two exhibitions of recent modernist art. Her only two known oils date from this year and show a drastic simplification. By 1914 her paintings had moved beyond a synthesis of Cézanne and Japanese art towards abstraction in the angular Vorticist style. This was probably due to her participation in the Vorticist circle through her friendship with the poet Ezra Pound, whom she married in 1914. She was present at the discussions at the Rebel Art Centre and would have seen Wyndham Lewis's work, so that she refined her paintings down to a few finely balanced formal elements. So thoroughly had she absorbed the current atmosphere that she was alarmed by her painting *War scare, July 1914* and did not want it shown to anyone. She contributed to the second issue of *Blast* but never exhibited with the group. Among her Vorticist works can be counted the covers she designed for volumes of Pound's poetry. Lewis clearly felt her sense of 'understated discipline' could be a distinctive contribution to the group and always encouraged her. As with Dismorr (*q.v.*), a return to figuration coincided with the demise of Vorticism after the war. From 1925 she and Pound settled in the south of France and later the Tyrol. She painted many watercolour landscapes in which the debt to Vorticism remains, but she did not attempt to exhibit.

*Publications: DSP: Etruscan Gate*; Exeter, 1971 [includes drawings and a notebook she wrote in 1909–11].

*Literature:* R. Cork, *Vorticism and abstract art in the first machine age*, 2 vols, London, 1976; Deepwell; *The Times*, 13 Dec. 1973 (obit.); Vergine.

## SHARP, Dorothea (1874–1955)

*English painter of children, indoors and outside, in an Impressionist style*

Born in Dartford, Kent, Sharp decided to become an artist when she was ten. This idea was discouraged by her parents because of its financial uncertainty and it was only at the age of 21, when she inherited £100, that she could undertake training. She attended the school run by C. Johnson until her finances were almost exhausted, whereupon she went to evening classes at the Regent Street Polytechnic. There she benefited from advice from Clausen and David Murray, who were visiting critics to the polytechnic's Sketch Club. She greatly wished to visit Paris, but her semi-invalid mother would not allow her to go unchaperoned. In was only when her mother's health had improved that they were able to go. They spent each morning studying churches and each afternoon Sharp painted at Castaluchio's atelier. She encountered the works of Monet, which revolutionised her ideas about the treatment of light. On returning to England Sharp declined an offer of marriage in order to concentrate fully on her painting; and it was from the small bedroom which she used for a studio that she submitted paintings to the Society of British Artists which were to bring her membership of that body at the early age of 26. She sent her first work to the RA in 1901 and continued to do so until 1948. Until 1924 her painting was severely restricted by having to care for her mother, but after the latter's death her output and reputation grew rapidly. Her first solo show was held in 1933 and she was elected member of many societies, including the SWA, of which she was acting- and then vice-president. Each year she spent a period away from London in order to paint. This was usually abroad, but she also worked in St Ives, Cornwall. Her pictures of children, often at play out of doors, are suffused with light and sunshine. The texture is rich and the broad brushstrokes emanate spontaneity and liveliness. In her lifetime there was a large demand for her work.

*Examples:* Auckland, New Zealand; Belfast; Cardiff; Doncaster; Newcastle-upon-Tyne; Northampton; Oldham; Rochdale.

*Literature:* 'DS', *The Artist*, Apr. 1935, 55–7; *Silver*

*bells and cockle shells*, Whitford & Hughes G, London, 1986; Waters; *Who's Who in Art*.

## SHERIDAN, Clare. née Claire FREWEN (1885–1970)

*English sculptor, notably portraits, writer and journalist*

The second child of an American society mother and an unreliable English father, Claire Frewen spent an unhappy childhood in London, relieved only by annual holidays with her cousins Winston and Jack Churchill, until her father inherited considerable estates in County Cork in 1896. As she was unorthodox in almost every respect, relations with her mother, who saw women's roles in a very traditional light, were always difficult. Required to marry someone rich because of the family's straitened circumstances, she would not be dictated to and accepted the impoverished Wilfred Sheridan in 1910. By 1913 she had borne two daughters, one of whom had died of tuberculosis. This tragedy proved the catalyst for her sculpture. Seeking to design a memorial for the baby, she began to model in clay, completing a second memorial for the family church in Dorset. It was the death of her husband in 1915, one week after the birth of her son, which caused her to turn professional. Furious at a society which allowed her to reach adulthood essentially untrained and without a means of earning a living, she took a studio in St John's Wood and began to sell plaster garlands, which could be quickly made and sold, to finance her statuettes of wartime figures, such as landgirls and soldiers. Despite reasonable sales she was always in debt until an American colonel gave her £1,000 to enable her to concentrate on learning to model portraits. Among her early sitters were Arnold Bennett, H.G. Wells, and Gladys Cooper, and in this respect she was helped by her many friends in high society. She commissioned her own portrait from Epstein with the American colonel's money in order to learn how he sculpted. The knowledge she gained revolutionised her sculpture. In 1920 her first solo show established her as a society sculptor with a highly individual approach. The first of several busts of her cousin Winston Churchill was executed on commission in 1920, and through him Sheridan met a member of the Soviet trade delegation in London who invited her to the USSR, not expecting her to accept the offer. She spent some weeks in a studio in the Kremlin, modelling several leading politicians, including Lenin and Trotsky. This episode, so typical of the impulsive Sheridan, caused her to be ostracised by the aristocratic and royal circles in which she moved, so, owing to the lack of commissions, she went to America. Through her contacts there she received many commissions, visited Mexico and began to write newspaper articles, since she was still in need of money. By the time she returned to England in 1922, as a roving reporter for the *New York World*, the former animosity had dissipated. The next phase of her career was chiefly taken up with journalism, travel and writing books, although she produced many non-figurative fountains while living in Algeria and attempted to model Mussolini until he tried to assault her. It was the sudden death of her son at the age of 21 which began the second part of her career in sculpture. This time she discovered carving in wood. She began producing many figures carved from tree trunks, and increasingly these had a religious theme. In 1947 at Assisi she was received into the Roman Catholic Church and moved to Galway Bay in Ireland. Her late work was rarely purchased, but Sheridan continued to work for her own satisfaction until almost the end of her life.

*Publications:* To the four winds, 1957 (autobiography).

*Examples:* Imperial War Mus., London.

*Literature:* M. Cole, *Women of today*, New York, 1968 (orig. pub. 1938); *DWB*; A. Leslie, *Cousin Clare: the tempestuous career of CS*, London, 1976; Mackay.

## SHERWOOD, Rosina. née EMMET (1854–1948)

*American painter of figure subjects, genre and portraits in oil, watercolour and pastel*

Sister of Lydia Emmet (*q.v.*) and cousin of Ellen Rand (*q.v.*), she was born in New York. She may have been taught in the first place by her mother, before studying in the atelier of William Chase. This was followed by a visit to Paris, where she enrolled at the Académie Julian in 1884–5. She exhibited actively from 1881 in Paris and America, where she opened her own studio in New York that year. In the early part of her career, Rosina Emmet lived from the sale of her illustrations, and in 1880 won a £1,000 prize for the design of a Christmas card. A little later she was collaborating with Dora Wheeler in a design firm, Associated

Artists, run by Dora's mother, Candace, which involved the design of items for interior decoration. However, Emmet was also becoming established as a painter and received medals from the Expositions of Paris in 1889, Chicago in 1893, Buffalo in 1901 and St Louis of 1904. By 1900 she had begin to have solo shows at a time when such things were unusual. This high profile was in spite of marriage in 1887 and the arrival of five children. Indeed for much of the time she was the main wage-earner for the family and used her family as models. As early as 1893 she is recorded as requesting urgent payment for one of the four smaller murals in the Women's Building at the Chicago Exposition (entitled *The Republic's welcome to her daughters*) because she had to support her three babies. Continuing to exhibit until her seventies, she was elected as Associate of the NAD in 1906. After 1900 her subjects consisted mainly of genre and family portraits, and she took on fewer commissions until 1918, when financial problems caused by the illness of her husband necessitated a return to full-time portraiture. Increasingly she also produced watercolour landscapes, many carried out on a world trip in 1922. The art from the second phase of her professional life was more independent of her teachers.

*Literature:* M. Elliott; M. Hoppin, *The Emmets: a family of women painters*, The Berkshire Mus., Pittsfield, Mass., 1982; W.S. Sparrow; Tufts, 1987; Weimann.

# SHONNARD, Eugenie Frederica (1886–?)

*American sculptor of animals, birds and Pueblo Indians*

Born in Yonkers, New York, she studied painting at the New York School of Design for Women under Alphonse Mucha. Although she won several prizes, it was an accidental encounter with clay which revealed her true medium. After a period of study at the Art Students' League, New York, Shonnard was even more determined to continue with sculpture. With her now widowed mother she settled in Paris in 1911 and, through Mucha, Shonnard was able to receive advice from Rodin. She also attended Bourdelle's class, and exhibited at the French salons from 1912 to 1923, although she spent the duration of the war in New York. While in France she stayed several summers in Brittany, where she carved figures of stoical peasants in broad simplified blocks, the forerunners of her Pueblo Indian figures. She soon adopt-

ed animals and birds for her chief subject in the earlier part of her career, carving in stone and wood, with some being cast in bronze. A particular speciality were the wading birds such as herons, although she was also commissioned to portray the gorilla in the New York zoo. In 1926 an invitation to New Mexico resulted in her settling there the following year. During the 1930s she carried out a number of government commissions, as well as an increasing number of private architectural sculpture works. The largest of these was the complete interior of a private chapel in Black Forest, Colorado, on which she had only the assistance of a carpenter and her (untrained) husband, whom she had married in 1933. To help with this kind of project, she invented a material called keenstone, which behaved like sandstone but was much lighter and less expensive. The largest part of her later works consists of representation of the Pueblo Indians. With the ability to match material to subject and technique, Shonnard endowed these figures with a monumental quality while retaining their essential dignity. Over the years she won many awards, received a great many commissions and was elected a member of the National Sculpture Society, the Société Nationale des Beaux-Arts and of the Salon d'Automne.

*Examples:* Presbyterian Hospital, Albuquerque, NM; Brookgreen Gardens, SC; Brooklyn Mus., New York; Art Institute, Chicago; Cleveland, Ohio; Fine Art Center, Colorado Springs; Metropolitan Mus., Whitney Mus. and MOMA, New York; Pennsylvania Academy of Fine Arts, Philadelphia; Jardin des Plantes, Paris; St Michael's church, Santa Fe.

*Literature:* E. Bell, 'The sculpture of ES', *American artist*, v30, June 1966, 62–7, 86–9; *An exhibition of sculpture by ES*, Mus. of New Mexico, Santa Fe, 1954; Proske, 1968; P. Walter, 'ES', *American Mag. of Art*, v19, Oct. 1928, 549–56; *Who's Who in American Art*.

# SHORE, Henrietta (1880–1963)

*Canadian-born painter of figures, landscapes and abstract works who lived in America*

Before World War II, Shore was more highly esteemed than Georgia O'Keeffe (*q.v.*) and Edward Weston. As a woman modernist dealing with landscape, shells and plant forms in a symbolic way, Shore and O'Keeffe both suffered from the

Freudian and patronising reviews of contemporary critics, notably in the 1920s. Born in Toronto, she was the seventh and last child in her family. Her mother supported her early artistic ambition and Shore enrolled in the classes of Laura Muntz. The traditional nature of Canadian art at this time is evident from her early dark-toned genre works. From 1900, Shore spent at least half of each year in New York, where she attended the Art Students' League. She was initially taught by William Merrit Chase, but in 1902 her teacher became Robert Henri, from whom she inherited the view of art as a vital and ongoing process. Some time before 1912 she paid two visits to Europe, studying at Heatherley's Art School in London, and also painting in Holland. By her mid-twenties she was participating in international exhibitions of Canadian art at the invitation of the government. Emigrating to California in 1913, she became an American citizen in 1921. She quickly established a reputation with her strong colour, lively brushwork, and rhythmical line, winning a medal in the Panama-Pacific Exposition of 1915. The two elements of brushwork and line struggle for supremacy at this time, but after settling in New York in 1920, it was a classicising line which emerged as the dominant feature, supported by flatter areas of vibrant colour. During her three years in New York she also produced numerous semi-abstract works, with symbolic titles such as *Source* and *The unfolding of life*, which evoke basic life-forces. After several major solo shows, Shore returned to Los Angeles with an apparently unassailable reputation. In 1927 she met Edward Weston, the modernist photographer, whose diaries and letters form an important source for Shore's later work, for they became good friends. Her paintings and drawings from the later 1920s are of simpified landscapes, particularly with rock formations, shells and desert plants. Eliminating details, she incorporated a sense of rhythm into the arrangment of mass and colour. In 1930 she moved for the last time to the artist colony of Carmel on the coast of California. During the next ten years she was actively teaching and painting, while six murals painted under the auspices of the Treasury Art Relief Project in 1936–7 provided her with much-needed income. She exhibited little after 1933 and was very poor in her later years. Attempting to reconcile herself to this she turned to religion. In the late 1950s she was put into a mental asylum, although the grounds for this are uncertain.

*Examples:* Monterey, Calif.

*Literature:* R. Aikin, *HS*, Monterey Peninsula

**Henrietta Shore** *Two leaves*, oil on canvas, 83 × 52.5 cm, courtesy of ACA Galleries, New York. (photo: P. Dunford)

Mus. of Art, 1986; A. Wolf, *New York Society of Women Artists 1925*, ACA G, New York, 1987.

## SIDDAL, Elizabeth Eleanor. (alt. SIDDALL) (1829–62)

*English painter of medieval and literary subjects; also a poet*

Born in London, she was the third of eight children of a Yorkshire-born retail ironmonger. She was apprenticed to a milliner, probably at the normal age of 13, and in 1849, by which time she was a qualified assistant milliner, she was introduced into the circle of Pre-Raphaelite painters through either Deverell, William Holman Hunt or William Allingham, becoming a model for several of them. Late in 1851 she posed for the first time for Gabriel Rossetti. It was in 1852 that she felt sufficiently confident to begin drawing, an occupation

from which 'her gender, class and occupation all tended to exclude her'. Gabriel took her wish seriously and gave her tuition. Her earliest work from 1852 is lost, but Gabriel's drawings of 1853 show her as simultaneously both model and artist, depicted drawing at her own easel. Her determination to challenge current views about the role of women in society and as artists marks her out as different from the passive person that she is usually presented to have been. Although her health was not good, her painting progressed steadily in the mid-1850s, and in 1855 John Ruskin purchased at least 12 of her works. He then proposed paying her £150 a year, enough to keep one person in comfort, for everything she produced. Siddal initially rejected this in favour of selling her work independently, but Gabriel persuaded her to accept. She subsequently discovered that Ruskin felt that his position as patron allowed him to proffer advice, not only on art, but also on her lifestyle; this she successfully resisted. Later that year she went to Paris and the Riviera for six months with a Rossetti relative, for Siddal's allowance from Ruskin gave her considerable independence. In April 1857 her work was shown in public for the first time at a small private Pre-Raphaelite exhibition organised by Ford Madox Brown. She received favourable comments and the sale of a work encouraged her to give up Ruskin's allowance. Her relationship with Gabriel, never straghtforward, was effectively broken for two years from May 1858. In July 1859 her father died, leaving her mother with two sons under 20 and four unmarried daughters, together with the ironmongery business. During this period her addiction to laudanum became particularly acute and in April 1860, when she was seriously ill in Hastings, her relations called Gabriel. Believing her to be dying, he promised to marry her if she recovered. She did, at least to a certain extent, and they were married in May, travelling to Paris afterwards. On their return, she was still actively painting and Gabriel promoted her work. Her first pregnancy ended in a still birth early in May 1861. Later that year, after she became pregnant again, Rossetti tried to curb her intake of the opiate. She died on 2 February 1862, probably from an overdose of the drug. The recurrent themes in her work of the 1850s were literary examples of suffering, fear of separation and death. Siddal's critical history has been obscured by her relationship with Rossetti and the emphasis given by historians to the male Pre-Raphaelites.

*Examples:* Fitzwilliam Mus., Cambridge; Tate G, London; Ashmolean Mus., Oxford.

*Literature:* Bachmann; D. Cherry & G. Pollock, 'Woman as sign in Pre-Raphaelite literature', *Art History*, v7/2, 1984, 206–27; W. Fredeman, *Pre-Raphaelitism: a bibliocritical study*, Cambridge, Mass., 1965 (bibl.); Harris; J. Marsh, *Pre-Raphaelite sisterhood*, London, 1985; E. Shefer, 'ES's *Lady of Shalott*', *WAJ*, v9/1, spring-summer 1988, 21–9.

## SITTER, Inger (1929–)

*Norwegian painter and printmaker*

Her studies began in her native Trondheim at the age of only 14, when she was taught by Stabell, and two years later she enrolled at the Academy in Oslo. From 1946 to 1949 she worked in Antwerp at the Institut Supérieur des Beaux-Arts, spending two months in Paris with André Lhote in 1948. Although she then began exhibiting, she spent time abroad in France, Italy and Spain in order to further her painting. She has participated in many exhibitions in European countries with both paintings and prints and has served on the governing bodies of several artistic organisations.

*Literature: Illustrert Norsk Kunstnerleksikon*, Oslo, 1956.

## SJOO, Monica (1938–)

*Swedish-born spiritual feminist artist and writer now working in Wales*

The daughter of two artists, she learnt at first hand the problems of artists' wives. Leaving school at 16, she has had no formal art training. While touring Europe with a female friend, she worked, *inter alia*, as an artist's model in Paris, became pregnant by someone from Bristol, married him and settled in that city, later having two further children. In 1968 she produced a large painting entitled *God giving birth*, which resulted from her increasing fascination with matriarchy. This painting has been banned from exhibitions in 1970, 1973 and 1980. Since the late 1960s she has been actively involved in various aspects of the women's movement. Through matriarchy she pursued ideas about female experiences, including childbirth, bisexuality, menstrual creativity and the great goddess, evolving rituals in performances as well as paintings. She has contributed articles to a variety of journals and has written two books. She

has exhibited many times but particularly in all women groups in both Britain and Sweden.

*Literature:* R. Parker & G. Pollock, *Framing feminism*, London, 1987; M. Vincentelli, 'Interview with MS', *Link: newsheet of the association of artists and designers of Wales*, July–Aug. 1985, n.p.

## SLAVONA, Maria. (pseud. of Maria Dorette Caroline SCHORER) (1865–1931)

*German Impressionist portrait, landscape and still life painter*

One of six children, she was born in Lübeck. Her father took the enlightened view that there was no reason why women should not become professional artists, so in 1882 she began her artistic education at Eichler's private art school in Berlin. In 1886 she spent some months at the school of the Kunstgewerbemuseums, before proceeding in 1887 to the Women's Art School in Berlin. It was there that her tutor, Carl Staufer-Bern, coined her pseudonym. The following year she set up her studio in Munich, although she also enrolled at the Women's Art School there and became a private pupil of Käthe Kollwitz (*q.v.*). During a holiday in Lübeck she met the Danish artist, Wilhelm Petersen, and they resolved to go to Paris. Arriving in 1890 she witnessed modernist art exhibitions, but also had personal and financial problems. Despite the birth of a child, she continued to work, and from 1891 her paintings show evidence of her contact with Impressionism, in part through her friendship with Camille Pissarro. She began to exhibit in 1893, albeit under a male pseudonym–Carl-Maria Plavona. In 1900 she married the Swiss collector, Otto Ackermann, and their house in Paris became a centre for German artists visiting Paris until she returned to Lübeck in 1906, before settling in Berlin in 1909 for the rest of her life. She had previously been a Corresponding Member of the Berlin Secession and was able to establish her career again, exhibiting with other German Impressionists such as Max Liebermann. Many of her paintings depict city scenes of unpretentious suburbs. She did not attempt to capture fleeting effects of weather, but contrasted more tightly painted areas of canvas with others which were more freely handled.

*Examples:* Nat. G., SMPK, Berlin; Düsseldorf; Kiel; Leipzig; Lübeck.

*Literature:* M. Bröhan, *MS, 1865–1931: eine deutsche Impressionistin*, Lübeck & Berlin, 1981 (bibl.); *Das Verborgene Museum*; Krichbaum; *Lexikon der Frau*.

## SLEIGH, Sylvia (*c.* 1935–)

*English-born painter of male nudes and female portraits who works in America*

Born in Brighton, Sussex, Sleigh trained at the School at Art there. Depressed by the reaction of her male tutors to her work she abandoned painting for a while, but resumed it on the advice of a doctor. While continuing to paint in total obscurity she met critic Lawrence Alloway during art history evening classes at the National Gallery, London. After their marriage, she settled in New York and had her first solo show in America in 1963. Around 1970 she came into contact with Nancy Spero (*q.v.*) and May Stevens (*q.v.*), and through them became involved in the women's art movement and the campaigns for greater representation in establishment shows and commercial galleries. This sense of sisterhood resulted in a series of parodies of famous European paintings of the nude, in which she replaced the female figure with that of a male. *Philip Golub reclining* is a reversal of Velasquez' *Rokeby Venus*, but with subtle differences. Sleigh never reduces her male models to the generalised flesh of the stereotypical female. They remain highly individualised, down to the detailed patterns of body-hair. Nevertheless, many were shocked by these reversals. From the mid-1970s, Sleigh painted a series of individual portraits of women whom she knew, mostly involved in art as practitioners, critics or historians, and her involvement in the women's galleries of AIR, and later SOHO 20, resulted in group portraits of each. Through feminist networks, Sleigh was one of the contributors to the *Sister Chapel* project of 1977–8, in which 11 artists depicted a role model from the past; Sleigh's choice was Lilith. To accompany her figures there are frequently patterned rugs, fabrics and other items rendered with the attention to detail which explains her admiration for the Pre-Raphaelites.

*Literature:* L. Nochlin, 'Some women realists', *Arts Mag.*, v48/8, May 1974, 29–33; Rubinstein; J. Semmel & A. Kingsley, 'Sexual imagery in women's art', *WAJ*, v1/1, spring–summer 1980, 1–6; L. Tickner, 'The body politic: female sexuality and women artists since 1970', *Art History*, v1/2, June 1978, 236–49; V. Tatransky, 'SS', *Arts Mag.*, Sept. 1983, 40–1.

**Sylvia Sleigh** *Bibi Lencek: #17 women artists' series*, 1985, oil on canvas, 91.3 × 61 cm, collection of the artist. (photo: Geoffrey Clements)

## SMITH, Jessie Willcox (1863–1935)

*American illustrator for magazine and children's books*

The American equivalent of Kate Greenaway (*q.v.*) in her depiction of idealised children, Smith came to a career in art by accident at the age of 17. She spent most of her life in Philadelphia and trained in three of its institutions: the School of Design for Women, then briefly at the Pennsylvania Academy under Thomas Eakins and finally from 1894 under Howard Pyle at the Drexel Institute. It was there that she met two lifelong friends, Violet Oakley (*q.v.*) and Elizabeth Shippen Green, who together formed a supportive household for many years (see under Oakley). By the time she began studying with Pyle, Smith was already executing advertisements and other commercial contracts which enabled her to support herself and, through Pyle, she was able to obtain others. She collaborated with Oakley on an edition of Longfellow's poem *Evangeline* (1897), although she is better known for her illustrations to Charles Kingsley's *Water babies* (1917). She exhibited at the Pennsylvania Academy for almost 50 years, in addition to the Plastic Club (see under Sartain), several of the major expositions and elsewhere, receiving many awards. In 1917 she executed the first of over 200 covers for *Good Housekeeping* magazine, in which she excelled in 'upholding the values of the American home'. Although famous for her illustrations, she also executed portraits, principally of children and families.

*Literature:* Bachmann; P. Likos, 'The ladies of the Red Rose', *FAJ*, v5, fall 1976, 11–15; B. Mahoney & E. Whitney, *Contemporary illustrators of children's books*, Boston, 1930; Rubinstein; *Women artists in the Howard Pyle tradition*, Brandywine River Mus., Chadds Ford, Pa., 1975.

## SNYDER, Joan (1940–)

*American abstract painter whose collages contain symbolic imagery, often arising from her feminism; also a printmaker*

Born in Highland Park, New Jersey, she graduated with a BA and MFA (1966) from Douglass College, Rutgers University. During the following years in New York, she worked in an Abstract Expressionist mode. Around 1971–4 she became involved in the women's art movement, which for her focused on the fact that the all-male staff at Rutgers would not allow women artists to show in the gallery. Snyder organized a series of exhibits by women in the library and the associated debates attracted great support. Her reactions to these events first appeared in *Symphony for women I* in 1974, the year in which she married a photographer and moved to rural Pennsylvania. The following year saw the beginning of the appearance of slits, sometimes with moulded papier-mâché edges, gauze, valentines and dripping thread and paint. It has been suggested that these are symbolic of female sexual experiences, with the slits resembling the vagina. There is no anecdotal content and compositional considerations dictate the arrangement of the elements over the richly textured surface, often with a grid format as the background. The variation in her works between formalist and expressionist styles arose from her questioning the need for structure in art, when there seemed so little of it in life. She separated from her husband and returned to live in New York with her daughter. Her prints also explore the material qualities of processes, aiming to create a tactile surface. For her imagery she draws in part on African and Pre-Columbian imagery and mythology. She believes in the existence of a female sensibility which can manifest itself through a range of processes and media.

*Examples:* MOMA, New York.

*Literature: Graphic Muse*; H. Herrera, *JS: seven years of work*, Neuberger Mus., State University of New York, Purchase, NY, 1978; R. Iskin, 'Towards a feminist imperative: the art of JS', *Chrysalis*, v1/1, 1977, 101–15; Petersen; Rubinstein.

## SOLOMON, Rebecca (1832–86)

*English painter of literary and other figure subjects in oil and watercolour*

The seventh of eight children, she was born in London. It is known that her mother was a capable amateur artist when time allowed. Rebecca Solomon's critical history has suffered from several factors; she is dismissed as having produced only one successful painting and as having succumbed to alcohol. Nunn has proved that her exhibiting record spanned 24 years (1850–74), not only in London but also in the provinces. In addition, in the late fifties and early sixties she produced a number of paintings, all of which were favourably reviewed and a number were engraved in art magazines. Critics particularly noticed those in which

a moral contrast forms the basic subject, although this may appear in the guise of a period anecdote as well as a contemporary life setting. Apart from a period of unknown date and duration at the Spitalfields School of Design, she was taught by her brother, Abraham, ten years her senior. In order to supplement the income from her paintings of a range of fashionable themes in the mid-fifties, she also copied old-master paintings on commission and produced copies of paintings by contemporaries such as Millais, Frith and Faed for which she, like all others who performed such tasks, received no credit. For the same reason, by the mid-sixties when she had lost her home on the death of Abraham in 1862, she was producing illustrations for magazines, as well as a number of portraits. She made at least two visits to the continent, each of which resulted in a number of figure paintings with French or Italian subjects. She remained close to her youngest brother Simeon, and although they mixed in the same social circles and acquired an increasing reputation for wild parties, Rebecca maintained an observance of Jewish customs, which her brother largely ignored. Nevertheless she would have been increasingly frustrated by the critics' assessment of her work only in relation to that of Simeon. Her brother's trial on a charge of homosexuality in 1873 brought about not only his own social downfall, but also contributed to a very large extent to the end of his sister's exhibiting career. From 1874 until her death in 1886, nothing more is known of her. The allegations of alcoholism, deriving from memoirs of a contemporary published in 1919, are not based on conclusive evidence but have been repeated without investigation.

*Examples:* British Library, British Mus. and Geffrye Mus. London.

*Literature:* A. Baldwin, *The MacDonald sisters*, London, 1962; Clayton; *DNB*; Nottingham, 1982; P. Nunn, 'RS: painting and drama', *Theatrephile*, v8, 1985; P. Nunn, *Victorian women artists*, London, 1987; P. Nunn, 'RS's *A young teacher*', *Burlington Mag.*, Oct. 1988, 769–70; *Solomon: a family of painters*, Geffrye Mus., London, 1985, essay on RS by P. Nunn (bibl.); Wood, 1978.

## SONREL, Elizabeth (1874–1953)

*French painter of literary and figure subjects, often with mystical feeling, as well as landscapes*

The daughter of the Tours painter, Stéphane Sonrel, she studied in the early 1890s at the Académie Julian in Paris under Lefebvre. She exhibited at the Salon from 1893, as well as in the provinces and Liverpool (1924–5), winning, *inter alia*, a medal at the Paris Exposition of 1900. In the earlier part of her career Sonrel produced large oils and watercolours of women and children, with mythological or allegorical themes. She has often been associated with Symbolism but her work contains mystical rather than symbolic elements. It is reminiscent of Botticelli and some aspects of Pre-Raphaelite painting. After 1900 she turned to the depiction of Breton landscapes and portraits.

*Examples:* Mulhouse.

*Literature:* Edouard-Joseph; Krichbaum; W.S. Sparrow; *Symbolist painting*, Hayward G, London, 1972, Yeldham.

**Elizabeth Sonrel** *Musique*, oil on canvas, 96.5 × 122 cm, private collection. (photo: courtesy of Whitford and Hughes, London)

## SOUTER, Camille. née Betty Pamela HOLMES (1929–)

*English-born painter of semi-abstract landscapes and still lifes, as well as completely abstract works, who lives in Ireland*

Her English parents moved from Northampton to Ireland the year after her birth. Initially intending to become a nurse, Holmes began her training at Guy's Hospital, London in 1948 but was soon struck down with tuberculosis. While recuperating she adopted the name Camille and took up painting seriously, deciding to abandon nursing. Details about her early life are sparse and contradictory. One source indicates that she began as a sculptor, but after a visit to Italy turned to

painting, while another suggests that when she painted during her convalescence she was taking up something she had already practised. No information is given about any training. In the late 1950s her work, along with that of many other Irish painters, became fashionably abstract in an active calligraphic style, although always on a small scale. During the 1960s her work hovered on the boundaries of abstraction, with landscapes – particularly canal scenes – and still lifes all reduced to bare essentials. Her colours are usually muted but with judicious use of small areas of red. In more recent years she has delighted in painting aircraft. In 1951 she married an actor, Gordon Souter, had children, and married again in 1960. After being widowed in 1971 she divides her time between Dublin and Achill Island. Although she has participated in many group shows since the 1950s and her work has many private collectors, she has had relatively few solo shows.

*Examples:* Belfast; Crawford; Hugh Lane Municipal G, Dublin.

*Literature: Irish women artists*; CS, Hugh Lane G, Dublin, 1986.

## SPARKES, Catherine Adelaide. née EDWARDS (1842–after 1891)

*English painter of genre, illustrator and china designer and painter*

Born in Lambeth, she was the sixth daughter of a gifted musician, her father being a piano maker. After a childhood spent out of London until 1854, she started three years of drawing lessons from John O'Connor in 1856. In 1858 she began also to attend the South Kensington Schools. During her four years there she won at least seven prizes. She persisted with her studies by frequenting the Lambeth School of Art and became a student at the RA Schools in 1863. There she won further awards and successfully supplemented her income by producing illustrations and drawings on wood for books and magazines. She ended her studies there only on her marriage in 1868 to John Sparkes, principal of the Lambeth School of Art and founder and director of the Lambeth Pottery. Although she exhibited her paintings from 1866 to 1890, by 1872 she had been drawn into the pottery business by her husband. She painted large scenes on tiles and her contribution to the 1872 Kensington Exhibition was bought by Doultons, who then commissioned many figure paintings on china and tiles from her. In 1875–6 she worked on an

11-metre-long tile picture of the Pilgrim Fathers for the Philadelphia Centennial Exposition. John Sparkes drew not only his wife into designing for the pottery but also several other women pupils from the Lambeth School of Art. Despite her obvious success in this sphere, Catherine Sparkes seems to have wanted to preserve her identity as a painter, where she was less anonymous than as a designer and less closely identified with her husband.

*Examples:* Nottingham.

*Literature:* A. Callen, *The Angel in the studio*, London, 1979; Clayton; Mallalieu; Wood, 1978.

## SPARTALI, M. See STILLMAN, Maria

## SPENCER, Lilly. née Angelique Marie MARTIN (1822–1902)

*American painter of domestic genre and portraits*

The oldest of four children, Lilly Martin was born in Exeter, Devon, where her French parents lived until she was eight. They emigrated to America and eventually settled on a farm near Marietta, Ohio, her father teaching French at the local college. Martin's parents were highly educated, teaching their children themselves, and liberal, working in various co-operative societies and reform movements. Her parents believed in women's rights and her mother corresponded with leading figures in the movement. They recognised their daughter's artistic talent, sending her to classes during their two-year sojourn in New York (1830–2). It was her portraits of the family on the plaster walls of their home which attracted attention, bringing the advice of two local artists. Refusing a patron's offer to send her to study on the east coast and in Europe, she settled in Cincinnati, an active centre of art at the time. Her training was therefore minimal, and is revealed in her paintings by the lack of proportion in some of her early figures. Through several difficult years, she endeavoured to establish herself with the active help of her father, and by 1846 she had acquired a reputation for her genre paintings and portraits. In 1844 she married Benjamin Spencer, a failed businessman from England, who took over all the domestic side of their life, for they had 13 children, of whom seven lived to adulthood. He also assisted Lilly Spencer with building frames, and seeing to the financial side of the business. At times he even filled in

some of the backgrounds for her. In this way she was able to produce an enormous number of paintings, in which her husband and children often featured as models. This high rate of production was necessary since she was the principal source of the family income. In 1848 the Spencers moved to New York, where Lilly Spencer exhibited successfully and the first of many engravings of her paintings was published in 1849, with over one million coloured lithographs and etchings by her being published. From this she received no income other than the purchase price of the painting. In 1858 she and her family moved to Newark, New Jersey. Her popularity declined from the 1870s and she did not exhibit after 1876, although portrait commissions continued to keep her busy. A widow from 1890, she moved back to New York in 1900 and once more enlarged her clientele. An astonishingly prolific and tireless artist, her paintings vary in their finish according to their audience. The necessity of producing 'pot-boilers', as she called them, was the cause of this. She died after spending a morning at her easel.

*Examples:* Newark NJ; NMWA and Smithsonian Inst., Washington, DC.

*Literature:* Bachmann; R. Bolton-Smith & W. Truettner, *LMS (1822–1902): the joys of sentiment*, Washington, DC, 1973; Fine, 1978; E. Freivogel, 'LMS; feminist without politics', *Archives of American Art J*, v12/4, 1972, 9–14; Harris; Heller; NMWA catalogue; *Notable American Women*; Rubinstein; Tufts, 1987; Withers, 1979.

## SPERO, Nancy (1926–)

*American feminist artist who produces long scrolls of painted, printed and collaged motifs dealing with mythological and historical episodes involving women*

Now recognised as one of the major artists exploring feminist imagery, Spero spent many years working in relative isolation on the periphery of the mainstream. Born in Cleveland, Ohio, she gained her BFA from the Art Institute, Chicago. The following year was spent in Paris at the École des Beaux-Arts and with André Lhote. After her marriage to artist Leon Golub in 1951, they settled in Chicago, where Spero had two sons, in 1953 and 1954. While they were living in Paris from 1959 to 1964, a third son was born. Her earlier images of mothers and children and fantasy subjects based on the Tarot cards came together in the Black paintings, in which vaguely outlined forms

emerged from a black expressionist ground. Back in America, Spero stopped painting in 1966 to become involved in artists' protests against the Vietnam war. Through dissatisfaction at the male dominance of this, she was one of a number of women who broke away to form the Art Workers Coalition in 1968. From this time on she was actively involved in feminist art groups, campaigns and demonstrations for much of the 1970s. She first used the scroll format to explore themes of violence and anger at her own political impotence as an artist in the *Codex Artaud* (1970–1). More specifically, an Amnesty International report triggered her scrolls *Torture in Chile* and *Hours of the night* (1974–6), which focused on brutality towards women, resulting in the decision to concentrate all her future work on women. A founder member of the AIR co-operative gallery, she exhibited in many women's shows throughout America and Europe. Her early scrolls include text in the collage, but this has almost entirely disappeared since 1980. Her later work has become less austere, with the introduction of bright colours and with figures often leaping and dancing across the paper. Positive images of women, including references to goddesses now predominate. Through the devices of fragmentation, repetition and overlaying of images, Spero draws attention to the process of representation and to her investigation of themes which concern both men and women by using only women. It is only since 1980 that her work has consistently been shown in establishment settings, and a major retrospective was held in London in 1987.

*Literature:* J. Bird and L. Tickner, *NS*, ICA, London, 1987 (full bibl.); L. Lippard, *Issue; social strategies by women artists*, ICA, London, 1980.

## SQUIRE, Maud Hunt (1873–*c.* 1955)

*American painter, printmaker and illustrator*

A native of Cincinnati, she attended the Art Academy there from 1894 to 1898. There she met Ethel Mars (*q.v.*), who was to be her lifelong companion. They moved to New York in 1900 and went to Europe three years later. Their transformation from a conventional appearance to something far more radical within a short time of arriving in Paris has been documented by Anne Goldthwaite (*q.v.*). They mixed in Gertrude Stein's circle and formed the basis of her short story, *Miss Furr and Miss Skeene*. The effect of Paris on Squire's

artistic style is most clearly seen in her prints, notably in etching, aquatint and colour drypoint. The fresh colours applied in broad flat areas appear like watercolour washes. Forced to return to America by the outbreak of war, Squire and Mars joined the expanding art community in Provincetown in 1915 and participated in the renaissance of the print, which took place there in the following years. In addition to exhibiting at the Panama-Pacific Exposition in 1915 and at Provincetown, Squire also illustrated children's books. When the opportunity arose, Squire and Mars returned to France, settling at Vence where, apart from European travel, they lived for the rest of their lives. Squire exhibited in Paris and became a member of the Société des Dessinateurs et des Humoristes.

*Examples:* Boston; Detroit.

*Literature:* E. Clark, *Ohio art and artists*, Richmond, Va., 1932; J. Flint, *Provincetown printers*, NMAA, Washington, DC, 1983.

## STANNARD, Eloise Harriet (1828–1915)

*English painter of fruit and flowers*

A member of the Norwich family of painters, of which the men were landscape painters, Eloise Stannard devoted herself to a more traditionally female subject matter. In this she may have been influenced by the example of her aunt, Emily Stannard (*q.v.*) as well as by the fact that still life both obviated the need to find a chaperone in order to sketch out of doors and also found a ready market. Eloise Stannard suffered from a heart weakness which made her unable to endure working in the open air. She trained with her father and by 1852 she was exhibiting in London. She must have established her reputation from showing in Norwich before this, for in the same year she was invited by the committee of the Female School of Art to act as a judge for the award of the Queen's Gold Medal, an honour she was unable to accept because of ill-health. In all, her exhibiting career lasted over 50 years and her success can be demonstrated by the consistent sale of all her works shown at the RA, and from the fact that she was the third most popular woman artist patronised by Art-Union prizewinners. She exhibited with and was elected member of the SWA. A newspaper photograph of 1910 shows her still painting at the age of 82.

*Examples:* Norwich.

*Literature: AJ*, 1859, 170; D. Cherry, *Painting women; Victorian women artists*, Art G, Rochdale, 1987; Clayton; W.F. Dilkes, *The Norwich School of Painting*, London, 1969, vIII, 207–21; Nottingham, 1982; P. Nunn, *Victorian women artists*, London, 1987.

## STANNARD, Emily. (née COPPIN) (1803–85)

*English painter of fruit and flowers*

Born in Norwich, she trained with her father Daniel Coppin, and also visited Holland to copy paintings. Like many other women artists, her mother was an active amateur painter. She married the marine painter, Joseph Stannard, a member of the Norwich family of painters, and had a daughter in 1827. Three years later her husband died and she continued to exhibit actively until her death, a total exhibiting career of 69 years. Her precisely rendered pictures of flowers and fruit reflect the influence of Dutch painting, knowledge of which she gained through visiting the country as the result of winning an award. Her daughter, Emily, became an artist.

*Examples:* Norwich.

*Literature:* Clayton; *DNB*; Nottingham, 1982; Wood, 1978.

## STARR, Louisa. (alt. CANZIANI) (1845–1909)

*English painter of historical, literary and genre scenes, as well as portraits*

The only child of an American merchant and banker, Starr did not need to take up a profession for financial reasons. Nevertheless, an early interest in drawing made her reluctant parents allow her to draw from antique sculpture in the British Museum at the age of 14. Amiable, talented and diligent, she received considerable help from other students there, until in 1864 she succeeded in gaining admission to the RA Schools in the third intake of women students. In 1867 she became the first female student there to win the coveted gold medal and she exhibited regularly at the RA and other venues. Starr spent the year following her

success in Italy, staying with relatives, and during that year became engaged to her cousin, Enrico Canziani, an engineer, who agreed to live in London so that Starr could continue to practise as an artist after their marriage in 1882. Both partners had unusually modern ideas about marriage for the time and Starr omitted the promise to obey from the ceremony. From their London house, Starr continued to paint prolifically and with considerable success. A number of her genre scenes showed her great sympathy for women struggling to earn a living, and throughout her life she worked actively for several causes, most notably dress reform and the Royal Society for the Protection of Birds (founded 1889). Her only daughter, Estella (*q.v.*), was born in 1886. The two enjoyed a close relationship and, in the absence of Enrico Canziani in Italy for both work and the care of his invalid mother, Starr's influence on her daughter was paramount. Always popular with others as well as a forceful and dynamic person, she was elected president of the Art Section of the International Congress of Women in 1889. Although she produced a large number of paintings, relatively few are known today.

*Examples:* Birmingham; WAG, Liverpool; Nat. Portrait G, London.

*Literature:* E. Canziani, *Round about Three Palace Green*, London, 1939; Clayton; P. Nunn, *Canvassing*, London, 1986; P. Nunn, *Victorian women artists*, Lonon, 1987; Sellars; W.S. Sparrow; Yeldham.

# STEBBINS, Emma (1815–82)

*American painter and sculptor of neo-classical figurative works*

The oldest of the group of women sculptors described by Henry James as the white marmorean flock, Stebbins was born in New York, the sixth of nine children of a financial broker and bank president. Encouraged by her parents, she drew much as a child, later receiving tuition from Henry Inman, a leading portrait painter. In 1843 she was elected an Associate of the NAD as an amateur, only deciding to make art her profession in 1856. The following year she travelled to Rome, where she was inspired to turn to sculpture by her friend Harriet Hosmer (*q.v.*). She studied with various sculptors and completed her first commission in 1859. While in Rome she met Hosmer's sponsor, the actress Charlotte Cushman, who became her lifelong companion. To Hosmer's chagrin, Cushman used her influence to gain for Stebbins the

commission for the statue of the educator Horace Mann, to be placed in front of the Statehouse in Boston. Stebbins' best-known work is the *Angel of the Waters* fountain in New York's Central Park, which was universally admired at its installation in 1873. Cushman and Stebbins returned to New York in 1870, but spent most of the time until Cushman's death in 1876 in the actress' house in Newport, Rhode Island. Thereafter Stebbins edited her letters and wrote a biography of her.

*Examples:* Statehouse, Boston; Civic Center, Brooklyn (Columbus); Heckscher Mus., Huntington, NY; Central Park, New York.

*Literature:* Bachmann; Clement; E. Ellet, *Women artists in all ages and countries*, 1859; A. Faxon & S. Moore, *Pilgrims and pioneers*, New York, 1987; W. Gerdts, *The white marmorean flock*, Vassar Coll. G, Poughkeepsie, 1972; Heller; *Notable American Women*; Rubinstein.

# STEIR, Pat (1940–)

*American painter who combines abstract and figurative imagery*

Born in Newark, NJ, she was brought up in a suburb of Philadelphia. At the age of 16 she decided, rather suddenly, to enrol at Brooklyn School of Art, where she studied both painting and graphics. On her marriage she followed her husband to Cambridge, Massachusetts, and attended the fine art course at Boston University, where she was particularly impressed by fellow student, Brice Marden, whose work contained an emphasis on painterliness, which was unfashionable at the time. Her paintings from the early 1960s were figurative, but from the later years of that decade come her first mature pieces, images of dog-men combined with an area of paint. After this, figures rarely appear in her works, although common motifs are birds and flowers. During this period Steir separated from her husband, but kept his name, and worked in a number of jobs, particularly in book design and production, until she felt the moment was right for her to put more time into painting. In 1970–1 begins a series of paintings which are basically autobiographical, but which are also about the process of painting, and are an equivalent to reality. These paintings derive from a repertoire of diagrams, graphs, numbers, words and phrases, abstract markings, paint drips and large painted areas, and recurring motifs are water, sky, and mountains. A visit to Agnes Martin (*q.v.*) in New Mexico was influential. Some images are

crossed out, not concealed, in the way that mistakes in life can never be erased. From 1975 to 1977 she produced only drawings, and her return to painting was marked by a change of direction. The square within a square motif and the heavily framed image which she adopted came from her extensive and experimental work in etching and lithography. In 1982 she was the first artist to participate in the Crown Point Press woodcut project in Kyoto, Japan, and the influence in particular of Hiroshige's prints remained with her. Gradually two or three square canvases came together in a triptych format, each containing a different view of an object, often a flower. In due course, this fused with some earlier paintings in which she had imitated the styles of different artists from the past, so that in the mid-1980s she has imposed a grid format on a subject, such as a vase of flowers, and in each square is painted an appropriate image in the style of a different artist. These works she entitles *Vanitas* paintings. This deprives the spectator of the unified image and is another of her methods of drawing attention to the medium itself. After several years of predominantly flower-based imagery, she moved into abstraction with circular paintings reminiscent of views from a satellite of eddying clouds around earth. After spending many years in New York, Steir now works also in Amsterdam. She has exhibited extensively in many countries as both printmaker and painter.

*Literature*: E. Broun, *Form, illusion, myth: prints and drawings of PS*, Spencer Mus. of Art, Lawrence, Kan., 1983 (bibl.); T. Castle, 'PS and the science of the admirable', *Artforum*, v20/9, May 1982, 47–55; *Graphic muse*; S. Greenspan, 'PS, the Breughel series (a Vanitas of style)', *Art & Auction*, v7/7, Feb. 1985, 56–9; *PS, paintings and etchings*, Crown Point G, Oakland, Calif., 1981; M. Tucker, 'PS: the thing itself, made by me', *Art in America*, v61/1, Jan.–Feb. 1973, 70–4.

## STEPANOVA, Varara Feodorovna (1894–1958)

*Soviet abstract painter and graphic designer*

Born in Kovno, Lithuania, she attended the Karzan School of Art in 1910–11, continuing her studies in Moscow from 1912 to 1914, firstly in the ateliers of Machkov and Yuon, and for the second year in the Stroganov Institute of Applied Art. During this time she earned her living by giving private lessons. She began exhibiting in 1914, and, particularly after 1918, was represented in many ex-

hibitions in the USSR and internationally. After the revolution she became deputy director of the Decorative Arts section of the Commissariat for Public Instruction, and in 1921 abandoned easel painting for less élitist forms of expression. Her involvement with various official bodies placed her in the centre of the debate about the form of the new proletarian art. Her belief in the application of art to everyday life, which she shared with her husband Rodchenko, led to her work in graphic design for publicity material, and to producing fabrics and clothes with Popova (*q.v.*). Her fabrics were predominantly geometrical, and her designs included a basic work-garment which could be adapted for different types of job. Parallel with these activities, she began producing texts which experiment both with collage, such as the book *Gaust Tschaba* (1919), and typography; in this area she extended the boundaries of Futurism's textual and typographical innovations. A major project was her designs of sets and costumes for the 1922 Meyerhold production of *Tarelkin's death*, which show her embracing Constructivist ideas. In her role as editor of the journal *Lef* during the 1920s she was able to publicise further the theories and applications of constructivism. During the 1930s she concentrated to a greater extent on graphic design, in which she now included photography, and in 1945–6 she worked as a printer for the magazine *Soviet woman*.

*Examples*: Mus. Ludwig, Cologne; Mississippi Mus. of Art, Jackson; MOMA, New York.

*Literature*: S. Barron & M. Tuchman, *The avant-garde in Russia 1910–30: new perspectives*, County Mus. of Art, Los Angeles, 1980; M. Dabrowski, *Constrasts of form*, MOMA, New York, 1985; *L'avant-garde au féminin 1910–30*, Artcurial, Paris, 1983; A. Lavrentiev, *VS: a Constructivist life*, London, 1988; *Russian women artists of the avant-garde, 1910–30*, G Gmurzynska, Cologne, 1979; A. Strausberg, 'Renaissance women in the age of technology', *Spare Rib*, no.19, 1973, 38–40; Vergine.

## STEPHENS, Alice. née BARBER (1858–1932)

*American illustrator, wood engraver and painter, the first teacher of a life class at the Philadelphia School of Design for Women*

The eighth of nine children, she was born on a farm near Salem, New Jersey, but the removal of her family to Philadelphia broadened the opportunities for her artistic training and employment.

She attended the School of Design for Women, part-time initially and full-time from 1873, although sources vary on this. She began as a wood engraver because she sought a training which would lead directly to employment. In this she was successful, for very soon her illustrations began to be published and continued to finance her while she undertook further training from 1876 to 1877 and from 1879 to 1880 at the Pennsylvania Academy under Thomas Eakins. His was the formative influence on the early part of her career, both as a painter, engraver and teacher. Such was her ability that Eakins chose Barber to engrave some of his paintings for reproduction. After leaving the Academy, Barber produced many illustrations for a variety of journals and gave lessons, but by 1886 exhaustion offered her the opportunity to travel to Europe. There she studied at the Julian and Colarossi academies, exhibited in the Salon and travelled in Italy. From 1889 to 1893 she taught the first life class at the School of Design for Women, where Emily Sartain (q.v.) was upgrading the standard of art education. In 1890 she married artist Charles Stephens, and in 1893 had her only child, a son. None of this hampered her reputation as one of the leading illustrators of the period, not only for publications, but also exhibiting widely and winning medals. During the 1890s her style broadened from the tightly drawn, cross-hatched realism deriving from Eakins. She increasingly painted out of doors in an Impressionist-based style, and the discovery of the halftone process enabled her to add colour to her illustrations. Her works became vigorous, with sweeps of movement and the dissolving of forms in light. Increasingly she depicted dramatic events. Overwork necessitated another rest-cure in Europe in 1901–2, but she resumed work until 1926.

*Examples:* Brandywine River Mus., Chadds Ford, Pa.; Pennsylvania Academy, Philadelphia; Library of Congress, Washington, DC.

*Literature:* Bachmann; A. Brown, *ABS: a pioneer woman illustrator*, Brandywine River Mus., Chadds Ford, Pa., 1984; H. Goodman, 'ABS, illustrator', *Arts Mag.*, v58, Jan. 1984, 126–9; *Notable American Women*; Rubinstein; Tufts, 1987.

## STERNE, Hedda (1916–)

*Romanian-born painter who works in New York*

Born in Bucharest, Sterne has retained the cosmopolitanism of a small European country. She has been fluent in three languages since her early teens, and her linguistic and literary interests have always played an important part in her life and fed into her art. She came from a comfortably off Jewish family where cultural life was encouraged. Early familiarity with reproductions of famous works of art and academic drawing lessons led to the study of philosphy and art history at university, but she left during the course to develop her artistic talents in Vienna. Through her compatriot Victor Brauner she exhibited with the Surrealists in Paris in 1939, and Jean Arp gave her an introduction to Peggy Guggenheim when she emigrated to New York in 1941. Through Guggenheim's gallery, where she had her first solo show, and that of Betty Parsons, where she exhibited from 1943, Sterne became involved with the groups of avant-garde European immigrants and married fellow Romanian Saul Steinberg in 1944. She was the only woman among the so-called Irascibles, who were then fighting the Metropolitan Museum of Art's conservative policies. At this time she was producing semi-abstract machine paintings, which in the 1950s became transformed into a contemplation of the mysteries of movement. This extra metaphysical dimension is a characteristic of her work. She never worried about being fashionable in terms of her style, for she shifted her visual language several times, having worked through a series in each. Her overall aim was to attempt to come to terms with the world as she knew it through her imagination. Some of her more austere works contain select arrangements of calligraphic marks, while *Diary* (1976) contains daily texts in coloured inks and pencils written in squares turned at 90 degrees so that the effect is that of a woven material. Her work of the 1980s has continued this exploration of subtle modulation of colour, line and movement.

*Literature:* D. Ashton *et al.*, *HS: forty years*, Queens Mus., Flushing Meadow, New York, 1985; Munro; Rubinstein.

## STETTHEIMER, Florine (1871–1944)

*American painter of figures, often friends and family, in a style which combines naivety and sophistication*

Born into a wealthy family of German-Jewish descent who lived in Rochester, New York, she was the fourth of five children. Deserted by their father

in childhood, Florine and her two sisters formed strong ties with each other, their mother and other female relatives. Their creativity was encouraged and Florine Stettheimer attended the Art Students' League, New York, between 1892 and 1895. During subsequent extensive European travel, she encountered the current artistic styles such as Art Nouveau, Symbolism and, later, Cubism. The experience of Diaghilev's Russian ballet in 1912 was to be of lasting influence. When she returned to New York on the outbreak of war, the sisters' artistic circle became legendary, being attended by many distinguished artists and critics. Through Florine's interest in Dada, Duchamp frequented their salon. A solo show at Knoedler's in 1916 was ignored by critics, and thereafter Stettheimer showed her works only to friends or at the unjuried Society of Independent Artists. This, however, gave her the freedom to ignore current trends and to develop an idiosyncratic style which combined bright colours with an almost oriental miniaturist's technique, with subject matter that was light-hearted, and fantastic or subtly satirical. Her delight in creating interiors led to her designing the set for the Virgil Thomson-Gertrude Stein opera, *Four saints in three acts*, in 1934. Her combination of materials such as cellophane, lace and feathers brought her to critical attention at last and inspired her to series of large-scale paintings which celebrate and satirise different parts of the city of New York. After her death from cancer, her two sisters organised a memorial exhibition at MOMA, New York.

*Publications: Crystal flowers*, New York, 1949.

*Examples:* MOMA and Metropolitan Mus., New York; Pennsylvania Academy, Philadelphia.

*Literature:* Bachmann; H. Davis, *FS*, New York, 1973; Fine, 1978; D. Graves, '"In spite of alien temperature and alien insistence": Emily Dickinson and FS', *WAJ*, v3/2, fall 1982-winter 1983, 21–7; Harris; M. Hartley, 'The paintings of FS', *Creative art*, v9, July 1931, 18–23; Heller; H. McBride, *FS*, MOMA, New York, 1946; L. Nochlin, 'FS: rococo subversive', *Art in America*, 1980, reprinted in *Women, art and power, and other essays*, New York, 1988; *Notable American Women*; Petersen; Rubinstein; *FS: an exhibition of paintings, watercolours, drawings*, Low Memorial Library, Columbia University, New York, 1973; *FS: still lifes, portraits and pageants, 1910–42*, ICA, Boston, 1980; Tufts, 1987; P. Tyler, *FS: a life in art*, New York, 1963; B. Zucker, 'Autobiography of visual poems', *Art News*, Feb. 1977, 68–73.

# STEVENS, May (1924–)

*American painter of political themes critical of various aspects of American society*

Born in Quincy, Massachusetts, she graduated from Boston College of Art in 1946. Two years later she went to New York and at the Art Students' League she met and married artist Rudolph Baranik. Shortly afterwards they went to Paris, where Baranik was studying and Stevens briefly attended the Académie Julian until her son was born. Her first political picture was exhibited there in 1951, the year of her return to New York. She taught for the next five years while establishing herself, and since then has only taught part-time. Her interest in the civil rights movement in the early 1960s resulted in her series *Freedom riders*, for which Martin Luther King Jr. wrote the catalogue introduction. Active in the anti-Vietnam war movement, Stevens evolved her *Big Daddy* image as a vehicle for criticising the imperialist, racist and sexist tendencies in American society. From 1968 the stylised figure with a phallic-shaped, bullet-like head, smug and complacent, appears in various contexts all critical of elements within American society. She avoids too much exaggeration and implies thereby the frequency with which these attitudes of self-righteousness and self-importance are encountered. With the rise of the women's movement Stevens used the same image to connote patriarchy, but she also moved on to the representation of the lives of women, both historical, mythical and contemporary. She contributed to the collaborative *Sister Chapel* project (1977), choosing to paint the Renaissance artist Artemesia Gentileschi as her role model. In 1979–80 she constructed an artist's book which considered the lives of several women, including Rosa Luxembourg and her own mother, whom she saw as crushed into literal silence and a mental home by patriarchal tradition. Critics have frequently reviled her work because its political content did not accord with the dominant aesthetic of post-war American art.

*Examples:* Allentown, Pa.; Brooklyn; Everson; Nassau; Whitney Mus., New York; San Francisco.

*Literature:* DWB; L. Lippard, *From the Center*, New York, 1976; L. Lippard, *Issue: social strategies for women artists*, ICA, London, 1980; L. Lippard, *Get the message*, New York, 1984; C. Nemser, 'Conversations with MS', *FAJ*, winter 1974–5, 4–7; Rubinstein; *Sense and sensibility in feminist art practice*, Midland Group G, Nottingham, 1982; A. Wallach, 'MS: on the stage of history', *Arts*

*Mag.*, Nov. 1978, 150–1; *Women look at women*, Muhlenberg College Center for the Arts, Allentown, 1981.

## STILLMAN, Maria. née SPARTALI (1844–1927)

*Greek painter in England of classical themes and, later, of medieval and Italian subjects*

Wealthy, talented and highly educated, Spartali has often suffered from the label of a Pre-Raphaelite follower and model. Born in London to a merchant who was also the Greek consul-general in London from 1866 to 1882, she and her sisters benefited from an extensive private education. During basic drawing instruction her ability became evident, and in 1864 she began receiving lessons from Ford Madox Brown, although one may conjecture that this was by way of compensation for her father's prohibition of her romance with Lord Ranelagh. These lessons, which lasted for some five years, were shared with Brown's daughter, Lucy (see under Rossetti), who became a close friend. When Brown first saw Spartali's work, he refused to teach her to be an amateur painter, advising her to adopt art professionally. She began exhibiting in 1867 and many of her earlier works contain female subjects from classical, and particularly Greek, literature and history, but often on the theme of love. She mixed with the Pre-Raphaelites and modelled for Brown, Rossetti and Burne-Jones, as well as for Whistler. In 1871 she married W.J. Stillman, an American journalist who helped to popularise the Pre-Raphaelite painters in America. He was a widower, with three children and little money. Her parents did not approve, but allowed the marriage to take place. In the same year she exhibited an important work, *Antigone*, and contributed a total of 89 paintings to a variety of London galleries until at least 1899. Three children were born, but Stillman could find no permanent job until 1875, when he became the Italian correspondent of *The Times*. This extended stay in Italy caused a change in her subjects. Of her medieval and Italian literary subjects one was shown at the Philadelphia Centennial in 1876. The appearance of some of her work in America from 1875 brought several portrait commissions. About this time she also began to paint flowers, both alone and in figure compositions. Her closeness to the Pre-Raphaelite circle socially and her choice of themes, which closely resembled those of Rossetti, has hindered her assessment as an artist. She was known for her rich colouring and the ability to 'fuse the emotion of her subject into its colour'. After the death of her husband in 1901 she lived with two of her stepdaughters, one of whom – Lisa – was a portrait painter; the other step-daughter – Effie – became a sculptor. Maria Stillman continued to paint for the rest of her life.

*Examples:* WAG., Liverpool; Bancroft English Pre-Raphaelite Collection, Wilmington Soc. of Fine Art, Wilmington, Del.

*Literature:* D. Cherry, *Painting women: Victorian women artists*, Art G, Rochdale, 1987; J. Christian, 'MS' *Antique Collector*, 1984/3, 42–7; Clayton; Clement; W. Fredeman, *Pre-Raphaelitism: a bibliocritical study*, Cambridge, Mass., 1965; *The last romantics: the romantic tradition in British art. Burne-Jones to Stanley Spencer*, Barbican G, London, 1989; J. Marsh, *Pre-Raphaelite Sisterhood*, London, 1985; Nottingham, 1982; Sellars; Yeldman.

## STINSON, Dilys Ann (1949–)

*American-born textile artist working in England*

Born in Proctor, Vermont, she graduated in sociology and anthropology from the University of New Mexico before going to England. There she studied at Hammersmith College of Art in 1973–4, turning to tapestry weaving at West Dean College in 1974–5. Stinson uses this technique to create predominantly abstract works in which her main concern is with texture and surface. Preliminary work takes the form of a collage of varieties of paper, which is then translated into weaving, using different kinds of fibres. In 1983 she undertook a three-month course at the Gobelins factory in France. She has exhibited in groups since 1972 and in solo shows since 1976.

*Literature: Fibreart,* Women Artists' Slide Library, London, 1985.

## STJERNSCHANTZ, Beda Maria (1867–1910)

*Finnish painter of figure subjects, often with musical themes, and predominantly melancholy*

The daughter of a railway manager, she studied from 1885–9 at the Drawing School of the Finnish

**Maria Stillman** *Madonna Pietra degli Scrovigni*, 1884, watercolour on paper, 77.1 × 58.1 cm, Walker Art Gallery, Liverpool. (photo: John Mills (Photography) Ltd)

**Beda Stjernschantz** *Everywhere a voice is calling*, 1895, oil on canvas, Ateneum Taidesmuseo, Helsinki.

Fine Art Association, followed by two years in Berndtson's atelier and one year in Paris at the Académie Colarossi. Her father died in 1886, and after this date she was almost always poor and had to provide for herself. In 1891 she began to exhibit in Finland, to which she returned in 1893. Never robust, in the late 1890s she visited Italy for some months, for reasons of health as well as art, but by 1905 she was confined to a sanatorium with tuberculosis. She committed suicide in 1910. An air of pensive melancholy pervades her work. Even when children are depicted, they are unnaturally wistful and sad, giving an air almost of mysticism to the paintings. The figures are depicted against flat backgrounds without the use of traditional perspective, and are reminiscent of Puvis de Chavannes and Gallen-Kallela.

*Examples:* Helsinki; Kokkola.

*Literature: Sieben Finnische Malerinnen,* Kunsthalle, Hamburg, 1983 (bibl.).

## STOKES, Marianne.
## née PREINDELSBERGER
## (alt. PREINDLSBERGER) (1855–1927)

*Austrian-born artist who lived in England, painting literary and biblical subjects, and scenes of everyday life, especially of children*

She first trained at the Academy of her native city of Graz and a prize enabled her to study in Munich with Professor von Lindschmidt. During the time she was there, her parents' financial circumstances deteriorated so much they could no longer support her. She therefore took her work to a dealer, who not only purchased all she had, but commissioned her to paint one work per month. Many of the works produced under this arrangement were studies of children. However, the sale of a larger and more important picture enabled her to go to Paris. For about ten months she studied in Paris with Collin and Courtois, before moving on to Concarneau in Brittany. There she met Adrian

Stokes, also a painter, and they were married in 1884. They returned to Paris in 1885–6 and also visited Skagen, the Danish centre of *plein-air* painting, before settling at St Ives. It was after winning her second medal from Munich that, inspired by the early Renaissance paintings she had seen in Italy in 1891, she evolved her distinctive techniques in gesso and tempera and her style simplified to become primarily concerned with line and colour on a two-dimensional surface rather than with representation. By the time she exhibited at the Chicago Exposition of 1893, she was regarded as one of the leading female painters in Britain. She continued to travel and exhibit until 1926.

*Examples:* WAG, Liverpool; Nottingham; Carnegie Inst., Pittsburgh.

*Literature:* AJ, 1900, 193–8; D. Cherry, *Painting women: Victorian women artists*, Art G, Rochdale, 1987; Clement; *Connoisseur*, v61, 1921, 177; v63, 1922, 112; v66, 1923, 50; v79, 1927, 127 (obit.); M. Elliott; *International Studio*, v10, 1900, 148–56; Nottingham, 1982; P. Nunn, *Victorian women artists*, London, 1987; Sellars; W.S. Sparrow; Weimann.

## STONE, Sylvia (1928–)

*Canadian-born sculptor and maker of painted aluminium reliefs who works in America*

Born in Toronto, Stone endured an insecure childhood after her parents separated when she was two. Although she had to start work at the age of 16 for financial reasons, she took night-shifts so that she could continue to attend the High School of Art and Music, where the teachers, themselves professional artists, were supportive and encouraging. In 1945 she emigrated to New York and for

**Marianne Stokes** *Polishing pans*, 1887, oil on canvas, 59 × 79.3 cm, Walker Art Gallery, Liverpool. (photo: John Mills (Photography) Ltd)

a period of some years studied part-time at the Art Students' League. During this period she married, had children, and painted mainly at home, taking her work in for her tutors once a week. This marriage ended in divorce, and she subsequently married the abstract painter Al Held. Her paintings moved from figurative to abstract, but it was from practical considerations that she began to use plexiglass. She cut large-scale geometric shapes from this material, painted it, and assembled the shapes into sculptural groups. Some pieces included mirrors and metal. Although this work apparently fitted in with the Minimalist aesthetic, Stone was always searching for greater visual and physical complexities. The titles often suggested particular settings, although the references to landscape in the works were oblique. As a sculptor she was never interested in mass, but rather has been preoccupied with light. In 1979–80 she had the opportunity of an extended stay in Rome. During this time she began to work on smaller wall reliefs of painted aluminium in which the references to architecture and more naturalistic phenomena are apparent. Stone is currently a professor at Brooklyn College.

*Literature:* R. Armstrong, 'SS', *Arts Mag.*, Dec, 1982, 48–9; T. Hess & E. Baker, *Art and sexual politics*, New York, 1973; Munro; Rubinstein.

## STRIDER, Marjorie Virginia (1939–)

*American sculptor who uses household imagery to explore motion and time*

Born in Guthrie, California, she gained her BFA at the Kansas City Art Institute in 1962. Her earliest works were paintings, but she then began to build out from the surface, before moving into sculpture. She has rejected any subject matter that cannot be dealt with life-size and has looked to her immediate domestic surroundings for these subjects. In the early 1970s she became well known for her brooms and soap-powder boxes from which oozed polyurethane foam. This sensation of breaking out, of a cyclical process of waxing and waning, has persisted through much of her work, although the subjects include clouds, vegetable boxes, Greek vases, packaging or women in bathing costumes. Recently she has used painted aluminium. Strider has exhibited extensively since 1963.

*Examples:* Albright-Knox G, Buffalo, NY; Des Moines, Iowa; Storm King Art Center, Mountain-

ville, NY.; Guggenheim Mus., New York; Hirsch-horn Mus., Washington, DC.

*Literature:* G. Henry, 'MS', *Arts Mag.*, Oct. 1984, 4; T. Hess & E. Baker, *Art and sexual politics*, New York, 1973; D. Kuspit, 'S's projecting presences', *Art in America*, v64/3, May–June 1976, 88–9; L. Lippard, *From the Center*, New York, 1976; L. Lippard, *Get the message*, 1984; Watson-Jones.

## STRINDBERG, Madeleine (1955–)

*English semi-abstract painter concerned with an atmospheric treatment of space and imagery which communicates a specific feeling*

Having studied initially at the Byam Shaw School of Art from 1977 to 1980, she trained as a teacher before starting an MA at the Royal College of Art (1982–5), where she studied with Jennifer Durrant (*q.v.*) and Ken Kiff. The recipient of several awards and a travel scholarship, she has visited northern Africa and particularly Egypt. This experience is evident from the light and colour in her paintings, which, although predominantly abstract, convey a dramatic sense of place and event. She has exhibited since 1981.

*Literature:* *Barclays Bank prizewinners*, Warwick Arts Trust, London, 1987; R. Fortnum and G. Houghton, 'Six interviews: 12.88' [one of these is with MS], *WASL J.*, no.28, Apr.–May 1989, 15–17.

## STUART, Michelle (c. 1935–)

*American mixed-media earth artist, sculptor and painter*

Stuart was born in Los Angeles, where her father was an engineer who mapped watercourses. A gifted child at school, she searched for women as role models. After attending the Chouinard Art Institute in her native city, she worked part-time as a cartographer and topographical draughtswoman, skills which fed into her fascination with geology, anthropology, archaeology and literature. Travel took her to Mexico, where at the age of 17 she became one of Diego Rivera's assistants on his last project. She married a Spanish artist and spent two years in Europe, which enabled her to study medieval architecture. Now divorced, she is based in New York. During the 1960s the surface of her works became thick and heavy as she

dipped her canvases in plaster. Her interest in texture and geology led her to make *frottage*-like rubbings on rag paper, but in 1972 she reversed the process by pounding the rocks and soil found at different sites into the paper. Employing a mechanical ritualistic rubbing allowed her to feel in harmony with the chosen site. The resulting scrolls are subtle fields of low reliefs, with deep, shimmering colours. In the later seventies she added the anthropological dimension so that *Stone/tool morphology records* (1977–9), a large grid of 682 units, is built up from alternating photographs of sites and paired images of stone tools. She has also made artist's books since 1974, although the form of these varies considerably. The earth hues, imprints and inclusion of natural objects such as feathers and shells, in addition to the grid format, are elements which she has retained in a recent return to thickly textured paintings, still using the same rag paper as earlier. Critics have praised her ability to combine science and art and to harmonise materials, methods and goals to achieve an end greater than the sum of the parts. She has exhibited in America and abroad since 1974.

*Examples:* Canberra.

*Literature:* L. Lippard, *Strata*, Art G, Vancouver, 1977; C. Lovelace, 'MS's *Silent gardens*', *Arts Mag.*, v63/1, Sept. 1988, 76–9; E. Lubell, 'MS: icons from the archives of time', *Arts Mag.*, June 1979, 122–4; Munro; P. Phillips, 'A blossoming of cells', *Artforum*, Oct. 1986, 116–7; C. Robins, *The pluralist era*, New York, 1984.

## STUMPF, J. See BAUER-STUMPF, Jo

## SWANWICK, Betty (1915–)

*English painter in oil, gouache, pen and ink of landscape and figurative subjects*

Swanwick was born in London, her father being a marine artist. She studied at Goldsmiths' College from 1931 to 1935 and followed this by a year each at the Royal College of Art and the Central School. A very versatile artist, she has designed and painted murals for, *inter alia*, the South Bank exhibition centre at the Festival of Britain in 1951 and at the Great Ormond Street Hospital for Sick Children. She has written and illustrated several humorous novels, and designed posters for London Transport between 1936 and 1954. Yet in addi-

tion to this her more orthodox painting practice earned her election as an Associate of the RA in 1970 and full membership ten years later. Between 1948 and 1969 she was a full-time lecturer at Goldsmiths' College.

*Literature: Who's Who in Art.*

## SWANZY, Mary (1882–1978)

*Irish modernist painter of landscapes and figure subjects, some of which have religious or allegorical overtones*

One of the most individual of all Irish artists this century, she did not influence her compatriots greatly, because of the large amount of time she spent away from Ireland. The second daughter of an eminent Dublin surgeon, she first studied painting with May Manning and modelling with John Hughes. After exhibiting her first work at the Royal Hibernian Academy in 1905, she followed Manning's advice and example by going to Paris, where she sampled several of the private academies. She came to know Gertrude Stein, at whose house she saw works by Cézanne, Gauguin, Matisse and Picasso. As a result of being in Paris at this time, she witnessed the Cézanne retrospective of 1906, as well as Fauvist paintings and the early stages of Cubism, all of which had a lasting effect on her work. Returning to Dublin, she at first pursued a traditional career as an illustrator and portraitist, with solo shows in 1913 and 1919, and exhibits in the Salon. Her first opportunity to travel beyond Western Europe came after the war, when she was engaged on relief work in Czechoslovakia and was able to paint mountain landscapes and Balkan peasants in their traditional costumes. In such works she was able to adopt brighter and less tonal colours, and she revealed a clear understanding of Cézanne's compositional structure. In 1923–4 she journeyed to Samoa and Honolulu, where she painted high-keyed scenes of tropical vegetation and local women. With the use of flatter areas of colour and reduction in detail, they are not unlike the works of Gauguin, although they do not contain his symbolism. These paintings were exhibited in Santa Barbara, California and in Paris. While in Dublin during World War II, she painted a number of works which appear to contain religious or allegorical meanings. There are widely differing moods, from the satirical and grotesque to tranquillity and joy. Through Cézanne she had studied early Renaissance painting, aspects of which

emerge in these paintings, although they were clearly filtered through her experience of early modernism. After the war she lived in London, exhibiting in a group show with Henry Moore, Braque, Chagall and others in 1946 and receiving a number of solo shows in both London and Dublin, where a large retrospective was held in 1968. She continued to paint until the final year of her long life.

*Examples:* Cork; Nat. G and Hugh Lane Municipal G, Dublin; Limerick; Waterford.

*Literature:* J. Campbell, *MS*, Pyms G, London, 1986; J. Campbell, *The Irish Impressionists: Irish artists in France and Belgium, 1850–1914*, Nat. G, Dublin, 1984; *Irish women artists*; H. Pyle, *Irish art, 1900–50*, Municipal Art G, Crawford, 1975; *MS retrospective exhibition*, Hugh Lane Municipal G, Dublin, 1968.

## SWYNNERTON, Annie Louisa. née ROBINSON (1844–1933)

*English painter of allegorical and mythological subjects who became the first female Associate member of the RA*

Swynnerton was born in Kersal, near Manchester, her father being a solicitor. She trained at Man-

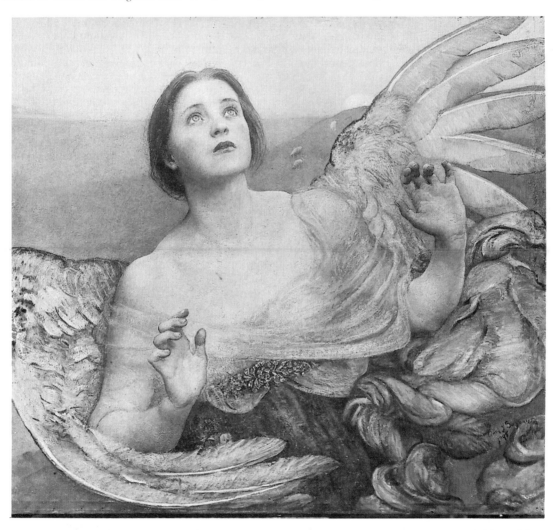

**Annie Swynnerton** *The sense of sight*, 1895, oil on canvas, 87.3 × 101 cm, Walker Art Gallery, Liverpool. (photo: John Mills (Photography) Ltd)

chester School of Art, at the Académie Julian, Paris and in Rome, beginning her exhibiting career in 1879. That year she co-founded and became secretary of the Manchester Society of Women Painters, which aimed to provide otherwise unavailable facilities, including life classes, for members. In 1883 she married Joseph Swynnerton, a sculptor from the Isle of Man, and they lived in Rome until his death in 1910, a location which accorded with her classical tendencies. Swynnerton became the second woman invited to be on the hanging committee of the Liverpool Autumn Exhibition in 1895. After her husband's death she divided the year between a flat in Rome and a studio in Fulham Road, Chelsea, where she slept on a makeshift bed with paintings round it as a screen. Contemporary accounts show her to have been somewhat indifferent to material things, forthright, independent and a little eccentric, but dedicated to her art. Sargent admired her works greatly and bought several, including *The Oreads*, which he gave to the Tate Gallery. It was through the support of Sargent and Clausen that Swynnerton achieved belated election as an Associate of the RA, at the age of 78. In addition to allegorical pictures, she also painted children and portraits and continued painting until her death, her final works being exhibited posthumously in 1934. She was also a member of the International Society of Sculptors, Painters and Gravers, and exhibited in America, including the 1893 Chicago Exposition. When she could no longer travel to Rome, she went to Hayling Island, near Portsmouth and it was there that she died.

*Examples:* WAG, Liverpool; Tate G, London; Melbourne, Australia; Metropolitan Mus., New York; Oldham; Mus. d'Orsay, Paris.

*Literature: Amer. Art News*, v32, 1933–4, no.4, 10 (obit.); Deepwell; M. Elliott; L. Knight, *Oil paint and grease paint*, London and New York, 1936; Nottingham, 1982; P. Nunn, *Victorian women artists*, London, 1987; Sellars; W.S. Sparrow; G. Storey, *Dickens and daughter*, London, 1939, 201–4; Waters; Wood, 1978.

## SYAMOUR, Marguerite. née GEGOUT-GAGNEUR (1861–?)

*French sculptor of mythological and allegorical figures and groups*

Born in Bréry, Jura, Syamour trained with Mercié. From 1886 she exhibited almost every year at the Salon and elsewhere. Her statue of Voltaire won

an award in 1887 and she executed many portrait busts in addition to mythological subjects. She won a bronze medal at the Paris Exposition of 1900.

*Examples:* Amiens; Issoudun; St Claude, Jura.

*Literature:* Clement; Mackay; J. Martin, *Nos peintres et sculpteurs*, Paris, 1897.

## TACHA, Athena. (alt. SPEAR) (1936–)

*Greek-born sculptor of monumental works in the landscape who works in America*

Born in Larissa, she gained an MA in sculpture at the Athens Academy in 1959. Emigrating to America, where she became a citizen in 1969, she studied for an MA in the History of Art at Oberlin College, Ohio (1961) and then spent two further years working for a Ph.D in aesthetics at the Sorbonne, Paris. Under her married name of Spear, she worked for the next decade as a museum curator and critic in addition to establishing herself as a practising sculptor under her own name. Her work matured during the socially restive 1960s and Tacha has always felt that her art should be physically accessible to all. She also wanted it to harmonise with nature, and to bring natural forms into places where they might otherwise not occur. As a result she has been ready to tackle projects reclaiming derelict land, for example. Since the mid-1970s she has received many public commissions, which have been executed in a variety of materials from painted Corten steel, to glass blocks and sandstone. Because she wants people to be able to walk in among her sculptures, as opposed to walking round the outside only, there are steps and paths worked into the design. Some of the designs echo natural forms. From 1973 she has been a professor at Oberlin College, Ohio.

*Publications:* 'Rhythm as form', *Landscape architecture*, May 1978, 196–205; 'Blair fountain, river sculpture', *Landscape architecture*, v74/2. Mar.–Apr. 1984, 72–4; as Athena Spear; e.g. 'Some thoughts on contemporary art' [on the work of several women artists], *Allen Memorial Art Bulletin*, spring 1973, 90; *Women's studies in art and art history*, College Art Association, New York, 1974.

*Examples:* Anchorage; Huron Road Mall, Cleveland, Ohio; International Airport, Columbus, Ohio; Metrorail Station, Miami; Vine Street Park, Oberlin; Riverfront Park, Tulsa, Okla.; Utah; NMAA, Washington, DC.

*Literature:* R. Campen, *Outdoor sculpture in Ohio*, Chagrin Falls, Ohio, 1980; E. Johnson, 'Nature as source in AT's art', *Artforum*, v19/5, Jan. 1981, 58–62; L. Lippard, 'Art outdoors: in and out of the public domain', *Studio International*, Mar.–Apr. 1977, 39, 41; L. Lippard, 'AT's public sculpture', *Arts Mag.*, v63/2, Oct. 1988, 68–71; Watson-Jones.

## TAIT, Agnes (1894–1981)

*American painter of landscapes, decorative panels and portraits*

Born in New York, she received her training at the NAD from 1908 to 1918. She then exhibited regularly and became known for decorative panels which emphasised the pattern elements within natural forms placed against flat metallic backgrounds. After a scholarship in 1930 enabled her to travel to Jamaica and Haiti, Tait became active on a number of government agencies and programmes. Her best-known work is probably *Skating in Central Park* (1934) and, although described generically as an American scene painting, it combines a strong sense of the abstract and decorative strands within contemporary art at the time. She went on to carry out mural paintings and was represented at the New York World's Fair of 1939. She had married journalist William McNulty in 1933, and in 1941 she moved to the artists' colony in Sante Fe, New Mexico, where she concentrated on printmaking and illustrating children's books, her work reflecting the Spanish culture around her.

*Examples:* NMAA, Washington, DC.

*Literature: Fair Muse;* Harris.

## TANNAES, Marie Katherine Hélène (1854–1939)

*Norwegian landscape painter*

Born in Oslo, she studied with several different teachers there and attended the painting school at Berglien. Between 1876 and 1883, she spent several periods working under Christian Wexelson, and from 1884 to 1887 attended Christian Krohg's painting school. From there she revisited Paris where, in 1882, she had studied with Puvis de Chavannes, and spent the year 1888–9 in the city, for some time enrolled at the Académie

Julian. She exhibited from 1883, evolving an atmospheric approach to landscape, which she usually depicted in either spring or autumn. Much of her painting was carried out in eastern Norway, although from the 1890s she spent several periods in Denmark and Italy. She received medals at the Expositions in Paris in 1889 and 1900, and that in San Francisco in 1915, and was given several solo shows early in the century when they were still a rarity.

*Literature:* A. Wichstrøm, *Kvinner ved staffeliet*, Oslo, 1983.

## TANNAHILL, Mary Harvey (1863–1951)

*American painter, miniaturist and printmaker who found her subjects in the people and objects around her*

The oldest of eight children, she was born on the family's North Carolina plantation, but grew up in New York City from 1865, with summers spent in the north of the state. Her childhood interest in art was encouraged by her parents and she proceeded to study with a number of eminent painters, including Kenyon Cox and Arthur Dow. Initially painting in watercolour on ivory, she exhibited portrait miniatures with the Philadelphia (later, American) Society of Miniature painters. Despite the financial rewards of this type of work, Tannahill explored a variety of size and media, including batik, embroidery and woodcuts. Shortly before World War I she travelled to Europe, but, as she was mistaken by Germans for an Englishwoman, the experience was not a happy one and she returned to America, dividing her time between New York and Provincetown, where she spent more than 30 summers. There she met Blanche Lazzell (*q.v.*), and began to produce characteristic Provincetown prints with white outlines. She exhibited there and in many of the other artists' societies and organisations with which she was involved during her 40-year-long career. These included the National Association of Women Painters and Sculptors (later, of Women Artists). For her subjects she preferred vegetables, goats and cats as well as people. At first sight her style appears naïve, but she was always ready to experiment, and manipulated natural and manmade objects to suit her imagination, using strong colours and little traditional perspective.

*Examples:* Public Library, Newark, NJ; Bibliothèque Nat., Paris.

*Literature: Eight Southern Women*, Greenville County Mus. of Art, 1986; A. Wolf, *New York Society of Women Artists 1925*, ACA G, New York, 1987.

## TANNING, Dorothea (1910/12–)

*American Surrealist painter*

Born in Galesburg, Illinois, she was one of three daughters of Swedish parents. From the age of seven, Tanning drew and painted, and cultivated her fantasy through voracious reading. After two years at Knox College and two weeks at the Art Institute, Chicago, she moved to New York in 1936, adopting a Bohemian lifestyle much to the consternation of her parents. Earning her keep through a succession of jobs, she began producing the first of her naturally surreal images. The major Dada and Surrealism exhibition at MOMA that year confirmed the direction of her art, and in 1939 she went to Paris, but because of the political situation did not encounter the Surrealists until her return to New York. Supporting herself by draughtswoman's jobs in advertising, she became part of the Surrealist Group. Ironically it was through her inclusion by Peggy Guggenheim in her 1943 exhibition that Tanning met Max Ernst, who subsequently divorced Guggenheim to marry Tanning. They moved to Arizona, where several Surrealists were based, until in 1952 they were able to return to France. Her precisely rendered paintings of the 1940s frequently show young girls or women, often wearing ragged clothing, in corridors with unexplained doorways. The works are full of allusions to transformations, sexual innuendo and impending threats. The ambiguity adds to the atmosphere of menace. While using imagery based on dreams and the unconscious, as did the other Surrealists, Tanning uses the image of woman very differently. Her style from the 1950s onwards is more loosely handled and abstract, but she has also written many books, designed sets and costumes for ballet, worked in graphic art and illustration and recently began to produce soft sculpture. She is much better known in France than America and has exhibited consistently since 1944.

*Literature:* W. Chadwick, *Women artists and the Surrealist movement*, London, 1985; Fine, 1978; Harris; Heller; P. Lumbard, 'DT: on the threshold of a darker place', *WAJ*, v2/1, 1981, 49–52; G. Orenstein, 'Women of Surrealism', *FAJ*, spring 1973, 17–21; G. Plazy, *DT*, New York, 1979; *DT*, 1974; Petersen; Rubinstein; *DT*, Centre Nat. d'Art Contemporain, Paris, 1974.

## TAÜBER, Sophie Henriette.
## (alt. TAÜBER-ARP) (1889–1942)

*Swiss artist producing geometrical constructivist compositions in various media*

Born in Davos, she studied textile design at the Gewerbeschule of Saint-Gall. During the next two years she was mainly in Munich, but on her return to Switzerland she became a member of the Swiss Werkbund (until 1932) and was appointed to teach textile design at the School of Fine and Applied Arts in Zurich, a position she held until 1929. In 1915 she had met Jean Arp and, although they were not married until 1921, they collaborated artistically from the beginning. Arp had been guiding Hilla Rebay (*q.v.*) in her moves towards abstract art, but now Arp's own work was influenced by that of Taüber towards a greater degree of abstraction. Her experience in decorative arts enabled her to transfer to oils and watercolour the coloured formats of rectangles and squares. Both Arp and Taüber also produced abstract embroideries. They became involved in Dada in Zurich, Taüber producing stage designs, marionnettes, a set of Dada heads and a dance performance. In the 1920s her teaching and sales gave them a regular income. Consistent in her allegiance to pure geometrical abstraction, she produced many designs for household objects, fabrics, jewellery and clothes. With Arp and Van Doesburg she designed the interior decorations for the Aubette restaurant in Strasbourg. From 1928 to 1940 they lived at Meudon in France, where she designed and decorated the house according to similar principles. They were associated with several abstract groups, including Abstraction-Création, with whom Taüber-Arp's preoccupation with Constructivist aesthetics fitted in well. In the late 1930s she made some painted wooden reliefs which retain the geometry and the saturated colours of her paintings. She also edited the journal *Plastique*. The Arps returned to Switzerland in 1940, and these last years were a period of great activity. Characteristic of her preference for remaining in the background, after her death in 1942 over 600 oil paintings by her were found.

*Examples:* Mus. Nat. d'Art Moderne, Paris; NMWA, Washington, DC.

*Literature:* Bachmann; *DWB*; Fine, 1978; Harris; Heller; C. Lanchner, *ST-A*, MOMA, New York, 1981; J. Marter, 'Three women artists married to early modernists', *Arts Mag.* v54, Sept. 1979, 88–95; Paris, Mus. Nat. d'Art Moderne, *ST-A*, 1964; G. Schmidt, *ST-A*, Basle, 1948; Vergine.

## TAWNEY, Lenore (1925–)

*American textile artist*

Born in Lorain, Ohio, into a Roman Catholic family, she left home at an early age, was married then widowed. In 1946 she enrolled at the Chicago Institute of Design, where several of the Bauhaus emigrés were teaching. She studied drawing with Moholy-Nagy and sculpture with Archipenko. From 1949 to 1951 she travelled in Europe and North Africa, and on her return took a short weaving course. It was in 1955 that she bought her own loom and began to produce open constructions with only the principal form filled in. Late in 1957 she moved to New York and became friendly with Agnes Martin (*q.v.*). Both were interested in the grid format and at this time Tawney's work was appreciated more by painters than weavers. In the early 1960s her work came to maturity with rich textures and colours. Extensive travel helped her to clarify her ideas and like Martin, she decided to simplify. This resulted in a series of black and white pieces in linen thread for which she used memory and imagination in a way normally tapped by painting and sculpture. By the time of her first solo show in 1962 she had evolved her 'woven forms', narrow pieces up to nine metres high, which she was able to make because she had a studio with a central shaft. Simultaneously she also produced small boxed assemblages. She is a believer in Zen and a follower of Jung, and austerity and mysticism characterised her work of the 1970s. Feminist critics have also drawn attention to certain assemblages which deal with the idea of the great goddess, and Tawney herself has drawn attention to the creation myth centred on the weaving woman. In 1983 she was given the award for Outstanding Achievement in the Visual Arts by the Women's Caucus for Art.

*Examples:* Art Institute, Chicago; Brooklyn; Cleveland, Ohio; MOMA, New York; Kunstgewerbemuseum, Zurich.

*Literature:* M. Constantine & J. Larsen, *The art fabric: mainstream*, New York, 1982; R. Howard,
'T', *Craft Horizons*, v35/1, Feb. 1975, 71–2; Munro; Rubinstein; Watson-Jones.

## TENNANT, Dorothy (alt. Lady STANLEY) (1855–1926)

*English painter of genre, especially London street children, figure subjects and portraits*

A Londoner by birth, Tennant studied from 1871 to 1878 at the Slade with Legros and Poynter, which meant that she was one of the first students to attend that school of art. She then went to Paris, where she worked in the ateliers of Henner and Carolus-Duran, both traditional Salon painters. She began exhibiting in 1879, although she was not represented at the RA until 1886. At the same time she had begun engraving, and she was elected to the Royal Society of Painters and Etchers in 1881, although for reasons unknown her membership did not last beyond that year. In 1890 she illustrated a book about the poor street children of London, known then as street arabs. Although sympathetic depictions, the children in her illustrations and paintings were idealised. In the same year she married Sir Henry Stanley, the explorer, who in 1875 had almost married the American painter, Alice Pike Barney (*q.v.*). After Stanley's death in 1904, she married Dr Henry Curtis in 1907. Throughout this period she exhibited widely in London, the provinces and in Paris.

*Publications: London Street Arabs*, London, 1890.

*Examples:* Lady Lever Art G, Port Sunlight; Wallington Hall, Northumberland (National Trust).

*Literature:* Clement; Sellars; Waters; *Who's Who in Art*; *Who was Who, 1916–29*; Wood, 1978.

## THESLEFF, Ellen (1869–1954)

*Finnish painter of landscapes, figures and portraits in an atmospheric Expressionist style*

Thesleff came from a fairly wealthy family which was able to subsidise her training. She spent approximately six years between the schools of Becker and the Finnish Association of Fine Art and with Gunnar Berndtson. The latter brought her into contact with Impressionism, and in 1891, when she began to exhibit, she took the logical step of

going to Paris, where she remained until early in 1894, attending the Académie Colarossi. Initially interested in the work of Puvis de Chavannes and spiritualist tendencies, demonstrated in *Thyra Elizabeth* (1892), the first Finnish example of Art Nouveau, she soon began to follow a more independent line. Having concluded her formal studies, Thesleff went to Italy, a country which was to have a profound effect on her work. At the end of her life she acknowledged her debt to early Renaissance art. The country drew her back on many occasions, and in 1906 she met Gordon Craig there and from him learnt woodcut techniques, something at which she excelled. From Symbolism her work moved in the early years of the century towards a highly coloured Expressionism in advance of her time. She exhibited briefly with the Finnish Septem Group but then withdrew, and spent much of the rest of her life in seclusion. As with Schjerfbeck (*q.v.*) she produced a wealth of strong work in isolation and to a considerable age. In the 1930s she was the most lyric of the Finnish painters, and became more concerned with particular atmospheric effects. After World War II her poetical and mystical side emerged more strongly and the forms became almost abstract. A considerable number of works from the whole of her career have connections with music in either title or content, or both.

*Publications: Dikter och tankar*, Helsingfors, 1954.

*Examples:* Cleveland, Ohio; Göteborg; V & A, London; Moscow.

*Literature:* J. Boulton-Smith, *Modern Finnish painting*, London, 1970; J. Boulton-Smith, *The golden age of Finnish art: Art Nouveau and the national spirit*, Helsinki, 1976, rev. ed., 1986; *Dreams of a summer night*, Hayward G, London, 1986; *Northern light: realism and symbolism in Scandinavian painting, 1880–1910*, Brooklyn Museum, New York, 1982; *Sieben Finnische Malerinnen*, Kunsthalle, Hamburg, 1983 (bibl.); W.S. Sparrow.

### THIL, Jeanne (1887–after 1938)

*French painter of landscapes and figure subjects frequently oriental in setting, sometimes on large panels for the decoration of public buildings*

From her native town of Calais, Thil went to Paris to train with Humbert and Fouquerary, first exhibiting in 1911. From 1920 she regularly won prizes at the Salon des Artistes Français, and in 1921 was awarded the prestigious *bourse de voyage*. Having already visited Spain on the advice of Humbert, she used the prize to visit Tunisia, and from this time produced many oriental scenes. The town of Calais was the first to commission a large panel for the council chamber. This led to other similar requests, including paintings for the transatlantic liner, *Ile de France*. She won many prestigious awards, was elected member of the Société des Artistes Français, declared *hors concours* at the Salon and in 1938 made a Chevalier de la Légion d'honneur.

*Examples:* Brooklyn; Calais; Nîmes; Strasbourg; Vincennes.

*Literature:* Edouard-Joseph; *Livre des peintres exposant à Paris*, Paris, 1930.

### THIOLLIER, Eliane (1926–)

*French painter of landscapes, still lifes, and marine scenes*

Born in St Germain-en-Laye near Paris, Thiollier was encouraged in her desire to be an artist by her

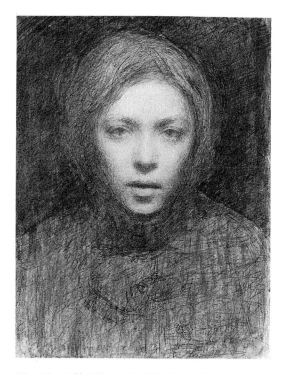

**Ellen Thesleff** *Self-portrait*, 1894–5, pencil on paper, 31.5 × 23.5 cm, Ateneum Taidesmuseo, Helsinki.

architect father. Soon after his death at the end of World War II, she began to study at the École des Beaux-Arts, financed by a state scholarship. Because of the need to assure herself of an income before she could expect a return from her paintings, she set up and ran a lithography studio until 1963. At the age of 20 she began to exhibit, and in 1955 she had her first solo show in Paris. During the late 1950s she became a regular participant in exhibitions, and her reputation spread through the rest of the country and then abroad over the following decade. She won many awards from 1960, and in 1982 became a committee member of the Salon d'Automne. Since 1950 she has lived in the south of France, where the brilliant light caused a change in her palette. Many of her landscapes were of the Camargue, with its wild horses. Since a visit to Mexico in 1971, she has begun to include figures in her landscapes.

## THOMAS, Alma Woodsey (1891–1978)

*American colour-field painter*

The oldest of four daughters, Thomas belonged to a well-off and intellectual black family in Columbus, Georgia. Her mother was a dress designer who loved working with bright colours, and she passed this love of colour on to her daughters. Anxious to educate their children well, the Thomas family moved to Washington, DC in 1907 into a house which Alma Thomas inhabited for the rest of her life. After training as a junior school teacher she worked in schools until after World War I, when Montessori methods were introduced for which she was not trained. Enrolling on a course of costume design at Howard University in 1921, she by chance met Professor James Herring, who was trying to start a Fine Art Department and persuaded Thomas to become its first student. Following her graduation she taught in the same Washington school until she retired in 1960. Although encouraged by Herring to continue painting full-time, she decided to maintain her economic freedom by teaching, and because of a sense of responsibility to her students postponed her career as an artist. In 1930 she began to work for an MA at Columbia University, and this enabled her to see art in the New York galleries. From 1943 involvement with the Barnett-Aden Gallery in Washington, co-founded by Herring and exhibiting young artists regardless of race or gender, brought her into close contact with contemporary art. In 1950 she enrolled at the American University in Wash-

ington for a course in painting and art history as a preparation for her second career. Although in her early sixties, she constantly challenged herself to explore new forms of expression, and an increasing feeling for abstraction became evident at this time. After 1960 when she was able to paint full-time, she had several solo shows. Encouraged by the prospect of a retrospective, she had been painting works inspired by wind, leaves and flowers. On one occasion she was suddenly struck by the effect of looking out of the window at the large holly bush with bright sunlight behind it. With a brush loaded with acrylic paint, she began to put down on canvas marks equivalent to the pattern of leaves between which the unpainted canvas functioned as the sunshine. Having found this method she spent the rest of her life perfecting it. Each work is initially inspired by the layout of beds of flowers seen from the air, although she subsequently went on to subjects inspired by the cosmic considerations of space travel. Her later works tend to be of only one colour, and despite failing eyesight and chronic arthritis, she communicates a vitality to the spectator.

*Examples:* Phillips Collection, Hirschhorn Mus. and Air and Space Mus., Washington, DC.

*Literature:* D. Driskell, *Two centuries of Black American art*, County Mus. of Art, Los Angeles, 1976; M. Foresta, *A life in art: AT 1891–1978*, NMAA, Washinton, DC, 1981 (full bibl.); Munro; C. Robins, *The pluralist era*, New York, 1984; Rubinstein; Withers, 1979.

## THOMPSON, E. See BUTLER, Elizabeth

## THORNYCROFT, Alyce Mary. (alt. Alice) (1844–1906)

*English painter and sculptor of figurative, often literary, subjects*

The second child and oldest daughter of sculptors Mary (*q.v.*) and Thomas Thornycroft, she was the sister of Helen and Theresa (*q.v.*). Like them she learnt to model and carve from an early age with her parents, and was admitted to the RA Schools at the age of 18, sponsored by sculptor John Foley. She made her début at the RA in 1864. Influenced by the medievalism of the Pre-Raphaelites she changed the spelling of her first

name in 1865. (Graves erroneously gives her name as Alyn.) Apart from portraits, her subjects were predominantly literary. She later gave up sculpture in favour of painting, and carried out portraits in the style of G.F. Watts, mostly of the family. In early adulthood, the sisters lived a relatively advanced lifestyle; they rowed and swam, and in 1871 Alyce and Helen spent a small legacy on a visit to Italy. Although she was undoubtedly clever and talented, she achieved least of the sisters. This was partly because, as the eldest sister, she had the burden of caring for her parents as they grew older, a task for which she was temperamentally unsuited. In turn she felt oppressed by her siblings, and became increasingly ill-tempered. For the last years of her life she was mentally unstable.

*Examples:* Nat. Portrait G, London.

*Literature:* E. Manning, *Marble and bronze: the art and life of Hamo Thornycroft*, London, 1982; Wood, 1978; Yeldham.

## THORNYCROFT, Helen (1848–1937)

*English painter of biblical subjects, landscapes and flowers*

The second daughter of sculptors Mary (*q.v.*) and Thomas Thornycroft, she was the sister of Alyce and Theresa (*q.v.*). The artistic family life led Helen to apply to the RA Schools at the age of only 14, and although her sculpture was accepted for exhibition then, Landseer judged her too young to be a student. Two years later she was admitted. Although she began as a sculptor, she later turned to painting, perhaps to avoid direct competition with her brother Hamo, and became particularly known for her small landscapes of Scotland and the Greek islands. With Alyce, she visited Italy in 1871. All the sisters became involved in the High Church movement, but this did not prevent them from being comparatively unconventional. After an accident while assisting her engineer brother John, she always wore her hair short, one of the first women to do so. She exhibited regularly at a number of London venues between 1864 and 1912. She was involved in the work of the SWA and served as its vice-president from 1901 to 1911.

*Examples:* Rochdale.

*Literature:* Mallalieu; *The Year's Art*; as for Alyce.

## THORNYCROFT, Mary. née FRANCIS (1809–95)

*English sculptor of neo-classical figures and groups*

As the daughter of sculptor, John Francis, who worked in Thornham, Norfolk, Mary began from an early age to demonstrate her talent for sculpture. Her father guided her and she had exhibited at the RA before 1836. By now they had moved to London and John Francis had three pupils who lived with the family. One of these was Thomas Thornycroft, whom Mary married in 1840. The next few years were financially difficult, for Thomas was independent now and commissions failed to arrive. Late in 1842 they went to Rome, where their son was born in 1843. Soon after this Mary was back at her sculpture, which was admired by John Gibson, then the leading English sculptor in Rome. It was through him that Mary received a commission from Queen Victoria to portray her third child, then a year old. With prospects thus improved, Mary and Thomas returned to England. From this time on a series of royal

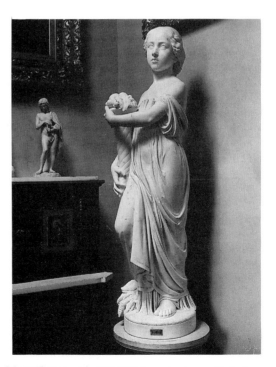

**Mary Thornycroft** H.R.H. *Princess Louise, aged 8, in the guise of 'Plenty'*, 1856, marble, 132 cm, Royal collection. (photo: reproduced with gracious permission of Her Majesty the Queen)

commissions came to Mary, who was more successful than her husband and maintained the family, which increased to seven children born before 1853. Two died young, the older son became an engineer, and the other four – Alyce (q.v.), Helen (q.v.), Theresa (q.v.) and Hamo – all became artists. Altogether Mary sculpted four generations of the royal family and she spent so much time at Windsor Castle that she had her own apartments there. She exhibited regularly at the RA until 1877. Her obviously greater success did not always make for domestic harmony. Thomas infuriated her by cutting the heads off her figures and trying them in different positions. Thomas also worked jointly with her on some projects but then claimed them as his own, while after his death in 1885 Mary completed the Boadicea group on which he had worked for many years but failed to complete. Although she worked in a neoclassical style, she did not slavishly follow antique figures, but imbued the figures with something of her own liveliness.

*Examples:* Royal collections.

*Literature:* DNB; *Mag. of Art*, June 1895, 305–7 (obit.); E. Manning, *Marble and bronze: the art and life of Hamo Thornycroft*, London, 1982; Nottingham, 1982; P. Nunn, *Victorian women artists*, London, 1987.

# THORNYCROFT, Theresa Georgiana (1853–1947)

*English painter of biblical and literary subjects*

The youngest child of sculptors Mary (q.v.) and Thomas Thornycroft, and sister of Alyce and Helen (q.v.), she was christened Georgiana but later adopted Theresa as her name. She attended Queen's College in Harley Street, where her close friends were future painters Nellie Epps Gosse (q.v.) and Catherine Brown Hueffer (q.v.), before being admitted to the RA Schools in 1870. She was the only one of the sisters to enter as a painting student. It seems she was never inclined to follow the family tradition. Like her sisters she joined the High Church movement and produced some ambitious religious paintings, as well as other subjects. She was said to be clever at composition. Her most successful work was judged to be *The Hours* of 1889, where 24 figures float across the sky from darkness into light. She exhibited regularly in the main London galleries. She was close to her brother Hamo and together they made several visits, including one to the Paris Salon of 1877. She also occasionally modelled for him. The only daughter not to remain single, she married Alfred Sassoon, despite the opposition of his Orthodox Jewish parents, and was the mother of the poet Siegfried Sassoon.

*Literature:* As for Alyce T.

# TOORUP, Charley. née Annie Caroline Pontifex TOORUP (1891–1955)

*Dutch realist painter of figures, especially portraits*

Born in Katwijk, she received her initial and only training from her father, the Symbolist painter, Jan Toorup. Also gifted in music, she decided in 1912 that she intended to concentrate on painting. Self-taught from then on she went to live for three years in an artists' colony in the isolated village of Bergen in northern Holland. She would subsequently spend most of her life there. From 1915 to 1923, when she returned to Bergen, she worked for some time in the Borinage region of Holland in addition to travelling to France, Spain and Norway. Her early work reflects the influence of Cubism and Expressionism, but she then found her own intense realist style, which showed elements of *Neue Sachlichkeit* painting in Germany. She executed many portraits both of individuals and of groups, and a striking series of self-portraits, including one in which she honestly confronted her full-length nude figure.

*Examples:* The Hague; Otterlo.

*Literature:* A. Hammacher, *CT*, Rotterdam, 1952; Krichbaum.

# TOYEN. (pseud. of Marie CHERMINOVA) (1902–80)

*Czech Surrealist painter*

Details concerning her early life are very sparse and it is known only that she adopted her pseudonym while in her teens. After taking a short course at the Prague School of Fine Arts, she joined the Devetsil Group, which encompassed many young poets and artists of a variety of persuasions. Cultural life in post-war Prague was very active, but in 1925 Toyen went to Paris for three years with her companion Styrsky. Her

earlier Cubist-inspired work gave way to sombre-coloured, heavily impastoed surfaces with the emphasis on facture, and she exhibited at least twice. After her return to Prague, her work moved towards Surrealism, using semi-abstract forms and certain colours to denote states of emotion. From the early 1930s, following Styrsky's discovery of Sade, she incorporated eroticism into her works, using it 'as the basis for a new language of psychological association and suggestion'. Although she surrounded herself with erotic objects and pornographic photographs, her erotic works are more subtle, less blatant and violent than those of Styrsky. Parallel to these she worked on paintings of desolate landscapes which reflect the increasing threat to Czechoslovakia and the onset of war. During World War II her work was banned and she was forced to live very secretly, Styrsky having died in 1942. She produced two cycles of drawings, only published in 1946, which, in a clear linear style, depict equivalent states of horror and desolation without in any way describing war. Early in 1947 Toyen left for Paris to prepare a solo show and participated in the first major post-war Surrealist exhibition later that year. She remained in Paris until her death.

*Examples:* Brno; Mus. Nat. de l'Art Modern, Paris; Prague.

*Literature:* W. Chadwick, *Women artists and the Surrealist movement*, London, 1985; Krichbaum; Petersen; Vergine.

## TREIMAN, Joyce. née WAHL (1922–)

*American figurative painter who uses traditional draughtsmanship to confront issues of violence and isolation*

Treiman was born in Chicago. Her childhood talent was so prodigious that she was put in an adult Saturday class at the age of eight. Encouraged by her parents, at the end of the school day she would go to the Art Institute to draw, so that by the time she became an undergraduate under Philip Guston at Iowa she was extremely accomplished. In the mid-1940s she married a businessman, and a 1947 award enabled her to devote herself full-time to painting. Since 1960 she and her husband and son have lived in Los Angeles, where she has no studio but works in half the family's double-garage. Her early work dealt with the human condition as evidenced by the poor and destitute. A period of semi- and even complete abstraction followed, but she later rejected this as too easy, and in the 1960s returned to figuration. Visits to Europe in the late 1960s aroused her interest in Rembrandt, Goya and Velasquez, and during the seventies she produced shadowy paintings with perhaps two figures and exotic props which had an aura of existentialism. With a host of awards and prizes and an exhibiting record stretching into several hundred shows, Treiman is now recognised as a major painter.

*Literature:* Rubinstein; W. Wilson, *JT: paintings, 1961–72*. Mus. of Contemporary Art, La Jolla, 1972.

## TRIEFF, Selina (1934–)

*American painter of realist, often autobiographical, figures*

Born in Brooklyn, New York, she studied at the Art Students' League, New York from 1951 to 1953 before gaining a scholarship to study at Hans Hofmann's School from 1954 to 1956. She gained her BA from Brooklyn College, where she studied with Ad Reinhardt and Mark Rothko. Her paintings are realist but not realistic, and the chief human protagonists are herself, her family and *Commedia dell'arte* figures. In many paintings animals, especially a goat, appear with human beings or, more rarely, alone. They are human surrogates, or symbolic of certain attributes. The life-sized figures, clothed in dark-coloured timeless robes or suits, are placed against light backgrounds which are never precisely indicated. Her earlier works were mainly monochrome, for she gained the technique of handling dark tones and the creation of mood from her Abstract Expressionist mentors, but in the 1980s she has introduced brilliant colours. There are many allusions to art of the past from Giotto's *Visitation* to Watteau's *Pierrot called Gilles*, Edvard Munch and medieval *Dances of death*. Over recent years the main figure has taken on Trieff's own features with increasing regularity, but she plays a varied cast of characters. This use of the self-image can be related to the use of autobiography by other women artists since 1970. She has exhibited regularly since 1956, although more frequently since 1972, and has taught part-time at a number of institutions.

*Examples:* Brooklyn; Kalamazoo; Public Library, New York.

*Literature:* L. Alloway, *ST*, Graham Modern G, New York, 1986; J. Marter, 'Confrontations: the

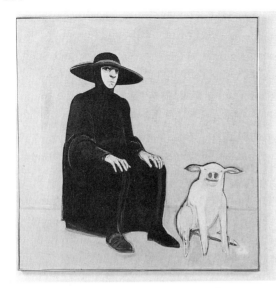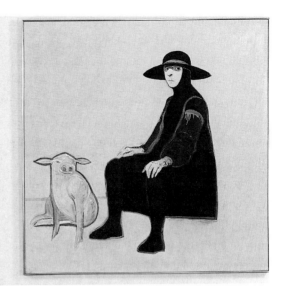

**Selina Trieff** *Pilgrim with pig*, 1988, diptych, oil on canvas, each canvas 152 × 152 cm, private collection. (photo: courtesy of Graham Modern, New York)

paintings of ST', *Arts Mag*, June 1986; C. Robins, 'ST', *Arts Mag.*, Apr. 1978.

## TROCKEL, ROSEMARIE (1952–)

*German mixed-media artist who questions representation and exclusion in art, particularly in relation to women*

Trained from 1974 to 1978 at the Werkkunstschule in Cologne, where she still lives, Trockel sets out to represent the unrepresented and unrepresentable. In patriarchal society this sphere is the feminine. One theme within her work is that of knitting, which has also been explored in different ways by Pauline Cummins (*q.v.*) and Elaine Reichek (*q.v.*). Some of her paintings imitate knitting and include the pure wool logo, and these deconstruct the masculine code of representation while alluding to the feminist attempts to raise the status of traditional crafts. Her work is very varied in material and form; but without placing itself outside the bounds of establishment art she questions both modern art and its implicit masculinity.

*Literature:* S. Eiblmayr, V. Export & M. Prischl-Maier, *Kunst mit Eigen-Sinn: Aktuelle Kunst von Frauen*, Vienna & Munich, 1985; K. Johnson, 'Tales from the dark side', *Art In America*, Dec. 1988,

140–4; J. Koether, 'Interview with RT', *Flash Art*, May 1987, 40–1; J. Keother, 'The resistant art of RT', *Artscribe*, no. 62, Mar.–Apr. 1987, 54–5; K. Ottmann, 'RT', *Flash Art*, May 1987, 38–9; I. Rein, 'Knitting, stretching, drawing out: RT', *Artforum*, v25/10, summer 1987, 110; *RT*, ICA, London, 1988.

## TRUITT, Anne. née DEAN (1921–)

*American painter of minimalist canvases and boxes, for whom colour is the key element*

Called by critic Clement Greenberg the artist 'whose painted structures helped to change the course of American sculpture', she only began to train as an artist after her marriage to a journalist and a move to Washington, DC in the late 1940s. After a happy childhood in Baltimore, Maryland, during which she was strongly influenced by her intelligent and dedicated mother, she read psychology at Bryn Mawr College. Shortly afterwards her mother died, leaving her financially secure. In Washington she learnt a variety of basic sculptural techniques from Alex Giampietro at the Institute of Contemporary Art, although she later destroyed all her work from before 1961, as well as that done in Japan from 1964 to 1967. Her husband's job necessitated regular moves and posts abroad but Truitt, after catering for her three children first,

would set up a studio for any spare time that she had. A visit to New York in 1961, when she saw the works of Reinhardt and Newman, was the catalyst for a solution to her problems of colour and form, and on her return to Washington she made her first box. Soon after this her marriage failed and financial problems arose, which left her less time. After she rented a studio near her friend Noland, he brought her work to the attention of Greenberg and David Smith, and she has exhibited extensively since 1963. Her boxes are tall, pillar-like constructions which have over 30 layers of paint applied in order to give the colour quality that she seeks. Often working in series, she also produces canvases in which two or more of the colours are placed on a flat field. In her more austere works, there are merely pencil lines on white ground. She regards her boxes as three-dimensional paintings.

*Publications: Daybook; the journal of an artist*, New York, 1982.

*Examples:* Albright-Knox G, Buffalo, NY; Baltimore; Houston; New Orleans; Metropolitan Mus. and Whitney Mus., New York; St Louis; Corcoran G, Hirschhorn Mus., and NMWA, Washington, DC.

*Literature:* C. Havice, 'AT's *Daybook*: introduction', *WAJ*, 3/2, fall 1982-winter 1983, 36–43; Heller; Munro; Rubinstein; *AT: sculpture and drawings, 1961–73*, Corcoran G, Washington, DC, 1974; Watson-Jones; Withers, 1979.

**Winifred Turner** *Young girl*, c. 1938–9, clay model or plaster cast of clay model, present whereabouts unknown. (photo: courtesy of Nicholas Penny and Miss J. Turner)

## TURNBULL, A. See BARTHOLOMEW, Anne

## TURNER, Winifred (1903–83)

*English figurative sculptor*

The younger of two daughters of the sculptor Alfred Turner, a leading participator in the New Sculpture style early in the twentieth century, she was brought up in London. Both daughters attended the Central School of Art and Design, where their father taught. After three years (1921–4) Winifred, who was more ambitious than her sister, proceeded to the RA Schools (1924–9), where she won many prizes. She began to exhibit portrait heads at the RA in 1924 and a series of female figures from 1929. Gradually developing in complexity of conception, the figures are predominantly seated or crouching but never languid. Several seem lost in thought; even the mother nursing a child does not look at the baby but gazes pensively into the distance. Although some of the titles imply allegory (*Spring*) or mythological sources, the works are not anecdotal, nor are the facial types purely European. She would appear to have looked at art from other cultures, including ancient Greece and India. Several figures bear witness to Turner's own love of and prowess at dance (she became too tall to continue with this professionally) and the bronze *Spring* (1935–7), one of her few standing figures, carries the same impulse from dance as the work of Harriet Frishmuth (*q.v.*) although Turner's figure is less slender and androgynous. Turner often modelled for her own sculptures. The 1930s saw her greatest successes: one of her sculptures was bought by the Chantrey Bequest for the Tate Gallery and she was elected Associate and then Fellow of the Royal

Society of British Sculptors. During this period she also taught at the Central School, a post she relinquished on her marriage in 1942 to a colleague, Humphrey (Tom) Paget. He joined her in the cottage at Burwash, Sussex, to which she had moved in 1940 on the death of her father. Because access to nude models was more difficult there, she began to sculpt the animals she kept and her medium changed to terracotta. Her sculptures of the 1940s included contemporary ones such as *Land girl* (1945) and the surfaces became rougher. She last exhibited at the RA in 1962, when she was experminting with concrete.

*Examples:* Tate G and V. & A, London.

*Literature:* N. Penny, *Alfred and Winifred Turner*, Ashmolean Mus., Oxford, 1988.

## UDALTSOVA, Nadiejda Andreyevna (1886–1961)

*Russian Cubist and abstract geometrical painter*

Udaltsova was born in Orel, central Russia, but her family settled in Moscow in 1892. From 1905 to 1909 she attended the Moscow Institute of Painting, Sculpture and Architecture and at the same time studied at Yuon's private school. But it was an encounter with the French paintings in the Shchukin collection which most impressed her. In 1908 she travelled to Dresden and Berlin, and on her return of Moscow was married. From this time she began to move in modernist art circles, including Tatlin's studio known as The Tower. She shared a studio with her great friend Popova (*q.v.*) and in 1912 they went to Paris with Vera Pestel (*q.v.*), where they studied in the Cubist arena of the Académie de la Palette with Metzinger, Le Fauconnier and Segonzac. On their return to Russia in 1914 they, with Malevich, were considered the foremost exponents of Cubism. *At the piano* (1914) shows her to be using bright colour and Cubist planes to reconstruct the painting rather than to analyse the subject. For a short time she was influenced by Rayonnism before turning to the production of paintings of geometrical planes in flat colours. The range of her colours was wider than that of Popova. She participated in most of the avant-garde exhibitions in Russia over the next few years and was involved in several artists' groups. This activity continued after the revolution so that, according to her diaries, she had little time left for her painting. In addition to administrative tasks within Narkompros (the

Commissariat for Public Instruction), she taught for some years in the Vkhoutemas (National Studios for Art and Design) and participated actively in the Constructivists' discussions in Moscow. At this time she was one of the leading exponents of the new art of the revolution and was one of the principal representatives of modern Soviet art at the 1922 Berlin exhibition. In 1920 she married the painter Drevin. After the closure of the Vkhoutemas, she taught elsewhere but her style reverted to Cubism, and by the end of that decade she was producing mainly landscapes. She continued to exhibit throughout the 1930s and 1940s undertaking several long journeys in order to acquire subject matter.

*Examples:* Russian Mus., Leningrad; Yale Univ. Art G, New Haven.

*Literature:* S. Barron & M. Tuchman, *The avant-garde in Russia, 1910–30: new perspectives*, County Mus. of Art, Los Angeles, 1980; Harris; Krichbaum; *L'avant-garde au féminin, 1910–30*, Artcurial, Paris, 1983; *Russian women artists of the avant-garde, 1910–30*, G Gmurzynska, Cologne, 1979; Vergine.

## UKELES, Mierle. née LADERMAN (1939–)

*American performance and installation artist whose work on the theme of cleaning up after others resulted in her working with New York's dustbin men*

Ukeles is a New Yorker, her work being centred on that city. After studying history and international relations at Barnard College, she attended the Pratt Institute, and gained her MFA from New York University. She worked in traditional media until 1966, but is best known for her Maintenance art, from 1969 onwards. As a mother of small children, she found that her time, energy and media were constrained, so she decided to make her art from what she would be doing – cleaning up. Performing, documenting and making installations, she has dealt with both individual and civic maintenance. In one event she cleaned the floor of a museum entrance, where the floor was stepped on as soon as it was cleaned. Her long-standing involvement with the New York sanitation department included shaking hands with each of the 8,500 dustbin men as well as other gestures to show the men their work is valued.

*Publications:* 'Manifesto for maintenance art' in G. Battcock, *Idea Art*, New York, 1973; 'Re-raw discovery', *Heresies*, v4/4, 1982.

*Literature:* L. Lippard, *From the Center*, New York, 1976; L. Lippard, *Issue: social strategies by women artists*, ICA, London, 1980; L. Lippard, *Get the message*, New York, 1984; Roth.

## VALADON, Suzanne. née Marie-Clementine VALADON (1865–1938)

*French painter of figures, especially female nudes, in strong colours*

Now one of the better-known women artists of the period, Valadon was born illegitimately in Bessines, Haute-Vienne, and was brought by her seamstress mother to Paris when still a baby. Based in Montmartre, she was left largely to her own devices while her mother undertook various menial jobs to pay for their keep. At the age of nine Suzanne was apprenticed to a dressmaker for three years, before taking on a succession of casual jobs and ending up as an acrobat. An accident at 16 forced her to abandon this and she became the model of artists whom she had enjoyed watching at work. At 17 she gave birth to a son, Maurice Utrillo, and, as well as continuing to model, first for Renoir, and then for Lautrec, she began using pastels. On discovering her natural talent for drawing, Lautrec took her to Degas, who not only urged her to become a professional painter but also arranged for her work to be exhibited in several Parisian galleries. After her son was recovering from a cure for alcoholism, she taught him to paint and he began to copy street scenes in Montmartre. About 1909 Suzanne fell in love with one of her son's friends, André Utter, despite an age gap of 21 years. The following five years were very productive artistically, resulting in her first solo show in 1915 and a joint show with Utter and Maurice Utrillo in 1917. In the post-war period they received considerably higher prices for their paintings and as a result bought the Chateau St Barnard, near Lyons. Both there and in her Paris studio, she continued producing works for a series of group and solo exhibitions, which brought her considerable financial rewards. From 1933 to 1938 she took part in the Salon of Modern Women Artists. Uneducated and untrained, Valadon worked against the voyeurism normally associated with the female nude in art. She uses strong dark, sinuous outlines and bold colours, but her models are often shown accompanied by older women, at moments not normally depicted in art because of an ungainly position, or because it is a moment exclusive to women, as in *The Abandoned Doll*.

*Examples:* NMWA, Washington, DC.

*Literature:* Bachmann; R. Betterton, 'How do women look: the female nude in the work of SV', *Feminist Review*, v19, Mar. 1985, 1–23; Fine, 1978; Harris; Heller; Petersen; E. Tufts, *Our hidden heritage: five centuries of women artists*, New York, 1974; J. Warnod, *SV*, New York, 1981.

## VALLET, M. See MARVAL, Jacqueline

## VANDENBERG, Diana (pseud. of Angele Thérèse BLOMJOUS) (1923–)

*Dutch hyper-realist painter*

After studying at The Royal Academy at the Hague, she became a member of the Meta-realist Group of painters. From 1946 to 1962 she was married to its leader Jonfra and since then has lived in the Hague. She uses extreme realism combined with occult and hermetic themes, and also executes portraits. She has been a strong influence on younger members of the group.

*Literature:* Krichbaum; J. Stellinghoff, *La peinture hermetique de DV*, Amsterdam, 1969.

## VANSTON, Diarine. (alt. Doreen) (1903–)

*Irish painter of figure subjects and landscapes with figures and animals in a simplified style which was among the most avant-garde in Ireland during the 1940s*

Vanston's mother was a sculptor of Dutch descent, who around 1920 sent her Dublin-born daughter to Goldsmiths' College, London. A year or so later Vanston was enrolled at the Académie Ranson in Paris, a city where she remained and, in 1926, married a Costa Rican law student. They moved to Costa Rica in the late twenties, but by 1932–3 Vanston had left him and returned to Paris, where she studied briefly with Lhote. The contacts with the School of Paris enabled her to use primary colours to particular effect and specifically clear tones of blue and green. These she used in a manner derived from Cubism as practised by Picasso and Braque. Returning to Dublin on the outbreak

of war, she joined the White Stag Group of artists, who were similarly wartime exiles from Europe working in modernist idioms. A visit to Costa Rica in 1947–8 helped to free her style further, to heighten the colour, simplify the composition and adopt Costa Rican motifs and landscapes. Despite exhibiting regularly, she became almost forgotten until the 1980s, since when interest in her work has revived.

*Literature: Irish women artists.*

## VARO, Remedios (1913–63)

*Spanish-born Surrealist painter who spent much of her life in Mexico*

Born in Anglés, Catalonia, she was strongly influenced by travels with her father, an hydraulic engineer, and throughout her life was interested in fantastic machines. After attending the Academy of San Fernando in Madrid, she was briefly married to another student. An early abortion prevented her from having children when she later married the Surrealist poet Benjamin Peret in Barcelona. After the Spanish civil war they lived in Paris until the outbreak of World War II necessitated their escape. They went to Mexico, where Varo remained for the rest of her life, separating from her husband in 1948. Their poverty at this period meant that Varo had little time for painting. In Mexico she was a regular visitor to Natalia Trotsky. Alchemy often features in her work, a theme which links her to other women Surrealists, including her close friend Leonora Carrington (*q.v.*), who also lived in Mexico. They parody the male-dominated scientific world with alternative female images of creativity, which Varo saw as 'a higher development of traditional domestic activities'. She believed the role of the artist was to seek truth and that the images of journeys are metaphors of the search for spiritual enlightenment. The same themes occur in the stories she wrote. She had a series of personal exhibitions in Mexico, culminating in two major retrospectives in 1964 and 1971.

*Literature:* W. Chadwick, *Women artists and the Surrealist movement*, London, 1985; J. Kaplan, 'RV: voyages and visions', *WAJ*, v1/2, fall 1980-winter 1981, 13–8; J. Kaplan, *Unexpected journeys: the life and work of RV*, London, 1988, Krichbaum; Petersen; Vergine.

## VASSILIEFF, Marie (1884–1957)

*Russian Cubist painter who established her own academy in Paris*

Born into a wealthy family in Smolensk, she attended the St Petersburg Academy from 1902. In 1905 she paid her first visit to Paris through a scholarship and returned to settle permanently in 1907. She enrolled at Matisse's academy, where she met many young artists and writers. When she established her own academy in 1909, it quickly became a popular meeting place for progressive literary and artistic people. The style of her paintings before World War I was based on Cubism, but she also attempted sculpture. During World War I she made her academy into a canteen for all academics and painters in Paris who were in financial difficulties. Valadon (*q.v.*), Picabia and Diaghilev were frequent customers. Moving to southern France, she had solo shows in Italy, London and France during the 1920s, when she worked in a decorative Cubist style. She also became involved with theatre decorations and set designs from 1924.

*Examples:* Petit Palais, Geneva; Mus. de la Ville, Paris.

*Literature: Modernism and tradition*, Whitford & Hughes G, London, 1986; Schurr, vl; Vergine.

## VELLACOTT, Elizabeth (1905–)

*English stage designer, later a painter of figure subjects and landscapes*

Born in Grays, Essex, Vellacott was the oldest child and only daughter of an accountant. Apart from a few years in London, her childhood was spent in the country, the family moving to Cambridge in 1912, when her father gave up his business to enter the Church. This part of England was to be the focal point of her artistic life. She attended Willesden School of Art, and in 1925 entered the Royal College of Art. She can recall little teaching there, but far more influential were visits to the Victoria and Albert Museum's decorative art collections, an exhibition of Russian ikons, and the spectacle of the Diaghilev ballet. In 1929 she tried to set up as an independent textile designer, but was invited by Cambridge University Musical Society to design sets and costumes for Purcell's *Fairy Queen*. In 1931 she took a full-time job as a scene painter at the Old Vic under Lilian

Baylis. Through this she worked with Sophie Fe-
dorovitch (*q.v.*) on *The Snow Maiden* and with Gwen
Raverat (*q.v.*) on several productions of Handel.
In 1939 the writer Lucy Boston commissioned
Vellacott to design fabrics and carry out decorative
frescoes for her house near Cambridge. Vellacott's
interest in painting began to reassert itself during
the 1940s, and after the war she took the opport-
unity to travel more. She became friendly with
Nan Youngman (*q.v.*) and Betty Rea (*q.v.*), with
whom she served from 1952 as an examiner in
crafts for the Cambridge Schools Examination
Board. During the 1950s she began her habit of
drawing in the open air. She also tried to find a
way of creating the impression of volume through
line, because she wanted to use flat unmodulated
areas of colour. Her subjects include landscape and
still lifes, while the figure subjects extend from
observation of social customs and figures in lands-
cape to religious subjects, some of which recall
early paintings by Stanley Spencer. There is a sur-
real or fantasy element in some of her works. The
concept of inside forms as man-made while out-
side forms are organic, which she evolved during
the early 1960s, led to her fascination in relating
figures to these two situations. Some paintings
also show an opening up of interior space, which
derives both from scene painting and from her
study of oriental art. She had her first solo show
in 1968 and since then has exhibited regularly.

*Examples:* Bolton; Kettle's Yard, Cambridge;
Derby.

*Literature:* B. Robertson, *EV: paintings and draw-
ings, 1942–81*, Kettle's Yard, Cambridge, 1981.

## VEZELAY, Paule. (pseud. of Margaret WATSON-WILLIAMS) (1892–)

*English abstract painter and constructor of boxes con-
taining linear wire elements*

Born in Clifton, Bristol, she was one of three
children of an ear, nose and throat consultant.
After three years at Bristol Art School, she moved
to London in 1912 and enrolled at the Slade.
Rapidly disillusioned by having to work in the
beginners' class with a 4H pencil, she left and
instead attended the London School of Art, where
the models were characters from the streets. She
became the head of Belcher's class. In the evenings
she studied printmaking, and it was this aspect of
her work which began her career, for in 1916 her

first illustrations were published, well received
and more were commissioned. From the time of
her first solo show in Brussels and her first visit to
Paris, both in 1920, she concentrated on painting,
moving from a late Impressionism to a stronger
more simplified style. In 1926 she settled in Paris,
inspired by its overall liveliness, and adopted her
pseudonym after a visit to the famous Romanesque
church in the village of Vézelay. Her work rapidly
took a more geometrical turn and from this period
date many of her paintings with vase-shaped
motifs derived from Synthetic Cubism. She came
to know many artists in Paris, including Sophie
Taüber-Arp (*q.v.*) and Jean Arp, who were to
remain lifelong friends. It was Jean Arp who
impelled her into abstraction by advising her
against starting from reality; abstraction was in-
vention. Some biomorphic shapes and calligraphic
lines from the early 1930s are indicative of her
contact with André Masson and Surrealism, but
gradually expunging this from her work she
turned to more classical compositions of flat
grounds with contrasting forms floating in front.
In 1934 she was invited to join the Abstraction-
Création group, and soon afterwards made one of
her few sculptures, extending the same ideas into
three dimensions. At the same time she also began
to produce her 'lines in space', small wooden
boxes in which thread, later wire, of various kinds
was stretched, and some contrasting curved motif
added. Each element cast a shadow, which pro-
vided another element. First exhibited in 1937,
they greatly enhanced her reputation as an artist
and she was invited to participate in prestigious
exhibitions in Milan and Amsterdam. Just as her
career was at this crucial point the outbreak of
war caused her to return to Bristol, where she
was able to do little work and felt very isolated.
A move to London in 1942 led to a solo show, and
she also carried out some drawings of a barrage
balloon centre operated by women. On her return
to Paris in 1946 she found that her studio had
been looted and reluctantly decided to remain
in England, although she was an active member
of several French-based groups of abstract artists,
as well as of the left-wing Allied Artists' Asso-
ciation in London (1944–7). She continued to
develop her 'lines in space' and other work, with
exhibitions in Europe and America, culminating
in a retrospective at the Tate Gallery in 1983.

*Publications:* See below under London, Tate G.

*Examples:* Tate G, London.

*Literature: Abstraction-Création 1930–6*, Mus. de

la Ville, Paris, 1978; R. Alley, *PV*, Tate G, London, 1983 (bibl.); Krichbaum; V. Rembert, 'PV's lines in space and other works', *Arts Mag.*, v58, Nov. 1980, 98–103.

## VIEIRA DA SILVA, Maria Elena (1908–)

*Brazilian-born abstract painter who works in France*

Now an internationally acclaimed artist, she was born in Lisbon to Brazilian parents. After initial study of sculpture in Paris under Bourdelle and Despiau, she turned to painting and became a pupil of Léger, Friesz and Bissière. However, probably the most profound influence on her was the Atelier 17 workshop of the English Surrealist Stanley Hayter, although she also received a thorough grounding in later Cubist painting from Léger and Friesz. In 1930 she married the Hungarian painter Arpad Szenés, who has been very supportive throughout her career and with whom she has exhibited several times. Her first solo show came in 1933 but, like many Parisian-based artists, her pattern of existence was interrupted by World War II. She went first to Lisbon and then spent 1940–7 in Rio de Janeiro. Returning to Paris she soon became internationally famous with a series of mysterious allusive paintings with titles such as *Enigma*, which suggest links with Surrealism. The complex linear forms are suspended in space in such a way as to create haunting vistas. Increasingly she made use of transparency to allow the walls of her structures to dissolve into wiry labyrinths. Some of her work was influenced by architectural forms so that, for example, the skyscrapers seen on her visit to New York in 1961 give her work a more geometrical form. She creates great depths combined with impenetrable spaces and mysterious horizons. In 1956 she became a French citizen, and ten years later won the Grand Prix International des Arts, the highest award given by the French state.

*Examples:* Stedelijk Mus., Amsterdam; Basle; Grenoble; Lille; Tate G, London; Mus. Nat. de l'Art Moderne, Paris; Carnegie Inst., Pittsburgh; Sao Paolo; Toledo, Ohio; Wuppertal.

*Literature:* Fine, 1978; Heller; Krichbaum; J. Lassaigne & G. Weelen, *V da S*, Paris, 1978, Eng. trans. New York, 1979; *School of Paris, 1959*, Walker Art Center, Minn., 1959; A. Terrasse, *L'Univers de V da S*, Paris, 1977; D. Valier, *La peinture de V da S*, Paris, 1971.

## VOLLMER, Ruth. née LANDSHOFF (1899–)

*German-born sculptor of geometrical works, a precursor of Minimalism, who worked in America*

Vollmer was born in Munich, where her musical parents, both professionals, brought many eminent intellectuals to the house. After World War I she lived in Berlin and was therefore aware of the Constructivists and the Bauhaus, and this helped the refinement of her work. In 1930 she married a pediatrician, but they moved to New York five years later with the rise of the Nazis, and became American citizens in 1943. At this period she was constructing sculpture out of wire mesh and industrial materials, but she acquired a kiln and after experimenting with clay began to cast the sculpture in bronze. Many of her works have explored mathematical concepts and some of her more recent sculpture is based on speculative geometry, including the representation of formulas in concrete form. In the early 1960s she was influential in the formation of the ideas of many artists who went on to produce Minimalist work, including Eva Hesse (*q.v.*) and Donald Judd.

*Literature:* B. Friedman, 'The quiet world of RV', *Art International*, v9/2, Mar. 12, 1965, 26–8; Rubinstein.

## VONNOH, Bessie Onahotema. née POTTER (1872–1955)

*American sculptor of small bronzes of genre subjects in a free-flowing style*

A native of St Louis, Missouri, she moved to Chicago with her family when she was two. At the age of 18 she enrolled at the Art Institute there under Lorado Taft, and was one of his assistants on the work for the 1893 Chicago Exposition. She independently entered a model of an allegorical figure for the Women's Building and this was subsequently made for the Illinois pavilion. At the Exposition she encountered the small bronze sculptures by Paul Troubetskoy, which led her to experiment with figurines. She travelled in 1895 to Paris, where she met Rodin, and also visited Florence in 1897, but she did not study with any artists in Europe. Her early figures were young women in full skirts and puffed sleeves, sometimes with silvered highlights to parallel the effect of light in Impressionist paintings. Although she always depicted female figures or children, she

turned from contemporary dress to the nude or classically draped figure. Her work was extremely popular and she was given a solo show at the Brooklyn Museum in 1913, the year in which she also exhibited in the Armory Show. She was equally at home with dancers or the seated figure. One group of three dancers won a gold medal at the NAD in 1921, an institution of which she had become an Associate in 1906, and in due course a full member. She was also elected to membership of the National Sculpture Society and of the National Institute of Arts and Letters. Later she worked on a larger scale although retaining her attachment to the theme of children, but sometimes including birds or animals, notably in fountains or site specific sculpture. In 1899 she married the painter, Robert Vonnoh, with whom she had several joint shows. After his death in 1933, her rate of work decreased. In 1948 she married Dr Edward Keyes, who died nine months later.

*Examples:* Brookgreen Gardens, SC; Brooklyn; Chicago; Detroit; Montclair; Newark, NJ; Metropolitan Mus., New York; Carnegie Inst., Pittsburgh; San Diego; Corcoran G and NMWA, Washington, DC.

*Literature:* Bachmann; M. Hill, *The woman sculptor: Malvina Hoffman and her contemporaries*, Berry-Hill G, New York, 1984; J. Lemp, *Women at work*, Corcoran G, Washington, DC, 1987; NMWA catalogue; Proske, 1968; Rubinstein; Tufts, 1987; Weimann.

## WALDBERG, Isabelle. née FARNER (1911–)

*Swiss sculptor of abstract works in metal wire*

Born into a modest rural family in Oberstammheim, she was interested from childhood in the plastic arts, literature and music. A chance meeting with Hans Mayer in Zurich led to his instructing her over a two-year period (1934–6), at the end of which she won a prize. She then went to Paris enrolling at the Grande Chaumière, Colarossi and Ranson academies and undertaking a course studying primitive art. A brief visit to Italy, where she saw the remains of ancient Roman civilisation, influenced her work of this period towards a classical tendency in form and content. She mixed in Surrealist circles and came to know Alberto Giacometti well. She married the Surrealist Patrick Waldberg. From 1942 to 1946 she lived in New York and during this time she was given a solo show at Peggy Guggenheim's Art of This Century Gallery. By this stage she was starting to work with wire, resulting in more abstract pieces in a Surrealist vein with titles which suggest only one of several possible interpretations. After her return to Paris, she contributed to the 1947 Surrealist exhibition and had a succession of other group and solo shows, winning a number of prizes. In 1973 she joined the staff at the École des Beaux-Arts, Paris.

*Examples:* Mus. Nat. de l'Art Moderne and Mus. de la Ville, Paris.

*Literature:* Krichbaum; Mackay; Vergine.

## WALKER, (Dame) Ethel (1861–1951)

*Scottish painter of landscapes, marine views, women and flowers in a style evolved from Impressionism*

Ethel Walker was born in Edinburgh, but it was only after visiting a private collection of oriental art when she was in her twenties that she determined to become a painter, and Chinese paintings were to remain an influence all her life. She trained in London, as her family had moved to Wimbledon, and for two years attended the Ridley School of Art, followed by Putney School of Art about 1883. During a visit to Spain in 1884 she met the writer and critic George Moore. After an interval she briefly went to the Westminster School of Art, before transferring to the Slade, where she was taught by Fred Brown and Sickert between 1892 and 1894. Her initial admiration for Whistler and Wilson Steer was extended, through visits to Paris and Madrid, to Velasquez and Manet. Her early paintings tend to be in rich but sombre tones and it was only through a series of large decorative panels that her palette lightened due to the influence of Impressionism. She executed such schemes at intervals through her career, but the opportunities for mural work in England have always been limited. These works showed the oriental influence most strongly, not only in form but also in content. She began exhibiting at the RA in 1898 and at NEAC in 1900, and maintained a regular presence there over many years. She was represented at the St Louis Exposition in 1904. Her membership of NEAC was logical, for the group were trying to establish a foothold for Impressionism in England at a time when she herself was taking up and freely interpreting elements of it for her own work. She modelled in pure colour, using

both sides and the couple, which persisted until their death. Ward herself had eight children but, thanks to domestic help and the support of her husband, she was able to continue painting even though she still had to administer the household. On occasion she made use of her children as models, for many of her historical scenes are fundamentally domestic. There were fewer competent women artists at this time and her work was viewed as exceptional for a woman, particularly her historical subjects, which had been regarded as a traditional male preserve. From the mid-1850s Ward began to receive the first of many portrait commissions from the royal family. She and Edward came to know Queen Victoria and Prince Albert well, and Henrietta Ward taught several of the royal children. Press attention continued until the advent of the *Roll Call* of 1874 by Elizabeth Thompson (see under Butler). In 1879 Edward Ward died, leaving Henrietta with eight children, the youngest of which were still dependent. She therefore decided to open an art school for 'young ladies' in London. From this time the number of paintings which she exhibited declined, partly because she was otherwise occupied and partly because her work appeared dated. She stopped painting historical themes and turned to landscape and genre, some of which were shown at the Chicago Exposition of 1893. Nevertheless she was still sending pictures to the RA in the year of her death, when she was 91. Two of her daughters, Eva and Flora, became professional painters, exhibiting at the RA from the early 1870s. She wrote two volumes of memoirs.

*Publications: Reminiscences*, London, 1911; *Memories of ninety years*, London, 1924.

*Examples:* Bristol; Leicester; WAG, Liverpool; Rochdale.

*Literature:* AJ, 1864, 357–9; D. Cherry, *Painting women: Victorian women artists*, Art G, Rochdale, 1987; Clayton; M. Elliott; P. Nunn, 'The case-history of a woman artist: HW', *Art History*, v1/3, Sept. 1978, 293–308; P. Nunn, *Canvassing*, London, 1986; P. Nunn, *Victorian women artists*, London, 1987; Nottingham, 1982; Sellars; Weimann.

## WARING, Laura. née WHEELER (1887–1948)

*American portrait painter*

Born in Hartford, Connecticut, she trained from 1918 to 1924 at the Pennsylvania Academy, winn-

ing a scholarship which enabled her to go for a year to Paris, where she studied at the Académie de la Grande Chaumière. From 1927, when she won a major prize, her work was included in many important exhibitions. In the 1940s she shared with Betsy Graves Reyneau the commission for portraits of 'Outstanding Americans of negro origin'. Her work is distinguished by a flair for depicting colourful personalities with warmth and regard. Her style is usually broadly brushed strokes of paint with her subject set against a light background. Although specialising in portraits, she also painted still lifes, landscape and genre scenes. For many years she taught at Cheyney State Teachers' College, where she became head of department. Her husband was on the staff of Lincoln University.

*Examples:* Nat. Portrait G and NMAA, Washington, DC.

*Literature:* D. Driskell, *Two centuries of black American art*, County Mus. of Art, Los Angeles, 1976; Rubinstein; Tufts, 1987.

## WATERFORD, Louisa Ann, Marchioness of. née The Hon. Miss STUART (1818–91)

*English amateur painter of biblical, allegorical and contemporary moral scenes*

Born in Paris, where her father was British ambassador, she moved to England in 1824, when her family went to live at Highcliffe Castle, then in Hampshire. Louisa Stuart and sister Charlotte, who was a year older, were very close and were brought up as part of the aristocracy. Their mother was a competent artist and ensured that the girls were well educated. Louisa's talent for drawing was encouraged but none of her teachers was particularly distinguished. Of greater influence were visits to Italy with her family. Her own inclination in art was towards observation of nature combined with a moralising subject, presented in a style influenced by the Italian Renaissance. In this she was not dissimilar to John Ruskin, whom she met in the early 1850s and with whom she carried on a considerable correspondence, in which he sent advice and criticism in a negative and discouraging way. However, it was through him that she was able to meet the Pre-Raphaelites, whose work and technique she admired. They in turn were impressed by both her work and her appearance. In 1842 she had married the Marquis

of Waterford and moved to southern Ireland, so that she met other artists only rarely. Her geographical location was one of the reasons why she did not participate in the art world to a greater extent. In addition her aristocratic position meant that she did not need to practise at a professional level, but had both the means and the leisure to paint as she wished. Nunn points to a further reason, her tendency to self-deprecation and humility, which may have derived from genuine Christian feelings as well as from social convention. She had no children and, on the death of her husband in 1859, she went to live in the village of Ford in Northumberland. There she carried out a cycle of frescos on the walls of the schoolroom. The design and style of the scheme is Italian and the subjects are biblical. In the 1870s she became increasingly frustrated by the way in which her position as lady of the manor impinged on her art, and by the competent work produced by younger and better-trained women artists. The exhibition of her drawings at the Grosvenor Gallery, which opened in the 1880s, broadened her horizons and gave her renewed enthusiasm. Many more of her works were seen shortly after her death, while in 1910 over 300 pieces of work were shown.

*Examples:* Bolton; Fitzwilliam Mus., Cambridge; Nat. G of Scotland, Edinburgh; Ford, Northumberland; parish church, Highcliffe, Dorset; British Mus., V & A and Tate G, London; Newcastle-upon-Tyne; library, Richmond, Surrey.

*Literature:* Clayton; A. Hare, *Two noble lives*, London, 1893; Nottingham, 1982; P. Nunn, *Victorian women artists*, London, 1987; W.S. Sparrow; C. Stuart, *Short sketch of the life of LM of W*, London, 1892; *Studio*, v49, 1910, 283–6; V. Surtees, *Sublime and instructive: letters from John Ruskin to LM of W, Anna Blunden and Ellen Heaton*, London, 1872; *Lady W centenary exhibition*, Lady Waterford Hall, Ford, Northumberland, 1983; Yeldham.

## WATERS, Susan Catherine. née MOORE (1823–1900)

*American animal and itinerant portrait painter*

Waters is one of the few documented women artists who earned her living as a travelling portrait painter. Born in Binghampton, New York State, she grew up in Friendsville, Pennsylvania, where by the age of 15 she was earning her school fees making drawings for her natural history teacher. In 1841 she married a Quaker, William Waters,

who encouraged her artistic activity, and from 1843 to 1845 they travelled together through the state so that Susan Waters could earn money as an itinerant portrait painter. Documentation is patchy, but in 1855 the couple were living in Iowa and by 1866 had settled permanently in New Jersey. There she painted animals, often with their food; her preferred species was sheep, of which she kept a small number, and she continued to work until her death. She also made daguerrotypes and ambrotypes.

*Literature:* Rubinstein; *Women artists of America, 1704–1964*, Mus., Newark, NJ, 1965.

## WATSON, Mary Spencer (1913–)

*English sculptor of figures and animals in stone and wood*

The daughter of a Royal Academician, the painter George Spencer Watson, she was born in London, but when she was nine the family moved to the Dorset village of Langton Matravers. Close by were many Purbeck stone quarries, where Watson spent much of her free time, and her future as a sculptor became clear. In due course two quarrymen showed her how to carve the stone and gave her a set of tools. Her formal training took place at Bournemouth College of Art from 1928, the Slade (1930–1), the RA Schools and the Central School (1934). In 1937 she studied woodcarving with Zadkine in Paris. In order to earn her living she taught part-time while establishing herself, but after 1951 she gave this up in order to concentrate on the many architectural commissions she received. Her carved monumental figures, particularly when in Purbeck stone, are imbued with a sense of movement in the windswept hair or garments. While aware of modernism, she was too sympathetic to traditional sculptural values to follow suit and has rarely mixed with other artists. She has been fascinated by the animal world since childhood, and a mystical quality pervades her birds, mammals and fish, as well as the mythical and legendary figures she depicts. Her London exhibitions include WIAC, for whom she served as a member of the sculpture committee in the late 1940s. In 1983 she exhibited in the Portland sculpture park.

*Examples:* St Etheldrea's chapel, Chesfield, Herts; Harlow New Town; cathedral, Guildford.

*Literature:* Mackay; B. Read & P. Skipwith,

*British sculpture between the wars*, Fine Art Society, London, 1986; Waters; *Who's Who in Art*.

## WATSON-WILLIAMS, M. See VEZELAY, Paule

## WATT, Alison (1965–)

*Scottish realist painter of figures, portraits and still lifes*

Born in Greenock, Watt trained at the Glasgow School of Art as both undergraduate and postgraduate (1983–8), where she formed part of an exceptional cohort of talented women painters. She has won several prizes, the most prestigious being the John Player Portrait award, in which she exhibited *Self-portrait with tea cup*, an intensely seen image whose hyper-realism borders on the surreal.

*Literature:* E. Hilliard, 'John Player Portrait award', *Arts Review*, 19 June 1987; J. Picardie, 'Here come the Glasgow Girls', *The Independent*, 22 June 1987.

## WAYNE, June Claire. née KLINE (1918–)

*American lithographer and founder of the Tamarind Lithography Workshop*

Born in Chicago, she lived with her Russian-born mother, who, after her divorce, worked to support both her daughter and her mother. From the start she believed that women were able to manage. Although intelligent, she was largely self-educated because she truanted from school. Her first solo show at the age of 17, under the name June Claire, brought her an invitation from the Mexican government to paint and exhibit there, after which she worked in the Federal Art Project in Illinois. Her political lobbying against legislation that downgraded the conditions under which artists were employed on such schemes marked the beginning of her continuous concern about artists' financial circumstances. The business experience acquired through a period in New York from 1939, when she designed and sold costume jewellery, was to prove invaluable when she set up the Tamarind Lithography Workshop in 1960, initially under a Ford Foundation grant. After marriage to a doctor in 1941, a move to Los Angeles and the birth of a daughter, Wayne became

fascinated by lithography in 1947. Her prints of the 1950s explored philosophical themes, many about the condition of modern life, influenced by the writings of Franz Kafka. Later works also deal with scientific discoveries such as that of DNA. It was after a period in Paris in 1957 that Wayne first became aware of the inadequacy of centres of excellence in printmaking. The aim of her workshop was to invite leading artists there for a set period to work with younger printmakers, who in turn left to set up similar workshops throughout America. It proved extremely successful, continuing to attract grants, and its work was exhibited at MOMA, New York, in 1969. In 1970 Wayne established the Tamarind Institute on a permanent basis at the University of New Mexico, but left it in order to concentrate on her own work, which has continued to expand the technical procedures for printmaking. An early participant in the women's movement, she ran business seminars for young women artists, in addition to writing and broadcasting.

*Publications:* 'The male artist as stereotypical female', *Art News*, v32, Dec. 1973, 414–6. Reprinted in *Feminist Collage: educating women in the visual arts*, J. Loeb (ed.), New York & London, 1979; 'The creative process', *Craft Horizons*, Oct. 1976.

*Literature:* M. Baskett, *The art of JW*, New York, 1969; Munro; Rubinstein.

## WEEMS, Katherine Ward. née LANE (1899–)

*American sculptor of animals*

In addition to her training at the school of the Museum of Fine Arts in her native Boston, she studied privately under Charles Grafly, Anna Hyatt Huntington (*q.v.*) and Brenda Putnam (*q.v.*). She began to exhibit in 1924 and only two years later won the first of a succession of national and international awards. In 1930 she demonstrated various sculptural techniques for a film entitled *From clay to bronze* for the Boston Museum. Her later work became increasingly simplified, but all her output is characterised by a strong sense of design which emerges from the natural forms. The three large relief panels, consisting of some 33 animals, which she executed for the biological laboratories at Harvard University in 1933, were carved directly onto the brick in a technique based on Chinese tomb carvings. At the age of 48 she married F. Carrington Weems and they lived in

**Katherine Weems** *Greyhounds unleashed*, 1928, bronze, 25.4 × 39.4 × 17.8 cm, Brookgreen Gardens, South Carolina. (photo: courtesy of Brookgreen Gardens, Murrells Inlet)

New York. She continued to win awards and was chosen to execute several official medals. Her distinguished career was marked by election to membership of the National Sculpture Society, of which she also served on the council, the NAD, and the National Institute of Arts and Letters.

*Examples:* Baltimore; Boston; Brookgreen Gardens, SC; Calgary; PAFA, Philadelphia.

*Literature: Fair Muse*; Proske, 1968.

## WEINREICH, Agnes (1873–1946)

*American painter, collagist and printmaker who evolved her own style from Cubism*

A wealthy family background in Burlington, Iowa, caused initial opposition to the aspirations of both Agnes and her sister, Helen, who was a talented musician and to whom she remained very close all her life. Nevertheless, Agnes studied first at the local college and then at the Iowa Wesleyan College, before travelling with Helen to Berlin, where each sister was able to study in her field from 1900 to 1903. Sources vary as to how long they remained in Europe, but Agnes at some stage studied at the Art Institute in Chicago and at the Art Students' League, New York. They also visited Italy before settling in Paris for a year. This was a formative period for Agnes Weinreich, who studied Cubism with Gleizes, Léger and Lhote before the outbreak of war forced the sisters to return to America. Like many others who had recently studied in Europe, the sisters went to Provincetown, where Agnes worked with Charles Hawthorn and led a group of artists who were experimenting with Cubism. One of these was

**Agnes Weinreich** *Musical forms*, c. 1925, oil on board, 32.3 × 25.3 cm. (photo: courtesy of ACA Galleries, New York)

## WEIR, Irene (1862–1944)

*American painter, art teacher and critic*

Born in St Louis, Missouri, she was of Scottish descent and many of her immediate family were involved in art. She trained at the Yale School of Fine Arts from 1881 to 1882 and later studied under her uncle, J. Alden Weir, as well as Twachtman and Pennell. During two early visits to several European countries she studied in museums. She obtained her first teaching position in 1887 and taught in several art schools. Later she founded and from 1917 to 1929 served as director of the New York School of Design and Liberal Arts. During this period she enjoyed a further study visit to Europe. She practised a variety of media in a vigorous and independent style. She carried out penetrating portraits, posters, flower paintings, landscapes and, in the late 1920s, boldly conceived murals. Her later paintings are characterised by religious intensity. During these years she published books and numerous articles on art, lectured widely, was director of the Art Alliance of America and the Salons of America, and also participated in many artists' organisations.

*Publications:* see *Notable American Women* for listing.

*Examples:* West Side prison (mural), New York; cathedral (mural), Washington, DC.

*Literature: Notable American Women.*

Karl Knaths, whom Helen married in 1922 and to whom Agnes introduced the theories of Gleizes and on whose work she had great influence. The three lived together until Agnes Weinreich's death. In 1927 the work of modernists such as Weinreich caused a split in the local art association. Weinreich produced many abstract works derived from synthetic Cubism, including collages in which she constructed the composition from a series of planes both with and without pattern. Recognisable subjects such as interiors with still life also occur. A good friend of Peggy Guggenheim, Weinreich was able to use family contacts to make a mark on the New York art scene, into which she introduced Karl Knaths. There she was active in NYSWA, of which she was at one stage organiser and director.

*Examples:* Phillips Collection, Washington, DC.

*Literature:* Withers, 1979; A. Wolf, *New York Society of Women Artists, 1925*, ACA G, New York, 1987.

## WEJCHERT, Alexandra (1920–)

*Polish-born painter, architect and sculptor of abstract works who works in Ireland*

It was not until about 1950 that Wejchert began to study architecture at the university in her native Krakow, but by 1956 she had graduated from the Academy of Fine Arts there. From 1957 to 1959 she pursued her studies in Italy, before returning to practise as both architect and artist in Warsaw. Deciding to take up painting full-time in 1963, she went with her family to live in Ireland two years later. From painting, she turned to abstract reliefs consisting of wooden pegs attached to a painted background. These brought her considerable success. A further evolution occurred into freestanding sculpture exploiting the particular qualities of sheet perspex, of which the cut edge is a

different colour. Because of the material's flexibility, she introduced perspectival complexities through series of holes, together with implications of movement and the interplay of space with the surface of the perspex. During the 1970s she used metal clips in combination with clear perspex tubing. Both her reliefs and sculpture are in demand by architects and she has received several commissions in connection with new buildings. She continues to exhibit regularly in Ireland and in Europe.

*Examples:* Huge Lane Municipal G, Dublin; G d'Arte Moderna, Rome.

*Literature: Irish women artists.*

## WELLS, J. See BOYCE, Joanna

## WENDT, Julia M. née BRACKEN (1871–1942)

*American sculptor of large memorials, allegorical figures, reliefs, statues and portrait busts*

A native of Apple River, Illinois, she entered the Art Institute, Chicago, when only 17. During her six years there as assistant to Lorado Taft, Bracken was one of the group of women sculptors who helped him prepare the exhibits for the 1893 Chicago Exposition, for which she also executed an independent commission. By her early twenties she was a well-established sculptor, with several prestigious awards to her name. In 1906 she married the landscape painter William Wendt and moved to the west coast, settling at Laguna Beach. In 1914, three years' work culminated in the unveiling of a three-figure allegory at the Los Angeles County Museum, for which local people had subscribed $10,000. The following year she won a medal at the Panama-Pacific Exposition. Her works were greatly in demand, but she still found time to teach at the Otis Art Institute in Los Angeles for several years, although sources vary as to the exact dates.

*Examples:* County Mus. of Natural History, Los Angeles; Educational Building (in front of), St Louis; State Capitol, Springfield, Illinois.

*Literature:* Clement; Rubinstein; L. Taft, *History of America sculpture*, New York, 1903; Weimann.

## WEREFKIN, Marianne Vladimirovna von (1860–1938)

*Russian painter of figures, landscapes and portraits in an Expressionist style*

Werefkin was born in Tula, but the transfer of her family to St Petersburg enabled her to study with Ilya Repin. In 1896 she and her partner, the painter Alexei Jawlensky, whom she had met in 1891, decided to go to Munich, following the favourable reports sent back by another Russian artist already there. Gradually more compatriots assembled around them in the lively atmosphere of Munich. Werefkin retained certain beliefs from her Russian days, notably the search for an art in which philosophy, music and religion would be united; but in its outward form her art became simplified and more colourful and expressive. Anecdotal detail was suppressed so as to leave only what was vital. In Munich she exhibited in the Secession and with the Der Sturm Gallery. She was a founding member of the New Artists Association and exhibited with Der Blaue Reiter (the Blue Rider artists). On several occasions she stayed with Münter (*q.v.*) and Kandinsky during their summers at Murnau, near Munich, but like Münter she never went over the boundary of abstraction. During World War I she lived in Switzerland, settling in Ascona, where she spent the rest of her life and where there is now a museum dedicated to her work.

*Publications: Briefe an einen Unbekannten*, C. Welier (ed.), Cologne, 1960; *MW: Zeugnis und Bild*, K. Federer (ed.), Zurich, 1975.

*Examples:* Fondazione von Werefkin, Ascona; Nat. G, SMPK, Berlin; Wiesbaden.

*Literature: Das Verborgene Museum*; Fine, 1978; J Hahl-Koch, *MW und der Russische Symbolismus*, Munich, 1967; *Jawlensky und MW*, Städtisches Mus., Munich, 1958; Krichbaum; Vergine; *MW*, Wiesbaden, 1980.

## WESTHOFF, Clara (alt. RILKE; RILKE-WESTHOFF) (1878–1954)

*German sculptor who later turned to painting*

Born in Bremen, she undertook extensive studies in Munich, Dachau and, with Max Klinger, in Leipzig. In 1901 she married the poet Rainer Maria Rilke. She was active in Rome in 1903–4 and from there joined the isolated community of artists

in Worpswede, where she studied with Fritz Mackenson. She was a close friend of Modersohn-Becker (*q.v.*), of whom she executed a portrait bust. In 1908 she was in Paris studying at the Académie Julian, and in the ateliers of Bourdelle and Rodin. After a period in Munich around 1911, she settled in Fischerhude, where she remained until her death, exhibiting in Worpswede and nearby Bremen. Retrospective exhibitions were held in Bremen in 1970 and 1980.

*Examples:* Bremen; Hamburg.

*Literature:* Krichbaum; *Lexikon der Frau*; M. Sauer, *Die Bildhauerin CR-W – Leben und Werk*, Bremen, 1987.

## WHITEFORD, Kate (1952–)

*Scottish painter of semi-abstract works with rich surfaces for which an interest in earlier cultures provides the initial impetus*

Born in Glasgow, Whiteford followed a course at the Glasgow School of Art (1973–6) with one in the history of art at Glasgow University (1974–6). As a British Council scholar in Rome in 1977, she drew flaking Renaissance frescoes and the remains at Pompeii and Herculaneum. She had the first of a series of solo shows in 1978, and has also undertaken several residencies. Inspired originally by the ways in which peeling advertisement hoardings revealed the layers of earlier posters, she moved on to work based on first-hand experience of prehistoric and archaeological sites. This material was used as a basis for a number of themes, which included the idea of passing from one state to another and of the matriarchy fundamental to many early cultures. Initially working with acrylic, Whiteford changed to the more traditional technique of oil on a gesso ground, which produces an individual texture for each painting. While covering the canvas with a field of flat colour, she recaptures something of the legend and mystery of the past through her use of colour and images from those earlier cultures.

*Examples:* Glasgow; Hunterian Mus., University of Glasgow; Actors' Institute, New York.

*Literature:* M. Kemp, *Votives and Libations in summons of the oracle*, Crawford Centre for the Arts, University of St Andrews, 1983; *KW: Rites of Passage*, Third Eye Centre, Glasgow, 1984.

## WHITNEY, Anne (1821–1915)

*American sculptor of portrait busts and figures, particularly concerned with the theme of social justice*

Born in Watertown, Massachusetts, Whitney was the youngest of seven children in a liberal, middle-class family. Sufficiently intellectual and independently minded to abhor the apparent futility of unmarried life (she was unable to marry the man she loved because of insanity in his family), Whitney attempted both the more usual alternatives; she founded and ran a school and her poetry was published from 1847. Her sense of social justice was reinforced by work in New York with Elizabeth Blackwell, the first woman doctor of medicine in modern times, and encounters with her family, in which there were many women adopting unusual roles. Inspired by this to begin a career in sculpture in her thirties, Whitney was virtually self-taught. She had studied anatomy at a Brooklyn hospital and continued this during the civil war, when she worked under Dr Rimmer. From busts of her family she began to produce large-scale figures, both historical and contemporary, who were concerned with social justice. From 1867 to 1871 she was in Rome, and her allegory of the city as an old beggar woman is today her best-known work, although at the time it had to be smuggled out of Rome. On her return to America, she opened a studio in Boston and began to achieve public success from 1873 with a statue for the Capitol. Two years later her anonymous entry won a competition for a monumental figure of Senator Charles Sumner, but when the judges discovered the winner was a woman, they gave the commission to a male finalist. Refusing to allow her anger to show, she was vindicated 25 years later, when her model was cast in bronze and erected at Harvard. She participated in the major expositions of the period, with three works at the 1876 Philadelphia Centennial and seven at Chicago in 1893. The latter included commissioned busts of four outstanding women of the century. Many of her other sitters, both male and female, were involved in the campaigns for civil rights and women's emancipation and, parallel with her artistic work, Whitney was active in many societies helping the disadvantaged and oppressed. She also returned to Europe on several occasions in order to select marble for her sculptures; she ranks as one of the most distinguished of nineteenth-century American sculptors.

*Examples:* Commonwealth Ave., Boston; Harvard Sq., Cambridge, Mass.; Women's Christian

Temperance Union Mus., Evanston, Ill.; Public Library, Watertown, Mass.; Capitol statuary and NMAA, Washington, DC.

*Literature:* Bachmann; Clement; *DWB*; Fine, 1978; Heller; *Notable American Women*; E. Payne, 'AW: art and social justice', *Mass. Review*, v12, spring 1971, 245–60; Rubinstein; L. Taft, *History of American sculpture*, New York, 1903; Tufts, 1987; Weimann.

## WHITNEY, Gertrude. née VANDERBILT (1875–1942)

*American sculptor of figures, monuments and reliefs, art patron and founder of the Whitney Museum in New York*

Born in New York, she and her six siblings were brought up in luxury by their wealthy parents. She was educated at home and in Europe. Her interest in art, which emerged in childhood, was reinforced by her father's collection of art. At the age of 21 she married Harry Whitney, and gave birth to two daughters and a son. After her second child was born, she became interested in watercolour and drawing, soon turning to sculpture, which she studied with increasing seriousness, first with Hendrik Andersen and then with James Fraser at the Art Students' League. She worked in Paris under Andrew O'Connor, who likewise specialised in monumental academic sculpture, but she also received advice from Rodin, by whom she was strongly influenced. Her first public commission came in 1901 for the Buffalo Exposition, but all her work before 1910, when she won a medal at the NAD, was exhibited under pseudonyms. From 1907 she worked in a Greenwich Village studio in New York, where increased contact with other artists helped her confidence. This also marked the start of her patronage of modernist American artists at a time when there was little acceptance of such works. By 1914 the Whitney Studio Club was established next to her studio; many artists were able to exhibit there and Whitney herself purchased a considerable number of works. In 1928 this was replaced by the Whitney Studio Galleries, which operated on a more commercial basis, selling the work of young painters who had no dealers. In this way Whitney gave invaluable support to modernist American art and her own collection of art formed the basis of the Whitney Museum of Modern Art (1931) after it had been rejected by the Metropolitan Museum.

She appointed the dynamic Juliana Force as the first director. Parallel with these activities and her social and domestic obligations, Whitney pursued her own career in sculpture. In 1914 she won a prestigious competition for the *Titanic Memorial*, which was installed in Washington, DC in 1931. After her first-hand experience in World War I, when she founded and directed a hospital in France, she moved away from allegorical work to more realistic monuments and reliefs based on soldiers in action and wounded. Other monuments include a colossal equestrian statue (1924) of Col. William F. Cody (known as Buffalo Bill), and during the 1920s she maintained a Paris studio from which her monuments for Europe emerged. In 1932 she published a novel under the pseudonym of E.J. Webb, but shortly afterwards her health was affected by constant newspaper attention during her successful attempt to gain custody of her niece. She was elected a member of the National Sculpture Society and an Associate of the NAD. She exhibited at many of the major

**Gertrude Vanderbilt Whitney** *Titanic memorial*, 1931, granite, height of figure 548.6 cm, South-West Waterfront, Washington D.C. (photo: P. Dunford)

expositions in America up to the New York World Fair of 1939, and a memorial exhibition was held at the Whitney Museum in 1943.

*Examples:* Brookgreen Gardens, SC; Chicago; Buffalo Bill, Cody, Wyo; Washington Heights war memorial, New York; statue, Stuyvesant Sq., New York; Whitney Mus. and Metropolitan Mus., New York; Mus. d'Orsay, Paris; Columbus memorial, Palos, Spain; war memorial, St Nazaire, France; Potomac Park, Washington, DC.

*Literature: Fair Muse;* B. Friedman, *GVW: a biography,* New York, 1978; B. Goldsmith, *Little Gloria ... happy at last,* New York, 1986; M. Hill, *The woman sculptor: Malvina Hoffman and her contemporaries,* Berry-Hill G, New York, 1984; *Notable American Women;* Proske, 1968; Rubinstein; *GVW – memorial exhibition,* Whitney Mus., New York, 1943.

## WIEGAND, Charmion von (1899–1983)

*American abstract painter and collagist strongly influenced by oriental art and philosophy*

Born in Chicago, she spent her childhood in San Francisco. Her father was a leading journalist, which involved several postings abroad, including Berlin, where Wiegand attended school. After attempting a training in journalism (1929), she transferred to a course on art history and archaeology at Columbia University, New York. Marriage produced profound dissatisfaction, and after psychoanalysis in 1926 she began to paint, divorced her husband and became more radical. She had cause to employ her experience of journalism when she went to the USSR, during the 1930s, as editor of *Art Front,* and in writing and reviewing. In 1932 she married Joseph Freeman, founder of several left-wing magazines. A catalyst for her artistic development came when she interviewed Mondrian in 1941. They became good friends, working on the translation of Mondrian's writings into English. It was at his suggestion that she joined the American Abstract Artists in 1942, the start of a long association with the group. Despite her closeness to Mondrian, it was the Dadaist Hans Richter who encouraged her to produce biomorphic abstract paintings through the technique of automatic drawing. After Mondrian's death she began to produce her first real geometrical works as a result of a revived interest in theosophy. Through reading theosophical texts, Wiegand became increasingly fascinated by Buddhist art

in addition to Chinese, Indian and Egyptian cultures which had been the source of theosophical theories. From the art of these cultures she took certain geometrical elements which built on the influence of Mondrian's verticals and horizontals. Like Mondrian she also frequently employed primary colours although overall her colour range was less restricted. Further influences in the 1950s were a visit to a Theosophical Temple in Freehold, New Jersey, where she was overwhelmed by the colours of the interior, and an encounter with Tibetan refugees. They showed her the paintings they had brought with them and, eager to help, she organised several exhibitions of Tibetan art while beginning to draw her own imagery from the geometric forms of pure Tantric art. Thus she adopted the equilateral triangle to demonstrate the three functions of the mind, at times employing other shapes to increase the dynamism – in the Tantric sense – of the initial form. In her paintings of the 1950s and 1960s she sought many ways of representing the search for the unity of body and spirit practised by Buddhists. Von Wiegand continued working until her last illness. She remains relatively unknown in Europe, but has featured in many solo and group exhibitions in America.

*Publications:* 'The meaning of Mondrian', *J of Aesthetics and Art Criticism,* fall 1943, 62–70; 'The Oriental tradition and abstract art', in *The World of abstract art,* New York, American Abstract Artists, 1957, 55–67; 'The adamantine way', *Art News,* April 1969, 39.

*Examples:* Seattle.

*Literature:* M. Hill, *Three American Purists: Mason, Miles, VW,* Mus. of Fine Arts, Springfield, Mass., 1975; *Mondrian and Neo-Plasticism in America,* Yale University Art G., New Haven, 1979; *Paris-New York,* Mus. National d'Art Moderne, Paris, 1977; V. Rembert, 'CvW's way beyond Mondrian', *WAJ,* v4/2, fall 1983-winter 1984, 30–4; Rubinstein.

## WIEGMANN, Jenny. (alt. MUCCHI-WIEGMANN) (1895–1969)

*German figurative sculptor whose themes became increasingly based on social history*

Wiegmann was the daughter of a baker in Spandau, Berlin, her mother coming from a family of doctors and engineers. As she showed a predilection for drawing from an early age, she enrolled at a private art school in 1917, because women were not

allowed at the state academies. There she studied with Corinth and August Krause, who directed her towards a study of Graeco-Roman sculpture, and a rigorously classical approach marked her work in the 1920s. She exhibited throughout Germany, at times with her first husband, sculptor Berthold Müller. A three-year stay in France in the early 1930s, combined with the stirrings of political protest against Fascism in its various manifestations, caused her to introduce elements of distortion into her figures. In 1933 she married an Italian critic and painter, Gabriele Mucchi, and from 1934 their Milan flat became the centre of a group of modernist artists and writers. This fruitful period for Wiegmann saw the production of works subsequently exhibited at major international exhibitions, but was brought to an abrupt end by the outbreak of war. Wiegmann was active in the Resistance and in 1944 her studio was destroyed. In the post-war years she modelled in plaster, since no other material was available at the time. Subsequently her sculpture was cast in copper and the surface embossed. After her return to East Berlin to seek her family, and the division of her time between Berlin and Milan after 1956, when her husband was appointed a professor in the Kunsthochschule, social themes in her art became stronger. A portrait of Rosa Luxembourg (1956, terracotta) was succeeded by several works with Algerian themes during the conflict in that country. Although relatively unknown in the West, she has featured in many exhibitions in East Germany and Italy. In 1970 a retrospective exhibition was held in East Berlin, where she had died the previous year.

*Examples:* Nat. G, East Berlin; Berlinische G, West Berlin.

*Literature: Das Verborgene Museum*; Edouard-Joseph; Mackay; Vergine; *JM-W*, Nat. G, East Berlin, 1970.

## WIIK, Maria Katarina (1853–1928)

*Finnish painter of interiors, figures and portraits*

Wiik came from an educated middle-class family. Her father was architect for the province of Uusimaa, while her mother was from an academic family. Her training in art began in 1873 with some months in Becker's Helsinki atelier. This was followed by attendance, again for several months, at both the Drawing School of the Finnish Fine Art Association and Falkman's studio. Like other Finnish women artists she realised the necessity for a period in Paris, and in 1875–6 she was enrolled at the Académie Julian. The death of her father caused an abrupt change in her life, and from 1876, with her return to Helsinki, her life had to be orientated more towards economic concerns. After working for a year in Helsinki, she succeeded in returning to Julian's from 1877 to 1880. She exhibited for the first time in 1878, in Helsinki. On her return from Paris she became a demonstrator at the Drawing School, where she had herself been a pupil. But after a year she seems to have been able to support herself from the sale of her paintings as she became well known for her convincing portraits. During the 1880s she travelled a good deal, both within her own country and to Paris (where she studied under Puvis de Chavannes) as well as Brittany (1884), Normandy (1886) and St Ives, Cornwall (1889). It was not until 1895 that she first visited Italy. She won a number of awards, including a bronze medal at the Paris Exposition of 1900. In succeeding years she spent more time in Finland, but the years were punctuated by visits to other parts of Europe. Up to 1923 she participated in exhibitions in several European countries, but she stopped showing after that. Her early works show a restrained realism, but by the late 1880s she was simplifying her composition and using a limited range of sombre tones for her interiors. She was, however, best known for her portraits and was regarded by her contemporaries as the foremost Finnish portrait artist.

*Examples:* Helsinki; Mänttä; Stockholm; Turku.

*Literature:* Krichbaum; *Lexikon der Frau; Sieben Finnische Malerinnen*, Kunsthalle, Hamburg, 1983; W.S. Sparrow.

## WILDING, Alison (1948–)

*English sculptor creating metaphors for states of mind or relations between objects or people*

Born in Blackburn, Lancashire, Wilding trained at Ravensbourne College of Art (1967–70) and at the Royal College of Art (1970–3). Her early pieces consisted of multi-media installations – often including photography, text and sound – through which she questioned apparently established tenets in order to try to structure and categorise experiences. Concerned with the physicality of objects, Wilding used everyday materials and manufactured goods. This attitude changed

in the late 1970s and a clear evolution took place. Although her works of the 1980s are often abstract they may derive from a simple everyday object which, through the direct engagement with materials, becomes transformed into an ikon. She uses wood and metals in imaginative combinations to contrast textures and surface finish. Some of her sculptures relate to floor, others to the wall. Some less abstract forms are still recognisable as an egg, a wing or a beak, for example. The metaphors are fundamental to the works in the way that verbal metaphors occur in poetry, so that Wilding is referred to by critics as a poetic sculptor. She married her boyfriend after he had been confined to a wheelchair, the result of an accident in which she too was involved, and now looks after him. Since her first solo show in 1976 she has exhibited regularly in England, America and Italy, and has been represented in a number of major exhibitions.

*Literature:* F. Crighton, *Eight artists: women*, Acme G, London, 1980; L. Cooke, *AW*, Serpentine G, London, 1985; *Current affairs*, MOMA, Oxford, 1987; M. Newman, 'New sculpture in Britain', *Art in America*, Sept. 1982, 104–14, 177–9; *The sculpture show: British sculpture, 1983*, Hayward G, London, 1983.

## WILLIAMS, Evelyn (1929–)

*English sculptor of figures and heads, usually of women, which often comment on social problems*

After 12 years' education at the progressive Summerhill School in Norfolk, Williams enrolled at St Martin's College of Art in 1944. Having spent three years there, she went on to the Royal College of Art, which she attended until 1950, winning a painting prize in her final year. From her earliest work she has looked intensely at people, seeing them as isolated individuals. She continued to work through marriage and the arrival of children. Indeed it was the birth of her first child which precipitated a change in her work. During her exploration of different media, she produced papier-mâché reliefs, later finding clay and finally wax more tractable to work with since they allowed for alterations. Her clay works are either moulded or carved from a solid block. Having found a suitable combination of waxes, she moulds them onto a wire form previously covered in bandages soaked with plaster. Her single faces gradually multiplied, so that in some works one or two women stand at each window-shaped opening in a large building. Williams still emphasises the loneliness of women in her work. Her more recent painted reliefs have been made in a new self-hardening clay.

*Literature:* M. Beaumont, 'EW', *Arts Review*, v36/15, 3 Aug. 1984, 386; S. Cawkwell, 'Out of the archive: EW', *WASL J*, Aug.–Sept. 1988, 18–19; *EW*, Ikon G, Birmingham, 1985; *EW: a retrospective exhibition, 1945–72*, Whitechapel G, London, 1972.

## WILLIAMS, Lois (1953–)

*Welsh sculptor whose works allude to commonplace objects and are constructed in a variety of easily available non-traditional materials*

Born in Denbigh, Clwyd, she trained at Manchester Polytechnic (1972–5) before undertaking a postgraduate teaching certificate at Goldsmiths' College, London. She then taught in schools for several years, while maintaining a studio in an old Welsh farmhouse, before deciding to spend all her time in Wales from 1985. Exhibiting since 1976 she has shown a commitment to working with other women. She was one of the original members of the Artemesia group of women artists, who live outside London and came together to organise exhibitions of their work. She also participated in the 1984 Pandora's Box touring exhibition of work by women artists. The theme fitted in with the sculptures centred around the idea of the box or container, which had recurred in her work over several years. Some of her works refer to domestic imagery, while others deal more directly with the processes involved, which focus on a direct response to the materials, including sewn sacking and papier-mâché structures. She prefers qualities of impermanence and changeability.

*Literature: Along the lines of resistance: an exhibition of contemporary feminist art*, Cooper G, Barnsley, 1988; *Conceptual clothing*, Ikon G, Birmingham, 1987; *Out of isolation*, Library Arts Centre, Wrexham, Clwyd, 1986; *Pandora's box*, Arnolfini G, Bristol, 1984.

## WILLIAMS, Gwendolen. née Lucy Gwendolen WILLIAMS (1870–1955)

*Welsh sculptor, particularly of bronze statuettes*

Born in New Ferry, Cheshire, she came from a Welsh family. As a vicar, her father was moved to

**L. Gwendolen Williams** *The Chase*, 1910, bronze, height 35 cm, Walker Art Gallery, Liverpool. (photo: John Mills (Photography) Ltd)

Bleasby, Nottingham, where she spent much of her childhood. Nothing is known of any early aspirations or instruction, and she is next heard of as a student at Wimbledon School of Art, the only residential art school for women, from 1892 to 1893. In 1893 her first work – a head of Hypatia – was accepted at the RA. Her tutor there was Alfred Drury, who advised her to make a career in sculpture. She therefore proceeded to the South Kensington Schools, where a group of exceptional women sculptors were working under Lanteri and where she won a medal in 1894. She followed this with a period in Paris at the Académie Colarossi, which provided her with the foundation for a successful career. She exhibited regularly in London, Glasgow and Liverpool, had a solo show of her bronzes and watercolours in 1935 and was represented in Paris, New York and Santiago. Early in her career she was based in Chelsea, but in 1912 was recorded as living in Rome. She became known for fountain figures, which were a natural development from her small bronze statues. The popularity of statuettes at this period created openings for sculptors and a number of women were active in this field in Britain.

Williams' subjects were drawn from literature and mythology, as well as the depiction of children.

*Examples:* Leeds; WAG, Liverpool.

*Literature:* S. Beattie, *The new sculpture*, New Haven and London, 1983; Mackay; *Mag. of Art*, 1901, 504; T.M. Rees, *Welsh painters, engravers and sculptors*, Cardiff, 1912; Sellars; Waters; *Who's Who in Art*.

## WILSON, Martha (1947–)

*American performance artist*

Wilson gained a BA at Wilmington College, Ohio, in 1969 and in 1971 obtained an MA from Dalhousie University, Nova Scotia. She has taught at the latter institution and at the School of Visual Arts, New York. Her early performances explored identity through the use of disguise, which enabled her to assume different identities. In 1972 she collaborated with Jacki Apple to create a composite person. With the formation of the group Disband in 1978, Wilson has pursued this idea of collaboration. Membership has changed but consists of five altogether. Each artist also has her individual career parallel to the group. Wilson's own work has been based on personal and social concerns. In 1976 she founded the Franklin Furnace Archive in New York and has remained its director. Its purpose is to act as a centre for artists' books, but performances are regularly staged there.

*Literature:* L. Burnham, 'Per/for/mance: American performance artists in Italy', *High Performance*, summer 1980; L. Lippard, *Get the message*, New York, 1984; Roth.

## WINSOR, Jacqueline. née Vera Jacqueline WINSOR (1941–)

*Canadian-born abstract sculptor, working in America, whose chief concern is with process*

The eldest of three daughters, Winsor spent her childhood in St John's, Newfoundland. She had a strong role model in her mother, who built one of the family houses virtually single-handed while her father was away. Despite recognition of her artistic talent she trained as a secretary, and only after finding she was not suited to this did she go to Massachusetts College of Art, graduating in 1965. Two years later she emerged from Rutgers

University with her MFA and settled in New York. She soon became anxious about the possible health risks involved in using resin for her large rough-textured, grey sculptures, which resembled rocks, and in the late 1960s she began to work with hemp and rope, at first in conjunction with resin so that the rope stood up by itself. Dispensing entirely with the resin, Winsor wound the rope round itself. In cases where the diameter of the rope was ten centimetres, the material dictated what could be done. By the addition of wood, Winsor created a series of bound structures, both indoors and out. The process of unwinding rope in order to obtain thinner strings of hemp, and the binding together or wrapping of the wood, often saplings, with the string became ritualistic. Made of natural materials, her sculptures fitted in with their outdoor surroundings. From 1974 she began to produce box-like structures, which have small openings like tunnels going inside, by which the interior space is lit and therefore made accessible to the spectator. Her materials for the boxes include wood, plaster, concrete and even gold leaf. The colour and texture of the boxes result from the combinations of these materials and, although the initial impression is one of density and solidity, the formal elements direct the spectator towards the private interior, the core of the piece. Winsor has exhibited extensively since 1968.

*Examples:* Akron; Boston; Albright-Knox G, Buffalo, NY; Detroit; Whitney Mus. and MOMA, New York; San Francisco.

*Literature:* J. Gruen, 'JW: eloquence of a Yankie pioneer', *Art News*, v78/3, Mar. 1979, 57–60; L. Lippard, *From the Center*, New York, 1976; L. Lippard, *Strata*, Art G, Vancouver, 1977; Munro; R. Pincus-Witten, 'Winsor knots; the sculpture of JW', *Arts Mag.*, v51/10, June 1977, 127–33; C. Robins, *The pluralist era*, New York, 1984; Rubinstein; Watson-Jones.

## WISE-CIOBOTARU, G. See CIOBOTARU, Gillian

## WOLFTHORN, Julie. née WOLF (1868–1944)

*German painter of figures, usually women, landscapes and portraits; also a printmaker*

Taking her name from her birthplace of Thorn in West Prussia, she came from a middle-class family in which there existed considerable interest in art. Wolfthorn's studies began in Berlin in 1890, although details of this are not known. She proceeded to Paris, where she enrolled at the Académie Colarossi in addition to studying with the academic painters Courtois and Aman-Jean. After setting up her own studio in Paris, she began to paint in the open air. On these occasions she would be accompanied by her model, partly to avoid adverse comment on her behaviour and partly because the figures were always the chief focus of her landscapes. This was not the only facet of her work, for Wolfthorn was one of the small number of women artists to engage in depictions of strong and sensual women, the late nineteenth-century *femmes fatales*. Around 1900 she produced pictures with titles such as *Amazon* and *The witch*, some of which were daringly erotic for a woman artist, and some critics commented on the 'manly vigour' of her execution. On her return to Berlin she participated in the Secession and other important exhibitions. Between 1898 and 1904 she produced a number of title-pages and illustrations for the magazine *Die Jugend* and a poster for the Social Democratic Party, all of which reflect the influence of Art Nouveau. Another means by which she increased her income was by taking pupils. From 1905 she concentrated on landscapes, including some of the North Sea and dune scenes executed in Holland and on the island of Hiddensee, where she visited the Muthesius family during the years 1910 to 1920. In contrast to her more heavily painted and sombretoned early works, these landscapes were executed with quick, light brushstrokes in which she captured something of the spontaneity of watercolour. Her most productive and successful period was from 1900 to 1914, but she continued to paint in Berlin throughout the 1920s. With the rise of the Nazis, Wolfthorn's Jewish origins caused difficulties. In 1944 she was deported and died in the Theresienstadt concentration camp.

*Examples:* Kupferstichkabinett, SMPK, and Berlinische G, Berlin.

*Literature: Das Verborgene Museum*; W. Sparrow.

## WOOD, Beatrice (1892/3–)

*American Dada artist and, later, ceramicist*

Wood was born in San Francisco, but her relatively wealthy family moved shortly afterwards to New York. Part of her schooling took place in France,

while the rest was at exclusive private schools in America. She rebelled strongly against the social conventions of her parents, announcing her intention of living in a garret and becoming a painter at the age of 16. As a reluctant concession, she was allowed to go to Giverny with a chaperone and recalls seeing the aged Monet in his garden. For a time she studied at the Académie Julian in Paris, but then turned to acting and dance. She was abruptly forced home by the outbreak of war. After two years with the New York-based French Repertory Company, during which time she played over 60 roles, she met, by chance, Marcel Duchamp. He encouraged her to draw imaginatively, had her first drawing published in *Rogue* and invited her to use his studio to enable her to work away from her parents. Duchamp and Wood had an immediate rapport and in due course became lovers. Through Duchamp, Wood met Walter and Louise Arensberg and became part of the circle of avant-garde writers and artists who met at their flat. Wood executed many Dadaist drawings and water-colours, the most notorious of which appeared in the same exhibition as Duchamp's *Fountain*. Wood's *Un peu d'eau dans le savon* of 1917 showed a semi-abstract female nude to which Wood attached a shell-shaped tablet of soap. This created such a furore that it was decided to continue making provocative verbal and visual statements in a journal. Wood, Duchamp and author Henri-Pierre Roché co-edited and contributed to the two issues of *The Blindman* which appeared in the spring of 1917. For financial and personal reasons, Wood returned to the theatre in Montreal that autumn for three years, during which time she married and separated from the theatre manager. Back in New York, she resumed her close friendship with Duchamp and other friends from the Arensberg circle, although the Arensbergs themselves had moved to Los Angeles, where she would renew her friendship with them. At this time she had to take odd jobs in order to survive financially. In 1923 she joined the Theosophical Society in New York (see also C. von Wiegand) and encountered Eastern religions for the first time. At the same time she made her first visit to Los Angeles, where she eventually settled in 1928. In 1930 she travelled to Holland with her friend, the actress Helen Freeman, to follow a course of instruction from the Indian philospher Krishnamurti, which influenced her strongly. In 1933 she moved to Hollywood and began to study ceramics at the High School Adult Education Department, then in an early stage of its modern development. Her first classes enabled her to mould and paint figures which she was able to

sell and from which she made her living while undertaking further study with Glen Lukens (1938) and Otto and Gertrud Natzler (1940). Until 1948 she worked mostly with on-glaze lustre and decorated surfaces, but after moving 70 miles to Ojai, she began to produce the in-glaze lustres of which she was the pioneer. Using basically simple universal forms for her vessels, she achieved a surface of unsurpassed richness. Her work has been compared with Zen Buddhist concepts of beauty and has been received with enthusiasm in Japan. From 1940 Wood exhibited extensively, in addition to travelling and lecturing. She was still actively producing ceramics on her 90th birthday.

*Publications:* 'I shock myself: excerpts from the autobiography of BW', F. Naumann (ed.), *Arts Mag.*, v51/9, May 1977, 134–9. See catalogue of Retrospective and Vergine under *Literature*.

*Examples:* Pennsylvania Academy of Fine Art, Philadelphia.

*Literature:* D. Frankel, F. Naumann and G. Clark, *BW: a retrospective*, Visual Arts Center, Fullerton, California State University, 1983 (publ. and bibl.); Vergine (publ. and bibl.).

## WRIGHT, Alice Morgan (1881–1975)

*American sculptor of portrait busts, allegorical and literary figures in plaster and bronze*

Apart from periods of travel and study, Wright remained in the town of her birth, Albany, New York. Her father was a successful merchant, and neither parent seems to have opposed her wish to become a sculptor. She graduated from Smith College, Northampton, Massachusetts in 1904, where she was a lively and independently minded student involved in various extramural activities. She proceeded to the Art Students' League, New York, where she studied under James Earle Fraser, whose influence upon her was to be long-lasting. Since women were unable to attend life-classes with male nudes, Wright attended boxing and wrestling matches to make good this deficiency, and in 1909 the award of two prizes enabled her to travel to Paris. She remained there for most of the time until 1914, studying at two private academies, that of Colarossi and the Beaux-Arts. She began to exhibit in Paris and at the RA in London (1913), some of her work reflecting the influence of Rodin. Art was not her only concern at this time, for her pre-existing interest in women's suffrage came to

the fore in Europe. She organised meetings and participated in demonstrations in both London and Paris. She met Emmeline Pankhurst on board a transatlantic ship in 1912, and the two became close friends, for Wright was already a member of the National Women's Social and Political Union. Wright was arrested at a demonstration in London and imprisoned for two months in Holloway Prison. Having smuggled plasticene and a sketch pad into her cell, she modelled a head of Emmeline Pankhurst, of whom she eventually carried out three portrait heads. Back in New York in 1914 she began to exhibit some of the work carried out in Europe, but her own style, while remaining committed to the human figure, began to reflect a knowledge of Cubism and Futurism at a time when few American sculptors had moved far from the traditonal mould. *Wind figure* of 1916 shows great simplification of form, almost to the point of abstraction, and parallels the work of Heidi Roosevelt (*q.v.*). Her fascination with modern dance is reflected in many of her drawings and sculptures, although the titles indicate literary or mythological figures. She also carried out some paintings, exhibiting a series of seven in 1926. The period from 1916 to 1930 was her most prolific but, although critics remarked on the potential of her work, she never established one firm direction, exploring several styles at the same time. Her father's wealth meant that she was never dependent on art for a livelihood. From 1930 her dominant interest, that of the humane treatment of animals, took all her available time. She became world famous for her activities in this field.

*Examples:* Brookgreen Gardens, SC; Newark, NJ; Folger Shakespeare Library and Nat. Collection of Fine Arts, Washington, DC.

*Literature: Avant-garde painting and sculpture in America, 1910–25,* Art Mus., Delaware 1975; B. Fahlman, *Sculpture and suffrage: the art and life of AMW,* Inst. of History and Art, Albany, NY, 1978 (bibl.); *Fair Muse;* M. Hill, *The woman sculptor: Malvina Hoffman and her contemporaries,* Berry-Hill G, New York, 1984; Proske, 1968 (bibl.).

## YABLONSK'A, Tetiana Nilivna. (alt. YABLONSKAIA, Tatyana Nilovna) (1917–)

*Soviet figurative painter*

Ukranian by birth, she studied at the Kiev Art Institute from 1935 to 1941 and first exhibited in 1945. By 1950 she had begun to win awards, achieving the Stalin prize in both that and the following year, while in 1951 she was also given the title of Merited Artist of the Ukranian Republic. Two years later she became an Associate member of the Academy of Arts of the USSR. Her finest work shows a tremendous assurance of line and colour, and several of her known works show women as the main protagonists. *Grain* (1949) portrays women filling sacks with corn, with male farmers barely visible in the background, a largely accurate reflection of the role of women in feeding the country after the decimation of the male population during World War II. Yablonsk'a has been described as the leading contemporary Soviet easel painter.

*Examples:* Tretykov G, Moscow.

*Literature:* V. Kuril'tseva, *TNY,* Moscow, 1959; W. Mandel, *Soviet women,* New York, 1975.

## YANDELL, Enid (1870–1934)

*American sculptor predominantly of statuettes, but who worked over a wide scale of figurative works*

A native of Louisville, Kentucky, Yandell trained at the Cincinnati Art Academy. She quickly made a name for herself in her home state and became involved in the sculptural work for the Women's Building at the 1893 Chicago Exposition. A dynamic and positive individual, she worked well with others and carried out the 24 caryatids which supported the roof garden. In addition she executed a statue of Daniel Boone, the American frontiersman. Still relatively inexperienced, she worked as assistant to Karl Bittner in New York, and in 1895 travelled to Paris, where she studied with Frederick MacMonnies. By the time of the next major exposition at Nashville in 1897, she was asked to make an eight-metre-high figure of Pallas Athene. In 1901 she won a competition for the Carrie Brown Memorial Fountain in Providence, Rhode Island; but because figures of different scales are included, although some are individually very fine, the overall impression is somewhat confusing. Nevertheless she went on to execute a number of other memorials and fountains. Parallel with this was her smaller-scale work, including the statutary portrait busts, statuettes and, perhaps best-known, the *Kiss tankard* (c.1899) which she designed for the Tiffany Company. One of her works was included in the

Armory Show of 1913, and she was one of the early women members of the National Sculpture Society. Later in life she taught sculpture at Edgartown, an artists' colony in Martha's Vineyard, off the coast of Massachusetts.

*Publications:* 'Sculpture at the World's Fair', *Current Topics*, v1, 1893, 251–5; 'Talent for sculpture', in *What women can earn*, New York, 1898, 226–8; with L. Hayes & J. Loughborough, *Three girls in a flat*, Chicago, 1892.

*Examples: Daniel Boone*, Louisville, Ky.; memorial fountain, Providence, RI.

*Literature:* D. Caldwell, *EY and the Branstock School*, School of Design Mus. of Art, Providence, RI, 1982; Clement; M. Elliott; M. Hill, *The woman sculptor: Malvina Hoffman and her contemporaries*, Berry-Hill G, New York, 1984; Rubinstein; L. Taft, *History of American sculpture*, New York, 1903; Weimann.

## YATES, Marie (1940–)

*English scripto-visual artist*

Born in Leigh, Lancashire, Yates was involved in the women's art movement in London from its early days in the 1970s. Her main concern has been theories of representation in relation to the female figure, and her art is constructed as a direct political intervention in existing cultural ideology. Using photography, text and sometimes paint, she puts together series of images which draw the spectator's attention to the way in which we have been conditioned to read photographs. By denying the spectator the pleasure of the expected complete and glossy view of the subject, she underlines the process by which images in culture are constructed to reinforce the ideology of a particular race, class and gender. This kind of art practice is regarded by some scholars as the epitome, even the only possible form, of feminist art. Yates has participated in most of the exhibitions in which this type of radical practice has featured.

*Literature: Difference: on representation and sexuality*, New Mus. of Contemporary Art, New York, 1984; L. Lippard, *Issue: social strategies by women artists*, ICA, London, 1980; R. Parker & G. Pollock, *Framing feminism*, London, 1987; *Sense and sensibility*, Midland Group G, Nottingham, 1982.

## YHAP, Laetitia (1941–)

*English painter of irregularly shaped figurative works of fishing scenes on Hastings beach*

After a childhood in St Albans, Hertfordshire, Yhap attended Camberwell School of Art from 1958 to 1962. During her course daily attendance in the life-drawing class was obligatory. Despite an awareness that it was a crucial discipline, she overcame the artificiality of the context in which it took place only by taking up pottery as the craft component of her course. At the end of this the winning of a Leverhulme Research Award allowed her to spend ten months in Italy. Resuming her studies at the Slade School of Art in 1963, she experimented with various styles before settling on small watercolours and irregularly shaped paintings in tempera. This uncertainty continued until 1976, when she suddenly realised that the everyday events of the fishermen at Hastings could take on a Proustian monumentality. Since then she has taken all her subject matter from a 600-metre stretch of beach, watching until one or more of the 'small transactions' among the men and boys there takes on a special resonance. After the end of a long-standing relationship in 1980, she suffered a nervous breakdown and was unable to paint for a year. Since 1983 when she met and began to live with Michael Rycroft, he has become the main protagonist of her paintings. Her son was born in 1984. Despite the potential nostalgia in the subject matter, she conveys the fishing community in a heroic and positive way. Elected a member of the London Group in 1971, she has exhibited extensively since 1964.

*Examples:* Hastings; Hove, Sussex; WAG, Liverpool; Tate G, London.

*Literature:* T. Hyman, *LY: the business of the beach. Paintings and drawings, 1976–88*, Laing Art G, Newcastle-upon-Tyne, 1988; *LY*, Mus. and Art G, Hastings, 1979; *LY*, Serpentine G, London, 1979; *LY: paintings since 1979*, AIR G, London, 1984.

## YOUNGMAN, Nan (1906–)

*English painter of landscape, town scenes and still life*

Born in Maidstone, Kent, Youngman is the daughter of a corn-merchant. Her family was sufficiently wealthy and liberal to be willing to pay for her

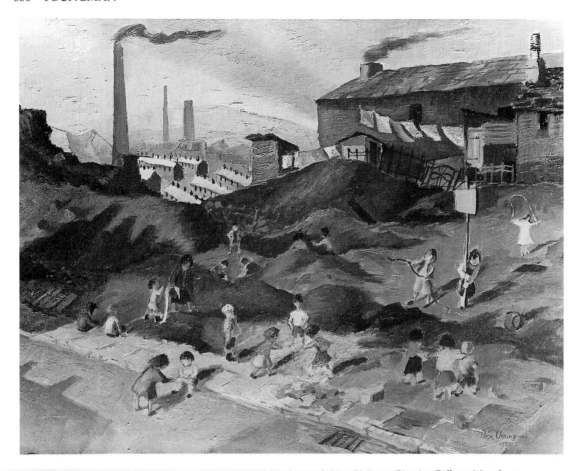

**Nan Youngman** *Waste land, Tredegar, S. Wales*, 1951, oil on plywood, 38 × 50.9 cm, City Art Gallery, Manchester. (photo: courtesy of the artist)

training. Accordingly she attended the Slade School of Art from 1925 to 1927 under the by then conservative tuition of Henry Tonks and Steer. She trained as a teacher at the London Day College and, after a year teaching and painting in South Africa (1928–9), she taught in London secondary schools until 1939. In the late 1930s she became politically active, belonging briefly to the Communist party and exhibiting with the AIA. On the outbreak of war she was evacuated with her pupils to Huntingdon, and it was only at the end of the war that she gave up teaching. She moved to Cambridge, where she acted as county art adviser, initiated and organised the first 'Pictures for Schools' exhibitions in England and Wales and visited the West Indies as a lecturer for the British

Council in 1952. It was only in the following year that she began to paint full-time and had her first solo show. From time to time she undertook further lecturing tours for the British Council and she was also an active member of WIAC. Her paintings are often concerned with capturing the particular characteristic of a place. Many have no human presence, and at times this creates an eerie, almost surreal, atmosphere.

*Examples:* Whipple Mus., Cambridge; Manchester; Salford.

*Literature:* Deepwell; K. Dunthorne, *Artists exhibited in Wales, 1946–74*, Cardiff, 1976; Waters; *Who's Who in Art*.

## ZAMBACO, Maria Terpithea. née CASSAVETTI (1843–1914)

*Greek artist who worked in London as a painter and subsequently as a sculptor, particularly of medallions*

Typical of the fate which has befallen the women associated with the Pre-Raphaelites, Zambaco is recorded principally for her affair with Burne-Jones and as a model for him and Rossetti. Born in Tulse Hill, near London, she belonged to a wealthy Greek family and was the niece of art-collector and patron, Alexander Ionides. In 1861 she married a Greek doctor in Paris, had two children, and after five years left both her husband and France and returned to London. She seems to have begun painting in the late 1860s at the same time as her involvement with Burne-Jones. Indeed he is the most likely person to have been her instructor in art. After the break with Burne-Jones in 1872, she returned to Paris, where she remained in poor health for some time. The main period of her artistic production dates from her arrival back in England in the early 1880s. While continuing to paint into the 1890s at least, she turned to sculpture for most of her output. She was taught by Legros, privately rather than at the Slade, for he was a family friend, but her daughter attended the Slade as a sculpture student from 1886. In the same year that Zambaco exhibited her first two works to be seen at the RA, Legros had revived the practice of designing cast medals but in a more robust style than had been seen in Britain. His female students at the Slade saw in these a form of sculpture in which they could more easily participate, and Zambaco realised its practical and financial potential. From 1885 she exhibited medals, and two cases of them were shown by the Society of Medallists in the New Gallery in 1888. With the portrait head on one side, they often depicted objects associated with the sitter on the reverse. By 1889 she was also making plaster reliefs for house decoration as well as large-scale sculpture. The latter were shown at the Salon throughout the 1890s, for at this period she was again living in Paris and became friendly with Rodin through their mutual friend Legros. She also ventured into photography at this time. There is no record of any work by her after 1900, when she was represented at the Paris Exposition Universelle, and she spent the years 1906–12 in Greece. During that time her health, never good, and her sight deteriorated and she returned to Paris for the last two years of her life.

*Examples:* British Mus., London.

*Literature:* P. Attwood, 'MZ: femme fatale of the Pre-Raphaelites', *Apollo*, no.293, v124, July 1986, 31–7; P. Fitzgerald, *Edward Burne-Jones: a biography*, London, 1975; J. Marsh, *Pre-Raphaelite sisterhood*, London, 1985.

## ZANARDELLI, Italia. née FOCCA (1872/4–1944)

*Italian painter and sculptor who also taught drawing*

Born in Padua, she trained at the Academy of Fine Art in Rome and with Ottin in Paris. As a sculptor she produced mythological and religious statues, but as a painter her subjects were landscape and genre; her best-known painting is a genre triptych of 1902 entitled *The worker's family*. She executed portraits in both media. She won a medal at Munich in 1893 and in an exhibition of work by women artists at London in 1900. She taught drawing in Rome schools and was a member several artists' groups.

*Example:* Leningrad.

*Literature:* Clement; A. Commanducci, *Dizionario illustrato*, 3rd ed., Milan, 1966; Krichbaum.

## ZATKOVA, Rougena (1885–1923)

*Czech painter and designer who was at one time a member of the Futurist group*

Born in Ceske Budeyovice, Bohemia, she belonged to a rich and important family, in which the six daughters all shared an interest in art. Two eventually pursued this in adulthood. In the early years of the twentieth century, she was a pupil of Antonin Slavitchek in Prague, before continuing studies in drawing at Munich. On her marriage to a Russian diplomat who collected modern art, she settled in Rome. She met Mikhail Larionov and Goncharova (*q.v.*) regularly and enjoyed a close friendship with the brother of the Futurist artist Benedetta (*q.v.*). From early figurative works with hints of Impressionism, she went on to paint landscapes which revealed influences from Munich. Interspersed with these were simplified paintings with motifs taken from Bohemian folk art. An interest in different forms of expression is evident throughout her work, and during her participation in the Futurist group she explored many different

materials in maquettes and abstract collages. Designs for costumes for a Russian ballet production were shown in a major retrospective held in Rome in 1921, the last occasion on which she is known to have exhibited. Because of her health, she spent much of the time from 1918 in Switzerland, where she died in 1923.

*Literature:* Petersen; Vergine.

## ZINKEISEN, Anna Katarina (1902–76)

*Scottish-born painter of figure scenes and portraits, designer and mural painter*

The younger of two daughters, who were both highly successful artists and designers, Zinkeisen was born in Kilcreggan, Dunbartonshire, her father being a research chemist of German descent. Both sisters drew obsessively from early childhood, much to the frustration of a series of governesses. In 1909 the family moved to Harrow, Middlesex, where both girls attended a small local art school. At the exceptionally young age of 15 she got a scholarship to the RA Schools, where she went on to win several medals. The two sisters shared a studio in central London and accepted all sorts of commissions from their student days in order to finance themselves. She gained another award, for Wedgwood plaques, at the international exhibition of decorative art in Paris in 1925, and having begun to exhibit at the RA in 1921 she continued to exhibit widely in London, Scotland, Paris and Canada. In 1933–4 she carried out a commission to execute four large panels for the liner *Queen Mary*, which represented a mythological interpretation of the four seasons. On several occasions in the 1930s she was commissioned to design posters and station panels by London Transport. Like her book illustrations, these were lively and stylish. She became well known as a painter of society portraits and her sitters included Prince Philip, Lord Beaverbrook and Alexander Fleming. She married Col. Guy Heseltine in 1928 and had one daughter. They lived in London, and Zinkeisen strove to combine the various roles in her life with considerable success. During World War II, her husband was away in the army and she served with the St John Ambulance Brigade as an auxiliary nurse in the casualty department at St Mary's Hospital, Paddington. When the surgeons became aware that she was an artist and that her own home had been bombed, they offered her vacant rooms high up in the hospital and asked her to make pathological and clinical paintings of wounds. She maintained her interest in the hospital after the war, campaigning with articles and lectures for brighter decor to aid morale of both staff and patients. She was elected a member of the Royal Institute of Painters in Oil in 1928, member of the Royal Society of Portrait Painters and Fellow of the Royal Society of Arts.

*Examples:* Bradford; Imperial War Mus. and Nat. Portrait G, London; Nottingham.

*Literature: Paintings and drawings by some women war artists*, Imperial War Mus., London, 1958; Waters; J. Walpole (ed.), *Anna: a tribute to AZ*, London, 1978; *Who's Who in Art*.

## ZINKEISEN, Doris Clare (1898–)

*Scottish-born painter and theatrical designer*

Elder sister of Anna Zinkeisen (*q.v.*), she was born in Roseneath, Argyll, and moved south with her sister at the age of 11. Working alongside Anna, she obtained a scholarship to the RA Schools in the same year as her sister and shared a London studio with her until Doris' marriage in 1927 to a naval officer, Grahame Johnstone. Despite the birth of a son, then twins, she exhibited at the RA and other London venues, in the provinces and at the Paris Salon, where she won medals in 1929 and 1930. Like her sister, she also executed a commission for the *Queen Mary*, which consisted of a ten-metre panel on the theme of entertainment. Early in World War II, with her husband on active service and the children despatched out of London for safety, she became an auxiliary nurse at St Mary's, Paddington, although she did not share her sister's fascination with painting wounds. Later she was commissioned by the War Artists' Advisory Commission to produce a painting of life in the WRNS and was sent out by the Red Cross and St John's joint war organisation as a war artist. For this she travelled to Belgium, France and Germany. However, she was best known for her theatrical designs, the first of which date from 1922. These included productions for Noël Coward, Ralph Richardson and Laurence Olivier, as well as for ballet and films. Her activity in this sphere lasted until at least 1972.

*Examples:* Imperial War Mus., London.

*Literature: Paintings and drawings by some women war artists*, Imperial War Mus., London, 1958; J.

Walpole (ed.), *Anna: a tribute to AZ*, London, 1978; Waters; *Who's Who in Art*.

## ZITZEWITZ, Augusta von (1880–1960)

*German painter of portraits, interiors, landscapes and still lifes in a vigorous modernist style; also a wood engraver*

Born into the Prussian nobility, von Zitzewitz did not conform to the expectations of her family. At the age of 27 she began her training under George Mosson at the School for Women Artists in her native Berlin. After four years she opened her own studio, but after receiving advice from Kollwitz (*q.v.*) she travelled to Paris, where she became a pupil of the Cubist Jean Metzinger. Through him she was introduced to other modernist painters working in a variety of styles and became one of the circle of young artists who met at the Café du Dome. Despite close contacts with the Cubists she never moved in that direction, preferring to forge an independent Expressionistic style in which the paint was thickly laid on, often with a palette knife. In this way the bodies of her sitters were formed of broad sweeps of pure colour, while the faces were captured in thick brushstrokes without the use of traditional perspective and chiaroscuro. In 1914 she returned to Berlin, where she remained for the rest of her life, visiting Italy, Holland and other areas of Germany from her studio in the Charlottenburg. This became the centre of the *Aktion* Group, a moderate left-wing circle of intellectuals, which included the physicist Albert Einstein. She took up wood-engraving in 1917, producing illustrations for the *Aktion* magazine. After her marriage to an art historian, she had one daughter, who often featured in her mother's paintings. Von Zitzewitz came under threat during the Nazi period because her husband and her first teacher were Jewish. After her husband's death in 1934, she supported her daughter through her portrait painting, for which she became well known. She is believed to have painted directly on to the canvas with no preparatory drawing. Despite the destruction of her studio towards the end of World War II, she began to work there again, exchanging her paintings for food. When the internal situation improved, she received official portrait commissions and was highly esteemed. A retrospective was held in Berlin in honour of her 75th birthday.

*Examples:* Nat. G, SMPK, and Berlin G, Berlin.

*Literature: Das Verborgene Museum*; *AvZ*, Schloss Charlottenburg, Berlin, 1955; *AvZ*, Mus., Kiel, 1980.

## ZORACH, Marguerite. née THOMPSON (1887–1966)

*American painter, printmaker and embroiderer*

Born in Santa Rosa, California, she was the daughter of a lawyer. Although she had always drawn and was taught art at school, it was only when an aunt wrote from Paris inviting her to study art there that she was able to escape from her well-meaning but conventional family. However, on her first day in Paris in 1908 she went to see the Salon d'Automne, where the works of the Fauves and the early Cubist works of Picasso and Braque were hung. This experience liberated her from preconceived ideas, and although she attended the traditional Grande Chaumière and Beaux-Arts academies, she also met Picasso and Gertrude Stein and became very friendly with Zadkine. In her last year in Paris (1911) she transferred to the more progressive Académie de la Palette, directed by the Scottish artist John Fergusson. This experience confirmed the direction in which her art had moved soon after her arrival in Paris, painting simplified forms, particularly landscape, with thick agitated brushstrokes and pure colour, including thick black lines. She had visited other parts of Europe, and certainly knew the work of Kandinsky and Münter (*q.v.*). After travelling round the world for seven months, she arrived home in 1912 with paintings which were among the most advanced in America before the Armory Show. Her first solo show was held in Los Angeles in 1912. Late that year she married painter William Zorach, whom she had met at La Palette, but she was never again to find the concentration to realise the potential of her early works. Both William and Marguerite exhibited in the Armory Show of 1913. In New York, she turned her creativity to decorating their apartment, painting on to unbleached fabric and introducing elements of modernist painting into embroidery. Two children were born, in 1915 and 1917, and the reduction in available time resulted in the production of tapestries, embroideries and batik, which earned much needed money. Although William helped her with some early tapestries, he could not match her skill, so turned to carving and became a sculptor. In 1925, Zorach was the founder and first president of NYSWA; as her children grew older, she

returned increasingly to painting, but was always overshadowed by her husband's reputation. Her later paintings reflect the influence of Cubism, which did not accord with her own temperament as her earlier style had. In the 1930s two completed murals executed for the town of Fresno in California were rejected and have still not been located despite the efforts of a special committee. She continued to exhibit into the 1950s and exhibited with her daughter Dahlov Ipcar (*q.v.*) in 1962. Her early works were discovered accidentally in 1970 by a scholar researching William Zorach. It is now known that he often borrowed motifs from Marguerite's embroideries and that she often designed his sculptures.

*Examples:* NMWA and National G, Washington, DC.

*Literature:* Fine 1978; Heller; M. Mannes, 'The embroideries of MZ', *International Studio*, v95, 1930, 29–33; J. Marter, 'Three women artists married to early modernists', *Arts Mag.*, v54, Sept. 1979, 88–95; R. Tarbell, 'Early paintings by MTZ', *American Art Review*, v1, Mar.–Apr. 1974, 43–57; R. Tarbell, *MZ, the early years: 1908–20*, Washington, DC, 1973; R. Tarbell, *William and MZ: the Maine years*, Farnsworth Library and Art Mus., Rockland, Me., 1979; Rubinstein; Withers, 1979; A. Wolf, *New York Society of Women Artists 1925*, ACA G, New York, 1987.

# Bibliography

All items which deal with one individual only can be found in the reference section of the entry for that person, and are not repeated in the bibliography.

Exhibition catalogues are listed under the author but in cases where this is not possible or appropriate, they are listed in the alphabetical sequence under the title of the exhibition.

Abrahamsen, M. 'The art on tour', *Look at Finland*, no.3, 1986, 18–25

*About time*, ICA, London, 1980

*Abstraction-Création, 1931–6*, Musée de la Ville de Paris, 1978

Allen, C., Chiti, J. and Hill, L. *Transformations: women in art: 70s and 80s*, Coliseum, New York, 1981

Alloway, L. 'Women's art in the '70s', *Art in America*, May 1976, 64–72.

*Along the lines of resistance: an exhibition of contemporary feminist art*, Cooper Gallery, Barnsley, 1988

Anscombe, I. *A woman's touch: women in design from 1860 to the present day*, London, 1985

Anscombe, I. *Omega and after: Bloomsbury and the decorative arts*, London, 1981

Armfield, M. *Tempera painting today*, London, 1946

Armstrong, R. 'Representative American women illustrators: the child interpreters', *Critic*, v36, May 1900, 417–30

Armstrong, R. 'Representative American women illustrators: the decorative workers', *Critic*, v36, June 1900, 520–9

*Avant-garde painting and sculpture in America, 1910–25*, Art Museum, Delaware, 1975

*L'avant-garde au féminin: Moscou, Saint-Petersbourg, Paris, 1907–30*, Artcurial, Paris, 1983

Bachmann, D. and Piland, S. *Women artists: a historical, contemporary and feminist bibliography*, Metuchen, NJ, 1978

Ball, M. and Godfrey, T. *Figuring out the 80s*, Laing Art Gallery, Newcastle-upon-Tyne, 1988

Baron, W. *The Sickert women and the Sickert girls*, Parkin Gallery, London, 1974

Barron, S. and Tuchman, M. *The avant-garde in Russia, 1910–30: new perspectives*, County Museum of Art, Los Angeles, 1980

Barrow, M. *Women, 1870–1928: a select guide to printed and archival sources in the United Kingdom*, London, 1981

Barry, W. *Women pioneers in Maine art*, Joan Whitney Payson Gallery of Art, Westbrook College, Portland, Me., 1981

Barry, W. *Women pioneers in Maine art, 1900–45*, Joan Whitney Payson Gallery of Art, Westbrook College, Portland, Me., 1985

Bassin, D. 'Women's images of inner space: data towards expanded interpretative categories', *International Review of Psycho-analysis*, v9, 1982, 191–203

Beckett, J. and Cherry, D. *The Edwardian era*, Barbican Art Gallery, London, 1987

Bénézit, E. *Dictionnaire des peintres, sculpteurs, dessinateurs et graveurs*, Paris, rev. ed. 1976

Benstock, S. *Women of the Left Bank, 1900–1940*, London, 1987 (orig. pub. University of Texas, 1986)

Bergen, J. *The American Artists' Congress, 1936–42*, ACA Galleries, New York, 1986

Berman, A. 'A decade of progress; but could a female Chardin earn a living?' *Artnews*, Oct. 1980, 73ff.

Biddle, G. *An American artist's story*, Boston, 1939

Bonsdorf, B. von. 'Finnish painting from 1840–1940', *Apollo*, May 1982, 370–9

Bonshek, A. 'Feminist romantic painting – a re-constellation', *Artists' Newsletter*, May 1985, 24–7

Boulton-Smith, J. *Modern Finnish painting and graphic art*, London, 1970

*The British art show: old allegiances and new directions*, Arts Council, London, 1984

*British painting, 1952–77*, Royal Academy, London, 1977

Brown, F. *South Kensington and its art training*, London, 1912

Brown, M. *Social art in America, 1930–45*, ACA Galleries, New York, 1981

Bryan, M. *Dictionary of painter and engravers*, London, 1903

Bunoust, M. *Quelques femmes peintres*, Paris, 1936

Callen, A. *Angel in the studio: women in the Arts and Crafts movement, 1870–1914*, London, 1979

Carandente, G. et al. *Knaurs Lexikon der modernen Plastik*, Zurich, 1961

Cardinale, S *Special issues of serials about women, 1965–75*, Council of Planning Librarians exchange bibliography, no.995, Mckeldin Library, University of Maryland, 1976

*Catalogue of the British Fine Art section of the Exposition Universelle*, London & Paris, 1889

*Catalogue générale de l'Exposition Universelle*, Paris, 1889

*Catalogue générale de l'Exposition Universelle*, Paris, 1900

*A centenary exhibition to celebrate the founding of the Glasgow Society of Lady Artists in 1882*, Collins Gallery, Glasgow, 1982

*A century of women artists*, Childs Gallery, New York, 1987

Chadwick, W. *Women artists and the Surrealist movement*, London, 1985

Cherry, D. *Painting women: Victorian women artists*, Art Gallery, Rochdale, 1987

Chew, E. *Women artists* [from the permanent collection], National Museum of American Art, Washington, DC, n.d.

Clayton, E. *English female artists*, 2 vols, London 1876

Clement, C. *Women in the fine arts from the seventh century BC to the twentieth century AD*, (Boston, 1904) New York, 1973

Clement, C. and Hutton, L. *Artists of the nineteenth century*, New York, 1879

Collins, J. and Opitz, G. *Women artists in America: eighteenth century to the present*, v1 revised ed. 1981, v2, 1975

Comanducci, A. *Dizionario illustrato dei pittori italiani moderni e contemporanei*, 4 vols, third rev. ed. Milan, 1966

*Contemporary visual art in Hungary*, Third Eye Centre, Glasgow, 1985

Cooper, E. *The sexual perspective: homosexuality and art in the last 100 years in the west*, London, 1986

*Cornwall 1945–55*, New Art Centre, London, 1977

Crowe, E. *Women artists: a selected bibliography of periodical material 1929–74*, San Jose, 1974

Dabrowski, M. *Contrasts of form: geometric abstract art, 1910–80*, MOMA, New York, 1985

Dallier, A. *Combative acts, profiles and voices: an exhibition of women artists from Paris*, AIR Gallery, New York, 1976

*Das Verborgene Museum: Dokumentation der Kunst von Frauen in Berlineröffentlichen Sammlungen*, Akademie der Künste, Berlin, 1987

Day, M. *Modern art in English churches*, London, 1984

Day, M. *Modern art in church: a gazetteer of twentieth century works of art in English and Welsh churches*, Royal College of Art papers, no.2, London, 1982

Deepwell, K. *Women artists in Britain between the two World Wars*, unpublished BA thesis, Leeds University, 1985

Deepwell K. 'Almost unknown: Royal Academy women, 1922–40', *Women Artists' Slide Library Journal*, Oct.–Nov. 1987, 6–8

*Dictionary of National Biography* and supplements

*Dictionnaire de biographie française*

*Dreams of a summer night: paintings from Scandinavia*, Hayward Gallery, London, 1986

Driskell, D. *Two centuries of Black American art*, County Museum of Art, Los Angeles, 1976

Dunthorne, K. *Artists exhibited in Wales, 1945–74*, Cardiff, 1976

Edouard-Joseph, R. *Dictionnaire biographique des artistes contemporains*, 3 vols. and supplement, Paris, 1930–4

Edwards, J., James, J.W. and Boyer, P. *Notable American women, 1607–1950*, 3 vols, Cambridge, Mass., 1971 (for v4 see under Sickermann)

Eiblmayr, S., Export, V. and Prischl-Maier, M. *Kunst mit Eigen-Sinn: Aktuelle Kunst von Frauen*, Mus. moderner Kunst, Vienna/Mus. des 20. Jahrhunderts, Munich, 1985

Eichler, M. *et al. An annotated selected bibliography of bibliographies on women*, Pittsburgh, 1976

*Eight Southern women*, Museum of Art, Greenville County, SC, 1986

Elinor, G. *et al. Women and craft*, London, 1987

Ellet, E. *Women artists in all ages and countries*, New York, 1859

Elliott, M. *Art and handicraft in the Women's Building of the World's Columbian Exposition, Chicago, 1893*, Chicago, 1893

Engen, R. *Dictionary of Victorian wood engravers*, Cambridge, 1985

*Eva und die Zukunft: das Bild der Frau seit der Französischen Revolution*, Kunstmuseum, Hamburg, 1986

*Famous British women artists*, Graves Art Gallery, Sheffield, 1953

Faxon, A. and Moore, S. (eds) *Pilgrims and pioneers: New England women in the arts*, New York, 1987

Fehrer, C. 'New light on the Académie Julian and its founder', *Gazette des Beaux-Arts*, no.1384–5, v126, May–June 1984, 207–16

*La femme: peintre et sculpteur de XVIIe au XXe siècle*, Grand Palais, Paris, 1975

*Les femmes artistes d'Europe*, Musée du Jeu de Paume, Paris, 1937

Field, R. and Fine, R. *A graphic muse: prints by contemporary women*, New York, 1987

Fine, E. *The Afro-American artist: a search for identity*, New York, 1973

Fine, E. *Women and art: a history of women painters and sculptors from the Renaissance to the twentieth century*, Montclair & London, 1978

Flanner, J. *Paris was yesterday, 1925–39*, New York, 1972; London 1973; [articles by JF published in the *New Yorker* between 1925 and 1939]

Flint, J. *Provincetown printers: a woodcut tradition*, National Museum of American Art, Washington, DC, 1983

*The flower show: an exhibition on the theme of flowers in twentieth century art*, Museum and Art Gallery, Stoke-on-Trent, 1986

*Fourteen Americans*, Museum of Modern Art, New York, 1946

Fox, C. and Greenacre, F. *Painting in Newlyn, 1900–30*, Barbican Art Gallery, London, 1985

Fredeman, W. *Pre-Raphaelitism: a bibliocritical study*, Cambridge, Mass., 1965

*French Symbolist painting: Moreau, Puvis de Chavannes, Redon and their followers*, Hayward Gallery, London, 1972

Fuchs, C. *Die Osterreichischen Maler, 1881–1900*, 2 vols, Vienna, 1976

Fuchs, C. *Die Osterrichischen Maler des 19 jahrhunderts*, 3 vols, Vienna, 1978

Furniss, H. *Some Victorian women: good, bad and indifferent*, London, 1923

Gabhart, A. and Broun, E. 'Old mistresses: women artists of the past', *Bulletin of the Walters Art Gallery*, v24/7, 1972, not paginated

Garb, T. 'L' art féminin: the formation of a critical category in late nineteenth century France', *Art History*, v12/1, March 1989, 36–65.

Gardner, P. 'When is a painting finished?', *Art News*, v84/9, Nov. 1985, 89–99

*The genuis of the fair muse: painting and sculpture celebrating America women artists, 1875–1910*, Grand Central Galleries, New York, 1987.

Gerdts, W. *Women artists of America, 1707–1964*, Museum, Newark NJ, 1965

Gerdts, W. *The white marmorean flock: nineteenth-century American women neo-classical sculptors*, Vassar College Art Gallery, Poughkeepsie, 1972

Gilbey, W. *Animal painters of England*, 3 vols, London, 1910–11

Gleichen, E. *London's open-air statuary*, London, 1928

Goldberg, R. 'Public performance, private memory', *Studio International*, July–Aug. 1976, 19–23

Golhany, A., Harris, A. and King, E. *Sculpture by women in the eighties*, University Gallery, Pittsburgh, 1985

Goodman, H. 'The Plastic Club', *Arts Magazine*, v59/7, Mar. 1985, 100–3

Graham, J. 'American women artists' groups', *Women's Art Journal*, v1/1, spring-summer 1980, 7–12

Graves, A. *Royal Academy exhibitors, 1769–1904*, London, (1905–6) reprinted 1970

Graves, A. *The British Institution, 1806–67*, London, (1908) reprinted 1969

Greer, G. *The obstacle race: the fortunes of women painters and their work*, London, 1979

Gunnis, R. *Dictionary of British sculptors, 1660–1851*, London, (1961) 3rd expanded ed., 1975

Hagen, L. 'Lady artists in Germany', *International Studio*, vIV, 1898, 91–9

Harries, M. and S. *The war artists: British official war art of the twentieth century*, London, 1983

Harris, A. and Nochlin, L. *Women artists, 1550–1950*, County Museum of Art, Los Angeles, 1976

Harrison, H. & Lippard, L. *Women artists of the New Deal era*, National Museum of Women in the Arts, Washington, DC, 1988

*Hayward Annual '78*, Hayward Gallery, London, 1978

*Hayward Annual 1979*, Hayward Gallery, London, 1979

Hedley, G. *Let her paint: ten women painters in Southampton City Art Gallery*, Southampton, 1988

Heller, N. *Women artists: an illustrated history*, London & New York, 1987

Herbert, R. *Impressionism: art, leisure and Parisian society*, New Haven, 1987

*Het Zelfbeeld/Images of the self*, Stichting Burcht, Leiden, 1987

Hilton, A. 'When the Renaissance came to Russia', *Art News*, v70, Dec. 1971, 34–9

Hilton, A. 'Bases of the new creation: women artists and Constructivism', *Arts Magazine*, v55, Oct. 1980, 142–5

Hinding, A. and Moody, S. *Women's history sources: a guide to archives and manuscript collections in the US*, New York & London, 1979

Hirsch, A. *Die Bildenden Künstlerinnen der Neuzeit*, Stuttgart, 1905

Holland, C. 'A lady art student's life in Paris', *Studio*, v30, 1904, 225–33

Hoppin, M. 'Women artists in Boston 1870–1900: the pupils of William Morris Hunt', *American Art Journal*, winter 1981, 17–46

Huber, C. *The Pennsylvania Academy and its women, 1850–1920*, Pennsylvania Academy, Philadelphia, 1973

Ingelman, I. 'Women artists in Sweden: a two-front struggle', *Women's Art Journal*, v5/1, spring-summer 1984, 1–7

*International exhibition of modern art*, Association of American painters and sculptors, New York, 1913 [Armory Show]

Ireland, N. *Index to women of the world from ancient to modern times: biographies and portraits*, Westwood, Mass., 1970

*Irish art in the nineteenth century*, Municipal School

of Art, Crawford, Co. Cork, 1971

*Irish women artists from the eighteenth century to the present day*, National Gallery of Ireland, the Douglas Hyde Gallery and Hugh Lane Gallery, Dublin, 1987

*The issue of painting*, Art Gallery, Rochdale, 1986

Jacobs, M. and Warner, M. *Phaidon companion to art and artists in the British Isles*, Oxford, 1986

Jaffe, P. *Women engravers*, London, 1988

Johnson, J. *Works exhibited at the Royal Society of British Artists, 1824–93 and at the New English Art Club, 1888–1917*, Woodbridge, Suffolk, 1975

Jönssen, H. *Danske kvindelige kunstnere fra det 19. og 20. århundrede*, Statens Museum for Kunst, Copenhagen, 1980

Katz, B. 'The women of Futurism', *Women's Art Journal*, v7/2, fall 1986-winter 1987, 3–13

Kent, S. *Problems of picturing*, Arts Council, London, 1984

Kingsley, A. 'Six women at work in the landscape', *Arts Magazine*, v52, Apr. 1978, 108–12

Krichbaum, J. and Zondergeld, R. *Künstlerinnen: von der Antike bis zur Gegenwart*, Cologne, 1979

Krichmar, A. *The women's movement in the '70s: an international English language bibliography*, Metuchen, NJ, 1977

*Kunst door vrouwen*, Stedelijk Museum De Lakenhal, Leiden, 1987

*Künstlerinnen international, 1877–1977*, Schloss Charlottenburg, Berlin, 1977

*Kvinnor som målat*, Nationalmuseum, Stockholm, 1975

*Landscape, memory and desire*, Serpentine Gallery, London, 1984

*The last romantics: the romantic tradition in British Art. Burne-Jones to Stanley Spencer*, Barbican Gallery, London, 1989.

Lewis, S. and Waddy, R. *Black artists on art*, 2 vols, Los Angeles, (1969) 1971

*Lexikon der Frau*, 2 vols, Zurich, 1953

Lippard, L. *From the center*, New York, 1976

Lippard, L. 'Caring: five political artists', *Studio International*, May–June 1977, 197–208

Lippard, L. *Issue: social strategies for women artists*, ICA, London, 1980

Lippard, L. *Get the message: a decade of art for social change*, New York, 1984

*Livre des peintres exposants en Paris*, Paris, 1930

Lucie-Smith, E. *Art in the seventies*, Oxford, 1980

Lucie-Smith, E., Cohen, C. and Higgins, J. *The new British painting*, Oxford, 1988

Lynes, R. *Art makers of the nineteenth century*, New York, 1970

Mackay, J. *Dictionary of Western sculptors in bronze*, Woodbridge, 1978

Mallalieu, H. *Dictionary of British watercolour artists*, Woodbridge, 1976

Mandel, W. *Soviet women*, New York, 1975

Manning, E. *Bronze and steel: the life of Thomas Thornycroft, sculptor and engineer*, Shepston-on-Stour, 1932

Manning, E. *Marble and bronze: the art and life of Hamo Thornycroft*, London, 1982

Marling, K. and Harrison, H. *7 American women: the Depression decade*, Vassar College Art Gallery, Poughkeepsie, 1976

Marling, K. and Morrin, P. *Woodstock: an American art colony 1902–77*, Vassar College Art Gallery, Poughkeepsie, 1977

Marshall, R. *New image painting*, Whitney Museum, New York, 1978

Marter, J. 'Three women artists married to early modernists: Sonia Terk-Delaunay, Sophie Taueber-Arp, and Marguerite Zorach', *Arts Magazine*, v54, Sept. 1979, 88–95

Martin, J. *Nos peintres et sculpteurs*, Paris, 1897

Mathey, F. *Six femmes peintres*, Paris, 1951

McWilliams, M. and Wood, M. *National Museum of Women in the Arts: catalog*, New York, 1987

Miller, J. 'America's forgotten printmakers', *Print Collectors' Newsletter*, v4, Mar.–Apr. 1973, 2–6

*Movement and the city: Vienna and New York in the 1920s*, Rachel Adler Gallery, New York, 1987

Munro, E. *Originals: American women artists*, New York, 1979

Munsterberg, H. *A history of women artists*, New York, 1975

Neilson, W. and F. *Seven women: great painters*, Philadelphia, 1969

Nemser, C. *Art talk: conversations with twelve women artists*, New York, 1975

*New Italian art, 1953–71*, Walker Art Gallery, Liverpool, 1971

Newman, M. 'New sculpture in Britain', *Art in America*, Sept. 1982, 104–14, 177, 179

Nochlin, L. 'Some women realists: part 1', *Arts Magazine*, v48/5, Feb. 1974, 46–51

Nochlin, L. *Women, art and power, and other essays*, New York, 1988

*Numaish exhibition of work by Asian women artists*, People's Gallery, London, 1986

Nunn, P. 'Ruskin's patronage of women artists', *Women's Art Journal* v2/2, fall 1981-winter 1982, 8–13

Nunn, P. *Canvassing: recollections by six Victorian women artists*, London, 1986

Nunn, P. *Victorian women artists*, London, 1987

*Off the shelf: recent sculptures by Cathy Acorns, Val Murray and Lois Williams*, Art Gallery, Rochdale, 1986

*Paintings and drawings by some women war artists*, Imperial War Museum, London, 1958